THE STAMP OF IMPULSE

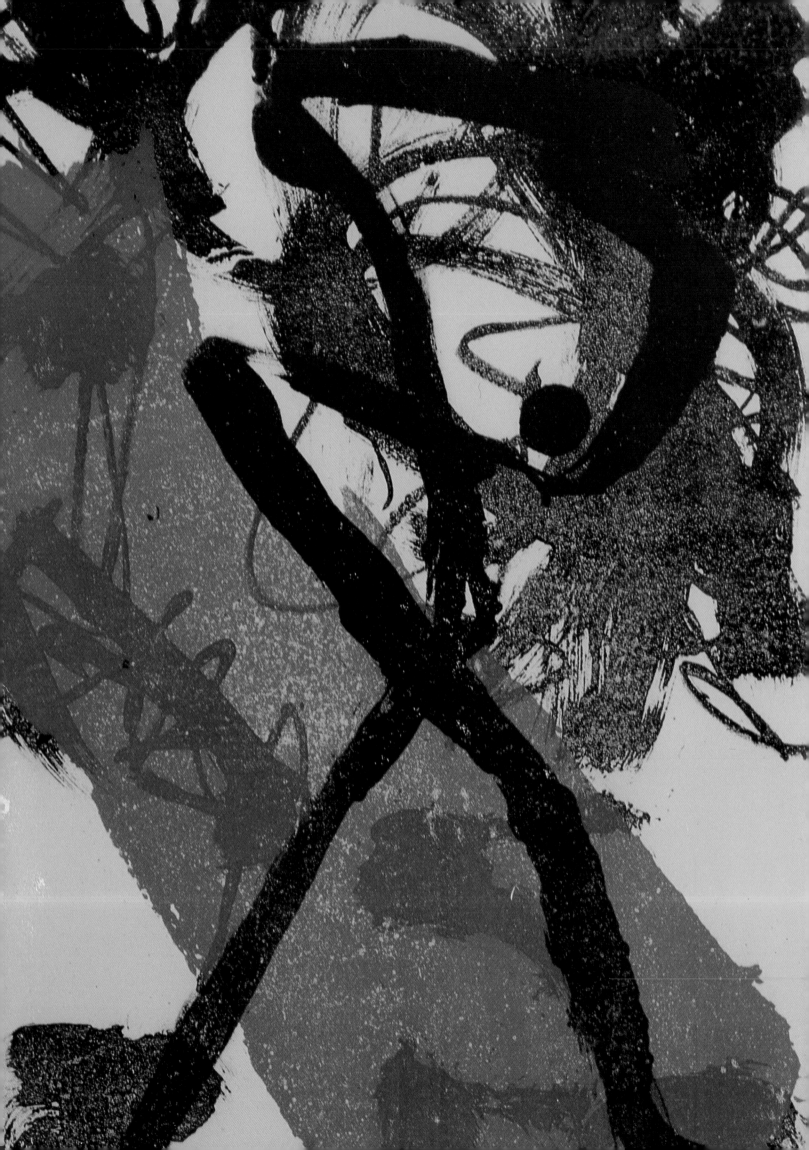

The Stamp of Impulse

ABSTRACT EXPRESSIONIST PRINTS

DAVID ACTON

with essays by

DAVID AMRAM

DAVID LEHMAN

HUDSON HILLS PRESS, NEW YORK

IN ASSOCIATION WITH THE WORCESTER ART MUSEUM

Worcester Art Museum
Worcester, Massachusetts
April 21–June 17, 2001

The Cleveland Museum of Art
Cleveland, Ohio
November 18, 2001–January 27, 2002

Amon Carter Museum
Fort Worth, Texas
March 2–May 12, 2002

Mary and Leigh Block Museum of Art
Northwestern University
Evanston, Illinois
January 16–March 16, 2003

The Stamp of Impulse: Abstract Expressionist Prints was
organized by the Worcester Art Museum, Worcester,
Massachusetts, with major support from the National
Endowment for the Arts, Allmerica Financial, The Judith
Rothschild Foundation, The Richard A. Heald Fund, and the
Christian A. Johnson Exhibition Endowment Fund.

FIRST EDITION

Frontispiece: James Kelly, *August*, 1952, detail, cat. no. 34

ISBN 1-55595-213-5

Library of Congress Control Number: 2001087749

Published by Hudson Hills Press, Inc.,
1133 Broadway, Suite 1301,
New York, NY 10010-8001.
Editor and Publisher: Paul Anbinder

Distributed in the United States,
its territories and possessions,
and Canada by National Book Network.

CONTENTS

Foreword 6

Acknowledgments 7

Introduction 9

Seeing the Music, Hearing the Pictures 19
DAVID AMRAM

Poetry and the Abstract Revolution 27
DAVID LEHMAN

Use of the Catalogue 41

Catalogue of the Exhibition 42

Notes 252

Bibliography 267

Index 285

FOREWORD

The imagery and concepts of Abstract Expressionism were the leading achievement of American art in the twentieth century. Despite its importance, the impact of this style on the graphic arts has never been fully examined. Intrigued by this remarkable situation, David Acton, the Museum's Curator of Prints, Drawings, and Photographs, began to study and explore this material, in collaboration with one of Worcester's leading collectors, James N. Heald II. This exhibition and publication are the fruits of their inquiries over the past decade and the Worcester Art Museum's extensive collecting of Abstract Expressionist prints, proofs, variants, technical materials, and drawings. Their research led them to the artists' friendships and collaborations with jazz musicians and avant-garde poets, and to illustrated *livres d'artistes*, many produced by printmakers in collaboration with poets who were the artists' friends. A vivid portrait emerged, of an era when people in a wide range of creative endeavor mixed socially, and freely shared their ideas and influences, in New York, San Francisco, and throughout the country. Concepts fundamental to Abstract Expressionist art helped to create distinctive American music and literature, and helped to reform postwar society.

This exhibition and publication were made possible by a grant from the National Endowment for the Arts. The catalogue was also supported by generous grants from The Judith Rothschild Foundation, and The Richard A. Heald Fund. This exhibition and catalogue would have been impossible without several key loans from the Museum of Modern Art, the Baltimore Museum of Art, the Oakland Museum, Deborah Remington, the estate of Nell Blaine, and the estate of Richard Diebenkorn. We are extremely grateful to Mr. and Mrs. James N. Heald for their enthusiastic and consistent support of this project, and to David Acton. His early recognition of the importance of Abstract Expressionist printmaking and his in-depth research in this field have not only produced this landmark exhibition and catalogue, but have also made the Worcester Art Museum an important repository and center for the study of this material.

James A. Welu
Director, Worcester Art Museum

ACKNOWLEDGMENTS

This project grew from an enthusiasm for American art and music of the 1940s and 1950s, shared with James N. Heald II, an astute collector, former Trustee of the Worcester Art Museum, and Chairman of its Collections Committee. Over a decade Jim and I shared the adventure of searching out artists, and the often exhilarating discovery of wonderful, long-forgotten works of art. I want to express my gratitude to Jim for his inspiration, enthusiasm, and support throughout this adventure. During my research for this book, and in the organization of its accompanying exhibition, many others have given their time, memories, and insights. I am most indebted to the artists and the printers, who without exception responded to my interest with consideration and generosity. I am grateful to David Amram and David Lehman for their important contributions of the catalogue's introductory essays, which help to demonstrate the richness of the era, and how printmaking was one of many skeins in a complex fabric of creative endeavor.

This catalogue would not have been possible without the support and assistance of Wilder Green, and of Michael Sakkalli. The project benefited from the advice and contributions of many colleagues, and I wish to thank Clinton Adams, David Anfam, Karin Breuer, Marjorie Devon, Jane Glaubinger, Jeff Gunderson, Trudy Hansen, Michael Herrmann, Irwin Hollander, Ruth and Jacob Kainen, Susan Landauer, Jane Myers, Mike Solomon, Kristin Spangenburg, June Wayne, and Deborah Wye. In addition, many art dealers provided enormous assistance in locating artists, their work, and the facts presented here, and I am particularly grateful to Deborah Bell, Gala Chamberlain and Dan Lienau, Sylvan Cole, Gil Einstein and Anne MacDougall, Adrienne Fish, Joe Goddu, Noah Hoffman, Alan Platt, Ellen Sragow, Susan Teller, Charles Young, and Virginia Zabriskie. I am also indebted to the families of many of the artists, who have been considerate and generous in helping me to pursue this research, and I would like to acknowledge the contributions of Maddy and Dave Berezov, Cary Bluhm, Michael Brenson, Charlotte Brooks, Christopher Busa, Nikki Casarella, Judith Childs, Ruth Cobb, Christine Conover, Phyllis Diebenkorn, Gretchen and Dick Grant, Carolyn Harris, Suzanne Donnelly Jenkins, Morris Kadish, Susan Stedman Majors, Mary Fuller McChesney, Jane Opper, Debby Paris, Wendy Snyder, Lilian Stillman, Nancy Uyemura, and Nick Wilke.

This project would not have been possible without the support of many colleagues at the Worcester Art Museum. Director James A. Welu has been enthusiastic about the project from its inception; Director of Curatorial Affairs Elizabeth de Sabato Swinton made incalculable contributions in helping to edit the catalogue manuscript and organize the exhibition and its programming; Maura Brennan, Assistant Curator of Prints, Drawings and Photographs, helped with research, arrangements for catalogue photography and reproductions, and organization of the exhibition; Debby Aframe and Jolene de Verges in the Worcester Art Museum library were most helpful at every stage of my research; paper conservators Alison Luxner and Joan Wright treated the prints and helped with technical research. The logistics of the traveling exhibition were expertly managed by Nancy Swallow; Patrick Brown designed and executed the exhibition installation with the assistance of John Hyden; Anne Greene prepared the prints for exhibition and helped create exhibition signage; most of the catalogue photography was done by Steven Briggs, and Jill Burns assisted with coordination of photographic materials. Julianne Faria helped to compile the bibliography.

The catalogue was edited with care and diligence by Margaret Jupe and Denise Bergman, and its elegant design was created by Susan Marsh, and to them I owe deep gratitude. Most of all, I am grateful for the steadfast support and inspiring encouragement of Gretchen Haas, to whom this work is dedicated.

David Acton

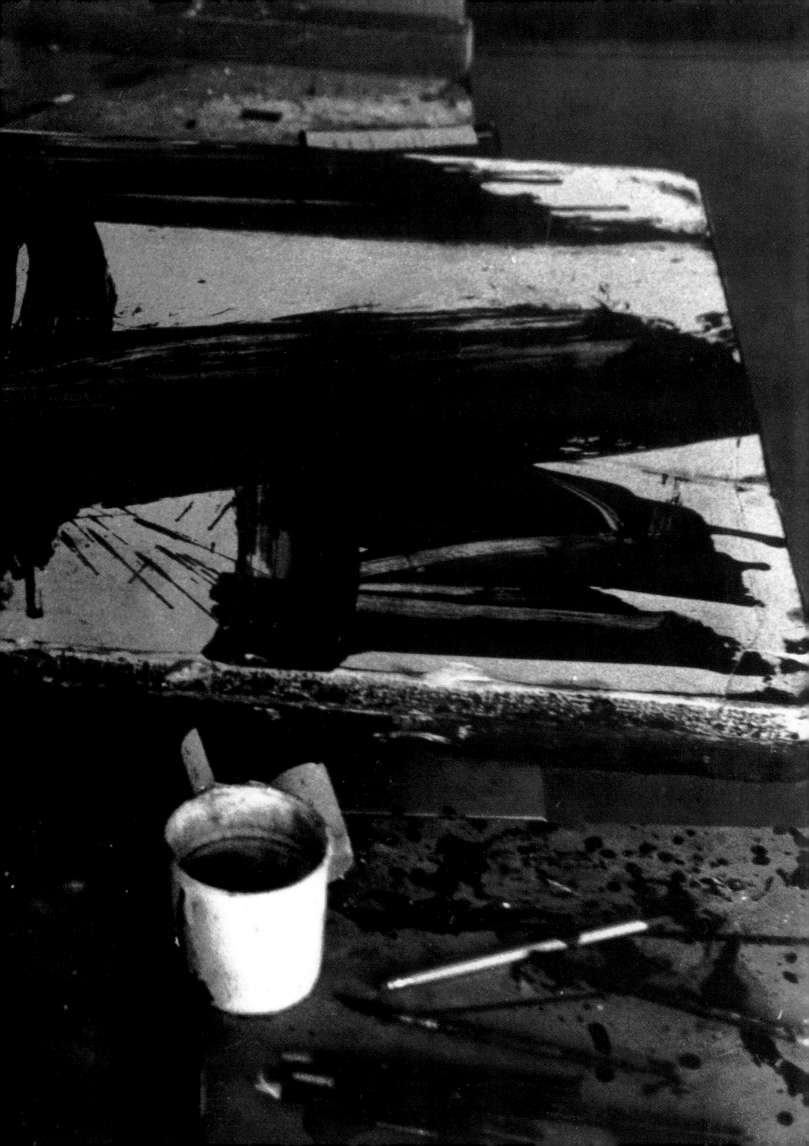

INTRODUCTION

In the decades surrounding World War II an energetic new avant-garde art developed in New York. The manner later described as Abstract Expressionism became the most important American contribution to modern art, and established New York as its center. Though their works are diverse in style and imagery, the pioneer Abstract Expressionist painters in New York during the 1940s shared common principles of spontaneity and subjectivity, largely derived from French Surrealism.[1] These concepts supported styles as varied as biomorphic fantasy and gestural calligraphy. The painters worked in an immediate, unpremeditated manner, seeking to tap the universal creativity of the subconscious mind. They came to think of a work of art as a reflection of the psychological and emotional state of its maker and as the record of its own creation. As the act of painting began to dominate the subject, the artists became more interested in the behavior and sensuous qualities of the paint itself. Abstract Expressionism had an extensive and lasting impact on printmaking. The full range of its styles and ideas appear in prints, many created by the progenitors of the movement. However, the relative scarcity of these works, and their subjectivity, have long kept them from being understood and appreciated. At this juncture, as we reevaluate the life accomplishments of many of the artists, a new picture begins to emerge of the remarkable conceptual, geographical, and chronological influence of Abstract Expressionism on American printmaking.

Abstract Expressionism originated in Manhattan during the 1940s, and its pioneers are commonly known as the New York School. Many of them had met in the previous decade, while working on the Federal Arts Project of the Works Progress Administration (FAP/WPA), emergency government programs enacted to sustain artists during the Depression. These programs were in place across the country, but the New York FAP was the largest and most productive, and attracted more artists to the city. As their community grew, New York artists felt a new confidence, sensing that they had finally become

an integral part of society. At that time, several of the most progressive artists of the day, including John Graham, Arshile Gorky, Stuart Davis, and Willem de Kooning, met informally in Greenwich Village cafeterias, to share ideas about European traditional and avant-garde painting, literature, music, and many other aesthetic issues. Unrecognized and impoverished, they were nonetheless very serious and optimistic. Many of the pioneers of Abstract Expressionism worked on the easel-painting, mural-painting, or sculpture divisions of the FAP/WPA, and they enjoyed a similar camaraderie. From 1935 to 1943, the New York City graphic arts division of the project became the largest and most productive in the country.[2] It established workshops where printmaking instruction was available, along with access to presses, technical assistance, and a relatively efficient system for remuneration. The artists who worked there gained the sense that printmaking was a worthwhile creative endeavor and the potential means for communicating with a wide audience.

By 1940 this situation began to change, as the WPA programs were gradually reduced during World War II, and replaced by defense support agencies employing artists in mechanical drafting, reconnaissance photography, poster and camouflage design, and other related occupations. As efforts to improve society were shifted to a campaign for its protection, it seemed to many artists that a hopeful era had ended. There were fewer jobs, and suddenly the encouraging artistic community was dispersed. Concern for the fate of Europe during the war brought an oppressive malaise to New York with its immigrant culture. The crisis deepened when Paris fell to the Nazis in summer 1940 and the very survival of modern art was in jeopardy. European artists found exile in New York at that time, and to some extent they transplanted their ideas, imagery, and society. Many came from Paris with its thriving café life and did not speak English, so they found alternative places to gather and converse. They met at the Free French Canteen and the cheap

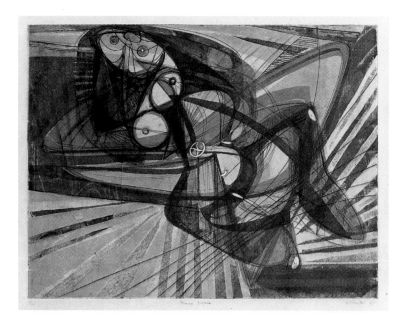

Stanley William Hayter, *Femme Instable*, 1957,
soft-ground etching and engraving, private collection

French restaurant Larré's, as well as at Curt Valentin's
Bucholz Gallery and Peggy Guggenheim's Art of This
Century Gallery. The Surrealists among them also met to
work at Atelier 17, Stanley William Hayter's experimental
etching studio.

The English-born Hayter had lived in Paris since
1926. He opened a unique teaching workshop for intaglio
printmaking near Montparnasse, at 17 rue Champagne-
Première; when the studio moved to New York, it kept the
name from that address.[3] Hayter exhibited with the
Surrealists in Paris in 1933, and their ideas about the
subconscious became central to his aesthetic theory.
Though he worked in the technically demanding process
of engraving, the artist strove to find inspiration in the
unconscious mind, and worked spontaneously, without
preconceiving his designs. In 1941, Hayter reopened
Atelier 17 at the New School for Social Research in New
York. The shop retained the open, experimental atmos-
phere of the Paris operation. Among the Surrealists in
exile who worked in the New York shop were Joan Miró,
André Masson, Roberto Matta, Max Ernst, Yves Tanguy,
and Kurt Seligmann. American artists knew their work
from the influential exhibition *Fantastic Art, Dada,
Surrealism* at the Museum of Modern Art a few years
before,[4] and the printshop was one of the few places
where they could observe or approach the French mas-
ters. Their creativity, technical skills, and esprit de corps
were impressive, and the fact that they gave serious
attention to original prints was significant.

Hayter promoted the graphic arts as much more
than craft, distinguishing the printmaker as an origina-
tive artist using highly technical processes as creative,
not reproductive media. He advocated the technique of
engraving, which was too rigorous for all but the most

committed printmakers and at odds with the Abstract
Expressionist desire for immediacy. However, in Hayter's
open, experimental workshop, where everyone worked in
plain view of their peers, technical information often
passed casually. These ideas influenced many of the
Abstract Expressionists, even those who worked only
briefly at Atelier 17, including Reuben Kadish, Robert
Motherwell, Louise Bourgeois, and Louise Nevelson.
Moreover, several of the young artists who worked at
Atelier 17 during the 1940s — including Mauricio
Lasansky, Gabor Peterdi, and Fred Becker — went on to
establish similar printmaking studios and programs at
American universities, perpetuating the spirit of the
experimental workshop.

Despite this concentrated experimentation, during
the war years the output of American printmaking gener-
ally diminished when demand receded. For many New
York artists in the 1940s, printmaking seemed beside the
point. The extended effort required, inaccessible equip-
ment, and the cost of materials were discouraging. To
some, prints carried lingering associations to the WPA,
and to the passé Social Realist and Regionalist styles.
Those artists who continued to dabble with the medium
often used plates, stones, and presses as creative tools,
exploring new imagery prompted by printmaking materi-
als and procedures, and experiencing the measured,
cadent creative experience that the process demands.[5]
When artists were poor and the market was negligible,
there was little reason to produce unsaleable editions of
avant-garde prints, and many experiments were printed
only as proofs. Jackson Pollock was among the painters
who periodically made private experimental prints, per-
haps to stimulate and inform his work in other media. He
and his fellow New Yorkers were willing to abandon tradi-

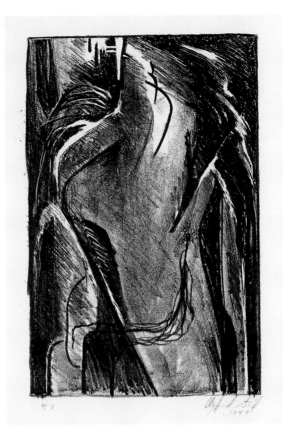

tion and refinement in their art, and replace them with raw energy and relevance. After Pollock's first solo exhibition at the Art of This Century Gallery in 1943, he helped identify Abstract Expressionism as a distinctly American style. To critics, this fiery, irreverent son of a Western farmer was the model of the young upstart eager to measure himself against European masters.

By the war's end Abstract Expressionism had emerged as a muscular American avant-garde, and the New York artistic community had begun to thrive once again. Local museums were actively collecting Abstract Expressionist painting, an expanding coterie of dealers provided new venues for exhibition and sales, and a growing audience resulted from the nationwide economic recovery. All this was documented by a troupe of critics, writing for newspapers, art periodicals, society glossies, and even national magazines like *Time* and *Life*. Their accolades helped establish some thriving careers and their inattention stalled others. Despite this modish attention, most of the avant-garde artists continued to struggle. Those who had been working steadily for a decade, and those just arriving in New York, scraped to survive. Many lived in cold water flats and small lofts near Union Square, and enjoyed few comforts as they labored alone to create works expressing their individuality. However, artistic society remained an encouraging mainstay, as artists met in cafés and bars to discuss issues of their art.

The ideas and imagery of Abstract Expressionism spread more rapidly across the country after the war. National magazines and traveling artists helped to disseminate its forms, but its underlying concepts of personal introspection and improvisation were in the air, passing naturally like teenage slang to permeate all American creative endeavor. In the late 1940s, San Francisco became an important outpost for the redefinition and continuing evolution of Abstract Expressionism.[6] Californian artists adopted such common modes as Abstract Surrealism and gestural improvisation, but they developed a relatively understated idiom, more connected to nature and landscape, sometimes more expansive, and often influenced by Asian art. When Douglas MacAgy became director of the California School of Fine Arts (CSFA) in 1945 he purposely looked to the East Coast avant-garde as he tried to give the school a focus on contemporary art. A former curator at the art museums of Cleveland and San Francisco, MacAgy had a strong inter-

est in Dada and Surrealism, and was acquainted with several New York artists. He had carte blanche to redesign the curriculum and appoint a new faculty at the CSFA, but he inherited an institution in financial peril that had nearly closed during the war. The director hired Elmer Bischoff, Hassel Smith, David Park, and Clay Spohn to teach painting, and appointed Robert Howard to head the sculpture program. Enrollment increased with the help of the GI Bill. Many veterans, discharged from the service in northern California, were eager to temper their wartime experiences with study and personal introspection, essentially subsidized by the government. MacAgy welcomed these mature students, several of whom — including James Budd Dixon, Edward Dugmore, John Grillo, and Frank Lobdell — had completed art degrees before the war. Many were given studios, and virtual autonomy to work on their own. The veterans had a passion for working and confronted serious issues in their art. To accommodate them, MacAgy created a freer atmosphere at the school, opening the studios and making himself personally available. He helped transform the CSFA from a sleepy debutantes' craft center into a serious, progressive academy, where artists worked, argued, and played hard. Its boisterous parties were accompanied by Dixieland from the faculty's Studio 13 Jazz Band, with MacAgy on drums.

In fall 1946 Clyfford Still began teaching at the CSFA. This opinionated, independent painter had developed a

dramatic, personal style that consciously rejected European tradition and synthesized some characteristics of New York School painting. Shortly before his arrival in San Francisco, a solo exhibition of his paintings appeared at the Art of This Century Gallery in New York. When his paintings were exhibited at the California Palace of the Legion of Honor in 1947, they alternately shocked and inspired the artistic community. Completely abstract, moody and evocative, Still's paintings stimulated the avant-garde in San Francisco. Many Bay Area artists, already experimenting with Abstract Expressionism, felt liberated to pursue individual stylistic explorations. At the CSFA, the temporary teaching positions of Mark Rothko, Stanley William Hayter, and Ad Reinhardt sustained the influence from the East Coast, and the encouragement of individuality.

Printmaking was part of the curriculum when Ray Bertrand, James Budd Dixon, Robert McChesney, and Nathan Oliveira taught at the CSFA in the 1940s and 1950s. Though the facilities were modest and instruction often *laissez-faire*, some of the most exploratory and interesting prints of the era were produced there. The veterans had access to the printshop, and could conduct free experiments there without the supervision or assent of an instructor, and they seem to have taught each other the rudiments of etching and lithography. These older artists, students with class projects, and faculty, all worked side by side in a shop that was open twenty-four hours a day. But for a hierarchy that honored painting, East Coast biases against printmaking were largely absent, and artists often included prints in their Bay Area exhibitions. It is noteworthy, however, that most of the

editions were very small, and seldom uniform. During the 1950s, healthy printmaking programs at the California College of Arts and Crafts in Oakland, at the University of California at Berkeley, and at San Francisco State College helped to make the Bay Area a quietly flourishing center for Abstract Expressionist printmaking.

It may have been the heady atmosphere of the CSFA that prompted Still to conceive a program in which advanced painting students would meet with working artists to discuss issues of their art. In 1948 he left San Francisco to establish the Subjects of the Artist school in New York, along with Rothko, William Baziotes, David Hare, and Robert Motherwell. They presented Friday night sessions, which included formal presentations on aesthetic philosophy and history, as well as discussions of the conceptual foundations of European Modernism and Surrealism. When the school closed the following spring, Tony Smith and fellow professors from New York University rented its quarters at 35 East Eighth Street as a work space for their students. They continued to present evening colloquia at Studio 35, inviting artists working in a range of styles to lecture and lead discussions about modern art and aesthetics.[7] When this series ended, Jack Tworkov, Franz Kline, and Willem de Kooning founded The Club as a place for artists to meet.[8] Its Friday evening meetings were part social gathering, part seminar, and sometimes open quarrel. There were serious lectures and exhaustive discussions relating to art, philosophy, literature, poetry, and music. The artists discussed their current projects and castigated dealers, museum directors, and critics. At that time few of them had established reputations outside their own circle but admission was exclusive. Later the rules relaxed and it became possible to attend if one knew a member and had fifty cents for the liquor kitty.

In 1950 Gorky, Pollock, and de Kooning were among the artists whose work was shown at the American pavilion at the Venice Biennale, and they captured the attention of European critics and viewers. Abstract Expressionism was the current style in university art departments across the country, where printmaking departments were established in the 1950s. At that time a complement of national juried print exhibitions developed, and Abstract Expressionist prints were ubiquitous, including works by artists who were chiefly painters and those who were primarily printmakers. The most prestigious of these competitive exhibitions were the Brooklyn Museum print national, and the Cincinnati Biennial of Color Lithography. They helped to legitimize the graphic arts, and made printmakers across the country realize that their creative community was large and diverse.

After the war a new generation of New York painters came of age to continue the development of Abstract Expressionism. They respected the achievements of their predecessors, who embraced them in artistic society and enthusiastically included their work in group exhibitions, like the Ninth Street Show of 1951. Though the younger artists employed the same creative process and painterly vocabulary, their outlook was fundamentally different. Rather than confronting a dark, existential, Freudian psyche in their work, they enjoyed a broad-minded adventure of self-discovery. To this generation the hardships of the Depression and World War II were history, as was Surrealism. Their era of American opportunity was characterized by industrial prosperity, a burgeoning mass media of paperback books and television, bebop jazz, pop psychology, and continued expectations for a bright future. Their art was extravagant, stylish, and cosmopolitan. They opened themselves to the inspiration of music, literature, and poetry. Some of these artists took a fresh, inquisitive attitude toward representation of the figure, landscape, and other recognizable imagery. The pioneers of Abstract Expressionism had generally sought to break free from European tradition and to replace it with something new, substantial, and relevant. Many of their successors lived cheaply in Paris or Rome with the support of the GI Bill, and were comfortable accepting influences from European artistic tradition. Some would embrace Abstract Expressionism for a lifetime, others would shift their style in the ensuing decades.

When Clement Greenberg and Meyer Schapiro organized the exhibition *New Talent* for the Kootz Gallery in 1950, they provided the initial recognition for several of these artists, including Helen Frankenthaler, Robert Goodnough, Grace Hartigan, and Alfred Leslie. The young painters brought new vitality to Greenwich Village society, centered on the Cedar Tavern and The Club. Along with several of their contemporaries, they exhibited their work at the Tibor de Nagy Gallery, operated by the tasteful John Bernard Myers. In the 1940s he had been managing editor of the Surrealist magazine *View*, and he was anxious to use the gallery to promote his continued interest in avant-garde poetry. In 1954 Myers began publishing the occasional broadside *Semi-Colon*, featuring the

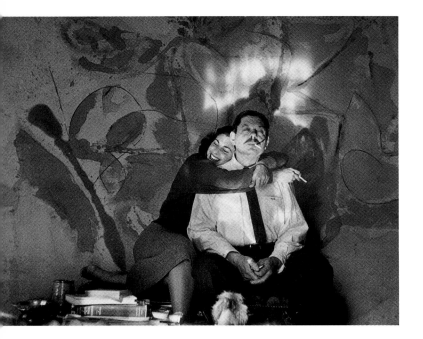

work of young poets — including John Ashbery, Barbara Guest, Kenneth Koch, Frank O'Hara, and James Schuyler — who associated closely with their contemporaries who were Abstract Expressionist painters. Myers actively encouraged direct collaborations between the poets and the painters, like O'Hara's poem-paintings with Goldberg and Hartigan, and cooperative print projects. Unlike their predecessors, most of these artists had few prejudices against printmaking.

Folder was an ambitious literary magazine of the time, illustrated with original artists' silkscreens from Tiber Press, a screenprint workshop on the lower East Side.[9] In 1952, Floriano Vecchi, an immigrant from Rome, opened the workshop and developed a thriving business printing greeting cards, placemats, and other ephemera. Vecchi was able to concentrate on the technical side of his growing business when Richard Miller became his business partner. Formerly a curatorial assistant at the Art Institute of Chicago and Edith Halpert's Downtown Gallery, Miller arranged for Tiber Press to edition screenprints after works by such artists as Stuart Davis, Ben Shahn, and Charles Sheeler.[10] The poet and actress Daisy Aldan had been a friend of Miller's since childhood, and together they conceived *Folder* as an avant-garde magazine that would combine the works of young poets, authors, and artists. Its modest success encouraged the team to begin the ambitious Tiber Press Portfolios in 1956. This set of four deluxe volumes combines poetry by Ashbery, Koch, O'Hara, and Schuyler, with original screenprints by Michael Goldberg, Grace Hartigan, Alfred Leslie, and Joan Mitchell. Working individually with Vecchi at the workshop, each of the artists devised individual ways to translate their imagery into screenprint.

This subjectivity mingled with an invigorating sense of collaboration. In the print *Ode on Necrophilia* Goldberg and O'Hara worked actively together, extemporizing verse and imagery in the printshop. Though the Tiber Press portfolios were much admired, they failed to generate profits to fund another project, and the studio had to return to commercial work to regain financial health.

Another enterprising project of the period to unite poetry and printmaking is *21 Etchings and Poems*, the landmark album that grew from the hothouse experimentation of Atelier 17.[11] The challenge of combining image and text on a single printing plate engrossed workshop members in the late 1940s. This interest originally sprang from the work of the English painter and poet William Blake, who in the early nineteenth century had devised a way to replicate his illustrated, hand-lettered poems from one intaglio plate. His invention fascinated the poet Ruthven Todd, a friend of Hayter's, who in 1947 arranged for the collector Lessing J. Rosenwald to loan one of Blake's rare printing plates to Atelier 17. Thus, by analysis and experiment, Hayter resolved how it was made and printed.[12] Once understood, this method joined the studio repertoire, and several artists, including Joan Miró, employed the technique to make prints at Atelier 17.

Soon after Hayter returned to Paris in 1950, Peter Grippe took over the management of Atelier 17 in New York. The following year he conceived a portfolio of illuminated contemporary poems, using Blake's process and the workshop's full spectrum of intaglio techniques. Like the landmark nineteenth-century album *Sonnets et eaux-fortes* this suite joined original verse — inscribed on the printing plates by the poets themselves — with artists' graphic interpretations.[13] Grippe's collaborative portfolio includes prints by artists working in a range of current styles, including geometric Modernism and Surrealism. Among the artists whose prints represent Abstract Expressionism are de Kooning, Kline, Adja Yunkers, and Pierre Alechinsky. Even after Atelier 17 closed in New York in 1954, Grippe remained committed to the portfolio, patiently recruiting artists and authors, and helping them to prepare and proof their plates. Morris Weisenthal, one of the poets on the project, became an essential ally. He helped to raise funds, corresponded with contributors and publishers, and escorted authors to Grippe's studio. The plates were finally completed in 1957, and a single set of proofs was exhibited at Weisenthal's Morris Gallery in Manhattan the following year.[14] Despite critical enthu-

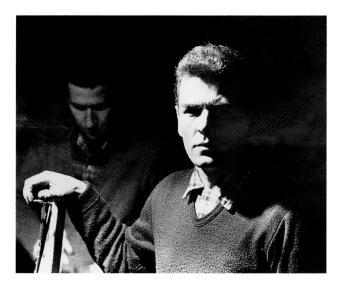

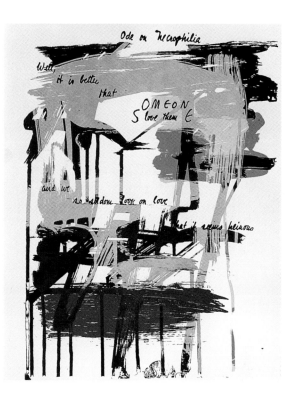

Above: Floriano Vecchi with Michael Goldberg, about 1959 (Walter Silver)

Right: Michael Goldberg and Frank O'Hara, *Ode on Necrophilia*, from *Odes*, 1960, screenprint, private collection

Below: A gathering to celebrate the Tiber Press Portfolios: Daisy Aldan, Richard Miller, Kenneth Koch, Grace Hartigan, James Schuyler, John Ashbery and Frank O'Hara, 1960 (Walter Silver)

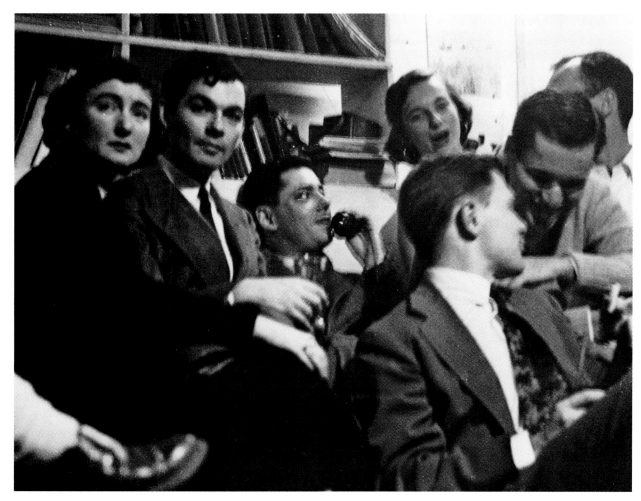

together, passing the crayon back and forth between them as they drew on the printing surfaces, using a mirror to write the text in reverse. More than any other project of the era combining printed images with poetry, their *Stones* portfolio was an immediate, active collaboration. Only when the first stones were prepared did Grosman begin to look for a printer. Eventually she engaged the Master Lithographer Robert Blackburn, who commuted from Manhattan to West Islip. The project proceeded in fits and starts, for funding was intermittent and it was difficult to obtain the handmade paper upon which Grosman insisted. In 1959 the *Stones* suite of twelve lithographs was finally published. Through untiring persuasion, Grosman succeeded in convincing many other painters and sculptors to make prints, including the Abstract Expressionists Sam Francis, Helen Frankenthaler, Robert Motherwell, Barnett Newman, and Cy Twombly. She helped transform the perception and acceptance of printmaking by the respectful collaborative experiences she provided, her uncompromising insistence on quality, and the beauty of her publications.

June Wayne conceived a plan that would have an even more profound effect on American printmaking. On her occasional visits to Paris in the 1950s, the artist made lithographs with French professional lithographers. She was frustrated to realize that such craftsmen were nearly extinct in the United States, and developed the scheme for a lithography workshop that would function simultaneously as a collaborative facility for a wide range of artists and as a teaching studio, training new generations of Master Printers who could then open their own workshops across the country. With the support of a grant from the Ford Foundation, Wayne's Tamarind Lithography Workshop opened in Los Angeles in summer 1960, with Clinton Adams as associate director and Garo Antreasian as technical director.[16] The endowment made it possible to invite artists for paid fellowships at the workshop where they created lithographs in collaboration with master craftsmen, often assisted by printer-trainees. The first Tamarind artist fellow was Romas Viesulas, who then employed a style profoundly influenced by Abstract Expressionism in his portfolio *Toro Desconocido*, combining his own poetry with original imagery. Among the many other artists who visited Tamarind in its first years to make Abstract Expressionist prints were Philip Guston, Frank Lobdell, Louise Nevelson, and Esteban Vicente.[17]

siasm, raising the funds for uniform printing and for presentation boxes remained an obstacle. Finally the printing was professionally done at the Anderson-Lamb Company in Brooklyn, and *21 Etchings and Poems* was published by the Morris Gallery in 1960.

The production of artists' books was also a motivating goal for the two preeminent American printmaking workshops of the 1960s, Tatyana Grosman's Universal Limited Art Editions (ULAE) and June Wayne's Tamarind Lithography Workshop, which together transformed printmaking in America completely. In 1956, Grosman and her husband Maurice opened ULAE in West Islip, Long Island, conceived to provide the equipment and expertise enabling artists to create original lithographs, which the workshop published and distributed.[15] Mrs. Grosman was also enchanted with the notion of artists and poets working closely together on fine printed books. She bought a used press and installed it in her living room, and asked the artist Larry Rivers and his friend the poet Frank O'Hara to collaborate on her first production. Small lithography stones were delivered to Rivers's Southampton studio, and he and O'Hara began working

Tamarind also focused new attention on quality production and precise record keeping. Soon it was customary in the United States to produce uniform editions, on high quality papers, that were systematically documented and inscribed. The objects acquired a new cachet and, as Wayne had intended, printmaking became more widely accepted by both artists and their audience. Among the many Master Printers trained at Tamarind who went on to produce noteworthy Abstract Expressionist prints are Juergen Fischer, Ernest de Soto, Kenneth Tyler, and Joseph Zirker. Irwin Hollander, who moved to New York in 1964 after completing his Tamarind stint, opened a workshop on East Tenth Street, at the very nexus of the New York School. In the coming years, several of the originative Abstract Expressionists living nearby worked with him, including Willem de Kooning, Philip Guston, Jack Tworkov, and Esteban Vicente. Many of the artists who eschewed printmaking during the 1940s and 1950s were now drawn to the process. During the 1960s and 1970s several Abstract Expressionist painters, including Robert Motherwell, Sam Francis, and Richard Diebenkorn, produced substantial bodies of remarkable prints.

There is much research still to be done, and many prints yet to be discovered, but it is apparent that the avant-garde revolution in American art of the 1940s affected printmaking as well as painting. The influences of the style were immediate, deep, and wide, and they continue to resonate in printmaking at the beginning of the twenty-first century. During the 1940s, several of the pioneers of Abstract Expressionism made prints, and the most progressive works of graphic art were made by painters, not by printmakers. However, the accidents of history that helped to generate Abstract Expressionism also mitigated against a wider activity in the graphic arts. Some artists rejected printmaking along with the styles against which they consciously reacted. Others who began to make their reputations in the 1940s simply could not afford to print unsaleable editions. Nevertheless, many continued to make prints for themselves, bringing the expressive innovation that they practiced in painting to the workshop.

Encouraged by the experimental spirit of Atelier 17, many Abstract Expressionists found that printmaking can be quite direct, and that a drypoint plate or lithography stone can record a momentary creative impulse. The artists discovered too that printmaking has its own language and look, its own creative pace and rhythm. These capabilities and limitations provided new conditions for the aesthetic experiences that the Abstract Expressionists explored so intently. Technical challenges of printmaking — like the necessity of drawing a plate or stone in mirror-image, or the use of black to prepare a design eventually to be printed in color — often revealed new understanding of creation and perception. Unfamiliar materials and procedures counterbalanced the technical facility that many struggled to renounce. Their uninformed experiments sometimes caused fortuitous accidents and pointed to new directions. As in painting, artists who made prints were compelled to find distinctive imagery and techniques to reflect their own ingenuity and creative personalities. This urge reinvigorated the spirit of innovation that had long characterized American printmaking, and expanded its boundaries in ways we are just beginning to appreciate.

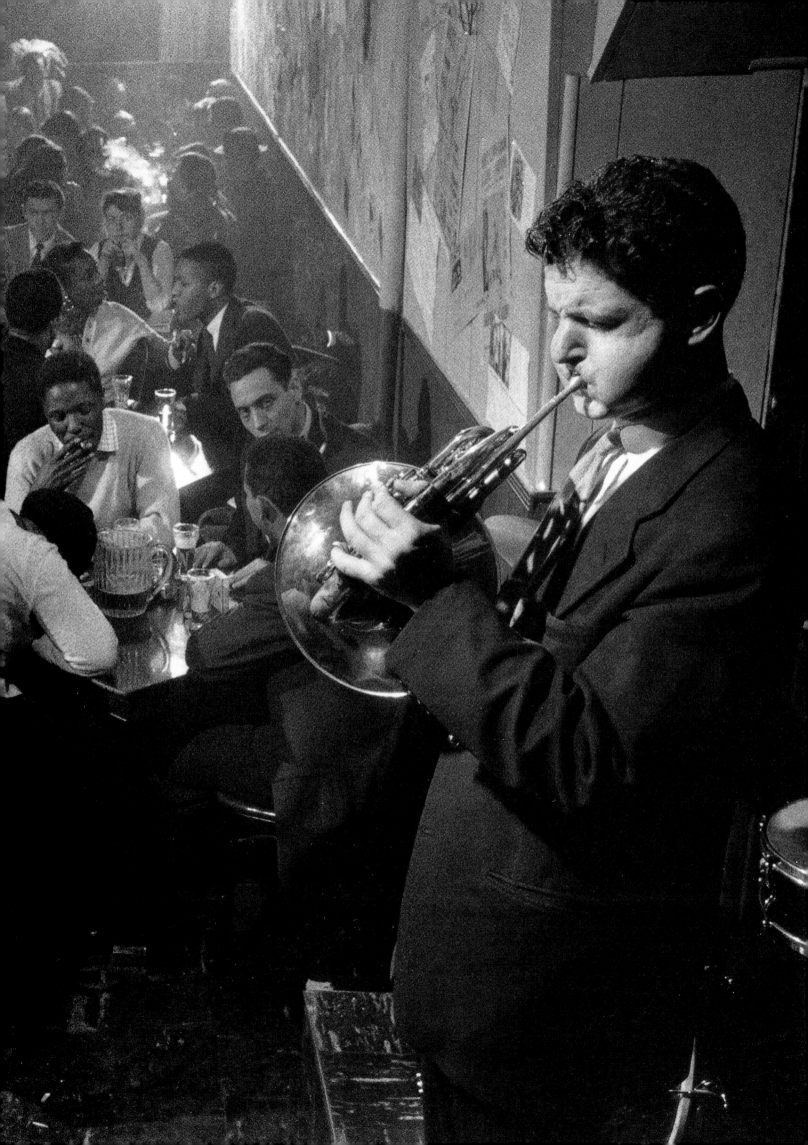

SEEING THE MUSIC, HEARING THE PICTURES

David Amram

There is no more solitary pursuit than painting a picture, writing a poem, or composing a symphony. They are professions akin to being a lighthouse keeper or a fire watcher. During the 1950s, when those of us so engaged left our solitary pursuits, we sought kindred spirits. The extraordinary gathering in New York of visual artists, musicians, and poets all met informally — along with writers, dancers, choreographers, photographers, actors, chess and checker players, race track aficionados, bartenders, waiters and waitresses, school teachers and off-duty postal workers — forming an unplanned interactive community. All these wildly energetic individualists, each pursuing their own dreams, were simultaneously interested in the work of others. This constantly changing group created personal friendships and bonds of mutual influence and inspiration that have survived the century's close.

At that time, television had not yet replaced the adventure of wandering nighttime streets, to rub shoulders with anybody and everybody, and perhaps to meet a special somebody. There was a security in knowing that a certain welcome was waiting at the legendary Cedar bar, that egalitarian temple of good cheer. For many of us it was a home away from home, the ultimate university of hanging out, and our own special twelve-step program center. I often sat there at the bar or a table, like many other fortunate souls, feeling quite comfortable as I listened to the amazing conversations around the room. Each table conducted its own seminar in world politics, Eastern philosophy, or affairs of the heart. Many of the discussions were about the world of the visual arts. One could hear debates on the techniques of painters from Titian to Albers, discussions of what constitutes hot colors, where to buy the best canvas, which critics were the most insightful, which dealers were the least honest. All of us, regardless of our discipline, critiqued each other's works, and most important, we discussed how to incorporate the treasures of everyday life into our respective works. The Cedar bar was like an energizing power plant

for its clientele, sending out ideas into the jazz clubs, artists' lofts, and park benches, where conversations would continue till dawn. Visitors from uptown (all America north of Fourteenth Street) took away some of those ideas into more established worlds of the arts and popular entertainment.

The visual artists were the natural leaders of this scene. Unappointed, unannointed, unelected, but highly respected, they practiced an unspoken doctrine of *in*-clusivity, rather than *ex*-clusivity. There were no A-tables at the Cedar bar. We were constantly reminded that the most successful artists had achieved acceptance late in their careers. They told us stories of how they had to manage to survive years of snobbery, rejection, and brutish behavior from others. They claimed the tavern as their forum, and they all insisted that any place they congregated be wide open and democratic. That kept the Cedar an oasis for the most anarchistic and rebellious among them to feel free to deliver a drunken harangue at the top of their lungs at three a.m. When the decibel level approached the threshold of pain, John, the huge and amiable bartender, would suggest a change of subject. He was the arbitrator and the principal art critic. Behind the bar hung a giant oil painting of a swordfish, created by John himself.

"I love these guys," John confided to me one early morning, after refereeing two painters in a drunken wrestling match, provoked by a heated discussion of the early influences upon Mark Rothko.

"This bar was nuthin' till they came here. They're like a bunch of grown-up kids, but they're like my own family. Jeeze, Dave, I thought musicians drank a lot, but these guys . . . they'll make me a rich man some day, if my liver don't give out first. You like this abstract stuff? I like Vermeer and Norman Rockwell; ya know what the hell they're telling you. How do you like my fish painting? You seen it enough times."

"It looks good enough to eat," I said.

"Franz Kline likes it too," said John. "If it's any good,

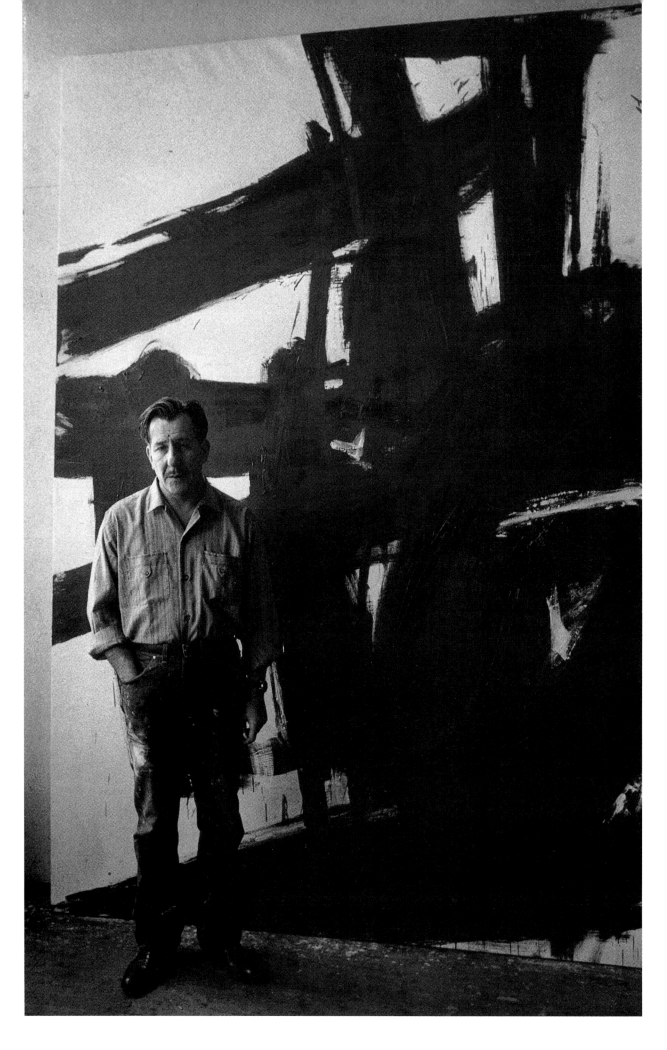

Opposite: Franz Kline, about 1961 (John Cohen)

Charles Mingus, 1955 (Bob Parent)

aside from seein' it up there on the wall, you can almost *taste* it cookin'."

"When I look at that picture of yours I can *hear* it splashing in the water and sizzling in the pan," I said.

"I'll drink to that," said Kline, grinding out a cigarette, and chug-a-lugging the remains of his drink. "If you can hear the music in John's pictures, play me something on your horn and I'll tell you what I see in your music. If it's a good picture you paint me, I'll buy you and your girlfriend a drink."

I took my ever-present French horn out of its case and played a mournful melody and a series of variations. No one except Franz and my girlfriend paid any attention.

"Not bad," said John the bartender. "Kinda reminds me of Tommy Dorsey if he got high and played *Hava Negila*."

"I liked that," said Franz. "With that French horn you're bringing our American experience into the rarefied courts of Europe. Bringing Wagner into jazz. The Old World meets the New World. That's what Dvořák did when he came to America and wrote the Symphony of the New World. That was the idea of the Hudson River School of painters. They celebrated their surroundings, and made their own rules from their own experiences. We all need to simplify what we do. Everything in New York is too complex. You remember Bunk Johnson, the great old Southern trumpet player who got rediscovered? My new series of paintings are for him and for King Oliver and all the old jazz pioneers. They kept it simple. They had their passion under control. That's what we have to do. The Europeans understand our artists and musicians. We have to understand ourselves, and simplify our lives. Like Matisse's final work or Richard Strauss's last songs: simple, precise. Play some more David. Keep it simple. You've already played enough ideas tonight for a hundred compositions. John, get David and Florence another drink! Here's a toast to Vivaldi and Mozart, Louis Armstrong and Bessie Smith, Renoir and Mondrian. They all knew how to say it simply."

"Don't harangue them, Franz," said Joan Mitchell. "I've already given David enough painterly philosophy. The poor boy's heard enough. We don't want to overload his brain. He needs some free space in his head to write music."

"He's got too much space," said Franz, laughing. "He'll write better music if he hears what I have to say. If he doesn't use his eyes and heart as well as his ears, his brain won't do him any good."

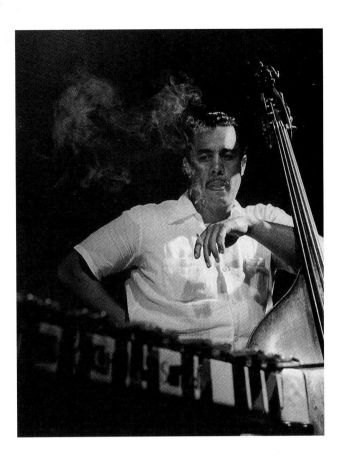

"I'll drink to that," I said. "Here's to Franz Kline, Joan Mitchell, and my sweetheart Florence, and all the painters that show us the way."

"Thank you for not forgetting me," said Joan. "I remember in the fall of 1955 when you left Paris to come to New York and I told you to come to the Cedar bar. I knew you would find what you need to survive here. When I came back and heard you play with Charles Mingus, and when you and Cecil Taylor opened up the Five Spot in the fall of 1956, I felt better about being in New York. All the musicians who create from the gut as well as their intellect can change things. People will never understand what we are doing if they can't *feel*. *All* art is abstract. All music is abstract. But it's all *real*. When you improvise, I can see the seeds of a symphony you could write. When I first heard Charlie Parker in Chicago, I could see he *was* a symphony. We were all trying to bring that spirit, that spontaneous energy, into our work. You used to say in Paris how narrow-minded the experts were who loved Beethoven but couldn't allow themselves to relate to jazz as significant music rather than just entertainment. We have the same struggle in painting. Except for a handful of critics like Clement Greenberg, uptown dealers like Sidney Janis, and a few collectors like Peggy Guggenheim, we're *still* not taken seriously. They don't even get Jackson Pollock. We're still a comic book culture."

"I love comic books," said Franz. "But there's more in the world to explore."

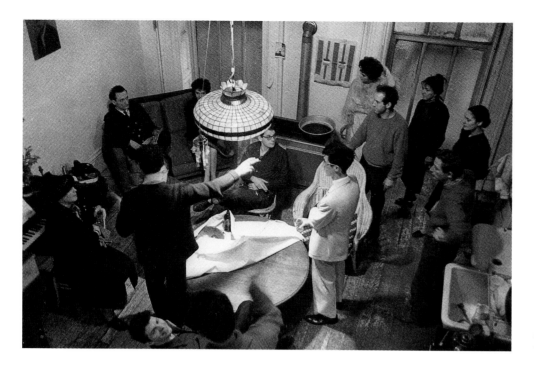

That night, Alfred Leslie, Larry Rivers, Jack Kerouac,
and Delphyne Serig were all at the Cedar bar. Joan, Franz,
Florence, and I joined them at their table, and we talked
until dawn. I wish we had filmed the conversations we
had that night. Fortunately we did make a film of *Pull My
Daisy*, based on one act of a synopsis of a play Jack was
writing, which captured the spirit of the time. Directed by
Alfred Leslie, and spontaneously narrated by Kerouac, it
was accompanied by my score, which combined jazz and
chamber music. The cast included the poets Allen
Ginsberg and Gregory Corso, actress Delphyne Serig
(before her appearance in *Last Year in Marienbad*),
gallery owner Richard Bellamy, and the painters Larry
Rivers, Dody Mueller, Mary Frank, and Alice Neel. I played
the deranged French horn player Mezz McGillicuddy.
Robert Frank was the cinematographer, and we all felt
quite at home at Leslie's studio where the film was shot.
We were already part of the collective ambiance of that
time, created by the artists whose studios had become
places of refuge and communion for all of us. The making
of *Pull My Daisy* was a natural extension of our informal
gatherings, and unbeknownst to us, a fond farewell to
the vanishing communal spirit of the moment.

After fifty hours of crazed behavior, Leslie and Frank
set to editing the film into a twenty-nine minute black-
and-white documentary. When it was finished, we cele-
brated with a cast party, and invited many other friends.
After a few hours of merriment, Kline stood up and raised
his hands. There was immediate silence, and even the
most incorrigible egomaniacs and hyperactive nut-cases
paid attention. Franz was one of the people we all
respected and admired.

"I want to say a few words to everyone. I congratu-
late all of you for making a film that brings us all together
and documents some precious moments of everyday life.
It shows us as we really are as artists. Hanging on and
hanging in and hanging tough. But I don't want to talk
about the film, I want to talk about our lives. I'm older
than almost all of you. Most of my life I barely got by;
recently I've become a rich man. But my life is not built
around fame and money. I was just as good an artist
when I painted portraits for a dollar in the Village.
Now those portraits are worth thousands; but they're no
better or worse than when I did them to buy myself a
meal. They're part of the body of my life's work, a docu-
ment of my survival. My older landscapes of Pennsyl-
vania are worth so much now that I have to hide them so
I don't get put in an even higher tax bracket. For years,
nobody would pay a dime for them. They're still the
same paintings. They didn't get any better. I treasure
them as much as my recent black and white abstracts.
What I'm doing now made me a rich man, but all that is
beyond my control, and has nothing to do with my work
or my commitment. My dealer was furious when I showed
him my latest work. I'm returning to color. He tells me to
ride it out and change when the fashions change. I told
him *no!*"

"Yeah, Franz," we cheered. "All right." "Right on."

"Sock it to that greedy sucker," shouted Corso.

"I told him, I paint each picture from the heart,"
Franz continued. "I've followed my heart all my life. I
can't change *that!* And none of you should, either.

"Don't confuse fame and money with art. Rejoice in
your fame if you get any. Spend your money if you get

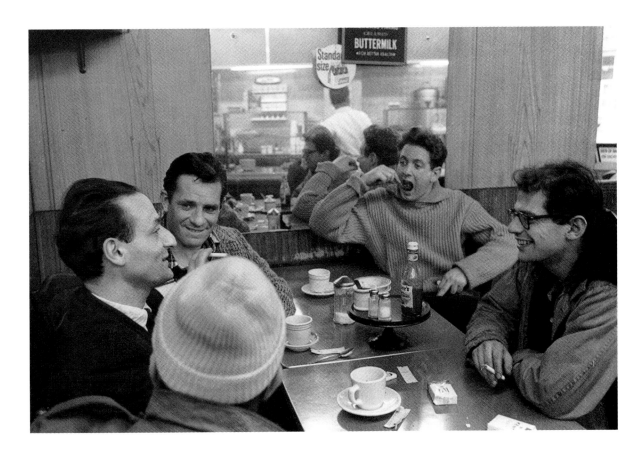

any. But don't *ever* forget what our job is. Don't forget we're in this for life! Now as for your film about the Beat Generation. Jack, without you, none of this would have happened. We all know there is no Beat Generation or Beatniks. Even the poseurs and merchandisers have a right to live. But let's not confuse fashion with fact. The fact is that *On the Road* is a great book that speaks to people where they live — in their hearts.

"Jack, I remember you and Amram performing at the Five Spot and painters' lofts long before *On the Road* came out. I remember you Alfred, Robert, and Larry, from years ago. I know almost all of you in this room. Let's all thank Jack. He has the cross to bear. He is recognized more for a false image created by a merchandising myth than he is for his true gifts — as an artist. I'm in the same position. I'm no spokesman for Abstract Expressionism, or any other *ism*. I'm Franz, from a small town in Pennsylvania. Anything people want to know about me they can see in my paintings. So, Jack, thank you for making it possible for all of us to be together and make a little film about our lives. I like it. It's simple, fun, and unpretentious. And it's in black and white!

"Now in order for my wonderful philosophy and sociological insights to be imprinted forever in your memories, I need a goddamn drink so I can toast you all." Robert Frank poured him a tumbler of Scotch whiskey. "Here's to *Pull My Daisy*," said Franz, raising his glass. "Here's to Jack Kerouac. Here's to all of you here

tonight. And here's to Jackson Pollock, and Charlie Parker, and Louis Armstrong, King Oliver, Bunk Johnson, Bessie Smith, Béla Bartók, and all those now on the other side in that spirit world. You're part of us. You're in our hearts. Remember us poor bastards down here and know that we remember you. We're still all sinners, so put in a word for us so we can join you upstairs when our time comes. Here's to life!" Franz gulped down the entire tumbler, walked over to Jack, and put his arm around his shoulders.

"Jack," he said. "Let's show these big-city sophisticates how to party."

Bedlam broke loose, with drinking, smoking, and dancing. Poetry was read, jokes and insults shouted. As bongos, congas, pots, and pans were banged and the whole loft shook until dawn, I felt the end of an era. I had no idea why. Perhaps we all sensed that changing times were demolishing our underground network of friends, bound together by shared desperation, mutual compassion, and respect. The 1950s were ending. The company store had bought up our ideas, sterilized and repackaged them. We realized that unless we joined the charade we were no longer welcome. I think Robert and Alfred knew better than Jack and me how *Pull My Daisy* captured that extraordinary moment.

Today, nearly half a century later, we can still hear the artists' voices. "I still see things when I hear you play," Kline said. "See what you can hear when you look

at what I do." Franz took me to his studio to see his work, as did Alfred Leslie, Joan Mitchell, Grace Hartigan, Jackson Pollock, Dody Mueller, Mary Frank, Willem de Kooning, Sam Francis (in Paris), David Smith (in Bolton Landing), and scores of other artists. They often asked me to play for openings or at their informal get togethers. Painters Howie Kanowitz, Miles Forst, and Larry Rivers often joined in improvising music with my quartet. At our parties in the Village, Alexander Calder and his wife along with composer Edgard Varèse would form a percussion section, and I would pass pots and pans around the room to anyone else who wished to be part of a spontaneous, one-time-only homemade orchestra.

"Slide into shortstop," Kline said on more than one occasion. "When you're told you've broken the rules, it doesn't matter. You're already there." In the repressed, post-McCarthy era of the 1950s, we celebrated the freedom that we found in one another's company. Our camaraderie was a mutual sharing of spirit, not an occasion for networking or career plotting. Anyone could be the host or the guest. It was wide-open and the joy we shared was possible because we all were looking for any oasis to counteract the negativity, elitism, and worship of mediocrity that Henry Miller called "an air-conditioned nightmare."

Most of us who had achieved some recognition still had day jobs to pay the rent. We accepted this cheerfully because we knew that we were part of something glorious. This enthusiastic fellowship is apparent in Fred McDarrah's candid photographs of Jack Kerouac, Allen Ginsberg, and me at the opening of Dody Mueller's exhibition in 1959, or in Roy deCarava's shots of musicians Sonny Rollins, Oscar Pettiford (in whose band I was a French hornist), and me attending an art show, or in Burt Glinn's photographs for *Esquire* magazine of our gatherings at the Five Spot. These snapshots are documents of our mutual respect.

We had no manifestos, textbooks, or badges. Since we lived outside the carefully constructed white-picket-fenced-in America, we always had to find ways to survive. The labels "Abstract Expressionism," and "Bebop" came *after the fact*. The improvised elements in painting and music were part of our everyday lives. In 1957, Joseph Papp presented free Shakespeare in the Park. I composed the music for these productions. Almost everyone from the Cedar bar and the Five Spot went to see the plays. After each show, I would invite the actors to come Downtown to share our improvised music and see the pictures at our bring-your-own-bottle parties at the artists' lofts. The actors tuned in immediately to what we were doing, and they sometimes extemporized brief performances for us. Methods of improvisation then pioneered at the Actors' Studio were parallel to the spontaneous techniques of the jazz musicians and painters. In 1958 I wrote the score for *JB*, the Pulitzer prize-winning play by Archibald McLeish. When staging the play, director Elia Kazan told his cast about the improvised Jazz/Poetry performances that Jack Kerouac and I had created at the Brata Art Gallery the previous year. He also spoke of the spontaneous energy of the painters, who combined a sense of classical structure with expressions of their own individuality, incorporating everyday ideas and objects into their work. Papp and Kazan shared in our desire to create the highest quality of art for as large an audience as possible, without compromising creativity or idealism.

We were all part of a much larger picture. In retrospect, those of us lucky enough to survive have become our own unofficial anthropologists. We remain friends at the beginning of this new millennium, and still share that eternal spirit. We are all working harder than ever. As most of my contemporaries with more conventional professions retire to enjoy the hard-earned fruits of their labor, our small group of survivors continues to work. We still pursue our dreams with a passion that defies our doctors' advice and the dire warnings of critics now retired, who for the past fifty years have declared us hopelessly passé. Like Rasputin, we still refuse to expire gracefully on cue.

Lawrence Ferlinghetti, now a hale and hearty eighty years of age, is painting, writing, publishing, and performing around the world. Lately I accompanied him at a poetry-music reading, where his energy was shared by an enormous audience of young people who felt a bond to his writing, his spirit, and his painting. I also recently performed with Larry Rivers at a memorial service for author Terry Southern. Larry played *Blue Monk* on his tenor saxophone and then sang *Boulevard of Dreams*. The poignancy of the moment transported us back to the 1955 Monday night jam sessions we played together at the 125 Club in Harlem. Larry's vitality is unflagging, and he is working harder than ever.

I composed and performed the music for Alfred Leslie's play *The Cedar Bar*, which had its first public

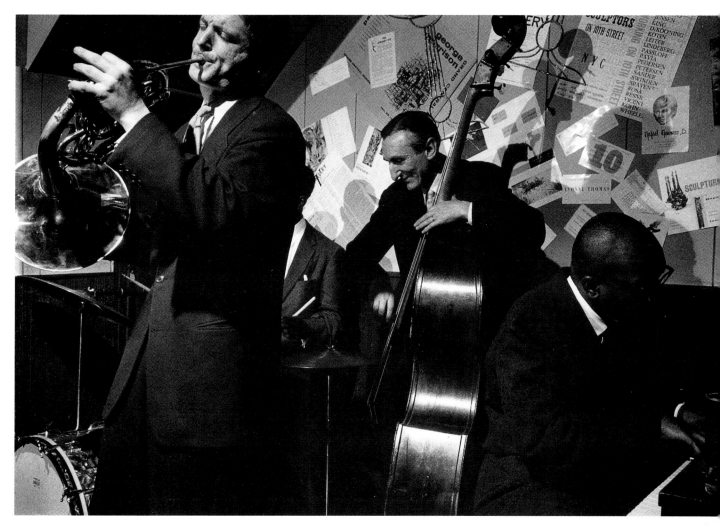

David Amram at the Five Spot, with Dennis Charles on drums, Valdo Williams on piano, and the French art critic Michel Tapié sitting in on bass, 1957 (Burt Glinn)

reading at the New School in 1998. The project was a chance to celebrate our collaboration on *Pull My Daisy* forty years before. To decide how to score Alfred's affectionate depiction of a night at the bar in the mid-1950s, I visited him at his new dwelling on East Fourth Street. As I arrived, he leapt up from his electric piano to greet me. Soon he was singing and drumming to music that had been important to him all those years ago, and describing how new music affected his present work. I felt the same burst of energy from his presence that I knew decades before when we were all together at the Five Spot and at each other's lofts. Alfred and I still believe in the spirit of Charlie Parker's classic composition *Now's the Time,* recorded in 1945. It will always remain an anthem for new generations. We talked about how we both honor the past in order to make the present more vibrant and fulfilling. As we went over the script of his play, noshing on falafel sandwiches and mint tea, we shared our delight and amazement in the interest of young people around the world who appreciate the artis-tic achievements of our day. We never expected any lasting acceptance, since we consciously broke the unwritten rules of the day, and made ourselves open to all people and experiences. Following our hearts and doing what rang true was all that mattered. That was the common bond that held together so many outrageous individuals, and prompted associations between cantankerous workaholics in many different disciplines. This honesty and strength expressed in our work has endured, and it gives new hope to young artists today to never give up striving for excellence.

Our individual efforts and our collaborations are fixed in time. When you look at the paintings, the sculpture, and the prints today you can still hear distant music. When you listen to recordings of the brilliantly constructed improvisations of Charlie Parker, Dizzy Gillespie, and Thelonious Monk or the lovingly notated compositions of Edgard Varèse, Samuel Barber, Leonard Bernstein, and myself, you can close your eyes and see the images.

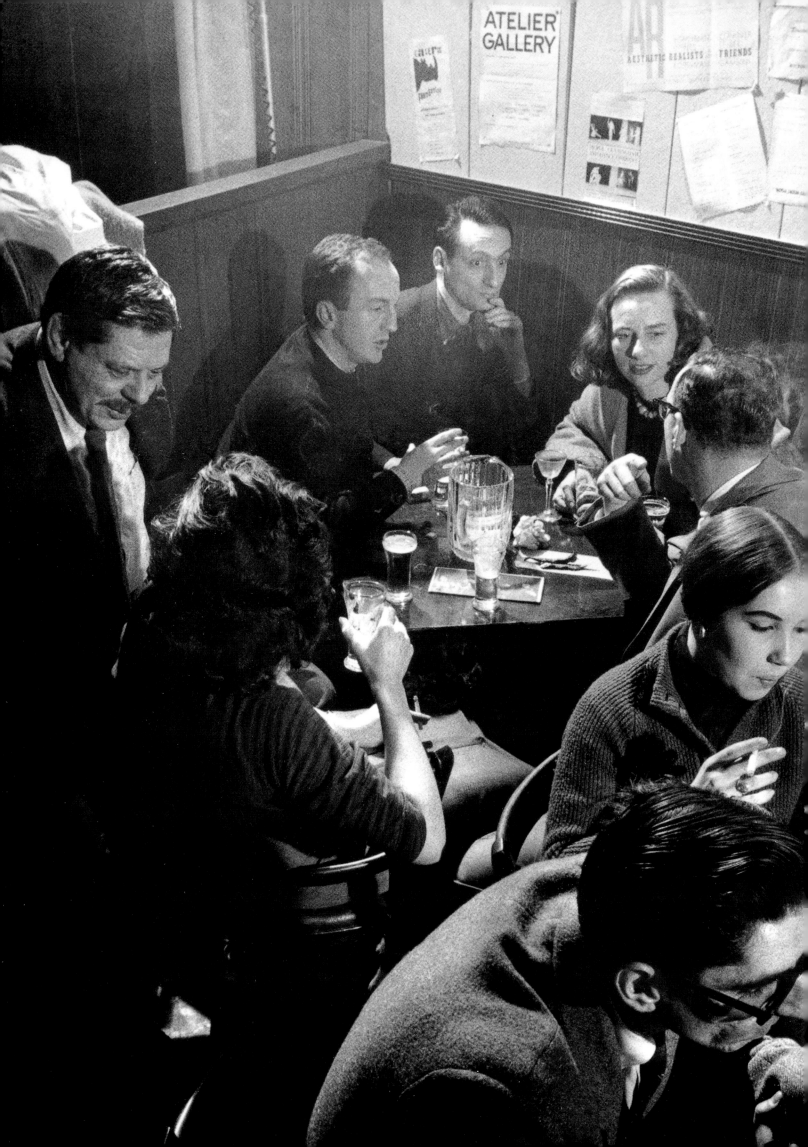

POETRY AND THE ABSTRACT REVOLUTION

David Lehman

I

"There seems to exist a corpus of remarks in respect to painting, most often the remarks of painters themselves, which are as significant to poets as to painters," Wallace Stevens observed in 1951. "I suppose, therefore, that it would be possible to study poetry by studying painting or that one could become a painter after one had become a poet, not to speak of carrying on in both métiers at once, with the economy of genius, as Blake did."[1]

That painters and painting could have an important, perhaps even decisive influence on the development of poets (and the other way around) may strike us as self-evident today. It was certainly taken for granted in Paris when that city was the uncontested international capital of modern art. Charles Baudelaire, the greatest French poet of the nineteenth century, initiated the modern tradition of the poet as art critic. In the years leading up to World War I, Guillaume Apollinaire continued that tradition with fervor and panache, proclaiming the emergence of "the New Spirit" in the arts. Apollinaire championed Cubism in his criticism even as he seemed to incorporate innovative tactics borrowed from painters in such brilliantly original poems as "Les Fenêtres" and "Lundi rue Christine."

In New York City in 1951, however, the interdependence of poetry and painting still felt like a new idea whose time had just arrived.

Stevens spoke at the Museum of Modern Art (MOMA) in New York. He subsequently published his address under the title "The Relations Between Poetry and Painting" as the final essay in *The Necessary Angel*, his major book on "reality and the imagination." The conjunction of this poet (Stevens), in that place (MOMA), in that year (1951) is as if calculated to arouse the notice of a cultural historian. If there ever was a time when American painting and poetry overlapped to their mutual enhancement it was in the years following World War II, during the so-called "heroic" period of Abstract

Expressionism and just after. If one place could be taken as emblematic of this sudden flowering and outpouring of artistic energy, it might be the Museum of Modern Art, which under the directorship of Alfred Barr had educated an emerging generation's artistic sensibilities. As for Stevens, he was the American poet of the first half of the century who most closely resembled a modern painter in his approach to his art. His poems are sometimes like still lifes ("Floral Decoration for Bananas," "The Poems of Our Climate"), sometimes landscapes or seascapes ("The Snow Man," "Sea Surface Full of Clouds"), and sometimes aesthetic investigations ("The Man with the Blue Guitar," "Someone Puts a Pineapple Together"). MOMA had institutionalized modern art. And modern art, as Stevens went on to say in his address there, was characteristically uncompromising — in poetry as in painting. "Modern art has a reason for everything," Stevens said in his aphoristic style. "Even the lack of a reason becomes a reason. Picasso expresses surprise that people should ask what a picture means and says that pictures are not intended to have meanings. This explains everything."[2]

Well, not quite everything, but a lot. If painting could serve as a touchstone for all the arts, then a poem as easily as a picture could be, in a phrase of Picasso's that Stevens liked quoting, "a hoard of destructions."[3] Poems no less than pictures are products of the imagination and exist by a certain grace that liberates them from the need to "have meanings." Poems are reducible ultimately to words, not ideas, as paintings are reducible to paint, or prints to ink, not ideas. In a conversation several years ago, the experimental writer Harry Mathews elaborated on the notion that the medium of expression takes precedence over the matter expressed. Looking at "what Cézanne did with paint, [and] what Picasso or Matisse did with paint," Mathews said he understood that "the surface of the paint is what was real. The rest is illusory. In writing, too — what's real are the words on the page and the act of reading. One thing I do, in all the books I write,

Opposite: A corner table at the Five Spot, with David Smith, Helen Frankenthaler, Frank O'Hara, Larry Rivers, Grace Hartigan, 1957 (Burt Glinn)

27

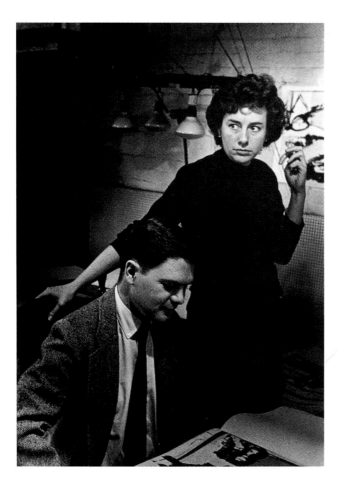

is to remind the reader very clearly that by the end of the book what he's been doing has been reading a book."[4]

The abstract revolution in painting made such literary recognitions inevitable. The poets of the New York School could not help knowing what Willem de Kooning and Franz Kline were doing in their paintings, because they were on close terms with these men, and indeed drank with them regularly at the Cedar bar and talked aesthetics with them at The Club. Keeping in mind that "the surface of the paint is what was real," the poets elevated the importance of the linguistic surface in poems as defiantly abstract as Frank O'Hara's "Second Avenue," Kenneth Koch's "When the Sun Tries to Go On," and John Ashbery's "Europe," all written in the 1950s, each in its way an homage to abstract art.

There were other lessons that painters, specifically the painters of the New York School, could and did teach poets in the sky's-the-limit atmosphere that prevailed in New York in the years just after World War II, the years when Abstract Expressionism overcame fierce resistance and gained acceptance on a scale few had foreseen. From gestural painters such as Franz Kline, the poets understood the value of spontaneity, immediacy, and improvisation. But they also learned from Kline that improvisation was the means to an end and not the end itself, and that sometimes what was wanted was the illu-

sion of spontaneity. For his massive black-and-white paintings, with their calligraphic appearance, Kline made studies in black ink on pages torn from the telephone book. Visitors to the big Kline show at the Whitney Museum of American Art in 1995 could not help noticing the number of studies Kline made and the extent to which he faithfully copied them in his paintings. The lesson: that in painting, as in jazz or basketball, successful improvisation requires careful preparation. And in poetry the same is true.

"Speed, as in most Action Painting, is subject as well as means," James Schuyler wrote in an *Art News* essay on Kline. "The experience of speed, as exhilaration, variation, risk or status quo, is second nature to us."[5] Schuyler's comment seems to apply almost as much to his friend Frank O'Hara's poetry as to Kline's paintings. The crisis in subject matter — the question of what subject an abstract painting might be said to have — prompted gambits that both poets and painters pursued. Intransigently abstract painters such as Barnett Newman, Mark Rothko, and Adolph Gottlieb insisted that subject matter was key — even when the only indication of a subject was to be found in the work's title. This new way of looking at a work, whether a painting or a poem, was a liberation. Title could veer from text. Frank O'Hara could call a poem "Easter" and know that he had named its subject, though Easter makes no appearance in the writing that follows, just as Barnett Newman could call a painting "Day One," and name creation and origin as the subject of a huge canvas consisting of two fields of saturated color bisected by a vertical stripe. From one point of view, a wall-sized Pollock was about only itself; from another, it was either an enactment (as opposed to a representation) of primal chaos or a vision of the cosmos in motion.

Pollock, de Kooning liked to say, "broke the ice." It was he who broke through to national notoriety (a step toward national acclaim) from the moment in August 1949 when *Life* magazine, unaware of its own power, asked rhetorically whether this man — who looked like a gas station operator with a scowl and a cigarette dangling from his lips — was America's greatest living painter.[6] *Life* had meant to poke fun, but the effect of the article was to raise the possibility that there just might be something great and momentous in Pollock's powerful swirls of paint that wiseass caption writers likened to macaroni. The response of journalists to Pollock

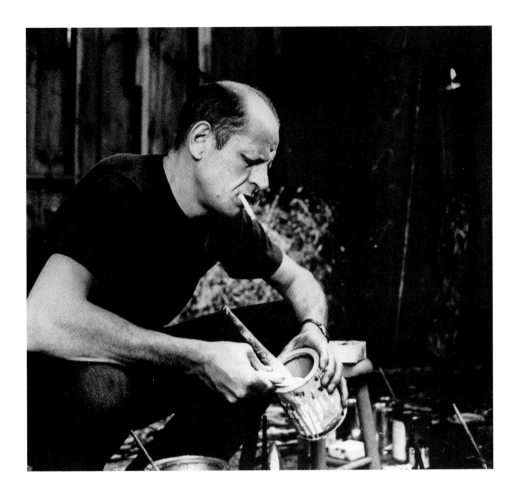

remained skeptical: a *Time* writer dubbed the painter "Jack the Dripper" as late as 1956, the year he died in a car crash.[7] The poets' response to Pollock was more likely to be rhapsodic. "The original singing quality of his work, impersonal but profoundly touching as a wave flinging ashore, implies a quality of genius that is unembarrassment when confronted by the surfaces and edges of things," James Schuyler wrote.[8]

Not until Abstract Expressionism did poets risk not making sense, not having meanings. It is an amusing irony that Mark Rothko, whose stacked cubes of color "mean" nothing that can be paraphrased, came to an evening of poetry and jazz at the Five Spot bar in New York and said, apropos of Kenneth Koch's experiments in verse, "Why can't these poets make more sense?"[9]

II

New York City had begun to displace Paris as the international headquarters of the avant-garde in the 1940s. How did such a revolution come about? Many have posed the question. Theories, paranoid or otherwise, have been advanced by clever writers convinced that the "triumph" of the New York School was the result either of a cabal of critics whose last names ended in "berg" or of an anti-

Communist plot.[10] While so radical a shift in the center of artistic gravity must be overdetermined, World War II figures significantly in most accounts. The political and military situation in Europe during the 1930s ("that low, dishonest decade") and 1940s drove many artists to New York, including the entire Surrealist movement. New York was home as well to Piet Mondrian (who launched Pollock in 1943 by praising one of his pictures to Peggy Guggenheim at her gallery) and to Hans Hofmann (at whose famous Eighth Street school such painters as Lee Krasner Pollock, Nell Blaine, Jane Freilicher, and Larry Rivers got their start). The influx of European artists inspired and emboldened their American counterparts. "I was painting in the same studio on Tenth Street with [Fernand] Léger and [Jean] Hélion during the war," de Kooning told a friend, "and one fine day it struck me that what I was doing was just as interesting as what they were doing." A demoralized Paris retained the foul taste of German occupation in its mouth long after the Allied forces liberated it. In New York, on the other hand, you had energy, confidence, daring — and you had articulate critics with access to the press. When Clement Greenberg proclaimed the greatness of Pollock and Hofmann and the sculptor David Smith, *Time* and *Life* ridiculed the "formidably high-brow" New York critic's proclamations but recycled them all the same to an ever wider audi-

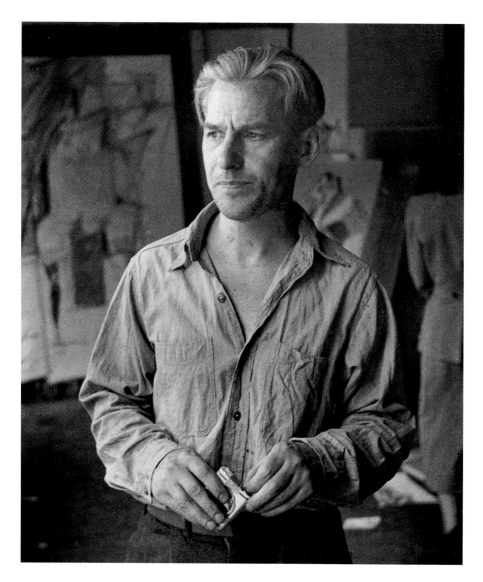

Willem de Kooning, 1950
(Rudy Burckhardt)

Opposite: Willem de Kooning,
Revenge, with poem by Harold
Rosenberg, from *21 Etchings and
Poems*, 1958, aquatint and
etching, Worcester Art Museum,
1998.220.5

ence, and soon — seemingly overnight — Greenberg's bold assertions established themselves as universally accepted truths. Thus it happened that painting became, of all the arts, the one that stood in the vanguard of change in America after World War II. And it was therefore to painters and painting that poets intent on renewing the modernist revolution in poetry turned for encouragement and support.

What the critic Harold Rosenberg said about Abstract Expressionism, which he called Action Painting, could do double duty as the poets' mantra. The poem, too, could be an "arena" of clashing impulses, as Rosenberg put it. What was to go on the page or the canvas was not a poem or a picture but "an event." A poem could chronicle the processes by which it came into being, just as Pollock's paintings seem to do. All sorts of "foreign" matter could be assimilated into a poem, like the nails and the sand and the cigarette butts that Pollock put into his canvases. (It is true that the application of collage techniques in poetry goes back to T. S. Eliot's *The Waste Land* in 1922, but Eliot confined his

technique of echo and allusion to world literature, whereas the poets of the New York School — such as O'Hara, Ashbery, Koch, and Schuyler — took the more radical step of splicing fragments from such unlikely sources as newspapers, adventure stories, and comic books.) "Artists in any genre are of course drawn to the dominant art movement in the place where they live," Schuyler wrote when asked for a statement on poetics, in 1959. "In New York it is painting." In New York, he added, "the art world is a painter's world; writers and musicians are in the boat, but they don't steer."[11]

The poets of the New York School were not into philosophy or theories of cultural implication but into new ways of writing poetry, because all the old ways had been done too many times, or done in an outmoded idiom, or with such deadly earnestness that one lost one's natural enthusiasm. In the 1950s the establishment in poetry was academic to a degree unthinkable forty and more years later. And the academy was stricter in enforcing its requirements before the advent of the creative writing workshop made rhyme and meter seem

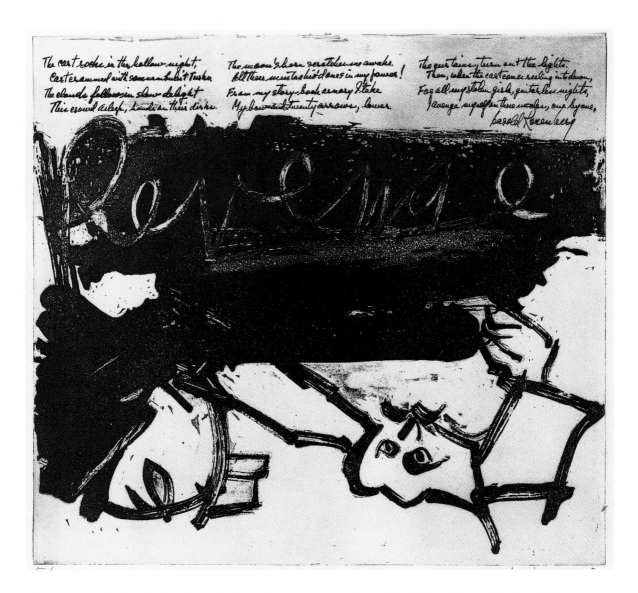

almost anachronistic. Rejecting the academic orthodoxies of midcentury, the New York School poets looked not only to modern painting but to modern music and to European poets then seldom taught in American universities. It was their conviction that the modern revolution in poetry that Ezra Pound and T. S. Eliot ignited in London had failed to complete itself. Perhaps this was because Pound self-destructed at the same time as Eliot turned conservative in matters cultural and political, making his status as the avant-garde author of "The Waste Land" more of an anomaly with each passing year. Eliot occupied poetry's throne room in his editorial chambers at Faber & Faber; at midcentury, his critical pronouncements on poetry — that it needed to be impersonal, that the Metaphysical poets rather than the Romantic poets should serve as one's guides, and that Dante had it luckier than we do because he had a coherent system of belief — had long since passed into dogma. The so-called New Criticism, which held sway in the English departments of the United States, followed Eliot's lead in placing a high value on ambiguity, complexity, difficulty,

and irony. Admirable as Eliot and the New Critics were as teachers and interpreters of literature, they pointed the art in a narrow direction. And for all the virtues of the best verse produced under the New Critical dispensation, it cannot be said to be as savagely, uncompromisingly modern as Eliot's own "Waste Land" had been in 1922. The wisdom and serenity achieved in Eliot's later works, his *Four Quartets* or his play *The Cocktail Party*, for example, are authentic and moving. But poets inspired by the spirit of the new had to look elsewhere for inspiration.

The New York School poets found this inspiration in Russian poetry (Mayakovsky), Spanish poetry (Lorca), Italian poetry (Ungaretti), and above all French poetry (Rimbaud, Mallarmé, Apollinaire, Max Jacob, Henri Michaux, Pierre Reverdy, et al.). Nor did they neglect the monuments of unaging intellect in English and American literature: O'Hara wrote sonnets in the manner of Sir Thomas Wyatt, Koch lifted Byron's narrative stanza form, and Ashbery assembled a cento consisting of lines lifted from Marvell, Wordsworth, Coleridge, Keats, Tennyson, Hopkins, Auden, and other masters in the Great

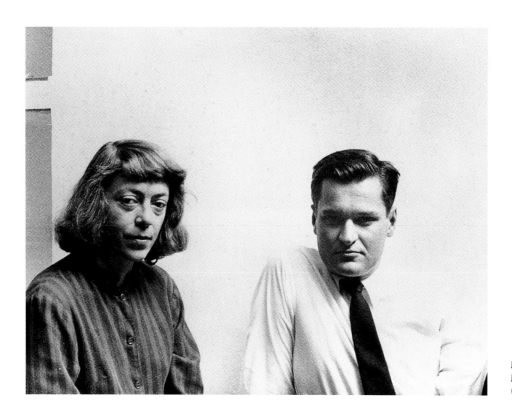

Tradition. The New York poets saw no contradiction between these "high" art predilections on the one hand and their enthusiasm for the artifacts of popular culture on the other. They loved the movies. "I'd have the immediacy of a bad movie,/ not just a sleeper, but also the big,/ overproduced first-run kind," O'Hara declared.[12] They also liked the humor and native American silliness they found in comic strips. "Popeye chuckled and scratched/ His balls: it sure was pleasant to spend a day in the country," Ashbery wrote in a sestina devoted to Popeye, Swee'pea, Olive, Wimpy, and spinach.[13]

Though the influence of the New York School of painting on the New York School of poetry was by no means as clear cut or as dominant as the names themselves imply, the relation between the poets and painters of that era was special and of an unprecedented intimacy. From abstract painters the poets received a measure of acceptance and approval at a time when this was most needed and was not to be had from the literary establishment. In the painters the poets found partners, collaborators, and an audience prepared not necessarily to applaud but to pay interested attention: their first readings were at galleries and at The Club, and their first publications came about because the Tibor de Nagy Gallery was directed by an avant-garde impresario with a vision, John Bernard Myers. Myers liked playing host and loved playing matchmaker, pairing up this painter and that poet for a book, a play, or anything else that could involve the collaboration of artists and writers. Myers signed up such "Second Generation" New York School

painters as Larry Rivers and Jane Freilicher, whose closest friends happened to include the poets Ashbery, Koch, O'Hara, and Schuyler. An era "fizzy with collaboration," as Koch put it, began. Poets and painters worked together on plays, parodies, collages, lithographs, screenprints, you name it. In 1952 Tibor de Nagy issued a pamphlet of O'Hara's poems and Larry Rivers's drawings under the title *A City Winter*; a year later the gallery published books by John Ashbery (*Turandot*, with art by Jane Freilicher) and Kenneth Koch (*Poems*, with art by Nell Blaine);[14] in each case it was the poet's first book publication. Such acts of collaboration are rarer as the century turns, if only because painters and poets today inhabit different income brackets and social classes. In the late 1940s and through the 1950s, the art market had not yet come into being, though anticipatory hints of it could be found in *Fortune* in 1955 when investors were advised to consider placing bets on blue-chips like Picasso and "speculative" issues such as Mark Rothko.

If you happen upon the quartet of beautiful, limited-edition books published by the Tiber Press in 1960 — *The Poems* by John Ashbery with prints by Joan Mitchell, *Salute* by James Schuyler with prints by Grace Hartigan, Kenneth Koch's *Permanently* with prints by Alfred Leslie, and Frank O'Hara's *Odes* with prints by Michael Goldberg — the first thing that hits you, after you take in the beauty and elegance of the books as physical objects, is the feeling that they, the poets and painters, must have had a hell of a good time together.[15] Their work was play. Two of Blake's maxims, that "energy is delight" and "exu-

Alfred Leslie at Tiber Press,
about 1956 (Walter Silver)

berance is beauty," come to mind. "There were parties,"
the late Nell Blaine, who had done the sets for a John
Ashbery play, told me. "I would paint all night sometimes
after partying with my friends."

The proximity of artists of all kinds was possible
simply because rents were cheap at the time in New York
City. When Blaine lived in a loft on West 21st Street, she
explained, the photographer Rudy Burckhardt lived in the
same building, a few floors down, sharing quarters with
the poet and dance critic Edwin Denby. Through
Burckhardt and Denby, Blaine met Willem de Kooning,
who lived next door, as well as the painter Fairfield
Porter. Blaine had previously formed lasting friendships
with Larry Rivers and Jane Freilicher, painters who had
studied, as she had, with Hans Hofmann. Rivers and
Freilicher visited Blaine sometimes in the company of
jazz musicians (there were jam sessions, with Blaine on
drums and Rivers on tenor sax) and sometimes in the
company of poets, Ashbery and O'Hara and Koch and
Schuyler among them. "I maintain that she [Blaine]
started the whole New York School," the playwright and
librettist Arnold Weinstein told me. "It started at her
place. That was the Big Bang." "We went to places in
groups," Blaine said. "We'd go, six or eight of us, to hear
Judy Garland together. We went as a group. Very late at
night frequently we'd go out, walking from my place in
the West 20s down to the Village. We'd be at Jane's house
sometimes with John and Frank. We'd be dancing. There
was a lot of dancing. Then when it got very late, one or
two at night, the gay boys would go off to a bathhouse.

There was phenomenal energy. I'd come home and paint
at two in the morning and sometimes all night. I had so
much energy then I needed to get rid of some before I
could paint."[16]

III

In my book *The Last Avant-Garde: The Making of the New
York School of Poets*, I argue that each of the four central
figures in the movement had a specific role or identity
within the group. The late-blooming Schuyler was the
ideal editor, the one to whom the others would show their
works expecting criticism that combined tact, honesty,
and a flawless ear for false notes. Ashbery was the myth-
ologized one, the enigmatic poet who had willingly
absented himself, choosing to live in Paris for a ten-year
stretch. Koch was the professor, first at the New School
and then at Columbia, who spread the word about the
group's activities. Bill Berkson has an excellent account of
studying with Koch at the New School in the early 1960s:

> Kenneth's class was held in the afternoon. Sitting
> upright at one end of the long table, he invented as he
> went, uncertain in spots, but with surges of glee at the
> edges of his thought. Part of each lesson, the fun and
> suspense, was watching him wind toward describing
> graphically the pleasurable aspects of the poetry he
> liked — the poetry of Whitman, Rimbaud, Williams,
> Stevens, Auden, Lorca, Pasternak, Max Jacob, and

Apollinaire, as well as of his friends Frank O'Hara and John Ashbery. Then, too, he would make an analogy between some moment in a poem and the sensibilities of New York painting — the amplitude of a de Kooning, Larry Rivers' zippy, prodigiously distracted wit, or Jane Freilicher's way of imagining with her paint how the vase of jonquils felt to be on the window sill in that day's light. All of these things would dovetail into the writing assignments Kenneth gave us, which were designed to (and really did) help precipitate and sustain energy and surprise in our poems.[17]

O'Hara was the charismatic hero, the catalyst, the guy who made it all make sense, divey downtown bars and midtown galleries, cocktail parties in tuxedos, and afternoon tabloids with a social conscience. Adored by the painters whom he befriended and promoted with a selflessness unusual in the competitive world of the arts, he was himself the closest thing to an action painter in verse, typing poems in a mad clatter of keys while listening to the radio. He wrote about the moment he was in, the present moment before it departed into the past. And if the music on the radio ("dreary" when he wanted Grieg, Honegger, or Prokofiev) disappoints, as in the poem entitled "Radio," he can console himself with the promise of an orange de Kooning:

> Well, I have my beautiful de Kooning
> to aspire to. I think it has an orange
> bed in it, more than the ear can hold.

The poem is an event and it is the record of that event. The poem's method or process of composition is implicitly one of its subjects.

O'Hara valued the "Grace" — as he put it, punning on his friend Grace Hartigan's first name — "to live as variously as possible." This fluidity of identity made him an ideal collaborator, and collaborate he did. His partners included Norman Bluhm, Michael Goldberg, Alfred Leslie, Larry Rivers, and Joe Brainard. "We felt as if we were Matisse and Eluard, in that this would bring us great attention," Rivers remarked of *Stones*, the series of lithographs he and O'Hara created together in 1958.[18]

All the poets felt themselves implicated in the radical new painting of their time. Three of the four made their living as art critics, and the fourth (Koch) wrote plays partly for the pleasure of collaborating with the painters who did the sets. O'Hara was the point man. He got a job at the front desk at MOMA — in order, he said, to be able to see Alfred Barr's monumental Matisse show as often as he liked — and wound up becoming a curator of exhibitions. O'Hara made painting and the visual arts a central focus of his professional life. Neither Ashbery nor Schuyler did, but both wrote with authority about contemporary art. Ashbery depended on the income he earned as an art critic for the better part of twenty-five years; his pieces in the *International Herald Tribune*, *New York*, and *Newsweek* would fill several tomes beyond *Reported Sightings*, the collection of his art criticism that he published in 1989.[19] Schuyler worked at MOMA, albeit briefly, and wrote on painting for *Art News*, as did O'Hara and Ashbery, which came about not just because the editor was a "nice man who happens to like poets," as Ashbery liked saying, but because *Art News* was the house organ of Abstract Expressionism and editor Tom Hess's taste and sensibility matched that of the poets — they were all in awe of de Kooning.

The poets found their own aesthetic notions articulated in the paintings they admired, and this makes their art criticism doubly significant. James Schuyler wrote with marvelous ardor about the Abstract Expressionists. "Anyone who has ever wondered what it was like to have seen with fresh eyes a masterpiece new from its creator's hand had only to go and look" at Mark Rothko's latest, he wrote in 1958. But Schuyler seems to have understood his own inclinations in verse in the course of looking not at abstract painting but at the work of Fairfield Porter and Jane Freilicher. Both Porter and Freilicher were figurative painters whose work had been deeply nourished by the example of Abstract Expressionism. Schuyler, in his poems, wanted to do something comparable. An interviewer asked him whether he ever wrote poems about Porter's paintings. "No," he answered, "but I tried to write poems that were like his painting." He states his own ambition when he writes that Porter gives us "an aspect of everyday life, seen neither as a snapshot nor as an exaltation."[20]

In a beautiful essay Schuyler describes Freilicher's practice as if it were the visual counterpart of his own. Like her, he was determined to let order emerge from a faithful rendering of a scene rather than from an exercise of the artist's will. He and she had in common the ability to be satisfied, aesthetically, with one view from one window at different times of day, in changing light, as seen

Norman Bluhm and Frank O'Hara, *A Haiku*, 1959, ink and gouache,
The Bluhm Family Collection

by a very fallible observer, whose moods may enter and alter the scene.

For Ashbery, too, Freilicher was an inspiration. One of the most beautiful passages in *Reported Sightings* is the paragraph Ashbery devotes to Freilicher's *The Painter's Table*, a reproduction of which adorns the book's cover. (The painting hangs in Ashbery's living room.) It is a still life in which cans and tubes of paint and brushes in jars of water substitute for flowers in vases or fruits in bowls. The painting, Ashbery writes, "is a congeries of conflicting pictorial grammars" — a "mellow realism" punctuated by various departures from realism. The result is "a little anthology of ways of seeing, feeling and painting" that puts Ashbery in mind of his own "fondness for a polyphony of clashing styles, from highbred to demotic, in a given poem."[21] Ashbery seems again to be adverting to his own strategies when he writes appreciatively of R.B. Kitaj's allusive paintings, which are "exemplary" because they are full of contradictory aims and are "beautiful because exemplary."[22]

Unlike Frank O'Hara, who was quick to grasp parallels between his and his friends' poetry and the abstract art that *Life* came to scoff at but returned to celebrate, Ashbery habitually plays down the connection between the New York Schools of painting and of poetry. For Ashbery, the lesson to be learned from the painters ("and I am speaking of artists like de Kooning, Franz Kline, Motherwell, Pollock") was "an abstract truth." The

painters were exemplary not because of this technique or that esthetic decision but because they "were free to be free in their painting in a way that most people felt was impossible for poetry."

If Ashbery's personal taste has always veered toward representational art, his poetry nevertheless suggests parallels with Abstract Expressionism. One of his earliest poems is the sestina entitled "The Painter." Written at the end of his junior year at Harvard, it is the earliest poem in his first book, *Some Trees* (1956). In it, Ashbery projects himself and his aspirations onto the figure of an avant-garde painter in the midst of the abstract revolution. The painter, unnamed in the poem, is determined to meet the crisis of subject matter head-on. He begins by wanting to paint "the sea's portrait":

> But just as children imagine a prayer
> Is merely silence, he expected his subject
> To rush up the sand, and, seizing a brush,
> Plaster its own portrait on the canvas.

Rebuked by critics, the painter seems to go through a de Kooning period: "He chose his wife for a new subject,/ Making her vast, like ruined buildings." But it is to the sea that he inevitably returns, still hoping "that nature, not art, might usurp the canvas." What happens next completes the parable; misunderstood by the public, searching for new means to achieve old aims, the modern artist is inevitably "crucified by his subject." This is the way the poem ends:

> Others declared it a self-portrait.
> Finally all indications of a subject
> Began to fade, leaving the canvas
> Perfectly white. He put down the brush.
> At once a howl, that was also a prayer,
> Arose from the overcrowded buildings.
>
> They tossed him, the portrait, from the tallest of
> the buildings;
> And the sea devoured the canvas and the brush
> As though his subject had decided to remain a prayer.

The ideas in "The Painter" are possibilities that Ashbery will work through in his poetry: that a seascape can be a "self-portrait," that the title of a poem or a picture may indicate a subject otherwise absent, that erasure may

35

afford a method of composition, and that subject matter may be eliminated altogether. "Neither the self nor the world will anymore sit still and be the artist's subject," Leslie Wolf has observed in an essay stressing the parallels between Ashbery's poetry and Abstract Expressionism. Referring specifically to "The Painter," Wolf writes, "The problematic nature of the subject of our art has entrenched itself *as* its subject, or at least as its persistent theme."[23]

Kenneth Koch's high-spirited poem "The Artist" stands in relation to Koch's subsequent oeuvre as "The Painter" stands in relation to Ashbery's. Koch's poem takes the form of an imaginary artist's journal. His works include *Bee* ("a sixty-yards-long covering for the elevator shaft opening in the foundry sub-basement/ Near my home"), *Campaign* (" a tremendous piece of charcoal. . . . it is extremely large and would reach to the sixth floor of the Empire State Building"), and *The Magician of Cincinnati* ("twenty-five tremendous stone staircases, each over six hundred feet high, which will be placed in the Ohio River between Cincinnati and Louisville, Kentucky"). This artist thinks big. *The Magician of Cincinnati* would, when installed, smash up all boats coming down the Ohio River, but this little detail fails to dent our hero's impregnable ego-armor. The scale of his narcissistic self is the scale of the world. Here is the final entry:

> June 3rd. It doesn't seem possible — the Pacific Ocean! I have ordered sixteen million tons of blue paint. Waiting anxiously for it to arrive. How would grass be as a substitute? cement?

Koch, a gifted parodist, instinctively turns admiration into parody, and "The Artist" isn't really a satire on conceptual art, pop art, earth art, none of which had come into being when the poem was written in the mid-1950s. It is rather a poem that delights in pushing an idea to its comic extreme. In this case, Koch says he got the idea from "a monumental sculpture in the Arizona desert by Max Ernst."[24]

I had a chance to ask Koch about how proximity to the Abstract Expressionist painters affected him and his friends. Going to The Club or to the Cedar bar was "a way we baby poets got to be part of the grown-up tough-guy Abstract Expressionist world," he said. "I went to the Cedar bar a lot. Frank [O'Hara] would be there. Philip Guston was very nice. David Smith would be there. Bill

de Kooning was a little awesome. Franz Kline I never felt comfortable with. Arnold Weinstein was there, and Rudy Burckhardt, and there were girls there, girls who loved art. It was a painters' bar. The painters were the upper classes in the art world. Painters had lives that were exciting. They painted in the daytime, so they got exercise, which put them in a good mood, and they had pleasant evenings. In an essay Virgil Thomson depicts each artist as a different kind of citizen. The best citizens are the painters, because they work hard in the daytime."

Koch's response to the new was to seize on its comic possibilities. In contrast O'Hara seemed to fling himself recklessly into the art of his time. In Action Painting as practiced by Pollock and Kline, O'Hara saw an image of himself. His panegyric to Pollock's *The Deep* (1953) — "an abyss of glamour encroached upon by a flood of innocence" — sounds almost like a self-description. Pollock, O'Hara wrote in accents as heroic as he could make them, "was totally conscious of risk, defeat, and triumph. He lived the first, defied the second, and achieved the last."

O'Hara was that rare breed of writer who could serve as the subject of an art exhibition at a major museum. He had occasioned, cajoled, provoked, and quickened into existence so many fine paintings, drawings, collages, and other art works, whether as a collaborator, a model, or an inspiration, that a rich multimedia show could be mounted, as the curator Russell Ferguson proved at the Museum of Contemporary Art in Los Angeles in 1999.[25]

To O'Hara the painters were the heroes of a modern artistic revolution. "You do what I can only name," he wrote in a poem dedicated to Larry Rivers. As a critic, O'Hara was very much the poet as critic, who wrote with enthusiasm and spirit, making metaphors rather than arguments. To others he left the task of making critical discriminations and comparative judgments; he preferred inclusiveness to hierarchy. Of bad poems he would say, "It'll slip into oblivion without my help." He was one of the few in the art world of the 1950s who refused to choose between Jackson Pollock and Willem de Kooning when everyone else had chosen sides as if at a stickball game in the street. O'Hara took up the rivalry in his monograph on Pollock, which was published in 1959. The years 1947 to 1950 were Pollock's "classical" period, O'Hara wrote, and the term itself seemed to spark the further observation that "Pollock is the Ingres, and de Kooning the Delacroix, of Action Painting. Their greatness

Larry Rivers and Frank O'Hara at work on *Stones*, 1958 (Hans Namuth)

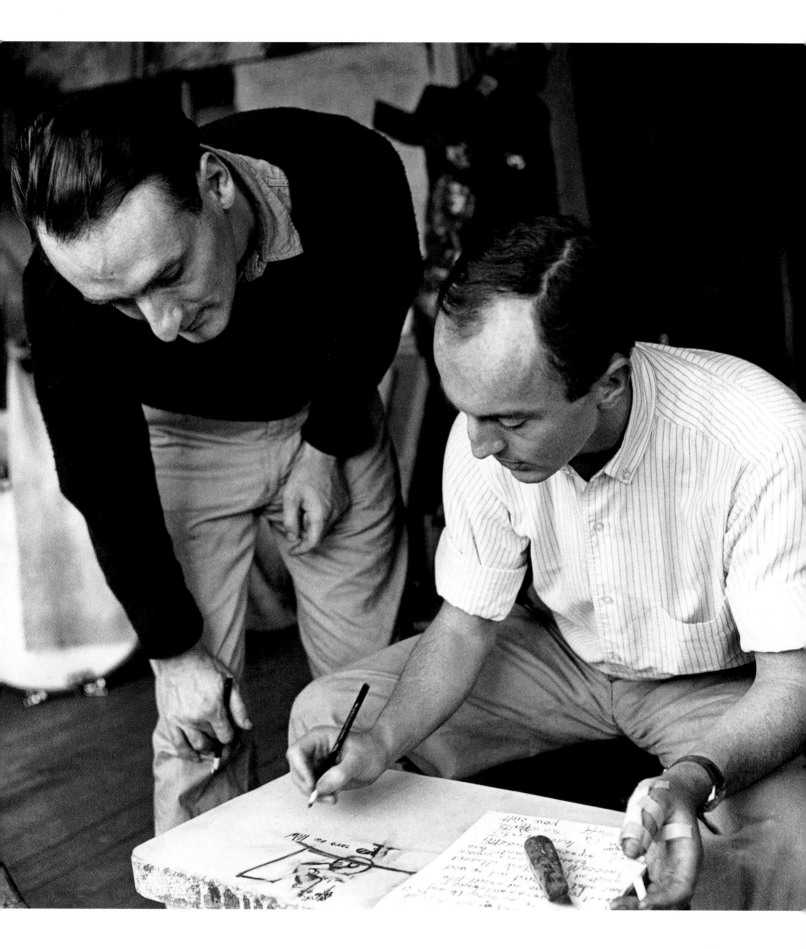

is equal, but antithetical. Because of this, to deny one would be to deny the other." The classification of de Kooning as romantic in the manner of Delacroix is somewhat arbitrarily made, as is the comparison of Pollock to Ingres, but to dwell on this is to miss the point. As with all his critical writings, the style of O'Hara's Pollock monograph is poetic rather than analytical, animated by ardor rather than cool detachment, and full of a phrase-maker's panache. O'Hara particularly favored what might be called the "Duke of Earl" construction: if Pollock was the Ingres of Action Painting, Salvador Dalí was "the Marshall Rommel of Surrealism" and Patsy Southgate, wife of abstract painter Michael Goldberg when O'Hara knew her, was "the Grace Kelly of the New York School."

O'Hara, who died in a freak accident at the age of forty in 1966, gives his own motto in "Personism," his manifesto disguised as a parody of the same. "You just go on your nerve," O'Hara exclaims. "If someone's chasing you down the street with a knife you just run, you don't turn around and shout, 'Give it up! I was a track star for Mineola Prep.'" This is stated with such bravado that the reader almost overlooks the fact that the poet as O'Hara depicts him is menaced by a knife-wielding assailant. By the end of "Personism," in a process replicated in a number of O'Hara poems, the poet has moved from wry resignation to nervy assertiveness, claiming that the movement he has just invented may be the death of literature as we know it. "While I have certain regrets, I am still glad I got there before Alain Robbe-Grillet did," he says. O'Hara explains that he created "Personism" when he wrote a poem as a deliberate alternative to making a phone call. "The poem is at last between two persons instead of two pages," he boasts. His jaunty manner conceals the importance of his insight: that poems can do the work of telephone calls, can have such immediacy, and can be energized by the vernacular in the same way. At the same time, the triumphant conclusion of "Personism" — "it, like Africa, is on the way" — completes a process of imaginative transformation.[26] No longer is the poet a victim chased by a thug; now there's a swagger in his gait. It is as if the act of writing itself were the decisive element, and that makes O'Hara, with his emphasis on the present moment and on the activity of writing, very much a poetic counterpart of the Abstract Expressionists he so greatly admired.

O'Hara was a great talker — "the Demosthenes of the telephone," in Richard Poirier's phrase — in an era of great talkers. Some of his greatest poems seem to arise out of talk; they are like conversations with an invisible partner, like Coleridge's so-called "conversation" poems but with a speed and in an idiom appropriate to midcentury America. O'Hara's talk, when he didn't transmute it into poetry, could transport the painter whose loft he was visiting. Philip Guston, who called O'Hara "our Apollinaire," drew his profile with lips parted in 1955. "Frank was in his most nonstop way of talking, saying that the pictures put him in mind of Tiepolo. Certain cupola frescoes. Suddenly I was working in an ancient building, a warehouse facing the Giudecca. The loft over the firehouse was transformed. It was filled with light reflected from the canal."[27] O'Hara made Guston feel that he "was a painter in Venice" without ever having to leave New York.

IV

Wallace Stevens wrote: "The paramount relation between poetry and painting today, between modern man and modern art is simply this: that in an age in which disbelief is so profoundly prevalent or, if not disbelief, indifference to questions of belief, poetry and painting, and the arts in general, are, in their measure, a compensation for what has been lost. Men feel that the imagination is the next greatest power to faith: the reigning prince."[28] This is grandly said. And it has its truth. Ashbery, in "The Painter," raises the possibility that the experience of art and the experience of religion may merge into one. The lure of the avant-garde in the 1950s had much to do with the element of risk and recklessness inherent in the enterprise, and this linked avant-garde art, in Ashbery's mind, to religion. Both, he wrote, are "beautiful because of the strong possibility that they are founded on nothing." But it is also worth keeping in mind Schuyler's insistence that a painting by Fairfield Porter that he admired "is not a statement." Paintings, Schuyler added, "are not a substitute for religion, they are an attitude toward life." It is the great and transcending value of Abstract Expressionism — whether encountered in mural-sized paintings or in smaller scale prints — that the works of art satisfy the highest aesthetic criteria and manage, almost despite their relentlessly aesthetic orientation, to raise the most fundamental issues of faith and belief in an age of irony and grave doubt.

Opposite: Claire Falkenstein, *Struttura grafica*, 1953, detail, cat. no. 42. Overleaf: George Miyasaki, *Light in March*, 1959, detail, cat. no. 57

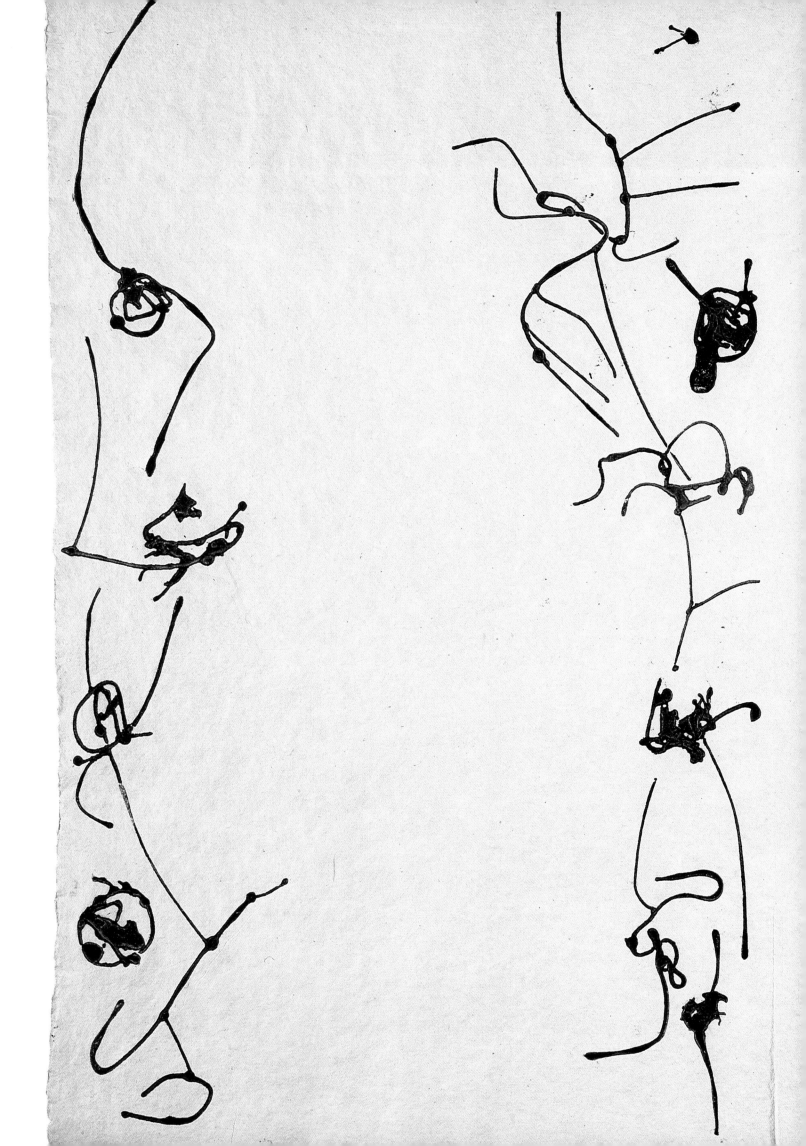

USE OF THE CATALOGUE

The titles of the works are those given by the artists, identifiable by inscription, by reference to other inscribed impressions, or reference to published descriptions. When this identification has not been possible, the prints are called *Untitled*. The catalogue is arranged in chronological order as established by the author. The basis for dating uninscribed works can be found in the entry. Measurements are given in centimeters, height preceding width. Watermarks and chops are described as seen, and further identified when possible. References from artists' workbooks or estate inventories are preceded by the artist's name. Other references include citations from a catalogue raisonné, standard definitive exhibition catalogues, or other publications that may provide further information or context for the print. Abbreviated bibliographical references are used throughout the catalogue; please consult the bibliography for the full corresponding citation. Unless otherwise noted, works from the collection of the Worcester Art Museum are the gifts of Mr. and Mrs. James N. Heald II.

JOHN OPPER

1908–1994

1. Stone #1, 1942

Lithograph on cream wove paper
19.7 x 29.6 cm (image)
31.4 x 48.4 cm (sheet)
Inscribed: in graphite, below image, l.r.:
 John Opper '42 Stone #1
Worcester Art Museum, Thomas Hovey Gage Fund,
 1997.113

A pioneering gestural painter in New York in the early 1940s, John Opper pursued an independent course throughout his long career. His analytical, disciplined temperament is revealed in his innovative painting, which often anticipated fashion.

Opper was born on October 29, 1908, in Chicago, where his father was a carpenter.[1] He attended Case Western Reserve University, while also studying at the Cleveland School of Art (now the Cleveland Art Institute). He took summer courses at the school of the Art Institute of Chicago in 1927 and 1928. Opper's first prints were student drypoints and woodcuts made in 1929–30. He was shocked when he first saw the work of Picasso and Georges Braque, and he struggled to understand that "painting is not another form of literature."[2] After receiving his bachelor's degree in 1931, he spent the summer in the artists' colony at Gloucester, Massachusetts, where he met Milton Avery and Hans Hofmann, who became lifelong friends.

In 1932 Opper moved to New York, where he and Edward Kaufmann founded the International Print Guild. This fine print publishing company marketed its products to art schools by subscription. It issued one edition in each of the nine months of the 1932 academic year.[3] Louis Lozowick and Adolf Dehn contributed to the series, which was printed by Kaufmann on presses at the Brooklyn Museum. The portfolio was completed, but there were few sales during the Depression, and the Guild soon closed. Afterwards Opper joined the easel painting division of the newly established FAP/WPA. Hoping to increase exhibition opportunities he became a founding member of the American Abstract Artists group. His contribution to the group's first portfolio of offset lithographs, published in 1936, is a Modernist abstraction. However, Opper's first solo exhibition, at the Artists' Gallery in New York, featured representational watercolors and tempera paintings of everyday life in Manhattan, and the New England landscape.[4] Late in the 1930s the artist studied with Hans Hofmann and adopted many of his concepts and practices.

During World War II Opper worked as a draftsman for the Navy, designing piping systems for PT boats. He also pursued graduate studies in education at Columbia University, where he received his master's degree in 1942. After the war, the responsibilities of a family prompted him to take a teaching job at the University of Wyoming in 1945. Opper was captivated by Western landscape, its enormity, its clear light, and the monumental forms of mountains and clouds. In plein-air studies he transformed these shapes and the spaces between them into nonobjective abstraction. Opper taught at the Women's College in Greensboro, North Carolina (now the University of North Carolina), and from 1946 to 1948 at the University of Alabama in Tuscaloosa. He continued showing his work in New York, and in 1947 a solo exhibition of his paintings appeared at the San Francisco Museum of Art. Opper returned to Manhattan from 1949 to 1952 to complete his doctoral degree in education at Columbia University. He went back to the Women's College in Greensboro, and over the next five years he brought the ideas and imagery of the New York School to the South.[5] In 1955 Opper exhibited bright, geometric abstractions in his solo show at the Egan Gallery in New York.

Opper moved back to New York in 1957 and joined the faculty of New York University, where his arrival was celebrated with a solo exhibition. By 1960 the artist had increased the scale of his paintings and simplified his compositions. Form subordinates gesture in these bold canvases, composed of two or three large, even-hued shapes. These color masses meet along a central jagged line of tension, often picked out in another bright hue, to create a shifting effect.[6] Perhaps under the influence of current Hard Edge painting, Opper progressed toward more intricate compositions in the mid-1960s. He switched from the use of oil to acrylic paint at that time, and his canvases were composed in colored vertical strips of varied widths, painted in exactingly balanced hues. The surface of his canvases became more refined, and for a time he reserved a thin border of unpainted fabric visible around the perimeter to enhance a sensation of levitation. The artist won a Guggenheim Fellowship in 1969.

Opper retired from teaching at NYU in 1974, the year he received a National Endowment for the Arts Fellowship to support his painting activities. Late in life Opper received some of the critical recognition that had earlier eluded him.[7] In 1989 the Guild Hall honored him with the Eloise Spaeth Award for lifetime achievement,[8] and the following year a retrospective exhibition of his work was shown at the Cleveland Institute of Art. Opper continued to paint until his death from a heart attack in New York on October 4, 1994.

This remarkable lithograph is one of the earliest to employ the free, painterly style that superseded geometric abstraction during the 1940s. It is one from a handful of experimental prints that

Figure 1. *Quarry*, 1942.

Opper executed in 1942, and its title suggests that it was his first lithograph from a stone. At first glance it seems to be a Cubist landscape, in which form and space are rendered as crystalline facets. The image defies literal reading, however, and its lines and shapes jangle and bounce as the eye is directed in and out of the composition. Opper created an engaging range of line and forms that are neither geometric nor natural, and no shape is repeated. Opposing diagonals and tipping lozenges evince constant flux. The artist prepared the stone with a lithographic crayon, allowing his rapid strokes, scribbles, and scrapings to reveal how the drawing was made. He achieved a range of textural effects, and a coloristic tonal spectrum. The print reflects the influence of Hans Hofmann, who advocated the construction of images from planar components, arranged so their form and color create sensations of visual dynamics.

We do not know who introduced Opper to lithography and helped to print this rare piece. The artist may have been acquainted with Albert Carman, who taught printmaking from 1934 to 1937 at the Florence Cane School in New York. He equipped a shop for printing stone and offset lithographs, and supervised his colleague Emilio Amero, who specialized in teaching lithography. The inscription "Printed by Cane Press," on the American Abstract Artists portfolio of offset lithographs, suggests that they printed the pioneering suite to which Opper contributed.[9] These artisans continued printing after the Cane School closed, and one of them may have given Opper access to a press and helped him with his experiments in 1942. At that time there was little market for prints, and most popular were Social Realist and Regionalist images, so it is reasonable that Opper pulled just a few proofs of *Stone #1*. The artist also did a slightly larger variant lithograph, adding references to representation and the descriptive title *Quarry* (fig. 1).[10] By inserting the figures of workers and a crane, he transformed his avant-garde abstraction into an American Scene print.

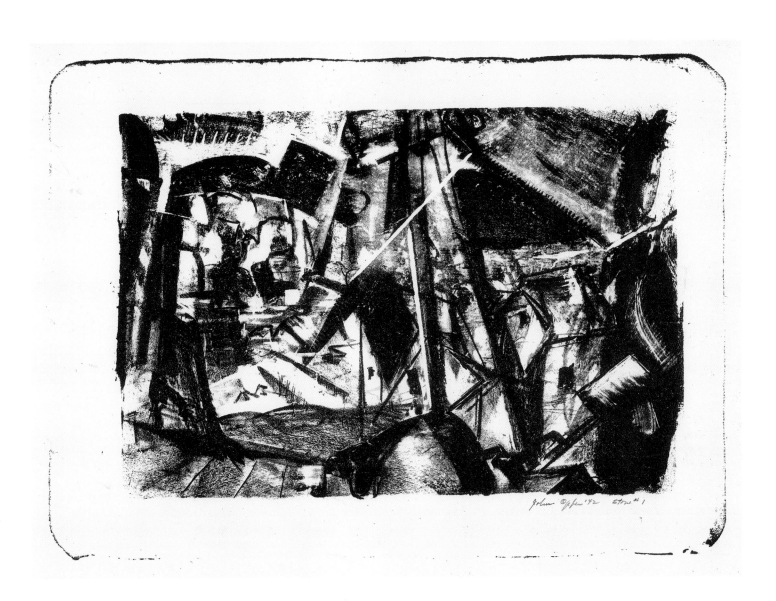

John Opper '42 Stone #1

JACKSON POLLOCK

1912–1956

Figure 1. *There Were Seven in Eight,* about 1945.

2. Untitled, about 1944

Engraving and drypoint on cream wove paper
38.0 x 44.8 cm (plate)
47.7 x 63.0 cm (sheet)
Inscribed: in graphite, l.l.: *#1*; in black ballpoint
pen, on verso, l.r: *Jackson PollockC44 CA/
Lee Krasner Pollock 1960*; in graphite, on
verso, u.ctr.: *P65*
Watermark: *MBM MADE IN FRANCE INGRES
D=ARCHES*
References: Castleman 1976, p.81; O'Connor/Thaw
1978, no. 1077 (P16); Williams 1988, no. 16;
Harrison 1997, pp.6, 15; Varnedoe 1998,
figs. 98–99.
Museum of Modern Art, gift of Lee Krasner Pollock,
1180.69

The revolutionary drip paintings that Jackson
Pollock produced in the late 1940s are the quintes-
sential Abstract Expressionist images. At several
points in his career, the artist made prints and
found that their techniques required a different,
measured creative approach.

Paul Jackson Pollock was the fifth son of a
sheep-ranch foreman, born on the Watkins Ranch,
near Cody, Wyoming, on January 28, 1912.[1] He was
a troubled youth, repeatedly expelled from school
for undisciplined behavior. As a teenager he stud-
ied the work of Diego Rivera and the painters of
the Mexican Muralist Revival. In 1929 he moved to
New York to join his older brother Charles as a stu-
dent of Thomas Hart Benton at the Art Students
League. He often hitchhiked back to Los Angeles to
spend summers with his family, and in 1931 he
began lasting friendships there with Reuben Kadish
and Philip Guston. Pollock's earliest surviving
prints are a group of lithographs done from 1934 to
1937. Some reflect Benton's Regionalist style and
imagery, while others reveal the more expressive
influence of the Mexican painters.

In summer 1935 Pollock and his younger
brother Sande joined the mural painting division of
the FAP/WPA in New York.[2] Sometimes they
attended the Laboratory of Modern Techniques in
Art, run by the Mexican painter David Alfaro
Siqueiros, and experimented with unconventional
materials such as enamel and new techniques like
airbrushing. In 1938, soon after he was dismissed
from the FAP for frequent absence, Pollock admit-
ted himself to the hospital for treatment of alco-
holism. The following year he was back on the
project, and began consultations with a psychoan-
alyst, who encouraged him to make expressive
drawings, which they analyzed and interpreted as
they would dreams.[3] Pollock met Lee Krasner in
1941, and they quickly became close friends. His
friend Joseph Meert got him a job at Creative

Printmakers, Inc., a commercial silkscreen shop,
where he worked on the night shift. He became
proficient in the screenprint technique and made
several experimental prints.[4] In 1943 Peggy
Guggenheim contracted Pollock to sell his work at
her Art of This Century Gallery and paid him a
monthly advance against sales. She also commis-
sioned the artist to paint a mural for the vestibule
of her Manhattan apartment. His first solo exhibi-
tion appeared at Art of This Century in November
1943, and soon after, the Museum of Modern Art
purchased his painting *The She-Wolf.*

After Pollock and Krasner were married in
October 1945, they moved to Springs, near East
Hampton, Long Island. A small barn behind the
house soon became his studio, and working there,
usually at night, he developed his splash and drip
style. The artist spread unstretched canvas flat on
the floor and stood above, pouring and dripping
enamel from coffee cans. He ladled the paint
through the air with sticks, trowels, or knives, lay-
ering the canvas with allover patterns of ribbons
and spatters of paint. In the trancelike execution of
these paintings, the artist opened a creative con-
duit to subconscious sources of inspiration.
Pollock's often lyrical canvases stand as records of
his dancelike movements and his split-second
reactions to previous actions and imagery. In 1948
these paintings created a sensation when they
were shown in the artist's first exhibition at Betty
Parsons's Gallery. The following year Pollock's
national reputation was further enhanced by fea-
tures in *Life* and other national magazines, with
photographs of him at work.[5] They helped to build
his personal myth, and bring popular attention to
Abstract Expressionism.

Pollock's fifth solo show with Betty Parsons, in
winter 1951, featured his Black Paintings, executed
in thinned black enamel poured onto unsized cot-
ton duck. The designs of six of them were later
reproduced in screenprints by the artist himself.[6]
In 1956 Pollock agreed to a solo exhibition of his
current work at the Museum of Modern Art, even
though he was struggling with alcoholism and
depression. His marriage was also in crisis, and
Krasner went to Europe alone for a working vaca-
tion. On the night of August 11, 1956, Pollock was
driving while drunk with his mistress near Springs
when he hit a tree and was killed. The Museum of
Modern Art exhibition opened at the end of the
year as a memorial retrospective.

This is the only pristine impression from
Pollock's hand of his most ambitious intaglio, one
of eleven prints that he made at Atelier 17 in
1944–45.[7] That fall the studio moved into a loft
across from his Eighth Street apartment; his old
friend Reuben Kadish had a job there and a key to
the shop. Meeting Pollock at the workshop late at

night, Kadish taught him to use the burin and dry-
point needle, working two sides of a plate, and dis-
carding the proofs they pulled.[8] It was a comfort
for the old friends to work side by side on their
own projects in companionable silence. Pollock
tested the feel of the graver and needle in the cop-
per, experimenting with different qualities of the
printed line. Halting and derivative at first, his
intaglios became proficient and exploratory. Some
plates evolved through different states, and he
tried coloring impressions by hand. He did not edi-
tion his prints but kept one or two careful proofs of
most of them. The nocturnal sessions ended in
early spring, when Pollock began furious prepara-
tions for a solo exhibition at Art of This Century. He
wrapped up six of the copper plates in brown
paper and took them along when he moved to
Springs in November 1945.

This print relates to Pollock's contemporane-
ous paintings in its style, imagery, and facture. It
seems he began by scratching arabesques over
much of the plate in a random grid. Shading some
lozenges thus created with scribbled hatching, he
picked out and developed forms, figures, and pat-
terns. An image evolved in the process of its cre-
ation, with totemic figures distributed across the
entire composition that seem to appear and dema-
terialize. Pollock detailed the image with motifs
then common in his work: rows of dots, bars, and
Xs, eyes, genitalia, hands, and feet. The still life in
the lower left, with its recognizable fork and news-
paper, suggests that he may have envisioned the
image of a picnic. This style has much in common
with Pollock's painting *There Were Seven in Eight*
(fig.1), which stood unfinished in his apartment
when he was in the printshop.[9]

Kadish later remarked that Pollock was frus-
trated with the obliquity of engraving.[10] It seems
equally likely that he considered intaglio a com-
fortable diversion at a time when he was emotion-
ally depressed and creatively challenged. He had a
handsome contract for his paintings, and knew
that there was no market for prints. Indeed, the
intaglios by Kadish and Motherwell made at Atelier
17 were printed only as proofs. Pollock experi-
mented with intaglio as he had with screenprint,
relying on the discipline and cadence required by
the process to motivate him and spark new ideas.
His experiments were never meant to be distrib-
uted, but were personal creations and perhaps,
like his so-called psychoanalytical drawings, they
were therapeutic.[11]

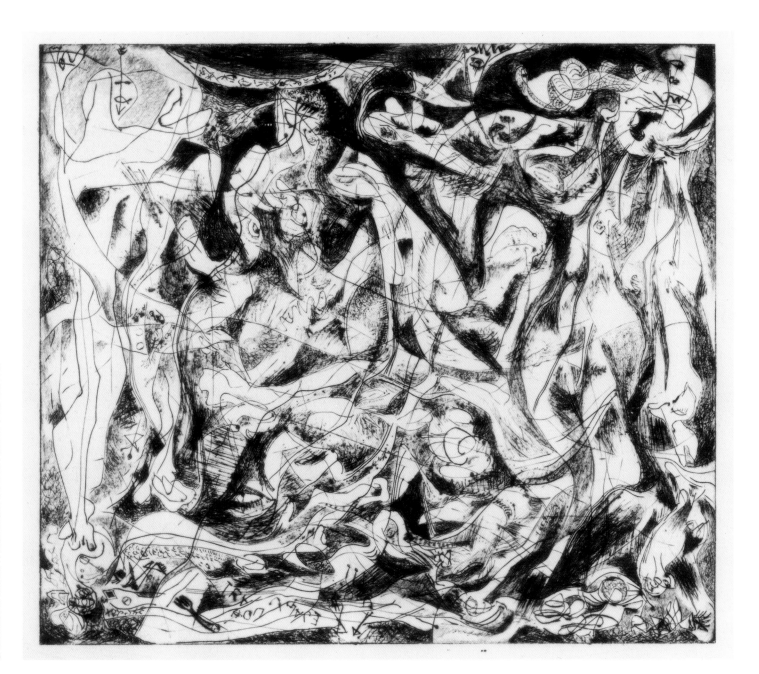

REUBEN KADISH

1913–1992

3. Lilith, 1945

Etching and aquatint with drypoint on cream
 wove paper, 9/20
35.0 x 25.0 cm (plate)
52.4 x 37.4 cm (sheet)
Inscribed: in graphite, below platemark:
 9/20 Reuben Kadish 1945
References: Moser 1977, pp.64–65.
Worcester Art Museum, purchase with funds given
 in memory of Abraham Travers, 1985.299

In the middle phase of his long career, Reuben
Kadish was closely associated with the New York
School. Along with Philip Guston, Jackson Pollock,
and other colleagues, he shared the conceptual
development that provided the foundation of
Abstract Expressionism.

Kadish was born in Chicago on January 29,
1913, the son of a decorative painter who special-
ized in marbling and faux-bois painting for interi-
ors.[1] In 1921 the family moved to Los Angeles,
where Kadish began private art studies with Lorser
Feitelson. He enrolled at the Otis Art Institute in
1930, and won a scholarship to the Stickney
School of Art in Pasadena the following year. He
also studied anthropology and zoology at Los
Angeles City College, and began to use stylized
zoomorphic elements in his work, motifs that
would recur throughout his oeuvre.[2]

At Otis, Kadish began a lifelong friendship with
fellow student Phil Goldstein (later Guston). His
first mature paintings are Social Realist images
depicting alienation and struggle. In summer 1931
Kadish met Jackson Pollock, and they quickly
became good friends.[3] They explored Mexican
painting and Native American art in the galleries of
the Los Angeles County Museum of Art. In 1932
Kadish made his first print, an offset lithograph
drawn in the movie studio printshop where his
friend Fletcher Martin worked. Its style reflects the
influence of David Alfaro Siqueiros, the exiled
Mexican muralist active in Los Angeles. Kadish and
Goldstein went to Mexico in 1935. They traveled
widely, studied pre-Columbian sculpture and con-
temporary murals, and painted their own fresco at
the University of Michoacan in Morelia, which was
hailed by *Time* magazine.[4] Kadish moved to San
Francisco in 1936, where he joined the mural paint-
ing division of the FAP/WPA. His most important
fresco is *A Dissertation on Alchemy* at San Fran-
cisco State College. He also worked in the graphic
arts division, and made Surrealist lithographs that
were featured in his first solo exhibition, at the
Stanley Rose Bookshop in Hollywood in 1937.[5] In
1940 he studied intaglio printmaking at the Califor-
nia School of Fine Arts with visiting instructor

Stanley William Hayter, and was soon at work on
Abstract Surrealist etchings.

During World War II Kadish was recruited for
the Army Artists' Unit, which documented foreign
military campaigns. He was posted to South Asia
in 1943, and spent several months observing the
Allied campaign and regional conflicts in India and
Burma. It was a devastating experience, and
Kadish's drawings reflect a wounded spirit. After
his discharge in 1945, the artist moved to New
York, perhaps seeking solace in old friends and
colleagues at the center of the American art world.
He worked as a printer at S.W. Hayter's Atelier 17,
printing for Joan Miró and other artists. He also
made his own prints, along with his friend Pollock.[6]
In 1946, Kadish settled on a farm in Vernon, New
Jersey, with his family; he abandoned his art and
became a dairy farmer. For a decade, he remained
out of touch with the New York art world.

Around 1950 Kadish modeled a small figure in
clay and recognized the path for a new artistic
direction. He had turned decisively back to his art
by about 1955, modeling human heads and female
figures reminiscent of the sculpture he had seen in
India, but with a rough, weathered, organic
appearance. Executed in unfired clay, they resem-
ble chipped rock or clods of dirt, with visible frac-
tures, lumps, and fingermarks of their creation. In
1961 the artist returned to New York and to teach-
ing at Cooper Union, where he would remain on
the faculty for more than thirty years. At that time
the first solo exhibition of his sculpture was shown
at the Poindexter Gallery.[7]

In 1961 Kadish was an artist fellow at the
Tamarind Lithography Workshop in Los Angeles.[8]
In most of his ten editions, he used short crayon
strokes to shape fuzzy-looking forms and figures,
similar to his sculpture (fig. 1).[9] From the 1960s
through the 1980s Kadish concentrated on sculp-
ture, mostly of terracotta. He produced series of
works that express the conquest of alienation, cru-
elty, and triumph.[10] In 1970 Kadish acquired his
own printing press and occasionally made
intaglios. His last prints were experimental mono-
types of the late 1980s; linear representations of
female nudes and monsters, they are alternately
amusing and disturbing. A retrospective exhibition
of Kadish's work was shown at the New Jersey
State Museum in 1990.[11] Another survey of sculp-
ture and drawings was presented at the State
University at Stony Brook, shortly before the
artist's death from leukemia on September 20,
1992, in New York.

The present print is one of the intaglios that
Kadish made at Atelier 17 in New York. He had a
key to the studio, and worked on his own projects
at night and on weekends. Many of these works

Fig. 1. *Untitled*, 1961.

combine the earlier influences of draftsmanship
and plasticity from the Mexican muralists with the
emotional Abstract Surrealism then practiced by
the European exiles who frequented Atelier 17. In
ancient Semitic myth, Lilith is an evil spirit who
kidnaps and devours the innocent. She began as a
wind goddess in Sumerian mythology, and was
represented as a bird-woman. In Judaic culture she
became a succubus, and a bogey who abducted
and devoured children. Her unseen spirit haunted
the homes of pregnant women, waiting to abduct
the newborn. Kadish's fearful image represents her
as a spectral figure, half-seen in darkness, perhaps
to symbolize her omnipresence. Her nightmarish
form emerges from shadows along the left of the
composition, as she consumes a victim. A terrible
head is merged into a bilobate form, symbolizing
breasts. Atop a long, laddered neck is a confusion
of shapes with hysterical eyes and a gaping mouth
spilling intestines. Projecting from the base of the
neck stalk are arms with grasping hands. One limb
projects horizontally across the center of the com-
position, terminating in a handful of gleaming
entrails. Behind these visceral forms, and looming
over a pile of bony bars, stands a carrion bird with
empty, soulless eyes. This creature may also relate
to Lilith's origins as a Sumerian bird-goddess. The
body of her victim is draped over Lilith's lap, prone
across the bottom of the image. Its head, on the
left, is a misshapen, ablated skull. Ribs project
from its twisted spine, and the form of its bruised
buttocks echos the shape of the monster's body.

This print demonstrates that Kadish was a
masterful draftsman. Though his earlier method
had been measured and precise, at this point in
his career, each stroke was immediate and ener-
gized, controlled by confining outlines and by over-
drawing. The artist laid aquatint in the darkest
passages of the plate, but he created other areas
of shading by texturing discrete passages in vari-
ous ways, with deep dashes, commas, scribbles,
parallel and crosshatching. The thick, pristine
paper of this edition is common to Kadish's prints
made in 1970, when he acquired his own etching
press. Despite its inscription, it is likely that this
impression was pulled at that time.

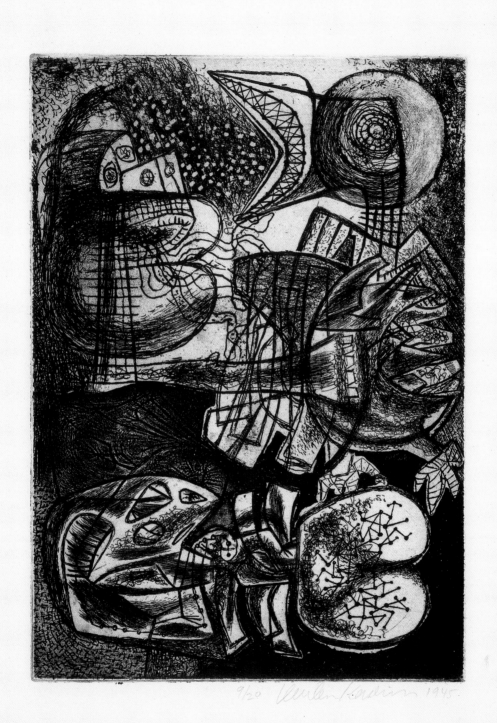

9/20 Willem de Kooning 1945

ADOLPH GOTTLIEB

1903–1974

4. Apparition, 1945

Etching and aquatint on cream laid paper, 15/15
51.0 x 37.5 cm (plate)
61.1 x 48.0 cm (sheet)
Inscribed: in graphite, below platemark: *15/15*
Adolph Gottlieb; l.l.: *Bottom*
References: Gottlieb Foundation no. 4528P; Harvey
1994, no. 21; Long 1986, cat. no. 10.
Worcester Art Museum, Richard A. Heald Fund,
1993.73

Throughout much of his career, Adolph Gottlieb
made prints, and during the early 1940s he em-
ployed etching as a creative tool in the develop-
ment of his distinctive Abstract Surrealist imagery.

Gottlieb was born on March 14, 1903, in New
York, where his father ran a stationery supply busi-
ness.[1] He left high school at age sixteen to enroll
at the Art Students League, where he studied
painting with John Sloan and attended the lectures
of Robert Henri. In 1921 the young artist embarked
for Europe; in Paris he studied at the Académie de
la Grande Chaumière, and he visited museums and
galleries in Prague, Berlin, and Munich. In 1923
he returned to high school in New York and also
resumed his art studies at the League, Parsons
School of Design, Cooper Union, and the Education
Alliance School. He was influenced by the work of
Milton Avery in the mid-1920s. Gottlieb won a
national competition, the award for which was his
first solo exhibition at the Dudensing Gallery
in 1930.

The artist became friendly with Mark Rothko,
with whom he shared his artistic experiments.
Both were among The Ten, a group of artists
devoted to personal expression, who began meet-
ing and exhibiting their work together in 1934.
Gottlieb worked briefly in the easel painting divi-
sion of the FAP/WPA in the mid-1930s. When he
lived in Arizona in 1937–38, he became interested
in Native American art and culture. In the early
1940s Gottlieb and Rothko conceived of an artistic
style with appeal across time and culture. In sum-
mer 1943 they sent a letter to the *New York Times*
describing their stylistic experiments, and in the
fall they explained their ideas in an interview on
WNYC radio.[2] In the mid-1940s Gottlieb made his
own woodcuts and intaglios, printing on a small
press in his studio.[3]

Gottlieb was active in the artists' symposia of
the 1940s where the conceptual foundations of
Abstract Expressionism were formulated, including
the Subjects of the Artist, Studio 35, and The Club.

In May 1950, in a closed meeting of Studio 35, he
organized a protest against the conservative jury
for the upcoming modern art competition at the
Metropolitan Museum of Art. The artists sent an
open letter to the *New York Times*, and a wave of
publicity followed. Dubbed the "Irascibles," they
were featured in an article in *Life* magazine, illus-
trated by a famous photograph of the artists
popularly identified as the leaders of Abstract
Expressionism.[4]

Around 1950 Gottlieb began a series of large
paintings that he called Imaginary Landscapes. In
these images astral shapes hover above a low
horizon, below which loosely scumbled elements
suggest craggy topography or choppy seas. The
artist executed several major public commissions
in the early 1950s, including the design of ark cur-
tains for Congregation B'nai Israel in Millburn, New
Jersey, and the monumental stained-glass facade
for the Milton Steinberg Memorial Center in New
York. He transferred the formula of his Imaginary
Landscapes to a vertical format in the late 1950s,
beginning a new sequence collectively known as
the Burst paintings. In these works an orb shape,
painted in red, hovers above a ragged gestural
form in black. Their simplicity and associations to
landscape, in combination with gestural energy,
made these popular paintings. For the remainder
of his career the artist produced variations of his
Imaginary Landscapes and Burst images.

Gottlieb's work was internationally recognized
during the 1960s, when he won major prizes in
international exhibitions. Returning to printmaking
in 1966, he represented his Imaginary Landscapes
and Burst images in collaborative screenprints, lith-
ographs, and intaglios. In 1967 he was appointed
to the New York City Art Commission, and the fol-
lowing year a retrospective exhibition of his work
was organized jointly by the Whitney Museum of
American Art and the Solomon R. Guggenheim
Museum in New York. Gottlieb suffered a stroke in
1970, which paralyzed the left side of his body.
Though he was confined to a wheelchair, he con-
tinued to work on paintings and monotype prints.
The artist died in New York on March 4, 1974.

Apparition, Gottlieb's largest print of the
1940s, is among his fully resolved Pictograph com-
positions.[5] Early in that decade he and Mark
Rothko formulated the notion of an art compre-
hensible to all viewers, regardless of their culture
or place in history. They were influenced by the
ideas of the psychoanalyst Carl Jung, who
described a collective unconscious, comprised of
fundamental psychic constructs, or "archetypes,"

such as earth, water, father, mother. Gottlieb and
Rothko aimed to develop an art that could activate
the subliminal understanding of these psychic
concepts common to all human experience. They
looked to ancient Greek mythology for ostensible
subjects and to universal symbols for a formal
vocabulary. Gottlieb created a series of works that
he called Pictographs, after the prehistoric rock
paintings of the Southwest.

Irregular grids divide the Pictographs into
cells, each holding a symbolic motif. Geometric
shapes, ciphers, human figures, animals, and
many other simple forms symbolize universal con-
cepts from cultural myth. Gottlieb derived these
elements from American, African, and Australian
aboriginal art, as well as from the work of Abstract
Surrealists like Joan Miró and Paul Klee. He wanted
his symbols to be evocative, but neutral, so that
their reading would be uncolored by cultural bias.
By the mid-1940s his Pictographs were freer, and
individual symbols became more ranging and mys-
terious. The motifs in *Apparition* are quite elusive,
reduced to abstract symbols that have a totemic
presence. Human heads become iconic lingam
shapes, and the powerful eyes — a recurrent motif
in the Pictographs — mark the wings of a butterfly.
Such deliberate ambiguity allows the viewer to
bring personal associations to these motifs.

Printmaking was a significant element in
Gottlieb's stylistic development. He first became
interested in etching in the early 1930s, when he
bought a press in a junk shop.[6] In a group of small
intaglios of the early 1940s, he explored the com-
positions and motifs that became the grid and
symbols of his Pictographs. Working alone in his
studio, Gottlieb pulled proofs or tiny editions for
his own edification. They are independent images,
not studies for paintings or reproductions of other
works. He occasionally exhibited his prints but did
not strive to sell them. Rather he used the etching
process as a way to vary and adapt imagery. It was
Gottlieb's practice to sketch an idea onto a plate,
print a proof or two, then rework the plate to alter
the image.[7] *Apparition* is among his most techni-
cally sophisticated prints of the 1940s. The artist
used aquatint rather than line to define the grid
and the symbols. These areas of rich black and
gray tones, together with the centralized focus,
give the image an impressive architectural quality.
The aquatint creates a dramatic chiaroscuro effect
that lends the signs a degree of dimension; they
appear as forms emerging from the dark, as from
the unconscious.

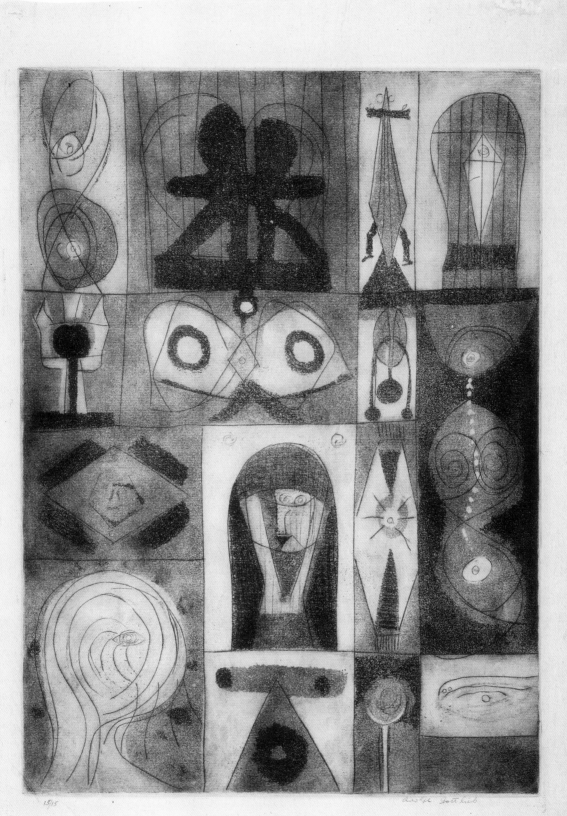

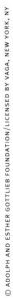

MARK ROTHKO

1903–1970

5. Untitled, about 1945

Etching on light gray wove paper
17.7 x 12.4 cm (plate)
24.5 x 29.4 cm (sheet)
Inscribed: in graphite on verso, l.l.: *1#*; *PRINTER*
Museum of Modern Art, gift of the Mark Rothko
 Foundation, 319.85

Mark Rothko was at the center of the conceptual and aesthetic development of Abstract Expressionism. During the 1940s he strove to express mythic content and psychological states in Abstract Surrealist drawings and watercolors, and those works directed his only incursion into printmaking.

Marcus Rothkowitz was born on September 25, 1903, in Dvinsk, Latvia, where his father was a pharmacist.[1] He emigrated with his family to the United States, moving first to Portland, Oregon, and settling in New York after his father died in 1914. An outstanding student, Rothko completed high school in three years. He attended Yale University from 1921 to 1923 but left before completing a degree. On returning to New York he took classes at the Art Students League and in 1925 studied painting with Max Weber, developing a representational style influenced by Cubism.

In 1929 Rothko began a close friendship with Adolph Gottlieb, with whom he shared artistic ideas and experiments. They both exhibited their work at Gallery Secession in New York and were among a group of Jewish painters, sympathetic to abstraction, who left that gallery to form The Ten in 1934. Working in the easel painting division of the FAP/WPA in 1936, Rothko became interested in Surrealism. Soon he and Gottlieb abandoned representation and experimented with biomorphic and abstract imagery, initially derived from the work of Joan Miró and Roberto Matta, as well as from ethnographic art. Rothko also experimented with automatist drawings at that time. His work was included in *The Ten: Whitney Dissenters*, an exhibition at the Mercury Galleries in November 1938, mounted to protest the Whitney Museum's bias against abstract art.

From 1941 to 1943 Rothko and Gottlieb devised a style based on ethnographic art, taking subjects from Greek mythology as a paradigm for the common experiences of all humankind. While Gottlieb created his pictographs, Rothko made compositions with symbolic motifs drawn from archaic sculpture and classical architecture. Working in watercolor at that time, he developed imagery from

the properties of that medium. In 1943 the two artists described their style in a letter to the *New York Times*.[2] Rothko exhibited these works in his solo exhibition of paintings at Peggy Guggenheim's Art of This Century Gallery in New York in 1945. Another solo exhibition of his work appeared at the San Francisco Museum of Art in 1946, and in the next year the first of five annual solo exhibitions of his paintings was mounted at the Betty Parsons Gallery in New York.

Rothko's association with Clyfford Still led to a teaching job at the California School of Fine Arts in San Francisco in the summers of 1948 and 1949.[3] There he helped transmit the ideas and imagery of the New York School to the Bay Area. Still shared with Rothko his idea for a school where advanced students could join in discussions with working artists, a project that evolved into the Subjects of the Artist School in New York, opened by Rothko, William Baziotes, David Hare, and Robert Motherwell later that year.[4] At that time his paintings became larger, simpler, and more intensely colored, and his mature style crystallized. He returned to the use of oil paint, but developed new techniques based on experiments with watercolor washes. In his paintings, rectangles of varying sizes seem to hover slightly on top of each other and above the background color field. He used dilute washes of pigment that saturate and stain the canvas, creating a luminous, translucent effect that he called "inner light." The artist intended that the viewer be immersed in the experience of color.

Rothko's new work was critically acclaimed, and his reputation was enhanced when he appeared in the 1951 *Life* magazine photograph of "The Irascibles," a group of artists who became identified as the leaders of Abstract Expressionism. In 1951, when the artist joined the faculty of Brooklyn College, he was assigned to teach classes in drawing, color design theory, and a graphic workshop. Since he had no experience in graphic arts, he attended Will Barnet's classes at the Art Students League for a week in January and February 1951.[5] He observed workshop practice, learned the rudiments of printmaking, and made a few prints himself. With Barnet's help, and that of workshop assistants and printers, Rothko tried color lithographs representing his familiar soft-edged, overlapping rectangles. However, none of these experimental prints are known to survive. The artist taught at Brooklyn College until 1954, and temporary residencies followed at the University of Colorado in Boulder and Tulane University in

New Orleans. A major solo exhibition of his paintings was mounted by the Museum of Modern Art early in 1961.[6] Through the 1960s his colors became more somber, less modulated and with less vivid interaction. This late style was exemplified by wall paintings executed for Harvard University and the series of murals commissioned for the De Menil chapel in Houston. In spring 1968 Rothko suffered a heart attack, and afterward, he concentrated on small acrylic paintings on paper. His final works are a series of elegiac black and gray paintings, perhaps influenced by a melancholic state. On February 25, 1970, Rothko committed suicide in his studio.

The present piece is Rothko's only known print. Found among his effects at the time of his death, it was apparently kept as a personal memento, which he never felt the need to sign or inscribe. It seems likely that the artist made this etching with the assistance of his friend Adolph Gottlieb, on that artist's press in his studio. Its imagery grew from Rothko's Abstract Surrealist drawings and watercolors of the mid-1940s, when he and Gottlieb searched for accessible ways to express universal human ideas, feelings, and experiences. With the understanding that great civilizations throughout history have communicated basic truths in symbolic myth, the artists sought their own mythic visual language. Rothko developed these ideas in watercolors representing biomorphic forms in misty, primordial space.

In this print the artist created a simple setting with bundled parallel lines to suggest a watery horizon. Wavy bundles above seem to suggest clouds or moving mist. Symbolic figures appear in this ambiguous, primordial setting. Simply delineated, they combine plant and animal forms and also seem to possess human qualities. As these diaphanous shapes emerge and blend into their surroundings, they are alluring and yet baffling. To create this image Rothko used a needle to draw on a grounded etching plate. When inking and printing the simple plate, he created tonal effects that enhance the sense of space. He left a soft, even film of ink on the plate, wiping the tone away in some areas to create white accents of unprinted paper. Rothko even used his inky fingerprints to detail the design. These effects of subtracting and adding layers of pigment are parallel to those of his experimental watercolor techniques of the mid-1940s.

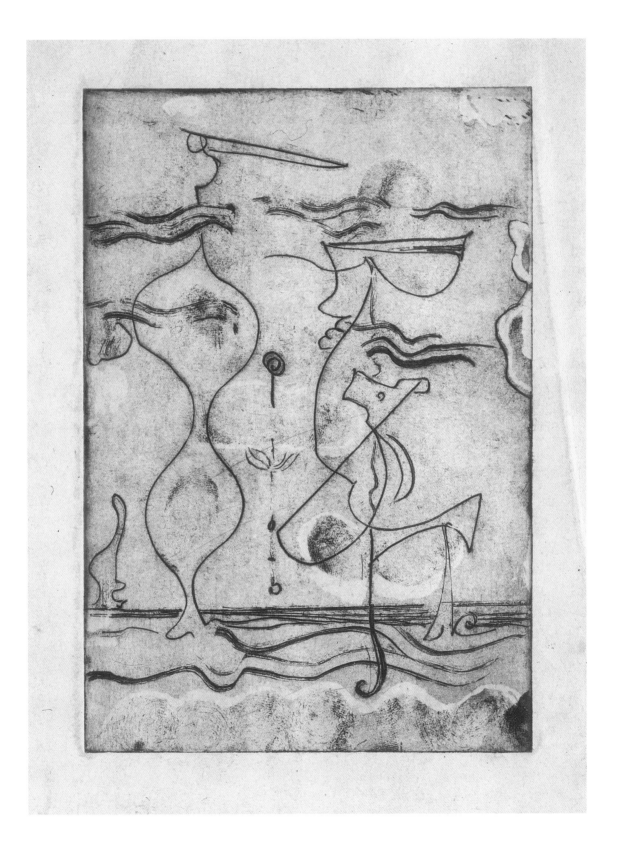

CLYFFORD STILL

1904–1980

6. Untitled, or Figure, 1945

Lithograph on cream wove paper
34.3 x 22.4 cm (image)
38.1 x 25.4 cm (sheet)
Inscribed: in graphite, below image: *To My Friend*
Bob Neuhaus Clyfford. /45
References: Heyman 1987 no. 34; Anfam 1993,
 p.266.
The Oakland Museum, gift of the Art Guild,
 Oakland Museum Association, A69.60

The originative painter Clyfford Still helped to transplant the style and ideas of Abstract Expressionism when he worked in San Francisco in the mid-1940s. Shortly before his arrival in California he made a group of experimental lithographs that characterize his individual imagery.

Still was born on November 30, 1904, in Grandin, North Dakota, and soon moved with his family to Spokane, Washington.[1] In 1910 his autocratic father claimed a homestead near Bow Island in Alberta, Canada, and each year he took Still from school to work the wheat fields on this frontier farm. As a teenager Still taught himself to paint by copying magazine illustrations. His first works reflect the current genre of Regionalism, sometimes depicting the hard lives of prairie farmers. In 1929 Still won a scholarship to study at Spokane University. After receiving his bachelor's degree in literature and philosophy in 1933, he moved to Pullman for graduate studies at Washington State College. Two years later he joined the faculty, and taught graduate courses in painting, sculpture, and graphic arts. At that time the artist systematically explored the history of modern European art in his own painting.

In 1941, Still moved to Oakland, California, to work in the wartime shipbuilding and aircraft industries. The paintings he did in his spare time were shown in his first solo exhibition at the San Francisco Museum of Art in 1943. Still taught at the Richmond Professional Institute (now Virginia Commonwealth University) from 1943 to 1945. Then he moved to New York, where a solo exhibition of his work appeared at the Art of This Century Gallery in February 1946. He strove for individuality, but rejected the notion of psychic Automatism. Uncomfortable with what he saw as the decadence of New York art circles, he returned to Canada in summer 1946. He went to San Francisco in the autumn, and joined the faculty of the California School of Fine Arts (CSFA). Still's teaching helped

to transform the institution into the most advanced art institution in the West, but his progressive art and personal hauteur polarized the school. At that time he experimented with large, monochromatic abstractions with craggy, trunklike forms and impasto surfaces. In 1947 an exhibition of his paintings at the California Palace of the Legion of Honor in San Francisco gave colleagues and students the first chance to see his work in depth. "Still's images were organic," wrote Kenneth Sawyer, "his colors and surfaces had nothing in common with what we had learned to regard as 'good' modern painting. It was unnerving to have one's preconceptions so efficiently shorn in a single exhibition. Here was painting that instructed even as it destroyed; the School of Paris had died quite suddenly for us; something new, something that most of us could not yet define, had occurred."[2]

In spring 1948 Still went to New York to pursue his vision of a school comprised of working artists and advanced students. He persuaded a group of distinguished artists to join the endeavor — including Mark Rothko, William Baziotes, Robert Motherwell, and David Hare — but was discouraged as the nascent organization seemed to stray from his original conception. He withdrew from the project and returned to the CSFA, leaving his colleagues to pursue the Subjects of the Artist school. In San Francisco Still applied some of his ideas to an elite graduate painting program. To showcase their work, his students organized the Metart Gallery, which presented a solo exhibition of Still's work when he resigned from the CSFA in summer 1950.

Still returned to New York, where he taught at Hunter College and Brooklyn College in 1951–52. His work was included in the exhibition *Fifteen Americans* at the Museum of Modern Art. Afterwards he painted in isolation for seven years, refusing to exhibit or sell his work. In 1959, a major solo exhibition of his paintings was mounted at the Albright Art Gallery in Buffalo. The artist purchased a twenty-two acre farm near Westminster, Maryland, and converted outbuildings into a studio. Late in life Still donated sixty-nine paintings to the Albright-Knox Art Gallery, the San Francisco Museum of Modern Art, and the Metropolitan Museum of Art, effectively creating a canon of works by which his artistic achievement must be judged.[3] Still died in Baltimore, on June 23, 1980.

The present print was made in Virginia when Still taught at the Richmond Professional Institute. Between fall 1943 and spring 1945, the artist executed twenty-one lithographs, systematically

exploring the techniques and visual effects that the medium offers, in images that reproduce his oil paintings of the late 1930s.[4] Their style and imagery range considerably, from linear geometry, to mechanomorphic forms, to figuration. Today most of these works are held by the artist's estate and are inaccessible for study. It is uncertain whether they were printed in editions.[5] The two prints that are known — from impressions Still gave as gifts to museum people, which made their way into public collections — are enticingly provocative.[6]

This lithograph is based on an oil painting of 1937, when Still experimented with expressive figuration. David Anfam persuasively argues that its imagery grew from the artist's college studies of ancient philosophy, mythology, and cosmography, merged with his formative experiences laboring on the family farm in Alberta.[7] Along with symbols of human toil, Still's images of that period are often metaphors of the earth and sun, and the seasonal elements of agricultural fertility. Like an ancient icon, this mysterious, totemic figure is more stylized than delineated. For Still, the long hair indicates that it is a female form, which towers against the sky and meets a radiant solar disc. The figure rises from behind a vertical beehive shape, reminiscent of an *omphalos*, or navel stone, an object of cult devotion in ancient Greek temples.[8] The *omphalos* at the Temple of Apollo at Delphi was believed to mark the very center of the earth, and a point where the netherworld met the heavens. Still's figure may represent an earth goddess, or she may be a sibyl, priestess of the sun god Apollo, who uttered his prophetic words in reply to questioners. When delivering her oracle, the sibyl of Delphi sat on a sacred tripod, perhaps also suggested in Still's mysterious image.

The artist prepared the lithography stone with crayon, superimposing layers of scribbled hatching to create darker passages. He used the side of the crayon to draw soft, broad areas of shading, and then detailed them with the sharpened point. The artist scraped ink away from the stone to clean up the edges of the bright, highlighted area in the upper center. Still also seems to have scraped away at the crayon work in tiny nicks throughout the area of the darkest hatching, to give the image a sparkling shimmer. Much of the composition is delineated by straight lines with rounded corners, which echo the outline of the image and the shape of the lithography stone itself.

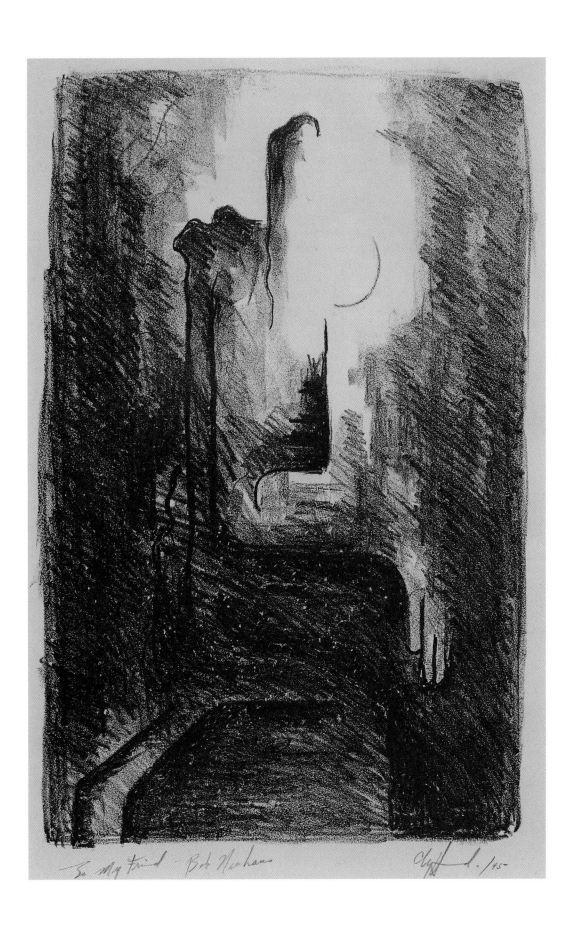

To My Friend – Bob Neuhaus Clifford. /45-

GEROME KAMROWSKI

1914–

7. Untitled, 1946

Drypoint on white laid paper, 3/20
12.5 x 15.1 cm (plate)
254 x 27.6 cm (sheet)
Inscribed: in graphite, below platemark:
 3/20 1946 ED.1996 G.Kamrowski
Watermark: *HANDMADE*
Worcester Art Museum, Sarah C. Garver Fund,
 1997.2

In the mid-1940s, Gerome Kamrowski and a few of his colleagues studied European Surrealism, seeking in its theories and practices a new, distinctly personal, American style of painting. In doing so, they laid the foundations for Abstract Expressionism.

Kamrowski was born in Warren, Minnesota, on January 19, 1914, and he grew up in Saint Cloud.[1] In 1932 he enrolled in the Saint Paul School of Art, where he studied with Leroy Turner and Cameron Booth. They initiated him in an expressive Cubist style, and his early paintings depict recognizable subjects in a Modernist mode. In the mid-1930s Kamrowski worked in the FAP/WPA mural division, and painted frescoes in the Northrup Auditorium of the University of Minnesota and at the Rockville community center. In 1937 he enrolled at the Institute of Design of the Illinois Institute of Technology in Chicago, where he studied with László Moholy-Nagy. He shifted to a geometric abstract style, and exhibited his work with the American Abstract Artists group. Thus, Kamrowski attracted the attention of Hilla Rebay, director of the Guggenheim Museum of Non-Objective Painting, who arranged for a fellowship that enabled the artist to return to Manhattan in fall 1938. First he went to Provincetown for the summer, to study with Hans Hofmann, under whose influence his painting began to loosen and become more expressive.

Soon after his return to New York, Kamrowski met William Baziotes and began a close friendship. They joined a circle of artists who gathered at the Tenth Street loft of the literary critic Francis Lee. Many were interested in Surrealism and in the work of Parisian artists then in New York in exile from the war. Kamrowski was drawn to the freedom and optimism of their work compared to the despair of Depression-era American Social Realism. He abandoned geometric abstraction to concentrate on biomorphism suggested by the work of Joan Miró, and overlapping veils of transparent color from the painting of Roberto Matta.

In the early 1940s a group of Americans — including Kamrowski, Baziotes, Jackson Pollock, Peter Busa, and Robert Motherwell — occasionally gathered at Matta's studio to discuss Surrealism and share their own ideas. Inspired by the concept of Automatism, they aimed for effortless, unconscious communication with the viewer.[2] Kamrowski also found inspiration in natural science, visiting the Museum of Natural History, and studying books like Darcy Thompson's *On Growth and Form*.[3] He developed a distinctive imagery in which organic figures, derived from microbiological and plant forms, float in layered spaces with bursts of color and light. In about 1941, Kamrowski collaborated with Baziotes and Pollock on an experimental painting created by the drip technique.[4]

In 1942 the artist's collages were included in the international collage exhibition at the Art of This Century Gallery, and he continued to show his work there through the decade. The following year, his paintings were included in the group exhibition *Adventures of the Inner Eye* at the Norlyst Gallery. Kamrowski's first solo exhibition appeared at the Mortimer Brandt Gallery in New York in 1946.[5] Soon afterward he took a teaching position at the University of Michigan in Ann Arbor. He continued to show his work in New York, in regular solo exhibitions at the Betty Parsons Gallery through the 1940s, and in such group shows as *Abstract Painting and Sculpture in America* at the Museum of Modern Art.

In 1950 Kamrowski's solo exhibition at the Galerie Creuze in Paris was accompanied by a brochure written by André Breton.[6] In the Surrealist tradition he found inspiration in language and literature. His solo show at the Hugo Gallery in New York in 1950 featured a series of mixed-media paintings inspired by Francis Thompson's poem *City of Dreadful Night*.[7] After meeting Buckminster Fuller in the 1950s, Kamrowski executed paintings on triangular and hexagonal panels that fitted together in geodesic domes, meant to be viewed from below. His solo exhibition at the Iolas Gallery in New York in 1959 featured a dome inspired by Edward Young's poem *Night Thoughts*.[8]

During the 1960s and 1970s Kamrowski's supports became sculptural, as he painted plywood forms with bright enamel. He shaped them as fantastic creatures, ornamenting their surfaces with studs and colored beads. The artist set up these animals to blow in the wind, and over the years, he mounted these "beaded beasts" as mobiles, whirligigs, and other kinetic sculptures, in a series he called the *Wind Menagerie*. Kamrowski

returned to printmaking in 1973 with a series of collaborative lithographs printed by Paul Stewart and Steve Murakishi. Occasionally over the next eight years he produced other gestural lithographs. In 1983 a retrospective exhibition of his work was mounted at the University of Michigan Museum of Art, and the artist retired from teaching the following year.[9] Today Kamrowski lives in Ann Arbor, and concentrates on sculpture and mosaic murals.

The present print is one of two intaglios that Kamrowski made at the University of Michigan, soon after his arrival in 1946. Among his new colleagues on the faculty was the printmaking instructor Alexander "Joe" Mastro-Valerio, who convinced the artist to work on a pair of small plates in spare moments between classes. The intaglios are similar in their scale and imagery to the artist's contemporaneous drawings. An eerie gray light seems to illuminate the present print, as sun- or star-shine filters through swaying leaves or palm fronds. The treelike form on the left is balanced on the right by the body of a circular creature with a toothy pair of jaws and a scorpion's sting. This organism seems to swell and burst in the middle like a pomegranate, revealing its innards of noded spiral ganglia. Perhaps this is transparent, like a single-celled microorganism grown to the size of a tree. Such ambiguous scale and form typifies the artist's imagery, in which the astronomical merges with the meteorological, and the botanical with the biomorphic.

A prolific draftsman, Kamrowski worked in watercolor, gouache, and pastel, and employed such experimental techniques as rubbing, blotting, drawing with candle smoke, spattering ink, and blowing through a straw to push the liquid across the paper. His linear intaglios seem austere compared to his complex drawings, reflecting his elementary grasp of the medium, but their compositions are deceivingly intricate. In this print the artist instinctively explored capabilities of drypoint for suggesting color, tone, and layering. He laid down scribbled enveloping passages, and concentrated bundled lines to drypoint burr. His two intaglios were experiments, and just one or two trial proofs were pulled from each. Kamrowski could not afford to edition these prints, and even if he had, there was no market for them. In 1996, at the request of the artist's New York dealer, Joan Washburn, the two plates were reprinted in small editions by Jennifer Melby in Brooklyn, on Bodleian Handmade paper.[10]

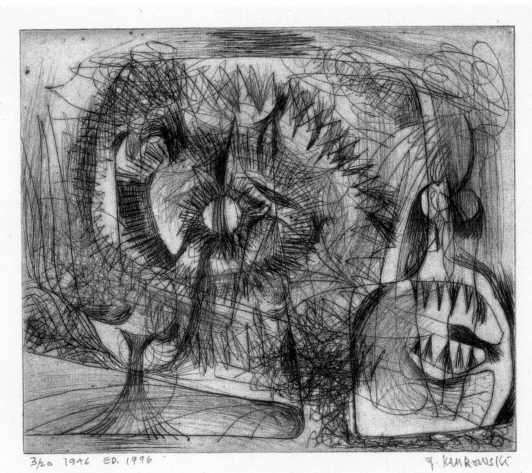

3/20 1946 ED. 1996 Gf. KAMROWSKI

PETER BUSA

1914–1985

8. Constellation, 1946

Screenprint on cream laid paper
28.4 x 35.2 cm (image)
31.8 x 48.3 cm (sheet)
Inscribed: in screen, l.r.: *Busa*; in graphite within
 image, l.l.: *Constellation*
Embossed: in dotted concentric circles, l.r.: *ESTATE
 OF PETER BUSA 1986/ COMMONWEALTH ★
 U.S.A ★ OF MASSACHUSETTS*
Worcester Art Museum, Thomas Hovey Gage Fund,
 1998.151

Over the course of a long career, Peter Busa con-
cerned himself with the concepts and forms of
Abstract Expressionism. In the early 1940s he
experimented with Abstract Surrealism, and later
he sought a fresh approach to abstraction in the
art of tribal cultures in the Indian Space Painting
movement.

Busa was born in Pittsburgh on June 23, 1914,
the son of Italian immigrants.[1] His father was a
decorative painter and gilder, trained in Sicily, who
worked in the Pittsburgh cathedral and other area
churches, banks, and theaters. At age twelve he
began taking Saturday morning art classes at the
Carnegie Institute of Technology. Four years later
he entered the school's degree program, to study
with Raymond Simboli and Alexander Kostellow,
who introduced him to Cubism. After Kostellow
moved to New York in 1933, Busa followed him. At
the Art Students League, Busa studied painting
with Thomas Hart Benton. In printmaking classes
taught by Harry Sternberg, he learned the basic
printmaking processes. He also began a friendship
with the printmaker Will Barnet, and some of
Busa's student etchings resemble Barnet's con-
temporaneous prints.[2] He became proficient in a
variety of techniques, and throughout his career
he often returned with ease to printmaking. Busa's
chief interest was in Cubism and abstraction, and
he found inspiration in the works of Fernand Léger
and Picasso. In 1936 Busa transferred to the Hans
Hofmann School on Fifty-seventh Street and in
Provincetown on Cape Cod during the summer. In
1936 he joined the FAP/WPA, working first in the
graphic arts division and later in the mural paint-
ing division.

Around 1940, at a party at the Tenth Street loft
of Francis Lee, Busa met Roberto Matta, the
Chilean-born painter who had worked and exhib-
ited in Paris with the Surrealists. He joined a group
of young Americans — including William Baziotes,
Gerome Kamrowski, Jackson Pollock, and Robert
Motherwell — who periodically gathered at Matta's
studio to discuss their work and explore the con-
cepts and practices of Surrealism. He was most
stimulated by Matta's notions of Automatism, and

his grasp of the physicality of paint itself.[3] In 1943
Busa married, began a family, and joined the faculty
of Cooper Union. His Abstract Surrealist watercol-
ors, gouaches, and oil paintings appeared in group
exhibitions at Peggy Guggenheim's Art of This
Century Gallery, which led to his first solo exhibi-
tion there in March 1946.[4]

At that time Busa shifted to flat, simplified
imagery suggested by Native American art. Along
with Barnet, Steve Wheeler, and other friends, he
studied ethnographic objects in New York muse-
ums. His work was featured in the group exhibition
Semiology, or 8 and a Totem Pole, organized by
Kenneth Beaudoin for the Gallery Neuf in New York,
the definitive show for the Indian Space Painting
movement.[5] He was particularly influenced by the
melding of figure and ground and parallel tele-
scoping of time, and the metamorphosis of people,
animals, and spirits. The artist's solo exhibition in
1948 at the Bertha Schaefer Gallery in New York
featured his paintings in the Indian Space style.
From 1949 to 1953 the artist taught at New York
University.

In 1953 Busa bought a house in Provincetown,
where he cofounded Gallery 256, and later worked
each summer. From 1954 to 1957 he taught at the
State University of New York in Buffalo, and there
he occasionally made prints, including a series of
abstract lithographs.[6] In 1959 he opened his own
summer school at Day's Lumberyard in Province-
town. At that time his style progressed to gestural
abstractions, with broad strokes of paint from
heavy impasto to spatters and drips of wash. The
artist translated these painterly effects in his print
Tidal (fig. 1) of about 1960.[7] His range of tech-
niques creates subtle interplays of light and depth.
He dredged diluted tusche over the stone in thin
layers and employed passages of resist and *peau
de crapaud*.

In 1961 Busa began teaching at the University
of Minnesota in Minneapolis, where a solo exhibi-
tion of his paintings was mounted at the Walker
Art Gallery.[8] From this point his paintings evolved
toward greater simplicity, and he acknowledged
the work of Tony Smith and Barnett Newman for
plotting their direction. These austere, geometric
works were included in his solo exhibition at the
Tweed Gallery at the University of Minnesota in
Duluth in 1965. In the early 1970s Busa returned to
printmaking and executed fifteen editions of large,
hard-edge color screenprints. In contrast to the
spontaneously wrought prints of his middle matu-
rity, the composition and palette of these works
were carefully planned. In 1973 Busa designed an
enormous abstract mural for the southwest exte-
rior wall of the Valspar Paint factory in Minnea-
polis.[9] For these murals, as well as his canvases,
Busa continued to seek harmonious compositions

Figure 1. *Tidal*, about 1960.

made of the simplest possible components, a goal
that he had been refining since his work was first
influenced by American Indian art. In 1977 the
artist's Guggenheim Fellowship allowed him to
travel to Italy. After retiring from teaching in 1982,
Busa settled in East Hampton, Long Island. He con-
tinued to paint, and to exhibit actively up to his
death in September 1985.

The present print is based on Busa's water-
color *Transfigured Night* of 1946, which is exactly
the same size, and so close in its design that it
may have been conceived as a maquette for the
silkscreen.[10] After calculating color separations,
and transferring the designs to the printing
screens, Busa used the resist or washout method
to prepare his stencils. For the last screens of
Constellation, printed in pink and white, he drew
on the fabric screen with a crayon to create a stip-
pled line on the silk.

This composition is unusual among Busa's
works of the mid-1940s for its narrative subject. A
tryst takes place beneath a dark night sky, and the
pale greens and salmon pink suggest brighter hues
perceived in darkness. The figures are defined by
white lines in circumscribing loops, and their four
limbs extend in dancelike movement. Their anato-
mies explode in expressive motion, and the
woman's eyes join the arc of stars hovering above
her head. Her heavenward glance seems to sug-
gest a moment of conception, shown literally in the
diagrammatic coupling of their lower bodies. The
zygotal form in the lower center of the composition
is poetically echoed by the angular butterfly that
passes from the hand of one figure to the other.
The movement of energy from right to left is
marked by this butterfly's path and fluttering
movement, which are wonderfully captured as its
beating wings seem transfigured. As it flies toward
the left, its trajectory is marked by the female's
eyes, and it then becomes the arms of the stars
above in the night sky. The largest star in this con-
stellation, which the woman seems to grasp in her
right hand, may also be read as an infant, the pro-
duct of this magical union. It is possible that Busa
created this image as a celebration of the antici-
pated arrival of his son, Christopher, born in 1946.

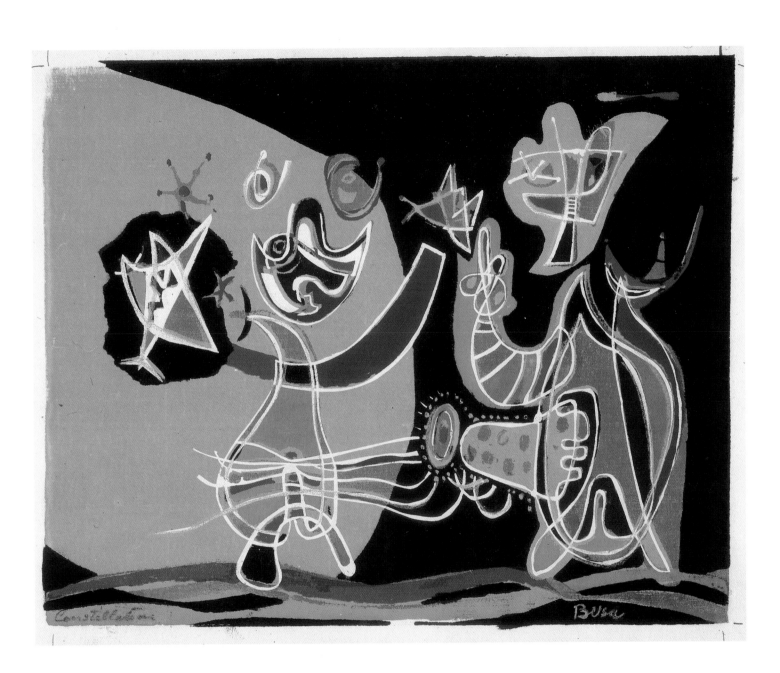

Constellation BUSA

JULIETTE STEELE

1909–1980

9. The Deacon's Shay, 1946

Lithograph on cream wove paper, 4/20
24.2 x 34.0 cm (image)
35.0 x 43.4 cm (sheet)
Inscribed: in graphite beneath image:
 "The Deacon's Shay" 4/20 Juliette Steele '46
Watermark: *WARREN'S OLDE STYLE*
Worcester Art Museum, 1996.12.12

Little is known about the life of this Californian painter and printmaker, who made remarkable Abstract Surrealist lithographs and intaglios in the mid-1940s. She created some of the most sophisticated prints of her time, which anticipate the distinctive innovation of Bay Area Abstract Expressionism.

Juliette Eleanor Wilm was born on July 21, 1909, in Union City, New Jersey, the daughter of a German immigrant father and an American mother.[1] She began her art studies in New York at the Traphagen School of Design in the late 1920s. In New York she married Edward Steele, an Englishman, and moved with him to northern California.[2] She continued her studies at San Francisco State College, and received a bachelor's degree. Steele's earliest prints date from the mid-1930s. These crayon lithographs depict views of life in San Francisco and such local landmarks as Fisherman's Wharf, Chinatown, Play Land, and the Golden Gate Bridge. The naïve style of these works contradicts their technical sophistication, suggesting that they may have been created for the FAP/WPA and printed by Ray Bertrand in San Francisco. The prints in this extensive series are inscribed as editions of fifty impressions, more, it would seem, than the artist would have produced during the Depression. In the late 1930s Steele concentrated on painting and progressed to a Modernist style derived from Matisse and Picasso. The artist began to exhibit her work in group shows throughout the region, including those of the San Francisco Art Association, the San Francisco Society of Women Artists, and the Laguna Beach Art Association.

Steele studied in the graduate program at Stanford University, and she received a master's degree in about 1944, while also attending the California School of Fine Arts (CSFA). She was a student there in summer 1945 when Douglas MacAgy became director, and shifted the school's focus to contemporary art. Steele apparently took lithography courses from Bertrand, and her prints reflect a new interest in Abstract Surrealism, probably in response to the teaching of Clay Spohn.[3] In Paris in the mid-1920s, Spohn had met Marcel Duchamp, Stanley William Hayter, and other Surrealists, and began making sculptures from found materials. When he taught at the CSFA from 1945 to 1950, Spohn created witty assemblages from found materials, notably the *Museum of Unknown and Little-Known Objects,* installed in a studio there. An inspiring teacher, he characterized the creative process as adventure and encouraged students to find inspiration in unusual places.

Steele's prints of the mid-1940s are dreamlike abstract visions, with organic shapes adrift in ambiguous space. The artist exhibited these prints in the annual drawing and print exhibitions of the San Francisco Art Association in 1946, and they garnered prizes from the San Francisco Women Artists in 1946 and 1947. Steele's first solo exhibition was at the Artists' Guild Gallery in San Francisco in 1947, and the following year a show of her prints was presented at the Weyhe Gallery in New York.

In summer 1948 Steele studied with Hayter at the CSFA and learned the techniques of intaglio printmaking. She began producing abstract color prints that are quite sophisticated in their combination of aquatint and soft-ground etching. The following academic year Steele herself taught printmaking at the CSFA, instructing students in both lithography and intaglio. When her lithograph *Bridal Veil* won a prize at the Montclair Art Museum in New Jersey and appeared in *Print Collector's Quarterly*, its progressive style stood out dramatically from the other, conventional prints.[4] A solo exhibition of Steele's paintings and prints was shown at the Kharouba Gallery in Seattle in 1949. She was president of the San Francisco Society of Women Artists in 1949–50, and later served as a juror for the San Francisco Art Association annual exhibition.[5] Around that time Steele moved to Marin, north of San Francisco. Although she continued to exhibit her work locally, by the mid-1950s, she had drifted from her artistic career. When her husband opened Steele's Patio Shop in Marin, she was recorded as a company officer. During that period the Steeles raised their family of three sons. In 1958 they lived in Corte Madera,[6] and afterward they built a house overlooking the ocean in Marin. Steele died at Marin County Hospital on March 4, 1980.

The present print exemplifies how Steele was influenced by Abstract Surrealism and how expressive her new voice rapidly became. The artist gave very concrete titles to her abstractions, presumably indicating the source of her inspiration. This image was suggested by the poem "The Deacon's Masterpiece, or The Wonderful One-Hoss Shay," by Oliver Wendell Holmes. The famous verse tells the story of a deacon who in 1755 had a carriage made from the finest materials so that it would last. The shay did not break or gradually wear out, and it long outlasted the deacon himself. Then, one hundred years after the very hour of its completion, the carriage suddenly disintegrated:

You see, of course, if you're not a dunce,
How it went to pieces all at once,
All at once, and nothing at first,
Just as bubbles do when they burst.[7]

This hallowed parable describes a moment when the concrete world fell into chaos, and Steele depicted a realm even more muddled and peculiar. She began by creating a dreamlike, incoherent setting, faceting space with varying shades of gray. The artist selectively masked areas of the design while atomizing tiny specks of liquid tusche over the stone with a sprayer or from the flicked bristles of a toothbrush. Into this paradox she drew forms and figures with a soft, rich crayon. In the center of the composition are the remains of the carriage and its canopy, surrounding four spoked wheels, and stray nuts and bolts. On either side of the ruin are insectlike figures, made of clamshell shapes fixed to spiraling backbones. On the right, distinguished by his spidery hands, is the parson who inherited the deacon's shay; he is still tethered to his hippocampus by a harness of linked chains or dashed lines. To differentiate forms and create varied textures, Steele used many different drawing techniques, wiping, smearing, and spattering tusche on the stone. She also scraped ink from the stone to highlight or model a form with hatching, or to create a peculiar effect, as in the furry chain in the lower left. This textural repertoire mirrors Holmes's twenty lines of verse listing the materials from which the Deacon's shay was constructed.

In Steele's design each component form is tied to the others with tension rods that imply synchronous movement, like that of a whirligig. A common feature of her designs, these linking lines are reminiscent of the twisted wire of Clay Spohn's assemblages. Steele's transformation of a concrete image into such an otherworldly realm of fragmented impression and associations recalls Spohn's direction to students: "The elements of art are similar to the elements of matter," he wrote. "All the artist has to do is discover them and rearrange them into concoctions according to his own formulae, creating new and powerful magic."[8]

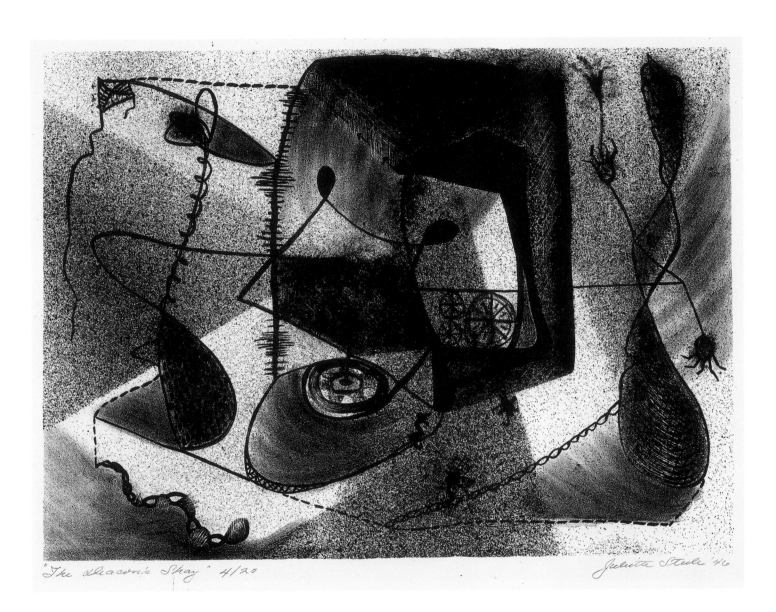

"The Deacon's Shay" 4/20 Juliette Steele '46

NELL BLAINE

1922–1996

10. Tropical Formation, 1947

Soft-ground etching on cream wove paper
22.6 x 14.8 cm (plate)
25.4 x 17.8 cm (sheet)
Inscribed: in graphite, below platemark, l.r.:
NBlaine 1947; on verso, in pen and blue ink,
u.r.: *"TROPICAL FORMATION"*; in pen and blue
ink on gummed label, affixed to verso: *Copy
#1./ Etching on ~~copper~~/ zinc.$5.00/ NBlaine/
128 W. 21st*
References: Blaine estate no. 02201
Estate of the artist

During the late 1940s Nell Blaine's gaiety and
charisma brought an enthusiasm for life to the
New York School. At that time her work was deeply
influenced by the concepts of creative spontaneity
and improvisation.

Blaine was born in Richmond, Virginia, on July
10, 1922; her mother was a former schoolteacher,
and her father a lumber inspector.[1] She was born
with severe strabismus, and five corrective surg-
eries during childhood improved her eyesight,
bringing new experiences of light and color. As a
teenager Blaine took a correspondence course
that taught her the rudiments of design and a
detailed, illustrative style. Afterward she sold her
designs to the *Richmond Times-Dispatch* for publi-
cation on the children's page.

In 1938 Blaine won a scholarship to the Rich-
mond Professional Institute (now Virginia Common-
wealth University), where her most influential
teacher was Worden Day,[2] who introduced her to
abstraction and encouraged her to continue her
studies in New York with Hans Hofmann. A fellow-
ship from the Virginia Museum of Fine Arts in
Richmond enabled Blaine to move to Manhattan in
1942. She eagerly absorbed Hofmann's theories
and practices. Her fellow student Leland Bell intro-
duced her to the paintings of Piet Mondrian and
Jean Arp and to jazz. Blaine came to love this
music, regularly attended performances and
befriended many musicians. Among them was
Robert Bass, with whom she shared a whirlwind
romance that culminated in a City Hall wedding in
1943. Their Twenty-first Street loft became a hive
of creativity, where jam-session performances and
recorded bebop provided constant inspiration for
abstract painting. Blaine's artist friends mingled
with Bass's circle of musicians, including the saxo-
phonist Larry Rivers and Jack Freilicher, whose
wife, Jane, later turned to painting. Blaine's
abstract painting of the mid-1940s derived its
rhythmic structure and improvisational process
from jazz.[3]

Blaine was the youngest member of the Ameri-
can Abstract Artists group, and her paintings were
featured in its annual exhibition in 1945. Among
them was *Great White Creature*, painted on the
back of an eight-foot theater placard, which com-
bines the spontaneity of Abstract Surrealism with
a linear biomorphism. Blaine joined the Jane Street
Gallery, one of the earliest artists' cooperatives in
New York, and her first solo exhibition was
mounted there in October 1945. In 1946, the artist
studied intaglio printmaking at Atelier 17 with a
second fellowship from the Virginia Museum of
Fine Arts. The following year, the museum pre-
sented a solo exhibition of her abstract paintings.
After the annulment of her marriage in 1948
Blaine's painting style began to shift from geome-
try toward painterly representation. Her work fea-
tures decorative patterns and figural references
derived from Henri Matisse; others have the free-
dom and tactile interest of the paintings of Willem
de Kooning. She frequently attended The Club and
maintained friendships with many Abstract Expres-
sionist painters, but she cherished an allegiance to
European Modernism.

In 1950, Blaine went to Paris where she met
Rivers, and she studied French painting during a
six-month stay. The artist visited the Atelier
Fernand Léger, attended the Saturday soirées of
Jean Hélion, whose work led her back to the figure,
and began drawing outdoors. After returning to
New York, Blaine began to show her paintings at
the Tibor de Nagy Gallery. Her solo exhibition there
in 1953 featured Légeresque paintings from Paris.[4]
Her collaboration with poet Kenneth Koch was one
of the first gallery publications, promoted by the
director John Bernard Myers. Blaine designed the
thin volume and contributed nine linocuts, in
styles tracing her development from nonobjective
geometry to figurative expression. One of the earli-
est in the book is the linocut *Abstraction*, designed
in 1947 (fig. 1). Its style is parallel to that of her
paintings inspired by Mondrian and jazz.[5]

In the 1950s Blaine worked in a style that com-
bined painterly gesture with representation, and
she painted still lifes, interiors, and landscape,
striving to translate natural light into pictorial illu-
sion. Her growing popularity was reflected by fea-
tures in such national magazines as *Life* and
Artnews.[6] In 1959 Blaine traveled to Italy, Egypt,
Turkey, and Greece, where she hoped to find an
economical place to work. She settled on the
island of Mykonos in May, and responded to the
particular light and atmosphere of the place. In
September Blaine was stricken with spinal-bulbar
polio and was transported back to New York. In the
polio unit at Mount Sinai Hospital, Blaine was
confined to an iron lung for five months.[7] Although
she regained partial use of her arms and torso, she
remained paralyzed from the waist down. As she
gradually regained her strength, she began to

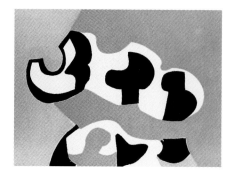

Figure 1. *Abstraction*, from *nell blaine prints/kenneth
koch poems*, 1947.

draw again but her right arm was paralyzed and
she had to learn to paint with her left hand. Blaine
moved to a large apartment on Riverside Drive
adapted to suit her wheelchair. She returned to
work and travel, touring Europe and living in Saint
Lucia in the British West Indies in 1964. In the mid-
1970s Blaine bought a house in Gloucester, Massa-
chusetts, where she spent part of every year. She
produced etchings in the 1980s at Robert Black-
burn's Printmaking Workshop in New York, and in
the 1990s at James Stroud's Center Street Studio.
Blaine died in New York, on November 14, 1996.

This etching is one of Blaine's first prints, dis-
covered in the artist's files after her death. It is one
of six small intaglios made at Atelier 17, which are
elementary in their technique and similar in
imagery to Blaine's paintings of the day. Their com-
ponent forms are outlined by both straight and
curved lines, giving them an organic rather than a
geometric character. In her canvases the artist
picked out these forms in carefully balanced colors
that separate figure from ground, creating sensa-
tions of movement, spatial projection, and reces-
sion. To create similar spatial effects in her early
intaglio prints, Blaine used roughly scribbled
hatching and stippling to approximate shadows,
pushing adjacent forms forward. At the workshop,
Blaine spread the waxy ground over the zinc
plates, placed a sheet of paper on top, and drew
her design with a pencil. When she removed the
paper, the soft-ground adhered to the paper,
pulling away from the metal. The artist flooded the
plate with acid, dissolving the exposed metal and
etching her drawn lines as furrows into the sur-
face. The printed lines reflect all the energy and
nuance of Blaine's drawing. The artist experi-
mented with this basic technique, and her inscrip-
tions show that she tried different tools to draw
her images to create different qualities of line.

This is one of the simpler images among
Blaine's Atelier 17 prints, the only piece among the
group that she titled and prepared for sale or exhi-
bition.[8] Parallel hatching, both simple and com-
plex, create an accented cadence of syncopated
rhythm. By contrast the single curving lines seem
melodic. Together their complexity creates a har-
monious whole. Though the present impression is
inscribed *Copy #1*, it seems unlikely that the artist
printed an edition.

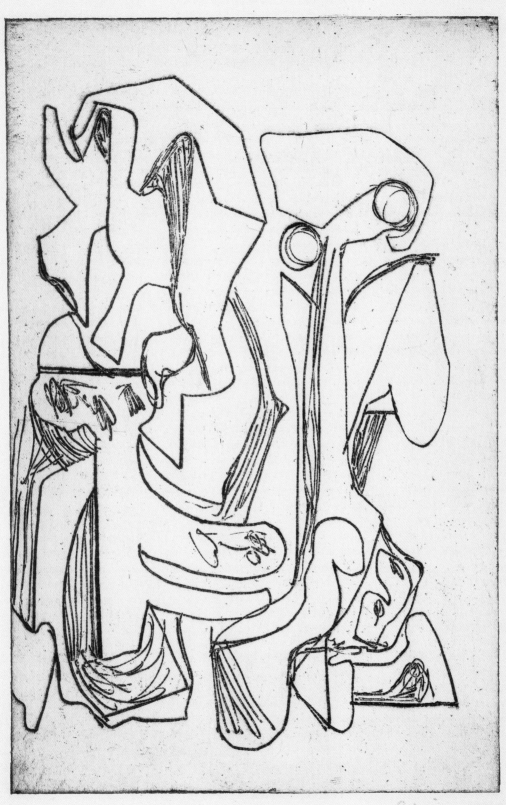

NORMAN LEWIS

1909–1979

11. Untitled, 1947

Lithograph on cream wove paper, 3/37
28.5 x 16.0 cm (image)
33.2 x 25.8 cm (sheet)
Inscribed: in graphite, below image:
 NORMAN LEWIS | 3-10-47 3/37
Worcester Art Museum, Sarah C. Garver Fund,
 1996.17

As Norman Lewis developed his personal Abstract Expressionist style during the 1940s, the painter drew from jazz. Recognizing this music as great African American art, he translated the energy of its rhythms, tonalities, and colors into visual imagery.

Lewis was born on July 23, 1909, in New York, the son of immigrants from Bermuda.[1] He grew up in Harlem, where his mother worked as a baker and a seamstress, while his father was a foreman on the Brooklyn docks. His talent became apparent when he was a teenager, and he studied drawing and commercial design at New York Vocational High School. After graduation, Lewis worked odd jobs, and sailed to South America in the merchant marine. From 1933 to 1935 he studied at Columbia University and began painting classes at the Savage Studio of Arts and Crafts. Lewis joined the 306 Group, a circle of Black artists who met regularly to share models and ideas. The artist worked in the fashionable Social Realist style during the 1930s, depicting urban life. Like many of his Harlem colleagues, he studied African art and strove to meld its influences with Realist imagery. He also explored European Modernism, encouraged by his acquaintance with Vaclav Vytlacil, the Modernist painter who taught at the Art Students League.

When Augusta Savage lobbied the FAP/WPA to include African Americans, Lewis was one of the first Black artists accepted into the project. There Lewis met Adolph Gottlieb, Jackson Pollock, and David Smith. In 1935 he was a founding member of the Harlem Artists Guild, where he first exhibited his work. The guild secured federal funding that made possible the Harlem Community Art Center, a facility that provided studio space, materials, and instruction to neighborhood residents. In 1937 the WPA assigned Riva Helfond to teach lithography at the center, and among her first students were Lewis and Robert Blackburn.[2] The artist's early crayon lithographs reflect the Social Realist style and imagery of his paintings. The artist continued to produce these prints at the center occasionally

until about 1943, and the later stones among them reveal the influence of Modernism on his style. In the late 1930s he taught at the Harlem Art Center, the Savage Studio, and PS 139. His work was included in the inaugural exhibition of the Salon of Contemporary Negro Art on West 125th Street. In 1938 the artist went to Greensboro, North Carolina, with a commission from the WPA to set up an art center and teach there. However, after an encounter with racism he returned to New York. During World War II he moved to Vancouver for a time, to take a defense job at the Kaiser Shipyard, but the racial discrimination he experienced shortened his stay. In the early 1940s he made semiabstract lithographs in which expressive manipulation of the figure and geometrized compositions derived from musical rhythms.[3]

In 1946 Lewis taught at the Washington Carver School in New York and then at the alternative Thomas Jefferson School of Social Science. At that time he experimented with a more fluent personal abstraction that combined spontaneous drawing in a manner analogous to jazz improvisation practiced by musicians who were his friends, such as Charlie Parker and Bud Powell.[4] In 1946 Lewis began to show his work at the Willard Gallery, where his first solo exhibition was mounted three years later. He attended the Friday evening meetings of Studio 35 in 1949, and continued his participation as this group evolved into The Club. "Out of this came . . . Abstract Expressionism, which I think was something beautiful," Lewis later recalled. "And I mention this, because they got together and talked about art like musicians talk about music."[5] Spontaneous inspiration and personal expression characterized Lewis's work in the 1950s, when his paintings were included in such prestigious group exhibitions as *Abstract Painting and Sculpture in America* at the Museum of Modern Art in 1951 and *American Artists Paint the City* at the Art Institute of Chicago in 1956, which represented the United States at the Venice Biennale.

In 1963 Lewis was a founding member of Spiral, a group of African American artists who came together to show concern for the Civil Rights movement.[6] When William Majors joined the group, he shared his expertise as an intaglio printmaker with fellow members, and in the mid-1960s he helped Lewis to etch and print several experimental plates.[7] Along with Romare Bearden and Ernest Crichlow, Lewis helped to found the Cinque Gallery, conceived as a showcase for emerging minority artists. The artist began teaching at the Art Students League in New York in 1972.

Occasionally during the 1970s he made intaglio prints derived from his drawings and paintings that were not editioned or published. In 1976 a retrospective of his work was presented at the Graduate School and University Center of the City College of New York.[8] Lewis died in New York, on August 27, 1979.

The present print is related in its technique and scale to Lewis's early lithographs, made at the Harlem Community Art Center, and in its imagery it parallels his improvisational drawings of the late 1940s. These abstract drawings range broadly in their use of line, and some are referred to as the "little figures" for their spiral doodles that often suggest the bodies of musicians or dancers. Like a musician performing different melodies, Lewis experimented with varied linear vocabularies. Some employ only straight lines and acute angles, others use ellipses, spirals, and whorls. Some of the linear designs are simple and brief, others are exceedingly complex. Most of them share repeated motifs and patterns arranged in cadent groupings. The artist experimented with the visual equivalent of a melodic line.

In the calligraphic design of this print Lewis repeated handlike motifs, many with five appendages tipped with ellipses. By varying the position and placement of these shapes, he evokes bodies moving through space to music, and suggests a more involved choreography. The forms also evoke the nimble movements of musicians' hands, like a complicated bebop trill performed by a horn player or pianist. Most of the image is based on a continuous line, also approximating the performance of a virtuoso soloist. However, in many places shapes are defined by three or four imbricated lines, like musical chords. The lithograph was printed from a small stone, the shape of which is partially embossed in the paper. The loopy calligraphic twists and spirals of Lewis's design seem to have been drawn on the printing surface in liquid tusche applied with a broadnibbed pen or brush. The lines are a uniform saturated black, but they have a peculiar, halting quality. Close examination reveals that they were carefully traced over pale, grainy lines that seem more flowing and spontaneous than the printed line. This suggests that, in processing the stone, the lithographic printer etched too long or used a chemical solution too strong. When his first, improvisatory drawing on the stone began to disappear, it seems that the artist traced it to preserve the design.

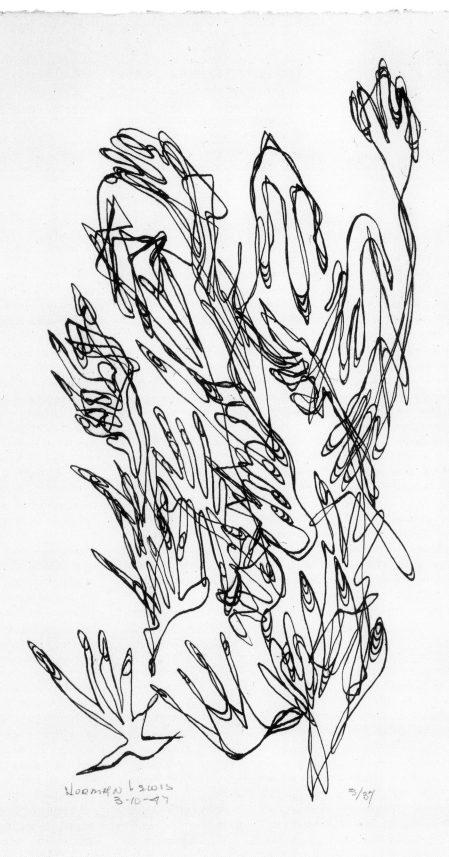

Norman Lewis
3-10-77

3/37

HANS BURKHARDT

1904–1994

12. After the Bomb, or Last Sunset of Humanity, or Destruction, 1948

Lithograph on cream wove paper, 3/6
24.7 x 36.3 cm (image)
30.8 x 42.8 cm (sheet)
Inscribed: in graphite, below image:
 3/6 H. Burkhardt 1948
Embossed: l.l.: printer's chop, *LK*; l.r.: artist's chop,
 ■ *HB* ■
References: Adams 1983, p.162.
Worcester Art Museum, 1997.171

Through much of his long career Hans Burkhardt made prints in an evolving style parallel to that of his painting. His work often reflected personal reactions to the moral dilemmas of human society and politics.

Burkhardt was born on December 20, 1904, in Basel, Switzerland.[1] When he was three years old his father abandoned the family, and his mother struggled to support her three children, working as a laundress. After her death from tuberculosis in 1910, Burkhardt and his sisters went to a municipal orphanage, where they endured deprivation and cruelty. On a class trip to the Basel Kunstmuseum in 1918, he first found solace in art. In 1924 he sailed to New York, where he was reunited with his father, a cabinetmaker for the furniture manufacturer Schmeig & Company. Burkhardt began working there too, painting period decoration on furniture. Diligent and ambitious, he took evening courses at Cooper Union, and in 1928 he attended a painting class at the Grand Central School of Art taught by Arshile Gorky. Recognizing his talent, and perhaps feeling empathy for the immigrant orphan, Gorky became his mentor and welcomed Burkhardt to his studio for private tutorials. There the young artist first learned about European Modernism by observing Gorky's studies of avant-garde painting. Burkhardt became a foreman at Schmeig & Company, and his relative prosperity during the Depression enabled him to help support Gorky.

In 1937 Burkhardt moved to California and established his own furniture refinishing business in Los Angeles. He continued to paint in a personal Abstract Surrealist style, and met Lorser Feitelson who arranged his first solo exhibition at the Stendahl Gallery in Los Angeles in 1939. He bought land in Laurel Canyon, where he built his own cliffside house and studio. During World War II Burkhardt worked in an airplane parts factory, and afterward he became a set painter at the Metro-Goldwyn-Mayer movie studios. In 1950 he gave away his business and moved to Mexico. Living in Zapopan and Guadalajara, he concentrated on paintings inspired by village life and nature. The artist's reflections on his mentor's suicide were manifested in the series of paintings, including *The Burial of Gorky*, which was included in the exhibition *American Painting Today* at the Metropolitan Museum of Art.[2] In Mexico, Burkhardt produced a handful of experimental lithographs from 1950 to 1953 that combine Modernist style with subjects inspired by the Mexican muralist painters. Through the 1950s the artist divided his time between Guadalajara and Los Angeles.

During the 1960s Burkhardt developed a distinguished teaching career, serving on the faculties of the University of Southern California, the University of California at Los Angeles, and the California State University at Northridge. In 1961 a retrospective exhibition of works from over thirty years was mounted at the Santa Barbara Museum, and in the following year another survey show appeared at the Los Angeles Municipal Art Galleries.[3] In 1964 Burkhardt returned to Europe for the first time since his emigration. He lived for a year in Basel, where he developed a friendship with Mark Tobey. In years to come he would visit his hometown for a month each summer.

Burkhardt returned to printmaking in 1965 with the direction of Tom Fricano, who taught printmaking at Northridge. The artist produced a series of experimental etchings that represent Gorkiesque biomorphic abstractions. In 1966, to express his moral outrage over the war in Vietnam, he produced powerful paintings, slathering large canvases with thick layers of dark impasto and affixing the fragments of real human skulls.[4] Burkhardt bought an etching press in 1969, but soon became frustrated by the technical complexities of intaglio. He began to make linocuts, selectively inking his printing blocks in many colors and printing them in one pass through the press. He used household chemicals to etch and build up the printing surface. In 1972 a retrospective exhibition of Burkhardt's paintings was shown at the Long Beach Museum of Art. In the late 1970s the artist made more prints than paintings, including a series of linocuts illustrating Ray Bradbury's poem, *Man Dead? The God Is Slain*, and other books.[5] Inspired by youth demonstrations and street paintings, the linocut *Graffiti, Basel* (fig. 1) exemplifies the strength of Burkhardt's late prints, which often feature gestural imagery.[6] Amid veils of iridescent color the artist printed swirls and drips from the etched linoleum. Black arabesques evoke a rhapsodic rhythm but also evoke the swirls of barbed wire. Burkhardt remained active until his death in Los Angeles on April 22, 1994.[7]

One of Burkhardt's first prints, *After the Bomb* is from a group of lithographs that reflects his per-

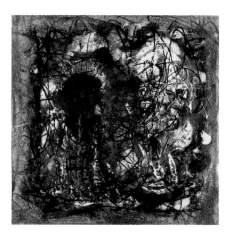

Figure 1. *Graffiti, Basel*, 1983.

sonal adaptation of Abstract Surrealism. It also exemplifies his social conscience and antiwar convictions, enduring impulses in his art. In 1947 Burkhardt began a collaboration with Lynton Kistler, the only printer in Southern California then working with artists.[8] The printer welcomed Burkhardt to the crowded workshop in his home on Third Street in Los Angeles, and invited him to draw his image on a small stone using crayon and liquid tusche. Burkhardt adapted a composition that he had used before, in paintings such as *One Way Road*, now in the Los Angeles County Museum of Art.[9] That canvas features a straight road receding into the distance toward a setting sun on the high horizon. The road is flanked by fields of dried plants, whose stalks and husks transmogrify into insect monsters. On the lithography stone, Burkhardt explored the varied visual effects of crayon and tusche, completing his drawing by scraping fine details in the ink with a knife point or etching needle to create keen white lines. Kistler pulled an edition of about six impressions and one or two artist's proofs. Some impressions were printed on red paper, which was appropriate to this image of devastation.

Burkhardt was haunted by the atomic destruction of Hiroshima and Nagasaki, and created a nightmare vision of the final destruction of mankind. Pointed angular and crescent forms suggest the jagged concrete fragments and twisted metal of demolished buildings, or the shards of crushed bone and torn flesh. Some of the jutting forms pierced by round holes drip dark liquid, evoking bleeding bullet holes. Similarly, the central form resembles a human skull, stained with drips of ink that suggest blood. Thus, the image foreshadows Burkhardt's most famous works, the antiwar paintings of the 1960s. The faceted distortion of this form helps to draw the viewer's eye into the distance, where the entire scene is dimly illuminated by a setting sun, just visible at the right on the high horizon. It casts its fading glow on mangled, more organic forms, which suggest blasted tree trunks and charred corpses with reaching arms, so mutilated that they have become indistinguishable.

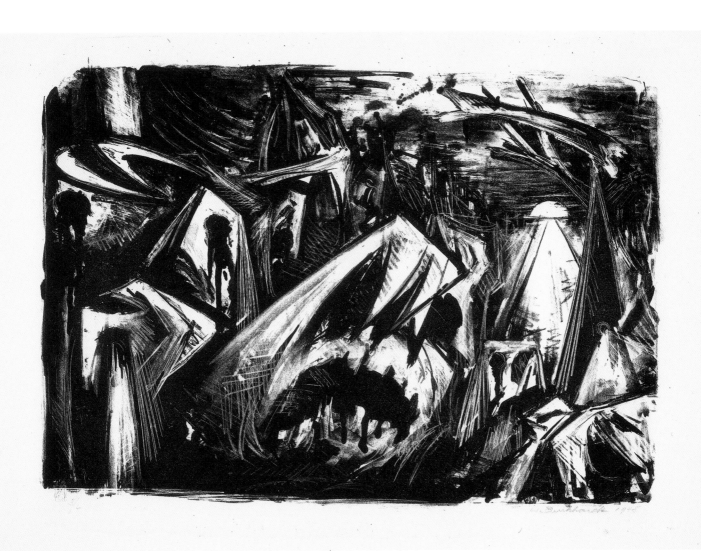

FRANK LOBDELL

1921–

13. Untitled, 1948

Lithograph on cream wove paper, 1/12
37.6 x 27.7 cm (image)
48.8 x 32.0 cm (sheet)
Inscribed: in graphite, below image:
 1/12 1948 F. Lobdell
Watermark: *WARREN'S OLDE STYLE*
Worcester Art Museum, gift of Frank Lobdell,
 Paula Z. Kirkeby, and Phillip Kirkeby, 1992.93

A pioneer of Abstract Expressionism in the Bay
Area, Frank Lobdell has made prints consistently
throughout his career. Major exhibitions of his
work have included prints along with his paintings.
These works reveal the evolution of his moody,
introspective style, and a constant sensitivity to a
wide range of media.

Lobdell was born on August 23, 1921 in Kansas
City, Missouri.[1] As a child he moved to Minneapolis,
where his father ran a small advertising agency.
At age seventeen he enrolled at the Saint Paul
School of Fine Arts in Minnesota, where he studied
with the Regionalist painter Cameron Booth, but
found inspiration in the work of Vincent van Gogh.
He began a friendship with his fellow student
Walter Kuhlman, and in 1940 they drove together
to Chicago to see the Picasso exhibition at the
Art Institute. This revelatory experience impelled
his independent painting experiments in the next
two years.

From 1942 to 1946 Lobdell served in the Army,
and fought in Germany as a lieutenant in the
infantry. After his discharge in San Francisco in
1947, he enrolled at the California School of Fine
Arts (CSFA) as a GI Bill student. Impressed by
Clyfford Still's retrospective exhibition at the
Palace of the Legion of Honor in 1947, he turned
away from the lyrical influence of Paul Klee to look
inward for inspiration, and his horrific experiences
of war began to shape his art.[2] Lobdell created
large, brooding canvases segmented by snaky
lines, often in bilious or bloody hues. He associ-
ated with the group of artists at the CSFA known as
the Sausalito Six,[3] and his works appeared in their
group exhibitions in 1948 at the Seashore Gallery,
the Contemporary Gallery, and the Schillerhaus in
Sausalito, and at Reed College in Portland, Oregon.
Lobdell's connection with Eric Ledin provided
access to the offset lithography press on which the
group printed their portfolio *Drawings* in 1948.[4] He
also provided designs for a book of offset litho-
graphs that combined his visceral images with
poems by Kenneth Sawyer.[5]

In 1950 Lobdell moved to Paris, where he
briefly attended studios at the Académie de la
Grande Chaumière and the Académie Colarossi.
Impervious to contemporary and historical Euro-
pean painting, however, he continued to develop
the style he began in San Francisco. Kuhlman
joined him in Paris in 1951, and the paintings they
exhibited in the *Sixième Salon des Réalitiés
Nouvelles* at the Petit Palais were picked out for
ridicule by French critics. Lobdell returned to the
Bay Area, where during the 1950s he did a series
of paintings in charred blacks and ashen whites,
featuring twisted figural forms, which developed
into a personal vocabulary. In 1957 the artist
began teaching at the CSFA. His first solo exhibi-
tion in New York was mounted at the Martha
Jackson Gallery in 1960. Soon his paintings fea-
tured heavily outlined, Picassoesque body parts,
swirling independently about the composition. The
artist transformed his memories of war into arrest-
ing images that convey a sense of vulnerability and
the threat of enclosure and torture.

The year following his residency at Stanford
University in 1965, Lobdell joined the faculty. A
solo exhibition of his paintings and prints was
mounted at the Pasadena Art Museum in 1966,[6]
and that year he had an artist's fellowship at the
Tamarind Lithography Workshop in Los Angeles as
well.[7] The artist used a sequence of lithographs to
develop an image, as he normally did in drawings,
and most of his thirty-two Tamarind prints are
experimental compositions leading to a large hori-
zontal lithograph printed on two sheets. Then the
artist transferred this imagery to canvas in his
painting *Summer 1967: In Memory of James Budd
Dixon*.[8] In 1969 a solo exhibition of Lobdell's paint-
ings and lithographs was shown at the San Fran-
cisco Museum of Art.[9] During the 1970s and 1980s
his style became less referential and brighter in
key, as he looked to African sculpture, Celtic inter-
lace, Islamic pattern, and other sources from the
history of world art, but his paintings always
remain highly emotional and deeply personal. A
solo exhibition of his paintings and monotypes
was mounted at the San Francisco Museum of
Modern Art in 1983.[10] During that period Lobdell
often returned to printmaking, in collaborative edi-
tions with Joseph Zirker, 3EP Ltd., and David Kelso.
In 1988 the artist won an award for distinguished
achievement in painting from the American Aca-
demy of Arts and Letters. In 1991 Lobdell retired
from teaching, and two years later a retrospective
exhibition of his work was mounted at Stanford
University.[11] The artist still lives in the Bay Area,

and in addition to painting and drawing, his print-
making activities have become focused on intaglio.

The present print is one from a group of litho-
graphs made at the CSFA, when several artists of
the Sausalito Six began experimenting with the
traditional techniques of lithography from stone.
Ray Bertrand taught them the fundamentals of the
process, but for the most part their experiments
were unguided and naïve. Their inexperience led to
misadventure when the press was adjusted too
tightly, and the stone popped out from under the
scraper bar, off the bed of the press and onto the
floor, breaking in half.[12] Using the smaller frag-
ment, Lobdell masked the broken edge and began
a design that evolved into a poster-announcement
for the artists' upcoming exhibition at the Seashore
Gallery in Sausalito. He physically carved his image
into the printing surface, and they pulled about
ninety impressions, a large edition at that time.[13]

Lobdell used the other section of the broken
lithography stone for his subsequent experiments,
including the present print. He masked a straight
edge along the left and printed to the other three
edges of the stone. Like Budd Dixon and Edward
Dugmore, the artist explored the tonal delicacies
of lithography by drawing and painting on the
stone, then manipulated the image by scraping,
rubbing, and blending ink on the printing surface.
He printed six different images, counteretching
between small editions, so that each successive
composition evolved from the ghostly image
printed before it. In this print Lobdell combined
liquid tusche and scribbled lithographic crayon;
he scraped ink away from the printing surface to
create highlights, rubbing the edges of forms to
soften transitions.

The image is similar to that of Lobdell's con-
temporaneous paintings, where wormy lines
emerge from ambiguous, dark, wet passages. Here
the lines create a vaguely symmetrical pattern, like
a halved fruit, while in others they more clearly
resemble coiled intestines and other internal
organs. These images grew out of the artist's trau-
matic wartime experiences, his visual memories,
and recurring dreams. The artist allowed accident
and his imperfect understanding of the materials
of lithography to guide his creative process.
Lobdell's forms emerge from clouds of scumbles
and scratches, which enhance the organic quality
of the image, and capture the dingy reality of
human existence.

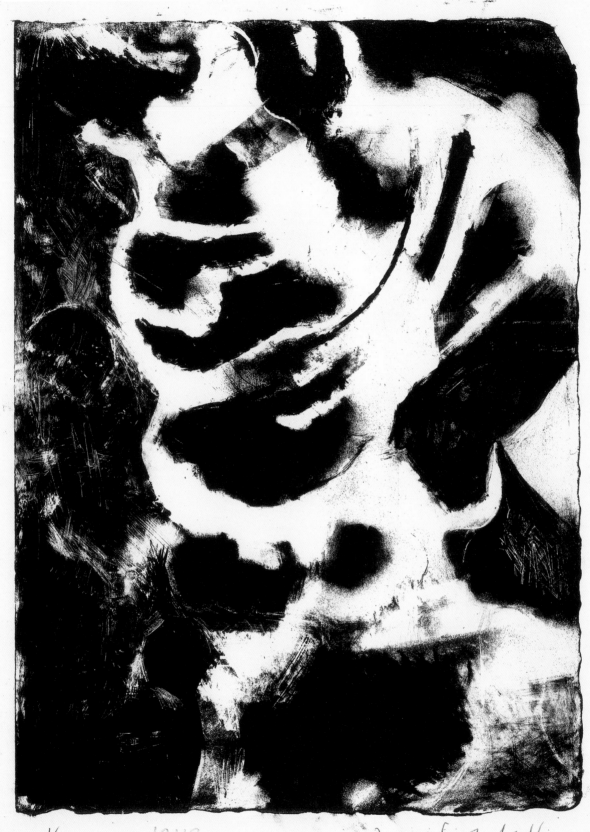

1/12 1948 7. Lordell

JOSEPH MEERT

1905–1989

14. Dancing Demons, about 1948

Woodcut on cream Japan paper, 3/12
27.5 x 24.4 cm (image)
30.7 x 30.0 cm (sheet)
Inscribed: in graphite, below image:
 3/12 "Dancing Demons" Joseph Meert
Worcester Art Museum, 1996.12.9

The gentle, sensitive Joseph Meert was fiercely dedicated and uncompromising in his art. In the 1940s and 1950s he transferred his explorations as an Abstract Expressionist painter to other media, including printmaking.

Meert was born in Brussels, Belgium, on April 28, 1905, the son of a railroad mechanic.[1] When he was five years old his family emigrated to the United States, and settled in Kansas City, Missouri. There his childhood fascination with trainyard sign painters awakened an artistic talent. In 1923 Meert won a scholarship to the Kansas City Art Institute, where he studied with Adolph Blondheim and Anthony Angarola. In 1926 another fellowship enabled him to attend the Art Students League in New York, where he joined the circle of young artists around Thomas Hart Benton, including Herman Cherry, Bernard Steffen, Charles and Jackson Pollock. In spring 1932 he traveled to California, where he studied with Benton's friend Stanton Macdonald-Wright. During the Depression he tenaciously continued to paint, supporting himself with a job as an elevator operator.

In spring 1935, when Benton became director of the Kansas City Art Institute (KCAI), he took along Meert to be his assistant. At that time the artist concentrated on Regionalist-style representational paintings, and made his first lithographs in the style. His first solo exhibition was mounted at the Colorado Springs Fine Arts Center in 1936.[2] When Benton left the school in 1938, Meert remained on the faculty. At that time he painted murals in the post offices of Marceline and Mount Vernon, Missouri. Meert's tempera painting *Evening in Autumn* was featured in the exhibition *American Art Today* at the New York World's Fair in 1939, purchased afterwards by the KCAI.

Meert resigned from the KCAI in 1941 and returned to New York. His wife, the artist Margaret Mullin, taught at the Traphagen School of Fashion, enabling him to reevaluate his career and artistic direction. He renewed his association with friends from the League, and began to experiment with abstraction. He took a part-time job at Creative Printmakers, a commercial silkscreen shop staffed by former FAP artists, including his friends Steffen and Pollock.[3] He also joined the Silk Screen Group, the New York artists' club where members shared screenprinting equipment and expertise, as well as

opportunities for exhibition in the Serigraph Gallery. During World War II, Meert worked in a gear-cutting factory, while continuing to paint Cubist-influenced representations and gestural abstractions. His work was included in the Whitney Museum annual exhibition in 1944. The artist's first solo exhibition in New York, mounted at the Artists' Gallery early in 1949, featured abstract paintings in which rectilinear forms suggest the illusionistic spaces of interiors or landscapes.[4]

Meert's interest in color led him to the study of colored light and stained glass. He learned the rudiments of the medium from Steve Babolcsay of the Astoria Stained Glass Studio, and then began to create new visual effects in glass.[5] He used a kiln to fire multicolored shards of crushed glass, fusing them into mottled sheets that were then leaded together with solid-colored panes (fig. 1).[6] Meert also melted ribbons and screens of copper into his composite sheets of glass, adding strength and pattern. This process exploited happenstance to create mottled passages of color that were similar to chance painterly effects. He sought to capture the immediacy and energy of improvisation that he practiced in his painting. Meert's canvases took on a new translucent glow and surface richness. In 1957 his stained glass windows were featured in the exhibition *The Patron Church* at the Museum of Contemporary Crafts in New York.[7] In 1964 the artist won a Tiffany Foundation grant for his work in stained glass.

In 1967, after his wife's retirement, Meert moved upstate to Lanesville, New York, in the Catskills. He continued to work in the solitude of the country, supported by an award from the Mark Rothko Foundation in 1971. In the late 1970s, when Mullin's health declined, the artist abruptly stopped working to care for her. An ambitious suite of canvases, *The Four Seasons*, remained unfinished in his studio when medical and financial problems prompted him and his wife to move to a nursing home in Staatsburg, New York in 1979. When Mullin died in 1980, Meert began a desperate struggle against depression. When his funds expired, he became a ward of the state, and was moved to a care facility in Hyde Park. His emotional frailty was misdiagnosed as mental illness, and he was overmedicated. Then, in 1983, while researching his book on Pollock, the author Jeffrey Potter interviewed Meert and was dismayed by his predicament.[8] He arranged for the artist to be moved to an appropriate facility, and one of the first grants from the Pollock-Krasner Foundation made it possible for him to receive art therapy. Meert died at Saint Mary's Hospital in Waterbury, Connecticut, on December 31, 1989.[9]

A print from the height of Meert's involvement with Abstract Expressionism, *Dancing Demons* is

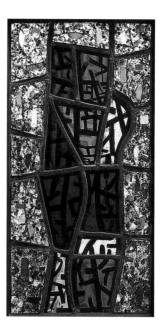

Figure 1. *Untitled*, about 1950.

intriguing for its ambiguity. Its immediate effect is one of movement and energy. A cyclonic swirl rotates around the perimeter of the composition, pulling along irregular bands of orange, yellow, and black that seem to ebb and distort in the windstream. These forms never assume substance, but wraithlike figural references appear in silhouetted profiles and ghostly pairs of eyes. In their hues and intangibility these forms are like flames, and they evoke the destructive, demonic nature of fire. At the center of the composition is a peculiar, illegible motif. It may be the ideographic image of a human form or an iconic talisman that calls up the changelings that swirl around it. Their dance may be enthralling or unsettling, but it is not frightening. Meert was a great lover of music, and many of his designs have a cadence or flow similar to musical rhythms or melodies.

In this print Meert cleverly used the woodcut technique to create the appearance of transparency and the sense of motion. To create the pattern that provides the foundation of the composition, he hatched the woodblock in a lacy circular pattern. This was softly printed in black and then superimposed with a translucent pale green ink. The artist may have printed both of these colors from lightly inked blocks onto dry paper, for the ink stands on the top of the sheet. By contrast, the overprinted orange, yellow, and saturated black were applied to wet paper; these inks are soaked well into the sheet and appear almost as intense on the verso of the sheet. The present print is remarkable for its use of the paper. Meert printed the edition on the long-fibered mulberry-bark paper preferred by the New York woodcut artists. In each impression the artist tore away the paper along one side of the sheet, sometimes feathering the edge well into the image. He seems to have created this effect by nipping away at the dampened sheet with his fingers. The irregular serration enhances the movement of the composition.

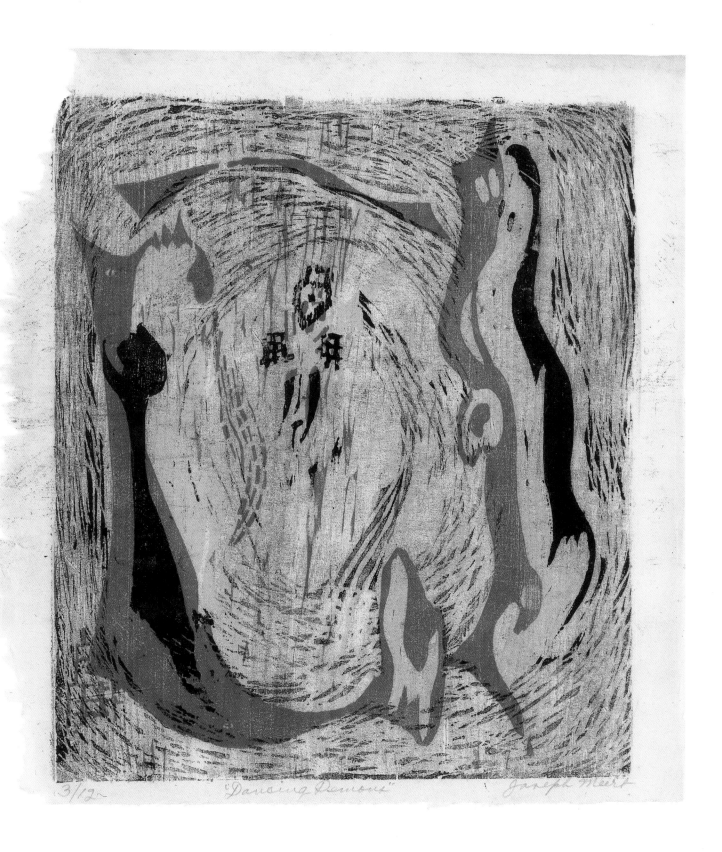

3/12 "Dancing Demons" Joseph Meert

JOHN HULTBERG

1922—

15. Untitled, from *Drawings*, 1948

Offset lithograph on cream wove paper
27.4 x 21.6 cm (image)
28.0 x 21.6 cm (sheet)
32.3 x 25.7 cm (mount)
Inscribed: in graphite, on mount, l.r.: *Hultberg*
References: Stone 1949, p.M-8; Landauer 1993,
 cat. no. 26.
Worcester Art Museum, 1990.128.8

The painter and poet John Hultberg combines gestural abstraction with Surrealist-inspired landscape. He experimented with printmaking early in his career and was among the first to use lithography to capture the spontaneous inspiration of Abstract Expressionism.

Hultberg was born on February 8, 1922, in Berkeley, California, the son of a fruit farmer.[1] He began his studies of art in high school and continued at Fresno State College, where he majored in literature. The daily journals he began at that time and kept faithfully for years to come document much of his artistic career and embody a poet's sensibilities and eloquence.[2] After completing his bachelor's degree in 1943, Hultberg enlisted in the Navy, and during World War II served as a navigator on a submarine chaser in the South Pacific, achieving the rank of lieutenant. After his discharge in 1946 Hultberg returned to the Bay Area, and the following year he enrolled as a GI Bill student at the California School of Fine Arts (CSFA), where he studied with Clay Spohn, Clyfford Still, and Mark Rothko. Soon he was experimenting with abstraction and Automatism, temporarily putting aside his interest in representation.[3] The artist's first solo exhibition was mounted in 1949 at the Contemporary Gallery in Sausalito.

Hultberg moved to New York in 1949 to study at the Art Students League, where Morris Kantor and Byron Browne were among his teachers. Illusionistic landscape soon dominated his imagery, influenced by Cubism and geometric Modernism, as well as the architectural environment of the city. He usually employed quickly painted, heavy black lines to plot a perspectival grid in his compositions, fragmenting space into tilting planes and windows that create confusing shifts of space. These images from the artist's imagination were meant to create the artifice of a stage set. Hultberg's first solo exhibition in New York was presented by the Korman Gallery in 1953. The artist spent much of 1954 in Paris, where he associated with *tachiste* painters including Alberto Burri, Antoni Tapiés, and Georges Matthieu.

However, it was the concepts of Surrealism that influenced him, as he explored ideas of the subconscious and dream imagery. In Paris, Hultberg met Martha Jackson, who presented a solo exhibition of his work in New York in 1955. In that year one of his paintings was included in the Whitney Museum annual exhibition, and he won first prize for painting at the Corcoran Biennial in Washington, D.C.[4]

With the support of a Guggenheim Fellowship, Hultberg toured Europe in 1956. During an extended visit in Paris he made several collaborative lithographs at the Atelier Desjobert. In 1958 the artist began a succession of temporary teaching positions at the Boston Museum School, the Portland Art Museum in Maine, and the Honolulu Art Academy. In early 1963 Hultberg was an artist fellow at the Tamarind Lithography Workshop in Los Angeles, where he completed twenty editions of lithographs.[5] Figures became more prominent in his painting during the 1960s, often represented in silhouette. A number of photomechanical screenprints and offset lithographs were made from photographs of Hultberg's paintings in the late 1970s; although the artist gave initial permission for these reproductions, he was not involved in their production or distribution.

In 1983 Hultberg settled in a house on Monhegan Island in Maine. A traveling retrospective exhibition of his work was organized in 1985 by Hamilton College in Clinton, New York.[6] Hultberg's landscapes became natural during the 1980s, when grids were replaced by painterly images of the northern cliffs and sea. Impressions of changing weather and the earth permeate these late paintings. In 1991 Hultberg returned to New York, where he began teaching at the Art Students League. During the 1990s the artist installed a printing press in his Tribeca studio, where he made scores of monoprints. Grants from the Pollock-Krasner Foundation and the Adolph and Esther Gottlieb Foundation supported his continued painting activities at that time. A solo exhibition of new canvases was mounted at the Denise Bibro Gallery in 1994,[7] and two years later a retrospective of his paintings appeared at the Portland Museum of Art in Maine. Today Hultberg lives in New York, where he teaches at the Art Students League and concentrates on small watercolors and paintings on paper.

One of Hultberg's first prints, this piece comes from a landmark portfolio of offset lithographs that are among the earliest in California to prove the potential of lithography for spontaneously inspired images. In about 1948 a group of artists associated with the CSFA began meeting informally in each other's studios, mostly in Sausalito. They were James Budd Dixon, Frank Lobdell, Richard Diebenkorn, George Stillman, and Walter Kuhlman, as well as Hultberg, who recalled that they all wanted to distance themselves from other artists at the school who were overly devoted to Clyfford Still.[8] They shared models and ideas, and sometimes created collaborative pen and ink drawings in impromptu "jam sessions." They exhibited together in local shows at the Schillerhaus, Seashore, and Contemporary Galleries and in exhibitions at the California College of Arts and Crafts and Reed College in Oregon. Later they came to be known as the "Sausalito Six."

One day Lobdell gave each of his colleagues paper offset lithography plates.[9] His friend Eric Ledin, who owned a radio and television business, had received an old electric Multilith offset press in lieu of a debt. Ledin set up the machine in the basement of his house in Mill Valley, and as he taught himself to operate it, his friend Lobdell drew on a few aluminum and paper plates. Then he invited his colleagues to participate. Each of the six artists drew two or three plates, which were printed in Ledin's basement over eight days. They completed seventeen prints in editions of 200 and compiled them in an album, contained in a black paper envelope with a lithographed label. The artists offered the portfolios for sale at some of their exhibitions and in the CSFA bookstore at a cost of one dollar. In the end, the proceeds were just enough to buy a case of scotch whisky and provide a rousing party.

Like his colleagues, Hultberg prepared his drawing with crayon. To isolate white forms against black, he colored-in the background. He used many formal elements — ellipses, X-shapes, and parallel bars — that characterized his imagery for years to come. Compared with the other prints in the portfolio, the edges of his forms are hard and straight, but his geometry is imprecise. Apparent crayon strokes and the mottled background give the image a raw energy and seem to set the forms adrift. Asymmetrical and unbalanced, Hultberg's compositions are meant to evoke a response of disquiet. "We can't be content with prettiness," he said, "when a feeling of turmoil seems most characteristic of our times."[10] Like all the works in the *Drawings* portfolio, this lithograph was printed on a sheet of typing paper and tipped onto a heavier paper mount, which was signed in pencil.

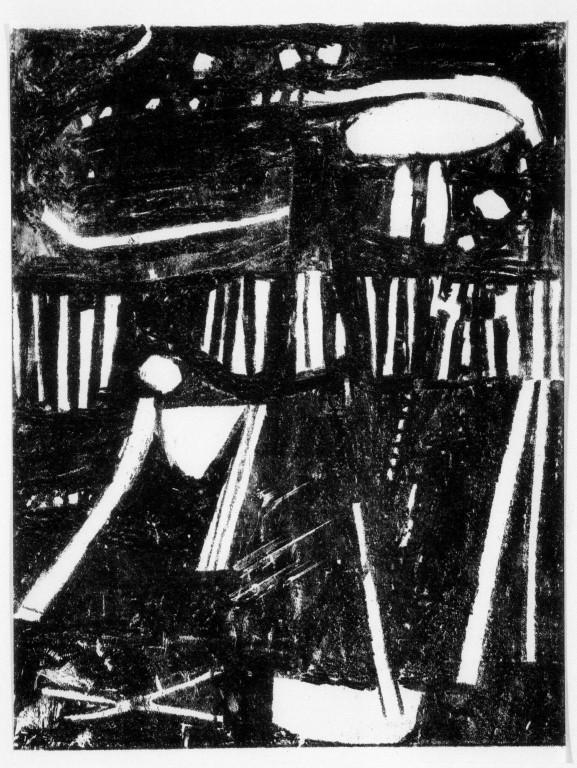

Hallberg

GEORGE STILLMAN

1921–1997

16. Untitled, 1948

Etching and aquatint on cream wove paper, 5/20
37.8 x 22.6 cm (plate)
48.6 x 32.0 cm (sheet)
Inscribed: in graphite, below platemark:
 5/20 Untitled George Stillman '48
Watermark: *WARREN'S OLDE STYLE*
Worcester Art Museum, Richard A. Heald Fund,
 1999.74

During the late 1940s, George Stillman established himself as a promising figure in Bay Area Abstract Expressionism. At that time, and occasionally over the course of his career as a photographer, painter, and teacher, he created prints that are notable for their technical experimentation.

Stillman was born on February 25, 1921, in Laramie, Wyoming, and he grew up in Ontario, California.[1] His father was a professional photographer, who taught him to use the camera and darkroom. He published his first photograph when he was twelve years old, and in 1939 he won first prize for creative photography at the Golden Gate International Exposition. Stillman attended Chaffey College in Alta Loma, California, in 1941 and continued his studies at the University of California at Berkeley, where he majored in chemistry. After one academic year he was drafted into the Army, and served as chief in the Signal Corps Photographic Unit on the East Coast. After his discharge in San Francisco in 1945, Stillman opened a commercial photography studio in Oakland. He also enrolled at the California School of Fine Arts (CSFA) as a GI Bill student and began to paint. His early figural works combined the naïve imagery, painterly style, and intense colors of Georges Rouault and Alexy von Jawlensky. Stillman made his first prints in a lithography class at the CSFA taught by Ray Bertrand. Broadly drawn in liquid tusche, they represent images of stylized cabaret performers, similar to those in his paintings. In 1947 the artist began to exhibit his work in the annual exhibition at the Palace of the Legion of Honor and in a solo exhibition at the Guild Gallery in San Francisco.

Soon Stillman moved toward abstraction in larger, darker paintings. He associated with the group of CSFA artists that came to be known as the Sausalito Six.[2] His work was included in their group exhibitions at the Schillerhaus, the North Beach Gallery, and the Seashore Gallery in Sausalito, and he contributed to their portfolio of offset lithographs, *Drawings*.[3] A turning point in Stillman's painting activity came in 1948, when he created a remarkable canvas during a forty-five-minute improvisational session at the school. The artist cast handfuls of dry pigment over a ground of wet enamel, then he applied a coat of oil paint with palette knife and brushes. When shown in the annual exhibition at the San Francisco Museum of Art, this painting won the Ann Bremer Purchase Award.[4] Stillman often painted in layers, employing unconventional materials like wallpaper paste, ammonium bichromate — a component of photo emulsion — and India ink, drawing sgraffito details through wet pigment.[5] At that time he often depicted ladder motifs, scraped away and traced in mechanical pens with tips of varying thickness. In the late 1940s Stillman also experimented with monotype. He used brayers and sponges to apply oil colors to copper plates, then printed these works in a single pass through the etching press. After printing, he often touched his monotypes with paint or India ink, adding webs of delicate lines or accents of color (fig. 1).[6]

After a year's study in Mexico in 1949, supported by the Samuel S. Bender Award, Stillman returned briefly to Berkeley, and then began teaching at the University of Guadalajara in Mexico. Solo exhibitions of his work were mounted in 1951 at the Galería Arte Moderna in Mexico City and at the Galería Camararuz in Guadalajara. In 1953 Stillman turned away from art to pursue a more lucrative career and provide for his family. Working for the United States Army, he became chief of the Reproduction Branch in Latin America and taught photolithography. From 1960 to 1966 Stillman worked in the Communications Media Office of the Department of State in Brazil and Bolivia. He published a national audiovisual magazine in Brazil, and produced technical manuals and training films on commercial printing in Bolivia.

In 1966 Stillman returned to the United States and became a producer-director at Arizona State University television in Tempe. Taking advantage of his university affiliation, he returned to his study of art, completing a bachelor's degree in 1968 and a master's degree two years later. He became a landscape painter, working in an up-to-date Neorealist style, but never returned to printmaking. In 1970 he moved to Georgia and established the art department at Columbus College. A retrospective exhibition of Stillman's work was mounted at the Columbus Museum when he left Georgia in 1972. At that time he moved to Ellensburg, to teach at Central Washington University. After retiring in 1988, Stillman continued to paint. A retrospective exhibition of his work was shown at the Sarah Spurgeon Gallery at Central Washington University in 1990, and he received a National Endowment for the Arts Fellowship.[7] Stillman died in Ellensburg on March 12, 1997.

The present print is one of a pair of experimental intaglios, comparable in size and imagery, that Stillman created at the CSFA, perhaps in conjunction with an intaglio printmaking course taught by

Figure 1. *Untitled #5*, 1949.

James Budd Dixon in 1948. Both plates feature the abstract imagery and technical exploration that characterize Stillman's work of that time. Open space at the top of the plate resembles a landscape horizon, and the oblong vertical format implies that Stillman found inspiration in Chinese scroll painting. Meaningless squiggles, ranged in vertical rows in the upper left, mimic the look of Asian calligraphy. In front of the cusped horizon, etched arcs and inverted crescents suggest complex envelopes of space and objects on a vertical hillside. Dark accents throughout draw the viewer's attention across the composition and in and out of space. They are reminiscent of the organic clumps of rich black in Chinese paintings that often evoke trees growing on mountainsides. However, Stillman's rectilinear shapes seem manmade rather than natural. The artist avoided any definition or details that could help to identify the image, forcing the viewer back to its abstraction; however, he titled its pendant *Golden Gate*, and its parabola curves become the incurved suspension cables of the bridge.[8] This relationship may indicate that the image grew from a local landscape, perhaps over the Sausalito Hills beyond the bridge that Stillman often drove over to visit his colleagues. The vertical knolls around Richmond Bay, often shrouded in ocean fog, are evocative of the Yangtze gorges and mountains.

Just as Chinese painters used their materials and tools to create visual effects distinctive to their medium, so Stillman explored the unique look of intaglio. He tested the medium's capabilities for fine, crisp lines, smoky aquatint, and rich passages of burry hatching. However, the complexity of the process had little appeal for Stillman, and he preferred the immediacy of monotype. The artist retained these two intaglio plates, and during the 1980s, it seems, he pulled editions of twenty-five from each of them. The burr and plate tone are missing from the later prints, which seem comparatively lifeless.

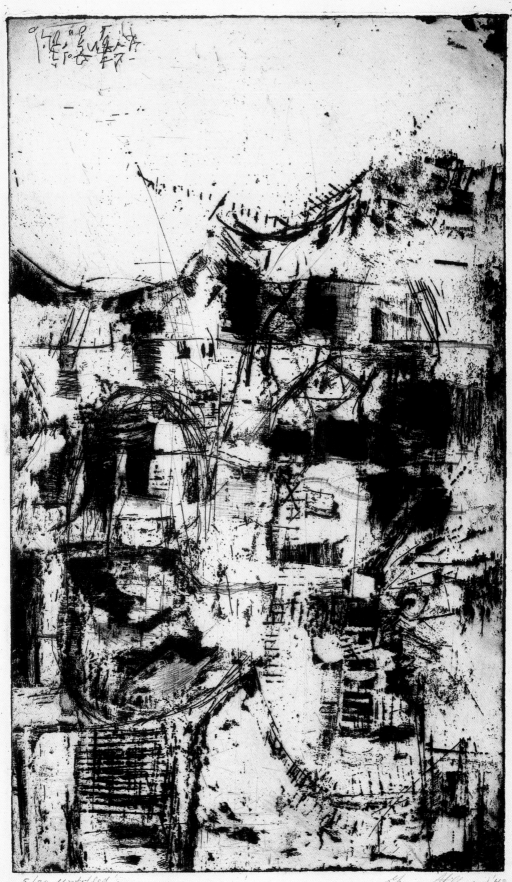

5/20 untitled. George Stillman '48

ANNE RYAN

1889–1954

17. XXXIV, 1949

Woodcut on black wove paper, 2/9
41.3 x 44.7 cm (image)
46.0 x 55.5 cm (sheet)
Inscribed: in white pencil, below image:
 XXXIV 2/9 ARyan
Worcester Art Museum, 1993.2

A poet and novelist as well as a versatile artist, Anne Ryan is best remembered today for her collages. She was an accomplished painter and printmaker who transformed the practice and ideas of Abstract Expressionism into very personal work.

Ryan was born on July 20, 1889, in Hoboken, New Jersey, the daughter of a banker who wrote poetry in his spare time.[1] After attending local parochial schools, she studied at the Academy of Saint Elizabeth near Morristown, New Jersey. Ryan majored in literature and dreamed of becoming a writer, but she left college during her junior year in 1911 to marry William J. McFadden, an attorney. They settled in Newark and began a family. However, Ryan held to her literary aspirations, and began writing poetry when her three children were still small. She also began to visit Greenwich Village and joined its literary circles. When McFadden began suffering from progressive emotional illness, Ryan's marriage became troubled, and in 1923 she legally separated from her husband. Her first book of poetry, *Lost Hills*, was published in 1925, and her novel *Raquel* appeared the following year. She also published a biography, short stories, essays, and criticism, but always found it a struggle to support her family as an author.[2] In 1931 she moved with her children to Majorca, where living was inexpensive and the solitude conducive to work. When she took her children on vacation in Paris and visited several museums, she found a new enthusiasm for the visual arts.

After returning to New York in 1933, Ryan developed friendships with the sculptor Tony Smith and the painter Hans Hofmann, who recognized and encouraged her artistic talents. In 1941 her first solo exhibition, at Rose Fried's Pinacotheca Gallery, included both representational and abstract paintings.[3] Though Ryan continued to earn her living as a writer, she progressively gave more time to her art, exploring different media. She designed ballet costumes and stage sets, decorated ceramic tiles, and learned to make intaglio prints in classes at Atelier 17. Among her first prints, made in 1941, were landscape etchings, figure studies, and symbolic Abstract Surrealist images of constellations.[4]

In 1945 Ryan learned the techniques of color woodcut in a class at Atelier 17 taught by Louis Schanker. She joined his Vanguard group of experimental printmakers, and her prints were featured in their exhibition at the Brooklyn Museum in 1946. That same year, solo shows of Ryan's color woodcuts were presented by the Eli Marquié Gallery in New York and the Philadelphia Art Alliance. Her prints also appeared in the prestigious Brooklyn Museum print national exhibition, where her woodcut *Fantasia* won a purchase prize.[5] Over a period of about four years Ryan made nearly a hundred color woodcuts, working simultaneously in abstraction and in a Modernist representational style for still lifes, mythological, religious, and circus subjects.

In 1948 Ryan was captivated by an exhibition of collages by Kurt Schwitters.[6] She began to make her own paper collages, using an array of found materials, like postage stamps, photographs, printed scraps, and special handmade papers from her friend, the papermaker Douglass Howell. Restrained geometric compositions characterize her early collages, which are no larger than a book page. Ryan first exhibited her collages in 1949 at the Kharouba Gallery in Portland, Oregon; they also complemented her paintings in a solo show at the Betty Parsons Gallery in New York in 1950.

Gradually Ryan turned from painting and printmaking to concentrate most of her artistic activity on collage. She began using scraps of cloth and soon came to prefer fabrics for her collages. Friends saved old cloth for the artist, and she found materials in thrift shops. She collected a wide variety of cloth scraps, in varied textures, dyed and printed colors, and patterns. Ryan favored a pale, delicate palette, and sometimes she faded and softened her materials by repeated washing or sun-bleaching. When her friends suggested that she increase their scale, she created several as large as easel paintings, which reflect the influence of Abstract Expressionist imagery. Some feature lengths of thread affixed to the surface, with eccentric curls that resemble the arabesque of an automatist brush line. She often created several pieces in a single day, and in about six years the artist made about four hundred collages. Ryan died suddenly from a stroke on April 17, 1954, in Morristown, New Jersey.

The present print is one of Ryan's last color woodcuts, created in November 1949 under the influence of her own collages and paintings. The artist used a single woodblock, repeatedly inked and overprinted with several hues, instead of the customary practice of employing a separate matrix for each color.[7] The simple, economical process required no printing press or specialized equipment. Ryan used inexpensive plywood or pine for her printing blocks. Usually she plotted a simple linear design on the surface of the block, then she carved away the drawn lines in deep grooves. The artist probably also used the traditional method of tacking her paper to the edge of the block to ensure registration. She applied oil paint to the printing surface, confining each hue to a flat cell isolated by grooves, so that the colors could not mix. Then, folding the paper over the charged printing surface, she printed by hand, rubbing the back of the paper with her palm. By lifting the sheet, reinking the block and printing again, she superimposed several layers of color and produced one complete impression at a time.

Ryan preferred to print on black paper. A grid of flattened folds visible on the verso of this sheet reveals that the black paper was once used to package photographic printing paper, protecting the sensitized sheets from the light. A friend who was a photographer saved these tissuelike leaves, which the thrifty artist recycled. She ironed the papers to flatten them before printing, creating a mottled burnished surface. Ryan used oil paints for printing ink, which did not soak far into the hard, calendered paper and thus retained their rich, undiluted hues. Rather than aiming for identical multiples, the artist seems to have allowed the creation of one impression to prompt the experimental direction of the next.

The primary impact of this image is one of shimmering hue enlivened by movement. Ryan achieved this iridescence by superimposing thin layers of color. Her methods for inking and printing were active and improvisational. She applied paint to the block with small rollers, sometimes extending the pigment into translucent films before printing. The artist also used a rag to blot small areas of blue, red, and orange onto the printing surface; under the pressure of printing, these passages became soft and emphemeral. Finally, Ryan touched the print itself with accents of yellow and pink with a cloth or sponge. She juxtaposed shiny surfaces with matte passages, and the varied surface qualities are similar to the effects she achieved in her paintings and collages.

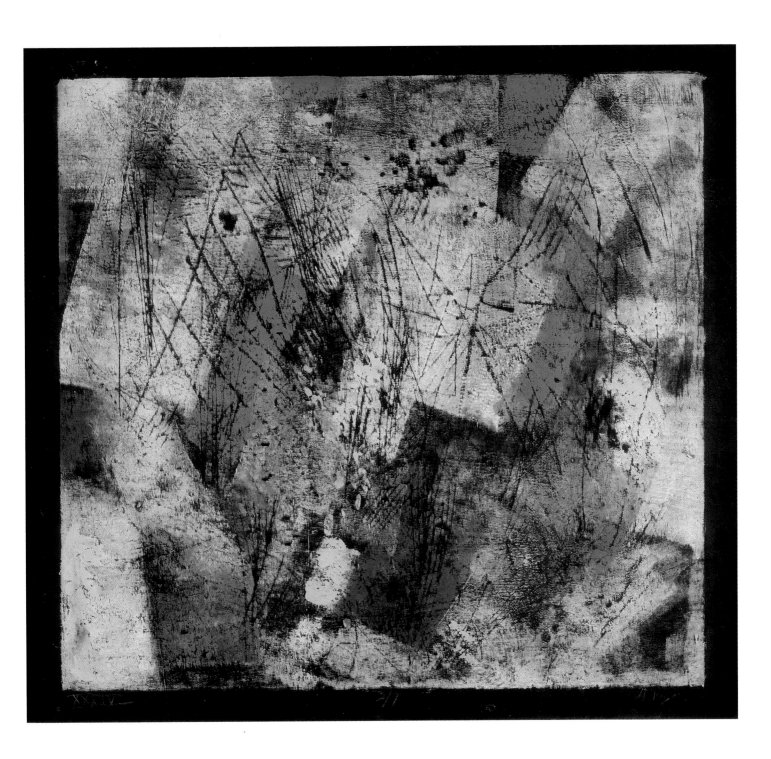

LOUISE BOURGEOIS

1911–

18. Ascension lente (Slow Ascent), or Le Grand Flottant (The Large Floating Form), or The Disappearance of the Mother,

1949

Soft-ground etching, engraving, and drypoint, with
pochoir on cream wove paper
22.2 x 17.6 cm (plate)
47.4 x 33.0 cm (sheet)
Inscribed: in black ink, below platemark:
ascension lente. L. Bourgeois. 49
References: Wye/Smith 1994, no. 53 xii, pp.120–22.
Worcester Art Museum, Stoddard Acquisition
Fund, 1998.183

One of the century's leading American sculptors, Louise Bourgeois is also a prolific printmaker. In the late 1940s, when Abstract Expressionism was evolving apace around her, she reflected this development in her experimental prints.

Bourgeois was born in Paris on December 25, 1911.[1] Both of her parents were artisans, who shared a successful business selling and restoring tapestries. In 1912 the family moved to a house in Choisy-le-Roi, but they kept their Paris apartment, where Bourgeois lived when she attended secondary school at the Lycée Fénelon. As a child she contributed to the family business, creating working drawings for her parents' weaving projects. In 1918 her mother became gravely ill with the Spanish flu, and remained frail thereafter, and her autocratic father brought his mistress into the household. The adolescent years were difficult for her. The emotional issues of human relationships and sexual politics that Bourgeois was forced to confront as a teenager would reappear as subjects of her art in years to come. In 1932 Bourgeois attended the Sorbonne in Paris, where she first studied mathematics before switching to art. She began a course at the École des Beaux-Arts but became discouraged by its academic rigors. Bourgeois also studied at the Académie Ranson, the Académie Julian, the Académie Colarossi, and the Académie de la Grande Chaumière in succession. She began to exhibit her work in the mid-1930s and worked in the studio of the Modernist painter Fernand Léger.

Bourgeois married the American art historian Robert Goldwater in 1938, and moved with him to New York to begin raising a family. She enrolled at the Art Students League and studied painting with Vaclav Vytlacil. In 1939 she began to experiment with printmaking on her own, and two years later she took printmaking courses from Will Barnet at the League. In 1941 Bourgeois made her first sculptures in wood. These are slender wooden poles, fixed upright and subtly shaped to suggest human figures, which symbolize the friends she left in France.[2] During World War II Bourgeois also helped to welcome European artists who found exile in New York. Her first solo exhibition in New York, at the Bertha Schaefer Gallery in summer 1945, comprised twelve paintings.[3]

In 1946 Bourgeois began to make prints at Atelier 17. At the workshop she made friends with artists such as Le Corbusier, Joan Miró, Yves Tanguy, and Nemencio Antunez. The artist learned advanced intaglio techniques and executed the series He Disappeared into Complete Silence.[4] It includes nine engravings and a prose parable, written by the artist, that tells a story in loosely constructed anecdotes from contemporary life. She became a United States citizen in 1951, the year the Museum of Modern Art in New York purchased her sculpture Sleeping Figure. Around 1960 the artist sculpted spheroid and teardrop forms in plaster that resemble the nests of insects or animals, with small holes for access, the first in an extended series of works described as Lairs. In the mid-1960s Bourgeois taught at Brooklyn College; it was the first of many varied teaching appointments. In 1967 the artist traveled to Italy to work in the marble quarries at Pietransanta. Over the next five years, she periodically returned there to carve, and to select marble for her sculptures.

After her husband died in early 1973, Bourgeois concentrated even more on her artistic career, as her work gained wider recognition.[5] She returned to printmaking at that time, producing a handful of intaglios and experimenting with new techniques, like rubbings from her lead relief sculptures, photogravure, and photolithography. Bourgeois was now able to utilize professional printers and publishers in the United States and in France, which made it possible for her to produce a steady stream of prints. From 1974 to 1977 she taught printmaking at the School of the Visual Arts in New York. The first traveling retrospective exhibition of Bourgeois's work was organized by the Museum of Modern Art in New York in 1982.[6] Among her many graphic arts projects of the period was the book Homely Girl: A Life, written by Arthur Miller, and illustrated with nineteen drypoints by Bourgeois, and eight images appropriated from medical photographs of human eyes. In summer 1994 an exhibition featuring a selection of Bourgeois's work

from the previous ten years was shown at the Brooklyn Museum. That autumn, the Museum of Modern Art in New York presented a retrospective exhibition of her prints.[7]

The title of the present print refers to Bourgeois's creative search, her gradual progress through technical obstacles, and continually evolving layers of meaning. She found its image in the process of its creation, and in the physical properties of her tools and materials; the present impression represents the twelfth of fourteen states of the printing plate.[8] Ascension lente was made at Atelier 17 in New York, and Bourgeois employed some of the workshop's most innovative techniques. She deeply gouged the plate with a scorper to create embossed accents, and she printed transparent colors from the surface of the plate.[9] Inking and printing the plate in color was a complex operation. First the artist applied black etching ink to the engraved passages and carefully wiped the plate surface. Then, using two paper stencils cut from earlier printed proofs, she applied pink and green inks to the plate surface. Perhaps using a cotton swab, she cleaned pigment from the carved hollows that embossed relief accents. Finally, all the colors were printed simultaneously when the plate was passed once through the press.

On an impression of an early state, Bourgeois inscribed the alternate title The Disappearance of the Mother, and her other comments about the print demonstrate that she conceived this as a symbolic image. This composition features forms, motifs, and textures that recur in Bourgeois's sketchbook drawings of the time. She often drew lozenge or teardrop forms, shaded with parallel striations, which suggest dimension, and a rough sculptural surface. The effect is biomorphic, sometimes suggesting the twisted fibers of sinew, an animal's coat of fur, or the rough bark of a tree. It seems that Bourgeois conceived the compound ovoid form as an insect egg case, or the abandoned nest of a reptile or bird. This shape is located in space by the colored background, which suggests a canted horizon, implying that the nest form hovers above the ground, tangled perhaps in branches suggested by the bracketing treelike motifs.[10] Bourgeois observed "this has to do with security . . . the security of the nest that does not have to stand on the floor. It is safer to be above."[11] A symbol for maternal protection, the nestlike shape also expresses the dangers of childhood. Parental responsibility and the act of nurturing were recurrent themes for the artist, and they appear in her work up to the present day.

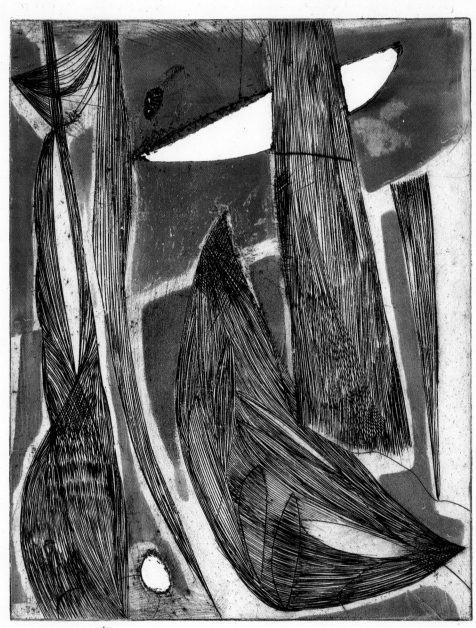

ascension lente. L. Bourgeois. 49

EDWARD DUGMORE

1915–1996

19. Untitled, 1949

Lithograph on cream wove paper
41.0 x 30.0 cm (image)
49.3 x 37.7 cm (sheet)
Inscribed: in graphite, below image: *Dugmore '49*
Watermark: *WARREN'S OLDE STYLE*
References: Landauer 1993, p.21.
Worcester Art Museum, Thomas Hovey Gage Fund,
 1994.231

The art of Edward Dugmore is characterized by a tenacious commitment to the ideas and imagery of Abstract Expressionism along with a search for the self through personal expression. "The painter," he once observed, "is really a philosopher with a brush."[1]

Dugmore was born on February 20, 1915, in Hartford, Connecticut, where he grew up.[2] At age nineteen he won a scholarship to the Hartford Art School, where the traditional curriculum was based on a foundation of life drawing. He also studied the painting techniques of the old masters, and throughout his career he ground his own pigments and mixed oil glazes. In Hartford Dugmore encountered Surrealism; in 1936 he assisted Eugene Berman on sets for the Hartford Festival. In summer 1941 he attended the Kansas City Art Institute, where he studied painting with Thomas Hart Benton. There he made his first prints, and learned the basic techniques of lithography in a class taught by John De Martelley.

During World War II Dugmore served in the Marine Corps. He moved to New York after his discharge and resumed painting. From 1946 to 1948 he taught at Saint Joseph's College in West Hartford. Dugmore was deeply impressed by Clyfford Still's solo exhibition at the Betty Parsons Gallery, and when he heard that the painter was teaching in San Francisco, he drove across the country to enroll at the California School of Fine Arts (CSFA) as a GI Bill student. He was one of about fifteen students in Still's graduate seminar — the precursor of the Subjects of the Artist in New York — for which the artists shared an exclusive common studio to promote constant interchange. Dugmore began a lifelong friendship with Ernest Briggs, who shared his devotion to uncompromising individualism.

In spring 1949, Dugmore was a founding member of the Metart Gallery, a cooperative, nonprofit exhibition space near the entrance to Chinatown in San Francisco, organized by Still's students. The gallery's name, a contraction of "metaphysical art," was meant to indicate the serious work presented there.[3] Over the course of the year, each of the twelve co-op members had the gallery for a month to mount a solo exhibition. The paintings in Dugmore's first solo exhibition, mounted at the Metart Gallery in 1950, expressed various moods through color and form. Squarish, ragged patches of solid color range across his canvases, generally along an invisible rectilinear grid. The thickness of paint varies from impasto to scrubbed washes. Dugmore's paintings have an expansive sense of space, perhaps resulting from his cross-country drive to California or from his experience of the Pacific Ocean. Their amplitude seems to extend beyond the frame into infinite space.

In 1951 Dugmore moved to Mexico, where he studied and painted at the University of Guadalajara. His works reflect the terrain, colors, and textures of the Mexican desert and jungle. To capture his fleeting perceptions, the artist mindfully strove to find and express the specific characteristics of places that moved him.[4] In 1952 Dugmore returned to New York, where his first solo exhibition in Manhattan was mounted at the Stable Gallery. Briggs followed him there, and the two artists maintained their friendship and their contact with Still. In the early 1960s Dugmore exhibited his paintings in regular solo shows at the Howard Wise Gallery in New York. He was a visiting artist at the Aspen School of Contemporary Art in Colorado in 1961, and several other temporary residencies followed, including positions at the University of Southern Illinois, the Montana Institute of Fine Arts, the University of Minnesota, and the Des Moines Art Center. In 1964 he began teaching at the Pratt Institute, where he remained on the faculty for a decade. The artist was awarded a Guggenheim Fellowship in 1966.

During the 1970s Dugmore exhibited his work at the Green Mountain Gallery in Green Mountain College, New York. He taught part-time at the Maryland Institute in Baltimore, and his painting activities were supported by grants from the National Endowment for the Arts in 1976 and 1985. He moved to Minneapolis in 1993, and the following year his paintings were included in the traveling exhibition *Still Working* at the Corcoran Gallery in Washington, D.C.[5] The artist was honored with a Lifetime Achievement Award from the Pollock-Krasner Foundation the year before his death, in Minneapolis, on June 13, 1996.

Dugmore experimented with printmaking early in his career, but abandoned the graphic arts when he became devoted to the Still ideal of painting.

However, he made a few Abstract Expressionist lithographs at the CSFA in 1949, and the present print is one from that group. Several artists produced such experimental lithographs at that time, including James Budd Dixon, Frank Lobdell, Walter Kuhlman, and George Stillman. It is likely that these advanced students were drawn to the open printshop, where Ray Bertrand made available equipment and expertise without any class structure. Some, like Dixon and Lobdell, continued to explore the process afterward, while others, like Kuhlman and Dugmore, turned away from lithography. Though these artists worked with comparable equipment and materials, they discovered a range of experimental techniques and effects, and each imparted his own style and vision to his few prints. These lithographs seem to have been printed in proofs only. Commonly among the group there are signed impressions of varying tone, ranging from light to dark, as the image faded or filled in on the stone.

In the present print Dugmore combined crayon, liquid tusche, and extensive blending and scraping on the stone to create a haunting image akin to his contemporaneous paintings. In his canvases light is often the activating element, as it is in this image, executed in black ink. To soften the edges of form and create subtle effects of illumination, he scraped and blended ink on the stone; to accent dark passages he overpainted with tusche, and for highlights he scraped ink completely from the printing surface. Dugmore seldom made explicit references to nature in his paintings. Here, however, the circular form at the upper right seems to evoke the sun, defining a landscape. Reaching toward this light from tuberous forms along the bottom, the vertical motifs seem plantlike. Their stems curl toward the radiance, which dissipates the morning mist, as their leaves seems to unfurl. Whether the artist intended a natural landscape, or figures in a ritual animist dance, the image embodies energy.

Like his colleagues in 1949, Dugmore began a work of art with a concept, but no preconceived design. He discovered the image during the process of its creation. "At times when I am painting I seem to be mindless and bodiless, but everything seems normal to me," the artist wrote late in life. "Once I am functioning perfectly and the painting is what I want it to be, it seems to become itself by its own volition. . . . All that has taken place is something that I have perceived and has always been there."[6]

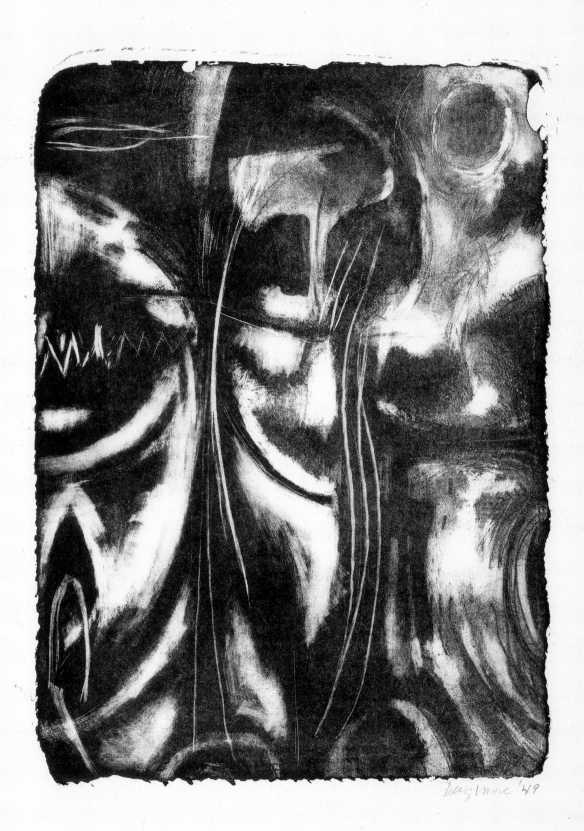

Dunsmore '49

JACOB KAINEN

1909–

20. Marine Apparition, 1949

Aquatint and drypoint on cream wove paper
22.5 x 30.2 cm (plate)
33.5 x 41.0 cm (sheet)
Inscribed: in graphite below platemark:
Marine Apparition Jacob Kainen '49
References: Flint 1980, no. 68; Graham 1987,
no. 13, p.37.
Worcester Art Museum, 1997.16

The painter Jacob Kainen has had a wide-ranging influence on the graphic arts in America, as a curator, scholar, teacher, and printmaker. Throughout his career he has made prints consistently, working in the full range of printmaking media, and in progressively evolving styles. He was one of the first to experiment with gestural imagery in his prints.

Kainen was born on December 7, 1909, in Waterbury, Connecticut, one of three sons of Russian immigrants.[1] His father, a machinist and inventor, took a job in New York and moved his family there in 1918. By the time he graduated from high school at age sixteen, Kainen had decided on a career in art. He was too young to enter a formal training program but took life-drawing classes with Abbo Ostrowsky at the Educational Alliance, a settlement house on the Lower East Side. While working as a stock boy at Brentano's bookstore, Kainen attended drawing classes at the Art Students League given by Kimon Nicoläides. He also studied life-drawing with A.J. Boganove at the New York Evening School of Industrial Art in 1926, and on Sundays he had private tutorials from Frank Leonard Allen in Brooklyn.

In 1927 Kainen entered the Pratt Institute in Brooklyn. Though printmaking was not taught at that time, he conducted is own experiments at home, scratching drypoints in aluminum plates and printing them in the wringer of his mother's washing machine. He also learned by copying old master paintings in New York museums. In 1930, just weeks before graduation, Kainen was expelled from Pratt for participating in a demonstration against a new curriculum that emphasized commercial art.[2] During the Depression he supported himself with odd jobs while he continued to paint. He made friends with many artists in the neighborhood, including Stuart Davis, John Graham, and Arshile Gorky, with whom he met in neighborhood cafeterias and visited museums and galleries.[3]

In August 1935 Kainen enrolled in the FAP/WPA.[4] Davis suggested that he join the graphic arts division where he could learn a variety of saleable skills from professional craftsmen, and though he had to turn over the prints he made on the project, the artist could keep the paintings from which his prints derived. Kainen produced the project's first two lithographs, Social Realist scenes of disaster, metaphors for society in disarray. During his seven years on the FAP/WPA, he worked in lithography, intaglio, woodcut, and even made an experimental color screenprint. Many of his prints of the 1930s derived from observation of city life, and reflect concerns of the artist's deep social conscience. Paintings made up Kainen's first solo exhibition, at the ACA Gallery in 1940.

After Kainen married and began a family, his responsibilities prompted him to accept a job as an aide in the division of graphic arts at the Smithsonian Institution in Washington, D.C. He gave printing demonstrations and assisted with the management of the national print collection. He faithfully painted in the evening in a rented studio, and made his own intaglio prints on the Smithsonian presses after office hours and on weekends. In 1946 he became curator of graphic arts at the National Museum (now the National Museum of American History). At that time he rarely exhibited his prints, but with few exception they remained representational. His canvases combined oversized gesture with spatially ambiguous forms and sensitive color.

A grant from the American Philosophical Society in 1956 supported Kainen's first trip to Europe, where he conducted research on the prints of John Baptist Jackson, the eighteenth-century English master of chiaroscuro woodcut.[5] Afterward figural references returned to his work, and in the early 1960s his considerable expertise on German Expressionist printmaking influenced his own woodcuts.[6] After leaving the National Museum, Kainen was curator of graphic arts at the Smithsonian's National Collection of Fine Arts (now the National Museum of American Art) from 1966 to 1970. During the 1970s the artist began to make collaborative prints, working in several different studios across the country and in Paris. He worked most extensively with Jack Lemon at Landfall Press in Chicago, producing colorful lithographs related to his contemporaneous canvases in their simple geometric compositions and unbroken passages of vibrant color. In 1973 Kainen began making monotypes, working on the press in his own studio. He found the technique to be satisfyingly immediate and personal. The artist's stature in American printmaking was confirmed in 1980 when a retrospective exhibition of his prints was presented at the National Museum of American Art.[7] Kainen's achievements were further celebrated during his eighth decade. In 1993 a retrospective exhibition of his paintings was presented at the National Museum of American Art, and the following year a survey of his prints appeared at the Portland Art Museum in Oregon.[8] Today Kainen lives in Chevy Chase, Maryland, where he continues to paint, to make monotypes, and to exhibit his work.

One of Kainen's earliest resolved gestural prints, *Marine Apparition* grew out of his personal, experimental paintings.[9] In 1948 the artist was painting Expressionist street scenes that progressively became more abstract. The previous summer he had visited Maine and employed this style in plein air paintings of the sea, sky, and sun. Kainen painted several abstract seascapes on site, including *Shoreline*, improvisational exercises suggested by the artist's observations.[10] After returning to Washington, he transferred this imagery to a handful of abstract prints drawn from his memory and imagination. Among this group are *Island I* and *II*, and *Marine Apparition*, which combine aquatint with drypoint; all have purely imaginary subjects. Though the intaglios are not as free as the paintings, they are among the earliest American prints to feature gestural abstraction. The artist used the energy and direction of his brushstrokes to suggest the movement of water, reflected in the sunshine. Hovering seagulls, twisted into calligraphic spirals, help to locate the image and define the transience of the moment.

Kainen began the print by sprinkling granules of resin onto the plate as an aquatint ground. Using a brush dipped in stop-out varnish, he drew the primary gestural imagery over the ground. As the loaded brush discharged unevenly, it created a dry passage through the middle of the stroke, revealing the direction of the artist's gesture and the physical behavior of the varnish. Kainen then drew the other light forms with the same brush. After faintly biting the entire plate in the acid, he stopped out the additional passages and put the plate back in the acid to etch the deep tones (as in the dark areas across the bottom and the flag shape in the upper left). Finally, the artist drew the heavy calligraphic drypoint lines using a mezzotint scraper. Then he took impressions without further etching.

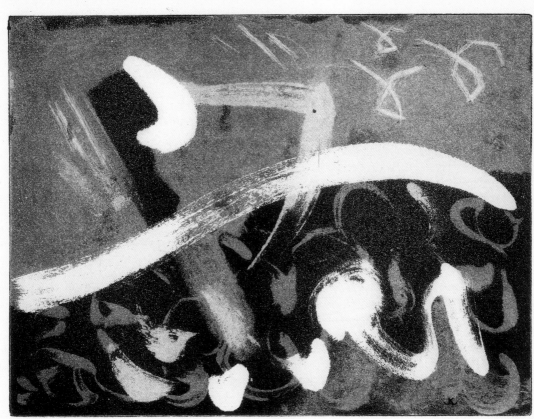

Marine Apparition Jacob Kainen '49

WALTER KUHLMAN

1918–

21. Untitled, 1949

Soft-ground etching and aquatint on cream wove
 paper, 1/3
22.8 x 18.8 cm (plate)
30.0 x 27.7 cm (sheet)
Inscribed: in graphite, below platemark:
 1/3 Kuhlman '49
Worcester Art Museum, Eliza S. Paine Fund,
 1996.81

At the California School of Fine Arts in 1948–49,
Walter Kuhlman made a group of remarkable stu-
dent prints that reflect the fresh, originative exper-
iments of a group of Abstract Expressionist
painters in Sausalito. Periodically throughout his
career the artist has returned to printmaking.

Kuhlman was born in Saint Paul, Minnesota, on
November 16, 1918.[1] Both of his parents were
Danish immigrants who maintained strong ties to
their homeland. After graduating from high school
in 1936, he enrolled in the degree program at the
Saint Paul School of Art, and became a pupil of
Cameron Booth. That Regionalist painter intro-
duced him to such nineteenth-century American
artists as Albert Pinkham Ryder and Timothy Cole,
whose work influenced Kuhlman's early paintings.
At school he met fellow students Seong Moy and
Frank Lobdell with whom he began a lifelong friend-
ship. In 1939 Kuhlman attended the University of
Minnesota, and received a bachelor's degree in
1941. He began to show his work in national group
exhibitions, and his first solo exhibition was pre-
sented by the Walker Art Center in 1940.

In summer 1942 the artist won a Cummington
Grant, which enabled him to travel to the Berk-
shires to work in the company of other artists like
Paul Wickert, and poets Marianne Moore and
Delmore Schwartz. Kuhlman exhibited the paint-
ings he produced that summer in a joint exhibition
with Wickert at the Berkshire Museum in Pittsfield.
Drafted into the Navy in 1942, Kuhlman worked as
a medical illustrator in San Diego and Betheda,
Maryland. After his discharge in 1945 he briefly
attended Tulane University, and then moved to
Saint Thomas in the Virgin Islands. Kuhlman set to
work on a series of exploratory paintings in the
style of Picasso, in which he confronted Modern-
ism and abstraction. Scuba diving among the tropi-
cal reefs brought a bright, Caribbean palette to his
paintings, and a new formal vocabulary of aque-
ous, biomorphic forms, some of them feathery and
delicate, others sharp and threatening.

In 1947 he joined Lobdell at the California

School of Fine Arts (CSFA) in San Francisco. As an
advanced GI Bill student he had his own studio
and was allowed to work with little disruption. His
first paintings in San Francisco recalled his
Caribbean experiences in their vivid tropical
palette and marine imagery. For a time, Clyfford
Still exerted a powerful influence on Kuhlman.
Kuhlman became friends with James Budd Dixon,
often attending his painting and printmaking
classes. The artist was among the group of artists
who lived and worked in Sausalito and often came
together to share models, ideas, and exhibitions.[2]
His first prints were his contributions to the pio-
neering *Drawings* portfolio of offset lithographs
published by the group in 1948.[3] Kuhlman was
unusual among his colleagues for his continuing
interest in the craft of painting. He studied the
painting techniques of the old masters, and strove
to use layered glazes in his abstract paintings. In
1951 Kuhlman followed Lobdell to Paris, where he
associated with the circles of American artists in
Paris, including Jerry Hitofsy, Sam Francis, and
Claire Falkenstein. She arranged for the artist to
meet sculptor Constantin Brancusi at his studio,
and critic Michel Tapié, who included one of
Kuhlman's paintings in his controversial exhibition
Un Art Autre at the Museum of Modern Art in Paris
in 1952. One of Kuhlman's paintings was featured
in the *Sixième Salon des Réalités Nouvelles* at the
Petit Palais, one of the first exhibitions in a French
Museum to feature American Abstract Expression-
ist painting.

When his GI Bill benefits expired in 1951
Kuhlman returned to Sausalito. In 1956 he won a
Graham Foundation Fellowship for Advanced
Studies in the Fine Arts. This fellowship took the
artist to Chicago for six weeks of discussions with
other fellows and visiting scholars, convened in
the office of Mies van der Rohe. From 1960 to 1965
Kuhlman taught at the University of New Mexico at
Albuquerque, followed by brief appointments at
Stanford University and the University of Santa
Clara. In 1969 he joined the faculty of Sonoma
State University in Rohnert Park, California, where
he continued to teach until his retirement in 1988,
when a retrospective exhibition was mounted
there.[4] In 1982 Kuhlman and his protégé Greg
MacIntosh won the annual award for outstanding
working artist and teacher from the California Arts
Council. The artist began to make monotypes in
the mid-1980s.[5] His first prints were executed with
oil paint, applied to a thick piece of glass, and
printed by rubbing by hand. The way that the ink
spread into the paper, and created patterns of

color and tone, prompted the artist to react spon-
taneously, and then touch the sheet with colored
pastel or ink, detailing a figure, a personality, and
spirit. Quickly executed and spontaneously
inspired, they very often have representational
details that make literary and mythological refer-
ences. Ghostly figures emerge from smoky atmos-
pheres, in images reminiscent of the work of
Odilon Redon or Nathan Oliveira. The artist still
lives in Sausalito, where he continues to paint,
make monotypes, and exhibit his work.

The present print is one of a group of intaglios
that Kuhlman created at the CSFA in 1948–49.
Soon after they were made, all ninety-seven of his
prints from this campaign were placed in a card-
board box and forgotten in a map drawer. Discov-
ered in 1996, they provided a remarkable snapshot
of the artist's early creative process. The group
reveals that Kuhlman experimented freely with the
technique, changing the plates or trying a new
manner of printing for nearly each impression.
Several of these interrogatory intaglios were
printed from two matrices — or perhaps from
opposite sides of the same copper plate — and the
artist varied their inking and orientation. Generally
it seems that Kulhman began with an abstract,
unpremeditated design in drypoint or etching;
then he applied aquatint to his plates in several
layers, altering and building on earlier imagery.
The present print was made from two superim-
posed impressions from the same plate. First
Kuhlman printed the intaglio matrix in black ink;
then he applied colors a' la poupée and over-
printed, so that some etched areas printed both
black and colored passages.

In its imagery, this print is similar to Kuhlman's
contemporaneous paintings, with their abstract
vocabulary related to the artist's experiences in
the Virgin Islands in 1946–47. In some of the
prints, sea stars and wormlike shapes seem to
float back into clouds of fluid color. Billows of fine
aquatint dissipate and shift before our eyes, along
with indistinct linear loops and hatchings that
appear to move, but never define. Kuhlman's print
also calls to mind the remarkable atmosphere and
light of the Bay Area, and the changing images that
he saw every day as moving banks of mist and
clouds moved in between the hills and across the
Bay, with shafts of sunlight descending through
them. Indeed, the bridgelike hatching at the bot-
tom of the composition and the shrouded sphere
on the left do seem to evoke landscape.

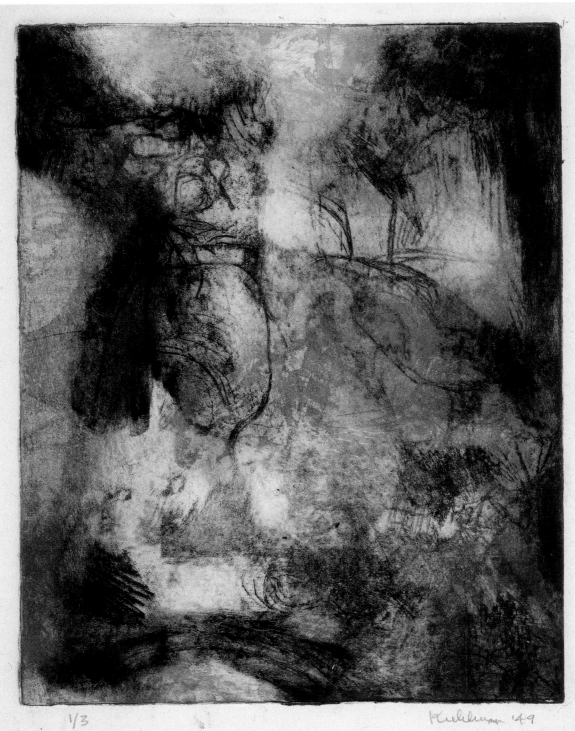

1/3 Kuhlman '49

RICHARD DIEBENKORN

1922–1993

22. Untitled, 1950

Linocut on cream wove paper
27.5 x 21.7 cm (image)
33.0 x 21.6 cm (sheet)
Inscribed: in graphite on verso, l.r.: *3562* in a
 rectangle
Watermark: *SEA FOAM BOND*
References: Diebenkorn estate 3562
Estate of the artist

Abstract Expressionism informed the development of Richard Diebenkorn's style in the late 1940s, and his work always combined the spark of momentary inspiration with deep psychological content. In printmaking he found a different, refreshing viewpoint on his own imagery and process.

Diebenkorn was born on April 22, 1922, in Portland Oregon, the son of an executive for a hotel supply firm.[1] When he was two years old his family moved to San Francisco. As a small child he began to draw every day. In 1940 Diebenkorn studied liberal arts at Stanford University. He married in spring 1943, and entered the Marine Corps officer training program at the University of California in Berkeley. This provided an opportunity to study art with Erle Loran, who instilled an appreciation of the work of Paul Cézanne. He also encountered the aesthetic legacy of Hans Hofmann. Eventually Diebenkorn was posted to Quantico, Virgina, where he worked as a cartographer. He was influenced by the work of Henri Matisse, which he viewed on frequent visits to the Phillips Collection in Washington, D.C.

After his discharge from the service in 1945, Diebenkorn returned to San Francisco and enrolled at the California School of Fine Arts (CSFA), where he had a studio and the freedom to work on his own. He met Clyfford Still, Mark Rothko, and Edward Corbett, whose images and ideas he assimilated. Distinctions between figure and ground disappeared from his canvases, which became larger and more painterly, divided into color passages from edge to edge. The artist made lasting friendships with David Park, Elmer Bischoff, and Hassel Smith. He also associated with the Sausalito Six group of painters; his prints in their *Drawings* portfolio of offset lithographs (fig. 1) have a distinctive, impetuous calligraphy that also characterizes his first experimental drypoint.[2] Diebenkorn's first solo exhibition appeared at the California Palace of the Legion of Honor in 1948. Two years later the artist entered the graduate program at the University of New Mexico in Albuquerque. Living in the desert under expansive skies, he refined an abstraction that combined linear gesture with expansive structure and subtle color.

After completing his master's degree in 1951,

Diebenkorn taught for a year at the University of Illinois at Urbana, then returned to Berkeley, where he painted a series of sensual abstractions with fluid lines and softer colors. Late in 1955 he began working in a representational style, depicting still life, landscape, and figures. He taught at the California College of Arts and Crafts from 1955 to 1957, and his work was included in the definitive exhibition *Contemporary Bay Area Figurative Painting* at the Oakland Museum. Diebenkorn taught at the CSFA from 1959 to 1963. In 1962 he made his first collaborative lithographs at the Tamarind Lithography Workshop in Los Angeles.[3] Soon afterwards, he approached Kathan Brown, who had just opened the etching workshop Crown Point Press. The artist attended a few of the shop's evening sessions, where artists drew printing plates directly from the model, and Brown began to print for him.[4] Diebenkorn kept a stack of zinc plates in his studio, drawing on them with a drypoint needle when he needed a change of pace and passing them to Brown. He continued this activity in 1962–63 when he was artist-in-residence at Stanford, and in 1964 when he traveled to the Soviet Union as part of a State Department cultural exchange program. The following year a selection of the prints was published by Crown Point Press in the portfolio *41 Etchings Drypoints*.[5]

From 1966 to 1973 Diebenkorn taught at the University of California, Los Angeles. At that time he returned to abstraction. In his large *Ocean Park* paintings, color and shape create sensations of projection, recession, movement, and transparency.[6] In 1976 a traveling retrospective exhibition of his work was organized by the Albright-Knox Art Gallery.[7] From that time he visited Crown Point Press nearly every year until his death, producing larger abstract intaglios, often in color. In 1981 a selection of his prints was shown at the Minneapolis Institute of Arts.[8] In 1988, the year an exhibition of Diebenkorn's drawings appeared at the Museum of Modern Art,[9] the artist moved to Healdsburg, in the vineyards north of San Francisco. He had heart valve replacement surgery the following year, and though his health was delicate, he continued working at Crown Point Press. An exhibition of the artist's work was mounted at the Whitechapel Art Gallery in London in 1991 and was circulated in Europe and in California.[10] He died in Berkeley on March 30, 1993.

The present print is one from a group of four linocuts that Diebenkorn made in Albuquerque, when he was a graduate student at the University of New Mexico. Unique and undescribed, it was made at home for the artist's own amusement. The project began when he set out to make labels for his homemade beer, "Diebenkorn's Brew," which was concocted outside the back door of his home.

Figure 1. *Untitled*, from the portfolio *Drawings*, 1948.

The artist and his family collected bottles left by college students along lovers' lanes, then sterilized, refilled, recapped, and labeled them for the private draft. Friends enjoyed the dark beer, which gained a reputation for its potency.[11] Diebenkorn's abstract linocuts were probably done in the last weeks of 1950, for he shared one of the printmaking sessions with his young daughter, Gretchen, who made her own Christmas cards.

Diebenkorn's experiments may also have been prompted by the work of Adja Yunkers. The color woodcut master was in Albuquerque at that time, struggling to establish his Rio Grande School of Art, where Diebenkorn was slated to teach painting. The thin, hard-surfaced paper of this linocut, and its juxtaposition of glossy and matte inks are similar to Yunkers's prints. Diebenkorn never signed this print, and its orientation is uncertain, but its imagery is parallel to his contemporaneous paintings. The composition is divided into rectilinear segments that seem to alternately project and recede. Its illusory space is flattened by prominent cipher forms, including X, and = symbols, a recumbent Y, and a circle within a square. These motifs suggest that the image holds some important but undecipherable meaning. Since his childhood fascination with heraldry, Diebenkorn had developed a personal vocabulary of these motifs, which he continued to use throughout his career.

The artist seems to have begun by plotting the image with a sharp knife, the cuts from which printed as fine white lines. Then he used a gouge to remove material from areas not meant to print. Each broad passage of the composition is marred by blotches, scratches, and scuffs, similar to the mottling and brushstrokes in his canvases. Like the intentional flaws in Hassel Smith's contemporaneous drypoint, these details impart an organic quality and imply change. This deliberate nonchalance belies Diebenkorn's precise crafting of the two linoleum blocks, their precise registration, and delicate hand-printing.

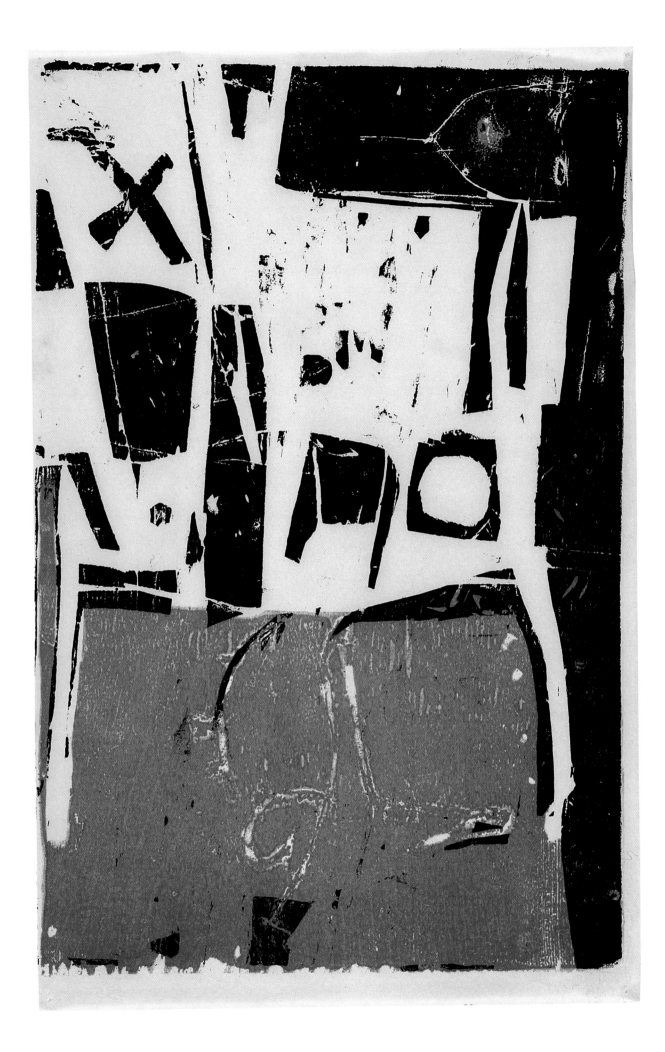

LAWRENCE KUPFERMAN

1909–1982

23. Microscopic Creatures from the Ocean Deep, 1950

Screenprint on black wove paper
20.6 x 27.4 cm (image)
25.3 x 30.4 cm (sheet)
Inscribed: in screen, l.r.: *Kupferman*; in white ink
 on verso: *EK 441.E/ "Microscopic Creatures of
 the Ocean Deep" / May, 1950/ Lawrence
 Kupferman*
References: Kupferman EK441.E
Worcester Art Museum, 1996.110

During the late 1940s Lawrence Kupferman developed his own style of biomorphic Abstract Surrealism based on studies of marine life. He merged this imagery with automatic painting dependent on the physical qualities and behavior of his materials.

Kupferman was born on March 25, 1909, in Boston, where his father owned and operated a succession of food markets and delicatessens.[1] As a teenager he set up a workshop in the basement of an aunt's home, where he taught himself the rudiments of intaglio printmaking. By about 1930 Kupferman was producing sensitive Whistleresque drypoints and etchings, representing urban views and genre studies. In 1931 he enrolled at the Massachusetts School of Art in Boston, where he met Ruth Cobb, a fellow student. They were married in 1937, the year Kupferman joined the FAP/WPA in Boston. During his three years on the project, the artist concentrated on prints of urban landscape, especially drypoints and etchings depicting the facades of Victorian houses.[2] He explored the neighborhoods of Boston with a small camera, taking snapshots of distinctive buildings. Later, at home, Kupferman adapted designs from his photographs, and transferred them to copper and zinc printing plates. Some of the buildings were abandoned and derelict, and their images summon contemplation of the people who erected and inhabited these homes, symbolizing their achievements and vulnerability and the passage of time. While the artist's early intaglios for the FAP were naturalistic and precise, he soon began to distort line and form in his urban landscapes, creating an expressive sense of the city's activity.

In 1941 Kupferman joined the faculty of the Massachusetts School of Art, where he taught printmaking and printing. His first solo exhibition was presented at the Boris Mirski Gallery in Boston in 1944. Two years later his work was shown at the Mortimer Brandt Gallery in New York, in the first of regular solo exhibitions in the city. For his sensitive line, intense palette, and painterly manner, critics compared the artist to Chaim Soutine.[3] In the mid-1940s he also painted images of devastated cities,

and a series of imaginary portraits of Nazi generals that expressed his outrage at the horrors of World War II. In 1946 Kupferman and his family leased a summer house on Cape Cod. For the first time he found inspiration in nature, in the creatures and plants he discovered along the beach. He developed his own biomorphic Surrealist imagery, and when these works were first exhibited at the Mortimer Leavitt Gallery in New York in spring 1948, they caused a minor sensation.[4]

In 1949 Kupferman's distinctive style helped him to secure a handsome commission from the American Export Lines Shipping Company. For their corporation headquarters in Quincy, Massachusetts, he painted two large maps in oil on metal panels, representing the sea routes of the luxury liners *Constitution* and *Independence*. These charts enabled office staff and customers to mark the ships' changing positions as they sailed between New York and the Middle East. In the 1950s Kupferman found inspiration for his work in the poetry of Dylan Thomas. His volume of Thomas's verse bears the artist's notes, often referring by number to drawings and paintings recorded in his own workbook. He often excerpted phrases from the poems as titles for his works. Kupferman exhibited his work at the Mortimer Levitt and Martha Jackson Galleries in New York during the late 1950s, and at the Margaret Brown Gallery in Boston.

Many of Kupferman's works of the early 1960s represent themes of contemplation. Each of the abstractions in the extended series *Le Penseur* features the shape of a human head in profile, usually placed at the bottom of the composition, surrounded by stained or dripped pigment, to suggest thoughts. In his series *Landscapes of the Mind* Kupferman defined the shape of a head with contour lines or hard edges, containing complex mixtures of poured pigments. Kupferman retired from the Massachusetts College of Art in 1969. The following year he experienced the first symptoms of Parkinson's disease. He also explored the art of ancient Egypt, Greece, and Precolumbian America, borrowing simple forms that he silhouetted against swirls of color. Evoking man's compulsion to impose structure on the natural world in order to understand it, these images also comment on the process of art itself. They were featured in a retrospective exhibition of his work at the Fuller Museum of Art in Brockton, Massachusetts, in 1974.[5] Kupferman died in Newton, Massachusetts, on October 2, 1982.

The present print is one of just a few to incorporate Kupferman's remarkable biomorphic imagery. In 1946, while summering at Provincetown, the artist became fascinated by the abundant life along the beach. He filled sketchbooks

Figure 1. *Oceanic Forms*, 1950.

with images of the sea creatures and biotic forms he saw and explored biology books illustrated with charts of typology. He also invented imaginary zoomorphic forms, which he depicted in spontaneous pen and wash drawings in colored ink. These experiments were encouraged by the artist's acquaintance with pioneer Abstract Expressionists who summered in Provincetown, including Adolph Gottlieb and Mark Rothko, who made Kupferman aware of biomorphism as suggested by European theories of Abstract Surrealism.

In summer 1947 Kupferman borrowed a microscope and began to examine biotic forms in drops of sea water. Rather than attempt to depict exactly what he observed, he strove to capture the spark of life and the cosmic nature of this unfamiliar realm. "I try to suggest, at least, the wonderful dense complexity of matter, or indeed of *being*; the miracle of being," Kupferman wrote of this work. "I try to allude to the atomic structure, to the ceaseless spinning movements, the endless pulsations inherent in all beings. The vibrations of colors in my paintings are developed to set in motion the suggestions of these endless movements."[6] In 1947 the artist also began to transfer this biomorphic imagery to oil paintings. He poured enamel onto panels, manipulating the flow and mixture of the paint with a heat lamp (fig. 1).[7] Most of Kupferman's abstractions have allover compositions, with shallow space where amoebic creatures appear to drift back and forth, but not to or from the viewer. The artist was fascinated by the suspension of geotropic space that he found under the microscope and in the sea. He often suggested this realm of antigravity by signing his works on two or four separate edges so that they could be viewed in different orientations. The artist also contemplated the world of cold and darkness at the bottom of the sea in pastel and casein drawings on black paper, including the watercolor *Microscopic Creatures of the Deep*, executed on the last day of 1949.[8] The present silkscreen is an adaptation of that watercolor. It was printed on May 30, 1950, in a small unspecified edition. Since Kupferman recorded that his student Mary Jane Hodges assisted him with the printing, it seems likely that it was produced in the printshop at the Massachusetts College of Art in Boston.

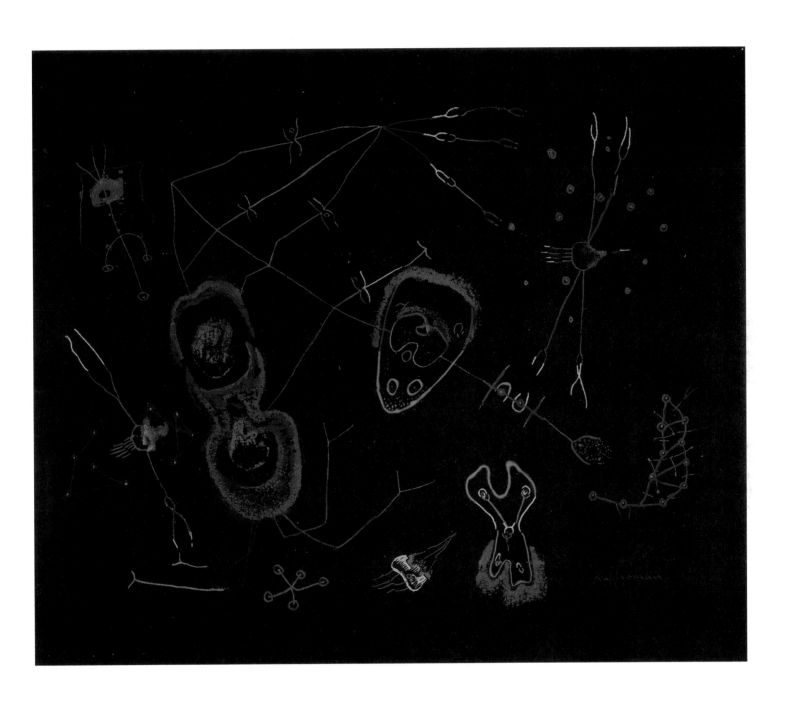

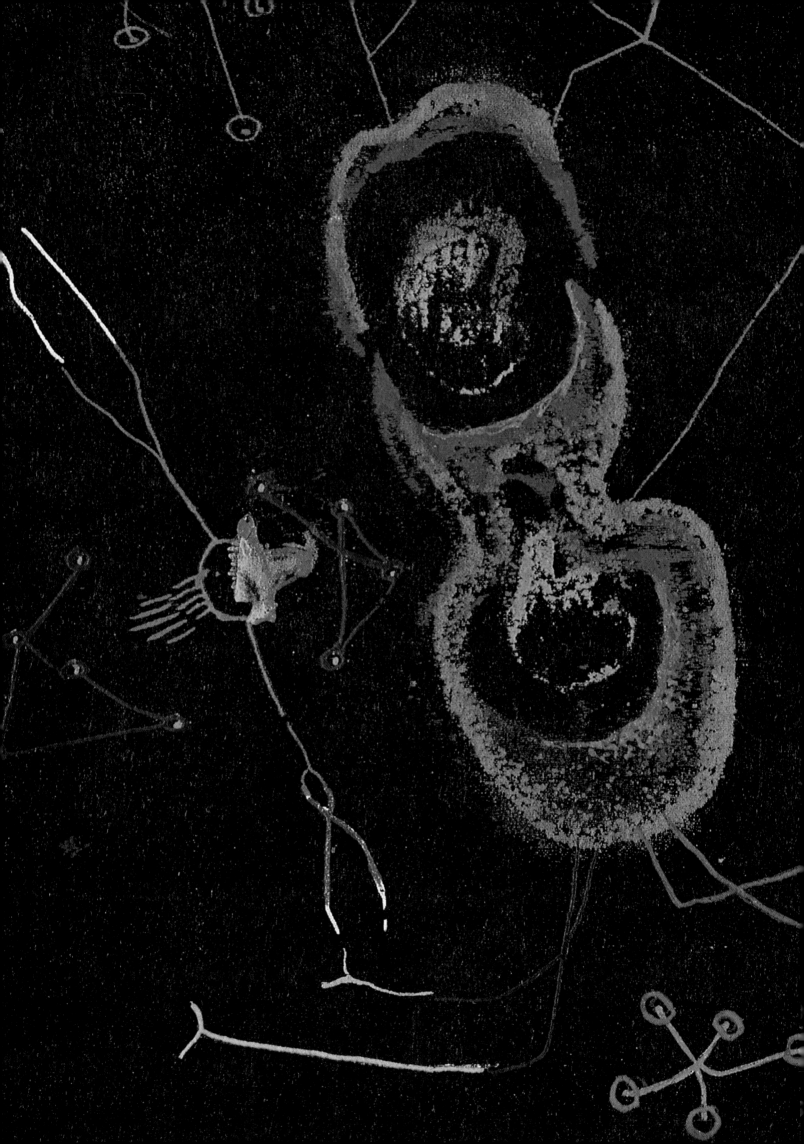

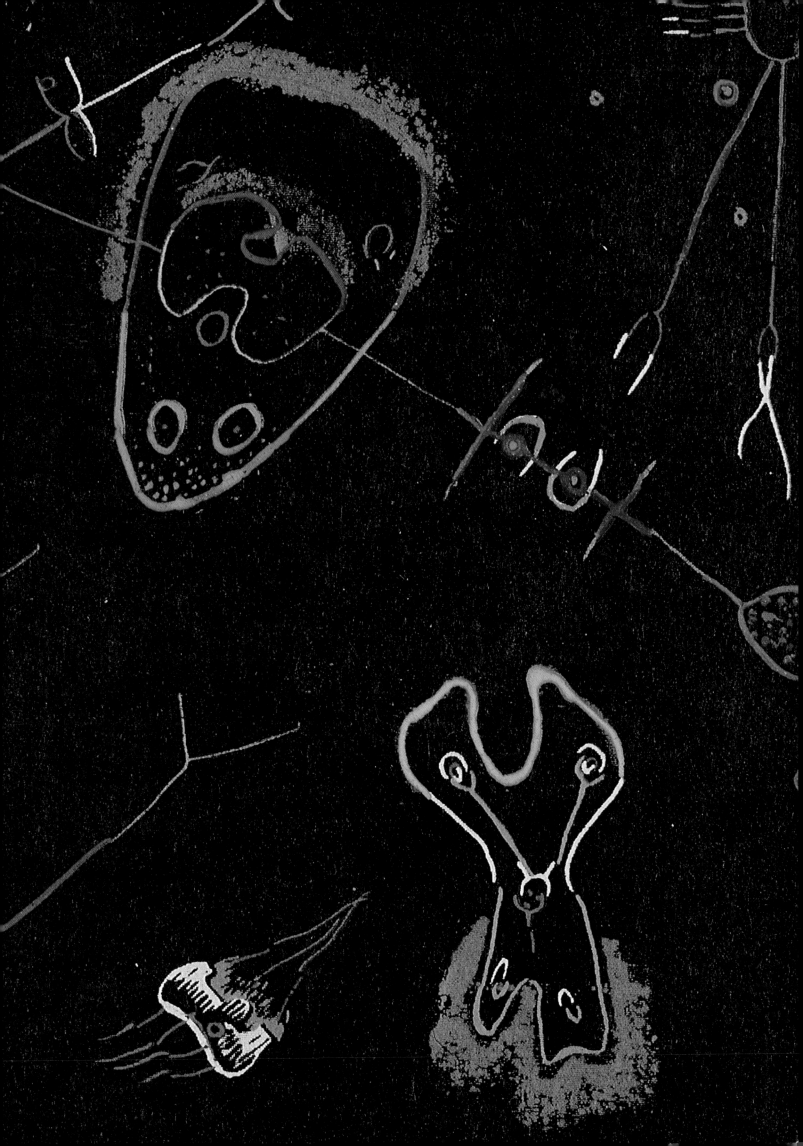

LEE MULLICAN

1919–1998

24. Untitled (Five), 1950

Etching and aquatint with drypoint on off-white
 wove paper, artist's proof
26.4 x 17.7 cm (plate)
43.4 x 33.1 cm (sheet)
Inscribed: in graphite, below platemark:
 Lee Mullican 1950 AP 1995; in graphite on
 verso, l.l.: *LK - 1950 (Five) 10⅕" x 8"*
Worcester Art Museum, Helen Sagoff Slosberg
 Fund, 1997.39

During the 1940s Lee Mullican associated with the Dynaton, a group of avant-garde artists in San Francisco who shared many of the intellectual principles that impelled early Abstract Expressionism. Their ideas are embodied in the experimental prints that he made for himself.

Mullican was born in Chickasha, Oklahoma, on December 2, 1919.[1] He began to study art in 1937 at Abilene Christian College in Texas, and two years later he transferred to the University of Oklahoma. In 1941 he attended the Kansas City Art Institute, where he was a student of Fletcher Martin. He learned the rudiments of printmaking at that time, and produced a few lithographs representing burlesque theater. After graduation Mullican joined the Army, and during World War II served in the Corps of Engineers as a topographic draftsman. The artist took aerial photographs in the South Pacific, constructed photomosaics, and drafted maps. While developing a special expertise in vegetation patterns, he became aware of abstraction in nature.

After his discharge in 1946, Mullican spent a year in New Mexico, sketching the landscape and Native American designs in pen and ink, and developing a few into linocuts. He also completed *The Gain of Aft*, an illustrated volume of original poetry.[2] These delicate line drawings are reminiscent of Yves Tanguy's Surrealist etchings made at Atelier 17 in New York. In 1948 Mullican moved to San Francisco, where he turned his attention to painting. His signature style emerged when he borrowed a printer's knife from Jack Staufacher at Greenwood Press, and piled discrete ridges of paint on the canvas.[3] Over abstract forms Mullican painstakingly superimposed hundreds of these tiny lines, radiating from a center point or standing in parallel tiers. He combined American Indian influences with ethnographic designs from Australia and Oceania, melded with patterns from his topographical maps. Mullican's work was included in the Corcoran Gallery Biennial exhibition in 1948, and his first solo show was mounted at the San Francisco Museum of Modern Art the following year. In 1950 the artist's first exhibition in New York was presented at the Willard Gallery.[4]

In San Francisco Mullican associated with the painters Wolfgang Paalen and his wife, Jacqueline Johnson, and Gordon Onslow-Ford and his wife, Luchita Hurtado, forming a loose intellectual and artistic movement. They shared interests in ethnographic art from around the world and wanted their work to express similar spiritual values.[5] Devoted to Surrealist Automatism, they believed the creative act to be one of self-revelation. Their works were conceived as objects of meditation, meant to project calming spiritual auras. The group was known by the title of their joint exhibition, *Dynaton*, mounted at the San Francisco Museum of Art in 1951.[6] After the show they disbanded.

In 1952 Mullican moved to Los Angeles, where he established a national reputation for his painting.[7] He joined Rachel Rosenthal's Instant Theater, an improvisational troupe that performed impromptu sketches characterized by the spirit of Automatism. During the 1950s the artist exhibited regularly at the Willard Gallery in New York and at the Paul Kantor Gallery in Los Angeles. For a time Mullican painted in a more gestural manner, later integrating his tiny impasto hatchings with this imagery. In 1959 he moved to Rome, where he painted for nearly two years with the support of a Guggenheim Fellowship. Afterward he joined the faculty of the University of California at Los Angeles (UCLA). In 1962 Mullican worked with John Paul Jones at the university printshop on experimental intaglios, producing four plates that were never editioned. The artist won a Creative Arts Grant from the university in 1964, the year that he was an artist fellow at the Tamarind Lithography Workshop. There he produced thirty-four editions of lithographs, including the portfolios *Hungry Ghosts* and *Fables*.[8] He traveled in South America in 1968, when he was artist-in-residence at the University of Chile. A solo exhibition of his work appeared at the Silvan Simone Gallery in Santiago, and a retrospective was mounted at UCLA in 1969.

In 1970 Mullican built a home near Taos, New Mexico, where he spent his summers. Late in the 1970s, when a reconsideration of West Coast Modernism began, his early work was often exhibited, and the achievements of his career became widely appreciated.[9] He had a joint exhibition with his son Matt at the University of New Mexico in 1989. The artist continued painting and exhibiting after his retirement from teaching in 1986. Mullican died in Santa Monica on July 7, 1998.

The present print is from a group of six experimental intaglios that Mullican made in 1950, when studying with Stanley William Hayter in San Francisco.[10] There was no market for the prints, so he pulled only proofs. None of the early prints seem to survive, but at our urging Mullican located the six printing plates in 1994. The present impression is one from a suite of modern proofs, reprinted for this project in November 1996. The imagery of each plate is quite different, and each combines multiple intaglio techniques. There is little burin work, but etching and drypoint are combined with soft-ground etching, aquatint, and intricate layers of resist. All the plates have an improvisational character, more casual than Hayter's curvilinear graphic style. Like Mullican's paintings and drawings of the period, his intaglios are based on Native American designs, and feature pictographic and masklike motifs. The design of the present print resembles shamanic figures in dancing positions. They emerge from layers of organic texture, like weathered images in ancient rock paintings or carvings. This stratified effect, with its painterly quality achieved by resist methods, is also reminiscent of ceramic decoration. Though Mullican invented these designs, they capture the liveliness and balance of ancient Indian motifs, and have a totemic spirituality that evokes ritual. Thus, the artist achieved some of the goals set in the early works of Adolf Gottlieb and Mark Rothko.

Though this print is visually complex, it was easy to make. Mullican worked spontaneously, with no preconceived design, building up imagery in layers, as in his canvases. He began by painting simple linear calligraphy on the plate in resist. Then he superimposed a fine aquatint ground, etched the plate, and washed out the resist. When the plate was printed, the original drawing appeared in white, surrounded by aquatint gray. Mullican repeated this process, drawing larger pictographs and patterns, and etching the plate more deeply for darker tones of gray. He finished the plate with a drypoint needle, in fine passages of hatching and defacing calligraphic scribbles. This layered effect was intended to slow the viewer. Rather than a bold, direct statement, the artist preferred a calming image, to be quietly examined over time. Mullican spoke of this overall balance as a "preference for the fall of rain without the lightning bolt."[11]

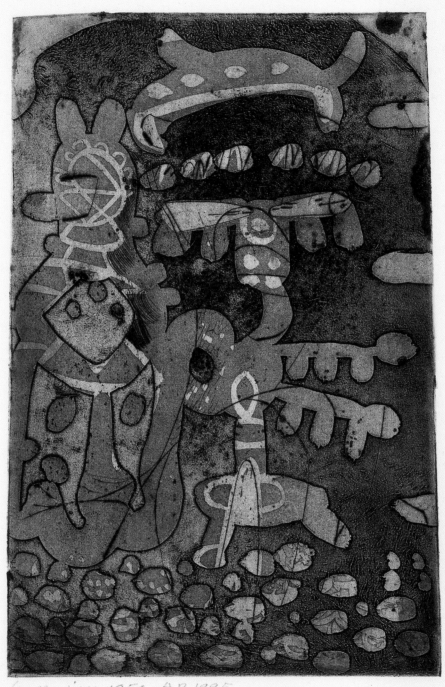

W. Rudican 1950 AP 1995

EMERSON WOELFFER

1914–

25. Untitled, 1950

Lithograph on cream wove paper, 4/6
33.8 x 44.8 cm (image)
43.0 x 51.5 cm (sheet)
Inscribed: in graphite, below image:
 4/6 Woelffer 50; in graphite, on verso:
 Colorado Springs/ Printed By Me
Worcester Art Museum, Richard A. Heald Fund,
 1991.106

Pursuing his artistic activities far from New York, Emerson Woelffer has nevertheless remained committed to his personal style of "psychic automatism" throughout his long career. Prolific and versatile, the artist has always worked simultaneously in a variety of media, including prints.

Woelffer was born on July 27, 1914, in Chicago, where his father was an insurance and real estate broker.[1] When he was twelve years old, he began Saturday classes at the School of the Art Institute of Chicago (SAIC). These courses sometimes included sketching expeditions to draw the dioramas at the Field Museum, but Woelffer ignored the stuffed animals, studying African art instead. A rebellious teenager, he was suspended from high school and never received a diploma. A maintenance job at the Art Institute in 1935 enabled him to attend classes at the school. He was a pupil of Boris Anisfeld and Francis Chapin, who taught him the fundamentals of lithography. His first solo exhibition, mounted in 1938 at Bennington College in Vermont, featured Modernist drawings and watercolors. After leaving the SAIC without a degree, the artist worked in the easel painting division of the FAP/WPA in Chicago, and the mural division in Saint Louis. In 1939 he joined the Army Air Force and worked as a topographical draftsman, producing aerial maps to guide Allied pilots over the Mediterranean at night.

After his discharge in 1942, Woelffer joined the faculty of the Institute of Design in Chicago at the invitation of László Moholy-Nagy. He became close friends with his fellow teacher Hugo Weber, and together they created the Dada decoration of Ruth Reinhart's Chicago night club Jazz Limited. An enthusiastic fan of Dixieland, Woelffer frequented area clubs and compiled a remarkable collection of jazz records. When in Chicago, musicians such as Danny Alvin and Doc Evans visited his home. He also began collecting ethnographic art from Africa and New Guinea. In his painting Woelffer experimented with influences from Cubism and Parisian Abstract Surrealism. His first solo exhibition in

New York appeared at the Artists' Gallery in 1949. That summer Woelffer was a visiting professor at Black Mountain College in North Carolina, where Elaine and Willem de Kooning were among his colleagues. Afterward he went to Mexico and painted diligently for nine months at Campeche in the Yucatán, forging a personal style of pictorial improvisation akin to jazz.

In 1950 Woelffer became director of the Colorado Springs Fine Arts Center. In Colorado his paintings became brighter and more spacious, perhaps reflecting the light and expanse of the Western landscape. He developed a personal calligraphic vocabulary in his *Numbers* series of paintings and employed cut-outs and collage in his *Bird Series*. In 1954 Robert Motherwell was artist-in-residence at Colorado Springs and the two artists began a lifelong friendship.[2] In the mid-1950s Woelffer experimented with intaglio; he produced several editions of abstract etchings and aquatints, but found the process overly technical and involved. At that time the artist was often in New York. He visited Motherwell, renewed his acquaintance with de Kooning, and attended The Club. On a visit to New York in 1957, his friends Franz Kline and Mike Kanemitsu encouraged the gallery owner Eleanor Poindexter to exhibit Woelffer's work. Over the next eighteen months he lived frugally at Forio d'Ischia near Naples, Italy, while preparing for his solo show in 1958.[3]

Woelffer moved to Los Angeles in 1959 to join the faculty of the Chouinard Art Institute (now the California Institute of Arts). In 1961, the year of his solo exhibition at the La Jolla Art Center, he was an artist fellow at the Tamarind Lithography Workshop in Los Angeles.[4] It was a nostalgic interlude, for June Wayne was a friend from Chicago, and his visit also coincided with that of Hugo Weber. In 1962 a retrospective exhibition of his paintings, collages, and prints was mounted at the Pasadena Art Museum.[5] A State Department grant enabled him to make an extended visit to Turkey in 1965. He established a gallery, organized exhibitions of his own work, and lectured at Ankara, Gaziantep, and Istanbul. In the 1970s the artist continued to produce occasional lithographs, working with Wayne's Tamstone Group in Los Angeles and at the Tamarind Institute in Albuquerque.[6] In 1974 Woelffer was appointed head of the painting department at the Otis Art Institute in Los Angeles. That summer a solo exhibition of his paintings appeared at the Phillips Collection in Washington, D.C.

In the 1980s Woelffer began to receive recognition for a lifetime's achievement in the arts. He

received a grant from the Pollock-Krasner Foundation and the Francis J. Greenburger Award from the Solomon R. Guggenheim Museum. In 1991 the artist was awarded an honorary doctorate from the Otis Art Institute of the Parsons School of Design, and when he retired from teaching the following year, a retrospective exhibition of his work was mounted at the Otis Gallery.[7] At that time he also received the fourth annual Award for Lifetime Contribution to the Arts from LA Artcore. In 1995 Woelffer's eyesight was first affected by macular degeneration, but he did not limit his activities. He started painting in white on canvas prepared in black since these contrasts are more legible. Recently the artist shifted to drawing with white oil stick on large sheets of black paper. Woelffer now lives in Los Angeles, and continues to draw every day.[8]

In 1950 Woelffer made a series of experimental lithographs in the lithography shop at the Colorado Springs Fine Arts Center.[9] At that time Mary Chenoweth taught lithography at the center, continuing the program initiated by Lawrence Barrett. Using the press in the evenings, Woelffer made a group of calligraphic prints related to his *Numbers* paintings series. He experimented with resist, various methods of toning the stone, and explored different effects of dimensional illusion. The present print is more complex and more turbulent in its impact than most of the lithographs made at that time.

On this stone Woelffer began quick scumbles of liquid tusche. Using the side of a crayon, he created a background of gray and then overlayered spontaneous arcs and slashes. His interlaced lines create a confusing spatial labyrinth. The artist strove for diversity in the length, tone, and shape of these drawn passages. Most of the white accents that dominate the composition were made by scraping the accumulated crayon from the printing surface. In this process, too, Woelffer sought variety, alternating the speed of this scratching, the width of his tools, and the cleanness of the lines. This visual cacophony matches the unbalanced composition. The inverted arc below the center of the image, teetering on an off-center foot anchored to the bottom of the composition, sets the image on edge. The black circle, hovering off-center above, emphasizes this instability. Like a canted column of jackstraws, the whole image appears to be on the verge of collapse, yet its anti-gravity stillness freezes time.

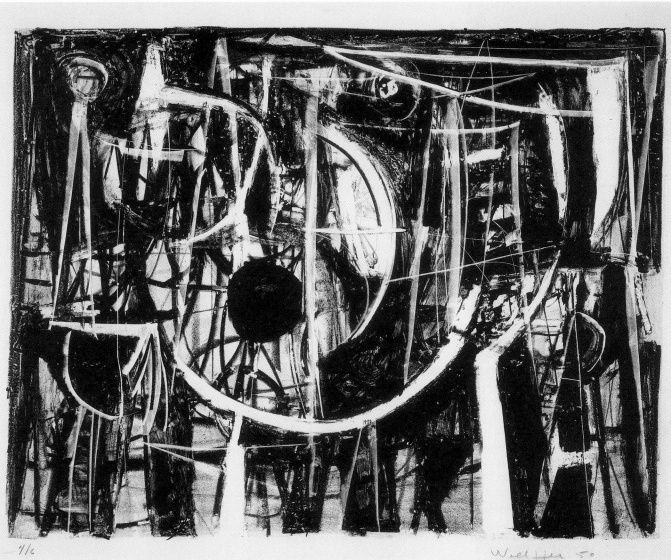

4/6 Wool fler 50

ROBERT McCHESNEY

1913–

26. S3, 1951

Screenprint on cream wove paper, 5/15
33.6 x 59.0 cm (image)
38.9 x 65.4 cm (sheet)
Inscribed: in pen and black ink, in image, l.l.:
 R. MᶜCHESNEY 51; in graphite, below image:
 *"S3" SERIGRAPH 5/15 ROBERT MᶜCHESNEY
 1951*; in black felt-tip pen, on verso: *S3* (in a
 circle) *R.McChesney*
Worcester Art Museum, gift of the artist, 1996.100

In the late 1950s Robert McChesney became one of
the leading abstractionists in the Bay Area and
gained the admiration of critics and the enduring
respect of his fellow artists. Printmaking was key
to the development of his style at that time, and he
continued to make prints throughout his career.

McChesney was born on January 16, 1913, in
Marshall, Missouri, where his father ran a success-
ful photography studio.[1] After graduating from
high school in 1931, he attended Washington
University in Saint Louis, where he studied with
Fred Conway. Between semesters, McChesney
taught himself the process of linocut. At the Otis
Art Institute in Los Angeles, he learned the tech-
niques of printmaking and made his first etchings
in 1936. Planning a career as an illustrator, he
refined a meticulous representational style. In
1938 McChesney worked in the FAP/WPA mural
painting division in San Francisco, assisting
Herman Volz in the design of murals for the Federal
Building and the facade for the Fine Arts Building
on Treasure Island erected for the Golden Gate
Exposition of 1939–40. At the FAP-sponsored art
school in San Francisco, McChesney learned the
fundamentals of intaglio printmaking and created
several drypoints.

In 1942 McChesney joined the merchant
marine, and served on transport ships supplying
the South Pacific during World War II. He painted
watercolors in his bunk aboard ship, influenced by
the ethnographic art he encountered, particularly
the figural sculpture and printed tapa-cloth
designs of Pacific cultures. McChesney's South
Seas watercolors were featured in his first solo
exhibition, at the Raymond and Raymond Gallery
in San Francisco in 1944. He also transferred the
imagery of his watercolors to linocuts and dry-
points representing Surrealist figures, flattened
and turned inside out like the symbolic figures
from Oceanic or Native American artistic traditions.
At that time he also learned the process of silk-
screen from artist Frank Cerda. In 1946 he assisted

Anton Refregier on his mural at the Rincon Annex
Post Office in San Francisco. In December 1949
McChesney married the novelist, critic, art histo-
rian, and sculptor Mary Fuller. They toured Mexico
in 1951, in a converted Ford Model-A mail van that
served as mobile home and studio for extended
visits in Guadalajara, Ajijic, and San Miguel
Allende. In his *Mexico* series the artist overlayered
many veils of translucent wash, creating remark-
able sensations of depth and luminosity.[2]

In 1952 McChesney and Fuller moved to Sono-
ma Mountain, near Petaluma, California. There the
artist began his *Mountain* series of paintings,
which evoke the deep landscapes and mercurial
atmosphere seen from the summit. When visiting a
commercial lithographer in San Francisco at that
time, McChesney found scrap paper that had been
randomly overprinted with images and text when
the sheets were used to clean ink from the
presses. He collected some of these pages and
used their agglomerate, accidental images in a
series of collage paintings titled *Slipsheets*.[3]

In 1955 McChesney found inspiration in Pyra-
mid Lake and the desert around Reno, Nevada,
and in its Native American traditions. For nearly
forty years the artist visited this area annually to
explore, contemplate, and paint. In his *Arena*
series of paintings — named after the Spanish for
"sand" — McChesney added sand to wet enamel
painted on gessoed plywood panels. Then, as he
superimposed thin layers of paint, the texture of
the sand diffused its color and form, creating
vaporous gradations of tone and depth.[4] In sum-
mer 1957 McChesney and Hassel Smith operated
the Sonoma Open-Air Art School at various scenic
areas around Sonoma County. Paintings from the
Arena series made up the artist's first solo exhibi-
tion in New York at the John Bolles Gallery in 1961.[5]

Soon the ethereal gave way to the material in
McChesney's *Hair Suite* and *La Noche* paintings.
Along with enamel and sand he affixed sisal fibers
to the panels, as well as bleached bones that he
collected in the mountains. He set these objects
into polyester resin on plywood in symmetrical
arrangements that evoke mandala designs and the
decorative patterns of Native American weaving.[6]
McChesney translated the shapes of bones into
two dimensions in the *Rojo* and *Yermo* series of
acrylic paintings and a related suite of screenprints
made in 1972.[7] In his *Barranca* paintings of the late
1970s, the artist perfected the painting technique
that remains the basis of his subsequent work. The
process begins with colorful abstract underlayers
of acrylic paint, squirted onto prepared panels

from plastic squeeze bottles, and blotted to create
random patterns. Then the artist superimposes flat
areas in black and white, allowing the most intrigu-
ing passages of organic color to show through.
This effect is a visual metaphor for the entropic
natural world brought to order, or the dichotomy of
the unconscious and the conscious. Both imagery
and technique have characterized the artist's
exploration of Native American design in his sub-
sequent series of paintings *Estadillo*, *Lahontan*,
Canyon Country, and *Point of View*. Retrospective
exhibitions of the artist's work were mounted at
the Nevada Museum of Art at Reno in 1994 and at
the Fresno Art Museum in 1996.[8] McChesney and
Fuller still live on Sonoma Mountain near Peta-
luma, and the artist continues to paint and to
exhibit actively.

The present print is one from a series begun in
conjunction with a screenprint course that
McChesney taught at the California School of Fine
Arts in summer 1950. This piece and others in the
series demonstrate variations of the tusche and
glue washout method, the basic painted technique
for preparing silk screens. The artist painted an
image in tusche directly on the surface of the
stretched silk. Then he superimposed a layer of
glue to block out the rest of the screen. When the
painted design was removed from the screen with
solvent, it left a negative stencil. McChesney
printed six different colored inks from as many
screens, and their combinations produced many
other hues and shades.

The imagery of this print is parallel to that of
McChesney's contemporaneous watercolors and
oil paintings.[9] It seems that the veils of color coa-
lesce momentarily into natural inchoate shapes
that imply change and movement. There are no
straight lines, and the uncertain scale of the image
might invoke weather, geology, microbiology, or
myriad other associations supplied by the viewer.
Overlapping passages and suggestions of space
between them create a great sense of depth but
spatial ambiguity as well. The artist skillfully used
the paper color as part of the design, and it seems
to shine like illuminated aether or plasma. Black
and tan lines meander through these veils of color,
like rivers flowing around hilly topography.
Winding sinuously before and behind passages of
color, these bundled lines sometimes resemble
muscle fibers, or spreading in angular webs, they
suggest oxidized cracks in stone caused by ancient
activities of water. Thus, the image might also pro-
voke contemplation of the passage of time.

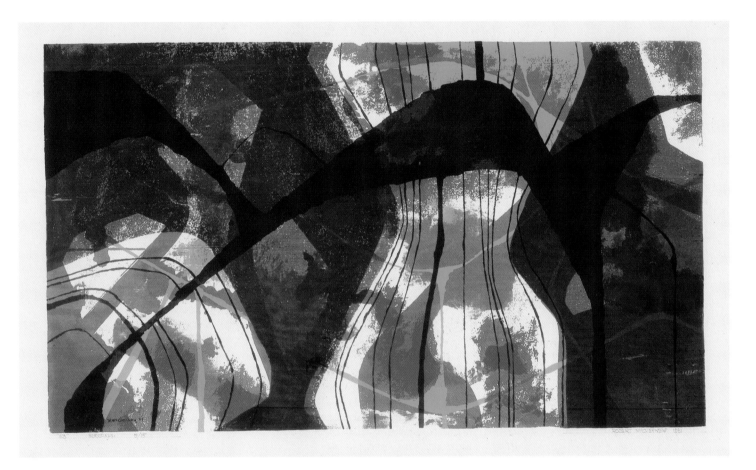

ALFONSO OSSORIO

1916–1990

27. Palimpsest, 1951

Lithograph on cream wove paper
22.2 x 15.9 cm (image)
26.2 x 21.1 cm (sheet)
Inscribed: in graphite, below image: *Palimpsest A OSSORiO '51*; in graphite, above image, upside down: *Palimpsest AOSSORiO '51*
References: Dubuffet 1951, frontispiece.
Worcester Art Museum, 1996.111

Ossorio began his career as a printmaker, and over the course of a long artistic development, as his style shifted from Surrealism to Abstract Expressionism and back, he continued to make prints in a variety of techniques.

Ossorio was born on August 2, 1916, in Manila, the Philippines, the son of a Chinese mother and a Hispanic-Filipino father.[1] His parents separated when he was ten years old, and he was sent to Catholic boarding schools in England, and, from 1929, in Providence, Rhode Island. Ossorio became a naturalized American citizen in 1933. At that time he had already begun to make wood engravings, representing Catholic and macabre subjects in a style derived from European Gothic and early Renaissance art.

In 1934 Ossorio attended Harvard University, where he was a student of Wilhelm Koehler and Edward Waldo Forbes. As an undergraduate he met Ananda Coomaraswamy, Lincoln Kirstein, and Eric Gill, the English sculptor, designer, and wood engraver. During college Ossorio spent his summers at Saint Dominic's Guild, Gill's workshop in Sussex. The sensuality and spiritual ecstasy of Gill's art influenced the young artist, who published his own volume, *Poems and Wood Engravings*, in 1936. Two years later, after completing his bachelor's degree, Ossorio enrolled at the Rhode Island School of Design. He was a pupil of John Howard Benson and Eugene Kingman, who taught him the technique of egg tempera. His precisely realistic paintings reflected a new interest in Surrealist painters such as Pavel Tchelichew and Salvador Dalí. In 1939 he was commissioned to decorate the sanctuary of the Greek Orthodox Cathedral in New York. The artist met Betty Parsons, then director of the Wakefield Gallery, which presented his first solo exhibition in 1943.

Ossorio was drafted into the Army in 1943 and spent most of the next three years as a medical illustrator at Camp Ellis in Illinois. His lurid wartime drawings of Surrealist fantasy made up his solo exhibition at the Mortimer Brandt Gallery in New York in 1945. In 1948 he met the dancer and choreographer Ted Dragon, and they began a lifetime relationship. At East Hampton on Long Island they met Jackson Pollock and Lee Krasner in 1949. Ossorio collected Pollock's work, and they began an influential artistic friendship. The work of Jean Dubuffet also interested him, and he went to Paris to meet the artist. He learned about *L'Art Brut*, Dubuffet's notion of an expressive art unconcerned with representation and undistorted by culture, like the work of Paleolithic man or the insane.

In 1950 Ossorio went to Victorias, Negros Occidental, the Philippines, where he painted Surrealist murals in the family's company Chapel of Saint Joseph the Worker. Over the ten months of this project he also created many drawings in ink and watercolor with wax resist. These uninhibited works synthesized the influences of Pollock and Dubuffet in Ossorio's own Abstract Expressionist voice.[2] The artist returned to Paris in 1951 and deepened his friendship with Dubuffet, collecting more than fifty works by the artist. In August of that year Ossorio purchased The Creeks in Southampton, an estate boasting ample studio space and extensive gardens. There, from 1952 to 1962, he housed Dubuffet's collection of *L'Art Brut*. In the mid-1950s Ossorio continued to create encrusted drip paintings, and in 1958 he began embedding objects like beads, pebbles, and glass eyes in the vividly colored impasto. Later, he used colored plastic instead of paint to affix bones, shells, and all sorts of larger found objects. To suggest their scale and dimension, Ossorio called these works *Congregations*.[3] They appeared in the era's most prestigious Surrealist exhibitions, including the Museum of Modern Art exhibitions *The Art of Assemblage* in 1961, and *Dada, Surrealism and Their Heritage* in 1968.

A retrospective exhibition of his work was mounted at the Guild Hall Museum in East Hampton in 1980.[4] Ossorio produced a lithograph at Solo Press in New York in 1982, and the following year he began working with Sylvia Roth of Hudson River Editions, with whom he collaborated on intaglios and monotypes until his death. Notable among their productions is the folio *Could I Ask You Something?* of 1984, which weds his Abstract Expressionist intaglios to poems by his friend Dr. Lewis Thomas. Ossorio died in New York on December 5, 1990.

The present print is one of the earliest to reflect Ossorio's Abstract Expressionism. In 1951, when he returned to Paris, he shared his new drawings in wax resist, ink, and watercolor with his friend Jean Dubuffet, who was so taken with the work that he wrote a book about it: *Peintures initiatiques d'Alfonso Ossorio*.[5] To accompany a deluxe publication of the book, Ossorio created this color lithograph, which was bound into the thirty-six copies. He visited the Paris workshop of Edmond and Jacques Desjobert, where he drew this and a handful of small lithographs, printed in black ink. *Palimpsest* was printed from three different stones, each carrying a different color, carefully registered so that the superimposed images and ideas complement and gloss each other, as the print's title implies. The lithographic crayons and liquid tusche Ossorio used to prepare the stones were comparable to materials that he used at Victorias. Ossorio even drew in resist for the stone printed in blue; he completed the stone printed in gray by scraping tusche from the printing surface, creating calligraphic accents of white that are similar to the incisions that pierce some of his Victorias drawings.

At first glance this image seems a chaotic swirl of scribbles and scrapings, where emotions twist with debris in a cyclone. However on close examination, haunting, revelatory images emerge. The composition is dominated by a fetal figure, its flaccid body tightly folded, even as its wide eyes create a disconcertingly adult expression. Distorted skulls and stick figures swirl about, like ghostly familiars attending a demonic imp. Less legible is the figure of a fat, grimacing woman, superimposed in white. Images of birth, infancy, and parenthood dominate Ossorio's Victorias drawings, which is reasonable since the artist had returned to his birthplace after many years abroad. While working at Victorias, Ossorio read *The Search for the Beloved: A Clinical Investigation of the Trauma of Birth and Pre-Natal Conditioning* by the psychoanalyst Nandor Fodor.[6] This popular study of the trauma of birth and its lasting psychological effects seems to have provided some explanation of the many motifs that had long appeared in Ossorio's art. It also focused the intense introspection of his work at that time. Apart from their technical and stylistic originality, these works may have been conceived as exercises in self-disclosure, like Pollock's psycholanalytic drawings of the late 1930s. The Surrealist conceit of signing the piece at the top and bottom, enabling the viewer to read it in either direction, has added meaning here. In one direction the fetus faces down, as if it is ready to emerge from the birth canal, and in the other orientation it is already born.

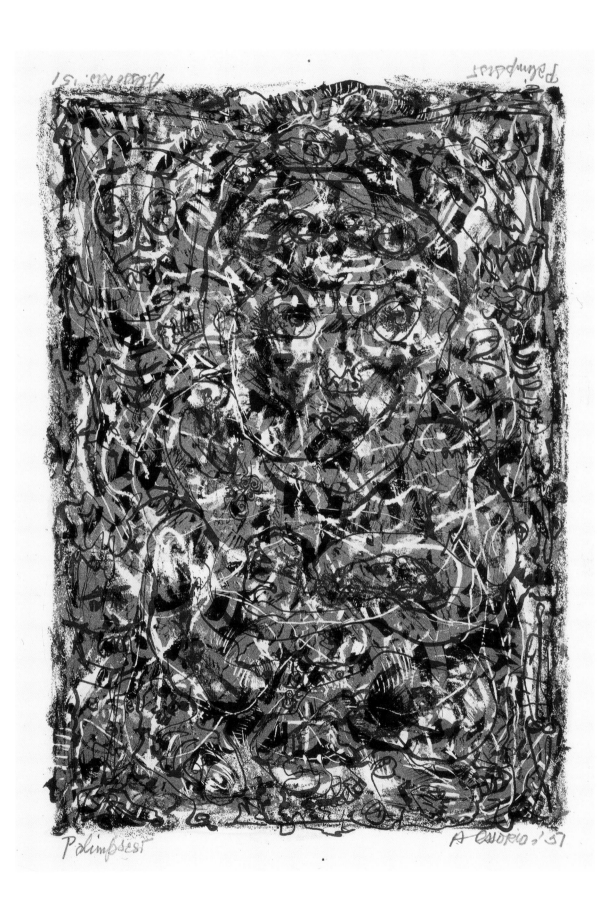

Palimpsest

A Osorio '51

HASSEL SMITH

1915–

28. Untitled, 1951

Aquatint, open bite, and drypoint on cream wove
 paper, artist's proof
23.0 x 15.8 cm (plate)
39.2 x 31.3 cm (sheet)
Inscribed: in graphite, below platemark: *artist's
 proof (no edition) HAS 1951*; in brown pencil,
 l.r.: *HAS* 1951____
Watermark: *WARREN'S OLDE STYLE*
Worcester Art Museum, 1993.101

A mercurial figure among the Bay Area Abstract Expressionists, Hassel Smith brought humor and jazzy vitality to his abstract paintings. He was charismatic, outspoken, and peripatetic, and his knowledge of art history and aesthetic theory helped to make him a role model to students.

Smith was born in Sturgis, Michigan, on April 24, 1915.[1] His father was an advertising designer, who used his skills as a cartoonist in his work. As a teenager, he moved with his parents to San Mateo, California, near San Francisco. Smith returned to the Midwest in 1932 to attend Northwestern University, where he studied studio art and art history. After completing his bachelor's degree in 1936, he returned to San Francisco to enroll at the California School of Fine Arts (CSFA). He studied with Spencer Macky, Lee Randolph, and Maurice Sterne, who may have induced his brief interest in printmaking. Smith created a number of Social Realist lithographs and also experimented with linocut. When he received the Abraham Rosenberg Fellowship in 1940, he moved to Angels Camp in the Sierra foothills to work on plein-air landscapes.

Exempted from the draft during World War II, Smith worked for the Farm Security Administration in California in 1942 and as a timber scaler for the U.S. Forest Service in Oregon in 1943. When he returned to San Francisco, he lived in Maynard Dixon's old studio in the Montgomery Block, and frequented the bohemian bars and cafés of North Beach. Suspicious of authority, Smith was an avowed Marxist, who believed in the social responsibility of art. He experimented with politically charged Social Realist imagery and a roughly painted, proto-Pop style, featuring American flags and cigar-store Indians. Semiabstract landscapes made up his first solo exhibition in 1945 at the Iron Pot Café in North Beach.[2] After temporary teaching positions at San Francisco State College and the University of Oregon, Smith joined the CSFA faculty in 1948.

After seeing Clyfford Still's exhibition at the California Palace of the Legion of Honor in 1947, Smith began a gradual shift to complete abstraction. He forged a style that combined thickly layered fields of color with controlled pictographic calligraphy. His paintings have a sense of improvisation that came from the artist's enthusiasm for Dixieland jazz, as well as an affected naïveté and attention to technical virtuosity. Smith enjoyed the fellowship of his colleagues Elmer Bischoff, David Park, and Richard Diebenkorn and participated in their drawing sessions and studio visits. He and Diebenkorn had a joint exhibition at the Lucien Labaudt Gallery in 1949. An influential teacher, Smith was remembered for his eccentric, effective assignments, like the six-foot mountain of crumpled newspaper he made as a model for still-life drawings.[3] However, in 1952 he resigned from the CSFA, along with Bischoff and Park, in a dispute over staff cutbacks. He took students in his studio on Potrero Hill and then taught at the Presidio Hill School in San Francisco. Smith's painting became lighter at that time, and more spontaneous, with rapid, calligraphic daubs of color multiplied into masses. In 1955 the artist purchased a small apple orchard in Sebastapol, and nature and landscape influenced his painting. In 1957 he joined with Robert McChesney in the Sonoma Open-Air Art School near Petaluma. At that time biomorphic forms and erotic imagery appeared in his paintings, and a poetic sense is apparent in his provocative titles, often scrawled on the paintings in graffiti-like inscriptions.

In 1961 Smith's paintings were shown at the Pasadena Art Museum, and his first solo exhibition appeared in New York at the André Emmerich Gallery.[4] He taught at the University of California at Berkeley from 1963 to 1965, and at UCLA in 1965–66. Then the artist moved to England, where he taught at Bristol Polytechnic, the University of Cardiff, and the West of England College of Art. In 1967 Smith won an Award for Distinguished Service to American Art from the National Endowment for the Arts. In the 1970s the artist abandoned oil paint for acrylic, and shifted to a style of hard-edge abstraction. A retrospective exhibition of his painting was mounted at the San Francisco Museum of Modern Art in 1975.[5] Smith returned periodically to California for temporary teaching positions at the University of California at Davis, Berkeley, and at the San Francisco Art Institute. In 1988 he was artist-in-residence at the College of Notre Dame in Belmont, California, where an exhibition of his latest works appeared.[6] At that time he visited Magnolia Editions in Oakland to produce two color lithographs in collaboration with Donald Farnsworth. Painterly gesture had reappeared in Smith's work when he returned to the printshop in 1992, and he created a series of monotypes from spontaneous drawings on Mylar. Now retired, Smith lives in the village of Rode, near Bath, England.

This remarkable print was an unusual experiment, conducted at the CSFA in 1951. It is one of a few plates by Smith that were each printed in a handful of proofs, with changes to the plates between every impression so that they may be considered monotypes.[7] The artist's impulsive personality kept him away from the involved techniques of printmaking and the monotony of editioning. A like disregard for workshop custom is apparent in this innovative plate, which is more complicated than it first appears. Smith began by applying an aquatint ground to the plate, much of which he painted over with resist, shaping negative passages. He then bit the plate in stages, to create different shades of printed gray in the patches of tone at the upper left and in the spot in the lower right. In some manner, Smith distressed the printing surface at random; he may have placed the grounded plate face down on the floor, standing on it to force grains of sand and other detritus through the ground and allowing the acid to bite pits and blemishes. He created a passage of delicate tone in open bite across the bottom of the plate, painting acid directly onto the copper and allowing it to etch away and roughen the surface as it evaporated. Smith continued to build on this random imagery by scratching the plate in drypoint and sketching lines and scribbles haphazardly over the entire surface, varying their quality.

In its imagery this intaglio is quite close to Smith's contemporaneous paintings, in which open fields of color are modulated with different hues in organically detailed surfaces. Passages of aquatint and open bite in the print are parallel to the patches of color — often in closely related hues — that emerge between layers of roughly brushed overpainting. Smith's paintings of the period are indebted to the work of Clyfford Still, and in their color impact and understatement they also parallel early experiments in Color Field painting then conducted in New York. The extraordinary delicacy of this plate, and its search for imagery in the nature of the medium, also anticipates the experiments in France by Jean Dubuffet, who conducted extensive technical experiments in the later 1950s to understand the nature of lithography.

artist's proof (no edition) J/vr 1951

HANS HOFMANN

1880–1966

29. Composition in Blue, 1952

Screenprint touched with gouache on cream wove
paper, 74/120
43.2 x 35.8 cm (image)
48.8 x 42.9 cm (sheet)
Inscribed: in graphite, below image, left: *74/120*; in
brown ink, below image, right: *Hans Hofmann*
References: Long 1986, cat. nos. 31–32; Williams
1987, p.32; Acton 1990, pp.192–93.
Worcester Art Museum, Anonymous Fund,
1988.40

The only artist of the New York School to have
experienced the development of Modernism in
Europe firsthand, Hans Hofmann enjoyed a career
that spanned two artistic worlds. For many years
he was primarily a teacher, and he had a formative
influence on the American avant-garde in the
1930s and 1940s.

Hofmann was born on March 21,1880, in
Weissenberg, Germany, the son of a government
official.[1] At age six, he moved with his family to
Munich, where he proved to be an outstanding stu-
dent, excelling in music and science. In the late
1890s he worked as an assistant to the state direc-
tor of public works. He was fascinated by the basic
phenomena of physics, such as light and magnetic
waves, tone intervals in music, and the associa-
tions of color and form. He invented several elec-
tromagnetic instruments, and these interests
ultimately led him to art. In 1898 he enrolled at
Moritz Heymann's art school in Munich, where he
was a pupil of Willi Schwarz. Hofmann went to
Paris in 1903 and attended classes at the Académie
Colarossi and the Académie de la Grande Chaum-
ière. His work evolved from conventional represen-
tation to a more expressive style, incorporating
Paul Cézanne's concepts of space and the bright
colors of the Fauves. He met Picasso, Georges
Braque, and Henri Matisse and became friends
with Sonia and Robert Delaunay, who influenced
his understanding of color. Though he respected
the achievements of the Cubists, it was the work of
Henri Matisse that most affected him. Hofmann's
first solo exhibition was mounted at the Paul
Cassirer Gallery in Berlin in 1910. Five years later
the artist opened his own School for Modern Art in
Munich. Around 1929 Hofmann experimented with
a new reproductive process known as *Lichtdrucke*
that photomechanically transferred simple, hand-
drawn linear images to unsensitized paper. He

duplicated several of his drawings and signed
them as if they were editioned prints.

In 1930 the artist first visited the United States,
to teach at the University of California at Berkeley.
Two years later he became a permanent resident.
Soon afterward he opened the Hans Hofmann
School of Fine Arts in New York, and in 1935 he
began to offer summer courses in Provincetown,
Massachusetts. Hofmann's curriculum emphasized
the understanding of color and the visual dynam-
ics of movement. He taught students to build pic-
torial compositions from planar components, using
form and color to control positive and negative
space. He also valued technical skill and personal
expression. Through long experience Hofmann was
able to apply these precepts equally to representa-
tion or abstraction. In his own paintings of the
1930s, recognizable subjects progressively dis-
solved into colorful abstract experiments in formal
and spatial distortion. During the Depression and
World War II Hofmann's school struggled finan-
cially, but the attendance of government-subsi-
dized GI Bill students in the mid-1940s brought a
new vitality and stature to the institution.

Hofmann became an American citizen in 1941.
His first solo exhibition in New York appeared at
Peggy Guggenheim's Art of This Century Gallery in
1944.[2] Two years later the term Abstract Expres-
sionism was first applied to describe a show of the
artist's paintings at the Mortimer Brandt Gallery.[3]
Hofmann's solo exhibition at the Addison Gallery
of American Art in Andover, Massachusetts, in
1948 was accompanied by the book *The Search for
the Real and Other Essays*, which set forth his aes-
thetic theories.[4] In 1950 he participated in the
three-day artists' symposium at Studio 35 that
eventually evolved into The Club. Soon after a ret-
rospective exhibition of his paintings was mounted
at the Whitney Museum of American Art in 1957,
the artist retired from teaching to paint full time.[5]

In 1960 Hofmann was one of four artists whose
work represented the United States at the Venice
Biennale. Two years later a retrospective of his
work toured Germany, and the artist was named an
honorary member of the Akademie der bildenden
Künste. In the United States he received honorary
doctorates from Dartmouth College, the University
of California at Berkeley, and the Pratt Institute.
In 1963 the Museum of Modern Art presented a
retrospective exhibition of Hofmann's work, and
organized a circulating show of his paintings and
those of his students.[6] The artist remained active

until his death in New York on February 17,1966.

Composition in Blue, Hofmann's only screen-
print, grew out of a series of mid-size automatist
paintings on paper of the late 1940s that the artist
called his "free creations."[7] At that time, perhaps
in reaction to the work of Jackson Pollock, he made
impromptu sketches in poured and dripped paint,
working in response to the physical behavior of
the paint itself. Gradually, he replaced the poured
skeins of paint with paisleylike biomorphic forms,
drawn with a brush or crayon, complemented with
geometric and organic passages of color. This silk-
screen is essentially another of Hofmann's auto-
matist drawings, created in an unplanned session
in the printshop.

The artist made the print in collaboration with
Esther Gentle, one of his students in the early
1950s. The wife of the painter Abraham Rattner,
she ran a small studio where the works of well-
known artists were reproduced in silkscreen. She
persuaded Hofmann to visit her shop at 67 Grove
Street in New York and try his hand at screenprint-
ing. Using a brush loaded with lithographic tusche,
Hofmann drew directly on two printing screens,
improvising the design. He varied the application
of the ink, alternating rich saturated lines and dry
scumbled areas, apparently to test the resultant
effects.

Gentle then applied a layer of glue to the
silkscreen and used solvent to wash away the
greasy tusche, thus creating a stencil on the silk.
When printing the image, Gentle used many sepa-
rate layers of ink to mimic the physical effect of
India ink, gouache, and diluted wash painted on
paper. She systematically printed thick layers of
ink over translucent layers. The printer used seven
layers of ink — two of diluted brownish black, two
of black, and three of different shades of blue — to
create the appearance of a drawing in black and
blue. After printing the first screen with a semi-
transparent, brownish black, oil-base screenprint
ink, the silk was cleaned, and Hofmann made a
supplementary drawing in the background. This
screen was printed with a diluted greenish blue
ink, and succeeding screens alternated black line
and form with blue ground, each layer becoming
progressively more saturated and opaque. Finally,
Gentle printed a chalky layer of bright blue, with
water-soluble show card ink. Despite the compli-
cated steps of the printmaking process this print
captures the moment of its creation, preserving its
energy and spontaneity.

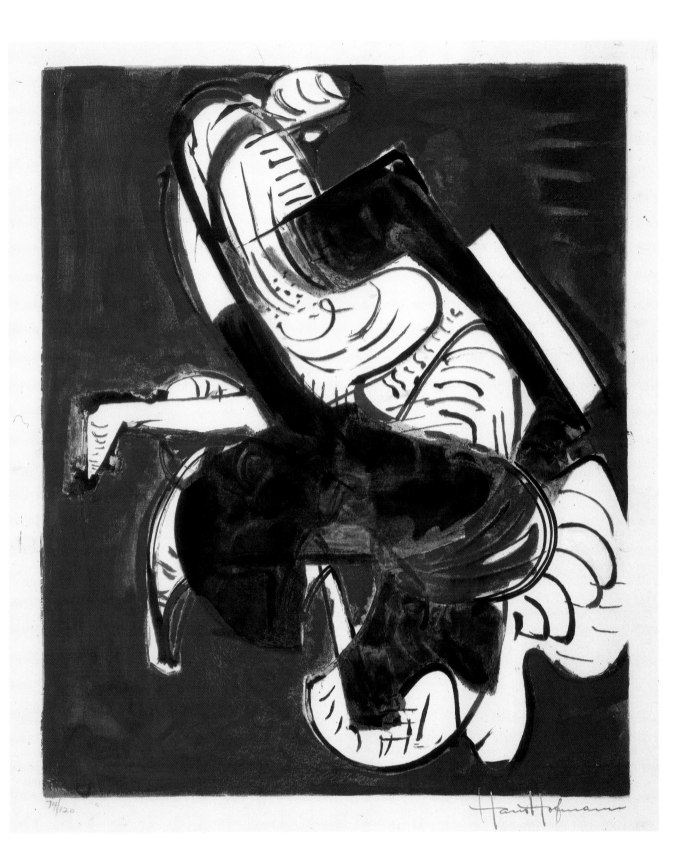

74/120 Hans Hofmann

LEON GOLDIN

1923–

30. In Limbo, 1952

Lithograph on cream wove paper, 8/8
38.1 x 52.9 cm (image)
42.5 x 57.1 cm (sheet)
Inscribed: in graphite, below image:
 In Limbo 8/8 Leon Goldin 52
Worcester Art Museum, 1996.112

The painter and teacher Leon Goldin was an innovative lithographer during the early 1950s, when his activities had an strong impact on printmaking in the Bay Area. The artist was born on January 16, 1923, in Chicago, where his father was a watchmaker.[1] As a young man he learned the fundamentals of lithography in a course at Hull House taught by Misch Kohn. In 1941 Goldin enrolled in the School of the Art Institute of Chicago (SAIC), where he was a pupil of Francis Chapin. However, his education was interrupted by World War II, when he served for two years in the Air Corps; he was then transferred to the Army and sent to Europe to fight in the infantry in France and Germany. After his discharge in February 1946, Goldin returned to the SAIC as a GI Bill student. Aside from his study of painting, he continued his work in lithography in classes with Max Kahn. "Instruction was given in the traditional manner employing the time-honored techniques of drawing with tusche and crayon. . . . Students went through the entire process, grinding the stone with Carborundum, making an image, etching the stone with a dash of nitric acid in gum arabic, rolling up the stone and printing on a hand crank press."[2] In 1947 Goldin's prints were first exhibited in the prestigious Brooklyn Museum print national exhibition. The following year, after completing his bachelor of fine arts degree, the artist enrolled in the graduate program at the University of Iowa to study intaglio printmaking with Mauricio Lasansky.

In 1950, after receiving his master's degree, Goldin moved to the Bay Area and began to teach painting at the California College of Arts and Crafts (CCAC) in Oakland. The next autumn he began to teach printmaking. In 1951 one of his still-life paintings was included in the exhibition *American Painting at Mid-Century* at the Metropolitan Museum of Art in New York. The following year he won a Fulbright Foundation Fellowship that enabled him to travel to France. His color lithographs were widely exhibited: in the Brooklyn Museum print national in 1952; in the exhibition *Young American Printmakers* at the Museum of Modern Art in 1953; and in the Third International Biennial of Contemporary Color Lithography at the Cincinnati Art Museum in 1954.[3] When he returned to Oakland in fall 1954, Goldin resumed his printmaking courses. Paintings comprised his first solo exhibition, mounted at the Oakland Museum in 1955, the year in which his prints were included in the Saõ Paolo biennial in Brazil. In the same year Goldin won the Prix de Rome, which enabled him to live and work at the American Academy in Rome for three years. During that time he concentrated on painting expressive landscapes inspired by the Italian countryside, works shown in a solo exhibition at the Galleria d'Attico in Rome in 1958.

When he returned from Italy in 1958, Goldin settled in New York, where his painting activities were supported by a Guggenheim Fellowship. His first solo exhibition in New York appeared in 1960 at Kraushaar Galleries, where the artist continues to show his work today. In 1961 Goldin joined the faculty at Cooper Union; in 1963 he taught a drawing class at Columbia University, and the following year he was appointed associate professor at Columbia. In the late 1960s the artist won grants and awards from the National Endowment for the Arts and the National Institute of Arts and Letters. He was chairman of the Columbia University art department from 1973 to 1975, and from 1977 to 1980. Since his retirement from teaching in 1991, Goldin has continued to work and exhibit. Today he divides his time between Manhattan and Deer Isle, Maine.

In Limbo is an example of the method of color lithography that Goldin perfected in the early 1950s and taught his students. Its distinguishing technical quality grew from necessity, for when the artist began to teach printmaking at the CCAC, he encountered practical problems with lithography. At that time, the school's printmaking studio was in a wooden frame building standing out in the blazing California sun. It was so hot inside that stones prepared with crayon and tusche clogged after printing just a few impressions, which was frustrating for students who were novices to this demanding technique. Goldin knew about the acid resistance of asphaltum since he had used it as an etching ground. He found that by drawing directly on the stone with an asphaltum solution, he could etch the printing surface more strongly than with traditional drawing materials and that stones thus prepared did not fill in so quickly. Goldin taught the students to paint their stones with an asphaltum solution comparable in its consistency to oil paint or enamel, providing them with immediate and satisfying results.

Goldin found too that this process worked well with the evolution method of color lithograpy, and he used a single counteretched stone to overprint several images in sequence with different colored inks. He made his own prints using this technique, and taught the process to his students. He had organized the CCAC printmaking program as an open workshop, based on the models of the Iowa print department and ultimately on Atelier 17. "The workroom was always open," the artist recalled. "As I did not have my own print facilities I did all of my own work in the print studio during off hours. The instructor and students shared ideas and watched each other at work."[4]

In the early 1950s Goldin worked in a semiabstract style in which settings and figures are obliquely suggested but seldom made explicit. Horizon lines and solar orbs often give Goldin's prints a sense of landscape, populated with cubistic figures. He used various methods of creating random patterns and tone on the lithography stone, subjugating these to his composition. The process of lithography and its unique visual effects are never allowed to take precedence over subject matter in his prints. The artist usually assigned poetic titles to his prints, which entice the viewer to subjective interpretations that can never be clear. Color is an important feature in Goldin's prints. The artist preferred unusual interstitial hues and balanced them exactly. Sometimes he purposely used dissonant combinations of colors.

The title *In Limbo* provides little help in the reading of this image. There seems to be a birdlike creature in the foreground, before a dark structure that may be a hill, or the crook of a tree above the ground. The sun in the sky, with sizzling heat radiating from it, seems to confirm this location. Perhaps this is a baby bird, younger than a fledgling, suspended in a branch above the ground. The bird is in a limbo between the ground with its earthbound predators, and the sky in which it will one day soar. Now, beneath the hot sun, it has only to wait for the arrival of its parent and grow. The viscid drips and swirls of asphaltum well suggest the tree bark and the straw and sticks making up the nest, and the painterly brushstrokes and scratches on the stone well suggest the chick's downy feathers. Its blank, naïve eye seems to stare ahead in half-consciousness as it stretches and flexes its wing.

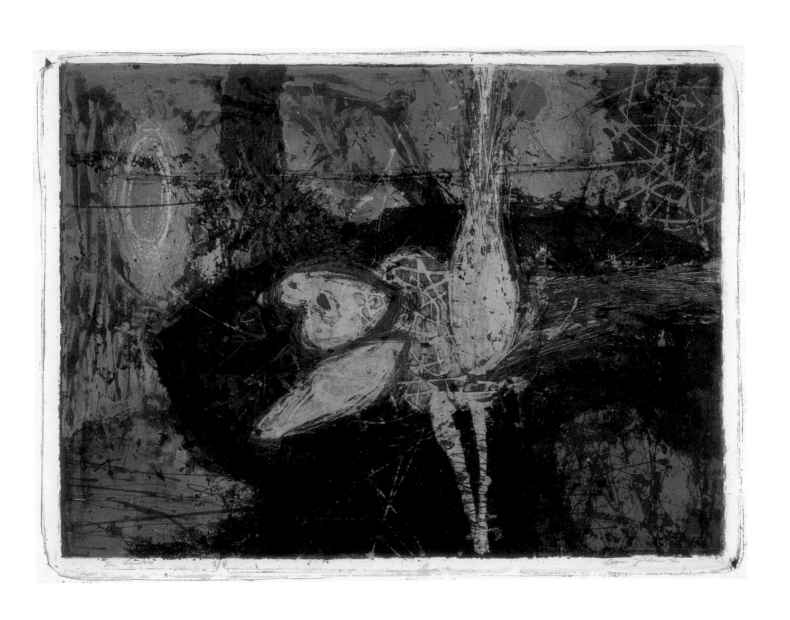

THEODORE BRENSON

1893–1959

31. Untitled, 1952

Etching printed as relief on cream wove paper
35.8 x 27.3 cm (plate)
58.5 x 45.1 cm (sheet)
Inscribed: in graphite, below platemark, l.l.:
 Theodore Brenson; in graphite on verso, along
 bottom edge: *APRIL 1952 EXHIBITED —*
 WASHINGTON WATERCOLOR CLUB 55TH *AN. EX.*
Worcester Art Museum, 1996.12.1

For most of his eventful career, Theodore Brenson
worked in the European academic tradition of the
peintre-graveur, creating illustrative prints. Late in
life he embraced the ideals and improvisatory
practice of Abstract Expressionism.

Brenson was born in Riga, Latvia, on November
27, 1893.[1] He began his studies at the Art School
of the City of Riga and later attended the University
of Moscow and the Imperial Academy of Arts in
Petrograd, where he received traditional academic
training as a painter and printmaker. During the
Revolution he escaped from Russia and settled in
Italy, where he established a career in Turin during
the 1920s as an illustrator of books on travel and
history. Brenson created the woodcut illustrations
for *Viaggo in Italia,* by Hippolyte Taine, published
in 1923. Afterward he published suites of etched
views of ancient Rome, and of Saint Peter's basil-
ica, inspired by the prints of Giovanni Battista
Piranesi. He exhibited his work with the Gruppo
Romano Incisori Artisti, and became a naturalized
Italian citizen. The artist also produced travel books
and illustrated histories of Naples and Calabria in
the late 1920s.[2]

In 1933 Brenson won a scholarship from the
French Direction générale pour les relations cul-
turelles and moved to Paris. There he established a
new career for himself as a portraitist for the liter-
ati. He recorded the likenesses of many leading
French authors and intellectuals of the day, includ-
ing Henri Focillon, André Maurois, André Gide, and
Paul Valéry.[3] Brenson was admired for his ability to
capture a sitter's personality. In Paris the artist
began to use lithography to illustrate his books on
travel and history. His designs appeared in nation-
al magazines, and his prints were included in
group exhibitions at the Bibliothèque Nationale.
Brenson's paintings of the period were chiefly
landscapes, done in a style influenced by Paul
Cézanne and Post-Impressionism, and they were
shown in the Salon d'Automne, the Salon des
Indépendants, and the Salon des Réalities. In 1938

he was awarded the title of Officier de l'Académie
by the French State.

Brenson left war-torn Europe in 1941 and
moved to New York. Connections within the intelli-
gentsia provided new subjects for his etched por-
traits, which included Robert Frost, Archibald
Macleish, and Mark van Doren.[4] His first American
exhibition was mounted in 1942 at the Fifty-eighth
Street Branch of the New York Public Library, and
included intaglio portraits of many of the world's
leading authors and intellectuals.[5] The artist
explored the northeastern United States, search-
ing for new subjects for landscape prints. He was
also a teacher, and operated the Theodore Brenson
School of Fine Art in New York. His paintings were
shown in the annual group exhibitions of the
American Abstract Artists, and the Federation of
Modern Painters and Sculptors.

During the 1940s Brenson associated with the
community of European intellectuals and avant-
garde artists in New York. Sometimes he visited
the experimental intaglio workshop Atelier 17, a
haven for artists in exile from the war, where
French was spoken and the ideas of Surrealism
and Automatism were discussed. Brenson began
to explore Modernist abstraction in his painting.
In 1949, the year he won a purchase prize at the
Brooklyn Museum print national exhibition, the
artist's first solo exhibition of paintings in New
York appeared at the Newcomb-Macklin Gallery.[6]
It included semiabstract American landscapes and
geometric abstractions. At that time, however,
Brenson had begun to experiment with gestural
calligraphy, informed by his interest in Chinese phi-
losophy and art.[7] Working on the floor, he painted
ink on paper and oil on canvas, placing broad,
immediate strokes of black across fields of white
and gray.

Brenson wrote the proposal for the First
International UNESCO Conference of Artists, held
in Venice in 1952, and he later served on several of
the organization's committees.[8] In the early 1950s
he taught at Wooster College in Ohio and at Man-
hattan College in New York. He was named chair-
man of the art department of Douglass College at
Rutgers University in 1954. The following year he
was the first American abstract artist named for
the Prix de la Critique in Paris. Brenson's mature
Abstract Expressionist style was reflected in easel
paintings, executed in oil with a wide brush in
broad, discrete strokes.[9] Myriad layers of gentle
curving lines, painted drily in unmodulated colors,
create effects of depth, movement, and transpar-

ency. After retiring from teaching in summer 1959,
Brenson went to work at the MacDowell Colony in
Peterborough, New Hampshire, and there he died
of a heart attack, on September 21, 1959.

The present print is similar in its striking, ele-
mentary design to Brenson's contemporaneous
paintings. In the early 1950s, the artist considered
a personal approach to Abstract Expressionism,
seeking his own distinctive voice. At that time he
experimented with Asian calligraphy, reduced his
compositions to bare essentials, and abandoned
color. He painted black and white canvases with
calligraphic zigzigs and spirals, simple linear
designs with twisting countermovements.[10] Like
crackling galvanic bursts, the opposing chevrons
in this print express the discharge of energy, a
momentary phenomenon occurring directly before
us on the picture plane. By contrast, the elliptical
spiral has duration, as its steady rotation draws us
back into undelineated space, which we sense
intuitively. For such an experienced printmaker,
this intaglio has a technical simplicity parallel to
its direct design. After grounding a copper plate,
Brenson rapidly drew lines with a broad, square
tool, like a chisel or screwdriver. He bit the plate in
the conventional manner, exposing it to the acid
for a long time and etching wide, deep incisions.
The artist then applied ink to the surface of the
plate, not to the intaglio grooves, and printed it as
he might a woodcut, using the color of the paper
to create white lines on a black field.

The products of immediate inspiration,
Brenson's black and white images represent primal
forces that we perceive intuitively. However, com-
pared with many Abstract Expressionists, the artist
had a different understanding of the sublime.
Brenson was a devout Catholic, and he seriously
considered how abstract art could convey truth in
a religious sense. This was an important pursuit
for Brenson, and he went so far as to exchange his
ideas with theologians.[11] While he contemplated
the role of art in Christianity, he was well aware of
the ancient Hebrew proscriptions against any rep-
resentation of perceived reality, even though art,
with its ability to delight and move the viewer,
played an important part in Judaic culture. Con-
sciously identifying eternal truth in the primary
forces of life, Brenson sought to translate it into a
visual language accessible to the functions of per-
ception and psychology, through the unconscious
process of his own creativity. He aspired to an
essential language of form that can make the
viewer more fully realize and experience life.

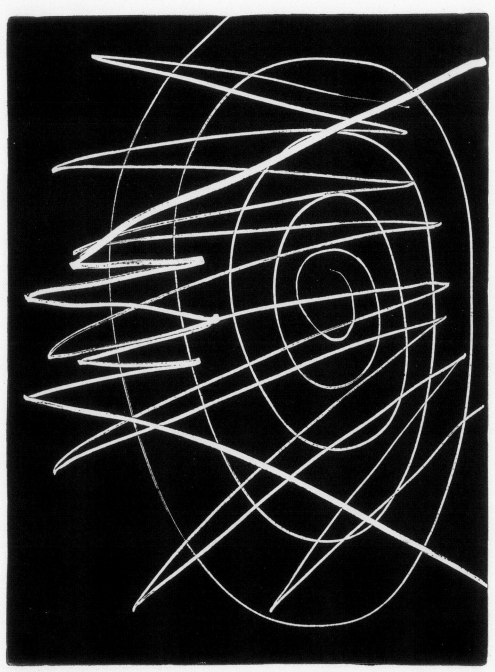

Theodore Roszak

HERMAN CHERRY

1909–1992

32. Deep Sea II, 1952

Soft-ground etching, etching, and aquatint on
 cream wove paper, 3/5
25.2 x 14.9 cm (plate)
29.4 x 27.0 cm (sheet)
Inscribed: in graphite, below platemark:
 3/5 Deep Sea II Cherry - 52
Worcester Art Museum, 1993.91

In addition to his activities as an artist, Herman
Cherry played an energetic role in the American art
world for half a century. He was a poet, critic, and
teacher, inveterate organizer, and resourceful busi-
nessman. In these activities he helped to shape
and perpetuate the New York School.

Cherry was born in Atlantic City, New Jersey, on
April 10, 1909.[1] He grew up in Philadelphia and
began his art studies as a schoolboy at a local set-
tlement house. In 1924 Cherry moved with his fam-
ily to Los Angeles, where he attended evening
classes at the Otis Art Institute. He dropped out of
high school in 1926 to take a job at Twentieth
Century Fox studios, where he worked in set pro-
duction, the poster shop, and even as an extra in
silent films. At the Art Students League in Los
Angeles he was a pupil of Stanton Macdonald-
Wright and painted in a style derived from Henri
Matisse. Cherry learned the history of art at that
time and became eager to see Europe. He signed
on to a freighter bound for Norway and jumped
ship at Hamburg. He spent almost a year without
passport or money exploring the city's churches
and museums. After working his passage back to
California, Cherry hitchhiked to New York in 1930.
At the Art Students League he studied with
Thomas Hart Benton, and assisted the painter with
his *Modern America* mural at the New School for
Social Research.

In 1931 Cherry returned to his studies in Los
Angeles. He worked at the Stanley Rose Bookstore
in Hollywood, and convinced the owner to let him
open a gallery on the second floor. In this space
Cherry exhibited the work of local artists, including
his friends Lorser Feitelson, Philip Guston, and
Reuben Kadish. Cherry mounted his first solo exhi-
bition at the bookstore in 1934. During the Depres-
sion he worked in both the easel painting and
mural divisions of the FAP/WPA in Los Angeles. In
1942 Cherry moved to New York, where he shared
an apartment with Joseph Meert. At that time he
painted in a robust Social Realist manner, influ-
enced by Benton. He worked as a costume and set
designer, and created the sets for Duke Ellington's

musical *Jump for Joy* in 1943. Cherry was the princi-
pal organizer of the First and Second National Art
Conferences in Woodstock, New York, in 1947 and
1948, which attracted artists, dealers, critics, and
museum professionals from across the country.[2]
His first solo exhibition in New York, mounted at
the Weyhe Gallery in 1947, featured amusing con-
structions that he called "Pictographs," made of
wire, metal, and glass, with moving parts.[3] He
exhibited a mobile in the Whitney Annual exhibi-
tion in 1947, and his next solo exhibition at the
Stable Gallery included sculpture and paintings in
a colorful style derived from Cubism. In 1948–49
the artist traveled in France and Italy with the sup-
port of a Guggenheim Fellowship.

In 1950 Guston introduced Cherry to The Club,
which he embraced with typical enthusiasm. The
ideas he encountered and the friends he made
there transformed his style.[4] After experiments
with Surrealist linear calligraphy, he progressed to
dark, painterly canvases in which passages of sat-
urated color jostle together to define shifting
space. In the late 1950s Cherry created a series of
energized gestural canvases that explore the mate-
rials of painting. He was a visiting professor at the
University of Mississippi at Oxford in 1956; over
the next twenty years he concentrated on teach-
ing, serving on the faculties of the University of
Minnesota and the New York Studio School. He
continued painting in the 1960s but withheld his
work from the galleries.

In 1975 Cherry devoted himself to poetry, and a
volume of his verse was published the following
year.[5] He executed several mural commissions in
the late 1970s, including paintings at Saint Mala-
chy's Church in Manhattan and at the Pomonok
Community Center in Queens. In 1984 a solo show
of his paintings was mounted at the City University
of New York Graduate Center. In the 1980s Cherry
painted large oils in which broad geometric forms
meet along electric blurred edges, achieved by
interweaving many layers of richly hued glazes.[6]
He used color to express mood and poetic titles to
ignite the viewer's experience. In 1989, to mark the
artist's eightieth birthday, a retrospective exhibi-
tion was organized by Ball State University in
Muncie, Indiana, and a show of his more recent
work at the State University of New York at Stony
Brook.[7] Despite the effects of heart and liver dis-
ease, Cherry continued to paint. An exhibition
including new work opened weeks before he died
at his Manhattan home, on his eighty-third birth-
day, in 1992.

In 1950 Cherry began working at Atelier 17 in

New York, and he worked there intermittently over
the next two years. He created mixed media
intaglios and lithographs that reflect his ranging
stylistic experiments during a transitional period.
His first prints depict semiabstract landscape and
figural compositions in a Cubist-related style; later
he made Abstract Surrealist etchings in a Miró-
esque style, as well as gestural lithographs.

One of Cherry's most technically sophisticated
prints, *Deep Sea* incorporates the full range of the
intaglio techniques practiced at Atelier 17. The
artist began by distressing the plate with a ham-
mer, creating a constellation of random spots. He
then covered the plate with soft-ground and used
the printing press to squeeze strawlike material
into the waxy resist, creating random tangles of
hairlike linear calligraphy. A hard aquatint ground
was applied next, and the plate was re-etched in
stages to create varied tonal passages. After
detailing the image with drypoint scribbles,
roulette, and a scorper or drill, Cherry pulled an
edition of ten impressions of the print he later
titled *Deep Sea I*. He wiped the plate carefully
while printing to take advantage of the paper color
as background. Then Cherry continued to work the
plate, burnishing, rebiting, and completely revising
the composition with new layers of aquatint. When
the artist editioned the print in its second state, he
employed dark plate tone and applied red ink with
the aid of a paper stencil cut from an impression of
the preceding state. Inking and printing the intaglio
in color was a tedious task, and Cherry printed
only five impressions.

The deep ocean, with its peculiar creatures and
altered gravity and light, was a common theme for
American Surrealists. Like Lawrence Kupferman's
Microscopic Creatures of the Ocean Deep, Cherry's
print seems to represent depths so extreme that
sunlight cannot penetrate. It is a dark, frigid realm
more like outer space than a marine ecosystem.
Strange animals swim through veils of drifting
plankton, their tendrils silently appearing from
mysterious darkness. In this image only the star-
like creature, with its bright fluorescent eye, seems
certainly animate. Inorganic elements and living
organisms comingle in this strange world, as in the
primeval soup that engendered life. The image has
no definite scale; we may be viewing great jellyfish
or microscopic organisms. Thus the artist evokes
for the viewer a contemplation of the nature of
life itself.

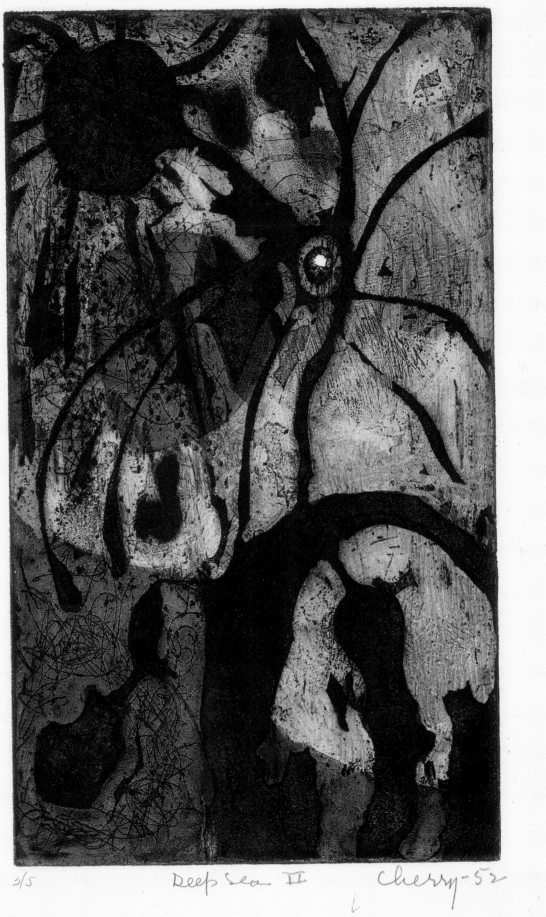

3/5 Deep Sea II Cherry-52

SONIA GECHTOFF

1926–

33. Untitled, 1952

Lithograph on cream wove paper
50.4 x 40.3 cm (image)
50.4 x 40.3 cm (sheet)
Inscribed: in graphite, l.r.: *Sonia Gechtoff '52*
Watermark: *Basingwerk Parchment*
Worcester Art Museum, 1996.12.6

Sonia Gechtoff was one of the most successful Abstract Expressionist painters of her generation in the Bay Area. The handful of lithographs that she created as a graduate student at the California School of Fine Arts (CSFA) exemplify the search for momentary inspiration and the spirit of experiment that characterized the style in the region.

The artist was born in Philadelphia on September 25, 1926.[1] Her father was the Russian-born painter Leonid Gechtoff, well known for his Expressionist landscapes and Futurist abstractions. When she was five years old, he encouraged her to work alongside him. Gechtoff majored in art at West Philadelphia High School and won a scholarship to continue her studies at the Philadelphia Museum School of Industrial Art. There she developed a Social Realist style influenced by the work of Ben Shahn. As a member of the Philadelphia Young Communist League, she also produced silkscreen posters in the League's artists' workshop in 1945.

After receiving her bachelor's degree in 1950, Gechtoff wanted a new start, far from the East Coast. She moved to San Francisco in 1951 and enrolled at the CSFA. Her first solo exhibition, at the Lucien Labaudt Gallery, included figural paintings in a Cubist manner derived from Max Weber. However, Gechtoff soon gravitated to the style of gestural abstraction that pervaded the CFSA, and her friend Ernest Briggs became her chief influence. Her paintings grew larger, and she applied thick daubs of paint in dynamic, torrential compositions. Sometimes, along with colleagues like Madelein Diamond and Julius Wasserstein, she attended the seminars given by Hassel Smith at his studio in Potrero Hill.[2] The painter James Kelly also associated with this circle of artists, but Gechtoff avoided him at first since he was also from Philadelphia. Eventually they met, became close friends, and were married in 1953. Gechtoff gained national recognition in 1954–55, when her paintings were shown in noteworthy group exhibitions in San Francisco, Los Angeles, and New York.[3]

When the artist's mother, Ethel Gechtoff, visited San Francisco, she was impressed by the art community and, having run a gallery in Philadelphia, was convinced of the potential for a new contemporary gallery. In 1955 Ethel Gechtoff moved to San Francisco and independently opened the East and West Gallery on Fillmore Street. She presented work by many Bay Area Abstract Expressionists, including the young artists Bruce Conner, Roy de Forest, and Jay De Feo. Both Gechtoff and Kelly occasionally exhibited in group shows at East and West Gallery.

In the late 1950s Sonia Gechtoff took flamelike shapes from the paintings of Clyfford Still and multiplied the motif in images suggesting quavering leaves or rivulets of flowing water. She applied paint with a palette knife, and her work reflects her interest in the sensuous qualities of the material. In 1956, when she was at work on a large canvas, Gechtoff read *The Mystery of the Hunt*, a poem by her friend Michael McClure. Since one stanza captured the ambiance she intended for her painting and inspired its completion, she adopted the poem's title.[4] These lines of verse accompanied the piece when it was shown in Gechtoff's solo exhibition at the M.H. de Young Museum in San Francisco. The notion of pairing a work of art and a poem intrigued Walter Hopps, and when he opened the Ferus Gallery in Los Angeles with an exhibition of her paintings, he hung other poems by McClure with the canvases.[5] Gechtoff taught painting and drawing at the CSFA in 1957–58. Her work appeared in prestigious exhibitions across the country, including the Carnegie International in Pittsburgh, the Whitney Museum annual exhibition, and *Seventeen American Painters* at the United States pavilion of the World's Fair in Brussels. However, after her mother died in July 1958, the artist no longer felt comfortable in San Francisco.[6] She and Kelly moved to New York, where she began showing her work at the Poindexter Gallery and teaching at New York University, where she remained adjunct professor of art for a decade.

In 1963 Gechtoff and Kelly each won an artist's fellowship to the Tamarind Lithography Workshop in Los Angeles. She transferred the imagery of her then current graphite drawings to her Tamarind prints.[7] Gechtoff created *6 Icons*, a suite of lithographs in which her featherlike motifs are rendered in delicate crayon hatchings and contained in architectural or altarlike enclosures. When she worked in the lithography studio, Gechtoff was pregnant with her second child, and weeks after returning to New York, she gave birth to Miles Tamarind Kelly.[8]

Gechtoff taught at Queens College from 1970 to 1974 and at the University of New Mexico (UNM) in 1974–75. She visited the Tamarind Institute in Albuquerque to make a print in early spring,[9] and contributed to the *2 x 3 > 7* portfolio of lithographs.[10] In the late 1980s she shifted her attention from drawing to painting in acrylic. In 1988 she was a visiting artist at the Vermont Studio School, and several temporary residencies followed, including positions at the School of the Art Institute of Chicago, Skidmore College, and Adelphi University. The artist returned to Skidmore as visiting professor in 1995, where the retrospective exhibition of her work *Four Decades, Works on Paper* was mounted.[11] Today Gechtoff and Kelly live in New York, where the artist continues to work, exhibit, and teach.

The present print was one of a few lithographs that Gechtoff made for a course at the CSFA in 1952 taught by Budd Dixon. Her friend Byron McClintock, who had studied lithography before, also assisted her with technical advice. Gechtoff's experimental lithographs are similar to her paintings of the period, in their painterly gesture and muted palette.[12] She drew on the printing surface with a brush and liquid tusche with no preconceived design or plan. Using her whole arm, she made straight, linear swipes up the middle and along the left side; then she drew a network of dynamic circular brushstrokes. Balancing the dense imagery in the lower left with open space diagonally opposite, Gechtoff suggested a structure with her calligraphy. This image evokes the frame of a ruined cathedral against a stormy sky, or the hulk of a sailing ship, and its skeletal structure and dark colors create a mood of foreboding. However, when Gechtoff printed these stones in different hues — using yellow ink in place of black, and purple instead of red — the mood became very different.

Like Dixon, Gechtoff exploited the look of lithography and valued the uneven inking of the brick red background. She touched the stone with blobs of purple and green ink, filling in some of the interstices of her drawing. Gechtoff's early prints were rough working impressions, like many created at the CSFA, smudged and stained in the commotion of the workshop. Years later, to remedy these defects she trimmed away the margins of this and others of her early prints, inadvertently emphasizing the Bay Area practice of printing to the edge of the lithography stone with its rounded corners and chipped edges.

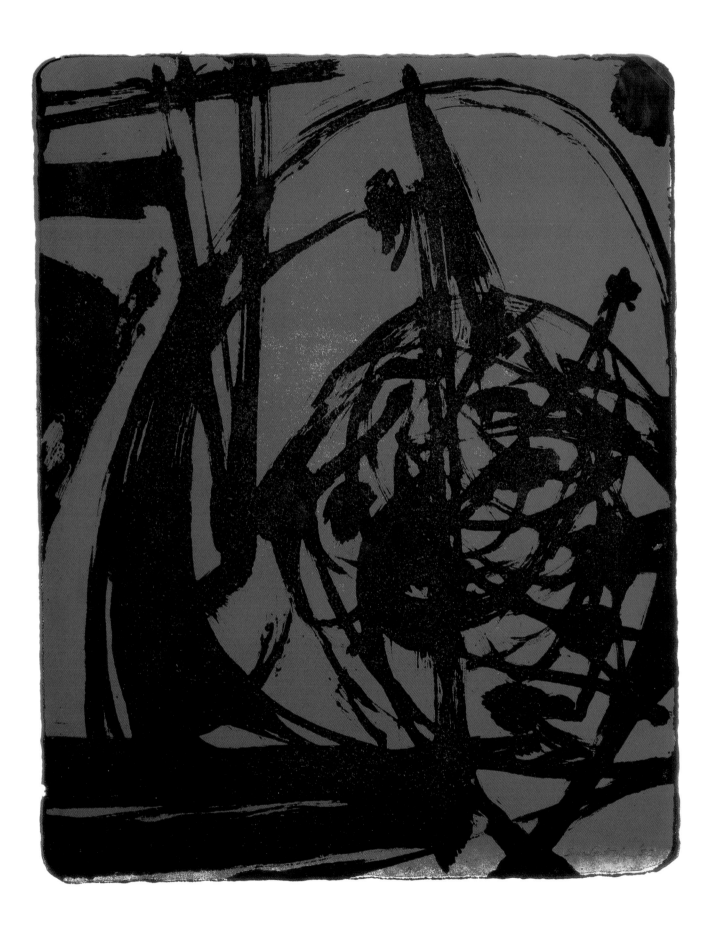

JAMES KELLY

1913–

34. August, 1952

Lithograph on cream wove paper, artist's proof
60.9 x 37.6 cm (image)
74.0 X 57.5 cm (sheet)
Inscribed: in graphite, below image: *A/P. "August"
J.Kelly '52*, in graphite on verso, l.c.:
LITHOGRAPH
Embossed: u.l.: *STRATHMORE ARTIST*
Worcester Art Museum, 1996.12.2

Ever determined to keep his work fresh, the painter James Kelly has transformed his style periodically throughout his career. In the 1940s he worked in a gestural abstract manner, and transferred his creative improvisations to his drawings and prints.

Kelly was born on December 19, 1913, in Philadelphia, the son of a shoe manufacturer.[1] He began art studies in 1937 in an evening class at the School of Industrial Arts. The following year he attended night courses at the Pennsylvania Academy of Arts, while working in his family's shoe factory in the daytime. In 1941 Kelly won a fellowship to study at the Barnes Foundation, where Angelo Pinto presented lectures on art history and aesthetic theory in front of works of art. This experience, and access to the work of artists like Vincent van Gogh, Picasso, Joan Miró, and Piet Mondrian galvanized Kelly's enthusiasm for painting.

Soon after the bombing of Pearl Harbor, Kelly enlisted and went to the South Pacific with the Thirteenth Air Force. As a technical sargent, he managed a shop that maintained autopilot navigation systems and the secret Norden bomb sight for B-24 aircraft. Discharged in 1945, he returned to Philadelphia, rented a studio, and began painting full time. The artist experimented with a variety of styles derived from his understanding of Picasso, Miró, and Mondrian, and he began working in hard-edge geometric abstraction. In 1950 Kelly went to California to join his friend, the Philadelphia painter John Lynch. He enrolled at the California School of Fine Arts (CSFA) in San Francisco, where like other GI Bill students who were mature artists, he was given his own studio and complete autonomy. He shared ideas with artist friends like Richard Brodney, Roy de Forest, and Knute Stiles and was influenced by the gestural abstraction still pervasive at the CSFA. Kelly began to paint sweeping oils of thick impasto,

applied with a palette knife, filled with pulsing rhythm and energy. Perhaps his best-known work of the period is his oil painting *The Last Days of Dylan Thomas* of 1953, in which a restricted palette concentrates the viewer's focus on its dynamic composition and painterly surface.

Kelly's first prints were experimental lithographs made at the CSFA in 1952. He also made a handful of gestural etchings, but he was not sympathetic to intaglio and pursued the technique no further. Kelly exhibited his work in local group shows. In 1953 he married Sonia Gechtoff and began a family. They lived on Fillmore Street, next door to Jay De Feo, Wally Hedrick, and Michael McClure, in a house that became a primary gathering place for artists. To support his young family, Kelly worked part-time in a photo-finishing laboratory and tended bar at The Place, a Grant Avenue gathering spot for artists and poets.[2] His first solo show was an installation of lithographs and paintings at The Place in 1954. Eventually Kelly took a full-time job as a preparator at the San Francisco Museum of Art, working with Julius Wasserstein. In the mid-1950s Kelly's painting became more physical, as he became more interested in the material qualities of paint. Solo exhibitions of his work appeared at the San Francisco Art Association Gallery and at the Syndell Studio Gallery in Los Angeles. In 1957 he taught painting and drawing at the University of California, Berkeley, and in the following year he won first prize for painting in the 77th Annual Painting and Sculpture Exhibition at the San Francisco Museum of Art.

In 1958 Kelly and Gechtoff moved to New York. His friend Richard Brodney helped him to get a job as a freelance designer for Grove Press, which was his chief source of income for the next five years. His painting became more colorful as he began incorporating figural references in the early 1960s. These works appeared in his first solo exhibition in New York at the Stryke Gallery in 1963. That summer both Kelly and Gechtoff were artist fellows at the Tamarind Lithography Workshop in Los Angeles, where he created fifteen editions, including the suite of color prints *8 from 9*.[3] In these works, scribbly passages of crayon and tusche are combined with heavily outlined forms, superimposed in a collage manner. Kelly's paintings in this style were exhibited at the East Hampton Gallery on Long Island. In the late 1960s the artist was drawn to the vivid hues of acrylic paint. Painting in a spartan, geometric style that had engaged him

twenty-five years before, he used glazes of transparent colors in stark juxtapositions. This style characterizes Kelly's lithographs in the *2 x 3 › 7* portfolio of 1974.[4]

In 1977 Kelly was awarded an artist's grant from the National Endowment for the Arts. The artist soon began reintroducing organic forms and gesture into his geometric compositions. He returned to oil paint, working more loosely, often in bright colors, as he began to employ recognizable figurative elements. In 1990 Kelly received a creative arts grant from the Peter and Madelein Martin Foundation to support his retrospective exhibition at the College of Notre Dame in Belmont, California.[5] Today Kelly and Gechtoff live in New York, where he continues to paint.

The present print was made at the CSFA, where Kelly made independent printmaking experiments in 1952–53. At that time the school printshop was a hive of activity, where faculty, independent artists, and students worked side by side. Wally Hedrick, David Simpson, Roy De Forest, Julius Wasserstein, Deborah Remington, and Sonia Gechtoff were among those working in the studio at that time. Kelly picked up the technique of lithography from friends and colleagues, having had no formal instruction in this process. It is not surprising therefore that his prints are technically elementary. However, this simplicity enhances their raw energy and their seizure of momentary inspiration. *August* is the only lithograph among his dozen or so early prints executed in multiple colors. Usually Kelly printed in a single color, like red, blue, or black. The printmaking process itself and its materials prompted the artist to make images more like his drawings of the time than his paintings. Rather than having complicated, overpainted scumbles and complicated depth, his prints are essentially simple linear improvisations with galvanic brushstrokes contrasting unmarked paper. This concentration on gesture encouraged Kelly's inclination to explore the nature of his materials. He drew with a solution of asphaltum, in a syrupy mixture that behaved like enamel. An example of this is the print *Zen Litho* of 1953, which combines these drips and splashes with bold calligraphy in simple geometric circles and bars, reminiscent of Japanese *zenga* brush painting. The use of asphaltum allowed viscid splatters and drips, with which Kelly made automatist drawings that depended on chance and the behavior of the paint.

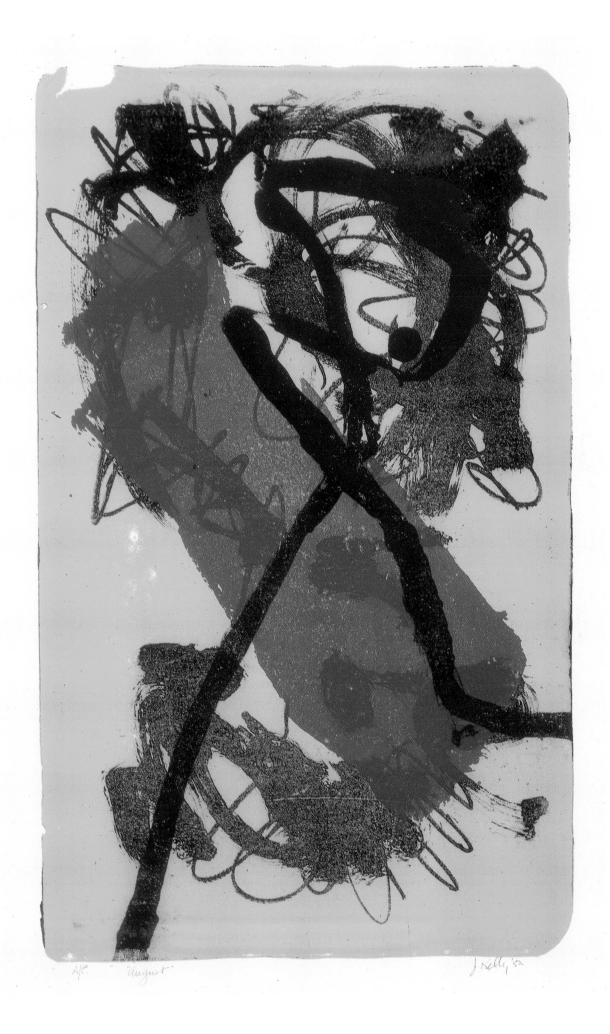

A/P "August" J. Kelly '53

DAVID SMITH

1906–1965

35. Don Quixote, 1952

Lithograph, touched with India ink on cream wove
 paper, edition of 30
45.5 x 60.6 cm (image)
61.2 x 74.5 cm (sheet)
Inscribed: in pen and India ink, in image, ul:
 (reversed); in pen and India ink, below
 platemark: *Greetings J-F. from David Jean &
 Rebecca and to artist circle David Smith Don
 Quixote E37 — 1952*
References: Schwartz 1987, no. 30; Graham 1987,
 p.56.
Private collection

In his sculpture of the 1950s, David Smith embodied many of the aesthetic and formal concepts of Abstract Expressionism. In that phase of his career, the artist occasionally transferred his inventive and personal vision to printmaking.

David Roland Smith was born on March 9, 1906, in Decatur, Illinois.[1] As a teenager he moved with his family to Paulding, Ohio, and he attended Ohio University in 1924–25. The following year he studied at Notre Dame University while working in the Studebaker automobile plant in South Bend, where he learned industrial metalworking. After attending George Washington University and working in a bank for a year, Smith moved to New York. He met Dorothy Dehner,[2] who introduced him to the Art Students League. There he studied painting with John Sloan and Jan Matulka and made his first prints in a class taught by Allen Lewis.

Smith and Dehner were married on December 24, 1927, and settled in Brooklyn. Their circle of friends included the artists John Graham, Arshile Gorky, Adolph Gottlieb, and Mark Rothko. Graham introduced Smith to African sculpture, and the latest European trends. When he showed Smith reproductions of sculpture by Picasso and Julio González, the young artist realized that he could use his metalworking skills for fine art. In 1929 Smith and Dehner bought a farm near Bolton Landing, in upstate New York. In 1931 they lived for several months in the Virgin Islands, where he created small constructions from found wood and coral. Two years later he began working at Terminal Iron Works, a machine shop on the Brooklyn Waterfront, and he set up his own shop in a shed at Bolton Landing. Smith's early metal sculptures are small, ranging from iron constructions with found objects, to relief plaques in cast bronze and aluminum.

From 1935 to 1936 Smith and Dehner traveled in Europe. In Paris their friend John Graham introduced them to Paul Éluard, André Breton, and Stanley William Hayter, and Smith made an etching at Atelier 17. The artist began a series of fifteen cast bronze medallions in 1937, titled *Medals for Dishonor*.[3] At that time he worked in the sculpture division of the FAP/WPA and developed his style from a wide range of sources, from Egyptian tomb sculpture to Picasso. The first solo exhibition of his work, mounted at the Willard Gallery in New York in 1938, included drawings and sculpture. When Smith and Dehner moved to Bolton Landing in 1940, he worked as a machinist in Glen Falls, then as a night-shift metalworker at the American Locomotive Company in Schenectady, while producing his own sculpture at his studio, now called Terminal Iron Works. Smith's work was included in the Whitney Museum annual exhibition in 1941 and the *Artists for Victory* exhibition at the Metropolitan Museum of Art in 1942. At that time he bought a used printing press and occasionally made etchings. Smith's sculpture became larger and more abstract during the 1940s, with recurrent forms, like a bird-fish-fetus and a phallic gun shape, that possess layers of significance. Solo exhibitions of his work appeared in New York at the Willard and Buchholz Galleries in 1946, and a retrospective show was circulated by the American Association of University Women the following year.

From 1948 to 1950 Smith taught at Sarah Lawrence College in Bronxville, New York. He won a Guggenheim Fellowship in 1950–51, which enabled him to concentrate on his work. Over the next few years he taught in temporary positions at Bennington College in Vermont, the University of Arkansas in Fayetteville, and the University of Mississippi in Oxford. After Smith and Dehner were divorced, the sculptor married Jean Freas. At that time he began to install his sculpture in the fields at Bolton Landing. In 1957 a retrospective exhibition of Smith's work was mounted at the Museum of Modern Art.[4] The following year his sculpture represented the United States at the XXIX Biennale in Venice, and an exhibition of his work was featured at the fifth biennial in Saõ Paulo, Brazil, in 1960.[5] In the early 1960s Smith executed the monumental sculpture for which he is best known. Intended to be seen in the open, these works have an unstable, dynamic quality that contradicts their density. During the 1960s the artist received international recognition. In 1962 he went to Italy, where he was commissioned by the government to create sculpture for the Fourth Festival of Two Worlds in Spoleto. In 1964 Smith received the Creative Arts Award from Brandeis University, and the following year President Johnson appointed him to the National Council of the Arts. Smith died in an automobile accident in Vermont on May 23, 1965.

Smith's most famous print, *Don Quixote* was his first lithograph done at Margaret Lowengrund's workshop in Woodstock, New York, in summer 1952.[6] Michael Ponce de León had just been hired as workshop assistant, and though a skillful intaglio printer, he had only Lowengrund's brief explanation of the process of lithography. He was alone at the shop on the second morning of his job when Smith arrived. The artist was anxious to start work, and the assistant was too embarrassed to admit his ignorance. "With a great deal of camaraderie and beer drinking we began to print from the first stone," Ponce de León later recalled. "We had no running water in the workshop, so David suggested that rather than . . . bring in water [from the brook outside] we should use beer, of which we had several packs."[7] When Lowengrund arrived, she was dumbfounded to find the first edition of *Don Quixote* printed and gave Ponce de León a scathing reprimand.

Smith spontaneously drew his image on the stone with a brush and liquid tusche. Several vertical drips show that he used thin pigment and propped the stone up to make his drawing. The artist's rapid, painterly lines with their knobby terminals create an energized rhythm. *Don Quixote* is similar in style to Smith's contemporaneous brush and ink drawings, in which he noted ideas for pierced standing sculpture.[8] His lines have an additive quality parallel to the modeled character of wax or clay that is later cast into bronze. The artist skillfully used this ragged quality to characterize Cervantes's picaresque hero with pathos. As his emaciated horse stumbles in the rocks, Don Quixote falls to the ground, bracing himself with his right hand and shield. His saddle, in a shape echoing the knight's body and the horse's head, flies out beneath him. As the knight's legs fly up, the rowels on his spurs seem to twirl and jingle, recalling the spinning windmills that he jousted. This is an impression of the second state of the lithograph, in which Smith scraped out the insides of many of his lines, animating the image and imparting a sense of hollow frailty.[9] As in many impressions of this print, the artist added finishing touches with India ink. Written in ink in the disc of the sun at upper left are the Greek letters $\Delta\Sigma$, Smith's normal manner of initialing his drawings at that time. However, they are backward, seemingly in a visual pun on the reversal of the image that occurs in the printing process.

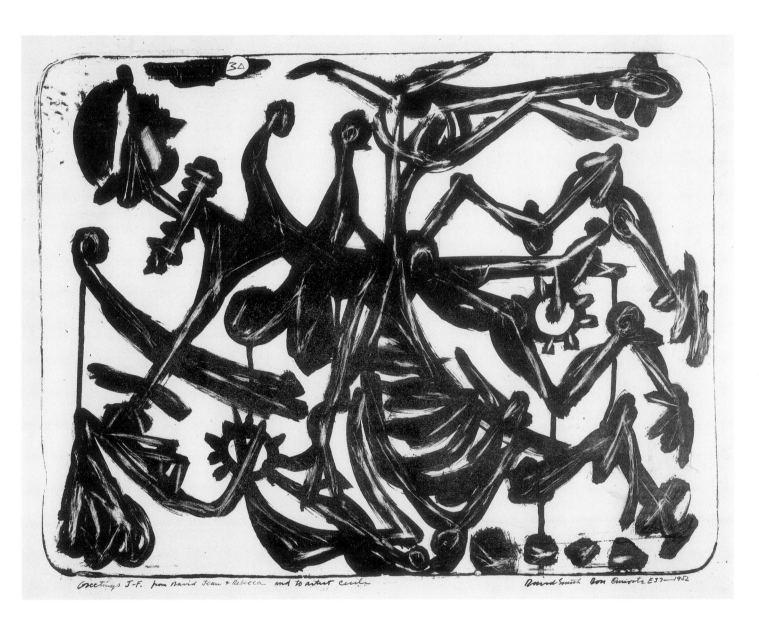

SYLVIA WALD

1915–

36. One; Another, 1952

Screenprint on cream wove paper, 18/22
54.5 x 38.9 cm (image)
66.5 x 47.9 cm (sheet)
Inscribed: in screen, l.r.: *Sylvia Wald*; in pen and
　　black ink, below image: *"One; Another" 18/22
　　Sylvia Wald '52*
References: Acton 1993, no. 38
Worcester Art Museum, 1997.178

During the 1950s the leading innovator of screen-
print in New York was Sylvia Wald. She used this
medium to explore fresh visions and new limits of
scale, combining the inspiration of nature with the
immediacy of Action Painting.

Wald was born on October 30, 1915, in Phila-
delphia, where her father was an attorney.[1] She
began her studies of art in 1931 at the Moore
Institute of Art, Science and Industry. After gradu-
ating in 1934, she taught art in elementary
schools. When her father died in 1937, Wald hitch-
hiked to New York to pursue her dream of becom-
ing an artist. She found another teaching position
in a program funded by the FAP/WPA, which
enabled her to concentrate on painting anecdotal
images of everyday urban life in a personal, Social
Realist style. In 1939 the artist won the third
annual competition sponsored by the American
Artists Congress, the award for which was a solo
exhibition at the ACA Gallery.[2] With the encourage-
ment of the gallery staff she set out to learn the
technique of silkscreen. After attending a demon-
stration presented by the artist Harry Gottlieb,
Wald began to make her own screenprints, repro-
ducing the designs of her earlier paintings, and
she soon progressed to original silkscreens.[3] Two
of Wald's prints were included in the groundbreak-
ing exhibition of artists' silkscreens at the Spring-
field Museum of Fine Arts in 1940. She joined the
National Serigraph Society in New York and regu-
larly exhibited at their gallery.

In 1942 Wald married Alter Weiss, an Army
physician, and she accompanied him to his posting
to Nichols General Hospital in Louisville, Kentucky.
There she established a friendship with Justus
Bier, head of the art department at the University
of Louisville, whose admiration for her work is
apparent in his reviews of her exhibitions.[4] In 1945
solo shows of Wald's work were presented at the
University of Louisville and at Kentucky State
College in Frankfort, which featured representa-
tional and semiabstract prints. In 1946 Wald and
her husband returned to New York where her style
evolved more quickly toward abstraction, influ-
enced by the currency of Abstract Surrealism in
New York. In 1949 a solo exhibition of Wald's paint-
ings and prints was mounted at the Allen R. Hite

Art Institute at the University of Louisville.[5]

In 1949 Wald and Weiss began to vacation near
Croton-on-Hudson, New York, where they pur-
chased a cottage three years later. There the artist
experienced nature as never before, and its influ-
ences appear in the style and technique of her art.
At that time she pushed the medium of screenprint
to fresh imagery and expressive fluency. Her prints
became larger, more painterly in their execution,
and subtle in their coloration. In early 1951 Wald's
innovative prints were exhibited at the Serigraph
Gallery in New York, and her screenprint *Metamor-
phosis* won a purchase prize at the prestigious
Brooklyn Museum print national exhibition.[6]
Around 1958 Wald created a series of remarkable
calligraphic screenprints that capture the imagery
and energy of gestural painting more than any
other works in the medium. The artist painted
rapid, scribbled lines directly on her screens and
thinly printed these images in several layers of
translucent color. Her titles for these prints — like
Onset, *Departure*, and *Arrival* — emphasize con-
cepts of progression. This was the style that occu-
pied the artist when she began to experiment with
woodcut around 1961. Wald used a brush to draw
directly on the surface of the plywood, in bold,
unpremeditated strokes; she employed the same
spontaneity when carving the plywood blocks, and
in printing them on strong, supple leaves of mul-
berry fiber paper. One of just a few of Wald's wood-
cuts to be printed in colors, *Black Moonlight* (fig. 1)
is reminiscent of her calligraphic screenprints in its
bold design and energy.[7]

After the death of her husband in 1963, Wald
took new directions in her life and her career. She
traveled abroad for the first time, and afterward
shifted her concentration to sculpture. She worked
in wire and plaster and made assemblages using
cord, paper, and found organic materials. This led
to experiments with paper collage. She occasion-
ally made screenprints of the 1960s, which reflect
her ideas and experiences in other media. In 1967
a solo exhibition of Wald's sculpture, painting, and
prints was mounted at the New School for Social
Research in New York.[8] In 1996 a solo exhibition of
her sculpture and prints was presented by at the
Dong-Ah Gallery in Seoul, Korea.[9] The artist lives in
New York with her husband, the Korean painter Po
Kim, and concentrates her work on sculpture.

The present print is one from a series devel-
oped from Wald's study of nature at her country
retreat at Croton-on-Hudson. In 1952 she built a
garden, and began sketching there and in the
nearby woods, drawing on quiet observations of
plants, animals, and changing weather. Later in the
studio she developed her sketches into a series of
prints, including the present silkscreen, inspired
by natural cycles of growth and decay. In *One;*

Figure 1.　Sylvia Wald, *Black Moonlight*, 1961.

Another the dull, mottled background suggests
surfaces of rock, moss, or leaf mold on a forest
floor. Several curvilinear forms jostle against and
over each other, like drying leaves that randomly
settled there. Their ambiguous shapes suggest the
natural forms and textures of a seed pod, insect
carapace, or shards of tree bark. One prominent
form evokes the wings and body of a moth. At that
time, butterflies and moths were favorite subjects
of the artist. Among her other screenprints of 1952
are *Chrysalis* and *Metamorphosis*, images of the
life cycle of a butterfly in dynamic compositions
implying change and growth. The overlapping
shapes of the present print, placed in such a way
that suggest a floating descent to their resting
place, also evoke movement and the natural cycles
of decomposition and fertilization.

Wald usually began preparation of her printing
screens with large forms made from paper stencils,
then added linear details with the tusche-and-glue
technique. Rather than commercial screenprinting
inks, she preferred oil paint. Her most usual and
striking printing effects were the veiny impasto
textures that stood out on the surface of the
sheets. These organic patterns and textures were
unique and unprecedented in editioned artists'
screenprints. Wald first used these textural effects
in the mid-1940s, yet the dendritic patterns were
perfectly suited to the content of her nature-
inspired prints of the 1950s such as this. They were
the product of the disorder of natural chance,
evoking the organic irregularity of nature and in,
this case, the protruding veins in a moth's wings.
To create the impasto patterns, Wald combined oil
pigments with a large amount of gel medium, and
she purposely used unevenly blended mixtures of
paint and gel to achieve ghostly, modulated scrims
of color. Experience taught the artist how to push
this viscid emulsion through the silk and to manip-
ulate it with the squeegee, so that when she
pulled the screen away from the surface of the
sheet the medium was drawn up in random pat-
terns of peaks and ridges.

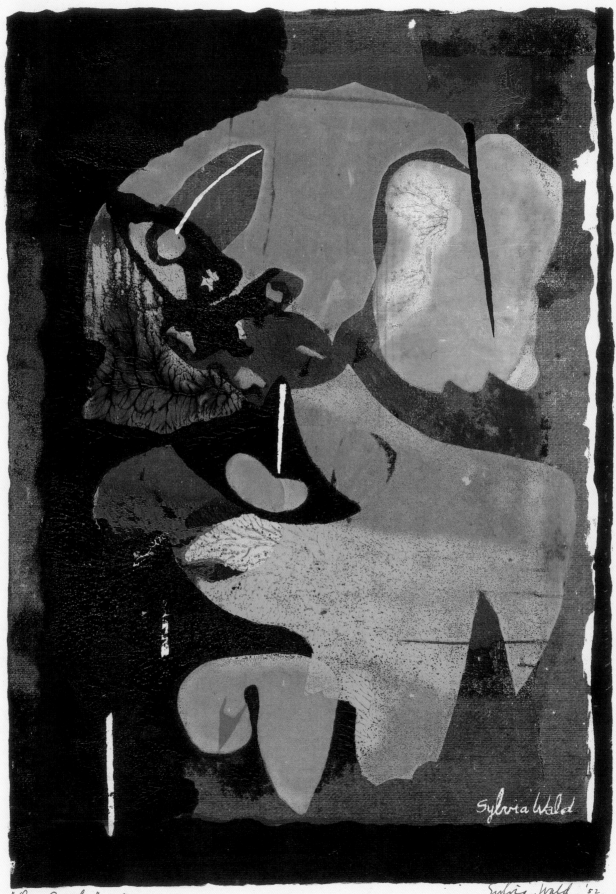

"One; Another" 18/32 Sylvia Wald '52.

JAMES BUDD DIXON

1900–1967

37. Untitled, 1953

Soft-ground etching and drypoint on cream wove
 paper, 5/6
12.4 x 9.9 cm (plate)
31.2 x 25.2 cm (sheet)
Inscribed: in pen and blue/black ink, below
 platemark: *5/6 James Budd Dixon*; in graphite,
 lower margin: *James Budd Dixon* ——
Watermark: *WARREN'S OLDE STYLE*
Worcester Art Museum, 1993.9

Best known today as a painter, Budd Dixon was
also an innovative printmaker in the Bay Area in
the early 1950s. As a teacher at the California
School of Fine Arts (CSFA), he influenced the work
of other students and colleagues.

Dixon was born on November 26, 1900, into a
wealthy San Francisco family.[1] He was named after
his great uncle, James H. Budd, who was the gov-
ernor of California in the mid-1890s. He grew up on
his father's prosperous farm in the San Joaquin
Valley near Stockton. At age thirteen he inherited
an aunt's fortune, most of which was lost through
his stepfather's mismanagement. Nevertheless, in
1920 Dixon took his Stutz Bearcat roadster to col-
lege at the University of California at Berkeley,
where his style was said to rival that of William
Randolph Hearst, Jr. When he enrolled at the CSFA
in 1923, he worked as an illustrator in a style
derived from Art Nouveau.[2] By 1930 he had shifted
to watercolor landscapes of northern California
and views of San Francisco.

In the mid-1930s Dixon worked on the FAP/WPA
in San Francisco with the sculptor Beniamino
Bufano. He was art director at Moore Machinery in
San Francisco in 1935–36, and his work appeared
regularly in the annual exhibitions of the San
Francisco Art Association. At that time he became
acquainted with European Modernism, perhaps
through his friends Clay Spohn and Reuben Kadish.
Dixon's watercolor experiments combining the
influences of Cubism and Surrealism made up the
first solo exhibition of his work at the San Francisco
Museum of Art in summer 1939. During World War
II he worked as a shipyard draftsman at Bethlehem
Steel in San Francisco, and from 1943 to 1945 he
served in an Oakland Army cargo planning unit.

Dixon was deeply impressed by the exhibition
at the San Francisco Museum of Art of paintings by
Jackson Pollock. Their energy and emotion moved
him to seek the same impact from similar means,
and he began painting loosely, combining thick

impasto and thin glazes. In the late 1940s Dixon
collected Polynesian and Oceanic art, and became
interested in tribal music. Simple symbols and pat-
terns from ethnographic art, like hatchings,
zigzags, and spirals, often give his paintings an
eerie, totemic presence. Despite their apparent
immediacy, his paintings were thoughtfully refined
over extended periods. He painted in the store-
front studio at 700 Lombard Street in North Beach,
where he moved in 1946 with his wife, Peggy
Nelson Dixon, a newspaper illustrator.

In 1948 the artist returned to the CSFA,
enrolling as a GI Bill student so that the school
could collect the government subsidy. When
Abstract Expressionism flourished there, he asso-
ciated with the group of advanced students who
came to be known as the Sausalito Six. His work
was included in their group exhibitions at the
Contemporary Gallery in Sausalito, at Reed College
in Oregon, and *Sixteen Lithographs* at the Lawson
Gallery in San Francisco. He contributed two prints
to the landmark *Drawings* portfolio of offset litho-
graphs.[3] Dixon's interest in intaglio printmaking
coalesced when he worked with Stanley William
Hayter at the CSFA in summer 1948. He also exper-
imented with stone lithography, probably working
with Ray Bertrand in the CSFA printshop.[4] His early
lithographs have the tribal imagery and smoky
mystery of his paintings, and he explored the tonal
delicacy of lithography by rubbing and blending
tusche and crayon on the printing surface.

In 1949 Dixon joined the CSFA faculty as an
instructor of printmaking, and he helped facilitate
the intaglio experiments of his friends Walter
Kuhlman and George Stillman. As a teacher he
influenced another generation of artists at the CSFA
in the early 1950s. Roy de Forest, Sonia Gechtoff,
David Simpson, Deborah Remington, and Julius
Wasserstein were among many devoted students
who adopted his preference for interrogative
experiment over technical elegance. He was a pas-
sive teacher, providing little more than technical
demonstrations at the beginning of term. Though
he was seldom in class, he was available for con-
sultation at the Buena Vista tavern or in his street-
corner studio, which became a gathering place.

In his paintings of the 1950s Dixon replaced his
linear vocabulary with layers of thick impasto.
Vivid accents seem to percolate from beneath the
surface of his canvases, like magma from the cen-
ter of the earth. This brutal style appealed to
Michel Tapié, the Parisan critic and champion of
Art Autre, an international postwar style of primi-

tive expressionism. He included Dixon's paintings
in group exhibitions and promoted his reputation
in Europe and in Japan.[5] From 1961 to 1965 the
artist taught painting at the San Francisco Art
Institute (formerly the CSFA). His health deterio-
rated gradually from the effects of alcoholism, and
he died in San Francisco on December 1, 1967.[6]

The present print exemplifies Dixon's intaglios
of the early 1950s, and reflects the resonating
influence of Stanley William Hayter. The English
Surrealist taught at CSFA in 1940, when his first
American solo exhibition appeared at the San
Francisco Museum of Art. When Hayter returned to
the school to teach again in summer 1948, Dixon
served as his studio monitor.[7] He was interested in
Hayter's notion of the printshop as an open, exper-
imental laboratory, but he lacked the patience
required to master the burin. Dixon's intaglios are
small plates that mingle calligraphic line and com-
plex patterns. There is not a straight line to be
found in this plate, which has the rugged, shaggy
look of Dixon's paintings and their primitive,
instinctive quality. However, intricate correlations
of line and shape, superimposition and trans-
parency make up the deceptively simple composi-
tion. Curving lines and shifting patterns evoke
natural textures, and overlapping forms create an
illusion of depth and impart the sense of slow,
fluid movement.

For this image the artist used soft-ground etch-
ing as an easy way to create patterns. This tech-
nique was typical of Atelier 17 in the 1940s, where
many artists used lace and other fabric to create
complex textural effects. After plotting his compo-
sition with a few drips of resist on its perimeter,
Dixon protected the copper plate with a soft waxy
substance, impervious to acid but malleable at
room temperature. He pressed torn bits of paper
into this soft-ground and a wad of strawlike
strands, perhaps fibrous Excelsior packing mater-
ial. Then he added netting and scraps of coarse
fabric and, it appears, a sheet of sandpaper. He
probably squeezed this sandwich in the press to
push the materials well into the soft-ground; when
removed, they peeled away the sticky ground that
adhered to them, exposing the bare metal plate.
Dixon bit the plate in acid, and the varied textures
of the objects were etched in. Finally, he scratched
the plate in random drypoint lines that follow the
basic forms of the composition and soften transi-
tions to the areas initially treated with resist. He
inked the plate in a conventional manner and was
not too careful in wiping and printing the plate.

5/6 James Budd Dixon

ALBERT URBAN

1904–1959

38. Untitled, 1953

Screenprint with oil paint on cream wove paper,
5/15
62.2 x 79.3 cm (image)
66.3 x 83.8 cm (sheet)
Inscribed: in India ink, in image, l.r.: *Albert Urban*
 53.; in graphite, in image, l.r.: *5/15*
Worcester Art Museum, 1996.113

In the late 1940s Abstract Expressionism pro-
foundly affected the work of Albert Urban. While
forging a new, personal painting style, he experi-
mented with new ideas of composition, form, and
color in screenprints that are remarkable in their
technical innovation.

Urban was born on July 22, 1909, in Frankfurt-
am-Main, Germany.[1] He began his studies of art as
a teenager at the Frankfurt Kunstschule, where he
was a pupil of Max Beckmann, Vincent Cissarz, and
Willi Baumeister. Semiabstract Expressionist paint-
ings comprised the first solo exhibition of his work,
mounted at the Schneider Galleries in Frankfurt
when he was nineteen years old. After graduation,
he joined the Kunstschule faculty, and a solo show
of his paintings appeared at the Frankfurt Kunst-
verein. In the mid-1930s Urban was among the
modern artists condemned by the Nazis, who
confiscated his work and included examples in the
infamous *Degenerate Art* exhibition in Munich in
July 1937. He was expelled from Germany during
the Third Reich. After spending a year in London,
his immigration to Philadelphia was sponsored by
the Quakers in 1940.

Urban eventually settled in New York, where he
continued to paint and exhibit. In the early 1940s
he produced original color silkscreens, working
alongside his wife Reva, who used the process to
reproduce the paintings of modern artists from
Claude Monet to Georgia O'Keeffe at their studio
Écran Urban, on Tenth Street in Greenwich Village.
Urban's first solo exhibition in New York, mounted
at the Weyhe Gallery in 1944, included both
screenprints and heavily-painted canvases that

combined Beckmann's expressive content and
bright palette with heavily outlined forms reminis-
cent of Georges Rouault.[2] Urban's wide ranging
musical interests were reflected in his works of the
mid-1940s, not only in their ostensible subjects of
instruments and operatic sets, but in their rhythms
of color and form.[3] The artist exhibited his semiab-
stract paintings and prints at the Kleeman Gallery
through 1948. At that time, impelled by Abstract
Expressionism, he began a period of reevaluation.
The artist sequestered himself in his studio and
conducted painting experiments that he shared
only with his closest friends. However, some sense
of his evolving work is reflected in the screenprints
he continued to produce, reflecting dark, simpli-
fied compositions with spare linear calligraphy. In
1955 Urban and his wife refurbished and reopened
their studio as Ganymede Gallery, exhibiting their
own, earlier work, and that of a group of gallery
artists including Felix Pasilis and Allen Kaprow.[4]

Urban's new work was unveiled at a solo exhi-
bition at the Zabriskie Gallery in New York in 1958.
The paintings were totally abstract, with whirling
circular compositions expanding beyond their
frames.[5] Urban was killed in an automobile acci-
dent in New York on April 4, 1959. After his death
his recent paintings were included in the group
exhibition *Sixteen Americans* at the Museum of
Modern Art in 1959, and in the *American Abstract
Expressionists and Imagists* at the Solomon R.
Guggenheim Museum in 1961.[6]

The potent influence of Abstract Expressionism
is reflected in the present print, which is radically
different in style and technique from the work that
established Urban's American reputation in the
1940s. His earlier silkscreens are generally small in
scale, and employ many colors in complex, semi-
abstract images, with specific themes. In the early
1950s, when the artist struggled to free himself of
earlier aesthetic preconceptions to find a simpler,
more profound expressive voice, the style and
technique of his prints also changed. His knowl-
edge and skill with the screenprinting process
enabled him to disregard customary procedure,

and use the equipment and materials creatively for
large, quiet, meditative prints.

Urban began this piece by printing a large
screen to establish the subtle compositional struc-
ture of the image. He seems to have prepared the
screen by painting directly on the silk with diluted
glue, which partially blocked the screen for soft
passages, like the central kidney-shaped form. The
artist printed this screen in a pale umber tone.
Then Urban placed six pieces of wire directly on
top of the impression printed with the first color.
The wires — which may have been soldered to
retain their positions — plotted straight lines,
curves, and looping arabesques that complement
the printed composition. When he placed a
silkscreen on top, and forced brown ink through it
with a squeegee, the wire protected the paper
reserving a pale-colored line. The dimension of the
wire also held the screen slightly away from the
paper, allowing more ink to pile up on either side,
creating dark-colored haloes of thick ink. After
printing, Urban completed the image by adding
touches of white ink by hand, and printing accents
of orange with a tiny stamp of some kind and, for
the central vertical, rolling the pigment from an
inky length of wire.

These innovative technical experiments pro-
duced a mysterious image in which delicate forms
play in ambiguous space. His juxtaposition of sta-
ble straight lines with fanciful volutes give the
image a lyricism parallel to Urban's earlier paint-
ings and prints, which is more truly musical for its
abstraction. As the viewer's eye naturally rests on
the open center of the composition, it is drawn up
and around the perimeter into a lilting choreogra-
phy. Perhaps it is the somber palette that makes
this experience calming as well as active. Despite
the deliberate process, Urban's experimental
prints have a motion and verve. His prints also
convey the physical qualities of the materials of
the process, and the inchmeal manner by which
screenprints are created.

DOROTHY DEHNER

1901–1994

39. In the Beginning, 1954

Soft-ground etching and engraving with roulette
 on cream laid paper, 1/25
17.0 x 27.7 cm (plate)
24.4 x 31.9 cm (sheet)
Inscribed: in graphite below platemark:
 In The Beginning 1/25 Dorothy Dehner '54
Worcester Art Museum, 1993.93

Dorothy Dehner's experiences in the orbit of the developing New York School were reflected in her works of graphic art. Later, when she shifted her attention to sculpture, she continued to work in a variety of print media.

Dehner was born on December 23, 1901, in Cleveland, Ohio, where her father worked as a pharmacist.[1] After the death of her parents when she was nine years old, she lived in Pasadena, California, with her aunt who encouraged her interests in art and drama. After a year of studying the performing arts at the University of California at Los Angeles, Dehner enrolled at the American Academy of Dramatic Art in New York. She toured Europe in 1925 and saw avant-garde art for the first time in Paris, where the work of Picasso and Matisse inspired her to change her aspirations.

On returning to New York, Dehner began studies at the Art Students League. She had hoped to become a sculptor, but found the League program too conservative, and studied drawing and painting with Kimon Nicoläides and Jan Matulka. When David Smith came to New York he settled in the rooming house where Dehner lived. She encouraged him to attend classes at the League, and introduced him to progressive galleries. A friendship grew into romance, and they were married on December 24, 1927. They settled in Brooklyn and associated with a stimulating circle of artists, including John Graham, Edgar and Lucille Corcos Levy, Adolph and Esther Gottlieb, and Mark Rothko. In 1929 Dehner and Smith bought a farm near the village of Bolton Landing in upstate New York, where they often retreated from the city.

In 1931 Dehner and Smith lived in the Virgin Islands. The artist painted abstractions inspired by shells and fishes in a style derived from synthetic Cubism. They went to Europe in 1935–36, and in Paris they met André Breton and Stanley William Hayter, and visited Atelier 17. The works of the old masters prompted the artist to shift to a more representational mode in her work. In 1940 Dehner and Smith moved to Bolton Landing, where in the early 1940s she produced *Life on the Farm*, a series

of small paintings in tempera and gouache, inspired by the fifteenth-century Burgundian illuminated manuscript *Les Très Riches Heures du Duc de Berry*.[2] Later she created a series of dark drawings with Surrealist-related biomorphic imagery that reflects the growing difficulties in her marriage. These were included in a solo exhibition at Skidmore College in Saratoga Springs, New York, in 1948.[3] Dehner left Bolton Landing in November 1950, and was divorced from Smith two years later.

Dehner received a bachelor's degree from Skidmore College in 1952 and began to teach. At that point she turned decisively to abstraction. Her first solo exhibition in New York, at the Rose Fried Gallery in spring 1952, included pen-and-ink drawings and watercolors.[4] Dehner also visited Atelier 17 in New York and made her first intaglio prints, which were shown in solo exhibitions at the Wittenborn Gallery in 1954 and 1956, and at the Art Institute of Chicago in 1955. In that year she married Ferdinand Mann, the widowed father of one of her students. Dehner finally began to work in sculpture in 1957. She pieced together planes and cords of wax, which were cast into bronze statuettes. The first solo exhibition of her sculpture appeared at the Willard Gallery in spring 1957. After Atelier 17 closed in New York, Dehner occasionally made prints at the Pratt Graphic Art Center in the mid-1950s.

The scale and technical sophistication of Dehner's bronze sculptures increased during the 1960s. Some of her works of that period comprise chambered boxes enclosing shapes and relief calligraphy, resembling Gottlieb's *Pictographs* realized in three dimensions. A major solo exhibition of her work was organized by the Jewish Museum in New York in 1965.[5] In the late 1960s and 1970s the artist began working in a simplified geometric style, constructing her bronzes of flat panels that isolate negative voids. In winter 1970–71 Dehner worked at the Tamarind Institute in Albuquerque, and created twenty lithographs, including *The Lunar Series*.[6] At that time the artist also designed color screenprints, which were editioned and published by Modern Classics, a company owned by her second husband. Late in the 1970s, when Dehner was able to afford the cost of steel fabrication, her earlier cast bronzes were fabricated in Cor-ten steel on a monumental scale. The artist also executed several private commissions beginning in the late 1970s, among them a bronze sculpture for Rockefeller Center in New York. A retrospective exhibition of the artist's work was organized by the Katonah Museum of Art in 1993

and traveled to the Corcoran Gallery of Art, Washington, D.C.[7] Dehner died in New York on September 22, 1994.

Dehner made the present print at Atelier 17 in New York, where technical experimentation was encouraged. She favored engraving, which suited her temperament and drawing skills with pen and ink. Drawing and dropping pigment onto flooded paper, she made use of the organic patterns and tidemarks thus created. The artist used plate tone and aquatint to approximate the organic wash effects in her drawings. Some of her early prints employ tonal techniques like aquatint and open-bite etching, and other plates utilize roulette and atmospheric effects of plate tone. This plate is reminiscent of Dehner's drawings of the late 1940s, which were inspired by the work of the biologist Ernst Haeckel's 1904 book *Kunstformen der Natur*, and its images of microscopic life and fossils of aquatic animals.[8] Her fantastic Abstract Surrealist images have a personal iconography, similar to those of her friends Gottlieb and Rothko, whose early biomorphic experiments were familiar to Dehner.

The artist began by preparing the plate with a soft-ground, applying the ground roughly and inexactly, so that it covered the middle area of the plate and was thin and irregular around its perimeter. Then she pressed the palm of her hand and her fingertips lightly into the ground in the center of the plate, pulling away bits of ground from the plate in the distinctive patterns of the fingerprints and whorls of skin. When she etched the plate, Dehner allowed areas of foul biting to create uneven clouds of microscopic pits in the plate that printed as clouds of tone. Then she began to work the copper plate with a burin, circumscribing areas of tone and the hatching created by her fingerprints, reacting spontaneously as she delineated the lines and forms suggested by the uncontrolled action of the acid on the plate. Sometimes her sinuous engraved lines suggest landscape, cracks in rocks, crevices in dry earth, or the outlines of rocky mountain crags. These undulating lines, mostly on the horizontal, also evoke the movement of water. From the black areas in the upper center growing from her fingerprints she engraved radiating hairs to suggest sea creatures or perhaps microorganisms. The image is evocative of primordial ooze in a terrain of volcanoes and moving oceans. However, Dehner maintained a purposeful ambiguity. She created spatial structure, figures, and then denied them.

In The Beginning 1/25 Dorothy Dehner '54

JOSEPH FIORE

1925–

40. Untitled II, 1954

Lithograph on cream wove paper, 1/10
37.2 x 29.7 cm (image)
47.9 x 37.0 cm (sheet)
Inscribed: in graphite, l.l.: *II 54 - 1/10*; l.r.: *J.Fiore*
Worcester Art Museum, 1993.96

As both student and teacher at Black Mountain College in Asheville, North Carolina, Joseph Fiore imbibed the remarkable interdisciplinary energy of American culture in the 1950s. He incorporated its manifold dimensions into his art, and continued to do so as his style evolved over his career.

Fiore was born in Cleveland, Ohio, on February 3, 1925, the son of a violinist who was a founding member of the Cleveland Orchestra.[1] He learned to play the piano as a child and may have inherited the drafting skills of his maternal grandfather, who was an architectural painter. As a child he attended summer courses at the Cleveland Museum of Art. Fiore was drafted into the Army at age eighteen and served as an infantryman in northern France during the final months of World War II. After his discharge in 1945, he attended the Summer Art Institute at Black Mountain College, where he studied painting with Jacob Lawrence. In the fall he entered the degree program as a GI Bill student. Fiore became a pupil of Ilya Bolotowsky, who guided his study of European Modernism; he was also influenced by Josef Albers's color theories and concepts of form. In addition he studied piano with Charlotte Schlesinger and sang in the chorus. He first encountered Abstract Expressionism as a student of Willem de Kooning and Franz Kline in the 1948 Black Mountain Summer Art Institute.[2] That fall, he moved to San Francisco for a year's study at the California School of Fine Arts (CSFA). He continued working in the style of gestural improvisation prompted by de Kooning and encouraged by the CSFA. In his paintings of the period, forms overlap and interlace to create vibrant pictorial space.

In summer 1949 Fiore returned to the stimulating environment of Black Mountain College. There, over the dinner table on any given evening, the ideas of Carl Jung, Zen Buddhism, Precolumbian culture, or American jazz were as likely to be discussed as poetic form or painting technique. In the fall he joined the faculty and taught drawing and painting courses. He was a popular, charismatic teacher, noted for his even temper and sensitivity. Among the art students at Black Mountain College in that period were Robert Rauschenberg, Cy Twombly, John Chamberlain, Jerry van der Wiele, and Dorothea Rockburne. In his own paintings of the early 1950s, Fiore combined soft, lyrical color with spontaneous gesture. He created a series of landscape paintings in 1952 that mark a progressive simplification of calligraphy. The following year he began making sketches in collage and then transferred the imagery suggested by the cut and torn paper to his drawings and paintings. At that time Fiore exhibited his work in group shows at the Stable Gallery in New York. In the late 1950s the artist was drawn to the late work of Claude Monet, and his style began to evolve toward plein-air landscapes, rendered with Monet's painterly color harmonies.

After Black Mountain College closed in 1957, Fiore moved to New York and worked as a freelance designer, which allowed him the freedom to paint. His work was included in the Whitney Museum annual exhibition in 1959, and the following year his first solo exhibition in New York was mounted at the Staempfli Gallery.[3] In 1962 the artist joined the faculty of the Philadelphia College of Art (now The University of the Arts). He bought a summer house in Maine, and his work moved toward legible representation as he found inspiration in the area's natural beauty. This evolution was apparent in the paintings in his solo exhibition at the Robert Schoelkopf gallery in New York.[4] From 1970 to 1974 the artist taught at the Maryland Institute College of Art in Baltimore.

In 1979, when Fiore taught in the summer program of Parsons School of Design at Les Eyzies, in the Dordogne region of France, he visited the Paleolithic cave paintings at Lascaux. The famous paintings prompted him to reflect on the interdependence of man and nature and the course of human creative history. He made further studies of ancient Native American art and forged a style that suggests a symbolic spiritual quest. In the mid-1980s Fiore combined imagery and techniques from different phases of his career. He employed the imagery of pictographs and petroglyphs, as well as spiritual ideas of lost human cultures, and his paintings incorporate gesture and calligraphy, while insistently evoking landscape in their structure. In 1988, while hiking along the Medomak River in Maine, the artist discovered a rock with ancient patterned carvings. This relic inspired his painting *Dark Stone Map* and other canvases that combine the shamanic patterns of ancient art with geological structure. In 1995 a retrospective exhibition of Fiore's painting was mounted at the Black Mountain College Museum and Art Center in Asheville.[5] Today the artist divides his time between New York and Maine, and continues to work and exhibit.

The present print is one from a series of a dozen lithographs that Fiore made at Black Mountain College in 1954–55. At that time Fiore also drew a lithograph that served as the frontispiece in a deluxe edition of *The Dutiful Son*, a volume of poems by Joel Oppenheimer.[6] The artist transferred the style and imagery of his contemporaneous drawings to the stones, working chiefly with crayon, adding black accents in discrete, methodical touches of liquid tusche. Fiore also scraped ink away from the printing surface, creating white scribbled passages, often finely adjusting compositional balance. The artist approached the stones without preconceived designs, allowing his images to evolve in the course of their execution. Throughout his suite of lithographs, Fiore experimented with different linear vocabularies; in some images confining himself to spare, short lines, and in others using dense, loopy scribbles. The result is a range of images that can vary from whimsical to intriguing.

In several of his lithographs, including the present print, Fiore divided the composition into rectangular and lozenge forms that are varied in their shape and tone. These faceted images are similar to those in his contemporaneous collage paintings, which combine cut and torn paper with freely applied strokes and patches of paint, sometimes applied in impasto. Like those works, the lithographs often suggest landscape, the forested hillsides, and fragmented rock walls of the North Carolina mountains. In the present composition the elements seem to jumble and slide together, like shifting tectonic plates. The movement is suggested by the vitality of Fiore's drawing, and by his unstable composition, which is thick and heavy at the top and seems to teeter on tiny, dark feet.

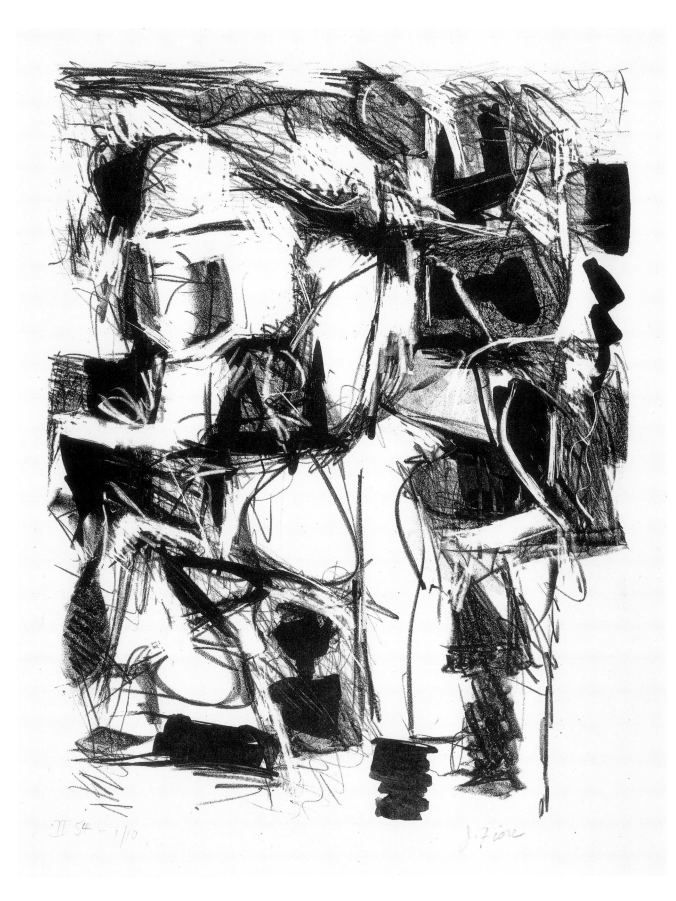

DOROTHY McCRAY

1915–

41. Denizen, 1954

Lithograph on cream wove paper, 3/6
36.0 x 46.0 cm (image)
45.3 x 55.4 cm (sheet)
Inscribed: in graphite, below image:
 3/6 "Denizen" Dorothy McCray 1954/Imp
Worcester Art Museum, 1996.12.8

The prints of Dorothy McCray reflect the saturating influence of Abstract Expressionism across the country, as well as the curiosity of a determined artist who has always been devoted to personal self-expression.

Dorothy Westaby was born on October 13, 1915, in Madison, South Dakota, where her father was a surgeon and her mother worked as an elocutionist.[1] Her parents encouraged her artistic talent, providing private lessons and sending her to summer art school at the Minneapolis School of Design. In 1933 Westaby enrolled at the State University of Iowa (now Iowa State University), where she studied painting and art history with Catherine Mcartney and Edith Bell. The art department changed in Westaby's second year, when a new generation of artists came to teaching, led by Grant Wood. He inspired students with his accessible Regionalist style and his admonition to paint the world they saw. Francis McCray, Wood's associate, accompanied him to Iowa. Westaby studied life drawing, painting, and lithography with him and they developed a close friendship.[2] "Mac" McCray and Wood shared a studio in 1935, and Westaby often worked alongside her teachers. Her first prints are Regionalist-style lithographs, made at the university, representing genre vignettes set in typical Midwestern landscapes.

Westaby completed her bachelor's degree in 1937, and the following year she and Mac McCray were married in Stone City, Iowa. Their son Peter Michael was born in 1939, the year the artist completed her master's degree. Her first solo show was her thesis exhibition at the Iowa art school, which consisted of painting, drawings, and prints, most in a personal style growing out of Regionalism. When Grant Wood died in 1942, the McCrays moved to Clear Lake, Iowa, where Mac worked as a portraitist and Dorothy taught art in secondary and high school. At that time she concentrated on experimental watercolors, which reflect her interest in the works of the School of Paris and the Surrealists.

In August 1948 Dorothy McCray joined the faculty of Western New Mexico College (now Western New Mexico University) in Silver City. She arrived just in time to enjoy the use of a new Senefelder lithography press ordered by her predecessor Elmer Schooley.[3] Her work was included in a group exhibition at the Museum of New Mexico in Santa Fe in 1951, and regularly appeared in shows of prints and paintings at that museum over the next twenty years. In 1954 McCray took a year's leave of absence to attend the California College of Arts and Crafts in Oakland. She studied watercolor with Louis Miljarek and lithography with Leon Goldin. After her return to Silver City, the artist continued her work in color lithography. The clear air and bright sunshine of New Mexico may have inspired the intense, acid colors of those prints. McCray's color lithographs were featured in the Fourth and Fifth International Biennials of Contemporary Color Lithography organized by Gustave von Groschwitz in 1956 and 1957.[4] In the early 1960s the artist also utilized this imagery in prints in other media, including intaglios and screenprints.

When Mac McCray died in 1960 the art gallery at Western New Mexico University was named in his honor. With the subsequent departure of her grown son, the artist concentrated more on her own paintings and prints, and became quite prolific. At that time her work was influenced by both Abstract Expressionism and by the New Mexican Transcendental Painters Group. For the next three decades McCray lavished her attention on teaching, and traveled in the summertime. She toured through Europe, and made extensive visits to Greece and Italy. She also pursued advanced studies at the Tyler School of Art at Temple University, and at the University of Florence in Italy. In summer 1970 she studied intaglio printmaking in Florence with the American etcher Ernest Freed. In her first intaglio prints McCray worked directly on the plates, incorporating motifs from works of Florentine art. Freed was a visiting professor at Western New Mexico University in summer 1971, and he continued to instruct her in advanced intaglio techniques.

When McCray retired from teaching in 1981 the art building at Western New Mexico University was named in her honor. She bought her own etching press, and continued to make intaglios, collagraphs, and monoprints from copper and plastic plates, in a range of styles. In the late 1980s and early 1990s the artist experimented with hand-made paper, which appears as collage elements in her work along with fragments of earlier drawings and prints. In 1993 a solo exhibition of her work was held at the Francis McCray Gallery, Western New Mexico University, as part of the university's centennial celebration. Today McCray lives and and works in Silver City, New Mexico.

Denizen was the first in a remarkable group of color lithographs that McCray executed when she studied at the California College of Arts and Crafts. They were all printed from a single counteretched stone by Goldin's simplified evolutionary method. Its imagery grew from McCray's work in watercolor, developed and practiced in New Mexico during the late 1940s. Many of her prints feature structures plotted by counterpoised arcs and then enlivened with gestural splashes of color. To make this print, McCray approached the lithography stone with no preconceived ideas, and began her image by printing a solid background in black ink. Then she reworked the stone, dripping a network of viscid tusche, which was printed in green ink. With the black peeking through the interstices, it became a dynamized background. By repeating this sequence of drawing on the stone, McCray proceeded through a total of eight printings in six different colors, each time relying on the ghostly shadow beneath, as she refined and detailed the image by overprinting. Sometimes she purposely left part of her design on the stone for printing in one color over another. In other areas the images were intentionally printed out of register in order to create little effects of echo and counterpoint, and also evoke a sensation of movement.

McCray always waited until her prints were complete before naming them. She tried to select a title that might spark the viewer's imagination and direct the attention, without being too specific. In Denizen we perceive what looks like a sea creature, perhaps a beast that lives at great depths like a nautilus. The left side of its body seems lobate, like the abdomen of an insect or the shell of a crab. Overprinted bundles of angled lines, on the right, not only seem to define multiple legs but also create the sensation of these appendages moving. Perhaps these legs seem unfocused for we view them through refractive water, or maybe we perceive their furious motion in stop-action, like a skipping Futurist film strip. This movement enhances an eerie sensation of conscious life, suggested by the eyelike concentric motif on the right, which seems to watch us in silence.

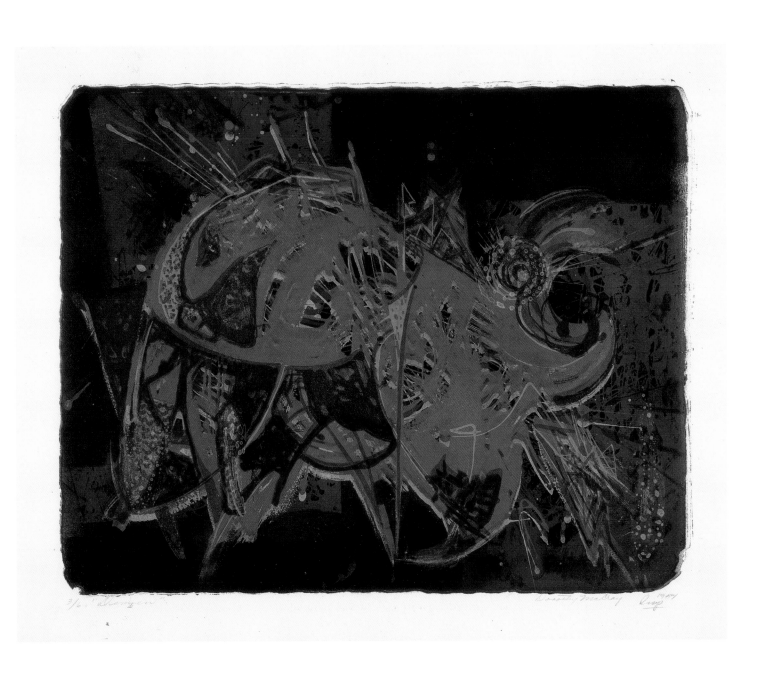

3/6 "Strangers" Dorothy MacRae 19 84

CLAIRE FALKENSTEIN

1908–1997

42. Struttura grafica, 1955

Collagraph on cream handmade paper, 4/10
45.2 x 29.0 cm (image)
47.4 x 59.6 cm (sheet)
Inscribed: in graphite, l.r.:
 Claire Falkenstein 4/10 1955
Worcester Art Museum, 1996.12

The Californian sculptor Claire Falkenstein was a remarkable printmaker. Always innovative in conception and technique, her prints challenge the boundaries between sculpture and the graphic arts, enticing the viewer to perceive the dimension of the paper.

Falkenstein was born on July 22, 1908, in Coos Bay, Oregon, where her father managed a lumber mill.[1] At age eighteen she attended the University of California at Berkeley to study anthropology and philosophy. When she took her first art classes in her junior year, Falkenstein realized that she would be an artist. Cubist-influenced student drawings made up her first solo exhibition, at the East-West Gallery in San Francisco in 1930. After graduating from college in 1930, she taught at the Anna Head School in Berkeley. Soon Falkenstein focused her concentration on sculpture, and in summer 1933 she studied with Alexander Archipenko at Mills College in Oakland. In 1934 she married Richard McCarthy, her high school beau who had become a lawyer, and they settled in Oakland.

Falkenstein made her first prints in 1935, when she studied briefly with Stanley William Hayter during his first visit to the California College of Arts and Crafts. Her innovative sculptures of the period are made from ribbons of clay, twisted into undulating Möbius strips and painted in a different color on each face. These were featured in her solo exhibition at the San Francisco Museum of Art in 1940. The artist taught drawing at Mills College from 1945 to 1948. She learned to weld in an industrial metal shop, and refined her technique in a series of three-dimensional drawings of bent wire and iron strips that she called "wire delineations." After the war she worked with surplus materials, such as aluminum, glass, and Hydrocal. Her most innovative works were made of plastic, which she shaped, carved, engraved, colored, and illuminated.[2]

In fall 1947 Falkenstein began teaching at the California School of Fine Arts (CSFA). She developed friendships with many of the Bay Area Abstract Expressionists, but it was Clyfford Still who influenced her most.[3] In 1950 the artist set out for a six-week tour of Europe, but decided to make a clean break with every aspect of her former life and settle in Paris. In 1951 Falkenstein went to

a Parisian metal shop with a little wire sculpture of arboreal form and engaged the French metalsmiths to enlarge this maquette into the fifteen-foot *Sign of Leda*. It was shown in 1953 at the Salon des Jeunes Sculpteurs at the Musée Bourdelle, where it caught the eye of Michel Tapié. A leading critic in postwar France, Tapié believed that contemporary art had to break free from European traditions corrupted by World War II.[4] He wrote one of the first essays on *Art Informel*, the reactionary, inelegant style that held much in common with Abstract Expressionism.[5] In 1952 Tapié's exhibition *Un Art Autre* sought to catalyze an artistic movement around his own critical viewpoint.[6] Falkenstein's work perfectly embodied *Art Autre*, and Tapié purchased and exhibited her work, wrote about her extensively, and introduced her to the Galerie Stadler.[7] At that time the artist was at work on her *Suns* series of sculptures, made from lattices of wire wound over brazed metal armatures with colored glass shards held in the membrane. In the mid-1950s she used metal rods or ribbons, studded with melted colored glass, to sculpt gates for the villa of Princess Pignatelli at Santa Marinella near Rome, and for Peggy Guggenheim's Palazzo Venier dei Leoni in Venice.

Falkenstein returned to California in 1962, and began a succession of large site sculptures. In fall 1963 she visited Milan to collaborate with the Master Printer Giorgio Upiglio on a remarkable suite of collagraphs, also called *Struttura grafica*.[8] For this portfolio the artist pressed paper over fabricated and found sculptural objects. Falkenstein's chief project of the late 1960s was her decoration of Saint Basil's Cathedral in Los Angeles. She covered the doors and windows with layered webs of steel and glass, and placed colored glass in their polygonal interstices. In 1968 the artist returned to the Grafica Uno workshop to produce three lithographs entitled *Fiori* (fig. 1).[9] For each she brushed vigorous calligraphy on a zinc lithography plate, printing on the recto of a sheet of feathery mulberry-fiber paper, while the verso was solidly printed in a strikingly different hue. Then she folded each impression according to a calculated pattern, so that polygons of the verso color alternate with slices of calligraphy. The visual effect of the sculptural *Fiori* prints is that of bouquets wrapped in colored paper cones. Falkenstein produced a remarkable range of public sculptures in the 1970s and 1980s. A retrospective exhibition of her work was organized by the Palm Springs Desert Museum in 1980.[10] The artist shifted her attention to painting in the early 1990s, when the physical demands of sculpture became too difficult.[11] Falkenstein died at her home in Venice, California, on October 23, 1997.

Figure 1. *Fiori*, 1968.

The present print is one from a series of experimental collagraphs that Falkenstein made at Atelier 17 in Paris, when the artist renewed her acquaintance with S.W. Hayter, who gave her access to an etching press. She experimented independently with printing from scraps of found metal and small constructions similar to her "wire delineations." To prevent the constructions from shifting in the press, she soldered them to armatures of thin copper sheets. Falkenstein daubed these objects with two or more colors of ink and sent them through the press with a sheet of dampened paper. The objects embossed the paper deeply, creating a satisfying bas relief, but their sharp edges tore the strongest papers, so Falkenstein had special handmade laid paper made of linen for her project. The artist deliberately calculated the placement of her tiny sculptures so the organic forms and spiraling calligraphy energized the spaces between them. Some of these were printed in small editions and individually titled. Many others were printed as proofs, and generically named *Struttura grafica* because it was in Italy that the artist first conceived these prints.

This collagraph is from a group made in 1955, when Falkenstein returned to the workshop to make a new group of *Struttura grafica* for a *livre d'artiste* that would combine her prints with original poems by Michel Tapié. She printed about eight different collagraphs in editions of ten. In most, like the present print, she confined the imagery to one side of a large sheet, leaving space for the poems. With bent stovepipe wire and globules of solder, Falkenstein created vigorous linear characters, ranged in vertical rows like Asian calligraphy. The proofs and poems were sent to Galerie Stadler, Falkenstein's Parisian dealer, which was meant to publish the portfolio. However, the project went unfunded and the artists lost interest. During her lifetime Falkenstein kept most of the small editions of her collagraphs.

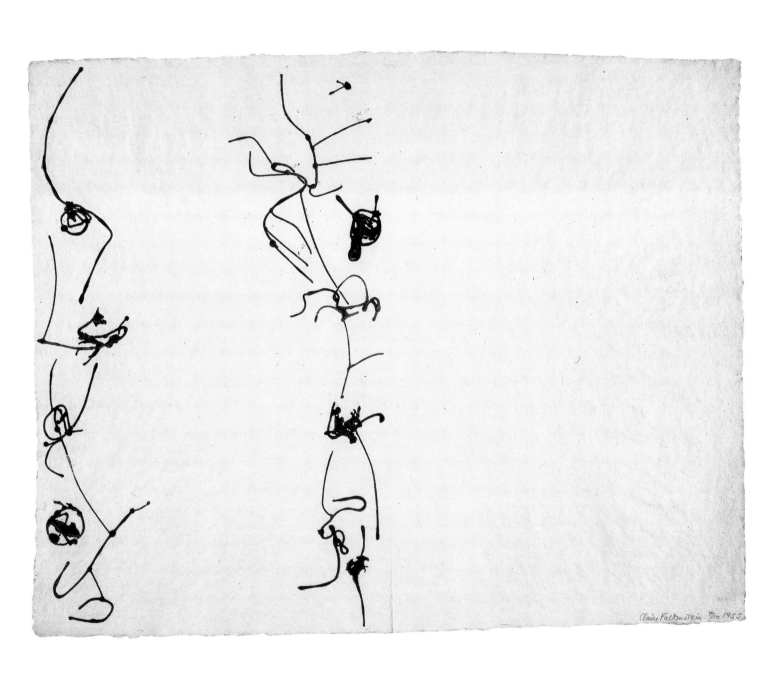

Claire Falkenstein 4/10 1955

ROLAND GINZEL

1921–

43. November 32nd, 1955

Collagraph on cream wove paper
50.2 x 65.7 cm (plate)
56.2 x 76.4 cm (sheet)
Inscribed: in graphite, below platemark:
 "NOV•32ND" RGinzel 55
Watermark: LAVIS J PERRIGOT ARCHES SPECIAL
 MBM (FRANCE) TRAIT
Worcester Art Museum, 1996.114

In the mid-1950s, the Chicago painter and print-maker Roland Ginzel developed an innovative technique to create prints similar to his Abstract Expressionist paintings. His remarkable paper intaglios capture the spirit of experimentation and creative spontaneity.

Ginzel was born in Lincoln, Illinois, on May 7, 1921. His father, an architect, died when he was eleven years old.[1] His mother fostered his childhood interest in art, arranging lessons with the local painter Julia McGrath. In 1940 Ginzel attended the School of the Art Institute of Chicago (SAIC), where he studied with Glen Krause and Edger Ewing. He joined the Coast Guard in 1942, and during World War II he was stationed at a series of domestic posts. Ginzel returned to the SAIC after his discharge in 1946 to study painting with Laura van Pappelendam. At that time he made his first prints in lithography classes with Max Kahn and courses in intaglio taught by Alan Philbrick. In spring 1946 Ginzel met Ellen Lanyon, a fellow SAIC student, and soon they decided to marry.[2] The artist's work was included in the Artists of Chicago and Vicinity at the Art Institute, and in the first Exhibition Momentum, a juried show begun in 1948 by young artists when that museum began to exclude student work from its annual exhibition.[3]

Soon after their marriage in Chicago in 1948, both Ginzel and Lanyon entered the graduate art program at the State University of Iowa, where they studied printmaking with Mauricio Lasansky.[4] In 1950, when Lanyon studied at the Courtauld Institute in London, Ginzel accompanied her to England. He worked in the printmaking studios of the Slade School of Fine Art with John Buckland Wright and studied stained-glass at the Central School of Arts and Crafts.

After returning to Chicago in 1951, Ginzel developed a personal painting style that combined Cubist-oriented composition with spontaneous gesture. In winter 1953 he and Lanyon helped to establish the Chicago Graphic Workshop.[5] At its premises on North Clark Street, the co-op made equipment available to subscribers, scores of whom worked there during the life of the shop. Its financial state was always precarious, but it became the center for printmaking in Chicago, a meeting place where professionals and students worked side by side. In 1955, smoke and steam from a fire in the store below damaged the Workshop. Members pulled together to organize a group exhibition at the Art Institute in the spring, but the principal partners had tired of administration, and the studio closed. Ginzel joined the faculty of the University of Illinois in that year and taught printmaking in a studio at Navy Pier. Dramatic gestural brushwork typifies his paintings and prints of that period, which were shown at Holland-Goldowsky Gallery (later B.C. Holland) in Chicago.

In the later 1960s Ginzel created a series of paintings that feature highly realistic motifs coupled with abstract passages of color. His interest in environmental issues prompted his Birdscape series of paintings of 1967–68. Ginzel and Lanyon bought an island cottage near the town of Desbarats, on Lake Huron in Ontario. The artist created large, minimal paintings during his summers there, in a loosely gathered series named for the town. He cut cardboard stencils and painted through them with thinned acrylic paint. Ginzel allowed the pigments to bleed and blur together along the edges of forms, creating automatic, organic effects that soften the geometry of the designs. In the 1970s Ginzel's stencil paintings became brighter and the compositions simpler. These works were included in a solo exhibition at the Illinois State Museum in summer 1975.[6]

The artist returned to printmaking in 1977, when he developed his own method for making complex monoprints. Working in the university printshop, he began a series he calls "press drawings," because in their creation he used the printing press as a drawing tool. In the early 1980s Ginzel had a studio on Bleecker Street in New York, and he held temporary teaching positions at Parsons and at Columbia University. He moved away from the use of stencils, turning instead to a renewed interest in the physicality of the paint. In 1985 Ginzel retired from teaching. The following year a retrospective exhibition of the artist's work in a range of media was mounted at Gallery 400 at the University of Illinois, simultaneously with a solo exhibition of new work at the Dart Gallery.[7] Since 1991 Ginzel has lived in Stockbridge, Massachusetts, where he now focuses his attention on sculpture.

The present print exemplifies Ginzel's innovative collagraph technique, developed at the Chicago Graphic Workshop. When the studio was damaged by the effects of the fire in 1955, presses survived intact, but the etching facilities were destroyed. Ginzel began to experiment with an intaglio process that did not require metal plates or acid.[8] At that time he was painting with automotive lacquer with the trade name Duco. He knew it was workable when wet and dried to a very hard surface, so he began building plates from paper illustration with lacquer. To vary the thickness and surface, Ginzel carved the chipboard with a knife and peeled away its layers of paper. He used sandpaper to scuff the facing paper with minute scratches that became bundles of burry drypoint lines when printed. The artist painted and drizzled layers of lacquer spontaneously onto the plate. He manipulated it while wet and scratched its dry hardened surface. To simulate the tonal effect of aquatint, the artist dusted granules of Carborundum powder onto the wet lacquer, which dried in a sandpaper surface. He used different grades of abrasive powder, and sometimes mixed it in the paint and brushed it onto the printing surface. Ginzel also collaged strips of paper tape to the plate, cut or torn at the edges.

The artist used a tamping pad to apply intaglio ink to his collagraph plates and printed them in the roller etching press. Though the plates were not as durable as metal plates, they were sufficient for the few impressions that the artist desired. Indeed, several of Ginzel's paper intaglio printing plates from the 1950s are still extant. They were printed as experimental proofs, not in controlled or inscribed editions.

Ginzel used this technique to make perhaps twenty different paper intaglio prints, and they all have a soft glow also apparent in the lacquer paintings that preceded them.[9] His interest in stained glass and the effects of colored light prompted him to emulate this luminosity by using glazes of lacquer in his paintings and smoky aquatint passages in his prints. In the mid-1950s, the artist equated these glowing rectangles of light with television, a new presence in American households, which united the entire country by shared experience. However, the images that confront the viewer in Ginzel's prints are cloudy, explosive, often chaotic visions of energy discharge. They also allude to the atomic bomb, with its terrible beauty and threat of annihilation, which was never far from the collective consciousness of 1950s America.

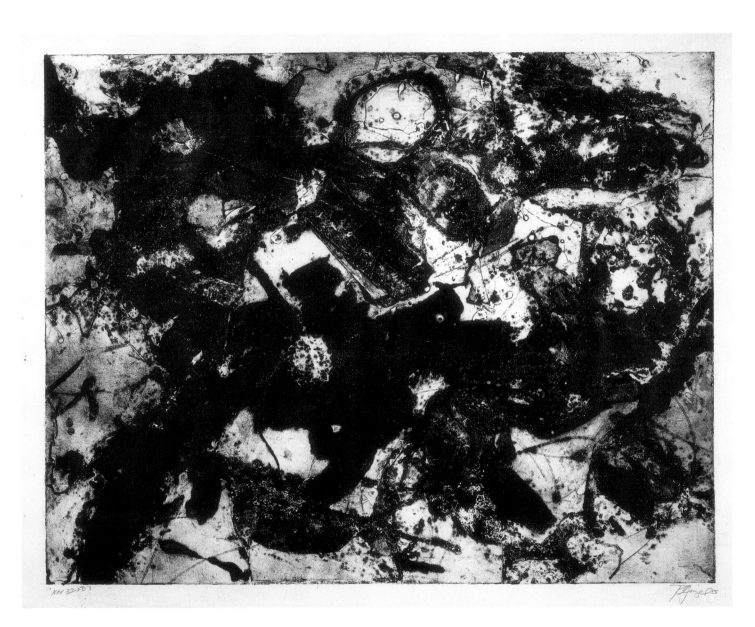

'NOV 32·FD'

MARK TOBEY

1890–1976

44. Composition, 1955

Lithograph on cream wove paper, 6/30
30.0 x 22.2 cm (image)
31.5 x 24.4 cm (sheet)
Inscribed: in graphite, l.l.: *6/30*; in purple
 watercolor, l.r.: *Tobey/ '55*
Worcester Art Museum, 1996.12.14

In the 1930s the painter Mark Tobey developed a style that prefigured Abstract Expressionism formally, and to a great extent, conceptually. His work influenced the New York School painters, and in turn they later affected him. Late in his career he produced an array of innovative, virtuosic prints.

Tobey was born on December 11, 1890, in Centerville, Wisconsin, where his father worked as a farmer and builder.[1] In 1906 he began weekly classes at the Art Institute of Chicago. His family moved to the city three years later, and he worked odd jobs, aspiring to be a magazine illustrator. In 1911 Tobey moved to New York, where he studied briefly with Kenneth Hayes Miller and worked as a portraitist and an illustrator for *McCall's Magazine*. The first solo exhibition of his work, at the Knoedler Gallery in New York in 1917, featured portraits. In 1918 Tobey joined the Baha'i World Faith, and its philosophy directed his artistic development and practice. He moved to Seattle in 1922 to teach at the progressive Cornish School of Allied Arts. Teng Kisei K'uei, a Chinese student at the University of Washington, introduced Tobey to Chinese painting and calligraphy at that time, and he began wider explorations of Asian art. In 1925 the artist went to Paris and visited Chartres; the following year he sailed from Barcelona to Beirut and Haifa, where he toured the holy sites of Baha'i.

In 1930 Tobey's paintings were included in the exhibition *Painting and Sculpture by Living Americans* at the Museum of Modern Art, and the following year a solo exhibition appeared at the Contemporary Arts Gallery in New York. In 1931 he sailed to England for a six-month residency at Dartington Hall, a multidisciplinary school in Devon, where he ended up staying for seven years. In 1934, Tobey and his Dartington colleague, the ceramist Bernard Leach, traveled to France, Italy, and then on to China and Japan. In Shanghai he painted again with Teng K'uei, and in Kyoto he spent a month in a Zen monastery, studying traditional calligraphy, sumi painting, and meditation. Afterward he spent months painting in a San Francisco hotel room, assimilating his experiences in Asia. In the mid-1930s Tobey used white to delineate the views, crowds, and figures in his representational paintings. Gradually his style became more abstract as he incorporated the influences of Arabic, Persian, Chinese, and Japanese calligraphy he had encountered in his travels. He used this vocabulary to describe the frenetic rhythms of the modern city, and soon white linear calligraphy dominated his images. After his visit to Turkey in 1938, political tensions in Europe prevented his return to England. He went back to Seattle, where he worked briefly on the FAP/WPA and began teaching in his studio.

Music became more important to Tobey during the 1940s, as he studied piano and music theory and played the flute. He shared these interests with his close friend, the artist and organist Lyonel Feininger. In 1943 Tobey's painting *Broadway* won a prize at the *Artists for Victory* exhibition at the Metropolitan Museum of Art in New York. The following spring, the works in his first show at the Willard Gallery in New York were described as "white writing," a term he adopted.[2] In 1945 his work was included in the exhibition *Fourteen Americans* at the Museum of Modern Art. During the 1950s Tobey's work became totally abstract as he sought to express the indivisibility of the universe. At that time Tobey became more deeply interested in Zen Buddhism; he was guided in his reading by D.T. Suzuki and in practice by his Zen Master in Seattle, Takizaki. In 1957 he began a series of sumi paintings with aggressively brushed and flung ink.[3] Some years later, the artist transformed this imagery into two dramatic lithographs (fig. 1).[4] When Tobey's work was exhibited at the XXIX Venice Biennale in 1958, he won the first prize for painting, the first American to do so since Whistler.[5]

In 1960 Tobey settled in Basel, Switzerland. He had solo exhibitions at the Musée des Arts Décoratifs in Paris in 1961 and at the Museum of Modern Art in New York in 1962. Encouraged by his dealer, Ernst Beyeler, he began making collaborative lithographs, and in his last years the artist became more involved with printmaking. Along with his friend Hans Burkhardt he explored monotype, printing his drawings on metal plates, glass, and Styrofoam.[6] From 1968 to 1972 Tobey made aquatints published by Gotthard de Beauclair, and lithographs published by Petersburg Press. His prints were shown at the Whitney Museum in 1971 and the Cincinnati Art Museum in 1972.[7] The artist signed his *Méandres* portfolio of engravings in his bed at the Klara Hospital, soon before his death in Basel on April 24, 1976.

The present print seems to be one of Tobey's first. It was likely made in Paris, perhaps in conjunction with his first solo exhibition there at the Galérie Jeanne Bucher. It is comparable to much of

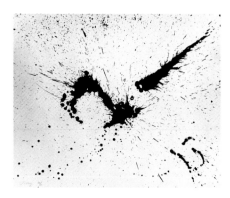

Figure 1. *Untitled*, 1970.

the artist's work in its small scale, which encourages long, intimate viewing. It is an image of simple visual means, but its design encompasses sweeping concepts. Tobey worked spontaneously, but believed that his inspiration came not from momentary access to the subconscious, but from a spiritual source contacted through a lifetime of meditation. The artist painted daubs of liquid tusche onto the printing surface, clustering the strokes around an invisible grid. Interspersed with the black strokes are subtle hues of dull green and red, indistinguishable from a distance. First Tobey printed the image in a pale olive green, defining most of the composition, then he overprinted accents in dull red. In the final image superimposed in black ink, smaller daubs partially cover each of the hundreds of colored spots, creating a vibrating appearance and agitating the voids between them.

Tobey's tiny brushstrokes cluster like iron filings reacting to bar magnets, delineating unseen fields of force. The five erect forms standing side by side are reminiscent of some of Tobey's earlier compositions, like *The Promenaders (Written in the Air)* in which calligraphy gathers in vertical bars that seem to dance through space. This image is a subtle variation of Tobey's calligraphic designs; it is as if he has painted the interstices between the lines, allowing the paper color to create his white writing. The varied size of the painted daubs, their subtle tones, and seemingly random placement are also reminiscent of light. Tobey was always fascinated by the spectacle of twinkling city lights, which inspired many of his paintings in the 1930s. "I have many ideas for lights," he wrote to Feininger in 1955. "I will paint only lights at night."[8] This image may provoke associations with aurora borealis, the stars above, and other imagined astronomical phenomena. Like all of Tobey's art, it is an analogy for the unifying principles of the natural universe and the spiritual energy that unites humanity to the cosmos.

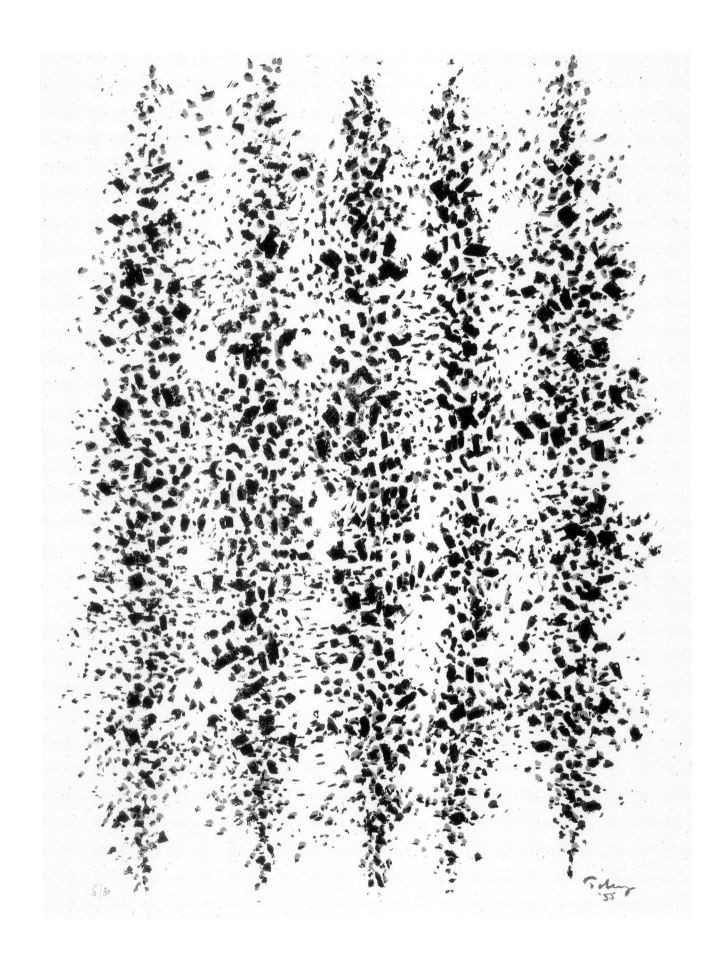

6/80 Tobey
 '55

DEBORAH REMINGTON

1935–

45. 2300 Skadoo, 1956

Lithograph on cream wove paper, edition of 3
54.4 x 45.1 cm (image)
62.5 x 37.9 cm (sheet)
Inscribed: in graphite, below image: *"2300 Skadoo*
© D.Remington 2/'56; in graphite on verso,
l.r.: *23 HUNDRED SKADOO/ COLOR LITHO/*
PRICE $40 (erased)*/ SIZE: 24 1/4" x 15"*
Lent by the artist

Throughout her career, the painter Deborah Remington has periodically made prints, in evolving styles that reflect those of her paintings. The earliest among them are Abstract Expressionist intaglios and lithographs, made when she was quite young, working in the midst of the Beat Movement in San Francisco.

Remington was born in Haddonfield, New Jersey, on June 25, 1935, the daughter of a stockbroker, who died when she was twelve years old.[1] Afterward, she moved with her mother to Pasadena, California. After graduating from high school at age sixteen, she enrolled at the California School of Fine Arts in San Francisco (CSFA) in 1949 and found herself in a hotbed of Abstract Expressionism, working alongside veterans with a passion for their art. "At a very young age I was introduced to a kind of hard, serious, knuckled-in feeling about painting."[2] Remington studied painting with Clyfford Still, David Park, Elmer Bischoff, and Hassel Smith, and printmaking with James Budd Dixon, and Nathan Oliveira. In 1953 she began to exhibit her paintings in group shows at the King Ubu Gallery, and her prints in the exhibitions of the Bay Area Printmakers' Society.

Remington was the only woman among the founders of the Six Gallery, an artists' collective that took over the space vacated by the King Ubu Gallery in 1954.[3] Over the next three years she regularly showed her work at the Six, which became a nexus for San Francisco's emerging Beat culture. Poems in typescript were displayed beside works of art as the gallery attempted to sell poetry as it sold objects; in early meetings the artists discussed how a jukebox might play recorded poetry recitations for a few cents. Poetry readings were regular events, and the most famous was in October 1955, when Kenneth Rexroth, Michael McClure, Philip Lamantia, and Gary Snyder presented their work, and Allen Ginsberg gave the first full-length reading of *Howl*.[4] There were jazz sessions at the gallery by the pianist Dave Brubeck with his trio,

the trumpetist Chet Baker, and the Studio 13 Jazz Band — composed of CSFA students and faculty. The Six also presented film, theatrical performances, and early Dada-inspired happenings.

Remington went to Japan after completing her BFA in 1955. She found an intimate experience of the culture by living with families and studying traditional calligraphy while supporting herself as an actress in movies and television. This experience had a subtle influence on her art, affecting the way that she organized space. After two and a half years in Japan, Remington traveled on her own through Southeast Asia and India for eighteen months. She returned to the Bay Area in 1959 and began teaching part-time at the CSFA, which led to adjunct faculty positions at San Francisco State College and the University of California at Davis. Remington's first solo exhibition, at the Dilexi Gallery in San Francisco in 1962, featured bright, centralized gestural paintings, executed in painterly impasto. In 1963 the artist painted *Statement*, now in the San Francisco Museum of Modern Art, a seminal work that marked a shift to precise, mirrorlike images. In the attempt to paint light itself, Remington executed mezmerizing canvases dominated by abstract forms that seem to hover beyond the picture plane in dark, limitless space. Their shiny surfaces seem to reflect light like a mirror, and their edges suggest precisely overlapping planes, outlined in greens, purple, and red.[5]

Remington's work first appeared in the Whitney Museum annual exhibition in 1965, the year she moved to New York. Her first solo exhibition in New York was mounted two years later at the Bykert Gallery, and she also began showing her work at the Galerie Dorthea Speyer in Paris. In 1973, the year Remington became an adjunct professor at Cooper Union, she was an artist-fellow at the Tamarind Institute in Albuquerque, where she created five editions of color lithographs.[6] In 1979–80 she won a NEA artist's fellowship. A retrospective exhibition of Remington's paintings was organized by the Newport Harbor Art Museum in 1983.[7] The following year a Guggenheim Fellowship enabled the artist to begin a period of professional seclusion and introspection, and over the next four years she forged a new direction in her work. In a sense, she returned to the foundation of her work in gestural abstraction. Remington depicted forms that seem familiar at first but become ambiguous on close inspection; she applied paint freely once again, leaving apparent brushwork. These paintings were shown at the Jack Shainman Gallery in

New York in 1987, at the Shoshana Wayne Gallery in Los Angeles in 1988, and at the Galerie Dorthea Speyer in Paris in 1992.[8] She was elected to the National Academy of Design in 1999. Today the artist divides her time between Manhattan and rural Pennsylvania and continues to work and exhibit actively.

The present print is one of Remington's earliest lithographs, created for a course at the CSFA taught by Nathan Oliveira, who employed and taught the technique of evolutionary color lithography from a single, counteretched stone. Brushing a solution of asphaltum onto the printing surface, she improvised a drawing and pulled several proofs. Then the artist washed the image from the stone and drew another, overprinting that in a different color on each print. As she repeated this process for each of several hues, Remington's image took form in the process of its creation. For some ink layers she prepared the stone with lithographic crayon, instinctively contrasting its grainy line with the viscid character of the liquid asphaltum. Somehow the asphaltum stains in the lower margin of the print and inky fingerprints enhance rather than deface the print, evoking the griminess of the printshop and the bright, exploratory creative process. In some measure this reflects a student's carelessness, but it also reflects the creative climate of San Francisco in the 1950s. Like their friends who were poets and jazz musicians, the young artists at that time valued the experience of creation above its products. A moment's improvised experience was more important than stultifying craft. "[There was a] feeling that you didn't care what you did today because tomorrow you might not be alive," Remington recalled. "You didn't have to take pains with your craft. . . . Today and the experience of painting were the important things."[9]

Remington's purposely casual drawing and her childlike imagery are parallel to those in the lithographs and paintings of her friends Wally Hedrick and David Simpson. Her palette is brighter and more intense, however, and she covered the entire surfaces of her prints with superimposed color, leaving no area of paper unmarked. Like those of her contemporaries, Remington's abstract images convey their meaning through the harmonious balance of form and color and the expression of energy. The title of this lithograph — like all Remington's works — is a random identifier, with no bearing on the image and its content. Nevertheless, its facetious, poetic quality only enhances the youthful energy of this delightful print.

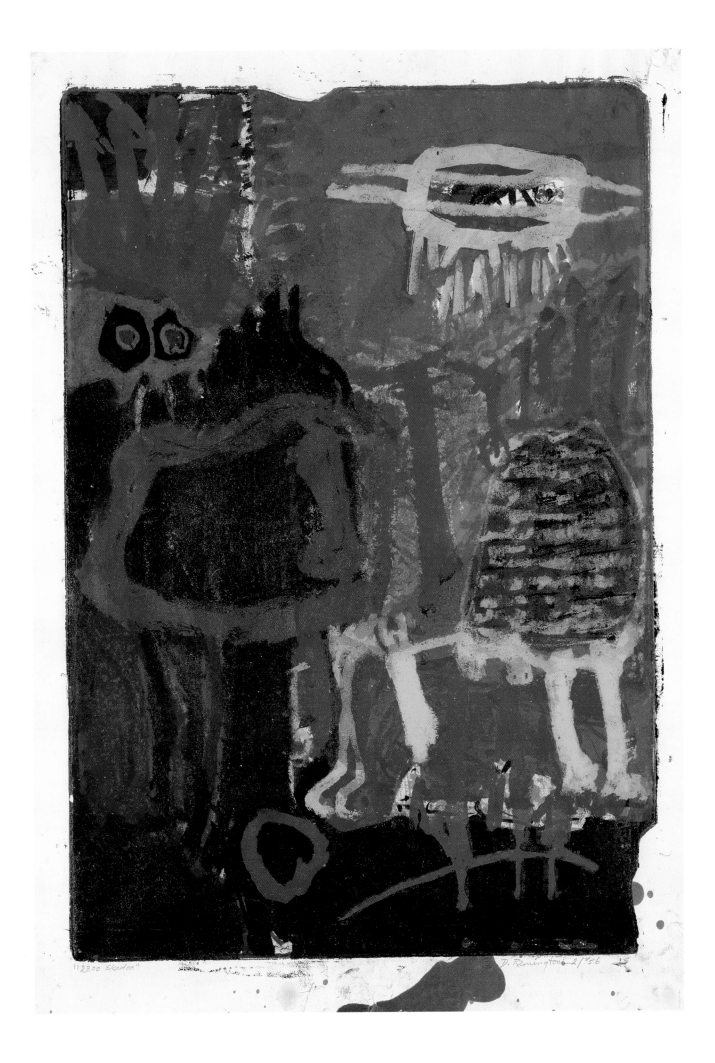

1/2300 "Skidoo" © D. Remington 2/'56

BERNARD CHILDS

1910–1985

46. Untitled, 1956

Drypoint on tan wove paper
35.6 x 52.3 cm (plate)
56.7 x 76.0 cm (sheet)
Inscribed: in graphite below watermark: *Childs '56
 unique proof of destroyed plate, untitled, 1/1*
Watermark: *Johannot*
Worcester Art Museum, 1993.92

In the mid-1950s the painter Bernard Childs cre-
ated remarkable gestural intaglios, impelled by
Abstract Expressionism and *Art Informel* in Paris
where he worked. These galvanic prints also
demonstrate his interest in Surrealist notions of
accident, and in automatist inspiration.

Childs was born in Brooklyn, New York, on
September 1, 1910, the son of Russian
immigrants.[1] At age eleven he moved with his fam-
ily to Harrisburg, Pennsylvania, and he began to
draw and paint when he was a teenager. From
1928 to 1930 he attended the University of Penn-
sylvania. After his sophomore year he decided to
pursue a career in art, so he moved to New York
and took evening classes with Kimon Nicoläides at
the Art Students League. Childs also became
acquainted with Per Smed, a Danish silversmith
living in rural Queens, who introduced him to the
craft of metalwork. After the bombing of Pearl
Harbor he became a machinist in a locomotive
factory converted to heavy armament production.
Two years later Childs joined the Navy, and during
World War II he served on a destroyer escort in the
South Pacific. The artist resumed his study of paint-
ing with Amédée Ozenfant in New York in 1947.
With the support of the GI Bill the artist moved to
Europe in 1951. First he went to the University of
Perugia in Italy where the work of Piero della
Francesca became his greatest influence. Then the
artist worked in Rome, where his first solo exhibi-
tion was mounted at the Galleria dell'Obelisco.

In 1952 Childs moved to Paris, where he began
to exhibit his work at the Galerie Breteau and in
the annual *Salon des Réalités Nouvelles*. In 1954
he spent several weeks working at Atelier 17,
where he learned the fundamentals of intaglio
printmaking, supplemented by observations of pro-
fessional painters in the old workshops of the Latin
Quarter. Throughout the 1950s the artist worked
consistently as a printmaker, sending his engrav-
ings to group exhibitions in the United States and
Europe. He participated in *Phases*, the series of
group exhibitions and publications organized by

Edouard Jaguer in the mid-1950s, and shown in
Paris, Buenos Aires, Amsterdam, and Montevideo.
The artist gave form to the drama and spectacle of
bullfighting in an extended series of gestural paint-
ings in the mid-1950s. He also made experimental
drawings with oil and wax on paper.[2] These works,
along with his paintings and prints, were featured
in Childs's first museum exhibition at the Stedelijk
Museum in Amsterdam in 1959.[3] At about that
time he began painting representational portraits,
which continued in counterpoint to his abstraction
throughout much of his career. After a visit to
Japan in 1960–61, Childs gave new attention to the
tactile qualities of his canvases; he applied paint
more thickly, adding sand, Carborundum, and brick
dust to the pigment. The artist was also touched
by the impact of the war on Japan and the
tragedies of the nuclear holocaust, and in 1963 he
began an extended series of works that warn
against nuclear annihilation. The artist created
about seventy-five editions of prints during the
1960s; he shaped and pierced his plates, engrav-
ing more deeply, and incorporating collagraph.

In 1966 Childs returned to New York, though he
maintained his Paris studio for many years and
regularly went there. A proposed commission for a
new hotel in Hawaii led to the 1968–71 series of
intaglios with subjects from Polynesian legends,
executed in a bright palette. Light became his dri-
ving interest at that time, and he created a series
of sculptures in clear polymer acrylic. In works he
called *Images in Light*, he carved the surfaces of
plastic blocks and sandwiched them together,
transmitting colored light through the polarized
plastic from their bases. A solo exhibition of the
artist's prints, paintings, and sculptures was
mounted at the Storm King Art Center in Mountain-
ville, New York in 1969.[4] Childs traveled widely
during this period, and his canvases reflect his
experiences of the light of the midsummer's night
in Sweden and of Caribbean sunsets. He also rep-
resented musings on the cosmos, the terrestrial
environment, and nature. During the 1970s he con-
tinued to develop metal-plate collagraphy, printing
on a mechanized letterpress. When the artist suf-
fered a stroke in 1978, he turned away from print-
making and sculpture to concentrate on drawing
and painting. He attended rehearsals for the
annual "Mostly Mozart" festival at Lincoln Center,
making color sketches of both representational
and abstract imagery. Childs died in New York on
March 27, 1985.

The present print exemplifies Childs's most

innovative use of power tools for engraving metal
intaglio plates. The artist began to experiment with
printmaking at Atelier 17 in Paris, where he studied
in November and December 1954. He realized that
intaglio provided a way to combine the challenges
of painting with his continued interest in metal-
work. When he had learned the traditional meth-
ods of preparing and printing intaglio plates, he
applied his own metalsmithing skills, and the use
of electric tools. However, the sound of steel bits
and abrasive wheels against the copper plates was
loud and disruptive in the communal workshop,
so Childs set up a printshop in his own studio.[5]
He bought a century-old French press and an
American-made Foredam flexible-shaft rotary
grinding tool, which could be fitted with different
drills, burrs, grinding wheels, and wire brushes.
The artist outfitted the apparatus with a rheostat
so he could control its speed more precisely.
During the 1950s he produced some forty experi-
mental engravings and drypoints, in addition to
twenty-seven editions. The present print is one of
many experimental plates of the mid-1950s, from
which the artist pulled a single impression. No edi-
tion was intended, and after printing he usually cut
down and continued to rework his plates.

The imagery of Childs's early prints grew from
the process of their creation. He began his plates
with no preconceived design or plan, using his
rotary graver to draw rapid, impulsive calligraphy
on the plate. The bite of the tool in the metal, and
one distinctive dotted line or cloud of fine
scratches, directed the next action. He often used
a specific tool for a specific linear vocabulary. The
dotted lines characteristic of these prints cause
the images to vibrate and radiate energy. The artist
often prepared his plates over a long period,
sometimes adding to a plate for years.

Childs perceived printmaking as a two-fold art,
comprised of plate making and printing. He lav-
ished equal attention on both activities. "The
press is not just a machine," the artist proclaimed.
"It can be as sensitive as a musical instrument. Ink
responds to every fiber of the paper and to the
warmth of the hand. . . . The difference in media
must not make any difference in result. A painting
and a print can and must have the same unique
personal quality. The poetry they evoke must be of
the same order."[6]

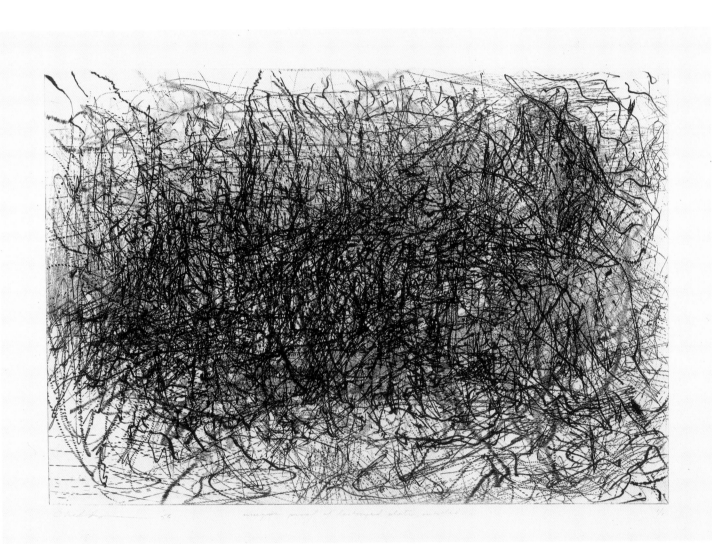

FRANZ KLINE

1910–1962

47. Poem, from *21 Etchings and Poems*, 1957

Soft-ground etching on cream wove paper, 5/50
21.3 x 36.8 cm (plate)
42.9 x 50.5 cm (sheet)
Inscribed: in graphite, below platemark:
5/50. Franz Kline.
References: Long 1986, cat. no. 33; Graham 1987,
p.20, no. 41; Castleman 1994, p.206.
Worcester Art Museum, 1998.220.9

When Franz Kline began to exhibit his large can-
vases with bold slashes of black paint on fields of
white, he suddenly became one of the best-known
artists in America. He turned away from printmak-
ing at that point, but the graphic arts were funda-
mental to his creative development.

Kline was born on May 23, 1910, in Wilkes-
Barre, Pennsylvania, the son of a tavern owner.[1]
When he was seven years old, his father became
depressed over his failing business and committed
suicide. His four children were dispersed to rela-
tives, while his widow returned to school to train
as a nurse. In 1919 Kline entered Girard College in
Philadelphia, a free boarding school for fatherless
boys, where he stayed for about six years. He
rejoined the family when his mother remarried and
settled in Lehighton, Pennsylvania. From 1931 to
1935 Kline attended Boston University; during
college he also studied drawing with John H.
Crossman at the Boston Art Students League and
decided to become an illustrator. After graduation
in 1935 he went to England to continue his studies
at Heatherley's School of Fine Art in London, where
the illustrators Bernard Adams and Steven Spurrier
were among his teachers. Kline met Elizabeth
Parsons, an art school model and a dancer.

In 1938, Kline returned to the United States,
and began working as a display designer for a
women's clothing store in Manhattan. In his spare
time he designed magazine illustrations and
painted urban landscapes. Parsons joined him,

and they were married on December 5, 1938. Kline
bought a tabletop printing press and made etch-
ings and woodcuts, similar in style and imagery to
his paintings. He probably intended to sell these
prints, but most examples known today seem to
have been done for his own amusement.[2] Kline
became a member of Greenwich Village art circles,
and made friends with a wide range of artists. He
was an habitué of the Cedar Tavern, where Jackson
Pollock was often his drinking companion.[3] In 1939
Kline painted a backdrop for a nightclub fortune
teller, which attracted commissions for other tav-
ern murals in Manhattan, Brooklyn, and Hoboken.
His tavern paintings attracted supportive patrons,
including Dr. Theodore J. Edlich, Jr., and I. David
Orr. In 1946 Elizabeth Kline began to suffer from a
progressive mental illness. She spent six months
at the Central Islip State Hospital, and over the next
fifteen years she was periodically institutionalized.

In 1947 Kline began to experiment with abstrac-
tion, encouraged by his friend Willem de Kooning.
At de Kooning's studio one night in about 1948, the
two artists were experimenting with a Bell-Opticon
machine — the forerunner of an overhead projec-
tor — displaying enlarged images of their draw-
ings on the wall. Soon Kline was recreating this
effect in enormous canvases painted in black and
white, amplifying the energy and immediacy of the
small calligraphic sketches. These paintings were
featured in Kline's first solo exhibitions at the Egan
Gallery in 1950 and 1951, which were commended
by critics.[4] The energy of the paintings, their dra-
matic gestural brushwork, large scale, and com-
pressed depth epitomized Abstract Expressionism.
Ubiquitous in the New York School community,
Kline was a founding member and active partici-
pant in The Club, and one of the principal organiz-
ers of the landmark Ninth Street Show in 1951.

Through the 1950s Kline's career flourished, as
he consistently sold paintings from solo exhibi-
tions at the Egan and Sidney Janis Galleries. As his
likeness appeared alongside his paintings in the
national press, he achieved celebrity status.[5] In
summer 1952 he was a visiting instructor at Black
Mountain College in North Carolina, and over the
course of the decade he also taught at the Pratt
Institute in Brooklyn and the Philadelphia Museum
School. In the mid-1950s Kline began to bring color
back into his work. In 1958 a show of his work was
presented by the Galleria del Naviglio in Milan, and
he was one of the first Abstract Expressionists to
achieve international recognition. Sadly, these suc-
cesses coincided with the decline of his health. In
December 1961, shortly after the opening of his
exhibition at the Janis Gallery, Kline suffered a
heart attack. He was hospitalized until March, and
afterward he remained weak and unable to paint.
He died on May 13, 1962.

Kline's best-known print is this reproductive
intaglio, an outstanding plate from the suite *21
Etchings and Poems*, the landmark collaborative
portfolio begun by Peter Grippe when he was
director of Atelier 17 in New York.[6] Grippe origi-
nally intended that the artists and poets collabo-
rate on the creation of their plates, conceptually
and physically. However, as time progressed and a
parade of artistic temperaments, objectives, and
schedules hindered progress, Grippe used all the
technical means at his disposal to complete the
project, including transfer printing and photome-
chanical processes. A combination of photoetching
and aquatint was used on *Poem*, the collaboration
between Kline and the poet Frank O'Hara, one of
the last plates to be completed for the suite. The
artist sent a collage to Grippe, which was photo-
graphically transferred to the plate and slightly
reduced (fig. 1).[7] Now in a private collection, this
collage was rapidly executed in black ink on three
sheets of paper, with another unmarked scrap
pasted on top. The subtleties of brushstrokes,
spatters, and torn paper edges are lost in the high-
contrast photoetched plate. Grippe also photo-
graphically transferred the autograph manuscript
of the poem to the printing matrix. It seems that he
captured the image from O'Hara's handwritten
verse, preserved today at the Harry Ransom
Humanities Research Center at the University of
Texas in Austin.

Though its technique was reproductive and
accomplished at a distance, *Poem* was a true col-
laboration between mutual admirers. O'Hara was
already a personal friend of Kline's, and in his work
as associate curator at the Museum of Modern Art,
he had come to know the artist's work well.[8] His
verse recalls a fleeting love, intense and transform-
ing in its day, though improperly understood. As its
fervor fades with the passage of time, its true
import becomes clear. It seems that in preparation
for the project, O'Hara gave several poems or ver-
sions to Kline, and that the artist chose this one.[9]
The collage he submitted to complement the verse
may have been done especially for the project, or
it may have already been in Kline's studio. To pre-
pare his paintings, he often produced several
sketches or collage maquettes. He pinned the
strongest of these beside his easel to serve as
models while he visually transferred the image to
the canvas, with sweeping arm gestures suited to
the enlarged scale. Kline developed the design of
the *Poem* collage into the painting titled *Elizabeth*,
signed and dated 1958.[10] It may be that the sub-
ject of both poem and collage was Kline's affection
for his wife, which changed as their relationship
was transformed by her mental illness and their
past intimacy became distant.

Figure 1. *Untitled (Study for Elizabeth)*, 1957.

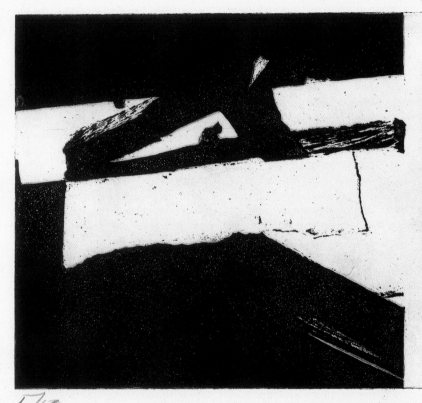

I will always love you Poem 1
though I never loved you
a boy smelling faintly of heather
looking up at your window
the passion that enlightens
and stills and cultivates, gone
while I sought your face
to be familiar in the likeness
or to follow your sharp whistle
around a corner into my light
that was love growing fainter
each time you failed to appear
I spent my whole life searching
love which I thought was you
it was mine so very briefly
and I never knew it, or you went
I thought it was outside disappearing
but it is disappearing in my heart
like snow blown in a window
to be gone from the world
I will always love you
 Frank O'Hara

5/50.

ALFRED LESLIE

1927–

48. Untitled, 1956

Screenprint on off-white wove paper, 8/9
42.5 x 36.6 cm (image)
44.5 x 40.5 cm (sheet)
Inscribed: in screen, l.l.: *Alfred Leslie*; in graphite
 within the image, l.l.: *8/9 Alfred Leslie 1956*
Worcester Art Museum, Richard A. Heald Fund,
 1995.67.41

Among the young New York painters who came of age in the late 1940s, Alfred Leslie stands out for his creative versatility. At that time, aside from his painting, he was already active as a filmmaker, photographer, author, and printmaker.

Leslie was born in New York on October 27, 1927, the son of an engineer who encouraged him to draw as a child.[1] He began taking photographs and set up his own darkroom at age twelve, and three years later he began making films. After graduating from Clinton High School in New York, he served in the Coast Guard in 1945–46. Leslie returned to film making after his discharge, while modeling and studying briefly at the Art Students League. He enrolled at New York University as a GI Bill student, where he studied painting with William Baziotes, Hale Woodruff, and Tony Smith. At that time he met Jackson Pollock, Willem de Kooning, and other New York School painters, and began to frequent the Cedar Bar. In 1948, along with fellow students Robert Goodnough and Larry Rivers, Leslie helped to organize the group exhibition at Studio 35. When The Club evolved from the Studio 35 seminars, he was a charter member and frequently attended its Friday night sessions.

At that time Leslie searched for a way to paint the radiance of light and color and express metaphysical ideas in his canvases. Meyer Schapiro and Clement Greenberg included his work in their *New Talent 1950* exhibition at the Kootz Gallery in New York. One of his paintings appeared in the Ninth Street Show in 1951, and the following year his first solo exhibition was mounted at Tibor de Nagy Gallery.[2] In the mid-1950s the artist's wide associations included the young painters who exhibited there and many poets in the circle of the gallery founder and director John Bernard Myers, in particular, Frank O'Hara. Leslie explored figuration at that time, derived from old master painting and popular magazine reproductions. When he bought an old American flag at a rummage sale, its design made its way into his large, gestural canvases executed in house paint, often in unusual, lyrical

colors.[3] The artist's interest in his materials is apparent not only in the prominent brushstrokes, splashes, and drips, but in the thick accumulation of pigment. In 1957 Leslie began the film *Pull My Daisy*, shot in his studio by Leslie and Robert Frank, with narration by Jack Kerouac and music by David Amram.[4] It was shown in the exhibition *Sixteen Americans* at the Museum of Modern Art in 1959, which included several of the artist's paintings.

In 1960 Leslie edited and published *The Hasty Papers*, an avant-garde review including poems by O'Hara, John Ashbery, Kenneth Koch, and James Schulyer. In that year a successful exhibition of his abstract paintings appeared at the Martha Jackson Gallery. However, he felt a need to connect his narrative work as a filmmaker with his painting. He began a group of representational full-face portraits of his friends in drawings and grisaille paintings derived from Polaroid photographs. Leslie also painted full-length nudes, each derived from four frontal photographs at different heights, merged in images that distorted proportion but achieved a confrontational directness.[5] A fulcrum picture in this development was Leslie's *Self Portrait*, which was shown in the Whitney Museum annual exhibition in 1964. It was destroyed in the tragic fire on October 17, 1966, that consumed the artist's studio and claimed the lives of twelve New York City firemen. Most of Leslie's Abstract Expressionist works were lost, along with all his films in progress, and most of his grisaille portraits. In 1967 the artist received a National Foundation for the Arts and Humanities Award, and two years later he won a Guggenheim Foundation Fellowship. Leslie responded to O'Hara's accidental death by painting a large narrative polyptych that reflects on chance and the fragility of life.[6] In 1971, the year Leslie was a visiting lecturer in Fine Arts at Amherst College in Massachusetts, he won a National Institute of Arts and Letters award. During the 1970s the artist made lithographs at Landfall Press, and in the coming decades he also made collaborative prints with Pace Editions, the Experimental Printmaking Workshop, and Jon-Ives Noblet. A solo exhibition of his work was organized by the Museum of Fine Arts in Boston in 1976.[7] Leslie has served as a senior critic at Yale, the University of Pennsylvania, and Boston University. The artist still lives in New York, and continues to work with the same prolific versatility.

The present print was made in conjunction with Leslie's contribution to the Tiber Press Port-

folios, one of era's most remarkable collaborations between poets and printmakers. The set of four volumes was printed and published by the New York screenprint studio operated by Floriano Vecchi and Richard Miller.[8] With Daisy Aldan, Miller began publishing the literary magazine *Folder* in 1952, which included original artists' screenprints. In 1956 they began the ambitious portfolio project, choosing four poets who had contributed to *Folder*, and artists who were among their friends. The final set includes: *Odes* by Frank O'Hara with prints by Michael Goldberg, *Salute* by James Schuyler with prints by Grace Hartigan, *The Poems* by John Ashbery with prints by Joan Mitchell, and *Permanently* by Kenneth Koch with Leslie's prints. The poets submitted their work to Miller and Aldan, whose selections often reflected the practicalities of space as much as content. Their colleague Frances Pernasse — then head of publications at the Museum Modern Art — helped to arrange for the typesetting and letterpress printing to be done by Brüder Hartmann in West Berlin, Germany. When the text arrived in New York to receive the screenprint images, the painters came one at a time to Tiber Press in the top floor studio at 1459 Third Avenue.

Vecchi taught each of the artists the fundamentals of the silkscreen technique, and he printed the editions. Each painter arrived with ideas and worked out different ways to use the process. Leslie helped decide the format of the books, creating his own bound maquette. He wanted to make collagelike images relating to his contemporaneous paintings, combining stripes and squares with spontaneous gesture. The artist spent some time experimenting with the silkscreen process, aiming for physical surface. For the present print he drew the image printed in black directly on the screen with liquid tusche. Then he tore and cut pieces of printed newspaper, arranging them on a sheet of paper underneath the silkscreen; when a layer of ink was squeegeed through it, the pigment effectively glued the newspaper to the underside of the silk, creating a negative stencil. By working in this way, Leslie printed in opaque colors, building up his images in a manner similar to collage. Some of the screens for this print were used in the fourth plate of *Permanently*, a photomechanically reduced version of which accompanied the prospectus for the Tiber Press Portfolios.[9]

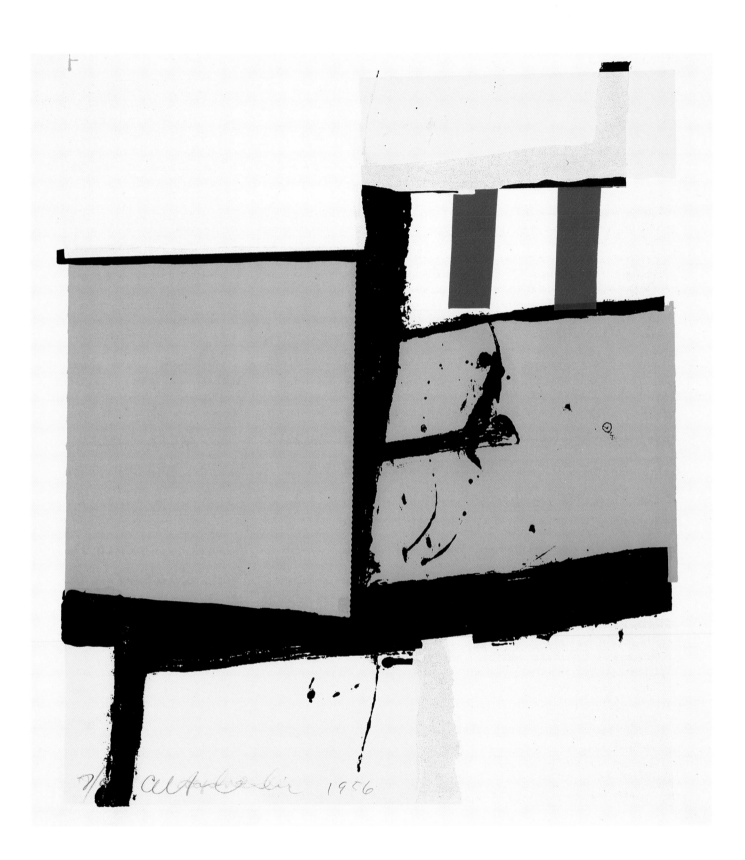

ROMAS VIESULAS

1918–1986

49. The Fall, 1956

Lithograph on cream wove paper
47.8 x 35.3 cm (image)
66.2 x 46.8 cm (sheet)
Inscribed: in graphite, below image: *A.P. R*
 (in a circle) *THE FALL Romas Viesulas 56*
Watermark: *BASINGWERK PARCHMENT*
Worcester Art Museum, 1996.115

When the Master Printer Romas Viesulas arrived from Europe in 1951, he worked in a manner founded in Expressionism and energized by *tachisme*. Under the influence of Abstract Expressionism, his style became yet freer, as he imagined new ways of expanding the possibilities of printmaking both conceptually and technically.

Viesulas was born on September 11, 1918, at Noreikiasi in Lithuania.[1] At the École des Arts et Métiers in Freiburg, Germany, he learned the full range of traditional printmaking techniques. His first solo exhibition was mounted at the Institut Français in Freiburg when he was still a student. After graduation, Viesulas won a French government scholarship to study at the École Nationale Supérieure des Beaux-Arts in Paris. The artist immigrated to the United States in 1951 and settled in Cincinnati. Gustave von Groschwitz, curator of prints at the Cincinnati Museum of Art, helped him to find teaching jobs, acquired his work for the museum collection, and featured his prints in the first three International Biennials of Contemporary Lithography from 1954 to 1958. The artist's first solo exhibition in New York appeared at the Matrix Gallery in 1954.[2] Two years later a solo show of his prints was mounted at the New York Public Library.

In 1958 Viesulas won a Guggenheim Fellowship that enabled him to visit Europe. He spent much of the next year working in Barcelona, but he also revisited Paris, where he produced his *Dainos* series of lithographs at the Atelier Desjobert. After returning to the United States, Viesulas joined the faculty of theTyler School of Art at Temple University, near Philadelphia. He was also chosen to be the first artist fellow at the Tamarind Lithography Workshop in Los Angeles. In summer 1960 he pursued his interest in color lithography at the workshop with its first technical director, Garo Z. Antreasian. Viesulas created *Toro Desconocido*, a portfolio of color lithographs with original poetry,

drawn from his experiences in Spain.[3] He developed a metaphor for World War II — and all human conflict — in the life and death spectacle of the bullring. His prints symbolize the agonies of all who died in obscurity.[4] *Toro Desconocido* is the sort of *livre de luxe* that Viesulas and June Wayne, Tamarind's founder, had known in France. The artist's prints and poems are related thematically and stylistically, establishing provocative relationships between word and image.

A solo exhibition of Viesulas's prints was mounted at the University of Michigan Museum of Art in 1961. The following year he became chairman of the printmaking department at Temple University. He submitted his prints to shows around the world, where they often won prizes, including purchase awards in the Brooklyn Museum print national exhibitions.[5] During the 1960s the artist produced editions under commissions from the Print Club of Philadelphia and the International Graphic Art Society. Viesulas won a Tiffany Foundation Fellowship in 1962, which enabled him to travel to Mexico. After reading Mayan and Aztec myths, he studied Precolumbian art in museums, and visited archaeological sites; then he returned to his Philadelphia studio to create his *Hew* suite of lithographs. With the support of a second Guggenheim Fellowship, Viesulas was artist-in-residence at the American Academy in Rome in 1964–65. The composers he came to know there, and his love of contemporary music, prompted the artist to create the print series *Notes on Image and Sound*.[6] The first half of the suite consists of nine abstract, interpretive lithographs. Inkless embossings printed from intaglio plates constitute the second section, presenting experimental scores that inspired Viesulas, including pieces by Milton Babbitt, Earle Brown, Sylvano Bussotti, Vladimir Ussachevsky, and Bülent Arel. In 1966 Viesulas was in Venice, as artist-in-residence at the workshop of the XXXV Venice Biennale, where he produced the *Overpass* series of lithographs.

In the late 1960s Viesulas strove to expand the boundaries of printmaking. He continued to develop embossing and progressively increased the size of his prints. When his work became too big for the press, he printed by hand, cutting relief blocks from linoleum and then vinyl. Soon conventional sheets of paper were inadequate, and he began to print on fabric, to be stretched on a frame

or draped for exhibition.[7] Viesulas taught printmaking in Rome for the Temple University Abroad Program in 1969–70. In the coming decade he often published reviews of technical manuals and of books on the history of printmaking for the English periodical *Leonardo*. Viesulas was in Rome again, as director of the Temple University Abroad Program, when he died in November 1986.

In the early 1950s Viesulas's prints contained discernible references to representation, either figures or still lifes. By the time he created this print, the artist had gone far in his progression toward abstraction. This intriguing image achieves a buzzing tentative balance between its dynamic facture and its interlocking composition. It is difficult to interpret the present print, with its enigmatic title. The linear structure of the design hints tantalizingly at an image, but none seems certainly legible. With its heaviest imagery at the top, and its rounded bottom, the composition does express a vertiginous sense of instability. It creates a jerky downward movement, enhanced by tapering brushstrokes and scratched highlights. Viesulas often represented biblical subjects during the 1950s, and it may be that the hint of a suspended central figure, perhaps a winged form plummeting to hell, represents the fall of the rebel angel. However, the artist chose not to be specific.

This is a painterly image, created by the processes of accumulation and reduction, in the way that Viesulas worked on his canvases. The artist printed this lithograph from a stone, probably working on his own in Cincinnati. Using the evolutionary method of lithography, he worked from one counteretched stone and printed the various colors over the ghosts of the preceding image. He painted his images on the stone with liquid tusche, generally working from light to dark. Viesulas developed a diverse vocabulary of marks and textures, which reveal the touch of the artist's hand, and visual effects characteristic of lithography. To exploit the different effects of transparency and opacity, he varied and interwove the complex images. He used the color of the paper as if it were another hue in his palette. In each stone, printed in a different color, the artist altered his image by scratching ink away from the printing surface with a pin or a knife point, creating keen, active highlights.

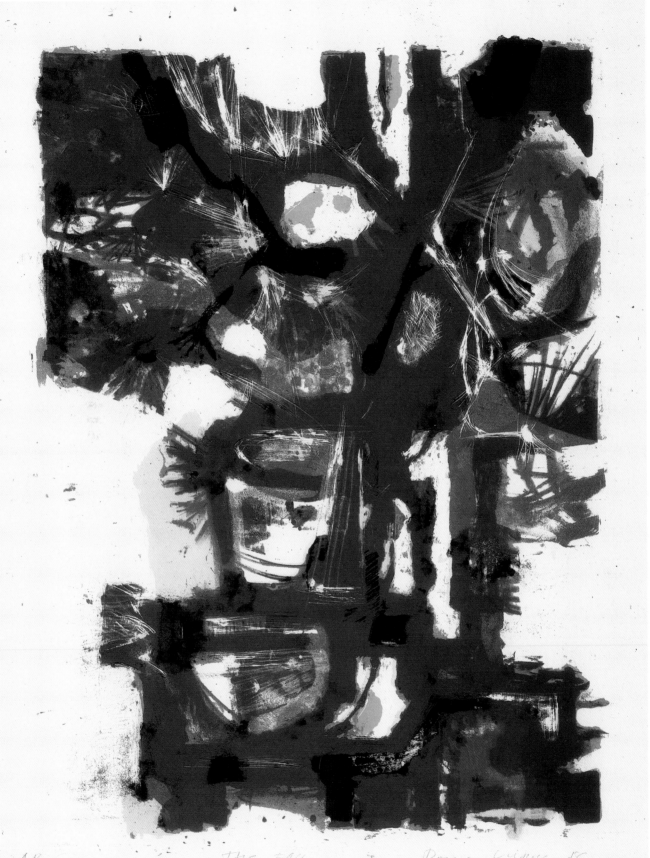

A.P Ⓡ THE FALL Romas Viesulas 56

WARRINGTON COLESCOTT

1921–

50. Chilly in Chiswick, II, 1957

Screenprint on cream wove paper, 1/10
34.5 x 41.4 cm (image)
45.9 x 57.4 cm (sheet)
Inscribed: in graphite, below image: *"Chilly in
 Chiswick, II" 1/10 Warrington Colescott 1957*
Watermark: *ENGLAND J. WHATMAN 1955*
References: Cox/Overland 1988, cat. no. 45.
Worcester Art Museum, 1996.117

The leading satirical printmaker in America,
Warrington Colescott creates color etchings with
engaging wit that belies their sophisticated con-
tent and technique. Early in his career he produced
remarkable Abstract Expressionist screenprints
that combine technical innovation with eloquent
color.

Colescott was born in Oakland, California, on
March 7,1921.[1] The year before, his Creole parents
had moved from New Orleans to the Bay Area,
where his father worked as a brakeman for the
Southern Pacific Railroad. He majored in art at the
University of California at Berkeley, and drew car-
toons for the campus newspapers. After graduat-
ing in 1942, Colescott was drafted into the Army,
and served as an officer in Okinawa and the Korean
Occupation force. In 1946 he returned to the gradu-
ate program at Berkeley as a GI Bill student. He
studied with Erle Loran and John Haley, and devel-
oped a semiabstract painting style based on
Cubism and European Modernism. His most influ-
ential teacher was Margaret O'Hagan, who sparked
an interest in the expressive potential of color.

When he completed his master's degree in
1948, Colescott had begun to experiment with
Abstract Expressionism. He taught briefly at Long
Beach Community College, where his colleague
Fred Heidel introduced him to the technique of
screenprint. Colescott was enchanted by the richly
colored inks that could be laid in opaque layers
onto tinted paper, and the process also pushed
him further toward abstraction. In 1949, when the
artist joined the faculty of the University of Wiscon-
sin in Madison, he found Alfred Sessler, Raymond
Gloeckler, and Dean Meeker operating a thriving
printmaking program. Meeker had financed his
own education by working in a commercial silk-
screen shop, and he had established connections
for the exhibition and sale of his screenprints,
which encouraged Colescott's growing interest.

In the early 1950s Colescott's colorful prints
expressed the painterly energy of abstract gesture.

He sent his work to invitational and competitive
shows across the country, and regularly exhibited
at Doris Meltzer's Serigraph Gallery in New York. At
that time he made extended visits to Paris, where
he studied briefly at the Académie de la Grande
Chaumière, and explored influences from Pablo
Picasso, Jean Dubuffet, and the Paleolithic cave
painting he saw in the Dordogne. A Fullbright
Fellowship enabled Colescott to live in London in
1956–57, and study intaglio printmaking with
Anthony Gross at the Slade School of Art.[2] Along
with a group of advanced students, including
Bartolomeu Dos Santos, he learned a full range of
intaglio techniques. In London, he also associated
with other printmakers, including Birgit Skiöld,
Michael Rothenstein, and David Hockney. Colescott
began to collect hand-colored English satirical
etchings of the eighteenth and nineteenth cen-
turies — including works by Thomas Rowlandson,
William Hogarth, James Gilray, and George
Cruikshank — which could then be bought for a
few shillings. Soon he began to represent his own
experiences in etched figural caricatures, and his
style became a combination of linear drawing and
rich color.

Colescott began to teach etching at Wisconsin
in 1960. He made prints of topical, narrative sub-
jects gleaned from the headlines, like *Birmingham
Jail*, of 1964, which comments on the Civil Rights
movement. This print also reflects his interrogatory
technical experiments with shaped plates, photo-
inserts, and letterpress additions, and his creative
use of printed color. From 1975 to 1979 Colescott
created the series *A History of Printmaking*, com-
memorating great masters and satirizing key
events from the history of Western graphic arts.[3]
Their lampoons of human foibles and Hogarthian
situations have broad appeal, yet for the knowing
viewer, the eleven-color intaglios are dense with
visual quotations, symbols, and subplots.

During the 1980s Colescott regularly exhibited
his prints in the Ljubliana International Biennial in
Yugoslavia and in solo exhibitions at the Perimeter
Gallery in Chicago. He retired from teaching from
the University of Wisconsin in 1986, and two years
later a retrospective exhibition of his prints was
mounted at the Elvehjem Museum of Art.[4] From
1993 to 1996 Colescott produced the satirical car-
toon "Needlepoint" in *The Progressive* magazine.
Throughout the 1990s the artist continued his
prolific output, producing satirical prints based on
his travels and personal experiences. A selection
of these appeared in a solo exhibition of recent

prints mounted at the Milwaukee Art Museum in
1996.[5] Today Colescott lives in Hollandale, Wiscon-
sin; he continues to work and to exhibit his prints
and drawings.

Chilly in Chiswick exemplifies the evocative,
painterly style of Colescott's Abstract Expressionist
screenprints.[6] The artist made the print in his stu-
dio near Fulham Broadway, and at his residence at
Chiswick in West London, where he worked as a
Fulbright Fellow in winter 1957. The title — always
an important element in Colescott's work — cap-
tures the subject in terse onomatopoeia. However,
color is the artist's primary expressive tool, and
the cool purples and pallid blues express the damp
chill of a London winter. Transparent films of pale
ink evoke frost and fog. Emerging in a diagonal
tumble through the middle of the image is a net-
work of tangled black lines reminiscent of wet city
trees that seem to shift gently in a cold wind.
Gestures and passages printed in tans and grays
evoke the colors of fallen leaves and the suburban
brick and stone on a rainy, overcast day.

To capture the energy and immediacy of
expressive painting, Colescott developed a free,
imprecise silkscreen technique. He prepared his
stencils chiefly by the tusche and glue washout
method, beginning with improvised gesture on the
first screen, drawing spontaneously with a brush
and liquid tusche. The next screen built on the pre-
ceding design, and Colescott thus constructed his
composite designs in layers, alternating linear
imagery with patches of color, and opaque inks
with translucent hues, to achieve effects of depth
and transparency. He encouraged his screens to
leak, and the ink to spread naturally. After com-
pleting a drawing on the screen, he often sprayed
water on top before applying the soluble glue,
which softened the edges of his printed lines and
forms. The artist also developed a method of
building stencils on the screen from tissue paper,
which imperfectly blocked the ink, allowing pig-
ment to bleed around the edges and even pene-
trate the thin paper, producing random stippled
passages of printed color. The influence of
Abstract Expressionism is apparent in the artist's
use of accident, and the organic physicality of his
screenprints, as well as his later etchings.
Colescott's choice of the etching needle over the
burin also reflects a characteristic preference for
the expressive over the restrained, the immediate
over the ponderous.

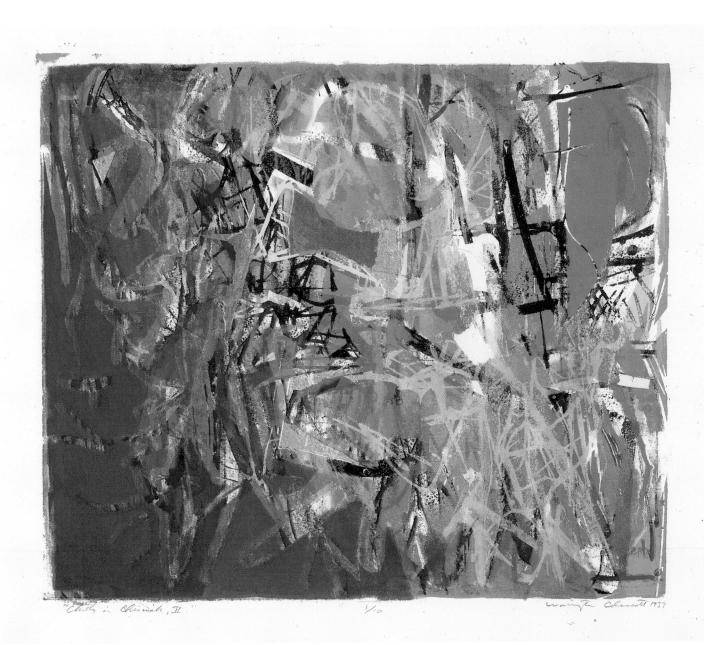

"Chilly in Chiswick, II" 1/10 Wainy R. Colemott 1957

ELAINE DE KOONING

1918–1989

51. Elaine de Kooning, Tibor de Nagy,

1957

Screenprint on cream wove paper
50.8 x 33.1 cm (image)
50.8 x 33.1 cm (sheet)
Inscribed: in pen and black ink, l.l.:
Elaine de Kooning '57
Worcester Art Museum, Sarah C. Garver Fund,
1995.54

The painter, critic, and teacher Elaine de Kooning was near the center of the Abstract Expressionist movement in New York from its inception in the late 1940s. Bright, gregarious, and articulate, she supported her opinions with a serious commitment to her art.

Elaine Marie Catherine Fried was born on March 12, 1918, in Brooklyn, the daughter of an accountant.[1] She majored in art at Erasmus Hall High School in New York, and continued her studies at Hunter College in 1936. The following year she attended the Leonardo da Vinci Art School, where Conrad Marca-Relli was among her teachers. Transferring to the American Artists School, she studied with Milton Hebald and Nauhum Tchachbasov. There Fried learned the basic printmaking techniques and made her first etchings. At that time she worked in a fashionable Social Realist style, influenced by the Mexican muralist painters. When she met Willem de Kooning, Fried was impressed by his work and technical expertise. She became his informal student and painted in his studio. Their friendship developed into intimacy, and they were married at New York City Hall on December 9, 1943. During World War II she worked in a defense plant, and the couple associated with the lively community of Greenwich Village, with its circles of artists, writers, critics, and musicians.

Elaine de Kooning began to experiment with abstraction in the mid-1940s but continued to create representational art throughout her career. In 1948 she accompanied her husband to North Carolina when he taught at the Black Mountain Summer Institute. She shared the stage with Buckminster Fuller in Eric Satie's *Ruse of Medusa*, produced by John Cage and Merce Cunningham, and she also designed the sets. The artist executed the *Black Mountain Abstractions*, seventeen paintings in enamel on paper, that established her personal voice as an Abstract Expressionist. In the fall de Kooning became an editorial associate for *Art News* magazine. Noticing the abstract composi-

tions suggested by newspaper sports photographs, she developed their compositions into mural-sized canvases. When The Club was established in 1949, Elaine de Kooning attended its early meetings. Clement Greenberg and Meyer Schapiro included de Kooning's work in their exhibition *Talent 1950* at the Kootz Gallery in New York. The following spring her first solo exhibition appeared at the Stable Gallery, and through the decade she exhibited there and at the Tibor de Nagy Gallery.

Elaine and Willem de Kooning separated amicably in 1957. The following year she was visiting professor at the University of New Mexico in Albuquerque. This was the first of many teaching positions in a distinguished career that included appointments at Yale University, Carnegie Mellon University, Bard College, Cooper Union, and Parsons School of Design. The space and color of New Mexico affected her painting style. After traveling to Mexico to see the bullfights, she used the theme for a series of canvases reflecting her impressions of the Southwest.[2] De Kooning continued with this series after returning to New York, where the paintings gradually expanded to mural scale. In 1960, when the canvases were sent to the gallery for exhibition, they were removed from their stretchers and rolled over large cardboard tubes. The artist was struck by the curved, colored surfaces, and for the next year she concentrated on cylindrical abstract paintings, up to twelve feet tall.

De Kooning painted a series of painterly portraits that were shown at the Graham Gallery in 1962.[3] Soon after, the White House commissioned her to paint a portrait of John F. Kennedy. She met the president vacationing in West Palm Beach, Florida, and drew hundreds of life studies. The artist took them back to New York, and was at work on her paintings when Kennedy was assassinated, an event that affected her deeply. Twenty-five of de Kooning's paintings of the president were shown at the Pennsylvania Academy of Fine Art, and today one hangs in the John F. Kennedy Library in Cambridge, Massachusetts.[4] Elaine and Willem de Kooning reconciled in 1975, and bought a house in East Hampton on Long Island. When the artist taught in Paris at the New York Studio School in summer 1976, she was enchanted by a sculpture of Bacchus in the Jardin du Luxembourg, and began a series of paintings and prints representing this figure in its bower.[5] She found similar inspiration in the Paleolithic cave paintings at Lascaux in France, which she saw in 1983 and interpreted in paintings and prints. The artist continued to work and exhibit steadily through the 1980s. Elaine de

Kooning died from lung cancer on February 1, 1989, in Southampton.

De Kooning's printmaking activities were occasional and intermittent. After making etchings as a student, she created a few abstract color screenprints during the 1960s. She produced her first lithographs at the Tamarind Institute in 1973, and returned there three years later to print eight editions in her Bacchus series. In 1985 she made her first collaborative intaglios at Crown Point Press in San Francisco.[6] The present print is one of de Kooning's earliest, a poster to promote her third solo exhibition, mounted at the Tibor de Nagy Gallery in November 1957.[7] The show consisted of lively abstract paintings, often in somber colors, with attention to the physical nature of the paint itself. At that time the artist had just separated from Willem de Kooning, and she concentrated on her own career with fierce determination. After seeing the screenprint poster that Alfred Leslie had made for his then recent exhibition at Tibor de Nagy, she wanted one to advertise her show and was encouraged by the gallery director John Myers.

The artist visited Tiber Press on Third Avenue to collaborate with the printer Floriano Vecchi. She began by inscribing her name on the silk with a brush and lithographic tusche — as well as the gallery name, address, and date — and then blocked out these passages with glue, to create textual windows within the image. Then de Kooning spontaneously sketched a gestural web of interlacing lines onto the screen, reminiscent of crossing tree branches. Vecchi squeegeed a layer of glue over the entire image, and when it was dry, he washed out the tusche with solvent to create a stencil. Using the same procedure, the collaborators created two supplementary screens to overprint gold and red ink, creating muted interstitial hues where the colors overlapped. De Kooning was dismayed at first by the flatness of the printed image. To enliven the prints, she used a tongue depressor to smear ink on wet impressions from the black screen. The effect was different on each print, though she used circular movements to give the design a whirlpool effect, always reserving the text. This unique touch gives the print a quality of change and ambiguity that characterizes de Kooning's paintings. Though this poster was signed and dated as a print, it was used to advertise the show, and many impressions were thus destroyed. The size of the edition is unknown but seems to have been about thirty impressions.

Elaine de Kooning

NOV. 12-30

24 E. 67

Tibor de Nagy

DENNIS BEALL

1929–

52. ¡Socarro!, 1957

Lithograph on cream wove paper, 2/6
45.7 x 32.4 cm (image)
57.5 x 43.5 cm (sheet)
Inscribed: in graphite, below image:
 2/6 isocarro! *Dennis Beall 57*
Watermark: *BASINGWERK PARCHMENT*
Worcester Art Museum, 1996.116

A versatile Bay Area printmaker who also promoted the graphic arts as a curator and teacher, Dennis Beall provided a link between Abstract Expressionism and the succeeding styles of Funk and Pop Art in San Francisco.

Beall was born on March 13, 1929, in Chickasha, Oklahoma, the small farming community where he grew up.[1] He became interested in art as a boy, and during his high school years he worked as an apprentice photographic technician. Anxious to escape from the monotony of small-town life, Beall joined the Navy in 1947. He went to San Francisco for training at the Electronics Materiel School at Treasure Island, and then served in active duty in Asia, spending eighteen months in Japan. He was deeply impressed by Japanese craft and design, which prompted his aspirations to become a graphic designer. After his discharge in 1950, Beall began to study art at Oklahoma City University, but the lure of travel and adventure proved irresistible. He toured Europe in summer 1952, and when his funds were exhausted, he joined the crew of an oil tanker in Naples. Over the next year he sailed back and forth on several different ships between the Persian Gulf ports and various French and Italian ports. By spring 1953 he had saved enough money to sail to California, and in the fall he enrolled at San Francisco State College (SFSC) as a GI Bill student. Beall completed his BFA degree in 1956. After a second trip to Europe he enrolled in graduate school at SFSC, and began working as registrar at the Oakland Art Museum as well. Beall completed his MFA in 1959, the year his first solo exhibition was mounted at the East/West Gallery, a show consisting entirely of Abstract Expressionist lithographs.

In 1959 Beall became curator at the Achenbach Foundation for Graphic Arts and worked with the foundation's director Gunter Troche, at the California Palace of the Legion of Honor in San Francisco. Fulfilling the wishes of Moore Achenbach, Beall became a liaison with working regional artists. He encouraged his colleagues to explore and employ the resources of the institution, and helped to bring their work into the collection. He was chairman of the California Society of Etchers in 1960–61, and sat on the Artists Council of the San Francisco Art Institute, serving as its chairman in 1964–65. Among Beall's outstanding projects of that period was the exhibition *Contemporary Prints from Northern California* at the Oakland Museum.[2] Unprecedented in its scale, this group exhibition of Bay Area contemporary printmaking was the first to include a range of Abstract Expressionist prints.

Beall began to teach printmaking and painting at SFSC in 1965. In his own work he concentrated on intaglio and collagraphy and experimented with shaped metal plates and embossing. Pop Art influenced his style, and social comment often appeared in his prints, which were noted for their wit and their technical elegance.[3] Several of these works were executed under commission from the San Francisco Art Commission and local galleries and museums. Beall's prints were featured in the Brooklyn Museum print national exhibition in 1967, and in a joint exhibition with the sculpture of John Battenburg at the Hansen Galleries in San Francisco. The artist experimented with a Photorealist style in the late 1960s, creating paintings, watercolors, and innovative mural-scaled color screenprints that are remarkable technical achievements. A retrospective exhibition of Beall's prints of the foregoing decade was presented in 1968–69 at the Achenbach Foundation, which still boasts the largest public collection of his prints.[4] Beall was named professor emeritus when he retired from teaching at SFSC in 1992. He now lives in the Russian River Valley in Northern California, and is a devoted naturalist and bird watcher.

¡Socarro! is one from a group of Abstract Expressionist color lithographs created from 1956 to 1958, when Beall was a graduate student at SFSC. He helped his mentor, John Ihle, to initiate the practice and study of lithography in the department. Beall was drawn to the medium for its peculiar combination of immediacy and obscurity. "It was complicated, sort of mysterious, and the secrets of the master prints were closely guarded to the extent that it had certain occult overtones. Some kind of magic, if you will."[5] Beall learned the rudiments of lithography at Oklahoma City University in 1950 from Duayne Hatchett, who had briefly explained the evolutionary color process from a single counter-etched lithography stone. Beall and Ihle used the instructional manuals of Bolton Brown and Lynton Kistler — and perhaps with an awareness of the prints made by Leon Goldin and his students at the California School of Fine Arts — to resolve a simple, direct technique to capture the immediacy of drip and gestural painting. "By using a strong solution of acetic acid between drawings," Beall later wrote, "the stone may be resensitized without regrinding. Areas of the preceding drawing may be retained, other areas scrubbed or scraped, new design elements introduced, old ones reinforced and, in general, the reconciliation of design and color development more cohesively obtained and controlled. . . . The enormous freedom implied by this system lies in its directness. The communication between the artist and his materials, the successive acts of printing, drawing, scrubbing, and correcting create a continuum which cannot be duplicated in the traditional workshop."[6]

Beall printed a few lithographs in a single color, but most were executed in three to five hues, often employing bright, transparent, or interstitial colors. He experimented with the expressive capabilities of the medium, employing tusche washes of different dilutions, spattered, splashed, and flooded over the stone. His lithographs are personal, and part of their energy and appeal is their simplicity and searching exploration. Fresh, confident, and expressive, they display little concern for technical sophistication and great respect for the truth of the moment.

The relatively small scale of Beall's lithographs belies their intriguing depth and explosive energy. Many incorporate powerful whorls that collide into one another like spinning tornadoes, drawing in the surrounding space and seemingly energizing the composition with radiating electrical discharges. The impact of these lithographs lies chiefly in their spontaneous calligraphy, artfully superimposed on the stone in layers so that the overlapping colors create new interstitial hues, enhancing complex illusions of depth. The artist dripped and spattered the tusche onto the stone, complementing these fluid passages with drybrushed areas that give the sense of the physical application of pigment. He combined syrupy swirls of asphaltum with vigorous calligraphy, rapidly drawn with a flat wide brush. *¡Socarro!* is unusual among Beall's lithographs in the relative flatness of its colors, for most have layers of transparent, glazelike colors that provide sensations of depth and luminescence.

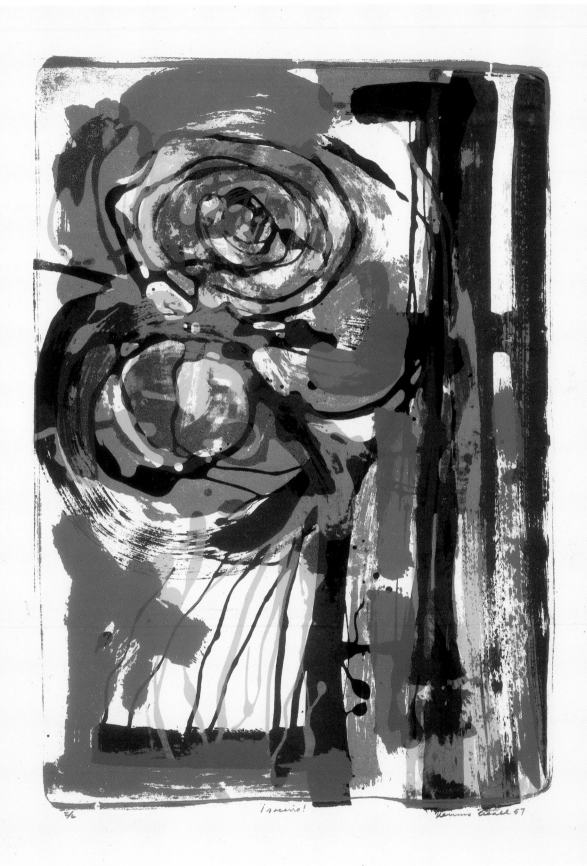

2/2 ¡sueño! Dennis Beall 57

NATHAN OLIVEIRA

1928–

53. Death of an Ant, 1957

Lithograph on cream wove paper, artist's proof
60.9 x 81.4 cm (image)
65.7 x 94.5 cm (sheet)
Inscribed: in graphite, below image:
Death of an Ant proof N.Oliveira57
Watermark: *BASINGWERK PARCHMENT*
References: Ball 1980, no. 15; Acton 1992, p.8.
Worcester Art Museum, 1997.177

The only printmaker among the artists of the Bay Area Figurative movement, Nathan Oliveira works in a style that blends an insistent representation of the figure with the spontaneity of Abstract Expressionism and its fascination with the physicality of materials.

Nathan Joseph Mendonca Roderick was born in Oakland, California, on December 9, 1928, the son of immigrants from Portugal.[1] When he was three years old, his mother married George Oliveira, who adopted him. Growing up in the the rural community of Niles (now Fremont) in the East Bay, he excelled in music and drawing. He took private art classes in high school and played the cornet in a jazz band. The family moved to San Francisco, where Oliveira attended his last years of high school. In 1947 he enrolled at the California College of Arts and Crafts (CCAC) in Oakland to study advertising design. Soon he shifted to fine arts and became a pupil of the figurative painter Otis Oldfield. He developed an Expressionist figural style, influenced by the work of Oskar Kokoschka and Max Beckmann, with whom he studied at Mills College in summer 1950. Oliveira made his first prints in lithography classes taught by Ray Bertrand and Leon Goldin who encouraged his interest in German Expressionism. He received his MFA degree in printmaking from the CCAC in 1952.

Drafted into the Army in 1953, Oliveira was trained as a cartographic draftsman and posted to Fort Winfield Scott in San Francisco. He married, began a family, and continued to paint. He was impressed by Richard Diebenkorn's retrospective exhibition at the San Francisco Museum of Art, and saw how the painterly immediacy of Abstract Expressionism could interpret concrete visual experiences. After his discharge from the service in 1955, Oliveira returned to Oakland and taught printmaking part time at the CCAC and at the California School of Fine Arts (CSFA) in San Francisco. He joined the CSFA faculty full time the following year and was soon head of the graphic arts department. At that time Oliveira bought an old lithographic press from a defunct art school and began to make prints in his own studio.[2] Lithographs comprised his first solo exhibition, at the Eric Locke Gallery in San Francisco in 1957, the year in which he won a Tiffany Foundation Grant.

At the CSFA Oliveira shared ideas with his colleagues Elmer Bischoff, Theophilis Brown, and James Weeks, who followed the example of David Park, applying gestural painting techniques to the figure, still life, and landscape.[3] The artist developed his signature figurative style, representing a single figure or head in an ambiguous space activated by brushstrokes. Oliveira's first solo exhibition in New York appeared at the Alan Gallery in 1958. A Guggenheim Fellowship enabled him to visit Europe, study the techniques of French lithographers, and see works by the old masters. In 1959, when his work was included in the *New Images of Man* exhibition at the Museum of Modern Art in New York, Oliveira met Willem de Kooning and Philip Guston, and began lasting friendships. The artist left the CSFA in 1960, and returned to the CCAC to teach graduate courses in painting. The following year he was artist-in-residence at the University of Illinois in Urbana, the first of several temporary residencies, which included positions at the San Antonio Art Institute, the University of Colorado at Boulder, the University of California at Los Angeles (UCLA), and Cornell University. In 1963, the year of his first major retrospective exhibition at UCLA, Oliveira was an artist-fellow at the Tamarind Lithography Workshop in Los Angeles.[4] The following year he began teaching at Stanford University. He received an honorary doctoral degree from the CCAC in 1968.

In the late 1960s Oliveira produced scores of lithographs, many depicting disembodied heads emerging from darkness, images derived from the nineteenth-century French lithographer Eugène Carrière. In *To Edgar Allen Poe*, his suite of forty lithographs printed at Stanford in 1970–71, this imagery became even more mysterious and evocative. At that time Oliveira began working in monotype, a painterly, direct printmaking technique that suits his personality. In 1973 a retrospective exhibition of his paintings was mounted at the Oakland Museum.[5] From the 1970s to 1990s Oliveira continued to work in a range of printmaking media, producing many collaborative prints at Stanford and other workshops around the country, including Tamstone, Collector's Press, the Tamarind Institute, and 3EP Ltd. A retrospective exhibition of his work was mounted by the San Francisco Museum of Modern Art in 1984.[6] Oliveira's inspired work in monotype distinguishes him as a leading master of the medium in America; solo exhibitions of the prints have appeared at the Dorsky Gallery in 1990, at Smith-Andersen Gallery in Palo Alto in 1993, and at the California Palace of the Legion of Honor in 1997.[7] Today the artist lives in Stanford and continues to paint, make prints, and exhibit his work.

The present print exemplifies Oliveira's early attempts to meld the immediacy of Abstract Expressionism with concrete subject matter, while exploiting the unique technical qualities of lithography. It is one of four prints made in 1955–56 that employ an active gestural style to represent insects. The title of the print helps us to identify the collapsed body of an ant, its legs drawn to its body, it eyes dark. Oliveira's swift, energized brushstrokes paradoxically remind the viewer of the creature's constant, purposeful activity in life. Thin ribbons of ink clustered near the ant's head suggest the quick sweep of the living insect's antennae. The vitality of this image of stillness prompts us to consider the frailty of life, the passage of time, and the potential for fundamental change in every moment.

Death of an Ant was created by the evolutionary method of lithography from a single counter-etched stone, a straightforward technique that was traditional at the CSFA. Oliveira began by preparing the stone with resist, applying scumbles and spatters over much of the printing surface. To soften this image he partially etched the stone with diluted acetic acid. Then using a brush and liquid asphaltum, he drew the ant in a moment's improvisation. The artist printed the edges of the stone, allowing its random chips and rounded corners to define the borderline.

Death of an Ant was printed in the studio at the CSFA, where Deborah Remington was among Oliveira's students in 1956. She recalled the workshop custom of using bacon grease to lubricate the scraper bar of the lithography press, helping the stones to glide more easily under its pressure.[8] Each year in springtime, ants would invade the studio, attracted by the grease, appearing in such numbers that they became a nuisance to all. Once Remington saw Oliveira killing ants one at a time with drops of nitric acid, taking the etching mordant straight from the bottle with an eye dropper. In a moment the insects stopped their lively motion, shriveling in mid-stride. Though Oliveira made other prints of insects at the time, it seems likely that this famous print was inspired by these small dramas.

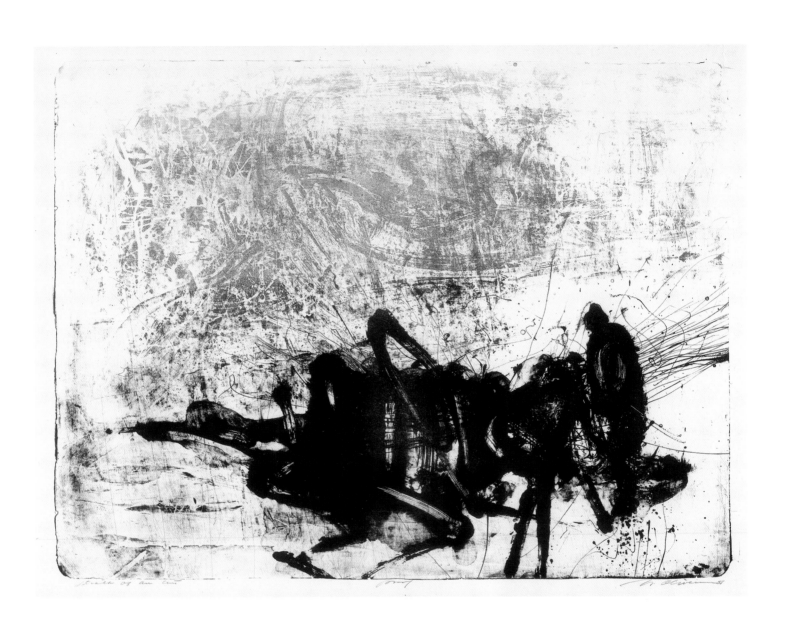

EDMOND CASARELLA

1920–1996

54. Black and Blue, 1958

Paper relief cut on black, coated and laminated
 wove paper, edition of 9
56.0 x 76.1 cm (image)
86.4 x 62.1 cm (sheet)
Worcester Art Museum, Sarah C. Garver Fund,
 1996.22

In the 1950s Edmond Casarella was at the center of a group of artists in Brooklyn who used innovative relief printmaking techniques to capture the vigor and immediacy of gestural abstraction. A talented sculptor, he developed simple additive methods for creating relief printing blocks that were analogous to modeling.

Casarella was born on September 3, 1920, in Newark, New Jersey, the son of a master mason.[1] At age eighteen he enrolled at Cooper Union in New York, where he studied with Raymond Dowden and Pepino Mangroviti. After completing his BFA degree in 1942 he joined the National Youth Administration and worked as a screen printer with Anthony Velonis — former head of the FAP/WPA silkscreen printing division — at Creative Printmakers, Inc.[2] Casarella enlisted in the Army in 1944, and he fought in the Battle of the Bulge in an anti-tank unit. After his discharge in 1946 he returned to Brooklyn, and enrolled as a GI Bill student at the Brooklyn Museum School along with his fellow student, Vincent Longo. They had been friends since childhood, and shared their love of Dixieland jazz and old master paintings. Together they experimented with relief prints to create images of gestural calligraphy. Around 1950 Casarella began using relief blocks cut from cardboard, a method that he called paper relief cut, and he perfected this technique over the following decade.

A Fullbright Fellowship enabled Casarella to travel in Italy and Greece in 1951–52. One of the many works created on that trip — the paper relief print *Civitavecchia* — won a purchase prize at the Brooklyn Museum print national exhibition.[3] In 1952 Casarella showed his work at Margaret Lowengrund's Contemporaries Gallery in New York, he shared a joint exhibition with Longo at the Brooklyn Museum,[4] and his first solo exhibition appeared at the Korman Gallery. Unable to afford a printing press, Casarella designed a machine that could be fabricated economically, and he freely shared the plans with colleagues. In 1955 his activ-

ities were supported by a Tiffany Foundation Grant. He taught printmaking at the Brooklyn Museum School from 1956 to 1960. He painted in oil and watercolor at that time, and made monotypes in addition to his relief prints, showing in regular solo exhibitions at Korman and then the Zabriskie Gallery. The artist traveled and worked in Italy, Greece, and France in 1960 with the support of a Guggenheim Foundation grant. During the 1960s Casarella taught regularly at Cooper Union, the Art Students League, and Hunter College in New York. Among his several temporary teaching appointments were positions at the Pratt Institute, New York University, Columbia, Yale, and Rutgers.

In the mid-1960s Casarella turned away from printmaking to concentrate on his metal Constructivist sculptures. A retrospective exhibition of his work was mounted at the Naroden Muzej in Skopje, Yugoslavia, in 1967. From 1969 to 1975 he taught at Cooper Union and at Finch College. After retiring from teaching the artist concentrated chiefly on sculpture in steel and bronze. He returned to printmaking in his final years, as his activities moderated when he suffered from Parkinson's disease. Casarella died in Englewood, New Jersey, on February 11, 1996.

The present print is an example of the artist's distinctive technique of paper relief cut, an uncomplicated, economical way to make sophisticated color prints without the use of a press. This process grew from his experiments at the Brooklyn Museum School, focused on retaining the verve and spontaneity of an Abstract Expressionist image through the protracted printmaking process. Casarella continued to refine and simplify the technique over many years, and taught it to his students. While the shape and energy of the brushstroke characterize his early color woodcuts, the artist tightened his imagery as time progressed and elaborated their spatial complexity. During the summers of 1953–55 he worked in Maine, making plein-air studies of seaside rock formations in which he developed his distinctive vocabulary of circles and bars.

This design creates a paradoxical tension between painting and sculpture. The opaque layers of ink are analogous both to the additive elements of the printing block, and to sculptural assemblage. Like a machine of perpetual motion, this image seems to rock back and forth around the fulcrum of the central blue ring. Circles and rectangle forms serve as visual counterweights, and projecting cantilevers help maintain their balance.

These are not strict geometric forms, but brushstrokes that retain the energy of the artist's hand, and the mottled texture of the larger color passages give the image an organic quality. By using black paper the artist created an alternating counteraction between line and field, form and void.

Black and Blue is unusual among Casarella's work for its black paper and the opacity of the inks. His earlier works were printed on soft Japan paper, and he often used transparent films of ink to make the images more subtle and varied. In this print he aimed for the paper color to create the primary linear imagery. He experimented with preparing papers by painting a layer of black gouche, and printing black ink, and then he tried using this laminated paper, but he may never have been fully satisfied with the results. Casarella began his process with a full-scale color sketch, usually in gouache.[5] He traced its design onto sheets of translucent paper, planning for the separation of colors onto different printing blocks, and often refining and simplifying the image at this stage. Only two blocks were used for this print, but the artist employed as many as eight, printing up to sixty different colors. He overturned the tracings when he transferred the designs to eight-ply laminated illustration board, thus reversing the image so that the finished print would be oriented in the same direction as the original sketch. Using a utility knife, Casarella cut out slightly larger component shapes and affixed them with rubber cement to gray chipboard. Then he trimmed and adjusted the composite blocks precisely, cutting on a slight bevel away from the compositional forms. To vary printing effects, Casarella sometimes adjusted the height of the block by peeling away the cardboard in layers, creating recessed passages that printed as softened shadows. To create textural or linear details in white — or black in the present print — he debossed or scored the printing surface with an awl, knife, or sandpaper.

Casarella used oil-based industrial printing inks, applying pigments to the unsealed paper blocks with small brayers. To control the gloss of the ink he mixed in transparent gel medium. He printed the blocks with the larger forms first, rubbing the back of the dry sheet by hand with a wooden spoon or a roller. The artist employed different systems to register the overprinted colors; for this print, he used small metal pins protruding from the blocks at exactly the same positions to transfix perforations in the paper margins.

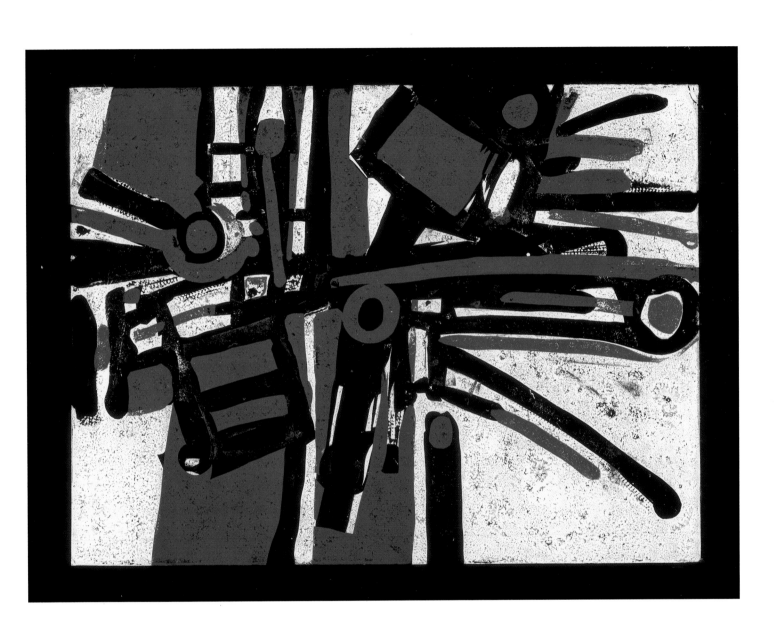

ROBERT CONOVER

1920–1988

55. Collision, 1958

Woodcut on cream Japan paper, 16/25
61.1 x 44.5 cm (image)
72.7 x 55.2 cm (sheet)
Inscribed: in graphite, below image:
 Collision 16/25 Robert Conover '58
References: Print Council 1959, cat. no. 12;
 Johnson 1980, p.94; Graham 1987, no.44.
Worcester Art Museum, 1998.221

During the 1950s Robert Conover gained a reputa-
tion for striking relief prints that capture the energy
and spirit of Abstract Expressionism, enhanced by
the use of simple means. Throughout his long,
consistent teaching career he continued to make
prints.

Conover was born in Trenton, New Jersey, on
July 3, 1920, and grew up in Morrisville, Pennsyl-
vania.[1] His father was a businessman, who took
his young son on tours of Philadelphia, sharing his
love of the city's architecture. As a teenager he
began his studies of art in classes at the Barnes
Foundation. At that time Conover made sketching
expeditions in the country, and on one of these
outings he met the painter Charles Ward, who
befriended and encouraged the young artist. In the
late 1930s he began to show his work in the annual
exhibitions of the Morrisville-Trenton Group, with
which he continued to show for over a decade.

In 1938 Conover enrolled at the Philadelphia
Museum School. He was drafted in 1942 and
served in the Army Corps of Engineers in the
Pacific theater of war. After his discharge in 1945
he moved to New York and resumed his studies at
the Art Students League. George Grosz and Will
Barnet were among his teachers, and he made his
first prints at the League. At that time he painted
figural, still-life, and landscape compositions in
the Cubist tradition. In 1948 a Shiva Scholarship
enabled Conover to study at the Brooklyn Museum
School, where he was a pupil of Max Beckmann,
Reuben Tam, and William Baziotes. His style
evolved into angular geometry and then toward a
more organic, entropic abstraction. At Brooklyn,
Conover renewed his interest in printmaking, and
associated with a group of contemporaries who
were advanced GI Bill students and instructors,
including the painters Edmond Casarella, Vincent
Longo, and Clinton Hill.

In 1949 Conover won the New Talent contest
sponsored by the Laurel Gallery in New York, the
award for which was his first solo exhibition.[2] The
show included abstract paintings with composi-
tions of fragmented rectilinear forms, and their
titles mark the artist's sources of inspiration in
urban and industrial landscapes. In 1950 Conover's
paintings were included in the Whitney Museum
Annual exhibition, and the following year his works
were included in the *Abstract Painting and Sculp-
ture in America* exhibition at the Museum of
Modern Art and the Spiral Group exhibition at the
New School of Social Research.[3] Conover won a
purchase prize at the Brooklyn Museum print
national exhibition in 1952.[4] His paintings and relief
prints of that period resemble stained-glass win-
dows in their fragmented compositions, in which
dark veins isolate lozenges of color. The artist
applied pigment thickly to his canvases with rapid
strokes, and their effect is reminiscent of the early
paintings of Piet Mondrian.[5] In summer 1954
Conover won a fellowship to work at the MacDowell
Colony at Peterborough, New Hampshire, where he
found inspiration in nature. He replaced architec-
tonic form with the crystalline contours of rocky
fragments, splintery wood grain, and the linear
tracery of trees, with their interstices enlivened
with slices of color. The artist used hue and form to
capture changing light and atmosphere and to sug-
gest mood. In 1957 Conover began teaching at the
New School for Social Research in New York. He
also showed his work at the Zabriskie Gallery at
that time, and was a fellow at Yaddo, the artists'
colony at Saratoga Springs, New York, in summer
1959.

In the 1960s Conover focused his attention on
teaching. Aside from his primary position he also
taught at the Lenox School and the Brooklyn
Museum School, and in 1966 he became an
instructor of printmaking at the Newark School for
Fine and Industrial Art. His productivity continued
undiminished, though he exhibited his work less
frequently during that period. In 1968 his solo
exhibition at the New School Associates Gallery
consisted entirely of prints.[6] In response to Color
Field painting during the early 1970s, Conover sim-
plified his compositions and often concentrated on
the interaction of colors. He made relief prints from
thick cardboard plates, which were divided into
components, separately inked in different colors,
and then fitted together like a jigsaw puzzle before
being printed by hand rubbing.[7] Printed on large
sheets of simili Japan paper from rolls, these bold
prints reached mural scale.

In the mid-1970s, perhaps in response to the
currency of Neorealism, Conover turned to repre-
sentational etchings of urban landscapes. These
views, which occupied him for the last two
decades of his career, were inspired by the city
around him, and by great architectural printmakers
of the past, such as Giovanni Battista Piranesi,
Charles Meryon, and Joseph Pennell.[8] The artist
worked from his own sketches, made on site.
Several of his prints record the decay and demoli-
tion of New York landmarks, particularly the
beaux-arts theaters in the Forty-second Street area
that provided the foci for city neighborhoods in the
era before television. Conover retired from teach-
ing in 1986, and a solo exhibition at the New
School for Social Research celebrated his career.
The artist continued to produce urban landscape
etchings, using the printmaking studios at the New
School for his own work, and continued to enjoy
the institutional camaraderie. He was at work in
the printshop there two days before his death in
New York on October 5, 1998.

The present print is Conover's best-known
woodcut, noted for its edgy energy. The image
evokes blowing tree branches darkened by rain, a
trunk splintered and charred by a lightning strike,
or shards of shattered glass. Conover used over-
lapping forms to create an illusion of space, but
his image remains purposely ambiguous. The top-
heavy composition provokes a sense of expecta-
tion, for it seems that the image could collapse at
any moment. The title reinforces the notion that
what we see is the result of momentary violence.

Collision is printed from two blocks of birch
plywood, delicately inked and printed in the gray
passages, which reveal the grain of the wood-
block, and printed heavily in the superimposed
black areas. Like his colleague Vincent Longo,
Conover began his woodcuts with a sketch on the
printing surface. When cutting thin lines perpen-
dicular to the grain, like the horizontal borders of
this print, the artist allowed the chips and voids
that give his prints a natural character. This is
emphasized by thin, gray striations in the white
areas, printed from the ridges of wood in the exca-
vated areas of the woodblock. When the artist
began to integrate other tones and colors — and
when he printed from cardboard relief blocks — he
carefully planned the more complex designs in
sketches. Sometimes, in order to print passages of
saturated black, he sealed the porous wood with
gesso before inking. Conover preferred Japan
paper, supple enough to take the uneven stresses
of hand printing and not tear. He used small
brayers to ink the blocks, laid a dry sheet on top,
and printed by hand, rubbing the verso with a flat
wooden rice paddle.

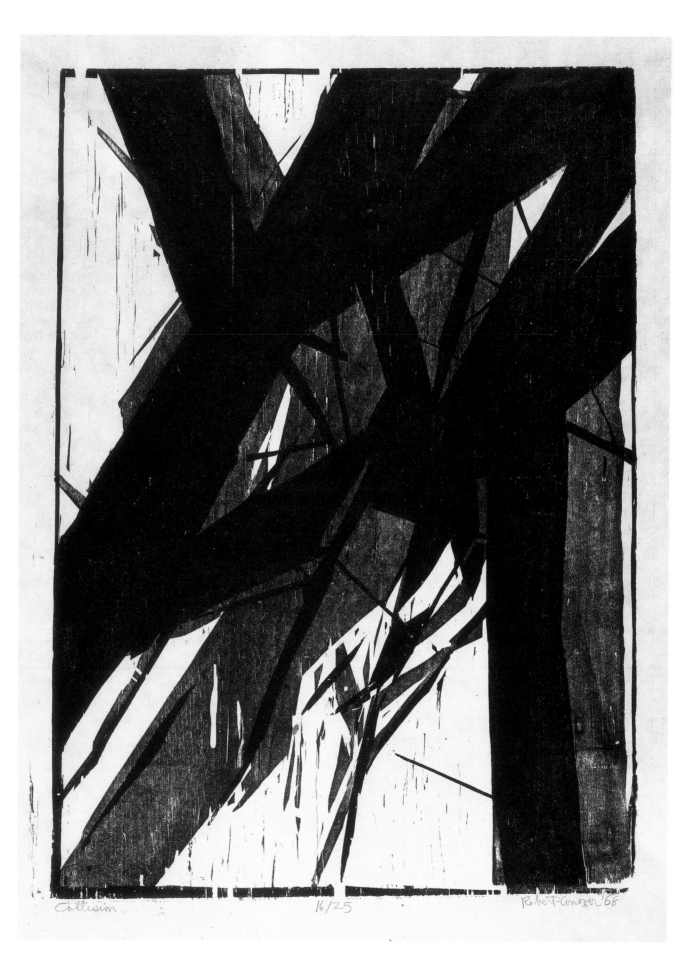

Collision 16/25 Robert Conover '68

LARRY RIVERS

1925–

56. Dark Plant, 1958

Lithograph on cream handmade paper, 1/4
25.8 x 30.7 cm (image)
33.8 x 42.5 cm (sheet)
Inscribed: in graphite, below image:
 1/4 ll Rivers'58
Watermark: *H*
Embossed: l.l.: *ULAE*
References: Sparks 1989, p.469, no.5
Worcester Art Museum, Museum purchase,
 1958.26

Around 1950, Larry Rivers's art emerged from a volatile mix of New York jazz, painting, and poetry. Though his style became representational, Abstract Expressionism was a formative influence, and its spontaneity characterizes his first lithographs, marking a milestone in American printmaking.

Yitzroch Loiza Grossberg was born in the Bronx, on August 17, 1923, the son of a plumber.[1] He began piano lessons at age seven, and took up the saxophone three years later. In 1940 he changed his name when he began a career as a jazz musician, in bands playing the resort hotels of the Catskills. He enlisted in the Army Air Corps in 1942, but was discharged within months when diagnosed with multiple sclerosis. The Veteran's Rehabilitation Program enabled Rivers to study music theory and composition at the Julliard School, where he befriended Miles Davis, who introduced him to many other jazz musicians. Rivers also met Jane Freilicher, a musician's wife and painter, who encouraged his interest in art and introduced him to her friends, including Nell Blaine. He attended informal sketch classes at Blaine's studio, and joined her circle of artists, musicians, critics, and poets, becoming a close friend to the critic, curator, and poet Frank O'Hara.

In 1947 Rivers studied with Hans Hofmann, and the following year he attended New York University (NYU), where he was a pupil of William Baziotes and Tony Smith. He began lasting friendships with fellow students Alfred Leslie and Robert Goodnough. Rivers developed a style that combined realistic observation with improvisational caprice. Blaine helped to arrange his first solo exhibition, at the Jane Street Gallery in 1949. Clement Greenberg and Meyer Schapiro included his work in their *New Talent 1950* exhibition at the Kootz Gallery. The following year he graduated from NYU with a bachelor's degree in art education, and his solo exhibition, at the Tibor de Nagy Gallery, featured paintings influenced by Chaim Soutine. In the early 1950s the artist experimented with drip paintings on paper derived from Pollock, and painterly gesture under the influence of Willem de Kooning.

In 1953 Rivers moved to Southampton, Long Island. Over the next four years he often painted in the nearby barn of his friend Fairfield Porter, and developed a delicate, linear style that combined naturalistic references with painterly swaths and scumbles.[2] This is the style of his painting *Washington Crossing the Delaware*, an irreverent parody of the painting by Emmanuel Leutze that had become an icon of American culture, which was acquired by the Museum of Modern Art. Purchases by the Corcoran Gallery, the Whitney, and the Metropolitan Museum of Art soon followed. At that time the industrious artist painted prolifically, played jazz, appeared on television quiz shows and in experimental films, created the sets for friends' plays, and designed covers for their books. He also wrote his own verse, collaborated with Kenneth Koch on poem-paintings, and with O'Hara on the mock manifesto "How to Proceed in the Arts." In 1957 Rivers began to weld steel sculpture, and to make collaborative lithographs at Universal Limited Art Editions (ULAE).[3]

During the early 1960s Rivers spent time in Europe, working and showing in London and Paris, where he collaborated with the French sculptor Jean Tinguely. The first retrospective exhibition of his work was presented by the Rose Art Museum at Brandeis University in 1965.[4] He also designed sets and costumes for the Metropolitan Opera. Rivers was devastated by O'Hara's accidental death in summer 1966, and he spoke at the grave site in Springs, Long Island.[5] The following year he began a collaboration with the poet Terry Southern on *The Donkey and the Darling*, a series of fifty-two lithographs. Working with the French filmmaker Pierre Gaisseau, Rivers made trips to Africa in the late 1960s; arrested in Nigeria as a suspected mercenary, he narrowly escaped execution. The artist was a pioneer of mixed media, and created monumental painting-constructions at that time. In the 1970s, he executed commissions in a variety of media, including video. Exhibitions of his work appeared at the Palais des Beaux-Arts in Brussels in 1972, the Museo de Arte Contemporaneo in Caracas, Venezuela, in 1981, and a large retrospective was mounted at the Kestner-Gesellschaft in Hannover, Germany.[6] The artist still lives in New York, where he continues to play jazz and to work in a variety of media, occasionally including prints.

Rivers was the first artist to work at ULAE, the pioneering collaborative printmaking workshop that Tatyana and Maurice Grosman set up in their home in West Islip, Long Island, in 1956. Conceived to enable artists to draw their own images on the printing surface, the studio provided the equipment and expertise to produce multiple originals.[7] Tanya Grosman was also enchanted with the notion of artists and poets working closely together on fine printed books. She had discussed these matters with Rivers when they first met on a transatlantic voyage in 1950. Years later, after she had bought a used press and installed it in her living room, she asked him and O'Hara to collaborate on her first production. She delivered lithography stones, and the artist and poet began working together, passing the crayon back and forth between them to draw the twelve lithographs for the portfolio *Stones*. More than any other project of the era that combined printed images with poetry, this was a direct, active collaboration. Grosman engaged the Master Lithographer Robert Blackburn, who began to commute from the city to West Islip. Inconsistent funding, a short supply of the handmade paper that Grosman preferred, and the demanding careers of Rivers and O'Hara stretched the project over three years. In the meantime, Rivers worked with Blackburn on ten other editions, including the present print.

Dark Plant is typical of Rivers's early prints at ULAE and reflects how the artist and publisher learned about printmaking together.[8] Its size and delicacy were determined by the old lithography stone that Grosman had found. She insisted that Blackburn ink and print its edges, and she chose the thick handmade paper.[9] These features complement Rivers's extemporaneous drawing style, with its pentimenti, smudges, and erasures. His improvisation grew from the Abstract Expressionist notion that the work reveal his own intellectual, psychic, and physical activity. He honored accident, retaining the mottled corrosion of the printing surface, and building his design from faint images left on the old stone, once used to print labels. Rivers used these pale images like a collagiste, transforming ghostly typographic arabesques into the stems and drooping leaves of a potted plant. We see his marking experiments with the lithographic crayon, careful shading, scribbles, smudges, and fingerprints. The artist's exploration of the process of lithography becomes the real subject of the print.

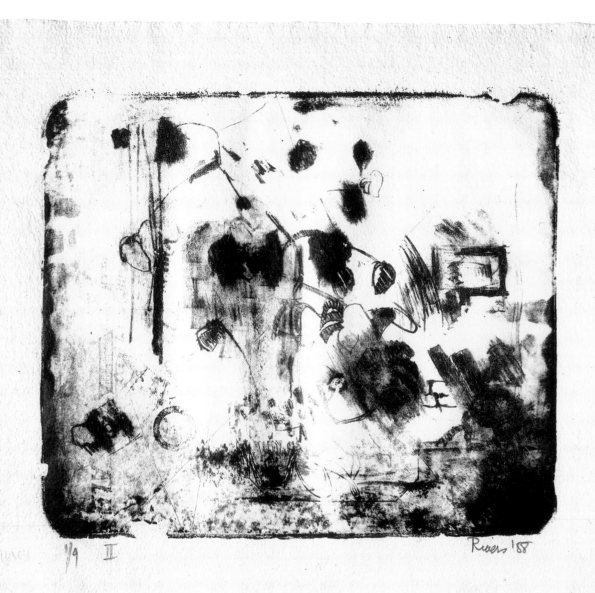

UNCI 1/9 II Rivers '88

GEORGE MIYASAKI

1935–

57. Light in March, 1959

Lithograph on cream wove paper, 5/12
63.7 x 48.8 cm (image)
66.1 x 51.0 cm (sheet)
Inscribed: in graphite, below image:
 5/12 Light in March Miyasaki '59
Watermark: *BASINGWERK PARCHMENT*
References: Acton 1992, pp.19, 32.
Private collection

George Miyasaki began making exquisite Abstract Expressionist lithographs when he was just a teenager, and for half a century he has remained an eminent figure in northern California printmaking. His outstanding skills as a lithographer have encouraged the work of many other artists, and he has enjoyed equally successful careers as a painter and a teacher.

Miyasaki was born on March 24, 1935, in Kalopa, Hawaii, where his father was a farmer.[1] Growing up in the country, he dreamed of a career in commercial art, and in 1953 he moved to Oakland to enroll at the California College of Arts and Crafts (CCAC). He first encountered abstraction there, not in class, but in the studios of his fellow students Manuel Neri, Bruce McGaw, and Charles Gill. "For a couple years it was just complete chaos in my mind," Miyasaki recalled. "But once I grabbed on to it, it was just like something incredible. I printed and painted anywhere it was possible. . . . I was just obsessed."[2] With a convert's zeal he changed his major to fine art and developed a personal painting style based on the work of Richard Diebenkorn.

Miyasaki made his first prints in summer 1955, in a lithography class at the CCAC taught by Leon Goldin. Instead of the conventional method of preparing an image in lithographic tusche or crayon, he learned a simplified technique of painting on the stone with asphaltum. A distinctive style grew from this process as he produced prints related to his paintings. Miyasaki's next lithography course was taught by Nathan Oliveira, whose *Death of an Ant* made a deep impression on the young artist for its use of gesture to evoke a mundane moment in everyday life.[3] Miyasaki was enthralled with the chemistry of lithography and compelled by its mystery. His prints appeared in the most prestigious shows of the day, including the Brooklyn Museum print national exhibitions, and the *Fourth International Biennial of Contemporary Color Lithography* at the Cincinnati Art Museum in 1956. The following year the artist won the John Hay Whitney Opportunity Fellowship, and his first solo exhibition was mounted at Gump's Gallery in San Francisco. After completing his bachelor's degree, Miyasaki continued in the grad-

uate program at the CCAC, studying lithography with Oliveira and painting with Diebenkorn.

At that time Miyasaki associated with a group of artists, poets, and jazz musicians for whom the experience of creativity was more important than its products. He joined in the ritual destruction of his art in their "burning parties" and festive expeditions to the city dump. After completing his master's degree, Miyasaki joined the faculty of the California School of Fine Arts (CSFA) in 1958. In that year his color lithograph *Autumn* won a purchase prize in the eleventh Brooklyn Museum print national, and in 1959 his lithographs appeared in *American Prints Today*, the landmark show organized by the Print Council of America.[4] Miyasaki helped to print Willem de Kooning's first lithographs at the University of California, Berkeley, in 1960. In that shop he also worked with friends and colleagues, Karl Kasten, John Grillo, Sam Tchakalian, and Harold Paris, printing their large Abstract Expressionist lithographs.

In 1961 June Wayne invited Miyasaki to visit the Tamarind Lithography Workshop in Los Angeles. The program directors quickly recognized his expertise and assigned him workshop projects. He printed three editions for Ulfert Wilke and seven editions of his own color lithographs, works that explored unfamiliar procedures and materials.[5] At Tamarind Miyasaki also learned about controlled editioning procedures and record keeping and became a more careful printer. In 1962 the artist won a Guggenheim Foundation fellowship that allowed him to spend more time painting. A show of his canvases was mounted at the University of California in 1963, and a solo exhibition of his prints appeared at the Achenbach Foundation for the Graphic Arts in San Francisco.[6] In 1964 Miyasaki traveled to Greece and Italy and produced a series of paintings based on the geometric patterns of ancient frescoes and vase paintings. These designs are apparent in several lithographs that he made on visits to the Clot lithography studio in Paris. He began to teach printmaking at the University of California, Berkeley, in fall 1965. His work reflected the influence of Pop Art at that time, as he appropriated images and experimented with iridescent paints and spray effects.

In the 1970s Miyasaki concentrated on painting, with the support of grants from the National Endowment for the Arts. After his visit to Japan in 1978, his paintings related more closely to nature, and his palette became softer. He collaged layers of translucent Asian papers to his canvases, wrinkling their surfaces in organic textures. Miyasaki's paintings were shown in solo exhibitions at the Stephen Wirtz Gallery in San Francisco in 1981 and in 1988.[7] His early lithographs also appeared in solo exhibitions at the Wirtz Gallery in 1992, and at

the Mary Ryan Gallery in New York in 1994. In that year Miyasaki retired from teaching. Today he lives in Berkeley and devotes much of his attention to painting.

Light in March exemplifies the lyrical imagery and virtuosic technique of Miyasaki's early lithographs. Its segmented rectilinear composition evokes both architectural and landscape associations. The asymmetry of the dominant canted, trapezoidal form, printed in a darker color, gives a sense of energy and change to the composition. Miyasaki usually began a print with concrete visual ideas, inspired by nature. His deep identification with nature might have reflected his Japanese heritage or perhaps his childhood experiences in the jungles and meadows and on the beaches of the Hamakua Coast of Hawaii.

Miyasaki made this print from a single counteretched stone. The artist approached lithography as an adjunct to his painting and drew spontaneously on the horizontal stone. "Printmakers before always had a predetermined idea . . . ," Miyasaki later recalled, "because you were not supposed to make mistakes. I just ignored that and figured if I made enough changes each time, the inconsistencies would become consistent enough that they would just work out."[8] He drew with a brush and a solution of powdered asphaltum mixed with grease and cleaning solvents, according to his own recipes. When the first improvisational drawing was complete, he inked and printed the stone in the conventional manner, pulling all the impressions for a projected edition in a single color. Then the artist washed the printing surface with acetic acid, chemically defacing the stone and negating its ability to hold ink. The image remained as a pale shadow to be used as a guide for the next layer of imagery, printed in a different color. Each layer of color evolved from the one before it, and the artist actively made all decisions about design and color during the preparation of the stone and its printing. Oriented to active creativity, the artist was impatient with the monotony of production and made small editions, seldom comprising more than ten impressions.

Generally Miyasaki printed light colors over darker ones. He used overlapping translucent tints to soften the image, blurring the edges of forms. By superimposing these translucent hues, he created many other colors. The bold contrariety of youth prompted his vivid palette. "If they told me I shouldn't be doing it, I probably did more of it. Like the colors they told me I shouldn't be using, light blues, . . . orange, red. What you call 'icy' color was not considered in the best taste, so I used nothing but those light colors!"[9]

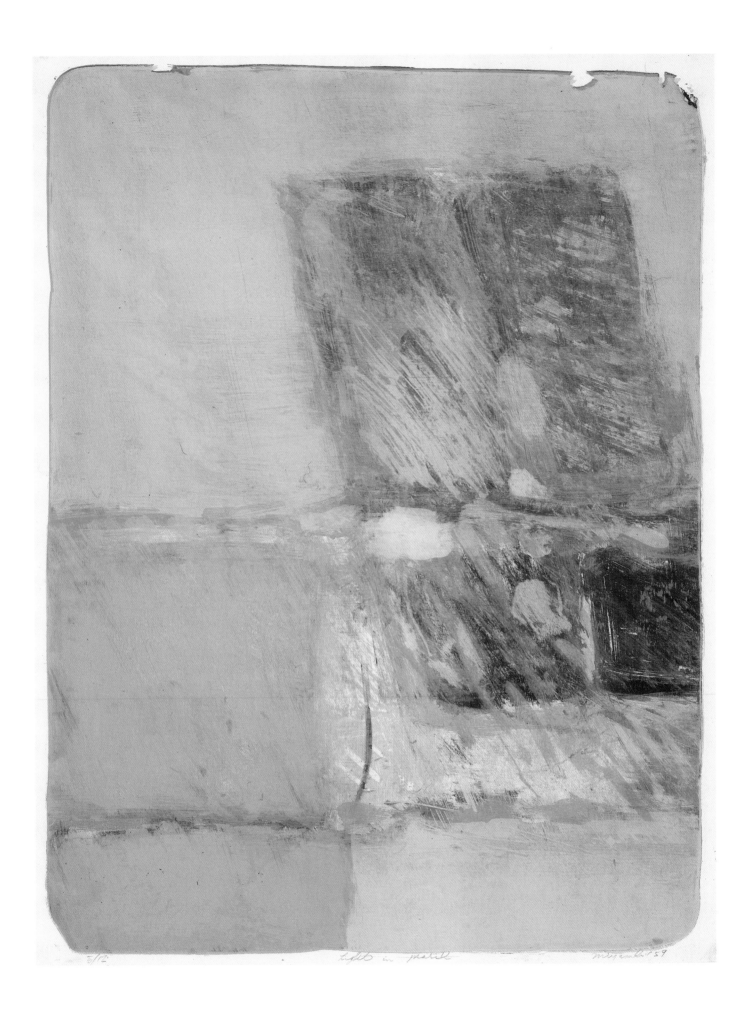

JULIUS WASSERSTEIN

1924–1985

58. Untitled, 1959

Lithograph on cream wove paper, 2/10
81.7 x 61.7 cm (image)
85.0 x 63.9 cm (sheet)
Inscribed: in graphite below image:
 2/10 JWasserstein 59
Worcester Art Museum, 1996.118

During the 1950s, the elusive Julius Wasserstein developed a painting style that combined dynamic gesture with a feeling for the tactile qualities of his materials. The passion of his work, and his unfaltering commitment to art, belied his retiring, gentle personality.

Wasserstein was born in Providence, Rhode Island, on May 16, 1924.[1] As an infant he moved with his family to San Francisco, where his father joined the family fur business. During World War II he fought as an Army paratrooper in Europe. He returned to the Bay Area after his discharge, and in 1950 he enrolled at the California School of Fine Arts (CSFA) as a GI Bill student. Wasserstein studied with David Park and Elmer Bischoff, and produced rather academic figural student paintings. He was studious and diligent, but shy among his peers. In 1952, along with several of his fellow students — including Madeleine Diamond, Roy De Forest, Sonia Gechtoff, Deborah Remington, and others — Wasserstein attended the seminars given by Hassel Smith at his Mission Street studio and at his home on Potrero Hill, but the experiences affected no immediate change in his style.[2] He also experimented with printmaking at that time, making intaglios and lithographs in classes at the CSFA given by James Budd Dixon. In 1952 he began working as a preparator and technician at the San Francisco Museum of Modern Art, soon to be joined by his friend the painter James Kelly.

In 1953, when a new degree program began at the CSFA, Wasserstein enrolled, and he was at the top of the first graduating class. Immediately thereafter he completely abandoned representation, and concentrated on large, moody, gestural canvases that reflect the lingering influence of Clyfford Still. In summer 1953 his abstract paintings were included in the exhibition of work by Smith's Potrero Hill group at the King Ubu Gallery,

and his first solo exhibition appeared there later that year. Large, sweeping gestures dominate Wasserstein's canvases of the period, and his style reflects his distant understanding of New York School painting. He worked quickly, and strove to convey the physical nature and behavior of his materials. After laying down a ground of wet wash he painted extemporaneous calligraphy, allowing the edges of his strokes to bleed into the background, creating fuzzy effects. In 1954 a solo show of Wasserstein's paintings was mounted at the Lucien Labaudt Gallery in San Francisco. The following year his work was included in *Action I*, the group exhibition of works by Bay Area painters organized by Walter Hopps, and shown at the Merry-Go-Round Building on Santa Monica pier. Afterwards he continued to exhibit in group shows at Hopps's Ferus Gallery in Los Angeles. From 1955 to 1958 Wasserstein continued his studies at San Francisco State College.

In May 1956 a solo exhibition of Wasserstein's works appeared at the Six Gallery, and the following year he had a solo show at Ethel Gechtoff's East and West Gallery.[3] In the late 1950s he continued to emphasize the tactile quality of his work, adding asphaltum to the pigment and building up thick, impasto layers of paint "in enormous shearing strokes that pulverize the strata into sparkling ore."[4] From 1960 to 1963 Wasserstein taught at the San Francisco Art Institute (formerly the CSFA), where a solo exhibition of his paintings was mounted in 1961. In that year he received the Nealie Sullivan Award from the San Francisco Art Association, and in 1962 solo exhibitions of Wasserstein's work appeared at the California Palace of the Legion of Honor and at the San Francisco Museum of Modern Art. The artist's style gradually evolved in the 1960s away from broad gestural calligraphy to sparer, more detailed imagery concentrated in marbled passages before dark fields of color.[5] As his peers moved away from the Bay Area, or transformed their styles according to fashion, Wasserstein continued working with fierce commitment, supporting himself in his museum job, and exhibiting regularly on the West Coast. The artist died of a heart attack in San Francisco, on October 28, 1985.

Little is known of Wasserstein's activities as a

printmaker. After experiments with etching and lithography in about 1952, he seems to have continued making lithographs through the decade. His prints reflect the style of his paintings and an interrogatory approach to the process. The technique and materials of the present print suggest that it was made in the shop at the CSFA. It was printed from a single counter-etched stone, a straightforward technique that the artist seems to have used for all of his lithographs. Another image printed on the verso of this sheet seems to be the result of Wasserstein's economy; this was a common practice in the CSFA printshop during the 1950s, where the focus was on experimentation and creativity in the moment. Deep colors and saturated black give this image a brooding quality, emphasized by the appearance of muscular, passionate gesture.

The manner in which Wasserstein executed the print in layers is analogous to his painting method, and ultimately derived from Still. He began by laying down a random, colored ground over the entire stone with two layers of ink. He used a brayer or flat knife to spread a thin, mottled film of tusche on the printing surface, which he printed in green ink. Then he effaced the stone and repeated the process, overprinting a similar image in red. Wasserstein contrasted thin, translucent films of ink toned by the paper color, with opaque saturated layers of pigment. For the final stone, printed in black, the artist developed a spontaneous but deliberate design and concentrated much attention on this image. He prepared the printing surface with liquid tusche, applied with brushes and rollers, drawing the negative areas to create the appearance of wide calligraphic brushstrokes. He scumbled ink and seems to have used a sponge to blot variegated passages. Wasserstein scraped ink away from the stone with a knife, used a wide lithographic crayon to isolate colored passages, and added spirited calligraphic details throughout. This intentionally varied vocabulary of marks reveals the visual capabilities of lithography. The progressive, additive nature of the technique is also revealed by the colored stripes along the right edge of the image, where Wasserstein purposely printed the superimposed ink layers slightly out of register.

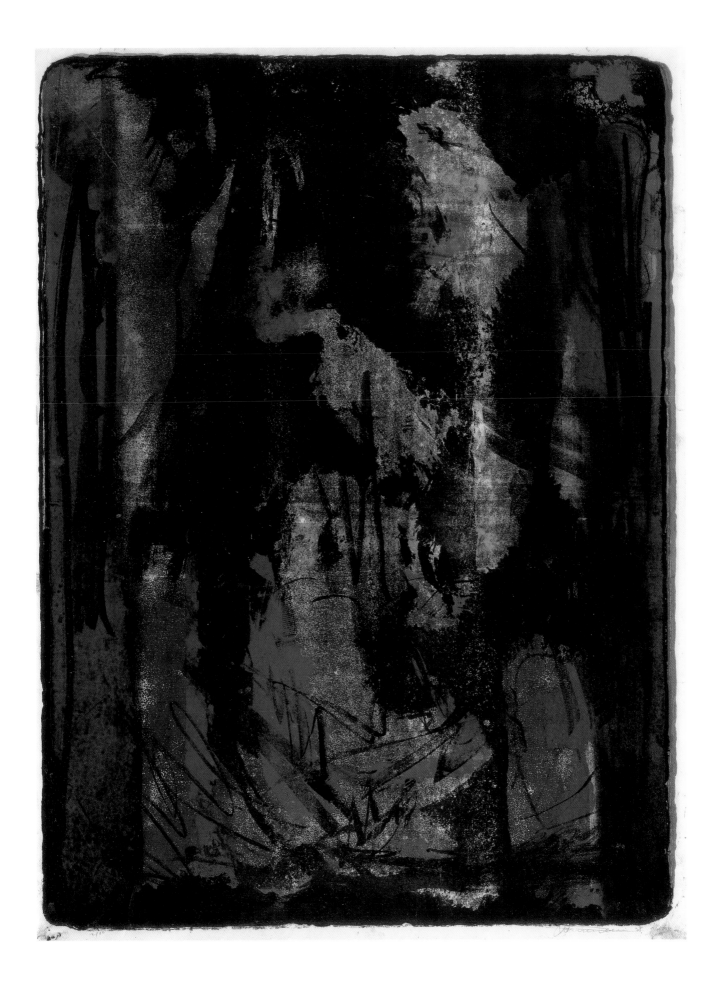

ULFERT WILKE

1907–1987

59. Music To Be Seen, 1959

Etching and drypoint on cream laid paper, 1/1
30.1 x 37.8 cm (plate)
40.6 x 48.0 cm (sheet)
Inscribed: in graphite, below platemark:
 1/1 UW (intertwined) '59
Worcester Art Museum, Alexander and Caroline
 DeWitt Fund, 1998.115

The Abstract Expressionist fascination with hand-writing found full expression in the art of Ulfert Wilke, who explored written languages around the world and throughout history, utilizing their vocabularies of line and form in the development of his own introspective style.

Wilke was born at Bad Tölz in Bavaria, on July 4, 1907.[1] His father, Rudolf, was a caricaturist, renowned for his work in *Jugend* and *Simplicissimus*, the Munich journals of style and social satire.[2] In 1923 he began painting lessons with the portraitist Wally Jaeckel, a family friend. He moved to Berlin in 1925 to continue his studies in Jaeckel's studio, and soon became a competent portraitist, working in an expressive representational style that readily attracted commissions. The artist studied in France in 1927–28, and won a prestigious Albrecht Dürer Prize. His first solo exhibition was mounted at Brunswick Castle in 1929.

In fall 1938 Wilke immigrated to New York. He worked as an advertising designer while continuing to paint, and soon he made close friends with the artists Lyonel Feininger and George Rickey. In 1939 Wilke was artist-in-residence at Kalamazoo College in Michigan, and he began teaching there the following year. Wilke was drafted in 1942 and served in Army Special Services, providing art therapy in hospitals in the South and Midwest. While in the military he became a United States citizen. After the war he married and began a family; he also completed his master's degree as a GI Bill student at the University of Iowa. In 1948 Wilke joined the faculty of the University of Louisville in Kentucky. His style began to evolve into nonobjective abstraction.

From 1955 to 1956 Wilke taught at the University of Georgia in Athens. At that time he began a series of drawings executed with a broad-nibbed fountain pen. He strove to capture the form of foreign alphabets and their visual rhythm, though he had no knowledge of the words or their meaning, and the series extended to hundreds of abstract drawings. Wilke gathered twenty-four of these designs in a portfolio of photomechanical reproductions, called *Music To Be Seen*, which he published privately in 1956.[3] Wilke's first solo exhibition in New York, mounted at the Kraushaar Galleries in 1958, featured his *Music To Be Seen* drawings and prints.[4] In that year Wilke traveled to Japan.[5] In Yokohama he visited calligrapher Nankoku Hidai, who taught him about the history and practice of Japanese calligraphy. In Kyoto he stayed for several weeks at a Zen Buddhist temple, where he studied meditation and painting. He was instructed in the traditional use of sumi inks and Japanese brushes and learned such principles of design as *yokaho*, the use of reserved spaces of unmarked paper as part of a design. The work Wilke produced there was shown at the Yamada Gallery in Kyoto. He also compiled and published *Fragments from Nowhere*, a portfolio of nineteen photomechanical reproductions of his calligraphic experiments.[6] Wilke worked in Rome in 1959 with the support of a Guggenheim Fellowship. He studied ancient Etruscan and Roman art and culture, and represented his experience of history in watercolors of the timeworn walls of Rome. In Rome he also continued his interest in meditative calligraphy, and he produced another album of facsimile drawings, *One, Two and More,* also printed and published in Kyoto.[7]

Wilke taught at Rutgers in 1960, when he lived in Manhattan and associated with the New York School painters. The following year during an artist's fellowship at the Tamarind Lithography Workshop in Los Angeles, he created several editions of gestural and Abstract Expressionist prints.[8] In summer 1964, working at his studio in a converted church in Anchorage, Kentucky, Wilke began to develop his orthographic imagery into large-scale paintings. Using a wide brush and a single flat color, he plotted circular passages side by side, isolating the small spaces between them as triangles in the white of the canvas.[9] Then the brushwork became more typographic, and Wilke formalized his compositions by hardening the edges of his script. The artist worked quickly and automatically, and his paintings multiplied rapidly, becoming progressively larger and bolder.

From 1968 to 1975 Wilke was director of the University of Iowa Museum of Art. He continued to paint and make prints; he executed a suite of color lithographs at Collectors' Press in San Francisco in 1969, and the following year he did a lithograph for the Cleveland Print Club, and two editions of lithographs at the Tamarind Institute. In 1976 the artist built a home and studio on Kauai, and in his final years he divided his time between Hawaii and the mainland. Wilke died in Anahola, Hawaii, on December 7, 1987.

The present etching is one of just a few original prints that grew directly from Wilke's *Music To Be Seen* drawings of the mid-1950s.[10] Those improvisational pen drawings explored a variety of graphic patterns, rhythms, and linear vocabularies derived from foreign and ancient scripts. "Old civilizations are conjured up and sources both Oriental and Occidental are found," Wilke's friend Mark Tobey wrote in the foreword to the portfolio of drawing facsimiles. "The calligraphy is never hesitant and the lines flow, connect, separate, and unite again to bring us a new aspect of art in modern life."[11] The artist strove to create these drawings spontaneously from deep in his subconscious. "I don't even care to think about anything, reminiscences or what else," he wrote in his journal on March 15, 1956. "I just like the pen to make its marks and to see that each mark adds to the drawing and doesn't subtract from its initial charm. . . . Just forget about anything; use up all the paper and do one after another."[12]

For this etching Wilke drew on the grounded plate with similar immediacy. He mindfully restricted himself to the simple linear vocabulary of straight lines, angled checkmarks, and crescents. Rather than arranging his rapid strokes in typographic rows, he clustered them together in a swarm that appears to vibrate. Lines occasionally escape from the tattered edges of the cluster and seem to float away, emphasizing this energy and imparting a sense of organic vitality. The artist probably used sandpaper to create a soft web of fine drypoint scratches in the copper. These delicate wisps of tone further integrate the linear cloud, negating its orthographic quality. The fine scratches almost give the effect of the tracers of movement as the lines seem to rocket through space. At this point, it seems, Wilke also incised his monogram and the date into the plate with the drypoint needle. It may be that the delicacy of the drypoint lacery, which certainly would have faded quickly from the plate in successive impressions, caused the artist to make just one impression instead of editioning this print. Although this image can be read as a musical metaphor, it would be a rhythmic and an atonal music, like layers of forest birdsong rather than the metered precision of a Bach composition.

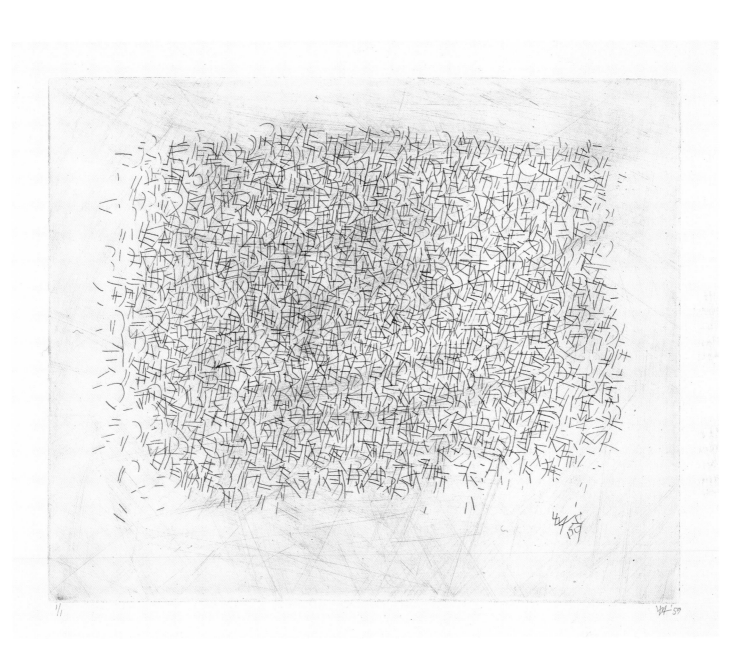

1/1 '59

PERLE FINE

1905–1988

60. Printed Collage #1, about 1956

Woodcut and cardboard relief, with aluminum foil
on cream Japan paper
30.4 x 65.4 cm (image)
30.4 x 65.4 cm (sheet)
References: Gordon/Johnson 1957, cat. no. 11.
Worcester Art Museum, 1997.172

Perle Fine was an active member of the New York
School in the 1940s and 1950s, but Abstract
Expressionism was only one stylistic phase in the
artist's development. A creative printmaker, she
consciously used the graphic arts to complement
and inform her primary work as a painter.

Born in Boston, on April 31, 1905, Fine grew up
on a dairy farm in Malden, Massachusetts.[1] She
began her studies of art in Boston, and in 1928 she
moved to New York to enroll at the Grand Central
School of Art. In the early 1930s she studied with
Kimon Nicoläides at the Art Students League,
where she met a fellow student, Maurice Berezov.
They married, and after graduation Berezov
became a magazine illustrator and later a success-
ful Madison Avenue advertising designer. In sum-
mer 1938 Fine studied with Hans Hofmann in
Provincetown, and she enrolled at his school in
New York the following autumn. In a building
opposite Hoffman's school on Eighth Street, Fine
and Berezov rented a pair of cold-water flats, and
they lived in one apartment and used the other as
a studio.

Fine began to exhibit her work in the spring
salon at Peggy Guggenheim's Art of This Century
Gallery in 1943. Her paintings attracted the atten-
tion of Hilla Rebay, director of the Museum of Non-
Objective Art, who arranged a fellowship for the
artist from the Guggenheim Foundation.[2] In 1944
Fine began taking classes at Atelier 17, S.W.
Hayter's intaglio printmaking workshop. Her early
etchings and engravings reflect the influence of
the distinctive Surrealism of Joan Miró, whom she
may have met at the studio (fig. 1).[3] The artist's

Figure 1. *Weathervane*, 1944.

first solo exhibition, mounted at the Willard Gallery
in 1945, included paintings that explore the rela-
tionships between music and visual experience,
one of the artist's favorite and enduring subjects.
She joined the American Abstract Artists, and her
paintings were included in the group's ninth annual
exhibition in 1945. Geometry and refinement domi-
nated the paintings in her solo exhibitions at the
Nierendorf Gallery in 1946 and 1947. "The stamp
of modern art is 'clarity'," Fine pronounced, "clarity
of color, clarity of forms and of composition, clarity
of *determined* dynamic rhythm in a *determined*
space. Since figuration often veils, obscures or
entirely negates purity of plastic expression, the
destruction of the particular (familiar) form for the
universal one becomes a prime prerequisite."[4]

In 1949 Willem de Kooning introduced Fine to
The Club, and under the influence of the New York
School painters, her style relaxed and became
more expressive. Her work was included in the
famed Ninth Street Show in 1951. Soft, amorphous
forms replaced hard-edged geometry as Fine's can-
vases grew larger and she applied paint more
freely. These works were shown in solo exhibitions
at the Betty Parsons Gallery from 1949 to 1952. In
summer 1951 Fine was artist in residence at Cornell
University, and in the fall she joined the faculty of
Hofstra University. She joined the Tanager Gallery
cooperative, which presented a solo exhibition of
her work in December 1951, and she rented the
front of her Eighth Street loft to the co-op as an
exhibition space. At the Creative Graphics Work-
shop she created a group of lithographs in collabo-
ration with the Master Printer Robert Blackburn,
several of which made up an exhibition at
Wittenborn Gallery in 1952.

In 1954 Fine and Berezov moved to Springs on
Long Island. In the country Fine's painting took on
an additive quality. She replaced visible brushwork
with thin, even layers of pigment, but she concen-
trated attention on the painting surface by adding
sand to the paint and strips of silver and gold
metal foil. These experiments were informed by
her color woodcuts of the mid-1950s, when Fine
exhibited with the 14 Painter-Printmakers group. In
1955 her color woodcut *Wide to the Wind* won a
purchase prize at the Brooklyn Museum print
annual exhibition. An exhibition at the Wittenborn
Gallery some weeks later focused on this print,
which was shown with gouache studies and work-
ing proofs that demonstrated how the artist trans-
formed her design into a color woodcut.[5]

During the 1960s Fine expanded her canvases
to mural scale, often working in polyptych formats.
Color relationships gradually superseded formal
issues as she turned back to the spare geometry of
Mondrian.[6] Struggling with ill health, the artist
retired from teaching in 1963. As it became difficult

for her to paint large canvases, she turned to small
paper collages and painted wooden constructions.
The artist's systematic working methods and the
timeless quality of her late work reflect the influ-
ence of Minimalism, but she insisted that the ideals
of Mondrian that had occupied her for half a cen-
tury were her inspiration.[7] Fine continued to work
until her death in East Hampton on May 31, 1988.

The influences of Surrealist biomorphism and
painterly gesture are apparent in the present print.
It is a unique experiment in mixed media, one from
a group of about five similar works that Fine exe-
cuted in the mid-1950s. It was featured in the 14
Painter-Printmakers group exhibition at Kraushaar
Galleries in 1957, at that time when most of the
group specialized in abstract color woodcut.[8] They
forged fresh directions for the medium, approach-
ing woodcut as a creative rather than a reproduc-
tive endeavor. After having made several color
woodcuts by conventional methods, Fine did sev-
eral unique printed collages, which paralleled simi-
lar experiments in her paintings. In its use of
organic imagery to create rhythmic abstraction,
Printed Collage #1 typifies her work of the 1950s.
There are no straight lines in this image, and the
only regular shape, a white lunar disc, is partially
covered to negate its geometry. The artist avoided
elements that could prompt association. As in her
contemporaneous paintings, the colors are in neu-
tral shades, and the composition is dominated by
black, contrasted with the creamy tint of the paper.
The only accents to rival the rhythmic black lines
are reflected highlights from the foil collage ele-
ments. Although the color forms cover up each
other in an intricate tangle, the image seems quite
shallow, and its movement is lateral rather than in
depth. The energy of this image depends largely
on the undulous rhythm of the wiry black lines and
their counterpoint of positive and negative space.

Fine began this piece by cutting shapes from
aluminum kitchen foil with scissors and affixing
them to a sheet of mulberry-fiber paper. To adjust
and amend the reflective shapes she painted over
the edges of the foil passages. Then she over-
printed the framing elements from a woodcut
block in black ink; she allowed the marks of the
gouge in the wood to print, and create a pattern in
the vermiculated background. The black twiggy
shapes were printed from a separate block, and
they impressed their imagery into the foil, and oily
haloes on the verso of the print suggest that Fine
used oil paint for her colors. After printing the flat
colored passages from separate relief elements,
probably made of cardboard, Fine added details
and refined passages printed in color with paint
and brush.

166

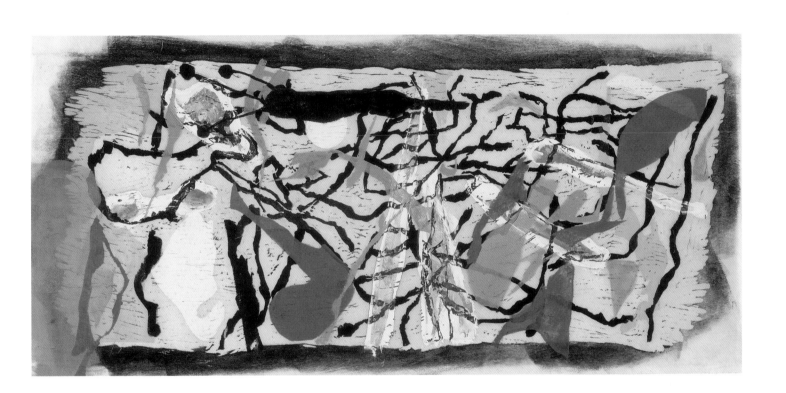

JOAN MITCHELL

1926–1992

61. Untitled, 1959

Screenprint on cream wove paper
44.9 x 36.8 cm (image)
50.8 x 40.9 cm (sheet)
References: Sheehan 1993, no.3.
Private collection

In her work Joan Mitchell combined the raw energy of Abstract Expressionism with a pastel palette and the bucolic lyricism of the French painting tradition. Several times in her career the artist's love of poetry brought her to printmaking.

Mitchell was born on February 12, 1926 in Chicago, the daughter of a prominent physician and dermatologist.[1] Her mother, Marion Strobel, was a scholar, poet, and editor of *Poetry* magazine, so Mitchell grew up in a house full of books and with such eminent friends as Ezra Pound, Dylan Thomas, and Wallace Stevens. As a child she made sketching trips to the park and the zoo with her father, and they frequented the Art Institute of Chicago. By the time she was in high school she had decided to become a painter. In 1942 Mitchell attended Smith College, and two years later she transferred to the School of the Art Institute of Chicago, where she made her first prints in a lithography class taught by Francis Chapin. After completing her BFA degree in 1947, she went to New York with Barney Rosset — who went on to found Grove Press — a childhood friend to whom she was briefly married in 1949. Mitchell studied for a short time with Hans Hofmann but disagreed with his teaching methods. When she returned to New York from an extended trip to France, she was impressed by Willem de Kooning's work in the Whitney annual exhibition in 1949 and introduced herself to him. She began experimenting with gestural abstraction, and was soon among the circle of painters who frequented the Cedar Tavern and attended sessions at The Club. Its members included her work in the Ninth Street Show in 1951. In 1953 Mitchell's first solo exhibition in New York appeared at the Stable Gallery, beginning a group of successful shows throughout the decade.[2] Mitchell painted with loose, darting brushstrokes, often gathered in clumps, on a background of white, which gives the images a luminosity. Her brushwork has a distinctive, handwritten quality, although she exploited the physical nature of the paint, allowing it to splash, drip, and collect in mounds of impasto. Though Mitchell worked in the

city, there was always a natural, lyrical sense about her work. She tried not to depict nature, but strove to express the personal feelings it inspired in her.

In summer 1955 Mitchell returned to Paris and associated with a group of American artists living in France, including Norman Bluhm and Sam Francis.[3] She met the Montreal-born *tachiste* painter Jean-Paul Riopelle, and they began a relationship that lasted twenty years. Mitchell summered in France for several years, returning to Manhattan in the fall. In 1959 she moved to Paris to live with Riopelle, continuing to paint in her own rented studio on the Rue Frémicourt in the fifteenth arrondissement. As art trends shifted in the 1960s and 1970s, the artist maintained her commitment to Abstract Expressionism and regularly exhibited her work in New York and Paris. In 1967 she used an inheritance to buy a house at Vétheuil, a small village northwest of Paris, where Claude Monet once lived. Her paintings of the 1970s became more open in their compositional structure, under the influence of the artist's peaceful country environment. Major retrospective exhibitions of Mitchell's work were organized by the Whitney Museum of American Art in 1974 and the Musée d'Art Moderne de la Ville de Paris in 1982.[4] During the 1980s the artist worked extensively in pastel. Her work was airy and bright, often in a sunny, rich palette that recalls French painting of the last century. Despite hip-replacement surgery and other health problems, she continued working at Vétheuil, until her death in Paris, from lung cancer, on October 30, 1992.

Mitchell was often drawn to printmaking by opportunities to integrate her images with poetry. A love of verse was instilled in her by her mother, and when she was young she composed poems herself. In 1964 her friends Sam Francis and Walasse Ting persuaded her to contribute designs for offset lithograph illustrations in *1¢ Life*. During the 1960s and 1970s, when she socialized with poet friends like J.J. Mitchell and James Schuyler, the artist interpreted their poems in pastel drawings, which she often presented to them as gifts. During that period Mitchell began to make collaborative prints, working occasionally with Arte Adriaen Maeght in Paris, Tyler Graphics, Ltd. in Mount Kisco, New York, and other workshops.[5] Notable among her projects was the portfolio *Smoke*, in which Mitchell's color intaglios accompany poetry by Charles Hine, published in 1989; and *Poems*, an

album combining her lithographs with the verse of Nathan Kernan, published in 1992.

When she lived in New York in the 1950s, Mitchell counted many poets among her friends and found the prospect of working with them irresistible. She was delighted when Daisy Aldan and Richard Miller chose her as one of the artists for the Tiber Press portfolio project, which published new poetry in deluxe volumes, illustrated by original color screenprints. These silkscreens, Mitchell's first mature prints, were coupled with verses by her friend John Ashbery in *The Poems*. In 1959, after reading several of the poems, the artist worked extensively at Tiber Press before the book was designed and its images selected. She made at least four color silkscreens that were not ultimately used in *The Poems*, including the present print.[6] Mitchell did not intend these prints to be illustrations of the verses, or even interpretations, but hoped to capture the personal feelings they provoked in her. The artist, poet, and editor wished to use images that conveyed the overall tone of all the poems. This may have been the reason that several of Mitchell's screenprints were printed only as proofs, and were not editioned. The cool green and pink that she used in this image are similar to the colors in her contemporaneous paintings, as is the black that provides compositional structure.

In the printshop, Mitchell began by working with liquid tusche and crayon directly on the silkscreens. Generally she printed one color and layer of ink at a time. She worked quite slowly, carefully calculating how superimposed color and imagery would affect her developing composition. Photographs of Mitchell at the studio show her sketches and proofs hanging on the walls and the artist standing back to scrutinize the designs from a distance. To plan for subsequent printed colors she sometimes painted on proofs in oil. When Mitchell became disconcerted that the weave of the silk imparted the same fuzzy contours to lines and forms in every color, she asked Vecchi if it was possible to create crisp edges. The printer instructed her on how to draw her component images with tusche on transparent Mylar, and he photographically transferred the designs to the screens. To manipulate the ink on the plastic, Mitchell broke a wooden tongue depressor in half, fraying its fibers into a brushlike tool. She used this to paint the tusche onto the Mylar and scratch the painted lines into brushlike striations.

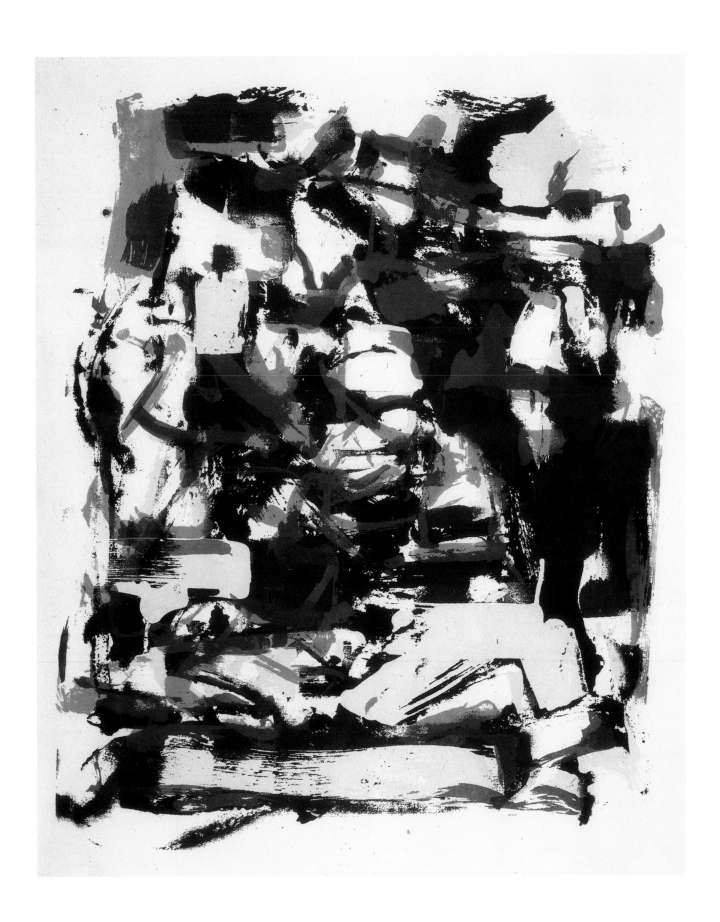

ROBERT GOODNOUGH

1917–

62. Horsemen, or Black and Sepia,

1960

Offset lithograph on white wove paper, 71/75
57.8 x 70.4 cm (image)
58.5 x 73.9 cm (sheet)
Inscribed: in graphite, l.r.: *71/75 Goodnough*;
 in graphite, on verso, l.r.: *22*
References: Collector's Graphics no.22;
 Grand/Adams 1994, n.p.
Worcester Art Museum, Sarah C. Garver Fund,
 1995.46

A prominent figure in the generation of Abstract
Expressionists who came of age in the early 1950s,
Robert Goodnough was active as a painter, sculp-
tor, critic, historian, and teacher. Late in the
decade he experimented with printmaking, and
worked at two pioneering lithography workshops.

Goodnough was born in Cortland, New York, on
October 23, 1917, the son of a toolmaker.[1] Scholar-
ships enabled him to study art at Syracuse Univer-
sity from 1938 to 1940, where he was a student of
George Hess. After graduation he was drafted into
the Army, and he was in combat in New Guinea in
1943. Goodnough remained on the island with
occupation forces, and it was there, in old copies
of American magazines, that he first saw images of
modern and abstract art. He went to New York
after his discharge in 1945, and enrolled at the
Ozenfant School of Fine Arts as a GI Bill student. In
summer 1947 Goodnough also studied with Hans
Hofmann in Provincetown. There he met fellow stu-
dents Alfred Leslie and Larry Rivers, and in the fall
he joined them in the art education program at
New York University (NYU). He was a pupil of Tony
Smith, who introduced him to Jackson Pollock and
other New York School painters. Goodnough
helped to organize the Studio 35 seminars, and
later helped Robert Motherwell and Ad Reinhardt
to edit and publish its proceedings.[2] Afterward he
became a charter member of The Club.

After graduation Goodnough began to teach
painting at NYU, and he started writing reviews for
Art News magazine.[3] His work was included in the
New Talent exhibition at the Kootz Gallery in 1950,
and two years later he began to show his paintings
at the Tibor de Nagy Gallery.[4] At that time his work
combined spontaneous linear calligraphy with dis-
crete patches of color. He condensed brushstrokes
in the center of the composition to suggest figures
in landscape settings. Goodnough became fasci-
nated by the fossilized dinosaur skeletons he saw
at the Museum of Natural History.[5] He was struck
by how these displays communicated a complex
impression of the animal itself, its size, strength,
and the grace of its movements. The artist made
drawings, collages, and sculptures of dinosaurs,

each assembled from tiny components, like fossil
bones. He used small pieces of paper to build lay-
ered compositions that balanced color and form.

This collage sensibility is combined with
improvised calligraphy in Goodnough's first prints,
made in 1959–60 at two vanguard lithography
workshops, Collector's Graphics in Manhattan and
Universal Limited Art Editions (ULAE) on Long
Island.[6] In *Dinosaur* (fig. 1), the artist outlined
angular and curving shapes to suggest the ani-
mal's form, then he superimposed crayon scribble,
creating the sensation of movement, setting, and
space.[7] Goodnough won the Garrett Purchase
prize at the Art Institute of Chicago in 1960, and he
taught at Cornell University. In the mid-1960s he
developed the imagery that would characterize
much of his maturity, concentrating on the rela-
tionships of color and form on a planar surface.
The artist used pieces of colored paper cut into tri-
angles or trapezoids, which he called "color
shapes." Collaging these on unmarked paper or
canvas, he created shifting swarms of color that
seem to flicker and move. The artist strove to bal-
ance the tension between the shapes and inter-
stices on the two-dimensional surface according to
the principles of Mondrian's dynamic equilibrium.

A solo exhibition of Goodnough's collages and
paintings was mounted at the Whitney Museum of
American Art in 1969, the year his work was exhib-
ited at the Venice Biennale. The artist expanded
this pictorial formula into a wide array of collages,
canvases, murals, sculptures, and prints. Among
them were several portfolios of screenprints,
including *Homage to Pablo Casals*, which made up
a solo exhibition at Tibor de Nagy Gallery in 1969.[8]
More than forty solo exhibitions of Goodnough's
work were mounted during the 1970s, and he exe-
cuted several public and private commissions. A
solo exhibition of his work was organized by the
Ulrich Museum of Art at Wichita State University in
1978. Today Goodnough lives in Thornwood, New
York, and continues to work and to exhibit.

The present print is one of Goodnough's first,
produced for Collector's Graphics, a nearly forgot-
ten publisher whose brief history reflects the vicis-
situdes of printmaking during this era.[9] In Decem-
ber 1959 the artist Reginald Pollack formed a
partnership with Jules Sherman, the proprietor of
Drum Lithographers, a commercial printing plant
on East Twentieth Street. Their goal was to enable
artists to make original prints as easily as possi-
ble. They employed the offset lithography process
to print hand-drawn plates oriented in the same
direction as the original design. For Sherman, who
supplied equipment, materials, and expertise, this
became an engaging diversion from business.
After experimenting with different materials for off-
set plates, the partners settled on plastic-impreg-

Figure 1. *Dinosaur*, 1965.

nated paper offset plates, which were inexpensive
and easily transported. They formed Collector's
Graphics, Inc., and in winter 1960 they began pub-
lishing prints that were distributed through
Pollack's brother Louis, proprietor of the Peridot
Gallery. Exhibitions of their prints appeared at
Peridot Gallery in April 1961 and in December 1963,
soon before Pollock moved to California and the
project ended. Among the artists who made prints
for Collector's Graphics were Nell Blaine, James
Brooks, and Larry Rivers.

Goodnough produced seven offset lithographs
with the press, all of which employ the same style
of tangled skeins and knots of line. One of the
largest, *Horsemen* is his only two-color offset litho-
graph. The artist prepared two separate plates,
drawing spontaneously with a lithographic crayon.
For the first plate, printed in brown, Goodnough
began a simple line drawing of a horse and rider,
using the same angular calligraphy that defines
the subject in *Dinosaur*; he then continued to
sketch over this design, with rapid lines and scrib-
bles conceived as a time and motion study of
horse and rider. When the second plate was over-
printed in black, the initial design was obscured,
leaving an impression rather than a representa-
tion. The linear mass is denser in the middle and
the widest horizontal lines are along the bottom,
giving the composition a sense of weight and a
geotropic illusion of space.

Goodnough strove to vary the lines, contrast-
ing thin, softly drawn strokes with wider, darker
lines, and even using the side of the crayon to
draw passages of grayish tone. The variegated
quality of the lines resulted from the grainy surface
of the offset plate, and the pebbled surface of the
paper. The artist purposely made his drawing in a
naïve, childlike manner, sacrificing elegance in
favor of kinesthetic feel. Goodnough conveyed
how it felt to make the drawing, with imagery and
technique that are within any viewer's capability.
The layers of simple scribbles add up — like the
bones of a dinosaur skeleton — to create an image
with surprising complexity and expressive energy,
which isolates the movement from the subject.

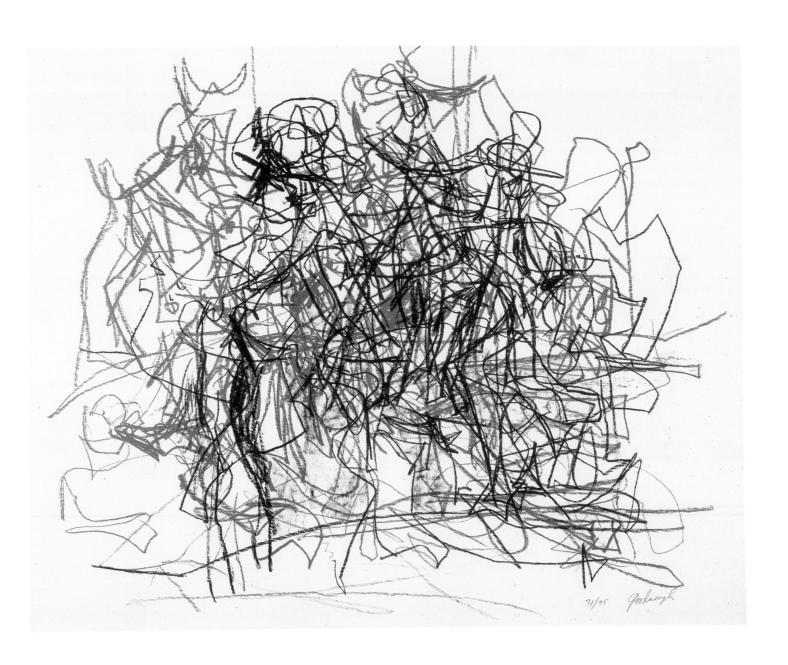

71/75 Goodnough

WILLEM DE KOONING

1904–1997

63. Litho #2 (Waves #2), 1960

Lithograph on cream wove paper
109.2 x 78.8 cm (image)
122.0 x 83.2 cm (sheet)
Inscribed: in graphite, below image, l.r.:
 de Kooning 60
References: Long 1986, cat. no. 2; Graham 1991,
 pp.9, 41, cat. no. 3; Graham/Walker/Budnik
 1991, pp.16–17.
The Baltimore Museum of Art, purchased as the
 gift of the Tilles Foundation, New York;
 Women's Committee Fund for Contemporary
 Prints and Photographs; and exchange funds
 from the Bequest of Saidie A. May, 1996.79

Erudite, sensitive, and prodigal, Willem de Kooning gave expression to his personality and experiences in canvases that celebrate the act of painting itself. His prints as well as his paintings combine Cubist form and figural representation with spontaneous inspiration and apparent revision.

De Kooning was born in Rotterdam, the Netherlands, on April 24, 1904, the son of a beverage distributor and bar owner.[1] He became an apprentice in a decorating firm at age twelve, while studying at the Académie voor Beeldende Kunsten ed Technische Wetenschappen. In 1920 he joined the studio of the Rotterdam designer Bernard Romein, who introduced the young artist to a range of contemporary European art. De Kooning moved to Belgium in 1924, to study at the Academie Royale des Beaux-Arts in Brussels and the van Schelling Design School in Antwerp. The following year he returned to the Rotterdam Academy to complete his degree.

Soon after his graduation de Kooning stowed away on a ship to America. In 1926 he arrived in New York, where he found work designing window displays, and painting signs and tavern murals. Soon he came to know John Graham and Arshile Gorky, and met them regularly at the Waldorf Cafeteria to discuss painting, craft, Surrealism, psychoanalysis, and many other topics. Along with Gorky, de Kooning explored the course of European Modernism, and the achievements of Picasso, in his own experimental paintings. Through his acquaintance with the painter Burgoyne Diller, de Kooning joined the mural painting division of the FAP/WPA; he executed one section of the mural *Medicine* in the Hall of Pharmacy at the 1939 New York World's Fair, and a fresco for the Williamsburg Federal Housing Project.

De Kooning began friendships with Jackson Pollock and Franz Kline in 1942, and shared their overindulgent lifestyle. At that time, too, he began tutoring the young painter and critic Elaine Fried; soon their friendship grew into intimacy, and they were married at New York City Hall on December 9, 1943. In 1947 the artist began to paint a series of female figures in black and white. One of these was purchased from his first solo exhibition at the Charles Egan Gallery by the Museum of Modern Art.[2] He taught at the Black Mountain College Summer Institute in 1948, the year his work first appeared in the Whitney Museum annual exhibition. A charter member of The Club, de Kooning often attended its Friday-night sessions. When he taught at Yale for a term in 1950, he was exhausted by the experience and never returned to teaching. That summer he began eighteen months' work on *Woman I*, the first of a series of paintings that became notorious for their combination of violent gesture, lush colors, and overt eroticism. Alfred Barr selected de Kooning's work for the XXV Venice Biennale in 1950; the following year his work was shown at the first biennial in São Paulo, Brazil, and his painting *Excavation* won the Logan Medal and purchase prize in the Art Institute of Chicago annual exhibition. As the artist's reputation increased, the effects of alcoholism and the invasions that accompany celebrity impeded his work. The artist and his wife separated in 1957, and he spent more time at East Hampton on Long Island, near Pollock, Krasner, and other friends. De Kooning made his first etching in 1957, to accompany Harold Rosenberg's poem *Revenge* in the portfolio *21 Etchings and Poems*.[3] At that time he began making lush, painterly abstract landscapes. In 1961 de Kooning became a naturalized American citizen, and he was elected to the National Institute of Arts and Letters. He bought a cottage in Springs, on Long Island, and settled there permanently in 1963. The first retrospective exhibition of his work in an American museum was presented by the Smith College Museum of Art in 1965.[4]

During the late 1960s de Kooning's critical and financial success enabled him to travel. He returned to Holland for the first time in 1968, to attend the opening of a traveling retrospective from the Museum of Modern Art at the Stedelijk Museum in Amsterdam.[5] The artist toured Japan, where he became interested in traditional drawing methods and materials. In Rome, in summer 1969, he made his first small sculptures in the studio of Herzl Emmanuel, which led eventually to large-scale bronzes based on the figure. He also executed twenty-four editions of lithographs at the Hollander Workshop in New York.[6] In the 1970s de Kooning received many awards and honors, and on his seventy-fifth birthday, the Dutch government named him an Officer of the Order of Orange-Nassau. In 1975 he reconciled with his wife, Elaine, and they bought a house together in East Hampton. A retrospective exhibition of his work opened at the Whitney Museum in 1984 and subsequently traveled to Berlin and Paris.[7] De Kooning suffered from Alzheimer's disease from the mid-1980s, and he died in East Hampton on March 19, 1997.

One of the great monuments of American printmaking, the present lithograph is one of de Kooning's first, created in 1960 at the University of California at Berkeley. Briefly in San Francisco to visit his young daughter, the artist attended a party given by his old friend Wilfred Zogbaum, where he met several local artists including Karl Kasten.[8] Conversation drifted to the huge lithography press and stones installed a short time before at Berkeley, and de Kooning was invited to try his hand at the process. The next day Kasten took him to Berkeley, where they met Nathan Oliveira and George Miyasaki, who served as his printers.[9] After a brief explanation of the process, the group retired to the faculty club, leaving de Kooning alone in the shop to develop his images in peace. They expected to be there for much of the day, but in less than an hour the artist arrived to say he had finished drawing the two oversized stones. The artist used a mop to make these drawings, standing on the worktable above the stones and broadly swinging both arms, as if he were cleaning a floor. Energized vertical strokes explode from horizontal diagonals in the lower quadrant of each design, like eruptions on the surface of the sun, or breaking ocean waves which give the prints their nicknames. These works are quintessentially Abstract Expressionist, in the way they reveal the artist's actions and the physical nature of the viscid tusche, in the brevity of their creation, and in their extraordinary scale. Indeed, they were the largest artist's lithographs of the time, and the prospect of their size may have enticed de Kooning to attempt them in the first place. The only available material large enough to print on was architectural paper that came in rolls. It was used for two small editions printed that afternoon, including a few proofs, and nine impressions of the present prints, which were signed but unnumbered. At a moment when collaborative workshops in the United States were in their infancy, de Kooning proved that printmaking was well suited to capture and preserve the energy and immediacy of gestural abstraction, setting the stage for an era of professional editions rather than provocative experiments.

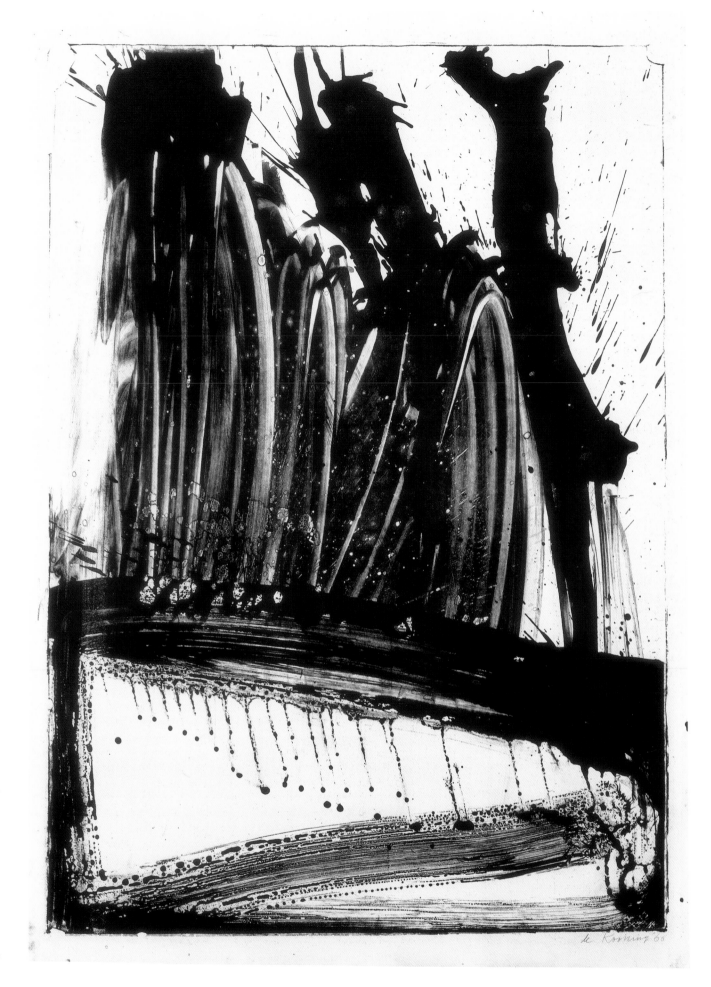

ARTHUR DESHAIES

1920–

64. The Death that Came for Albert Camus, 1960

Plexiglas relief print on cream Japan paper, 11/25
50.0 x 80.2 cm (image)
55.6 x 90.3 cm (sheet)
Inscribed: in graphite, below image:
> The Death That Came For Albert Camus 11/25
> ADeshaies 60

References: Deshaies 1961, p.22; Johnson 1964, n.p.
Worcester Art Museum, 1993.94

During the 1940s and 1950s the resourceful and visionary Arthur Deshaies worked in university printshops, where some of the most exciting technical innovation in American printmaking took place. He developed new methods for transferring the energy and freedom of gestural abstraction to mural-scaled prints.

Deshaies was born in Providence, Rhode Island, on July 6, 1920.[1] He made his first prints at age ten, scratching an image into an aluminum plate, and printing the drypoint in the wringer of his mother's washing machine. From 1939 to 1942 he studied art at Cooper Union. Prints comprised his first solo exhibition in New York at the Weyhe Gallery in 1940. The artist continued his studies at the Rhode Island School of Design, where he completed his BFA degree in 1948. At that time he worked in a Modernist style influenced by Picasso.[2] As a graduate student at Indiana University he was given charge of the printmaking workshop, and he organized the publication of annual portfolios of students' work.[3] Deshaies won a faculty grant for painting in 1950, the year he completed his MFA degree, and joined the faculty of Indiana University to teach printmaking. At that time he produced colorful stencil prints representing Surrealist fantasies with treelike biomorphic constructions.[4] In 1952 a Fulbright Fellowship enabled the artist to study and work in Paris, where two years later a solo exhibition of his work was mounted at the Studio Paul Facchetti.

In the mid-1950s Deshaies began to work in wood engraving, creating complex gestural white-line images. He progressively increased the scale of his work, and when he reached the physical limits of the medium, he began to carve printing blocks out of clear plastic, or Plexiglas.[5] In his print *Landscape Sign*, which won a purchase award at the Brooklyn Museum print national exhibition in 1956, the artist worked the plastic with a burin and drypoint needle, and printed it as an intaglio.[6] He also carved his designs in white line, like wood engravings, and printed in relief from Plexiglas blocks. In 1956–57 Deshaies taught at the Pratt Institute in Brooklyn. He became a fellow of the MacDowell Colony in Peterborough, New Hampshire, where he worked during the winter of 1959–60. In 1960 he was a resident at Yaddo, the artists' colony in Saratoga Springs, New York. Grants from the Tiffany Foundation in 1960 and the Guggenheim Foundation in 1961 enabled the artist to continue his work. At that time he turned his attention to printing from blocks of plaster, a technique that allowed him to create mural-scaled intaglio and relief prints. Deshaies constructed wooden trays into which he poured wet plaster. Sometimes, he began to work the material after it had set but before it was completely dry, rapidly pulling it into peaks and cutting gestural incisions as if he were brushing paint onto a canvas. When the plaster was dry, the artist carved into the surface with knives, gouges, and power tools. The heavy, brittle plaster blocks made it necessary for him to print from them by hand.

In 1963 Deshaies began teaching at Florida State University in Tallahassee. Under the influence of Pop Art in the mid-1960s, he created prints that combine deeply embossed inkless forms with brightly colored passages, often arranged in symmetrical, mandala compositions with erotic imagery.[7] After retiring from Florida State University in 1989, Deshaies continued to lecture and write on art and printmaking.

The Death that Came for Albert Camus is perhaps Deshaies's best known Plexiglas relief print, created soon after he heard of the tragic death of the Existentialist author in an automobile accident in the South of France. This complex, detailed abstraction seems to represent a continuum of time and experience, broken by violence and momentarily interrupted, before continuing its flow. The image is divided into horizontal registers, gently curving as they seem to stream along. A row of spherical forms detail the dominant dark band, like a chart of the lunar phases and other astronomical graphs, and seems to suggest the passage of time. Where this band curves into a gentle apex, one of the globes is brighter than the others. It glows over what may be a bowing human figure, described by black forms resembling a head above two legs. The beam of intense light that descends from above onto the shoulders of this figure may symbolize a moment of violent death and natural annihilation, or perhaps the instant of spiritual redemption. The formal and linear vocabulary of this image is similar to that of Deshaies's other Plexiglas engravings that represent the moving oceans. The artist was fascinated by the sea, by the flow of tides, marine weather, and aquatic life. He sailed along the Atlantic Coast and through the Mediterranean studying and taking photographs from which his imagery derived. In his art oceanic forms came to symbolize the earth, biological life, the continuity of existence, and the cycle of man's inner being. "I wish to speak of these natural forms and forces in my own vocabulary," Deshaies wrote, "in the belief that man's turmoil, his disaster and triumph, parallel the turmoil and disaster, and triumph of the sea in the same manner that the essence and meaning of man are contained in the earth, and in root and stem and in the plant's eventual flowering."[8]

Deshaies achieved unprecedented refinements in his use of Plexiglas. He liked the white line appearance of wood engraving, but was dissatisfied with the rigid quality of the burin in the hard boxwood. So when he began to carve in larger sheets of plastic, he experimented with tools that provided more gestural freedom. He employed electric tools to carve impulsive gestural strokes, and with practice became quite adept at drawing with electric drills and flexible-shaft rotary gravers. He found that an electric router provided a distinctive vermiform line, and was also useful for excavating broad areas that appear as white. Deshaies used an array of hand tools, including knives, gouges, toothed chisels, and gravers. Thus he created the various textural patterns that give his prints such detailed interest.

Deshaies modified a Sturgis etching press to print his large plastic blocks, and as he developed and refined his techniques, he discovered many unforseen advantages to the material. Its transparency allowed him to transfer designs easily to the block from full-scale drawings, placed underneath the clear plastic for tracing. Deshaies rolled a layer of black ink over a new sheet of plastic and allowed it to dry, then spontaneously scratched a design through this film, so that when white paper was placed under the block he could approximate the image of the final print. After inking a Plexiglas block, the artist could hold it up to the light to gauge the density of the ink layer.[9] Deshaies followed *The Death that Came for Albert Camus* with even larger Plexiglas engravings, and polyptychs up to six feet in height and width.

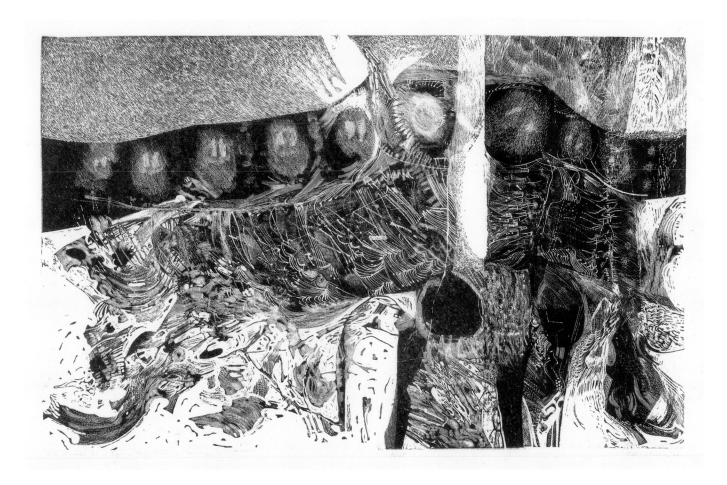

SAM FRANCIS

1923–1994

65. First Stone, 1960

Lithograph on cream wove paper, 39/65
63.2 x 90.3 cm (image)
63.2 x 90.3 cm (sheet)
Inscribed: in graphite, below image, l.l.: *39/65*;
l.r.: *Sam Francis*
Watermark: *Rives BFK*
References: Lembark 1992, vol.1, pp.44–45, no. L-1.
Private collection

The prominent Californian painter Sam Francis was one of the principal links between the second generation of Abstract Expressionists and the parallel *Art Informel* movement in Paris. He was a committed and prolific printmaker, who established his own graphic arts studio.

Francis was born on June 25, 1923, in San Mateo, California, the son of a mathematics professor and a piano teacher.[1] He attended the University of California at Berkeley in 1941, studying botany and psychology. In 1943 he enlisted in the Army Air Corps and became a pilot, but his back was injured during a training flight, and he later developed spinal tuberculosis. During his long convalescence Francis started to paint. He was sent to the Fort Miley Veterans Administration Hospital in San Francisco, where David Park was his first teacher. In 1948 he returned to Berkeley to study art and art history and completed his bachelor's degree the following year.

In 1950, after receiving his master's degree in fine arts, Francis went to Paris. He studied briefly at the Académie Fernand Léger. He associated with several American artists working in Abstract Expressionist styles, including Joan Mitchell, Norman Bluhm, and the Canadian-born painter Jean-Paul Riopelle. Francis developed a style that combined the splash and drip techniques of Jackson Pollock with the light, color,and space of French painting. His first solo exhibition was presented by the Galerie du Dragon in Paris in 1952. Three years later, the Museum of Modern Art in New York acquired one of his paintings, and his work was included in its exhibition *Twelve Americans* in 1956. Francis traveled extensively at that time, circling the globe twice in 1957 and 1958. When he was commissioned to paint a mural in Tokyo, the artist encountered the traditional *haboku*, or flung-ink style of painting, which encouraged his personal style and helped him to understand the spiritual implications of calligraphy.

In 1962 Francis moved back to the United States and settled in Santa Monica, California. The following year, as an artist fellow at the Tamarind Lithography Workshop, he produced eighteen editions of color lithographs. In 1964 Francis served as editor *1¢ Life*, the book of poems by his friend Walasse Ting, illustrated with original works by European and American artists; he also contributed six lithographs to the book. In Kyoto he made ceramic sculptures, and in Tokyo he executed a "sky painting" in 1966, consisting of choreographic plans for five helicopters that each trailed streams of different colored smoke. In the mid-1960s Francis's gestural paintings became progressively larger and brighter. In 1967 the first retrospective exhibition of his work was mounted at the Houston Museum of Fine Arts;[2] the following year the Basel Kunsthalle organized another retrospective that traveled in Europe.

During the late 1960s Francis worked extensively in lithography, producing scores of collaborative editions at many different workshops, and his prints were popular in Europe and Japan as well as the United States. In 1970 he established the Litho Shop in Santa Monica, a fully outfitted facility for the production and publication of his own lithographs and intaglio prints.[3] A retrospective of his work was mounted in 1972 at the Albright Knox Museum in Buffalo and traveled to Washington, D.C., and New York.[4] In addition to his editioned prints, Francis began making monotypes in the mid-1970s, and he created hundreds of them over the following decade.[5] In the late 1970s the artist became involved with the development of new pigments, in a partnership with his former printing assistant, Dan Cytron. They worked closely together to develop brilliantly hued lightfast printing inks and paints, which gave Francis's palette a keen radiance. A solo exhibition of Francis's work was mounted at the Centre Georges Pompidou in Paris in 1978. The artist executed many commissions for murals during the 1980s, including monumental paintings for the United International Terminal at the San Francisco airport, and for the ceiling at the Théâtre Royal de la Monnaie in Brussels. In 1983 Francis was named Commandeur de l'Ordre des Arts et des Lettres by the French ministry of culture. A solo exhibition of his work appeared at the Museum of Modern Art in Toyama, Japan, in 1988. At that time he bought property at Inverness, Scotland, and established a large studio. In his last years he divided his time between

Scotland and California. Francis died from cancer in Santa Monica, on November 4, 1994.

The present print was Francis's first editioned lithograph, produced in Switzerland in 1961. The artist was introduced to the process the year before, when he was in New York painting a mural for the Chase Manhattan Bank. He met Tatyana Grosman of United Limited Art Editions, who invited him to make a lithograph, describing the mystery and sensuality of the process. She sent stones to Francis's studio, and he was intrigued by the process of their preparation, but he returned to Europe before the lithographs were printed.[6] In Switzerland where he then lived, the artist told his friend Eberhard Kornfeld, owner of the auction house Kornfeld and Klipstein, of his adventure with preparing the stones. Kornfeld arranged for Francis to work with the printer Emil Matthieu in Zurich, and the present print is the first product of that collaboration. Fifteen other editions followed, published by Kornfeld and Klipstein in Bern. These lithographs immediately became popular, encouraging the artist's continued printmaking and advancing the new American abstraction abroad.

In his first experiments Francis realized the potential of lithography to record spontaneously inspired and executed images, and that once an image was fixed on the stone, it could be printed in different colors. Moreover, since each hue of a color print was carried on a different matrix, there were infinite possibilities for experimentation and adjustment. In many of Francis's prints, color and a carefully balanced composition convey mood and lyricism. In the workshop the artist preferred to be alone while preparing the stones, combining meditative concentration with momentary inspiration. He was actively involved with the printing process, working at the press alongside the printer, sharing all the decisions. He became fascinated by the bright, translucent hues of lithograph ink. Their peculiar color and light influenced his painting, and later prompted him to development new pigments. In this abstract image, a sense of motion is enhanced by the juxtaposition of areas of transparency with passages of saturated color. A vertical central bar appears to be disintegrating, pulled apart by the energy of magnetic poles on opposite sides of the composition. Rectilinear fragments separate, and the pieces are set in motion with drips and directional spatters of tusche, suggesting complicated oppositional forces at work.

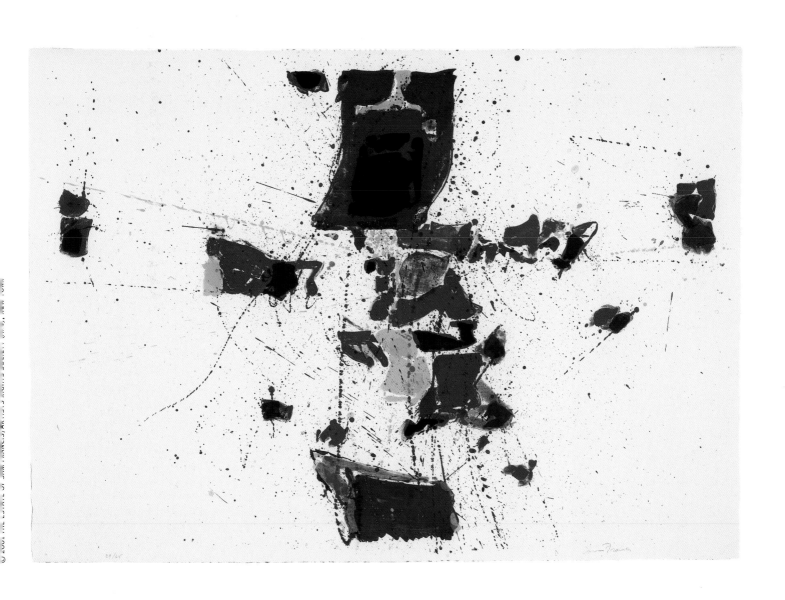

39/25

HAROLD PERSICO PARIS

1925–1979

66. Study for a Sculpture, 1960

Etching, engraving, drypoint, roulette, and
collagraph in Plexiglas, artist's proof
50.3 x 40.0 cm (plate)
66.7 x 53.6 cm (sheet)
Inscribed: in graphite, below platemark: *Trial Proof*
"Study for a Sculpture Harold Persico Paris 60;
in graphite, above platemark, l.: *To Joyce and
George, New York Aug 7, 1960*; in graphite on
verso, u.r.: *202*; l.l.: *95A* in a circle.
Watermark: *ARCHES*
Worcester Art Museum, Richard A. Heald Fund,
1995.55

Best remembered as a sculptor and pioneer of
installation art, Harold Paris was also an innova-
tive printmaker. Most of his prints were made dur-
ing a dynamic period from 1945 to 1965, when
Paris's style shifted mercurially, alternatively fea-
turing expressive figuration and Surrealist fantasy.

Paris was born in Edgemere, Long Island, on
August 16, 1925, the son of an actor in the Yiddish
Art Theater of New York.[1] In 1943 he was drafted
into the Army, and served in a Corps of Engineers
model-making detail, where he learned to work
with plastics. Later Paris became an artist-corre-
spondent for *Stars and Stripes*.[2] In 1945, while cov-
ering the Nuremberg trials, he was deeply affected
by evidence of the Holocaust, which prompted him
to make his first prints. He carved relief blocks in
plastic rather than wood, and pulled small, undoc-
umented editions; together the prints make up a
loosely organized suite known as the *Buchenwald*
series. After his discharge in 1946, Paris worked as
a freelance designer in New York. In 1949, when
one of his works was purchased by the Museum of
Modern Art, he was encouraged to return to print-
making, and a Tiffany Fellowship allowed him to
concentrate on his art. Paris learned the basic
intaglio techniques in classes at Atelier 17, and
the fundamentals of lithography from Robert
Blackburn at the Creative Graphics Workshop. He
created an experimental group of prints inspired
by his favorite artists from history, including
Francisco Goya and Odilon Redon, which were
shown in his first solo exhibition, at the Argent
Gallery in 1951.[3]

In 1953 a Guggenheim Fellowship enabled
Paris to begin an ambitious suite of prints, inspired
by great European mystical artists, as well as
Jewish and Christian scripture. He moved to
Majorca, in Spain, where he created dreamlike,
tenebrist prints.[4] Studying as he worked, the print-

maker became increasingly fascinated by Hebrew
myth and folklore. On a visit to Barcelona in 1954,
Paris first saw the work of Antonio Gaudí and he
decided to become a sculptor. He moved to France
to teach at the United States Army Special Service
Headquarters in Nancy, where he established a
foundry and cast Abstract Surrealist bronzes. In
Nancy he finished the prints of his Guggenheim
Fellowship series, which he titled *Hosannah* — an
exclamation of praise for God.[5]

Paris returned to New York, and in summer
1960 he taught printmaking at the Pratt Graphic
Art Center. His solo exhibition at the Esther
Stuttman Gallery in 1960 featured both prints and
sculpture. The next fall he joined the faculty of
University of California at Berkeley. Paris quickly
found a friend in Peter Voulkos, who encouraged
him to work with clay, and he soon realized that
the medium was ideal for a long-contemplated
sculptural project. In 1960 he executed his first
ceramic wall, in a twenty-four-hour session begin-
ning at four o'clock in the morning.[6] From a wall of
wet clay, about seven feet tall and nine feet wide,
he spontaneously modeled what appears to be a
crumbling monument from a mysterious, lost civi-
lization. Two other walls of sculpted terracotta fol-
lowed in 1961 and 1962. In the early 1960s, Paris
pursued a stunning variety of sculptural projects. A
range of fantastic bronzes, sometimes incorporat-
ing found objects and patinated in colors, identi-
fied the sculptor with the Funk Art movement of
the Bay Area.[7] In 1963 Paris won the first of three
consecutive annual sculpture awards in the San
Francisco Museum Art Annual exhibition. At his
studio in El Cerrito he created *Room I*, a pioneering
work of installation art in 1964–65.[8] Paris suffered
his first heart attack in 1965, and medical tests
revealed a progressive condition. Nevertheless he
began an ambitious series of installation projects.
Among them are *Pantomina Enfanta*, a children's
play space made for the Balboa Pavilion in Newport
Beach, and *Pantomina Illuma,* which employed
electronics to create contrasting effects of light,
temperature, and sound. Paris explored new mate-
rials in his freestanding sculpture of the period. An
extended series of small pieces called *Souls* is
composed of found objects encased in slabs of
transparent silicon gel. A retrospective exhibition
of Paris's prints was mounted at the Berkeley Art
Center in 1970.[9] Two years later a more compre-
hensive survey of his work appeared at the Univer-
sity Art Museum at Berkeley.[10] One of his last
works was an environment for the Oakland City
Center Plaza, completed in 1976, which incorpo-

rated landscape architecture and eleven bronze
sculptures. Paris died in Berkeley on July 21, 1979,
following his fourth heart attack.

The present print is one of several interrelated
works leading up to Paris's series of ceramic walls,
Mem. The artist conceived this project in the late
1950s, and began sketches when he was in Europe.
In summer 1960 he made this print at the Pratt
Graphic Art Center, as well as *Thoughts about a
Sculpture*, a series of etchings and embossings
that developed his ideas more fully.[11] After moving
to Berkeley, he transferred these motifs to the
three terracotta walls of the *Mem* cycle. *Study for a
Sculpture* represents the Moloch, the figure of a
horrible monster that also appears in the center of
each ceramic wall. The artist based its image on an
ancient Ammonite demon described in the Bible.
To placate the Moloch the Ammonites sacrificed
their children to the fiend. According to tradition
the children were placed in the arms of an idol,
over a burning altar, and fell into the flames to be
burned alive.[12] Paris's image shows a ghostly form
seated against a stele, suggested by the dark
ground line and the upper edges of the image,
which appear chipped and eroded. The ambiguity
of the figure enhances its menace. The Moloch is
seated with its legs crossed at the ankles, and the
figure of a lifeless child is draped across its lap.
The monster's face is a ghostly skull with dark eye
sockets, and it seems to hold to its mouth a pulpy
mass, perhaps the remains of another victim. This
gesture and the shape of the fiend's head and
shoulders recall the famous painting of *Saturn
Devouring His Children* by Francisco Goya, whose
work Paris admired.

For his printing plate Paris used a thick sheet
of plastic, which is softer to carve than metal and
can be easily reformed and augmented. He created
the dark, reticulated passages of this print by
chemically etching the plastic, painting acid on its
surface with a brush. The natural action of the etch
created random organic patterns, and by biting the
plate in stages he controlled how deeply the pas-
sages were bitten. Paris also carved the plastic,
using conventional woodcut and intaglio tools,
including a toothed wheel, perhaps powered by an
electric drill. He also built up the plate in some
areas to deboss the printed sheet; for this purpose
he probably used thick epoxy, dripping and driz-
zling the glue onto the plate to create viscid pas-
sages. The artist carefully inked and wiped the
plate, to take full advantage of the bright accents
in relief and the rich, saturated intaglio passages.

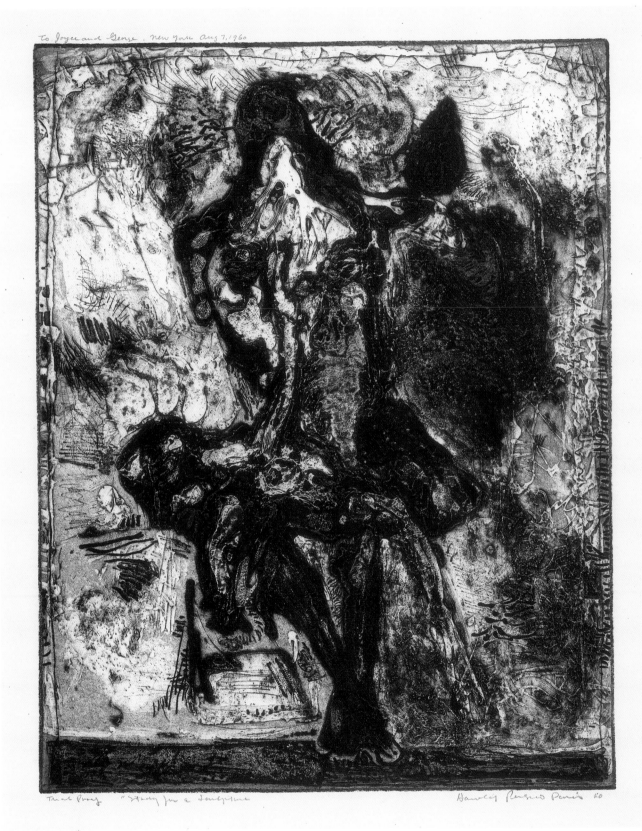

ADJA YUNKERS

1900–1983

67. Untitled (Skies of Venice VIII),

1960

Lithograph on cream wove paper, artist's proof
56.0 x 79.4 cm (image)
75.0 x 105.2 cm (sheet)
Inscribed: in graphite below image:
*„SKIES OF VENICE VIII". ARTISTS PROOF Adja
Yunkers.60*; in graphite, on verso: *Adja Yunkers*
Watermark: *BFK RIVES*
Embossed: l.l.: Tamarind chop; l.r. *GA* (Garo
Antreasian)
References: Tamarind no.195; Adams 1983, p.203;
Gilmour 1988, p.347; Devon 2000, pp.11–12.
Worcester Art Museum, 1997.179

Adja Yunkers mastered all the traditional printmaking media as his style evolved and shifted over the course of his eventful life. In the late 1950s he became an imperious Abstract Expressionist, and qualities of the style remained in his work through the second half of his career.

Born in Riga, Latvia, on July 15, 1900, Adolf Eduard Vilhelm Junker was called "Adja" by his family, an affectionate Latvian nickname that remained with him for life.[1] His father was an industrial mechanic, who moved the family to Petrograd at the beginning of World War I. There he began his studies of art around 1916, probably at the Drawing School of the Society for the Encouragement of the Arts.[2] As bourgeois foreigners, the Yunkers family faced peril during the Bolshevik Revolution, and they made a harrowing secret journey back to Riga. After being wounded while fighting for the Latvian nationalist army, Yunkers quarreled with his father and left home in 1919. He wandered through Europe, struggling to paint and sometimes just to survive. In 1921 his first solo exhibition was mounted at the Maria Kunde Gallery in Hamburg, featuring works in a style similar to that of Marc Chagall.

In spring 1922 Yunkers would have died from an overdose of opium, but for the attention of Hildegard Kutnewsky, a medical student who became the first of his five wives.[3] In January 1926 he moved to Havana, Cuba, to become art director for the department store La Casa Grande. His paintings and woodcuts of the period combine Cubist influences with the colors and emotion of Afro-Cuban ethnic art. When his Leftist political activities necessitated his flight from Cuba, he went to Mexico, where he met Diego Rivera. When Yunkers returned to Berlin in fall 1927, he wanted his art to reach the working classes. He made woodcuts influenced by the prints of José Guadelupe Posada and Frans Masereel. In 1930 Yunkers

moved to Paris, where he painted murals at the industrial suburb Ivry-sur-Seine, which were said to reflect Rivera's style.[4] In 1933 the artist moved to Sweden, where he joined the Anarcho-Syndicalist Party, which commissioned prints and murals. In 1936 Yunkers joined a party delegation to Barcelona, where he encountered the work of Picasso, whose potent influence affected his paintings and prints of the late 1930s. At that time Yunkers joined the Minotaur Grüppen of Surrealists, and his work explored the subconscious and metaphorical myth. During World War II he produced the illustrated Surrealist journal *Création*, as well as *Ars* and the *Ars-portfolios*, editioned albums of original prints.

Fire destroyed Yunkers's Stockholm studio in 1947, and soon afterward he sailed to America. In New York he began teaching at the New School for Social Research.[5] He exhibited and sold his color woodcuts widely. In 1948 the artist spent the first of five summers teaching at the University of New Mexico in Albuquerque, and the atmosphere of the Southwest affected his art. He worked in monotype, using found textures to manipulate an image on a plate before printing.[6] With the support of a Guggenheim Fellowship, Yunkers tried vainly to establish a printmaking workshop in New Mexico, and then the Rio Grande School of Art. In 1950 he published *Prints in the Desert*, a portfolio of original art and poetry by the artist and his students. Then his adobe home flooded and much of his work was lost.

Yunkers returned to New York, and began *Polyptych*, an ambitious color woodcut project. Its five large prints are united by a complex iconographical program, and its central panel alone is printed in fifty-six colors.[7] Just a month before its scheduled exhibition, most of the prints were destroyed when the ceiling of Yunkers's apartment collapsed. Over the remaining weeks he printed three new sets of *Polyptych* in time for the triumphal show. In December 1953 the artist became an American citizen. He traveled to Rome the following year with a second Guggenheim Fellowship. There he created his *Ostia Antica* series of color woodcuts and monotypes, inspired by a visit to the archaeological site of the Roman seaport. When Yunkers returned to New York in fall 1955, he abandoned color woodcut. His fifth wife, Dore Ashton, then a critic for the *New York Times*, brought him into contact with the New York School painters. Over the next seven years, Yunkers became involved in their activities, forming close friendships with Philip Guston and Mark Rothko. He concentrated on large, gestural pastel paintings, which were exhibited in solo exhibitions in New

York and at the Baltimore Museum of Art in 1960.

The artist abandoned pastel in 1962 and turned to painting in acrylic with torn paper collaged to the canvas. Yunkers's prominence in American printmaking was shown by his retrospective exhibition at the Brooklyn Museum in 1969.[8] At that time he was at work on *Poems for Marie José*, a series that united his prints with the verse of his friend Octavio Paz; in 1974 they collaborated again on the folio of love poems, *Blanco*. In his late paintings Yunkers collaged rope to canvas, and replicated these effects in deeply bitten etchings. By 1980 his sight had begun to fail. Respiratory difficulties made it hard for him to work, and he concentrated on small painted collages on canvas board. Yunkers died on December 24, 1983, in New York.

This is perhaps the most famous lithograph from Yunkers's suite *Skies of Venice*, produced in 1960 at the Tamarind Lithography Workshop, where he was among the studio's first artist fellows.[9] He reveled in the printers' skills and the well-equipped studio and spent long days there. In six weeks he created twenty editions, including five prints to accompany the poem *Salt,* by Stanley Kunitz, and nine lithographs of the *Skies of Venice* series.[10] The imagery of this suite grew from the artist's then recent trip to Italy and memories of how the city sits low on the water, where the sea meets the sky with its Mediterranean light. The remarkable tonal breadth and chiaroscuro subtlety of these prints lyrically evoke the inspiration and achievement of such Venetian old masters as Titian, Canaletto, and Tiepolo.

Yunkers transferred the imagery, style, and process of his current pastel paintings to the *Skies of Venice* prints. He drew those abstractions with big sticks of oil pastel on enormous sheets, mixing powdery pastel with tempera, gouache, and liquid fixative directly on the paper. The artist worked in broad physical gestures, intuitively superimposing layers of imagery, creating a sense of depth and luminosity. Yunkers employed a similar process at Tamarind, building his compositions in strata. He combined liquid tusche of varied dilutions, with powdered and liquid asphaltum, and bits of crayon directly on the lithography stone. He also utilized a technique he had learned in Europe, combining the black tusche with Chinese white. The gum arabic in this gouache acted as a resist, allowing the greasy drawing materials to penetrate and adhere to the printing surface in varying degrees. Their bold imagery notwithstanding, these were delicate stones, requiring all the printers' skills to continue printing legibly through the editions.

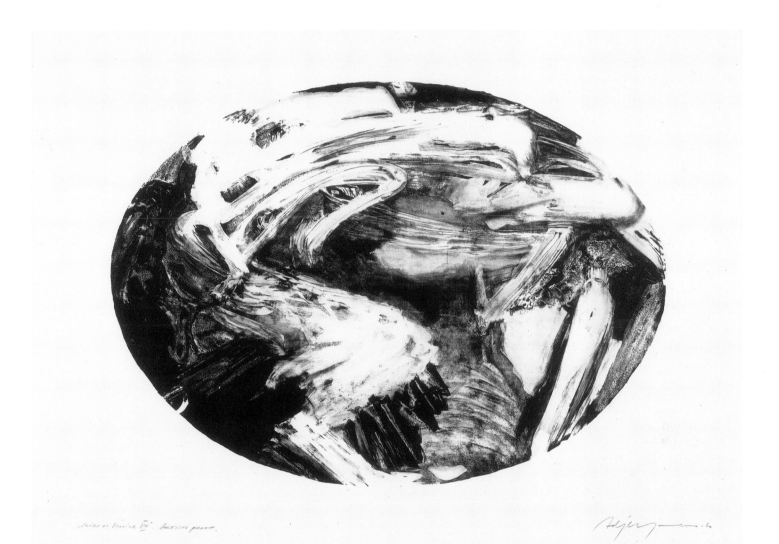

Series of Marine VIII, Artists proof.

GRACE HARTIGAN

1922–

68. Pallas Athene, 1961

Lithograph on cream wove paper, 1/30
50.5 x 35.5 cm (image)
76.5 x 56.8 cm (sheet)
Inscribed: in graphite, below image:
 1/30 Hartigan '61
Watermark: *Arches FRANCE*
Embossed: l.l.: *ULAE*; l.l. corner: *VERITABLE
 PAPIER D'ARCHES/ SATINÉ SATINE*
References: Sparks 1989, pp.118, 342, no.5;
 Graham 1987, pp.27, 83; Hansen 1995,
 pp.112, 129.
Worcester Art Museum, Museum purchase, 1962.9

A prominent New York School painter who began her professional career in the early 1950s, Grace Hartigan took part in some of the era's pioneering printmaking projects. Her early works of graphic art were often conceived and presented in association with poetry.

Hartigan was born in Newark, New Jersey, on March 28, 1922, the eldest of four children.[1] Her family moved to Bayonne, New Jersey, where at age five she was stricken with pneumonia, and during the year of her convalescence she taught herself to read and draw. She grew up in Millburn, New Jersey, and was active in drama in high school. In 1941, months after graduation, Hartigan married Robert Jachens. They moved to Los Angeles, where she took drawing classes in night school. Soon after the birth of their son in 1942, Jachens was drafted into the service, and Hartigan returned to New Jersey with the baby. During World War II she studied mechanical drawing at Newark College of Engineering and took a drafting job in an aircraft factory. She studied with the painter Isaac Lane Muse, and in 1945 she transferred to a job in New York, where he had a studio. When she saw Jackson Pollock's exhibition of drip paintings at the Betty Parsons Gallery in 1948, she was enthralled. She left her teacher and changed the course of her painting experiments. Hartigan visited Pollock and Lee Krasner at their home in Springs, and began an encouraging friendship. They introduced her to Willem de Kooning and Franz Kline, under whose influence she developed a more painterly abstract manner, using energetic swaths of dripping housepaint and collage. Soon she began to frequent the Cedar Tavern and the Waldorf Cafeteria, and she attended sessions at Studio 35.

In 1950 Hartigan's work was shown at the Kootz Gallery in the *New Talent* exhibition organized by Meyer Shapiro and Clement Greenberg. Months later, when her first solo exhibition

appeared at the newly opened Tibor de Nagy Gallery, she used the pseudonym George Hartigan, in homage to the authors George Sand and George Eliot.[2] The gallery director, John Bernard Myers, helped to acquaint these painters with an exciting circle of artists, poets, actors, and musicians.[3] He induced Hartigan to make gestural screenprints to illustrate his literary magazine *View*, where they accompanied poems by such friends as Frank O'Hara, James Schuyler, and Barbara Guest. She also contributed to the literary magazine *Folder*. In 1952 Hartigan collaborated with O'Hara on *Oranges*, a suite of paintings on paper featuring a poetic phrase or stanza in each design.[4] She copied old master paintings and forged a style that melded figuration with painterly abstraction, finding subjects in the city around her. The Museum of Modern Art purchased the artist's painting *Persian Jacket* from her third solo exhibition at Tibor de Nagy. Soon afterward, Hartigan began a collaboration with James Schuyler, on *Salute*, one of the Tiber Press portfolios that combines poetry and original color screenprints.[5] She also started to make lithographs that were published by Universal Limited Art Editions (ULAE).

In 1960 Hartigan married her fourth husband, Dr. Winston Price, a research scientist at Johns Hopkins University, and she moved to Baltimore. The artist continued to express the vitality of American life in her paintings, finding inspiration in the bustle of the city streets. She continued to exhibit her work at the Martha Jackson Gallery in Manhattan from 1962 to 1970, but gradually lost touch with the New York scene. In 1967 Hartigan began teaching at the Maryland Institute College of Art. In the early 1970s she was attracted by the publications of Bellerophon Books, children's coloring books featuring literary and historical subjects, which were translated into bold linear designs; they prompted her series of paintings inspired by past civilizations. At that time the Baltimore Museum of Art organized a traveling exhibition of Hartigan's watercolor collages, and a painting retrospective was mounted at the Fort Wayne Museum of Art.[6]

During the 1980s Hartigan returned to expressive figural paintings, often representing historical subjects in an evolving style influenced by the work of Edouard Manet and Georges Seurat. In her *American Places* series she investigated the power and superficial glamour of American culture. In spring 1989 a retrospective exhibition of her work was presented by the Kouros Gallery, and the following year a similar survey appeared at the ACA Gallery in New York.[7] The achievements of her career were recognized during the 1990s with hon-

orary doctoral degrees from Moore College in Philadelphia, the Maryland Institute of Art in Baltimore, and other honors. When her work was included in the exhibition *Hand Painted Pop* at the Museum of Contemporary Art in Los Angeles in 1993, it was recognized as a precursor of Pop Art.[8] Today the artist lives in Baltimore, where she continues to teach, paint, and show her work with undiminished vitality.

Pallas Athene, perhaps Hartigan's most famous print, is one of the earliest color lithographs made at ULAE. Tatyana Grosman approached the artist to make a print in 1959, when her friends O'Hara and Rivers were at work on *Stones*. Her first works were a series of four prints, *The Hero Leaves His Ship*, inspired by a poem by her friend Barbara Guest.[9] The successful results prompted the publisher to ask for another color lithograph. Since by that time Hartigan had moved to Baltimore, the Grosmans and the printer Robert Blackburn loaded their car with stones and supplies and drove south. Working on a press at the Baltimore Museum of Art, she labored over *Pallas Athene*, hardly leaving the museum to eat or sleep. *Pallas Athene* was printed from six stones, prepared with crayons of different consistency and liquid tusche.

Again Hartigan found inspiration in the poetry of Barbara Guest, who was then working on themes from the ancient Greek epics of Homer.[10] In the *Odyssey*, Pallas Athene, the Greek goddess of wisdom and the art of war, is patron of the hero Odysseus. Despite the challenges wrought by other gods, she safely brings him home to Ithaca after his decade of wandering after the Trojan war. Pallas was also the patron of the city of Athens, where in the Parthenon stood a towering statue of her, wrought in ivory and gold by the sculptor Phidias. Hartigan's print suggests the majesty, as well as both the contemplative and active personalities of Pallas in ancient Greek culture. The basic composition of the print is architectural, with horizontal parallel hatchings to suggest the marble steps and entablature of a temple and vertical striations to suggest its columns. By printing the edges of the lithography stone, Hartigan cleverly imparted a heavy ashlar quality to the image. Veils of muted color evoke the dark silence of the temple's interior, where the dimly illuminated icon of the goddess stood erect. This refinement is contrasted with rapid brushstrokes and calligraphy that suggest violence, and even spattered blood — allusions to the domain of the goddess, as well as to the gory battles in which Odysseus triumphed.

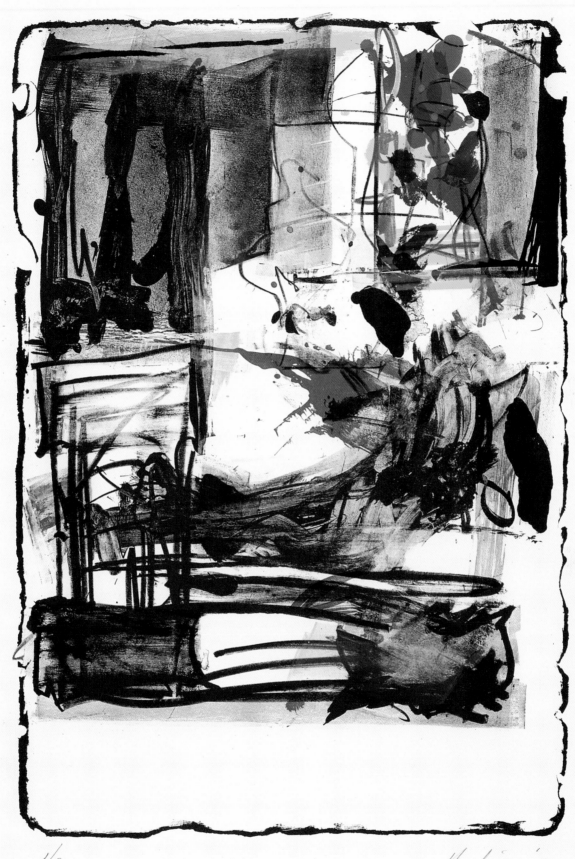

1/30 Hartigan '61

MICHAEL GOLDBERG

1924–

69. Untitled, 1961

Lithograph on cream wove paper, 15/30
66.0 x 46.0 cm (image)
76.1 x 57.0 cm (sheet)
Inscribed: in graphite, below image:
 15/30 Goldberg '61; u.r., within blindstamp *AS*
 (intertwined); in graphite, on verso, l.l.: *G529*
Watermark: *ARCHES*
Embossed: u.r.,between two dotted concentric
 circles: *PRATT•GRAPHIC•ART•CENTER•N•Y•★*
Worcester Art Museum, 1996.119

Perhaps more than any of his colleagues who began to exhibit in New York around 1950, Michael Goldberg has continued to focus on the act of painting itself throughout his career. His occasional activities as a printmaker have been characterized by technical virtuosity parallel to his painting.

Goldberg was born in New York on December 24, 1924.[1] At age fourteen he began attending Robert Brackman's Saturday classes at the Art Students League. His studies with Hans Hofmann were interrupted by Army service from 1942 to 1946, when he was a paratrooper in North Africa and Asia. After his discharge he returned to New York, and resumed his studies with Hofmann from 1948 to 1950 as a GI Bill student, producing expressive paintings inspired by landscape and urban views. Soon, he began to work in gestural abstraction influenced by de Kooning; his paint became thicker and his spontaneously inspired canvases incorporated representational references and written words. Goldberg's work was included in the Ninth Street Show in 1951. At that time he became a member of The Club, and frequented the Cedar Tavern, interacting with the older New York School painters and his contemporaries like Grace Hartigan, Alfred Leslie, and Larry Rivers. He also became acquainted with wider circles of the avant-garde, including critics, musicians, dancers, and poets like Frank O'Hara, who became a close friend. From 1952 to 1954 Goldberg shared an intimate relationship with Joan Mitchell. His work was included in group exhibitions at the Stable, and the Tanager Galleries, and his first solo exhibition appeared at the Tibor de Nagy Gallery in 1953.[2] In 1955 the artist moved into a loft on East Tenth Street near the studios of de Kooning and Milton Resnick. At that time he based his abstractions on commonplace still-life subjects and urban landscape. In order to work more rapidly, he used wide brushes, trowels, and spatulas, and his pigment became even thicker and more tactile.

A solo exhibition of Goldberg's paintings appeared at the Poindexter Gallery in 1956. The following summer, when he shared a house with Norman Bluhm in East Hampton, he began his *House Paintings* series, works that feature a central architectural form, suggesting both an edifice, and a window from an interior into distant landscape.[3] In 1960 the artist produced screenprints at Tiber Press to accompany O'Hara's verse in the volume *Odes*.[4] Their collaboration was active and direct, particularly on the print *Ode on Necrophilia*, in which the friends worked on the screens simultaneously. In the early 1960s Goldberg exhibited his work at the Martha Jackson Gallery. In 1962 he moved into the Bowery studio formerly used by Mark Rothko, where he still works.

In 1968, when Goldberg taught at the University of Minnesota, he created a series of lithographs in collaboration with Zigmunds Priede. Their diagrammatic images combine quickly plotted geometry with inscribed instructions and dimensions. In the early 1970s the artist began using pigmented bronze powder, combined with pastel, and clear alkyd spray. He placed rough geometric shapes against white grounds, detailing their surfaces with subtle, tight gestures to achieve shimmering surface effects and illusions of depth.[5] Goldberg also created dramatic paper works, abrading, mutilating, and excavating the surface of the center of the sheets, to create tactile surfaces analogous to impasto. In 1979 the artist started teaching at the School of the Visual Arts in New York, and he began spending his summers in Italy. In his *Codex* series of 1979–83, he gave form to his fascination with the mathematical codes employed by Renaissance architects and painters to create an exciting panoply of harmonious form. He applied his improvisational metallic powder and alkyd spray technique to compositions derived from architectural forms, often naming his works with allusions to both Florentine architecture and American jazz to underscore the merging of purposeful calculation and creative spontaneity.[6] Goldberg transferred these ideas and imagery to his first intaglio prints, made in collaboration with Alan Koslin in 1981, and published by Orion Editions in New York.

When he returned to the use of oil paint in the mid-1980s, the artist found inspiration in the works of Tuscan Mannerist painters of the sixteenth century, like Domenico Beccafumi and Rosso Fiorentino. He used peculiar interstitial colors, and delineated shallow, ambiguous space with mixtures of paint and chalk. The black and white zebra-stripes of Sienese architecture also characterize these paintings. During the 1990s he employed a painterly calligraphic style in works that reflect the movement of his body and wrist.[7] Goldberg still divides his time between New York and Italy, and he continues to teach, paint, and exhibit his work with undiminished vigor.

The present print, made in collaboration with Arnold Singer at the Pratt Graphic Art Center in New York, captures the painterly immediacy of Goldberg's contemporaneous canvases. Broad, interwoven vertical and horizontal gestures create a rectangular form, densely detailed inside and rough along its edges, not unlike the central motif of Goldberg's *House Paintings* or images from his *Codex* series. This print was created from three stones, with umber, gray, and purple inks, working from light to darker hues. The artist achieved rich black passages by printing purple over gray, using tiny pins that pierced the sheet and accurately positioned the paper for precise registration. Working directly on the stone, with no preconceived design, Goldberg applied and manipulated liquid tusche in many different ways. He brushed on very thin pigment, allowing it to drip and run. Pouring thicker, viscous ink onto the stone, he used the broad edge of a printer's knife to pull it across the printing surface, just as he applied heavy pigment to his canvases, causing similar streaks and spattered edges. One of these scraping tools had comblike edges, creating the purple area of parallel hatching in the middle of the composition. The artist also distributed and blotted thin ink, using a wad of gauzelike fabric that left the mark of its coarse weave on the stone. He exploited such accidents of design, and the behavior of the greasy tusche, as his image grew from the process of its creation.

Goldberg's print creates effects of depth and transparency by layering veils of screenlike gesture. The brooding colors create a sense of mystery. Umber highlights break through chinks between dark gestures, and draw the viewer close to examine obscured layers of spontaneous imagery. Despite its dark mass, the feathery edges of the image, particularly along the bottom, impart a weightless, hovering quality. It is these visible paradoxes, like density and lightness, calculation and immediacy, control and chance, that make this image fascinate.

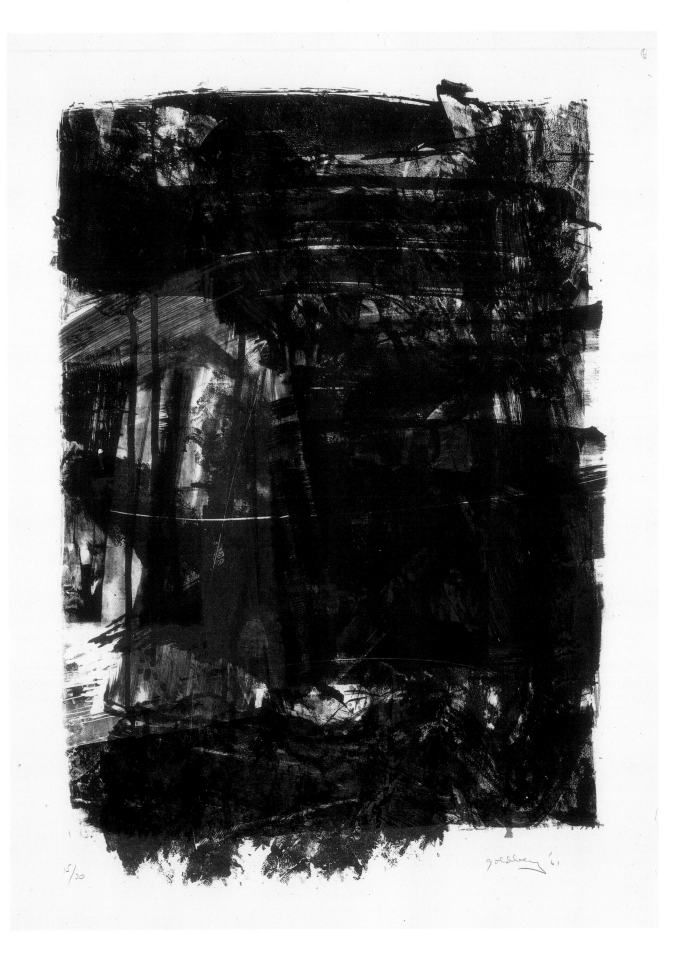

15/30 goldberg '61

HELEN FRANKENTHALER

1928–

70. First Stone, 1961

Lithograph on white Arches wove paper, 11/12
51.5 x 69.0 cm (image)
56.6 x 76.0 cm (sheet)
Inscribed: in graphite, below image: *11/12*
 Frankenthaler/'61
Watermark: *Arches/FRANCE*
Embossed: *ULAE*
References: Krens 1980, no. 1, pp.84–85; Sparks
 1989, pp.76, 313; Harrison 1996, no.1,
 pp.53–54; Fine 1993, pp.14, 34, 35.
Private collection

Helen Frankenthaler is the most prolific printmaker among the New York School painters who came of age in the 1950s. She has explored the full range of graphic arts media at many of the leading American printmaking workshops, impelled by the challenges of unfamiliar processes.

The artist was born on December 12, 1928, in New York, the daughter of a State Supreme Court Justice.[1] She grew up in Manhattan, where she attended private schools, including the Dalton School, where Rufino Tamayo introduced her to the techniques of oil painting. From 1945 to 1949 she attended Bennington College in Vermont, where she studied with the Cubist painter Paul Feeley, who instilled an appreciation of the work of Paul Cézanne, Henri Matisse, and Wassily Kandinsky. During her college years Frankenthaler also studied with Wallace Harrison, and with Vaclav Vytlacil at the Art Students League. She began graduate studies in art history at Columbia University, but was drawn to painting, and took a studio in lower Manhattan.

In 1950 Frankenthaler met the critic Clement Greenberg, who took her to The Club and the Cedar Bar, and introduced her to Jackson Pollock, Lee Krasner, Willem de Kooning, and Hans Hofmann. She also made friends with younger painters like Larry Rivers, Grace Hartigan, and Alfred Leslie and their poet friends John Ashbery, Barbara Guest, and Frank O'Hara. She was the youngest artist whose work was included in the Ninth Street Show in 1951, the year of her first solo exhibition at the Tibor de Nagy Gallery.

In 1952 Frankenthaler traveled in Nova Scotia, where she painted plein-air landscape watercolors. When she returned to her studio, she spread unprimed sailcloth on the floor and poured diluted paint directly onto the canvas to create *Mountains and Sea*. Its colors stain the fabric as watercolor wash infiltrates paper, giving the painting a translucent glow. The artist replaced tactile brushwork with a more delicate painterly physicality, combined with the chance liquid effects of colors bleeding together.[2] When the painters Morris Louis and Kenneth Noland saw the painting in her studio, they also developed methods of staining unprimed canvas, and the Color Field painting movement ensued. In her works of the 1950s Frankenthaler combined drawn and painted linear calligraphy with amorphous passages of poured color. In 1957 her work was included in the exhibition *Artists of the New York School: Second Generation*, at the Jewish Museum.

From 1958 to 1971 Frankenthaler was married to Robert Motherwell. She taught part-time at New York University from 1958 to 1961, and later had temporary teaching positions at Hunter College and Yale University. Her work was exhibited at Documenta II in Kassel in 1959, at the fifth biennial in São Paulo, Brazil, and at the Paris Bienalle where her painting *Jacob's Ladder* won first prize. Frankenthaler made her first prints in 1960 at Universal Limited Art Editions (ULAE), where she produced fifteen editions of lithographs.[3] The first retrospective of her work was organized by Frank O'Hara for the Jewish Museum. Much of the linear calligraphy disappeared from Frankenthaler's paintings of the mid-1960s, to be replaced by large, saturated passages of lush pigment, frequently in deep translucent layers, and often in framelike compositions with central voids. Later in the decade, perhaps in response to Minimalism, her compositions became simpler and more controlled. Frankenthaler was one of three artists featured in the United States pavilion at the Venice Biennale in 1966. Three years later a retrospective exhibition of her work was mounted at the Whitney Museum of American Art and traveled in Europe.[4] In 1972 the artist visited Crown Point Press in California to made an intaglio print, and in the coming decades she would also make collaborative prints at 2RC Edizioni, Tyler Graphics, the Institute for Experimental Printmaking, Ediciones Polígrafia, and Mixografia, in addition to her continued work at ULAE. She experimented with screenprint, woodcut, pochoir, monoprint, and handmade paper pulp.

In 1973 Frankenthaler was awarded an honorary doctorate in fine arts from Smith College, and the following year she received another honorary degree from Moore College of Art, and was elected a member of the National Institute of Arts and Letters. A solo show of her work was mounted at the Corcoran Gallery of Art in 1975. When Frankenthaler was artist-in-residence at Williams College in Massachusetts in 1980, the first survey exhibition of her prints was mounted at the Sterling and Francine Clark Art Institute.[5] In 1989 a retrospective of Frankenthaler's paintings was mounted at the Museum of Modern Art in New York, and four years later the National Gallery of Art organized a traveling exhibition of Frankenthaler's prints.[6]

This is Frankenthaler's first published print, made in February 1961 at ULAE in Islip, Long Island, and printed by Robert Blackburn.[7] The artist's friends Rivers and Hartigan, who had already made prints there, encouraged her to answer the invitation of the publisher Tatyana Grosman. Despite her initial reticence, lithography captured Frankenthaler's imagination from the beginning, and she likened her first experiences with the medium to learning a foreign language. She asked Grosman and Blackburn many questions, gauging the capabilities and limitations of the process before beginning to draw on the stone. The artist began by pouring liquid tusche onto the stone, impulsively spreading the ink with her brushes, her fingers, and a stick. Then she supplemented her image with diluted tusche and crayon. She pulled proofs between the colors printed from different matrices, and sketched on them with graphite and oil paint, carefully planning and adjusting the composition.[8] Working proofs show that she removed some of the marks earlier applied to the printing surface, and created light accents by rubbing or scraping ink away from the stone. Thus, while she worked the stone in momentary gestures, each was calculated and deliberate. The artist lavished effort and consideration on the print, and strove to preserve a sense of effortlessness. This deliberate procedure was well suited to the interrupted stages of the printmaking process. Even in her first collaboration the artist insisted on making every creative decision herself. She mixed her own colors, supervised the registration of inks, and selected the paper, making certain that the creative process was her own.[9]

The formal vocabulary and palette of *First Stone* is parallel to the artist's contemporaneous paintings in its balance, harmony, and animation. It is also comparable to Motherwell's robust gestural calligraphy of that time. From the start Frankenthaler understood the capabilities of the medium for color, despite the dark ponderous images that dominate the medium's history. Bright hues and translucent effects fill this lyrical image with light and energy.

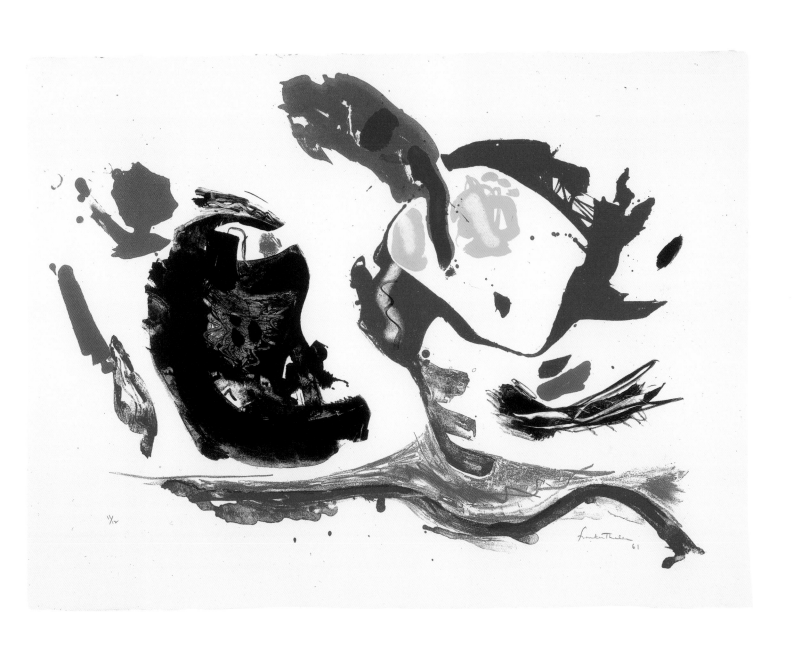

MATSUMI KANEMITSU

1922–1992

71. Lovers, 1961

Lithograph on cream wove paper, artist's proof
45.4 x 32.4 cm (image)
57.6 x 43.5 cm (sheet)
Inscribed: in white pencil, in image, l.l.:
 Artist Proof Kanemitsu 61
Watermark: *BFK RIVES*
Embossed: in image, l.l.: Tamarind; in image, l.r.:
 GA (Garo Antreasian)
References: Tamarind no.237; Donovan/Kanemitsu
 1990, p.11.
Worcester Art Museum, Heald Foundation Fund,
 1997.148

The painter and printmaker "Mike" Kanemitsu found his most sympathetic medium in lithography. Like his paintings, his prints usually present imagery derived from nature, and they combine effects unique to the medium with traditional Japanese sumi imagery and techniques.

Kanemitsu was born on May 22, 1922, in Ogden, Utah, where his parents ran a bathhouse and barbershop for railroad laborers.[1] Since they wanted their son to know his linguistic and cultural heritage, they sent him to Japan when he was three years old to be raised by his maternal grandparents outside Hiroshima. His rural childhood left him with a love of nature, and a Japanese sensitivity to inspiration. Kanemitsu returned to Utah in 1940, relinquishing his dual citizenship. During World War II he enlisted in the Army, but soon after the bombing of Pearl Harbor, he was sent to Fort Riley, Kansas, along with other interned Japanese Americans. Though he was an enlisted man, Kanemitsu was assigned such undesirable duties as washing dishes in the service club. However, the base librarian recognized his artistic talent and encouraged him to paint, helping to arrange an area in the barracks to serve as a makeshift studio. The first solo exhibition of his work was mounted at Fort Riley in 1945.

After his discharge from the service, Kanemitsu moved to Baltimore. While working in the shipyard, he attended the Baltimore Trade School to learn bricklaying and stonemasonry. The technical expertise he acquired there reinforced his growing interest in sculpture, which he was studying at that time with Karl Meltzer. In 1948 Kanemitsu began to show his work in the annual group exhibitions at the Baltimore Museum of Art, and in 1953 a show of his drawings appeared at the museum. Kanemitsu attracted the attention of Dr. Martinet, a retired engineer who provided encouragement,

funds, and professional contacts. Martinet bought the artist a tailor-made suit, and sent him to Paris, to study with Fernand Léger.

When Kanemitsu returned to the United States, he settled in New York. At the Art Students League he was a pupil of Yasuo Kuniyoshi, who encouraged him to continue working in traditional Japanese ink painting while exploring Western Modernism. The artist also studied with Byron Browne and Philip Guston at the League and learned the fundamentals of printmaking from Harry Sternberg. In the mid-1950s Kanemitsu developed a personal mode of Abstract Expressionism, combining automatist gesture with sumi techniques. His abstract canvases often evoke landscape and the forces of nature. The artist's first solo exhibition in New York was at the New Gallery in 1957. Kanemitsu frequented the Cedar Tavern, attended The Club, and summered in East Hampton.

"I never met anyone who didn't like Matsumi," wrote June Wayne, "or didn't claim to be his friend."[2] Wayne first met Kanemitsu in the studio of Ossip Zadkine in Paris in 1957. Four years later she recommended him for an artist's fellowship at her Tamarind Lithography Workshop in Los Angeles. Their friendship grew as he developed a talent for lithography. In January and February 1961 the artist completed sixteen editions at Tamarind, many printed in color.[3] These prints combine scumbles and washes of tusche with passages drawn in the distinctive rapid brushwork of Japanese painting. The artist created effects of transparency and depth, employing the chemistry of lithography to simulate organic textures. Kanemitsu settled in Hollywood in 1961, and over the next thirty years he became a leader in the Japanese-American art community of southern California.[4] In the late-1960s he incorporated the influence of Pop Art when he combined Hard Edge shapes with calligraphy, as in the *Mikey Mouse Series* of prints, and when he incorporated visual excerpts from American and Japanese popular culture, as in the *Illustrations of Southern California* suite of lithographs.[5] In 1970 June Wayne produced *Four Stones for Kanemitsu*, a film documenting the collaborative process of the artist and Master Printer Serge Lozingot in creating a lithograph.[6]

In the early 1970s Kanemitsu taught at the University of California at Berkeley, the Otis Art Institute, and the California Institute of Arts in Valencia. During the 1970s and 1980s, the artist made collaborative lithographs at several different California workshops. These prints represent organic abstract imagery in veils of misty tone, fre-

quently accented with dramatic calligraphy. After retiring from teaching in 1983, Kanemitsu continued to work and to exhibit. In 1990 a traveling retrospective exhibition of his lithographs was organized by the Yamaki Art Gallery in Osaka, Japan.[7] Kanemitsu died of lung cancer in Los Angeles on May 11, 1992.

The present lithograph is Kanemitsu's final print from his first visit to the Tamarind Lithography Workshop in 1961. Its imagery grew out of his sumi paintings, and the lithograph *Spectre* he had produced six weeks before. Like many of his prints of the 1960s, it combines boldly brushed calligraphy with organic tonal effects derived from the chemistry of lithography. The image is also an elegant synthesis of Abstract Expressionist and Asian ideas. Automatist gestures suggest rather than explicitly depict ideas and motifs. *Lovers* was created in collaboration with Master Printer Garo Z. Antreasian, Tamarind's first technical director. The artist began the print by painting in resist on a zinc plate; then he overlaid scumbles and spatters in washes of lithographic tusche. The resist was removed, and the plate printed in black, allowing the initial drawing to read as calligraphy in the white color of the paper. These brushstrokes reveal the artist's activity and the direction, hesitation, and rapidity of his hand as he painted. The effect was further emphasized when another zinc plate was used to overprint the background in a flat beige hue. This tonal plate pushes the background away and evokes landscape.

Kanemitsu employed straight strokes to define the simple forms of circles and triangles. His fluent economy is reminiscent of the Japanese tradition of *zenga* calligraphic painting. In their shape the white lines resemble stalks or branches, perhaps entwining two rocks perched on a hillock. Similarly, drips, splashes, and mottled clouds against the tan background create the sense of an unspecified natural perspective, perhaps evoking a cloudy sky, a view through the water to the bottom of a pool, or the surface of a rock wall. Encouraged by the print's title, one reads two figures in the headlike circles on triangular shoulders. They are differentiated by the color of the circular forms on each head and each shoulder. Their position implies an embrace, and its intimacy is emphasized by the horizontal elision above their heads, symbolically pulling the lovers together. Perhaps in the circles at their shoulders the artist meant to suggest their hearts and the visibility of their emotion. In any case, Kanemitsu begins an engaging process of association for the viewer, using simple, elegant means.

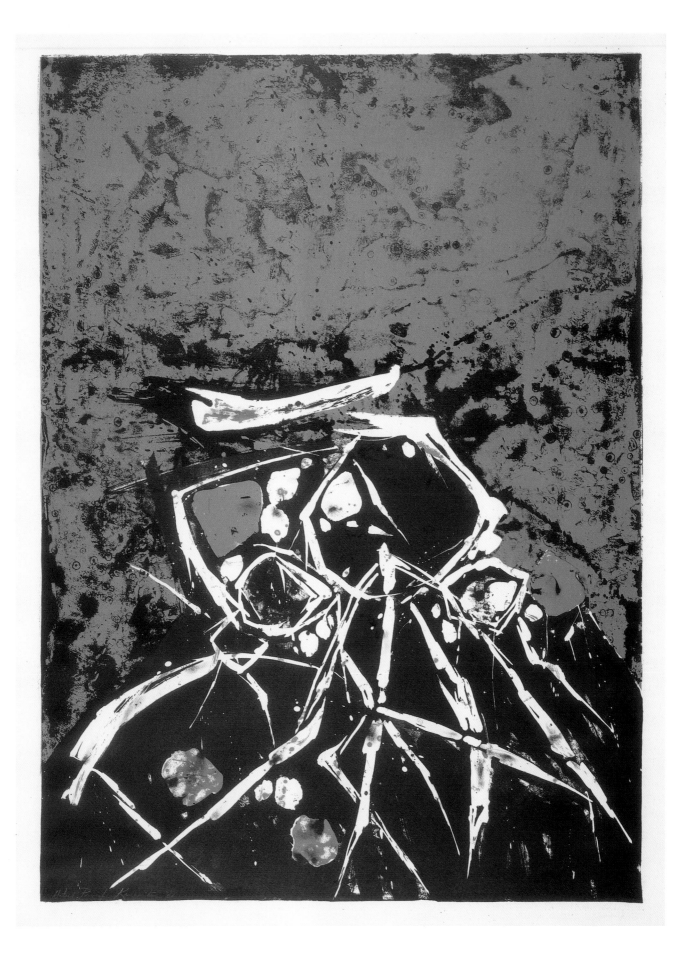

KARL KASTEN

1916–

72. Aix, 1961

Soft-ground etching, aquatint and etching on
 cream wove paper, 4/20
32.2 x 20.3 cm (plate)
48.7 x 38.0 cm (sheet)
Inscribed: in graphite, below platemark:
 Aix 4/20 Karl Kasten 61
Watermark: *ARCHES*
References: Landauer 1999, p.17.
Worcester Art Museum, 1996.120

The dean of Bay Area printmaking, Karl Kasten has been a leading artist and technical innovator in San Francisco for four decades. His establishment of printmaking workshops and teaching programs, and his work in artists' organizations helped to change the face of the graphic arts in the region.

Kasten was born in San Francisco on March 5, 1916, and he grew up in the Richmond district of the city, where his father worked as an electrical engineer and inventor.[1] His first prints were linocut illustrations, made in 1934 for his high-school newspaper. After graduating as class valedictorian from the College of Marin in 1936, Kasten attended the University of California at Berkeley (UCB), where he studied with Worth Ryder, Erle Loran, and John Haley. After completing his bachelor's degree in 1938, he continued in the graduate program at Berkeley and was awarded a master's degree in fine arts the following year.

The first solo exhibition of Kasten's work appeared at the Albatross Bookstore in San Francisco in summer 1940. He taught at Williams College in Berkeley in 1940–41, and took a position at the California School of Fine Arts. However, weeks later he was drafted into the Army, and was commissioned as lieutenant. Kasten was posted to Europe, and on D-Day he was promoted to captain when he led the 295th Engineer Combat Battalion in the invasion of Normandy. After his discharge he taught at the University of Michigan from 1946 to 1948, and then returned to the Bay Area to join the faculty at San Francisco State University. At that time he concentrated on oil painting in an Abstract Surrealist style. In summer 1949 Kasten studied with Mauricio Lasansky at the University of Iowa, where he learned the intaglio techniques and the exciting potential of teaching printmaking in the university. He joined the UCB faculty the following year, set up a graphic arts studio and began the first university printmaking program in California.

He also began teaching a course on the history of artists' materials and techniques that became a perennial favorite in the department and influenced generations of students. In summer 1952 Kasten studied painting with Hans Hofmann in Provincetown, and he adopted a style of painterly abstraction.

Kasten traveled in Europe in 1957, visiting Atelier 17 in Paris where he met Stanley William Hayter, and Grafica Uno in Milan where he met Giorgio Upiglio. A solo exhibition of the artist's paintings was mounted at the Palace of the Legion of Honor in San Francisco in 1959. The following year he discovered a large lithographic press in a commercial shop that had been modified to carry oversized stones; he purchased the machine and four nearly three- by four-foot stones and installed them in the UCB printshop. Soon afterward, Kasten met Willem de Kooning, and invited him to visit the university and make his first two lithographs on the big press.[2]

In 1964 Kasten experimented with collagraphy, creating printing matrices from acrylic modeling paste and cardboard cuttings.[3] Then, when Harold Paris brought a thermal vacuum-form machine to UCB to make his sculpture, Kasten realized that he could use the process to create collagraph plates. This apparatus heats sheets of polyvinyl plastic to a malleable state and then uses a vacuum pump to draw the material tightly around objects placed in the bed of the machine.[4] Kasten collected objects, formed plastic plates around them, and then inked and printed its surface. By removing these found elements from the plate, inking them separately in different colors, and then refitting them into their niches in the plastic, he could print a multicolored collagraph in one operation. The first solo exhibition of Kasten's collagraphs was presented in January 1968 at the Catholic University Art Department Gallery in Washington, D.C. A few weeks later he was an artist fellow at the Tamarind Lithography Workshop in Los Angeles, where he executed sixteen editions of lithographs, with glomerate imagery that reflects a persistent collage aesthetic.[5] A solo exhibition of Kasten's prints was mounted at the Achenbach Foundation for Graphic Arts in 1975. At that time he built the prototype of an etching press, constructed of high-density aluminum that employs a lever principle to greatly increase its vertical force. The engineer Scott Berglin embraced the design, and began factory production of the K-B Etching Press in 1980. The

artist retired from teaching in 1983. At an anniversary celebration of VE day in 1995, Kasten was awarded the medal of the city of Rennes for his World War II service in Europe, and a solo exhibition of his work was mounted at the Institut Franco-Américain in Rennes. A retrospective exhibition of Kasten's prints was presented at the San Francisco Center for the Book.[6] Today the artist lives in Berkeley, where he continues his painting, printmaking, and exhibition activities, and is completing an illustrated memoir of art and war.

The present print typifies Kasten's Abstract Expressionist intaglios of the 1950s, which derive in their style from the teaching of Hans Hofmann, and in their technique, ultimately, from Atelier 17. At that time Kasten drew gestural drypoints on copper plates with steel needles and photoengraving roulettes, and he adapted soft-ground etching and aquatint for painterly color intaglios, printed from one plate *à la poupée*. He aimed for works of rich textural complexity that bridge the languages of painting and printmaking. Just as Kasten explored the physical substance and behavior of paint in his canvases of that period, so he also explored the distinctive visual capabilities of the intaglio process in prints such as this. In this plate he combined soft-ground etching and aquatint, biting the plate in stages, and adding details with the burnisher and etching needle at each phase. He worked in an unpremeditated, spontaneous manner, encouraging accidental effects. However, the artist consciously aimed for subtle gradations and a wide range of tones, to function as color does in his paintings and create a mood.

This print is one from a series of intaglios, begun in 1959, named for locations in France where Kasten often spent his summers. Its title refers to Aix-en-Provence, the city where Paul Cézanne lived and worked. Cézanne obsessively painted the Provençal landscape, simplifying and geometrizing its elements in order to capture the sense of space and the distinctive qualities of light as they shifted and changed with the seasons and throughout each day. One of the most important influences in Kasten's early career, Cézanne's work encouraged the artist to develop a style and imagery derived from landscape, based on dense, activated space. By his use of this title, Kasten evokes an environment and atmosphere and light, and he also invokes the practical concerns, activities, and the lore of art history.

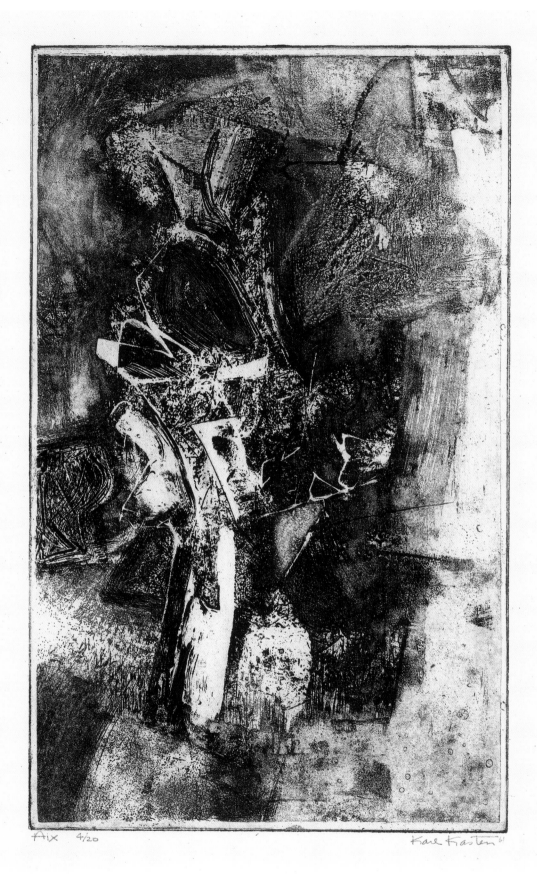

Aix 4/20 Karl Kasten '61

VINCENT LONGO

1923–

73. To Admiral Meaulnes, 1961

Woodcut on cream Japan paper, 3/10
110.0 x 78.0 cm (image)
128.7 x 90.6 cm (sheet)
Inscribed: in graphite below image:
 To Admiral Meaulnes 3/10 Longo 61
References: Baro 1970, p.3, fig. 13; Acton/Goldman
 1995, p.37.
Worcester Art Museum, gift of Ursula M. Scott,
 1993.83

In the 1950s the inventive painter Vincent Longo
was among a group of young artists in Brooklyn
who transferred the energy and spontaneity of
Abstract Expressionism to innovative relief prints.
A decade later, his innovative intaglio prints
reflected the early development of Minimalism.

Longo was born in New York on February 15,
1923, the son of Italian immigrants.[1] Both his par-
ents died within months of each other when he
was two years old, and he was sent to the Saint
Agatha School for Boys in Nanuet, New York, to be
raised by the Sisters of Charity. In 1937 he was
adopted by a distant cousin, Rose Ferrari, and
joined her large, boisterous family in Brooklyn,
where opera was often heard, and art and culture
were well respected. He concentrated on art at
Textile High School in Manhattan. After graduation
in 1942, Longo attended the Cooper Union Evening
Art School, where Leo Katz and Sidney Delevante
were among his teachers. The success of his first
solo exhibition, at the Regional Arts Gallery in New
York in 1949, helped him to win a scholarship at
the Brooklyn Museum School, where he continued
his studies with Max Beckmann and Ben Shahn.

In 1951–52 Longo went to Italy with the sup-
port of a Fulbright Fellowship. He toured the coun-
try, and visited his extended family at Ferrandina in
Basilicata. In Florence he studied the works of the
old masters, and made his first experimental
woodcuts. When Longo returned to New York, he
signed up for classes at the Brooklyn Museum
School taught by Louis Schanker, the inventive
Modernist who led the woodcut revival of the
1940s.[2] Under the influence of Abstract Expres-
sionism, Schanker carved and printed his wood-
cuts spontaneously, sometimes developing their
successful images into paintings. Longo adopted
his method and experimented with large, improvi-
sational woodcuts. In 1954, when he was a fellow
at Yaddo, the artists' colony at Saratoga Springs,
New York, Longo created the first of a series of
large gestural woodcuts that made his early repu-

tation as a printmaker. His enthusiasm for Abstract
Expressionism and printmaking were encouraged
by his friends and colleagues at the Brooklyn
Museum School, including Edmond Casarella,
Clinton Hill, and Robert Conover.[3]

In 1955, Longo succeeded Schanker as print-
making instructor at the Brooklyn Museum School.
At that time he began developing simple, immedi-
ately rewarding printmaking methods to engage
his students.[4] Painting remained Longo's principal
creative activity, but he found that the discipline of
printmaking and its advancing, cadent process
could spark creativity and suggest new formal
ideas and directions. In 1957, when the artist
started teaching at Bennington College in Vermont,
his work began an evolution toward simplicity. He
painted regular compositions based on simple
geometric schema, and transferred these designs
to his first etchings. In the late 1950s the artist
taught in the Yale Summer Art School in Norfolk,
Connecticut. In 1959 Gabor Peterdi and Richard
Ziemann also taught printmaking at Norfolk, and
their workshop became a friendly gathering place
for the faculty. Longo conducted his own experi-
ments, etching fifty plates, and methodically
searching for the directness and clarity of expres-
sion he commanded in painting. Printmaking
became a more intellectual, strategic practice as
he restricted himself to a linear vocabulary describ-
ing only circles, squares, and diamonds. His first
editioned etchings explored the use of acid and
the distinctive grainy line it produced. Longo was
fascinated by the centralized schematic designs
that occur in nature, and in world art throughout
history. His paintings and prints based on the con-
centric square and circle were conceived to initiate
a resonant, contemplative experience in the
viewer. In 1964 the artist began using masking
tape as an acid resist for etching and aquatint
plates, simplifying the laborious process of stop-
ping-out hard-edged forms. He created mandala
and grid compositions using this technique, build-
ing increasingly complex networks of layered tape.
To achieve enhanced effects of spatial illusion and
movement he etched these plates in stages.

In 1967 Longo joined the faculty at Hunter
College of the City University of New York. A major
retrospective exhibition of his prints was mounted
at the Corcoran Gallery in Washington, D.C., in
1970.[5] During the 1980s Longo transferred the
geometric imagery of his paintings and intaglios to
relief prints.[6] In 1995, when he retired from full-
time teaching, a retrospective exhibition of his
prints was mounted at Hunter College.[7] Today the

artist divides his time between Manhattan and
Amagansett, Long Island. He continues to paint
and make prints, actively showing his work in solo
and group exhibitions.

To Admiral Meaulnes is one of the latest of
Longo's woodcuts that translate the energy and
immediacy of gestural calligraphy to relief print-
making. These purely abstract images reflect the
momentary discharge of energy that the artist
experienced when drawing his unplanned design
on the woodblock. However, they were often moti-
vated by thoughtfully considered themes from
philosophy and literature. In the mid-1950s some
of his first gestural woodcuts were inspired by the
Duino Elegies of Rainer Maria Rilke. They prompted
him to express themes of physical and spiritual
freedom, and the initial motifs drawn on his wood-
cut blocks often feature winged or angelic motifs.
Longo explored a range of formal and calligraphic
styles in his gestural woodcuts, purposely employ-
ing different vocabularies of looping brushstrokes
and splotches from one print to the next, creating
different rhythms and moods. Every print achieves
a balanced, coherent composition and — like
handwriting — reflects a facet of the artist's per-
sonality. The present print, Longo's last work on
this angelic subject matter, was inspired by Alain
Fournier's novel *The Wanderer*. In a homage to the
book and its main character, Meaulnes, this image
incorporates the angelic symbol of aspiration, iso-
lated in white in the upper right quadrant of the
image. Evocative as they may be, however, these
images move the viewer not by association but by
the energy and emotion they convey.

Longo's process for his gestural woodcuts was
straightforward. He began by painting an unpre-
meditated design directly onto a large sheet of
pine plywood with a brush and India ink. Then he
carved away the surrounding areas with knives and
gouges, leaving the painting on the block to pro-
ject in relief plateau. When carving, Longo carefully
preserved the feathered edges that suggest part-
ing bristles, and the modulation in width, shape,
and tone of the painted lines. He also remained
open to accident and new directions prompted by
his materials. Longo printed on pliant Japanese
paper, placing the dampened sheets face down on
his inked woodblock, and rubbing on the back with
a wooden scraping tool to print. This was also a
creative operation, enabling the artist to refine his
prints in a subtractive manner, analogous to the
painter's prerogative to edit by overpainting.

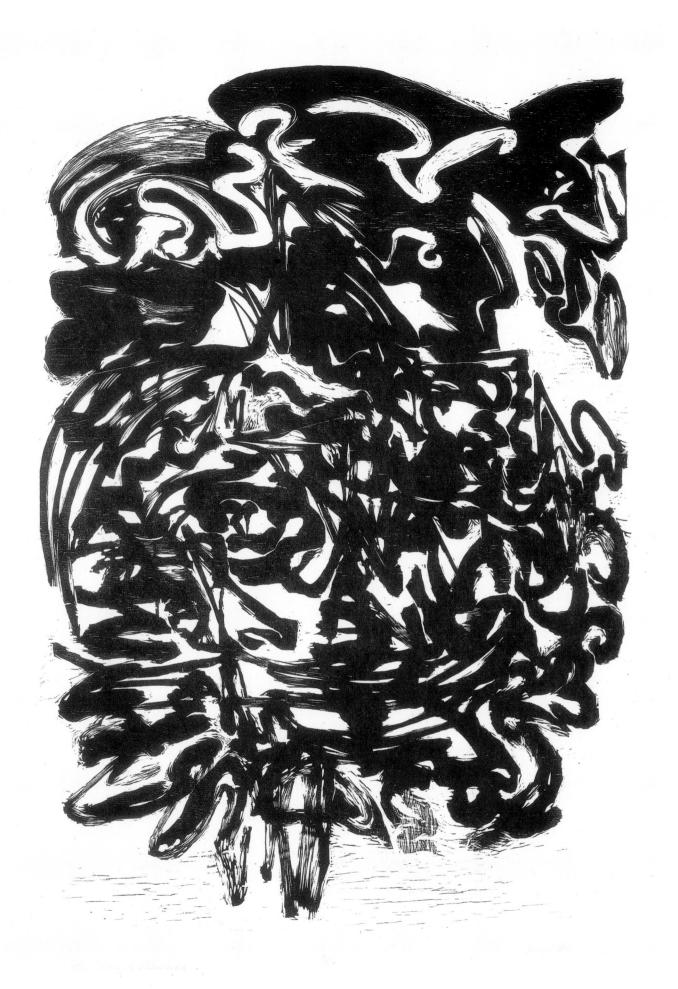

WILLIAM LUMPKINS

1909–2000

74. Untitled, 1961

Screenprint on cream wove paper
86.1 x 99.0 cm (image)
86.1 x 99.0 cm (sheet)
Inscribed: in graphite, l.r.: *Lumpkins 61 • La Jolla.*
Worcester Art Museum, gift of the artist, 1993.84

The freedom and expanse of the American West, and a sense of confident individuality characterizes the work of William Lumpkins. His painting style was affected by Abstract Expressionism during the 1940s, and over the following decades the artist continued to find inspiration in self-reflection and in nature.

Lumpkins was born on April 8, 1909, on his father's Rabbit Ears Ranch, near the town of Clayton in Territorial New Mexico.[1] He grew up on a succession of cattle ranches in New Mexico and Arizona, working from a young age and attending school sporadically. When his family lived on a ranch in Lincoln County, New Mexico, Lumpkins attended high school in Roswell, sixty miles away. There, in 1927 he became friends with the painter Peter Hurd, who encouraged his aspirations to become an artist, critiqued his drawings, and shared sketching expeditions in Lincoln County. Ever curious and widely read, Lumpkins also became interested in Zen Buddhist philosophy.

In 1929 Lumpkins enrolled at the University of New Mexico in Albuquerque to study art and architecture. Irwin Parsons and Nils Hogner were among his teachers, but the catalytic influences on his art came from his fellow students, such as James Morris and Cady Wells, who introduced him to abstraction. In 1930 Lumpkins continued his studies of architecture at the University of Southern California in Los Angeles. At that time he painted watercolor abstractions and landscapes in a style influenced by John Marin, which were shown widely in group exhibitions at the New Mexico Art League in Albuquerque, the Art Institute of Chicago, and the Palace of the Legion of Honor in San Francisco. After graduating from college in 1934, Lumpkins joined the FAP/WPA architectural division, and worked on the design of the Carrie Tingley Children's Hospital in Hot Springs, New Mexico. At that time he designed his first solar building.[2]

In 1938 Lumpkins opened an architectural firm in Santa Fe. Along with Raymond Jonson and Emil Bistram, Lumpkins was one of the founders of the Transcendental Painters Group, artists who shared a belief in the metaphysical capabilities of art. "We were transcending not only virtuosity of technique," Lumpkins recalled, "but also attempting to transcend verbal explanation as well to stimulate the richest mental capabilities within us."[3] His paintings were featured in the Transcendentalists' group exhibitions *American Art Today* at the New York World's Fair in 1939 and at the Museum of Non-Objective Art in New York the following year. World War II curtailed the group's activities, and they officially disbanded in 1942. Like many Southwestern ranchers in the 1930s, Lumpkins was an accomplished pilot. During the war the Navy commissioned him as a flight instructor, and he was posted to Memphis in 1941. He continued to paint watercolors in his spare time and exhibited in group shows at the Brooks Memorial Art Gallery in Memphis. In 1942 Lumpkins began to compose *koans*, brief poems phrased as questions, used in Zen practice to provoke a moment of realization in the aspirant. During that period, also encouraged by the currency of Abstract Expressionism, the artist incorporated intuition and accident in his work. Lumpkins became chief of flight operations at the Memphis base in 1943, the year in which a solo exhibition of his paintings was mounted at the Dallas Museum of Fine Art.

After his discharge in 1946, Lumpkins resumed his career as an architect in Santa Fe. Recognizing that the postwar building boom offered more architectural work in California, he moved to La Jolla in 1950, where he established a firm that designed modular housing for the Custom Craft Institute. He became architectural contractor for the Eleventh Naval District in 1952. During that period Lumpkins continued to paint and became acquainted with many of the avant-garde artists of Southern California. He married and began a family. In 1967 he returned to Santa Fe, where he founded Sun Mountain Design Group in Santa Fe in 1972.

After retiring from his architectural practice in 1978, Lumpkins continued to write about solar architecture, and in 1981 he published his book *Casa del Sol*. In 1982 a solo exhibition of his work was presented at the Martin Diamond Gallery in New York. Three years later shows of his paintings were mounted at the Graham Gallery in New York, and at the Governor's Gallery in Santa Fe. In 1988 a retrospective exhibition of the artist's works on paper was mounted at the University of New Mexico in Albuquerque.[4] Lumpkins died in Santa Fe on March 31, 2000.

The present work is one from a group of experimental silkscreen monoprints that Lumpkins made in La Jolla from 1958 to 1961. Intrigued by the simplicity of the screenprint process, he noted that others used the technique to imitate painting and recognized its potential for direct expression.[5] Lumpkins never produced identical editions of multiple originals, but made unique screenprints on a scale to rival easel and mural painting. Most of the shapes in the present print were determined by the torn paper with which Lumpkins prepared his stencils, and their irregular edges give the image the effect of a paper collage. Broad areas of subtly mottled color, some bounded by straight lines and others by irregular contours, evoke the topographical patterns shaped by nature and man that were so familiar to Lumpkins the pilot. Some of his other screenprints evoke the bold patterns of Native American weaving and sand painting.

Like the commercial screenprinters who decorate wallpaper with repeated patterns, Lumpkins moved the screen around an enormous sheet of paper, rather than using the conventional artist's technique of moving a page under the printing matrix. He printed on enormous sheets of the paper used by photographers for backdrops and supplied on big rolls like bolts of fabric. The artist began by building large wooden frames of similar size and shape — in the present print its interior measures about 82 x 63 cm — over which he stretched silk like a window screen. To create an image on the screen, Lumpkins used the paper stencil technique, the most direct method and easiest to change. Sometimes he twisted and flattened long strips of paper onto the screens, and their folds and overlappings created interesting patterns and spatial suggestions. After printing, the artist sometimes drew linear accents, scraping away the wet ink with his finger or the tip of a brush. Just a few tiny scrapings in the middle of this composition reveal accents of the contrasting ink layer beneath, but in other prints this sgraffito work is extensive.

When the ink had dried, Lumpkins sometimes cut smaller prints from the larger whole, creatively searching for unexpected croppings. He selected the images in varied shapes and sizes and plotted them with a pencil and straightedge, before cutting them apart. However, one monumental uncut sheet surives, measuring nearly eight by nine feet. Now in the collection of the Albuquerque Museum, it is the most remarkable of Lumpkins's screenprints.[6]

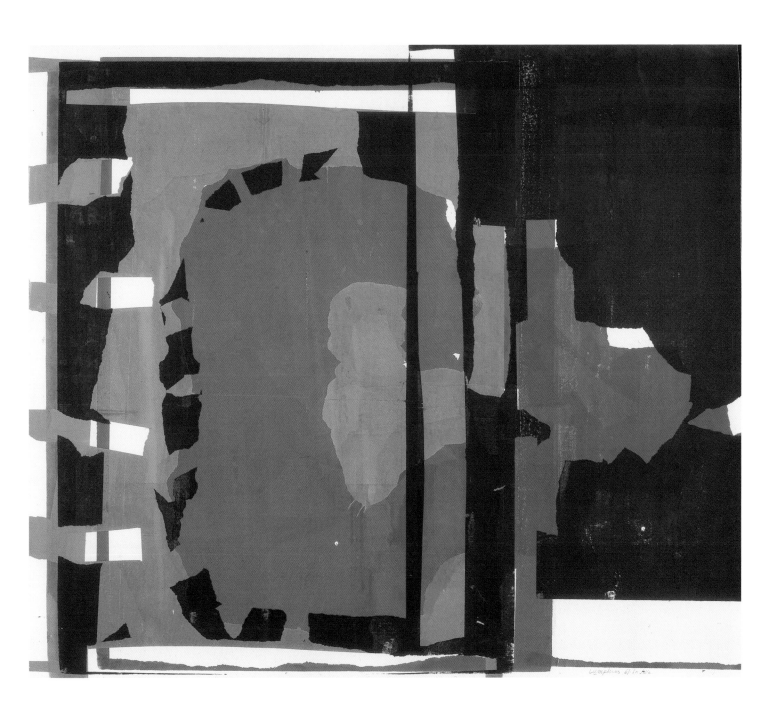

SEONG MOY

1921–

75. Nassau County #1, 1961

Woodcut on cream simili Japan paper, A/P 10/15
86.6 x 28.1 cm (image)
93.2 x 35.8 cm (sheet)
Inscribed: in graphite, below image:
 Nassau County #1 A.P. 10/15 SMoy—
References: *Artists Proof*, vol.1, no.2, 1961, p.9;
 Schmeckebier 1962, pp.46–47; Gray 1964,
 p.107; Graham 1987, pp.19, 60.
Worcester Art Museum, 1996.12.11

During the 1950s, under the influence of Abstract Expressionism, the painter and printmaker Seong Moy gave emphasis to the gestural calligraphy and energy that had long been latent in his work.

Moy was born on April 12, 1921, at Guangzhou in the province of Canton, China.[1] When he was ten years old, he came to United States to live with relatives who had settled in Saint Paul, Minnesota. There he began his art studies as a teenager at the Federal Art Project school. In 1936 Moy enrolled at the Saint Paul School of Art, where he was a pupil of Cameron Booth. In 1939 the young artist joined the FAP/WPA graphic arts division, located at the Walker Art Center. Two years later he won a scholarship to the Art Students League in New York, where he studied painting with Vaclav Vytlacil and printmaking with Will Barnet. Moy also won a scholarship to the Hans Hofmann School in the early 1940s. His first solo exhibition, presented at the Carmel Art Association in California in 1943, included both paintings and prints.

During World War II Moy enlisted in the Air Force, where he was trained as a photographer and assigned to the famous Fourteenth Air Force, the "Flying Tigers," whose campaigns over China he recorded. After his discharge he returned to New York and to the Art Students League as a GI Bill student. Semiabstract paintings in a style influenced by Picasso and Joan Miró comprised Moy's first solo exhibition in New York, presented at the Ashby Gallery in fall 1946.[2] He was a founding member of The Printmakers, a group of young graphic artists, who exhibited at the Jacques Seligmann Galleries in New York in 1947. At that time Moy also worked at Atelier 17, creating mixed-media intaglios. He concentrated on color woodcut, however, becoming a prominent figure in the revival of the medium in New York during the 1940s and 1950s. Moy traveled to China in 1947, where he was reunited with his mother, and met his wife whom he brought back to New York.

An Opportunity Fellowship from the John Hay Whitney Foundation supported the artist's work in 1950–51. The popularity of his prints at that time is reflected by commissions from the International Graphic Arts Society, the Society of American Graphic Artists, and many others. Moy joined the faculty at the University of Minnesota in 1951, and in the course of his distinguished career he taught at Smith College, Vassar College, Cooper Union, Columbia University, the Art Students League, and other institutions. The influence of Abstract Expressionism is apparent in a group of his ink drawings that combine Abstract Surrealist imagery with the sensibilities of Chinese calligraphy.[3] His woodcut *Classical Horse and Rider* won a purchase award at the tenth Brooklyn Museum print national exhibition in 1952, the year his Rio Grande Graphics portfolio of color woodcuts was shown with his paintings in his solo exhibition at the Borgenicht Gallery in New York.[4] At that time he also exhibited with the 14 Painter Printmakers Group at the Stable and Kraushaar Galleries, and at the Brooklyn Museum.[5] Moy opened his own art school in Provincetown, Massachusetts, in 1954, and in the summer months for over twenty years he offered instruction in painting, drawing, and printmaking.

Moy won a Guggenheim Fellowship in 1955, the year in which he executed a mural painting at the Architectural League of New York. He took up book illustration in the late 1950s, and occasionally over a decade he contributed to books that sometimes represent Chinese subjects. Moy also began to work in collage, adding torn scraps of colored paper to his small-scale paintings. This additive quality was transferred to his woodcuts. Strokes of the knife in wood are combined with layered colored passages reminiscent of collage elements from painted sheets of paper, with tattered edges of white separating the passages of local color. In the mid-1960s, the artist began to create brightly colored screenprints that capture the visual effect of his collages.

From 1970 to 1987 Moy taught at the City College of New York. He concentrated on acrylic paintings with collage and experimented with collagraphs.[6] In the mid-1970s the artist executed several large commissions, including murals for the Fourth National Bank of Wichita, Kansas. He created a ceramic mural for the secondary school PS 131 in New York in 1984. The artist suffered a stroke in 1987, and returned to painting after a long recuperation. In 1990 an exhibition of Moy's prints was mounted at the Sylvan Cole Gallery in New York, and the following summer there was a show of his color prints at the Provincetown Art Association.[7] The artist still lives and works in Provincetown, Massachusetts.

One of Moy's best known woodcuts, *Nassau County* reflects a delicate lyricism that contrasts with the bold, heavily printed, vivid works for which he is best known. Its energy and use of painterly gesture reveal the influence of Abstract Expressionism, as well as the artist's interest in the traditions of Chinese painting. A delicate gray-green palette is reminiscent of ink painting on silk or absorbent Asian paper, and the print's tall, narrow format is like that of a hanging scroll painting. In the middle of the image an unadorned horizontal bar seems to divide the space, defining passages above as distant hills and sky and the foreground area below as verdant foliage. However, with poetic ambiguity typical of Asian art, Moy's design is unspecific, providing only suggestions and leaving the viewer's imagination to complete and enhance the scene of trees, grass, water, and sky. The entire image is drawn together by sweeping brushstroke gestures throughout, giving the sense of a blustery wind blowing through a landscape, and yet denying perspectival illusion.

Moy began his woodcuts with a finished color sketch, and found that a precise mechanical process enabled him to transfer its design to the blocks and prints while preserving its energy and immediacy. He planned the separation of hues to be printed from different woodblocks by tracing the drawing onto cellophane, one transparent sheet for each color. Stacking the cellophane sheets together provided a sense of the finished image, and allowed the artist to make adjustments to composition and color at this stage. The image on each sheet was then traced onto a woodblock, and the areas that were not to be printed were carved away. The blocks for *Nassau County* were made of quarter-inch plywood faced with clear pine, and the artist carved with knives, gouges, rasps, and files, creating a variety of textures and striving to exploit the grain and texture of the material. He used a combination of printer's ink and oil paint, which he preferred for its range of colors and its soft, matte tone. Moy applied the colors to the block with small rollers. Placing a sheet of dry Asian paper over the inked blocks, he printed by hand-rubbing on the back of the sheet. In prints like *Nassau County* Moy sought to combine the energy of his initial sketch with "the inherent quality of the woodcut medium and the nature of its material [which] retains a beauty all its own."[8]

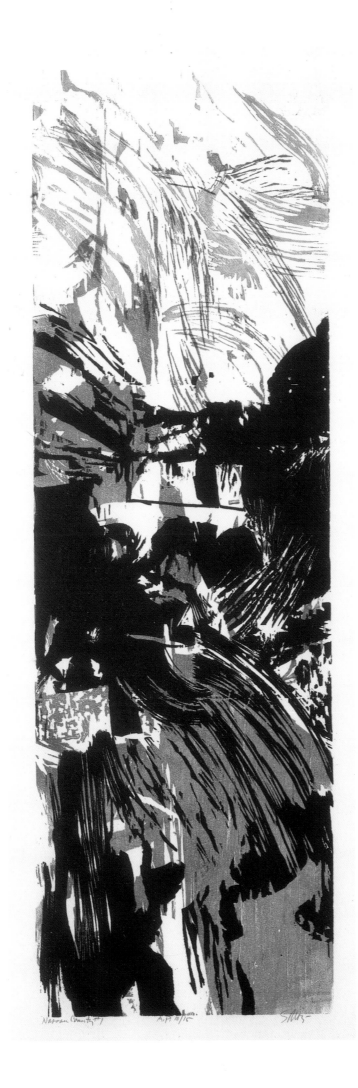

Nassau County #7 A.P. 10/15 Stiles

BARNETT NEWMAN

1905–1970

76. Untitled, 1961

Lithograph on cream wove paper, 5/30
62.4 x 41.8 cm (image)
76.3 x 56.6 cm (sheet)
Inscribed: in graphite, below image:
 5/30 Barnett Newman 1961
Watermark: *ARCHES*
References: Newman Foundation 3; Davies 1983,
 pp.97, 99; Long 1986, cat. no. 51.
Worcester Art Museum, 1994.1

In the late 1930s Barnett Newman helped to formulate and express the conceptual foundations of Abstract Expressionism. Fifteen years later he developed a very different style, based on similar metaphysical ideas, that made a new reputation for him as a pioneer of Color Field painting and Minimalism.

Newman was born on January 29, 1905, in New York, the eldest son of Russian-Polish immigrants.[1] When he was six years old, his family moved to the rural Bronx, where his father built a successful menswear manufacturing business. While attending De Witt Clinton High School in Manhattan; he frequented the Metropolitan Museum of Art, and as a senior he took an introductory drawing class at the Art Students League. In 1923, when Newman enrolled at City College as a philosophy major, he continued to attend the League, studying painting with John Sloan and printmaking with Harry Wickey. The artist worked in the family haberdashery business from 1927 to 1929, and then returned to the League to complete his teaching certificate. In the early 1930s he taught art in the New York City high school system, while continuing to paint with the encouragement of such friends as Adolph Gottlieb and Mark Rothko.

After marrying in 1936, Newman continued to pursue his catholic interests. He studied the work of Henry David Thoreau, as well as botany and ornithology. An uncompromising perfectionist, he destroyed nearly twenty years of his artwork in 1940. For years at a time he stopped painting, waiting for an original idea that he felt compelled to explore. In 1942 Newman declared himself a conscientious objector to the war. The following year he helped Gottlieb and Rothko to compose a letter to the *New York Times*, describing the goals of their style. That summer he met the artist Betty Parsons, who ran the little Wakefield Gallery in a New York bookshop. He wrote the catalogue essay for an exhibition of Gottlieb's drawings at the Wakefield Gallery, and in 1944 he organized a show

of Precolumbian sculpture for Parsons. In experimental drawings Newman strove to transform the concepts expressed in his writings into a formal style. He derived imagery from Native American and tribal art, and may have been influenced by André Masson's Surrealist figural studies. In 1945 Newman developed his signature motif, a vertical slash of unpainted white paper that isolates the ragged, painterly edges of flanking fields of paint. This simple device, which he called the "Zip," evolved from the artist's understanding of the power of symbol in tribal art and the principles of spatial illusion. The Zip functions both as a form upon a ground and as the division between two grounds.

In summer 1945 Newman exchanged ideas with Hans Hofmann in Provincetown, where he met the artist Tony Smith, who became a lifelong friend. That fall he organized *Northwest Coast Indian Painting*, the inaugural exhibition at the Betty Parsons Gallery in New York.[2] In 1947 his group show *The Ideographic Picture* included works by Parsons Gallery artists, including his own. Newman rented a studio on East Nineteenth Street, where he painted *Onement I*, and other seminal canvases with fields of a single color articulated by vertical Zips. In 1949 he joined Rothko and Robert Motherwell on the faculty of the Subjects of the Artist school. Newman initiated a series of Friday-night discussions for artists, sessions that eventually evolved into The Club. The first solo exhibition of his paintings, at the Betty Parsons Gallery in January 1950, received antagonistic reviews. The following spring he was disappointed with the poor reception of his second show by critics and artists. However, Newman's ideas and achievements were made clear in a retrospective exhibition of his work at Bennington College in Vermont in 1958, which appeared at French & Company in New York the following spring.[3] Now the most respected critics paid him the compliment of attention and analysis. In 1959 his work was included in *The New American Painting* exhibition at the Museum of Modern Art, a show that circulated in Europe. During the 1960s Newman's exhibitions were critically and financially successful. His prominence was demonstrated by his interview with Frank O'Hara on New York public television on December 3, 1965. Newman lectured widely on aesthetics in the United States and Europe. A solo exhibition of his series of paintings *The Stations of the Cross: lema sabachthani* appeared in 1966 at the Guggenheim Museum in New York.[4] His work dominated the United States' exhibition at the

eighth biennial in São Paulo, Brazil, in 1968. He was awarded the Brandeis University Creative Arts Medal in Painting for 1969–70. Newman died in New York on July 4, 1970, following a heart attack.

Most of Newman's prints were made at Universal Limited Art Editions in West Islip, Long Island, in three separate campaigns.[5] The first was in 1963–64, when he produced the *18 Cantos* series of color lithographs; in 1968 he created a series of etchings titled *Notes*, and the following year he completed two more large intaglios. The present print is one of Newman's first, made at the Pratt Graphic Arts Center in New York. After the death of his brother George in spring 1961, Newman became depressed and stopped working. To inspirit the artist, his friend Cleve Gray suggested that he investigate lithography, noting that drawings related to his *Stations of the Cross* paintings would translate well into prints.[6] On April 2, 1961, they went together to Pratt, where Newman began drawing on a small stone, which he completed at home. He returned to the printshop to see Arnold Singer proof the lithograph, and in the coming weeks he produced two more large prints. With mindful calculation, the artist investigated how to translate his imagery into lithography. He contrasted solid fields of black ink with unprinted white and scumbled and scraped liquid tusche on the stone along the edges of vertical Zips. Newman realized, however, that the lithographs' blank margins — or mounting and framing — prevented the Zip from running the entire height of the image, negating the oscillation of figure and ground. So in the present print, his last at Pratt, he reduced the format to an essential schematic of duality.

Newman began by rolling a solid layer of liquid tusche over the entire stone. Then, with a flat tool, like a razor blade or printer's knife, he scraped much of the ink away from a little less than half the printing surface. The resulting corrugated pattern represents the artist's activity and the behavior of his materials as eloquently as brushstrokes. The pattern is also organic, evoking associations with natural textures. This simple design diagrams one of Newman's main preoccupations at that time, the duality of all existence.[7] With a divided image he represented the juxtaposition of action and rest, rough and smooth, spontaneous and calculated, gestural and minimal, sensual and cerebral, existence and oblivion. In fact, Newman's print has much in common with the lithographs that Gray then created at Pratt, works that grew from Asian conceptions and representations of the duality of our world.

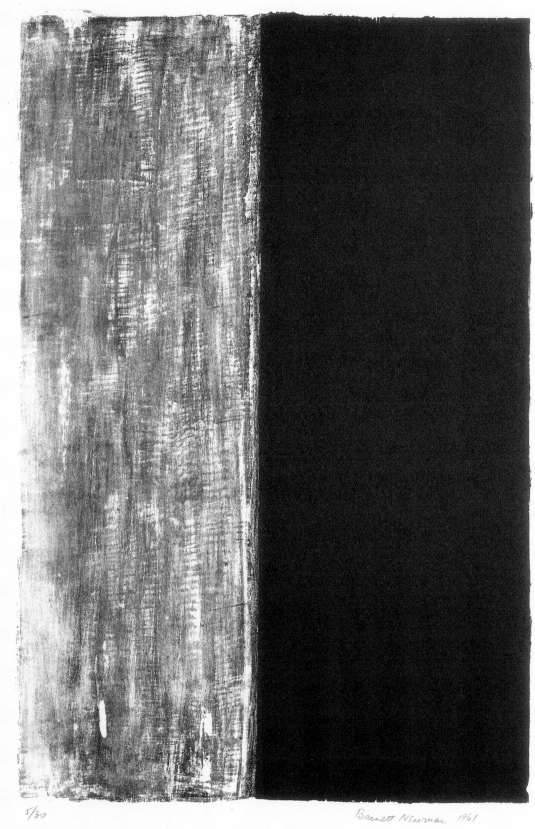

5/30 Barnett Newman 1961

ED COLKER

1927–

77. Poetic Myth I, from The Song of Amergin, 1962

Lithograph on cream wove paper, edition of 15
46.2 x 36.5 cm (image)
56.3 x 45.3 cm (sheet)
Inscribed: in graphite, lower margin: *Ed.15 poetic myth I from the Song of Amergin Colker*
Watermark: *BFK RIVES*
References: Kenyon 1975, pp.12–13; Bermingham, 1976, pp.1, 13; Bermingham 1990, pp.88–89; Bermingham/Anania 1998, p.4, 44.
Worcester Art Museum, 1998.223

For forty years Ed Colker has produced elegant books and portfolios that combine his original prints with the poetry that inspires them. In his work the fastidious design and production of the French book art tradition is wedded to images in the free American idiom of Abstract Expressionism.

Colker was born in Philadelphia on January 5, 1927.[1] His fascination with paper began in childhood, for his father was a wholesale paper merchant. He majored in art at Olney High School and won a scholarship to the Pennsylvania Museum School of Industrial Art (now The University of the Arts). Colker served in the Army during World War II with the Eighty-eighth Infantry Division in Italy. After his discharge in 1946, he returned to the Philadelphia Museum School as a GI Bill student. He studied lithography with Benton Spruance, and intaglio printmaking with Ezio Martinelli, who introduced him to the prints of Stanley William Hayter, the paintings of Arshile Gorky, and the work of other Abstract Expressionists. Among Colker's first prints were abstract intaglios reflecting the influence of Surrealist painters like Roberto Matta and André Masson, which were shown in group exhibitions of the Print Club of Philadelphia. After graduating in 1949, he joined the faculty of the Museum School, and developed its typographic division.

In 1951 Colker's work was included in the group exhibition *Some American Prints* at the Museum of Modern Art in New York. Solo exhibitions of his paintings and prints appeared at the Donovan Gallery in Philadelphia in 1954, and the Korman Gallery in New York in 1955.[2] He continued to be inspired by the energy and spirit of Abstract Expressionism. A jazz aficionado, Colker was acutely aware of the relationships between automatist delineation and musical improvisation. In 1954, when he traveled to California to meet the jazz musicians Dave Brubeck and Paul Desmond, he became engrossed in the thriving Bay Area arts and extended his stay to six months. In 1956 Colker moved to New York and set up a printmaking studio in his flat on Ninth Street. There, in 1960, he printed new editions of etchings for Edward Hopper.[3]

For Colker, *The Artist and the Book 1860–1960* exhibition at the Museum of Fine Arts in Boston was an epiphany.[4] He recognized how poetry and printing can be combined with engaging elegance. In 1961 he won a Guggenheim Fellowship to travel in Europe and study the history and practice of the book arts. At the Bibliothèque Nationale in Paris he examined many of the finest *livres d'artistes*. He also visited Georges Le Blanc, who printed at Atelier 17, the Parisian studio of Roger Lacourière, who printed for Matisse, Joan Miró, and Yves Tanguy, and other venerable artists' printers. His Guggenheim Fellowship was extended, and Colker became a frequent visitor to the workshop of Edmond and Jacques Desjobert, and over the next decade he returned there several times to print his own editions. When Colker returned to New York in 1962, he resumed his studies at New York University. Inspired by his European experiences, he began to produce folios of his own prints, melding select typography, engaging design, beautiful papers, and meticulous printing. Among his early publications was *The Duke*, Brubeck's piano homage to Duke Ellington in 1963. The composer's musical score is accompanied by Colker's dance movement drawings and an etching. After completing his bachelor's degree in 1965, Colker joined the faculty of the University of Pennsylvania Graduate School of Fine Arts. He moved his studio to Hampton, New Jersey, and began publishing under the imprint of Éditions du Grenier. Notable among the works he created at that time is Charles Baudelaire's poem *L'ennemi*, accompanied by his woodcuts.

To sustain his work, and to promote centers for art practice and education, Colker became a teacher and academic administrator. He held positions at the University of Illinois in Chicago, Cornell University, The University of the Arts in Philadelphia, Cooper Union, and the Pratt Institute. In 1980 he became dean of visual arts at the State University of New York in Purchase, where the woodcut artist Antonio Frasconi was on the faculty. They developed the Center for Edition Works, a new facility joining a graphic arts study collection with print studios, facilities for papermaking, and advanced phototypesetting. In 1983 Colker moved his own workshop, renamed Haybarn Press, to Chappaqua, New York. In the late 1970s and 1980s he produced illuminated portfolios of poems by Pablo Neruda, Michael Anania, and Kathleen Norris, with prints in a full variety of media. A selection was included in Colker's solo exhibition *Prints for Poetry and Prose*, mounted at the State University of New York in Albany, in 1990. A more complete retrospective exhibition of his prints and books, organized by the University of Arizona Museum of Art in 1998, subsequently traveled across the country.[5] Today Colker lives and works in Chappaqua, New York.

The present print is one of three lithographs based on *The Song of Amergin*, a cycle of ancient Celtic poetry published in *The White Goddess* by Robert Graves, who believed the text to be the progenitor of poetic symbolism. The lyric expresses the beauty and power of Nature, and its spiritual connections to tribal life in Northern Europe:

> *I am a wind of the sea,*
> *I am a wave of the sea*
> *I am a sound of the sea*
> *I am a stag of seven tines*
> *I am a hawk above a cliff*
> *I am a tear of the sun*
> *I am fair among flowers*
> *I am a boar*
> *I am a salmon in a pool*
> *I am a lake on a plain*
> *I am a hill of poetry*
> *I am a battle-waging spear*
> *I am a god who forms smoke*
> *From sacred fire for a head!*[6]

Colker began each of the prints for this suite in a referential sketch with brush and tusche on the lithography stone, here depicting the hawk soaring above a craggy hill. Then, in painterly improvisation he distilled the essential mood of the verse. The sense of movement in this image evokes the winds and floods of the poem, but also invites associations to shifting banks of mountain mist and crashing waterfalls. Colker captures too the spark of life, the vitality of the raptor's flight and of the animals described in the poem. In one sense, this vital energy is personified and controlled in the poem by the shaman, and Colker's tornado of calligraphy also evokes such a magician, able to appear and dematerialize at will.

There are three prints in Colker's *The Song of Amergin* suite, reflecting separate segments of the poem and conceived as a triptych, each printed in a different colored ink. Deft brushstrokes, the skillful control of washes, and the sensitive combination of ink and paper are reminiscent of Asian painting. When Colker drew on the stones at the Atelier Desjobert in Paris, he came prepared with basic notions of design and metaphor. The artist worked in rapid improvisation, striving to complement the verse and capture its essence, providing new awareness for the reader. Apparent brushstrokes reveal his actions. The triangular composition, with its apex in the air, creates a gravitational effect. Like a levitating shaman, or the vigor in a living being, this energized vision could seemingly disappear at any moment.

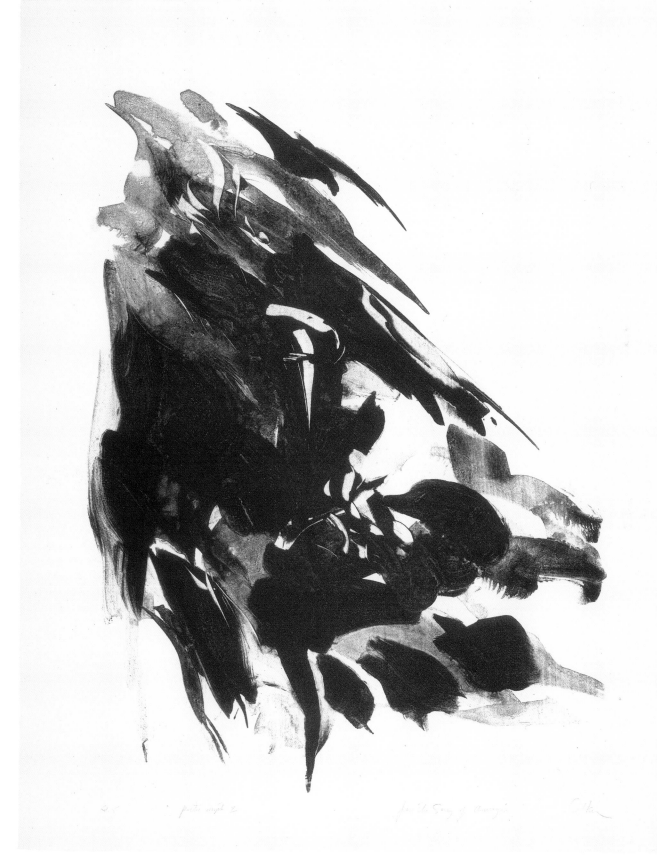

GUY WILLIAMS

1932–

78. Untitled, 1961

Wood engraving and screenprint on white wove
 paper, 27/100
14.9 x 16.9 cm (image)
18.8 x 20.4 cm (sheet)
Inscribed: in graphite, below image, l.r.: *Guy
 Williams*; in graphite, l.l.: *27/100 iii*
Embossed: u.r.: *Hollander*
Worcester Art Museum, 1996.121

The painter, photographer, and teacher Guy
Williams became a pioneer in the use of the com-
puter as a tool for serious printmaking during the
1990s. However, he came of age in the era of
Abstract Expressionism, and that style nurtured
his aesthetic temperament, and characterized his
earliest prints.

Williams was born on June 21, 1932, in San
Diego, where his father was an airplane mechanic.[1]
As a young adult he shared his interest in art with
his friends John Baldessari and Richard Allen
Morris, both of whom developed professional
careers as artists. While working at the CBS televi-
sion affiliate in San Diego from 1954 to 1958, creat-
ing sets and scenery, Williams began to paint
seriously. He began exhibiting his gestural abstract
oil paintings in local group shows in the mid-
1950s, winning awards at the Coronado Annual
exhibition in 1956 and the Art Guild annual exhibi-
tion in 1957. The first solo exhibition of Williams's
work appeared at the La Jolla Art Center in 1957. In
1959 he became an instructor of painting at the La
Jolla Museum of Art, where a solo exhibition was
mounted in 1961. At that time the artist began to
show his work at the David Stuart Gallery in Los
Angeles, where he had solo exhibitions almost
annually through the decade.

In 1962 Willliams moved to New York, only to
find the heyday of Abstract Expressionism had
ended, to be superseded by Pop Art and Minimal-
ism. He returned to California within a year, and
soon began a reorientation of his style to the
strategic logic of Minimalism. He produced mural-
scaled canvases in a single even hue, interrupted
by one fine line along an edge. Similar spare lines
intrude on outlined rectangles in his drawings and
prints, and to further suggest the annihilation of
the picture plane he worked on transparent clear
Plexiglas. Williams taught at the California Insti-
tute of the Arts from 1965 to 1967, and at Pomona
College in Claremont, California from 1967 to 1974.
A solo exhibition of his work appeared at the

California Institute of the Arts in 1968. In 1972, the
year that one his paintings was included in the
annual exhibition at the Whitney Museum of
American Art in New York, the artist made collabo-
rative lithographs at Cirrus Editions in Los Angeles.
A National Endowment for the Arts artist's fellow-
ship supported his activities in 1975. At that time
he painted tiny bars of discrete color disposed in
an allover pattern across the canvas, so that hues
optically blend and shift in subtle, provocative
effects of vibration. In 1976 a solo show of his work
was the inaugural exhibition at the Los Angeles
Institute of Contemporary Art. The following year,
when he began teaching at the University of Cali-
fornia at Santa Barbara (UCSB), an exhibition of
his paintings, photographs, and writings was
mounted there.[2]

Beginning in the late-1970s Williams created
complex geometric compositions by painting flat,
solid colors on paper in acrylic, and then cutting
the sheets into strict geometric shapes, and
affixing them to complementary-colored paper,
canvas, or panel. The artist carefully balanced
forms against the fields, activating interstices and
harmonizing colors. Often he bifurcated shapes
and separated their components with a thin white
line, achieving paradoxical illusions of space,
rhythm, and movement. Indeed, like the work of
Piet Mondrian, this precise, cool geometry often
carried musical connotations. In 1982 these
painted-paper cutouts made up a solo exhibition
at the Los Angeles Municipal Art Gallery at Barns-
dall Park.[3] The following year the artist transferred
similar imagery to lithographs during his fellow-
ship at the Tamarind Institute in Albuquerque. An
exhibition of Williams's work was presented by the
Santa Barbara Museum of Art in 1985.[4]

In 1990 fire destroyed Williams's home and stu-
dio, and nearly all of his previous work. Undaunted,
the artist began a period of intense activity, and in
the ensuing decade he created over a thousand
works. He became interested in the use of the
computer for creating images, and began digitizing
his drawings and photographs with a scanner,
altering them in the computer and making inkjet
prints. His recent works include images based on
NASA satellite photographs taken from the
Internet, subsequently manipulated and produced
as both Iris and inkjet prints. Having retired from
UCSB, Williams lives in Santa Barbara, where he
produces giclé prints nearly every day.

The present print is one of Williams's earliest,
created in the studios of the La Jolla Art Center,

where he taught a course in printmaking. Among
his students at that time was William Lumpkins,
who experimented with techniques leading to his
mural-scaled screenprints. Using similar tech-
niques, Williams created this miniature in a style
related to his contemporaneous gestural painting.
It is one in a set of three prints that began as play-
ful experiments. In the Art Center basement the
artist discovered a group of nineteenth-century
wood-engraved blocks, the fragments of larger
matrices once used to print advertising. Williams
distributed some of these among his students, and
combined them with screenprinting in his three
small prints. The results are parallel to his latest
work in its combination of appropriation and tech-
nical manipulation. Williams used simple tech-
niques to create his silkscreens. He dripped and
drizzled liquid tusche onto the screen, squeegeed
over a layer of glue, and then washed it away with
solvent to create a stencil with the image of his
drip drawing. For similar, negative images he used
ribbons and splashes of glue to block the screen.
The artist also employed the paper stencil tech-
nique, adhering bits of cut and torn paper to the
underside of the stretched silk, so that when the
wet ink was scraped through the fabric it adhered
to the screen, creating a stencil. The artist took
advantage of the feathery edges of these collage-
like elements. Alternating printings from the wood-
engraved blocks and these spontaneously wrought
silkscreens, Williams built his compositions in lay-
ers. He made immediate decisions about place-
ment and colors, reacting to the image taking
shape before him. Subtly interwoven organic line
and form create fascinating effects of depth and
transparency. The screenprinted images often have
a liquid, oceanic character that contrasts with the
cartographic hatchings in the wood engravings.
Its subdued palette creates a mysterious mood in
this print which is quite different from that of its
pendants.

Later these three prints appeared in Williams's
Painter's Notebook, a privately printed volume
containing his original poems and prose, with the
three prints tipped-in. The book was printed by
Irwin Hollander, who at that time worked in a com-
mercial printshop in La Jolla, where he printed the
text and illustrations of Williams's book after hours
when the workshop was closed. In September 1961
Hollander began a printer fellowship at the Tama-
rind Lithography Workshop, and subsequently
opened his own studio in New York.

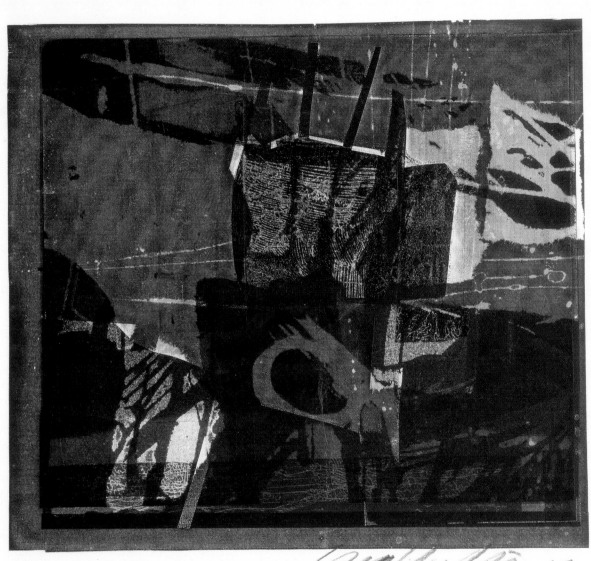

LEE KRASNER

1908–1984

79. The Civet, 1962

Lithograph on cream wove paper, artist's proof
51.0 x 75.1 cm (image)
56.5 x 76.1 cm (sheet)
Inscribed: in graphite, below image: *artist proof
 "The Civet" Lee Krasner 1962*; in graphite on
 verso, u.r.: *#75*; in red color pencil, u.r.: *#1196*/①
Watermark: *ARCHES*
Embossed: u.r.: between two dotted concentric
 circles: *PRATT•GRAPHIC•ART•CENTER•N•Y•★*
References: Landau 1995, no.CR 384.
Private collection

During the 1940s Lee Krasner participated in the intellectual and formal development of the Abstract Expressionist movement. She is one of the few women artists to be recognized for her significant role in the New York School.

Lena Krassner was born in Brooklyn, on October 27, 1908, the daughter of a Ukrainian immigrant who worked as a grocer.[1] She was a bright, headstrong child, uncompromising in her aspirations to become an artist. After graduating from high school in 1926, she enrolled in the Women's Art School of Cooper Union. In 1928 she attended drawing classes at the Art Students League, and that fall she was admitted to the National Academy of Design where she studied with Charles Curran, Leon Kroll, and Raymond Nielsen. At that time Krasner was influenced by works of Henri Matisse and Picasso, which she viewed at the Museum of Modern Art, and she began to experiment with abstraction. In 1932, after completing the course at the National Academy, Krasner continued her studies at City College of New York, with the pragmatic goal of becoming a high school art teacher. After an assignment in the Public Works of Art Project, Krasner joined the mural division of the FAP/WPA in summer 1932, and worked as an assistant to Max Spivak. In the mid-1930s the artist briefly experimented with Surrealism, and also studied with Hans Hofmann. She began to exhibit her work in the early 1940s in group shows sponsored by the Artists Union and the American Abstract Artists group.

In December 1941 one of Krasner's canvases was included in *French and American Painting*, a group exhibition organized by John Graham for the design firm McMillen, Inc. Viewing the show, she recognized all the American artists except for Jackson Pollock, so she went to his apartment to introduce herself. The two soon became insepara-

ble, and in 1942 Krasner moved in with Pollock. She introduced him to artists in Hofmann's circle and helped to arrange his first solo exhibition at the Art of This Century Gallery. In 1945 they were married in a private ceremony in New York, and moved into an old farmhouse in Springs, near East Hampton on Long Island. There Krasner executed her *Little Image* series of paintings, featuring divided compositions each cell of which carried a hieroglyphic symbol. In fall 1948, Krasner exhibited her work in a group show at the Bertha Schaefer Gallery, and in the following year she and Pollock shared an exhibition at the Sidney Janis Gallery. In the early 1950s she experimented with large painted collages, made of fragments of earlier works. These were shown in her first solo exhibition in New York at the Stable Gallery in 1955.[2]

Krasner was devastated by Pollock's accidental death in August 1956, and she painted furiously for over a year, creating her first cycle of large Abstract Expressionist paintings, *The Seasons*. In 1957 she moved back to Manhattan, and a solo exhibition of her paintings was mounted at the Martha Jackson Gallery the following February. An ambition of the artist's from the 1940s to do a major mural was fulfilled when she won a commission from Uris Brothers Corporation for two monumental mosaics in a new corporate building. When her mother died in 1959, Krasner expressed her emotions in a series of large gestural canvases, known as the Umber and White paintings, which received critical disfavor when they were shown at the Howard Wise Gallery in 1960.[3] On December 25, 1962, Krasner suffered a brain aneurysm and underwent surgery. Afterward, when she settled in a new apartment in Manhattan, her paintings became bright, lyrical, and fresh. Energized, rhythmic forms suggest birds and growing plants, enlivened by painterly brushwork, drips, and spatters.

A 1965 retrospective exhibition of Krasner's work was mounted at the Whitechapel Gallery in London.[4] At that time she finally began to receive the acknowledgment that had long eluded her. In 1969 Krasner was the only woman included in *The New American Painting and Sculpture: The First Generation,* at the Museum of Modern Art. She created large paintings that reacted to current developments in Color Field painting, built on the vocabulary of her *Little Image* paintings of the mid-1940s. In 1983 a major retrospective exhibition of her work originated at the Museum of Fine Arts in Houston, but the artist did not live to see its pre-

sentation in New York.[5] She died on June 19, 1984, and left the bulk of her estate to support individual artists through the Pollock-Krasner Foundation.

The present print is one of Krasner's first lithographs, made in 1962 at the Pratt Graphic Art Center in New York in collaboration with the printer Arnold Singer. They worked together on three lithographs, and for each the artist used thick crayons to draw on the stones, working with confident speed. All three prints are parallel in their style and energy to the artist's contemporaneous paintings, which feature rhythmic arcs and slashes, swirling near the picture plane. Krasner strove to explore every visual effect in her materials, twisting and scraping the lithographic crayon against the printing surface, causing it to scutter and skip, and also to delineate smooth, rich lines. She drew with the side of the crayon to create wide, gray tonal passages and retraced lines to darken them, causing the wax to clump and flake on the stone.

The energy and immediacy of Krasner's drawing are restrained by her cyclotronic design, though a few electrons do escape its borders. It derives from her Umber and White paintings, begun in 1959, which feature screenlike patterns of line and form, balancing unpainted white interstices in pulsing rhythm.[6] The linear vocabulary of arcs, ellipses, and diagonals can be found in the artist's Modernist canvases of the 1930s; however, here organic complexity has replaced geometric clarity, and transparency has replaced formal solidity. *The Civet* is slightly different from its pendant lithographs, *Soundings* and *Obsidian,* in the vertical and diagonal lines — implied as much as delineated — that give the composition a screenlike appearance. The lithograph's poetic title evokes associations to deep jungle undergrowth, where a stealthy jungle cat lurks silently, imperceptible even as it watches us. Like a forest prospect, Krasner's mysterious image is composed of myriad indistinguishable details. Some of the elliptical forms have parallel hatching reminiscent of the veins in leaves. The repeated arcs evoke drooping branches of banana stalks, and the almond-shaped lozenges marked by diagonal hatching are also suggestive of decorated African tribal shields. Parallel lines, often in groups of three, recall the striped camouflage of the jungle cat. In its personal expression of vitality, change, imperfection, and ambiguity, the image embodies Abstract Expressionism.

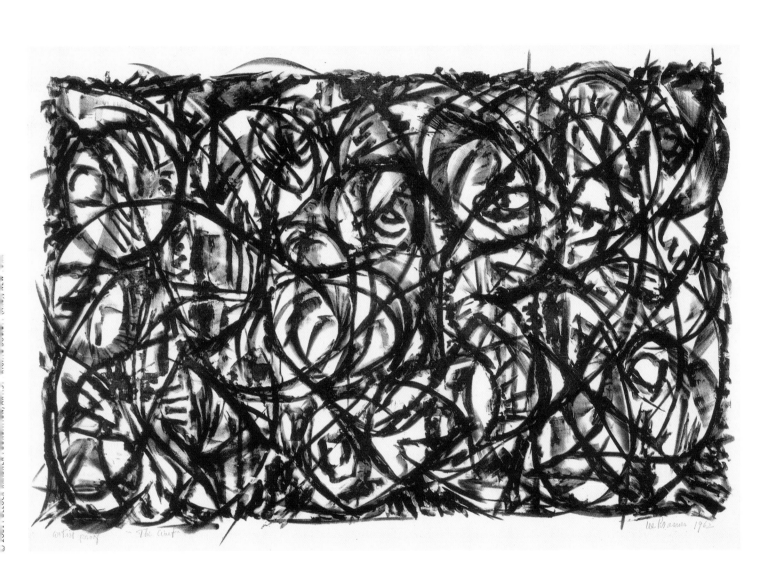

artist proof — The Unifier Lee Krasner 1962

ESTEBAN VICENTE

1903–2001

80. Untitled, 1962

Lithograph on cream wove paper, 12/20
28.2 x 35.7 cm (image)
36.0 x 35.7 cm (sheet)
Inscribed: in graphite, below image: *12/20 Esteban Vicente*; in graphite, on verso: *650*
Watermark: *BFK*
Embossed: l.r.: *Tamarind*; l.r.: *JZ* (Joseph Zirker).
References: Tamarind 1989, p.260, no.650; Devon 2000, p.12.
Worcester Art Museum, 1993.102

The spontaneous energy of Abstract Expressionism and the tactile sensibilities of drawing, painting, and collage are masterfully transferred to the prints of Esteban Vicente. The artist was born on January 20, 1903, in Turégano, Spain.[1] He was educated at the military academy that his father and grandfather had attended before him, and there, at age sixteen, he decided to become an artist. In 1921 he enrolled at the Real Academia de Bellas Artes de San Fernando in Madrid, where he began studying sculpture but soon shifted to painting. He developed an expressive representational style based on the works of the old masters that he studied at the Prado Museum. The work of Picasso and Paul Cézanne influenced his work when the artist lived in Paris from 1927 to 1932. He struggled for recognition, painting at night while supporting himself with work as a stage-set designer and photograph retoucher. Disheartened with what was becoming a career in commercial art, he returned to Madrid.

With the support of a scholarship from Spain, Vicente moved to New York in 1936. At that time he painted semiabstract figural paintings reminiscent of the work of Honoré Daumier, and works in this manner comprised his first solo exhibition in New York at the Kleeman Gallery in 1937. The outbreak of the Spanish Civil War prompted Vicente to stay in the United States, serving as vice-consul in Philadelphia for the Spanish Loyalists. In 1940 he became a naturalized American citizen. As the decade progressed, the artist came under the influence of the New York School, and his work became more abstract. Clement Greenberg and Meyer Schapiro selected his work for the landmark *New Talent* exhibition at the Samuel Kootz Gallery in 1950, and his paintings were included in the Ninth Street Show the following year. At that time

the artist shared a studio on Tenth Street with Willem de Kooning, and he was an active member of The Club.

In 1954, when Vicente arrived in California for a temporary teaching appointment at the University of California at Berkeley, he became frustrated by the delayed arrival of his tools and materials. He tore up the colored supplement from the Sunday newspaper, and made collages to plan for a large painting; he found the process so satisfying that he began working seriously in collage. The artist prepared large sheets of paper with oil paint, lacquer, or pastel, then tore them to shape his collage elements, and the paper color became visible along feathery edges that enlivened his compositions. Vicente usually completed his collages with spontaneous overdrawing in paint or charcoal.[2] His activities in collage, drawing, and painting influenced each other, and soon he forged a single, unified style. In the mid-1950s his solo shows at the Peridot Gallery featured both oil paintings and collages, graceful compositions in which were reflected a delicate sense of color and line, and the immediacy of their making, as well as an interest in the materials. In 1958 the artist contributed an aquatint to *Twenty-One Etchings and Poems*.[3] In 1959 Vicente began teaching at New York University, where he remained on the faculty for a decade. Among his temporary appointments were positions at Yale University, University of California at Los Angeles, Princeton University, and the Honolulu Academy of Fine Arts. He made his first lithograph in 1961 during a brief visit to the Tamarind Lithography Workshop in Los Angeles.

From 1965 to 1986 Vicente taught at the New York Studio School. His paintings became simpler and more monumental in the early 1970s, with lush color and refined surfaces that reveal little of their facture.[4] During the 1980s Vicente enjoyed wider recognition for a lifetime's achievement. In 1984 he received an award from the American Academy of Design, a gold medal from the American Institute of Arts, and an honorary doctorate in fine arts from the Parsons School of Design. Three years later a retrospective exhibition of his paintings and collages was mounted at the Banco Exterior de España in Madrid. In 1991 Vicente was awarded Spain's Medallas de Oro de las Bellas Artes, presented by King Juan Carlos and Queen Sofia in a ceremony at the Prado. A retrospective exhibition of his collages was mounted at the

Centre Julio Gonzalez in Valencia, Spain, in 1995. Vicente continued to exhibit actively and paint every day, until his death in Bridgehampton, New York, on January 10, 2001.

The present print is one of the sixteen lithographs that Vicente made when he was an artist fellow at the Tamarind Lithography Workshop in late summer 1962.[5] He drew on the stone on September 25, and Joseph Zirker pulled the edition the following day. Vicente's Tamarind lithographs are essentially translations of the artist's contemporaneous drawings in charcoal, brush and ink, or paint, his most direct and intimate works.[6] At that time his activities in drawing, collage, and paintings were inextricably linked, influencing one another and producing a distinctive, cohesive style. Vicente included pasted bits of paper in some of his drawings, and in others he drew the chunky rectilinear shapes and layered compositions of his collages. Whatever their medium, these works always exploit qualities unique to their materials.

With the same tactile sensitivity, Vicente's early lithographs explore the capabilities of lithography with his signature formal vocabulary. For the present print the artist drew on the stone with lithographic crayons, picking out rectilinear forms with his handwritten calligraphy and shading them with sinuous ribbons of hatching. He used crayons of different size and density to create varied lines and layered the scribbled hatching to create dark accents. Vicente also smeared the pigment across the printing surface, blurring edges and producing smoky effects like those of smudged charcoal in many of his drawings. The resulting tonal richness emphasizes the contrast with unmarked areas of the paper, accentuating the gleaming central passage. The artist carefully selected the paper for this and all his early Tamarind lithographs, mindful of its color, texture, and deckled edges.

Vicente worked rapidly, without a specific preconceived design, and the composition emerged in the process of its making. Resonant lines and shapes blend with each other in this image, never coming to rest, or allowing us to focus on them sharply. The juxtaposition and overlap suggest space, and imply landscape. This notion is emphasized by the arch shapes that repeat throughout the composition, conveying a sense of weight. A literal reading is unintended and impossible, but the image achieves an imposing monumentality despite its small scale.

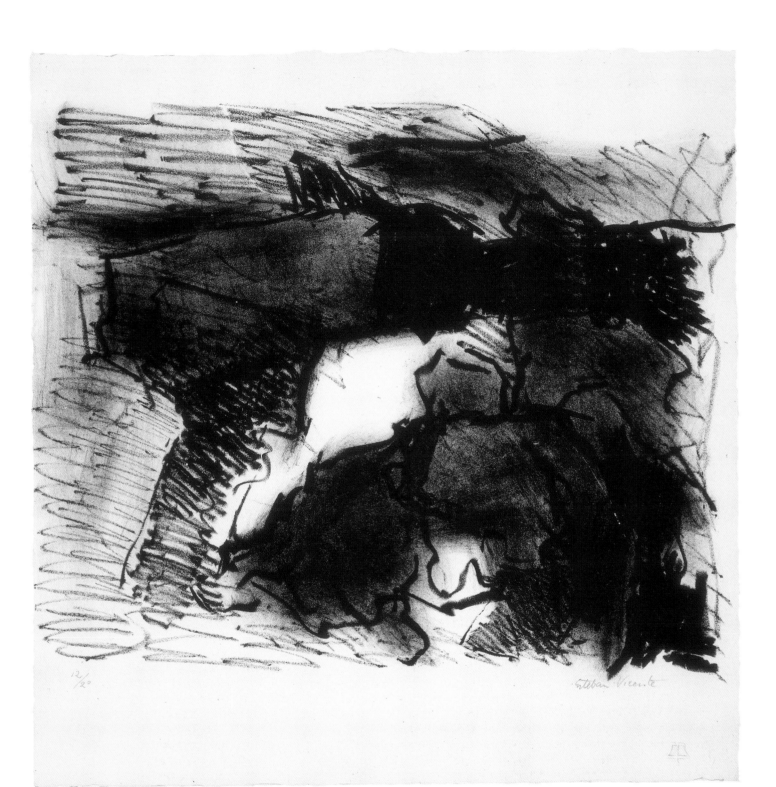

12/20 Esteban Vicente

JOHN GRILLO

1917–

81. Untitled, 1963

Lithograph on white wove paper, artist's proof
97.6 x 73.6 cm (image)
100.4 x 75.5 cm (sheet)
Inscribed: in graphite, l.r.: *Proof 1 Grillo 63*
Worcester Art Museum, 1997.175

A painter admired for his vitality and originality, John Grillo was at the forefront of Abstract Expressionism on both the West and East coasts in the 1940s and 1950s. He has been an active printmaker throughout his career, often devising his own techniques and printing his own editions.

Grillo was born in Lawrence, Massachusetts, on July 4, 1917.[1] His childhood talent for drawing was encouraged by his father, an amateur painter. When he was fourteen years old he moved with his family to Hartford, Connecticut, where he took Saturday morning classes at the Hartford School of Fine Arts. In 1936 Grillo entered the school's degree program with the support of a scholarship. After graduation in 1938, he married and began a family, and worked on the night shift in a gun factory while painting each day in a rented studio. In 1944 he was drafted into the Navy, trained as a teletype operator and posted to active duty in Okinawa. He continued to paint, and began experimenting with abstraction, working from ideas suggested by old art magazines.[2] Fascinated by the idea of Automatism, Grillo improvised materials, painting with coffee and cocoa, and throwing coffee grounds onto damp paper to produce speckled abstract patterns.

In 1946, after he was discharged in San Francisco, Grillo enrolled as a GI Bill student at the California School of Fine Arts, where he was given his own studio and great independence. He began a series of abstraction paintings that rivaled vanguard developments in New York for their spontaneity and technical freedom. "Grillo was throwing paint all over the room," recalled John Hultberg. "You couldn't get near him."[3] His first prints were Abstract Surrealist lithographs, made in 1946 when Ray Bertrand taught him the process in the modest school printshop. His first solo exhibition was mounted at Daliel's Gallery in Berkeley in 1947, and his first show in New York appeared at the Artists' Gallery in October 1948.[4] A few months later he won the Samuel S. Bender Award for painting, and he used the money for the bus fare to New York.

Grillo attended Hans Hofmann's school in Manhattan and in Provincetown during the summers of 1949 and 1950. He was influenced by the master's theories of color and composition, and his automatist canvases became larger and more

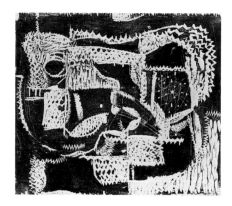

Figure 1. *Untitled*, 1955.

painterly. The artist began independent experiments with woodcuts in 1952 (fig. 1).[5] Carving spontaneously, Grillo worked his blocks with a fresh, naïve energy, creating lines and passages that exploit the splintery nature of the wood. He developed a distinctive jagged line, made shaggy by the chipping of the knife cutting against the wood grain, creating an electric vibration. In 1953 the artist had two solo exhibitions in New York, at the Tanager and Tibor de Nagy Galleries.[6] The paintings reveal both Hofmann's influence and Grillo's own concentration on color. Intensely hued patches of impasto make up these compositions and appear to move. As the decade progressed, the artist became more interested in the physical qualities of paint. His canvases became larger and more lyrical, inspired by and titled for air, sun, cloud, topography, and atmosphere. In 1960, when Grillo was artist-in-residence at the University of Southern Illinois at Carbondale, he made a group of gestural lithographs, painted in tusche-laden brush strokes on the stones, and printed in small editions. At that time his paintings featured layers of color filtering through from underneath, to reveal the method of their creation, and by analogy the mysterious processes of nature.[7]

In 1962 Grillo's paintings were included in notable circulating group exhibitions, including *Hans Hofmann and His Students* and *Fourteen Americans*, both organized by the Museum of Modern Art. Grillo was an artist fellow at the Tamarind Lithography Workshop in Los Angeles in March 1964, when he made his last significant group of Abstract Expressionist prints.[8] He produced four single-leaf lithographs and the suite of color prints *Illuminations of Time and Space*, which correspond in their astral imagery, palette, and style to his contemporaneous paintings.

In 1967 Grillo began teaching at the University of Massachusetts at Amherst. His style shifted dramatically to representational imagery, and he depicted stylized Rubenesque figures in vivid col-

ors, sometimes in Pop-influenced geometric settings.[9] Some of the most striking of these works grew out of Grillo's extended visits to Colombia in 1981, when he lectured in Bogatá and in Medellín. At that time the first of his five solo shows in Medellín was mounted at the Museo de Antioqua. In 1988 the Provincetown Art Association presented a retrospective exhibition of Grillo's work.[10] Three years later Grillo retired from teaching and moved full time to Wellfleet on Cape Cod.

The present lithograph was made when Grillo was visiting artist at the University of California at Berkeley in 1963. His friend Karl Kasten encouraged the artist to work on the unusually large stones available in the Berkeley printshop, and the Master Printer George Miyasaki helped him to prepare the stones. These prints transfer the style and impact of his contemporaneous paintings, and capture the immediacy of his improvisational creative process. Like Grillo's canvases, the lithographs are records of the physical and temporal events of their creation. They also explore the distinctive physical qualities and behavior of the medium. The artist addressed the printing surface as he did the canvas, without plans for a composition or mood. He drew on the stone, which lay flat on the press, building up an image in response to the visual results of his previous actions. The artist concentrated on delineating forms rather than calligraphic lines, and by their placement, surface patterns, and tonal values, these shapes appear to locate in space, and even to suggest movement and trajectory. He skillfully exploited the tonal capabilities of the process to create effects of transparency and illusions of depth.

Grillo worked the stone in many different ways, employing lithographic crayons and tusche applied as viscid paste and liquid in various dilutions. He blotted and scrubbed the wet ink from the stone to soften a passage, and then he overlaid new details in other shades. Miyasaki recommended techniques that captured the expressive spontaneity of Grillo's paintings, like spattering the stone with lithotine to approximate the effect of dripped paint. When the artist dripped and drizzled a diluent like lithotine or alcohol on passages of black, it separated the oily ink into thin globules, which appear as droplets when he allowed the thinner to dry in the air. In other areas he scrubbed the dissolving ink in straight or circular strokes to create passages of gray that reveal ghostly layers of ink underneath. Remarkably, this myriad of strokes, splashes, blottings and scrapings achieves a comfortable coherence. The delicate and physically challenging task of inking the big stones fell to Miyasaki, and both he and Kasten helped to print the editions.

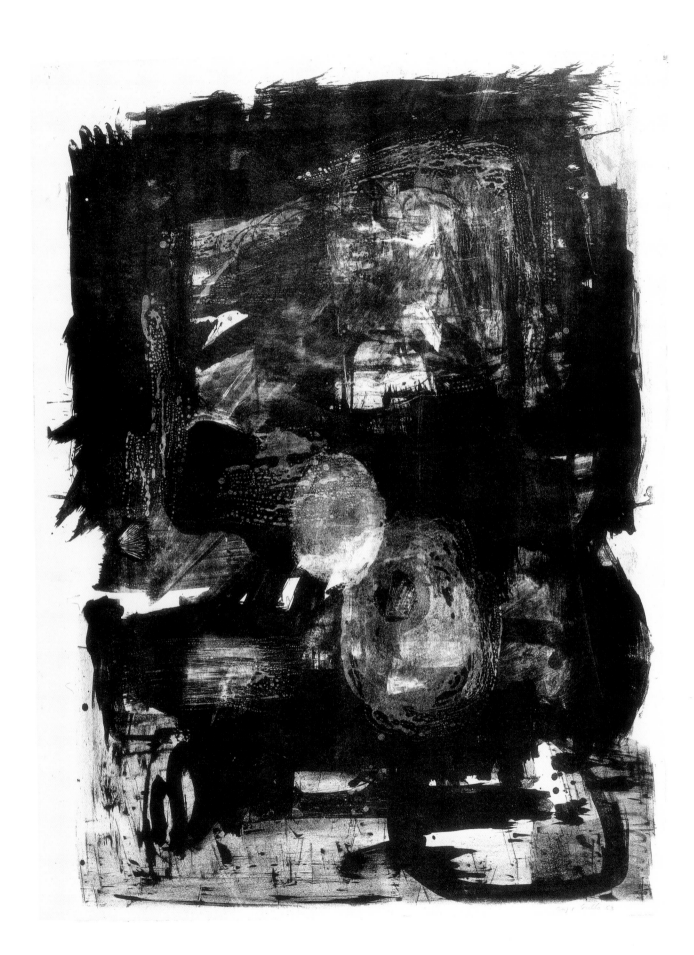

SAM TCHAKALIAN

1929–

82. Strike Hard, 1963

Lithograph on white wove paper, 2/11
104.9 x 76.3 cm (image)
104.9 x 76.3 cm (sheet)
Inscribed: in graphite, lower margin:
 2/11 Strike Hard Sam Tchakalian '63
Worcester Art Museum, 1996.12.13

Perhaps more than any of his contemporaries, Sam Tchakalian has retained the influence of San Francisco Abstract Expressionism in his work. His enormous canvases, slathered with thick impasto, reveal the activity of their creator and reflect an obsession with the material properties of paint.

Tchakalian was born on March 13, 1929, in Shanghai.[1] His family had emigrated from Armenia to China, where his father and uncles owned and operated a group of French confectionery shops in Shanghai. In 1947 he came to San Francisco with his immediate family. He attended San Francisco State College and majored in psychology, receiving a bachelor's degree in 1952. Tchakalian served in the Army during the Korean War. After his discharge from the service in 1954, he seriously began to consider a career in art. He enrolled at San Francisco State University as a GI Bill student and studied painting and art education, receiving his master's degree in 1958. At that time Tchakalian worked extensively in collage, producing works of torn, crumpled, and wadded leaves of Asian paper, accented with pigment.[2] These works were parallel to those of colleagues like Jay De Feo, who moved away from the use of traditional materials. In the late 1950s when the artist gave more attention to painting, he transferred the thick, roiling surfaces of his collages to heavy impasto and began to develop a personal vision.

Tchakalian's first solo exhibition was presented by Dilexi Gallery in San Francisco in 1960. In that year his collage *Rubicon* won an award at the First Winter Invitational Exhibition at the Palace of the Legion of Honor. He was a guest lecturer in painting at the California College of Arts and Crafts in 1962–63, and the following year he taught painting at the College of San Mateo. His canvases grew larger in the mid-1960s, and their surfaces became more refined as he concentrated on subtle effects of color. In 1966 Tchakalian joined the faculty of the San Francisco Art Institute, where he continues

to teach today. He has also held several temporary residencies, including positions at Hampshire College, Cooper Union, the Whitney Studio School, and the University of California at Berkeley. In 1967 the artist shared a joint exhibition with Wally Hedrick at the Balboa Pavilion Gallery in Balboa, California.[3]

Tchakalian returned to impasto during the 1970s, as his paintings grew to monumental scale. Using palette knives and scrapers, he pulled thick mounds of paint across the canvas delineating horizontal stripes. He won a National Endowment for the Arts fellowship in 1975, and at that time solo exhibitions of his paintings appeared at Ruth Braunstein's Quay Gallery and the Susan Caldwall Gallery in New York.[4] Retrospective exhibitions of the artist's work were shown at the Oakland Museum in 1978, and at the Portland Center for Visual Arts in Oregon in 1979.[5] Tchakalian continued to construct his paintings in strata during the 1980s, scraping the top layers of pigment to reveal colors and patterns underneath. The paint is relatively thin on some canvases of the period, while others have deep, buttery impasto. In their accidental designs and their revelation of the artist's activity, these works remain quintessentially Abstract Expressionist. The physical substance of the paint, and the process of its manipulation become the very subject of the work. His canvases also evoke topography and effects of natural light and weather, adding to the perception of mood. In 1981 the artist won the Adaline Kent Award from the San Francisco Art Institute, in addition to his second artist's fellowship grant from the National Endowment for the Arts.

In 1986 Tchakalian collaborated with Donald Farnsworth in Oakland, California, on a group of gestural color lithographs. He returned to China in summer 1987, visiting Shanghai, Beijing, Huangshan, and Hangzhou. Then the artist journeyed to Seoul, South Korea, where a solo exhibition of his paintings was mounted at the National Museum of Contemporary Art.[6] In 1991 Tchakalian was invited to Smith Anderson Editions in Palo Alto, where he produced a number of colorful monotypes. The following year he continued working with the Master Printer Chaen Chan on another group of monotypes. A retrospective exhibition of twenty paintings was mounted at the Fresno Art Museum in 1997.[7] When Tchakalian visited China again in

spring 2000, his monotypes were included in a group exhibition at Shanghai University, organized by the artist Rem Ming. Tchakalian currently lives in San Francisco, where he continues to paint, teach, and occasionally make prints.

The present print is one from a group of lithographs that Tchakalian made in collaboration with the master lithographer George Miyasaki, at the University of California at Berkeley. Though it is primarily a teaching workshop, many distinguished Abstract Expressionist lithographs were produced in that studio during the early 1960s, including prints by Harold Paris, John Grillo, and Willem de Kooning. Tchakalian produced about a dozen editions at Berkeley in 1963, ranging in size. They are the products of friendly collaboration, made chiefly for the pleasure of their creation and printed in small editions.

The artist worked directly on the lithography stones, drawing spontaneously and reacting immediately to the behavior of the materials as the image evolved. He used lithographic crayons of different densities and sizes, placing soft sticks on their sides for wide gray tones, and pressing so hard with others that the crayons skipped across the printing surface. He often used bold paired lines to organize and dominate the composition, supplementing the image with detailed activity in clouds of scribbling and delicate calligraphic passages. Tchakalian also created dark accents by painting liquid tusche onto the stone with a brush. He continued to scrub and scumble as the brush dried, emphasizing the energy and direction of his gestures. The resulting image captures the speed with which the artist explored the distinctive visual effects of unfamiliar materials. Lines and brushstrokes circumscribing the image fail to contain its intensity and give the effect of a swirling tornado of energy. In its scale and its visual impact, this print is parallel to Tchakalian's contemporaneous painted collages of crumpled paper. One can imagine that in the lithograph, as in those craggy surfaces, messages may hide in obscured calligraphy of an unknown language. As with all of Tchakalian's work, compositional subtleties and undetected details become apparent with long, careful viewing, while the immediate impact of frenetic energy remains undiminished.

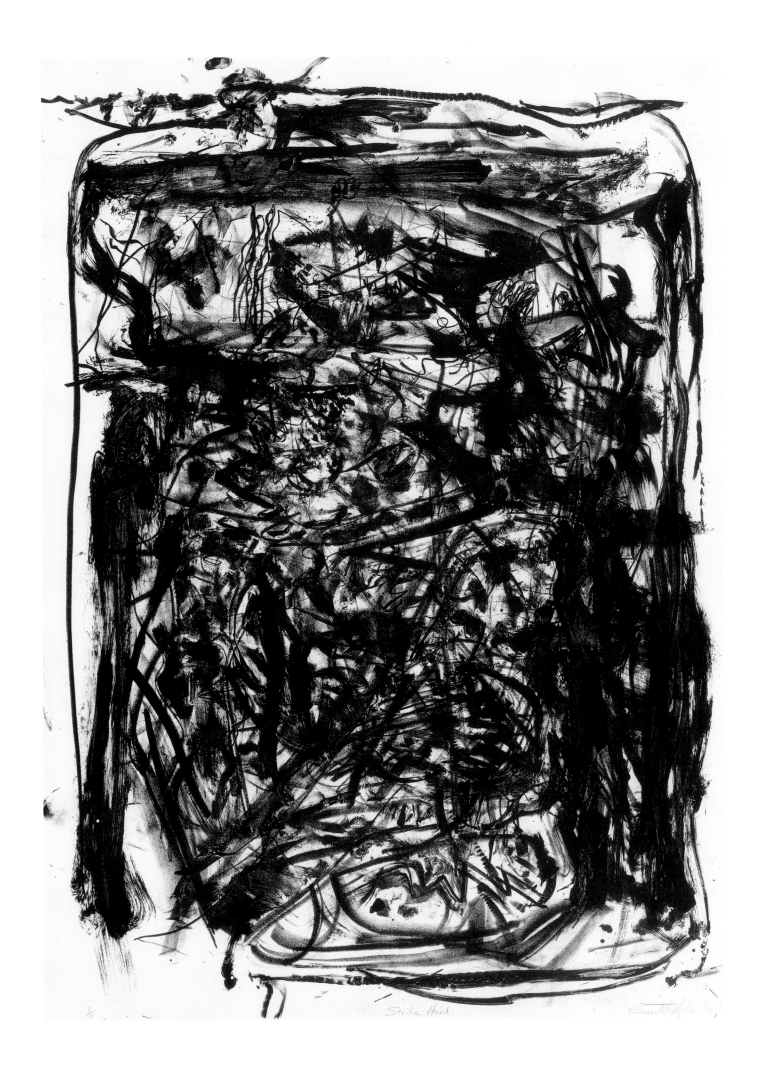

Strike Hard. Smith John

JOHN VON WICHT

1888–1970

83. Icarus, 1963/64

Pochoir on cream simili Japan paper, edition of 10
172.0 x 78.5 cm (image)
184.6 x 94 cm (sheet)
Inscribed: in pencil, lower left: *"Icarus" Black and
 White 2 colors Stencil Ed. 10*; in pencil, lower
 right: *v. Wicht 64 – 65*
Worcester Art Museum, 1996.12.15

When John von Wicht's style was transformed by
Abstract Expressionism in the 1950s, he sought to
transfer the impact of his paintings to large prints.
He made large lithographs, stencils, and screen-
prints, exploiting the unique capabilities of each
graphic medium.

Von Wicht was born on February 3, 1888, in
Malente, in northern Germany, the son of a
Protestant minister.[1] He was a natural draftsman,
and as a teenager he won a place in the presti-
gious private art academy in Darmstadt, spon-
sored by Ernst Ludwig Hohe, the grand duke of
Hesse. In 1909 von Wicht continued his studies at
the Royal School for Fine and Applied Art in Berlin.
There he made his first prints and learned the fun-
damentals of lithography. During World War I von
Wicht was drafted into the German army. In Octo-
ber 1914 he was severely wounded, and secondary
infections postponed his complete recovery. Since
it was impossible to find work as a craftsman after
the war, he emigrated to the United States in 1923.
He settled in Brooklyn Heights and soon began
working as a decorative artisan in mosaic and
stained glass. In 1936 von Wicht became a natural-
ized American citizen. He worked in the mural
painting division of the FAP/WPA, producing a wall
painting at the radio station WNYC in New York and
decorative murals in the Federal Building at the
1939 New York World's Fair.[2] The artist worked in a
geometric abstract style derived from Wassily
Kandinsky. In the late 1930s von Wicht began to
exhibit with the American Abstract Artists group
and the Federation of Modern Painters and Sculp-
tors. His first solo exhibition in New York appeared
at the Theodore A. Kohn Company in 1939.[3]

From 1944 to 1948 von Wicht supported him-
self working as a barge captain in New York harbor.
Painting in his cabin, he produced Cubist paintings
of harbor subjects, which were shown in group
shows and in solo exhibitions at the Kleeman
Gallery. He sometimes worked in the printshop run
by Margaret Lowengrund adjacent to her New York
gallery, The Contemporaries. In 1949, by donating
funds and expertise, von Wicht and his friend Will

Barnet helped Robert Blackburn, the Master
Printer from the Art Students League, to open his
own lithography workshop in New York. Gesture
replaced geometry in von Wicht's work in the
1950s, which became progressively freer and
lighter. From 1951 to 1953 the artist taught paint-
ing at the Art Students League, and the following
year he taught lithography at the John Herron
Institute of Art in Indianapolis, where a solo exhi-
bition of his prints appeared.

While he was at the MacDowell Colony in
Peterborough, New Hampshire, during much of
1955, the artist brought new lyricism to a series of
unpremeditated oil sketches on Japan paper.
These inexpensive materials, and the solitude of
the north woods, enabled von Wicht to find a new
voice. His work grew larger, and he began working
on the floor, using palette knives and rollers to
apply paint. The artist opened up his composi-
tions, using unmarked paper as an integral part of
the swift, rhythmic compositions. In early 1956
these works were shown in a solo exhibition at the
Passedoit Gallery in Manhattan.[4] Von Wicht regu-
larly exhibited his prints in the group exhibitions of
the New York Painter-Printmakers and the 14
Painter-Printmakers group. At that time he often
showed his work in California, and in 1959 a retro-
spective exhibition of his work appeared at the
Santa Barbara Museum, In the late 1950s von Wicht
spent a few summers at Grandview Farm, near
Pownal, Vermont, where he built a studio in an old
barn. He continued to experiment with freer paint-
ing techniques, applying paint simultaneously with
both hands and using pieces of wood gathered in
the forest. A large window in his studio helped to
provide the constant inspiration of nature.

In 1959 a traveling exhibition of von Wicht's lat-
est work was organized by the Galerie Internation-
ale d'Art Contemporaine in Paris. His growing
reputation in Europe prompted him to buy a cot-
tage in the village of Galilea on the island of
Majorca. In the early 1960s the artist spent his
summers on Majorca, and winters working in the
Alexander Studio at the MacDowell Colony. His
mature gestural style is exemplified by *The Four
Seasons*, a suite of large paintings done in
1963–64, now at Saint Lawrence University in
Canton, New York.[5] At the end of his life the artist
arranged for much of his work to go the Syracuse
University Art Collection. Von Wicht died of pneu-
monia in Brooklyn, on January 22, 1970.

In the mid-1950s, as von Wicht progressively
increased the scale of his paintings, he strove to
transfer the impact of this scale to his prints. Since

the expense and technical demands of large litho-
graphs were prohibitive, he developed his own
stencil technique. Working in his Brooklyn studio
and at the MacDowell Colony in New Hampshire,
he devised a pochoir technique using the materi-
als of the large oil paintings on simili Japan paper.
He began with a painting on cardboard, and then
cut out the primary elements of the composition.
When cutting the stencil, von Wicht simplified
forms and removed fine linear details; thus his
pochoir prints appear tighter and more angular
than his contemporaneous paintings and litho-
graphs. Using the sheet of cardboard as a stencil,
the artist applied oil-based ink to the dampened
paper with rollers. He chiefly used black ink for his
early pochoir prints, which measure about three to
four feet across. Von Wicht often printed several
layers of ink to create dark, opaque passages, on
which he sometimes drew in white chalk to create
areas of diaphanous gray. When he added colors
to these prints, he cut another stencil for each hue.
Von Wicht planned these compositions carefully,
so that each color lies directly on the paper.
Printing these pochoirs must have been a trying
and exhausting process; many of them exist in
unique proofs, and most others in very small edi-
tions. By 1963 the artist had reached such
refinement in his technique that he was able to
produce two prints, including *Icarus,* on nearly the
same scale as his paintings, in editions of ten
impressions.

Icarus is so impressive in its size, and in the
bold simplicity of its composition, that it elicits a
kinesthetic response in the viewer. Though the
design was created in a series of rapid brush-
strokes, the simplified cutting of the stencil pro-
duced an angular, geometric image, which never-
theless retains the sense of energized movement.
The title shows that this is actually a humorous
image. In Greek mythology, Icarus was the son of
Daedalus, the legendary Athenian inventor impris-
oned on the island of Crete. The resourceful crafts-
man built two pairs of wings from birds' feathers
and wax, to enable him and his son to fly away
from the island. Despite his admonitions, the
cocky Icarus carelessly flew too close to the sun,
where the heat melted his waxen wings, and he
plunged to his death in the ocean. Von Wicht's
image represents the moment when Icarus
splashes into the sea. His half-submerged figure is
reflected in the water above and beneath a blue
splash, as the sun blazes above.

"ICARUS"
Black and White, 2 Colors
Stencil, Ed. 10.

v. Wicht, 19-65.

CLEVE GRAY

1918–

84. Untitled, 1964

Lithograph on cream wove paper, 4/25
66.8 x 53.0 cm (image)
78.8 x 564 cm (sheet)
Inscribed: in graphite, below image:
 4/25 Gray — 64
Watermark: *ARCHES*
Worcester Art Museum, 1997.174

Cleve Gray brings intellect, spirit, and the power of conviction to his art. His paintings combine tenets of Western philosophy with Asian discipline and Abstract Expressionist immediacy. These qualities are also present in his prints.

Gray was born in New York City on September 22, 1918, the son of a successful banker and businessman.[1] At age eleven he began his studies of art with Antonia Nell, and three years later one of his still-life oil paintings was shown in the annual exhibition at the National Academy of Design. At that time he made his first experimental etchings. He continued his studies with Bartlett Hayes when he attended Phillips Academy in Andover, Massachusetts. From 1936 to 1940 Gray attended Princeton University, where he was a pupil of James C. Davis. He also studied the history of Asian art with George Rowley, for whom he wrote his thesis on Chinese landscape of the Yuan Dynasty.[2] In 1942 Gray enlisted in the Army, and served in Europe during World War II. In Paris from 1943 to 1946, he was able to study intermittently with André Lhote, and Jacques Villon whose Cubist style he admired. The first solo exhibition of Gray's work in New York, at the Jacques Seligmann Gallery in 1947, featured works that grew out of his wartime experiences.[3] In the early 1950s the artist settled in Connecticut, where he painted a series of visionary canvases in a Cubist style. In 1957 he married the essayist Francine du Plessix, stepdaughter of the artist Alexander Liberman. He began to exhibit his work at the Staempfli Gallery in 1960, and became a contributing editor of *Art in America* magazine. Later in the decade, Gray compiled sketchbooks, writings, and photographs by his friend the sculptor David Smith into a revealing monograph.[4]

The artist made his first lithographs at the Pratt Graphic Art Center in New York in 1961. The following year Gray renovated a haybarn on his Connecticut property as a studio, and its spacious interior prompted him to produce larger paintings, as gestural imagery began to replace Cubist form in his work. When he visited Greece in summer 1964, the artist contemplated the spiritual and psychological possibilities of abstraction. He conceived a symbolic vertical form, based on the female figure, a tree, and a classical column, and developed the design in his *Ceres* and *Hera* suites of paintings. Their imagery developed from his shift from oil paint to acrylic, inspired by the effects of transparent ink in his color lithographs, which were exhibited at the Betty Parsons Gallery.

In the late 1960s Gray became deeply concerned about American military involvement in Vietnam. As the war progressed, he and his wife became outspoken in their opposition to the war. In 1972 Gray was commissioned to do a series of monumental murals for the Neuberger Museum at the State University of New York in Purchase. He devoted much of the next two years to the *Threnody* series, fourteen paintings, each about twenty feet square. The artist concentrated his anguish over the Vietnam War on the theme of the ancient Greek song of lament for the dead. He painted swirling vertical forms on a truly heroic scale, spreading pigment in enormous gestures with the aid of a push broom. The *Threnody* paintings were unveiled in May 1974, a year after the American withdrawal from Vietnam. In summer 1977 a retrospective exhibition of Gray's work of a decade was mounted at the Albright-Knox Art Gallery.[5]

Gray works in series, over periods of years, pursuing one idea at a time before exploring a new idea or technical problem. A voracious reader, an insightful writer, and an intrepid world traveler, Gray expresses his ideas and experiences in his work. Among his disparate works are a series of sculptures inspired by the flow of lava from the Kilanea volcano in Hawaii,[6] or his *Roman Wall* series of paintings on paper and prints, that grew out of experiences in Rome during his long-term association with the American Academy. After experimenting with calligraphy drawn with a bamboo pen, Gray visited Japan and saw most of the Zen Gardens in Kyoto; afterward he executed his *Zen Gardens* series of paintings during the early 1980s. Inspired by a visit to the old Jewish cemetery in Prague, his *Holocaust* series deals with the tragic themes of destruction, death, and anguish, themes that pervade the artist's World War II drawings. These works were followed by Gray's *Resurrection* series of the late 1980s. Today the artist still lives in rural Connecticut, and he continues to paint and exhibit his work.

Gray's occasional printmaking activities mark the evolution of his style. In 1944 he made a Cubist etching in Paris, related to the work of Jacques Villon. It was not until 1961 that he returned to prints, when he explored lithography at the Pratt Graphic Art Center in New York. The artist transferred the imagery of his contemporaneous drawings, employing crayon and tusche in Futurist-inspired images that suggest the reflection of light, movement, and the passage of time. Gray experimented with color lithographs in 1962, combining collagelike overlapping forms with painterly gesture. The following year he created four color lithographs in Milan, based on completed paintings, which were published by the Galeria Gratacielo. Gray visited the Atelier Mourlot in Paris to make a print in 1968; later, when the Mourlot Workshop opened in New York, he worked there on a suite of color lithographs derived from his *Ceres* paintings. The artist employed the imagery of his *Roman Wall* series in three color aquatints, done in Rome in 1986, in collaboration with Walter Rossi at his AA Press.

The present print is one from a group of black ink lithographs, produced in collaboration with the printer Arnold Singer at Pratt in 1964. Gray became intrigued by how the tonal effects of lithography parallel Asian painting, where black ink produces translucent grays when applied in diluted washes to long-fibered mulberry-bark paper. The artist explored these dynamic similarities in lithographs that combine brushed calligraphy in concentrated tusche with vaporous gray wash. In this print Gray built an image in layers, working from soft tones to saturated black. He poured and brushed diluted tusche onto the stone, splashing ink into the pool to produce spots of diffusing black, and dredging water into the solvent-thinned wash, causing it to separate in random, organic patterns of *peau de crapaud*. After the ink dried, Gray returned to the stone to paint with tusche in full strength. He applied the delicate horizontal slash along the bottom and the heavy vertical bar and ellipse on the right, scrubbing the oval form to blur its edges physically.

In its active brushwork and organic texture, this print suggests change and formation. Like all Gray's black lithographs, it also embodies the Chinese principle of the duality of existence, a concept omnipresent in his work. The balance of dark and light, image and void, Yin and Yang, symbolize the mystical precept that the whole is comprised of two interdependent halves, meaningless in isolation but together achieving the harmony of the universe.

RICHARD STANKIEWICZ

1922–1983

85. Untitled, 1964

Drypoint and open bite on cream rayon-fiber
 paper, no. 23
85.6 x 37.2 cm (plate)
99.3 x 67.0 cm (sheet)
Inscribed: in graphite, within platemark, l.l.:
 #23/1964; l.ctr.: *R.Stankiewicz*
Worcester Art Museum, Richard A. Heald Fund,
 1994.284

The sculptor best known for his assemblages of
rusty junk, Richard Stankiewicz also experimented
with printmaking, in works that sometimes relate
to carving and modeling processes.

The artist was born in Philadelphia on October
18, 1922.[1] After his father was killed, when
Stankiewicz was six years old, the family moved to
Detroit. He grew up beside a field used as an
industrial dump, where broken machine parts,
scrap metal, and casting-pit sand provided toys for
Stankiewicz and his boyhood friends.[2] At Cass
Technical High School he studied art and music, as
well as mechanical engineering. In 1941 he was
drafted into the Navy, and sent to Seattle for train-
ing as a radio operator. When he was posted to the
Aleutian Islands, Stankiewicz used caribou horn
and other natural materials for carvings inspired
by Inuit art.

After his discharge in 1948, Stankiewicz
enrolled as a GI Bill student at the Hans Hofmann
School of Art in New York. He went to Paris in 1950,
where he briefly studied painting at the Atelier
Fernand Léger, and then became a pupil of Ossip
Zadkine, who convinced him to shift his attention
to sculpture. At first Stankiewicz modeled small
abstract sculptures from terracotta, progressively
refining their proportions until he reached the
material's limitations. Then, to achieve a similar
claylike surface, he worked with wire covered in
plaster. When Stankiewicz returned to New York in
1951, he took a job as a mechanical and patent
draftsman, and in years following he worked as an
industrial designer. In his spare time he faithfully
pursued his art, creating sculptures from metal
wire and plaster, ornamented with shredded rope,
buttons, or tubing. In summer 1951, while digging
a garden in the yard of his house, Stankiewicz
unearthed several rusty metal scraps. He was
struck by the beauty of their corroded patina and
fascinated by their forms now divorced from func-
tion. Soon he began to combine these objects in
sculptural constructions, and he taught himself to

weld by making a worktable from pipe and metal
sheeting.

Though Pablo Picasso and David Smith had pre-
viously made sculpture from found metal scraps,
Stankiewicz made it his focus and explored its lim-
its. His first assemblages were abstract, but he soon
began to mimic natural forms, producing junk
plants, animals, and human figures with distinct
personalities. The artist frequented metal shops
and junk yards to scavenge for old car parts, refrig-
erators, and boilers, which provided favorite dimen-
sional forms. He cut apart pieces of junk, shaped
them with an oxyacetylene torch, and welded the
components together. He also patinated the sur-
faces with the torch and by controlled oxidation.

In 1952 Stankiewicz was one of the founding
members of the cooperative Hansa Gallery in New
York.[3] His biomorphic plaster-coated wire pieces
comprised his first solo exhibition there in Decem-
ber 1952.[4] His junk sculptures caused a sensation
when they were first shown in his solo exhibition
at the Hansa Gallery in 1953.[5] Like Abstract Expres-
sionist painting, Stankiewicz's style grew from
Surrealist fantasy and biomorphism. In the mid-
1950s he occasionally wrote criticism and com-
mentary for *Arts* magazine.[6] In 1958 his sculpture
was exhibited at the Venice Biennale, and in the
exhibition *Sculpture U.S.A.* at the Museum of
Modern Art. From 1959 to 1965 the artist exhibited
his work at the Stable Gallery.

During the 1960s Stankiewicz's work became
lighter and more lyrical. A major exhibition of his
work was mounted at the Jewish Museum in New
York in 1964. After temporary residencies at the
University of Southern Florida and Tampa Art
Institute, the artist joined the faculty of the State
University of New York in Albany in 1967. As scrap
metal became a common material in sculpture,
Stankiewicz abandoned the form. During a two-
month stay in Sydney, Australia, in 1969, he worked
at Transfield Foundry using standard industrial
forms, like steel cylinders, I- and T-beams, and
sheet metal. With these newly manufactured steel
components he created a series of fifteen sculp-
tures that are quite different from his earlier con-
structions. As he worked in new steel his style
evolved toward abstract compositions of interlock-
ing circles and squares. In 1977 Stankiewicz trav-
eled to Paris, where his work was included in the
inaugural exhibition at the Musée National d'Art
Moderne, Georges Pompidou Centre. Two years
later a retrospective exhibition of his work was
organized at the State University of New York in

Albany.[7] Stankiewicz died at his home in Worthing-
ton in 1983.[8]

Little is known about Stankiewicz's remarkable
prints. Some are virtually printed sculpture, works
that the artist had never shared, found in his stu-
dio after his death. For a brief period in the mid-
1960s he experimented with works on paper. He
made drawings in charcoal and ink wash on large
sheets of Japanese paper. The artist transferred
related imagery to a group of small intaglios, com-
bining etching and aquatint, that he printed him-
self in the art department of the University of New
York at Albany.

The present print is one of two large, experi-
mental intaglios that Stankiewicz made with black-
smith's tools instead of the jeweler's implements
common to printing. He began with a large steel
plate, and used a torch to remove its corners and
cut rough slots in its lower quadrant. At the top he
pierced the metal with a circular hole, folding over
the removed metal flap like the semidetached lid
of a tin can. Stankiewicz used files to roughen the
edges of his cuts leaving tiny parallel hatching. To
create tone on the metal, he opened its surface
chemically, perhaps employing caustic solutions
used for patinating steel sculpture, approximating
the printmaking technique of open-bite etching.
He used brushes to paint the acid in a broad swath
across the top of the plate and in descending rivu-
lets that suggest the action of gravity and resem-
ble flowing water. By reapplying the mordant in the
same area, he created darker passages of printed
tone. When Stankiewicz inked the printing surface
as a conventional intaglio plate, the open bite held
the ink to print delicate tones, and the rough,
burry edges of the cuts in the plate made by torch
or file printed as drypoint. It seems, however, that
it was difficult to print this plate, for the folded
metal doubled the depth of the printing matrix,
causing the paper to tear in the pressure of the
printing press. Stankiewicz solved this dilemma by
printing on an unusually thick, resilient paper,
made from rayon fibers. This industrial material —
which the artist acquired in a roll — was perhaps
intended for filtering chemical or gases. Like
Stankiewicz's junk sculpture, the printed image is
at once brutal and delicate, repellent and haunt-
ingly lyrical. This is an object of industry, harsh,
random, and unyielding. It looks like a discarded
slab of iron, deformed by time, stained and cor-
roded by weather and rain. Indeed, its apparent
corrosion seems to signal the return of its con-
stituent elements to the soil.

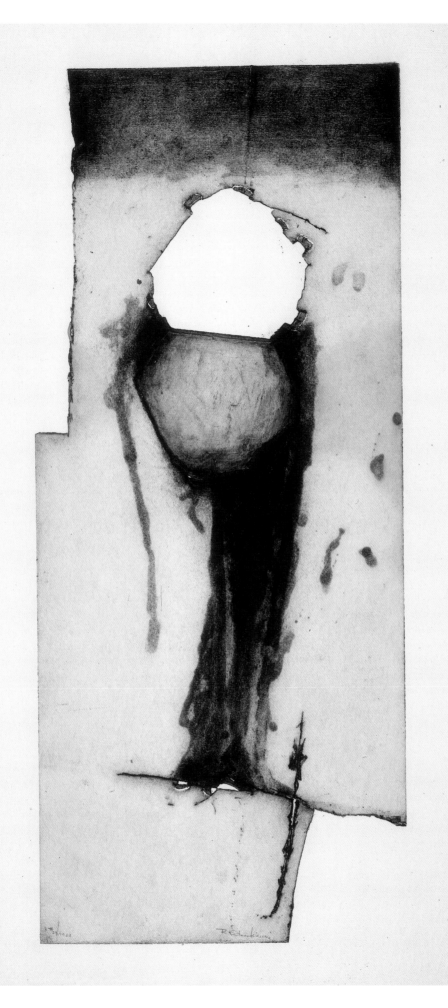

WALASSE TING

1929–

86. Black Orpheus, plate 6 from the suite
Hollywood Honeymoon, 1964

Lithograph on cream wove paper, 14/20
71.0 x 96.3 cm (sheet)
Inscribed: in graphite, l.r.: *14/20 Ting 64*; in
graphite, on verso, l.c.: *1158*
Embossed: l.c.: Tamarind chop; CS (Clifford Smith)
References: Tamarind 1158; Devon 2000, pp.25–27.
Worcester Art Museum, 1996.122

In the early 1960s Walasse Ting provided a bridge
between *Art Informel* in Paris and Abstract Expres-
sionism in New York. His style combined the lyrical
elegance of Chinese calligraphy with the muscular
force of *tachisme*. Ting is also a poet, who writes
prolifically in several languages, and during that
period he often incorporated his original verse in
paintings and prints.

Ding Xiong Quan was born on October 12,
1929, in Shanghai, China.[1] When he was a boy, he
taught himself the traditional Chinese method of
ink painting, and he went on to study both calligra-
phy and poetry at the Shanghai Art Academy. In
1949 Ting moved to Hong Kong, where his first solo
exhibition was mounted three years later. Sales of
his work to local collectors enabled the artist to
travel and to establish contacts outside Asia.
Following a brief stay in Japan, he went to Paris in
1953, where he began using the name Walasse
Ting. He met the Belgian painter Pierre Alechinsky,
who was interested to learn about Chinese paint-
ing, and in turn introduced him to the concepts
and practice of *Art Informel*. Working with oil paint
for the first time, the artist developed a style that
melded gestural swirls and painterly scumbles
with childlike images of mythic and symbolic ani-
mals. These paintings reflect the influence of Jean
Dubuffet as well as Alechinsky. Ting's first solo
exhibition in Paris was mounted at Galerie Paul
Fachetti in 1954. The artist became friends with
Karel Appel and Asger Jorn, original members of
the CoBRA group, who helped to instill in him a
love of intense color.

Ting also befriended American artists in Paris,
particularly Sam Francis, who helped arrange for
him to exhibit his work at the Chalette Gallery in
New York in spring 1957.[2] The artist first visited the
United States two years later, when a solo show of
his paintings was mounted at the Martha Jackson
Gallery in New York. He worked in creative bursts
and later destroyed many works that he judged
unsuccessful. On his next visit to New York Ting
had no studio in which to paint, but he expressed
his experiences and ideas in verse. "I wrote 61

poems in 1961 in a small black room like coffin,
inside room only salami, whisky, sexy photographs
from Times Square. No Bible, no cookbook, no
telephone book, no checkbook. Two short fingers
typing about World & Garbage, You & I, Egg &
Earth."[3] Written in purposely broken English, his
free verse combines traditional lyrics about natural
beauty with similar aesthetic observations of mod-
ern life in the twentieth-century megalopolis. It
may have been Ting's exposure to the portfolio *21
Etchings and Poems* that prompted the idea for a
lithographic album combining his own poetry with
images by a group of his artist friends. After
returning to Paris, he enlisted Sam Francis to fund
the project, and the dealer Eli Kornfeld to publish
the book in Bern. Both Ting and Francis elicted
work from artists on both sides of the Atlantic.
They delivered zinc lithography plates to their
friends, and welcomed some Americans to Paris to
supervise press runs. The result was *1¢ LIFE*,
published in 1964, a remarkable production that
reflects the transition between the styles of
Abstract Expressionism and Pop Art.[4]

In 1963 Ting began to exhibit his work at the
Lefebre Gallery in New York, in three consecutive
shows of simultaneous works in quite different
styles. The first comprised scroll paintings in tradi-
tional Chinese media, drawing on various art his-
torical styles and subjects, updated and emotion-
alized; the second exhibition featured colorful
abstract splash paintings for which the artist was
best known; the third exhibition featured figural
paintings, chiefly female nudes, executed in thick,
painterly, CoBRA colors.[5] He settled in New York,
and maintained his breakneck creative pace
throughout the decade, painting in a range of
styles and techniques, writing and publishing his
poetry, often in deluxe editions that include origi-
nal prints.[6] The artist made prints at Irwin
Hollander's Workshop in New York, and also at
Sam Francis's Litho Shop in Santa Monica. In 1970
he received a Guggenheim Fellowship, and two
years later he became a naturalized American citi-
zen. While his earlier work generally consisted of
calligraphic forms on unmarked fields, during the
1970s, the artist superimposed many layers of
paint in bright, fluorescent hues, completely oblit-
erating the ground. Today the artist divides his
time between Amsterdam and New York City.

Black Orpheus was among Ting's first litho-
graphs made in the United States, produced at the
Tamarind Lithography Workshop in fall 1964. The
previous spring, when arranging for his visit to Los
Angeles, Ting wrote an excited letter from Paris to
Tamarind director June Wayne, describing the pro-

duction of *1¢ LIFE*: "Day and night I work in lithog-
raphy place; I think litho; I talk litho; even in my
dream."[7] He wanted to make big prints, and he
inquired about the scale of the Tamarind presses.
In Los Angeles during September and October of
1964, Ting produced two suites of large litho-
graphs, *Fortune Kookie* and *Hollywood Honey-
moon*. He painted with abandon onto the stones
and plates, using broad, heavily charged brushes
and rags, scrawled wide calligraphic lines with lith-
ographic crayons laid on their side. This imagery is
parallel to his contemporaneous paintings, in
vivid, unusual shades of prink, green, and yellow.
Chinese symbols and ideograms transform into
star- or gun-shapes in these prints, reflecting the
artist's contemplation of the Asian immigrant to
the West. Ting confronted the lithography stone as
he did the canvas, working in momentary bursts of
energy, spontaneously drawing several lithographs
in quick succession. Later, on reflection during
proofing, he culled the unsuccessful images and
sometimes did not edition the prints.[8]

Black Orpheus is one of Ting's Tamarind prints
in which poetry is well integrated with the image.
The verse expresses the delight of the artist's first
visit to Los Angeles, the center of modern Ameri-
can mythology. Ting was fascinated with the
cinema, its history, business, and potent cultural
impact, and this interest is reflected in the imagery
and poetry of the *Hollywood Honeymoon* series.
In this image a dark star spins, as its whirling arms
spew centrifugal spatters. In his own hand Ting
inscribed a poem that contrasts the power of the
star with the observer's futile impulse to contem-
plate it:

> *Moon naked white*
> *Star sweet diamond*
> *Earth spin too hot*
> *No time sit down drink glass beer with me*

Ting's dark star is not an astronomical body, but a
movie actor, a symbol of the mythological power of
cinema. *Black Orpheus* was inspired by the film
starring Paul Robeson, filmed by Marcel Camu in
Brazil in 1939. By citing the film, Ting expresses
how in the twentieth century, throughout the
world, the cultural and human relationships that
traditionally instill values have been replaced by
this new mythologizing medium. Now, actors of
different races and cultures, whom the film goer
will never meet and whose roles mask their own
personalities, assume the traditional roles of
family, teachers, and clergy.

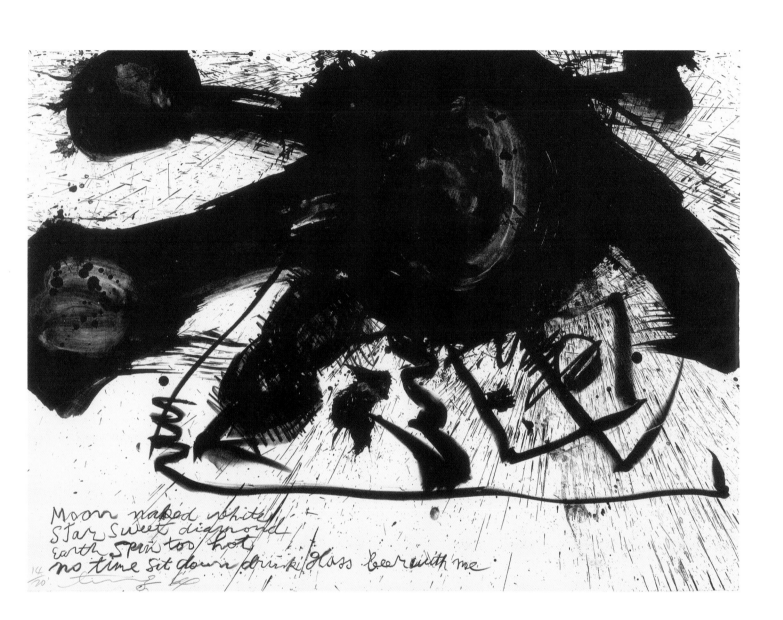

Moon naked white
Star sweet diamond
Earth spin too hot
no time sit down drink glass beer with me

14/20

HUGO WEBER

1914–1971

87. Untitled, 1964

Lithograph on cream wove paper, 20/20
55.9 x 76.2 cm (image)
55.9 x 76.2 cm (sheet)
Inscribed: in graphite, in image, l.l.: *20/20*;
 l.r.: *Hugo Weber, LA, 64*
Watermark: *Arches*
Embossed: l.l.: *Tamarind*; l.r.: *AK* (Aris Koutroulis)
References: Tamarind 1021.
Worcester Art Museum, Austin S. Garver Fund,
 1997.114

In Chicago, the cosmopolitan Hugo Weber combined a wide variety of influences in developing a personal Abstract Expressionist style. He was prolific and remarkably versatile, working as a printmaker, aside from his activities as a sculptor, painter, photographer, filmmaker, and teacher.

Weber was born on May 18, 1914, in Basel, Switzerland, where his mother's family had worked as pewtersmiths for generations.[1] His parents and teachers encouraged his childhood proclivity for drawing. In 1937 he worked in the studio of the Basel sculptor Ernst Suter, while taking evening classes at the Basel Gewerbeschule. Two years later he spent a month in Paris, where he studied with Marcel Gimond at the Académie Colarossi, and met Alberto Giacometti. Over the next few years Weber made contact with several Parisian sculptors, including Aristide Maillol, Constantin Brancusi, and his contemporary, Marino Marini. After serving in the Swiss military from 1939 to 1942, he enrolled at the University of Basel, to study art history, archaeology, and philosophy. At that time he and Marini worked side by side on etchings printed on Weber's own press. At the end of the war, Weber became a student and personal assistant to the sculptor Hans Arp in Basel.

In 1946, László Moholy-Nagy invited Weber to Chicago, to teach at the Illinois Institute of Design (ID). He taught a variety of subjects, including foundation courses in design and art history. He began a lifelong friendship with the architect Mies van der Rohe. In 1948 Weber wrote the catalogue introduction for the first *Exhibition Momentum*, a juried show begun by young artists when the Art Institute of Chicago excluded student work from its annual exhibition. At that time Weber created Dada sculpture in wire, plaster, and synthetic materials. When the artist vacationed in the West in summer 1948, he became fascinated with Native American culture, and made a series of drawings based on the dances of the Hopis. In Chicago, Weber shared experiments in film and abstract photography with his friend and fellow teacher Harry Callahan. He also began a close friendship with his colleague Emerson Woelffer, frequenting that artist's Pearson Street studio to exchange ideas, work, and listen to Dixieland jazz. The influence of jazz improvisation imbued Weber's work with new spontaneity.

When Weber visited New York in 1949, the photographer Aaron Siskind — whom he knew through Callahan — introduced him to Willem de Kooning, Jackson Pollock, and Franz Kline. Weber's first solo exhibition in Chicago was mounted at the 750 Studio in 1950. At that time he created his *Energetic Figures* series of calligraphic paintings that represent the human body in dancelike motion. In 1951 Pollock visited Weber's studio, when both artists were on the jury of *Exhibition Momentum*. At that time Siskind came to teach at ID, but Woelffer had moved to Colorado Springs, where he helped to mount Weber's landmark exhibition *Vision in Flux*.[2] This innovative installation comprised twenty-three canvases and eleven panels, in a distinctive style of improvisational gesture. Many were painted on both sides, and suspended in the gallery between floor and ceiling, some well over the viewer's head. In the middle of the room stood the focal work, a three-panel standing screen painted on both sides. They featured thin, straight slivers of color in drifting bundles, combined with broad swaths of rollered pigment. Their dynamic compositions quickly directed the viewer's eye to adjacent works, crisscrossing the exhibition with fields of motion and energy.

In 1953 a solo exhibition of Weber's work appeared at the Alan Frumkin Gallery in Chicago, and his first solo exhibition in New York appeared at the Betty Parsons Gallery the following March.[3] The artist married, began a family, and became an American citizen. By 1955, however, he was exhausted by teaching and discouraged by school politics, and he returned to Europe in search of creative regeneration. Weber lived in Paris from 1955 to 1960, spending his summers at Cadaqués on the Costa Brava in Spain. His work became freer at that time, as he combined superimposed layered color passages with impulsive stylography in graphite, pastel, and brushwork. This manner reflected the influence of Japanese calligraphy, as well as the painting of Mark Tobey, Wols, and Hans Hartung.

In 1960 Weber moved to New York, where he continued to work in a style of gestural abstraction. The following summer he taught at the ID, but concentrated his creative energies on the commission to portray Mies van der Rohe in drawings, paintings, and sculpture.[4] He created a series of portrait heads, including the bust of Abraham Lincoln commissioned by the Container Corporation. In the mid-1960s Weber developed a close friendship with the author Jack Kerouac, whom he had known since 1951. They often drank together at the artist's studio, and collaborated on poems and paintings. Although the artist remained productive and versatile during this period, he suffered from liver disease caused by chronic alcoholism. Weber died in St. Vincent's Hospital in New York on August 16, 1971.

The present print is one that Weber made in early 1964, when he was an artist fellow at the Tamarind Lithography Workshop in Los Angeles.[5] The nineteen editions of lithographs from that campaign represent the apogee of his work as a printmaker. Weber's fellowship coincided with those of his old friend, Emerson Woelffer, and the gestural painter Dick Wray, and it was a cheerful, productive interlude. In their style and technique, the artist's lithographs are parallel to his contemporaneous paintings and drawings, in which broadly brushed fields of color are superimposed with progressively finer calligraphy. Several of the images employ Japanese-style brushwork, others combine washes of tusche with crayon scribbles and ciphers. Weber thoughtfully explored the capabilities of lithography, working on stone and zinc plates with a variety of tusches and crayons, experimenting with tone and color. Intrigued by the medium's capability for amending images, he often reworked one component stone or plate for another, unrelated image.

This lithograph was made in collaboration with Aris Koutroulis on February 24–28, and printed from two zinc plates. Having drawn the first plate nearly three weeks before for his second Tamarind edition, *Black Punch*, Weber reworked the image slightly, and printed it in orange as a framing element. On a second plate he used a fine brush with liquid tusche, and a variety of lithographic crayons, to create the central linear calligraphy. He drew a variety of quick circles with the brush, which often appear to move, trailing wiggling tails. With the point and sides of the crayons, Weber drew spontaneously, twisting the stick for tailing lines and sometimes causing it to stutter across the printing surface. In the center of the image he drew a large spiral, with a conical cap and radiating limbs that transform the motif into an ideograph. With more impulsive slashes the artist made the form appear to spin and dance.

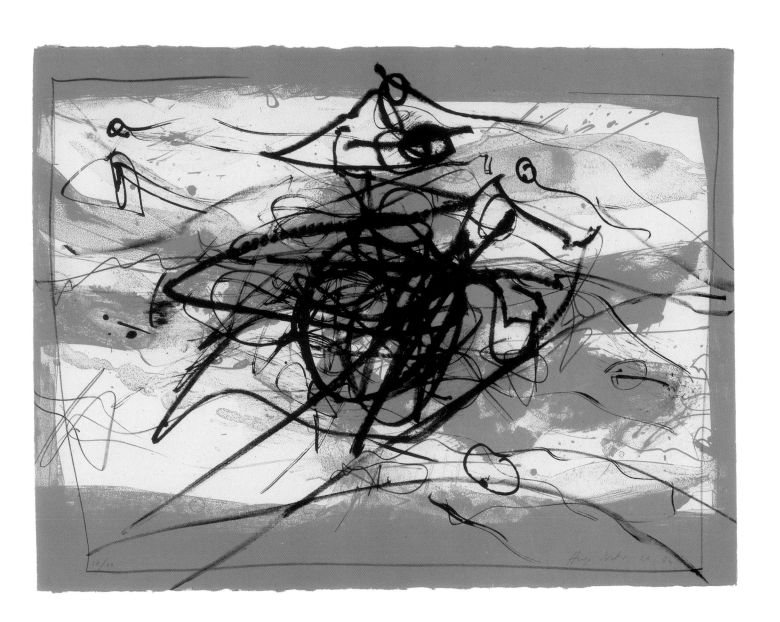

WILLIAM MAJORS

1930–1982

88. Genesis II, 1965

Collagraph on cream wove paper, 4/4
40.2 x 45.2 cm (plate)
52.8 x 49.8 cm (sheet)
Inscribed: in graphite, below platemark: *Estate
 Proof '85 4/4 Genesis II/ 1965 Majors Estate*;
 in graphite, on verso, l.r.: *65GII/ SSM*
Watermark: l.l.: *Z* in a circle
Embossed: *M* in a circle
References: Panzera/Stedman-Majors 1993;
 Taylor/Warkel 1996, pp.105–06, 157.
Worcester Art Museum, Richard A. Heald Fund,
 1999.73

William Majors found enduring inspiration in the Christian mysteries. Like his Abstract Expressionist predecessors, he believed that the sources of creativity lie deep within the individual, and that understanding of self is the key to an artist's development.

Majors was born on July 21, 1930, in Indianapolis.[1] His father died when he was an infant, and his mother worked as a housekeeper to support him and his sister. A devout member of the Shiloh Baptist Church, his mother was a soloist in the Wings Over Jordan Choir. Theirs was a close-knit family, strengthened by the church and a deep sense of community. Majors was stricken with spinal tuberculosis in 1946, and during his young adulthood he was hospitalized at the Sunnyside Sanatorium in Marion County. Helen Mowrey, a social services worker and art teacher at the hospital, instructed Majors and nurtured his talent. The medical staff also encouraged the youth by engaging him to execute anatomy and pathology drawings.[2]

After leaving Sunnyside at the age of twenty-three, Majors won a scholarship to the John Herron School of Art in Indianapolis, where he studied with Garo Antreasian and Joe Messing. Abstract Expressionism was the style of the day, and he gradually adopted its imagery and method. Rather than working from the unconscious, he based his work on nature, picking out salient forms he observed and developing compositions from them. From 1956 to 1958 he attended the Cleveland School of Art, then he returned to Herron to complete his BFA in 1960. A Whitney Foundation Fellowship and Wolcott Travel Award enabled Majors to travel to Italy in 1960 to study the works of the old masters. Majors found a combination of spirituality and human accessibility in Italian sacred art, and he resolved to bring these qualities to abstraction. In 1962 Majors moved to New York, where he

soon became a security guard at the Museum of Modern Art, a job that enabled him to study the collections and meet many artists. He studied printmaking with John Ross at the New School for Social Research, and soon concentrated much of his attention on works of graphic art. Majors took grounded etching plates to the museum to draw on them between shifts or on night duty, in proximity to the art in the galleries that inspired him. Soon he began to teach painting and printmaking at the museum's Institute of Modern Art. In 1963 the artist Richard Mayhew introduced Majors to the newly formed Spiral Group, where he met Norman Lewis and other established African-American artists.[3] He became devoted to Spiral's weekly sessions, and after the group gave up its headquarters, these informal gatherings were held at Majors's studio on Seventh Avenue.

In 1964 Majors worked at the Pratt Graphic Art Center in New York, where he printed editions for such artists as Salvador Dalí, and produced his own intaglios. The following year the Junior Council of the Museum of Modern Art commissioned the artist to create the suite of intaglios *Etchings from Ecclesiastes*. Inspired by Old Testament scripture, the series consists of subtle abstractions that evoke the forms and powers of nature. The prints were designed to be viewed close-up, and Majors intended that viewing and studying the prints provide a quiet revelatory experience.[4] In the late 1960s Majors devoted much of his time to teaching, at the Orange County Community College in Middletown, New York, the New School for Social Research, and the Northern New Jersey Art Center in Tenafly. Majors's paintings of that period combine the influence of calligraphic gesture with hard-edge imagery. He incorporated influences from African art, Chinese and Japanese calligraphy, as well as the work of the mime Etienne Decroux. Majors avoided the art market, and never sought gallery representation. However, he received several prestigious awards in the late 1960s, including grants from the Ingram Merrill Foundation and the Tiffany Foundation. Majors's paintings were featured in the exhibition *Thirty Contemporary Black Artists* at the Minneapolis Institute of Arts in 1968.[5]

In 1969 Majors married Susan Stedman, whom he had met at the Museum of Modern Art. In 1971 he joined the faculty of the University of New Hampshire in Durham, and he began teaching at the Rhode Island School of Design in 1974, the year a Guggenheim Fellowship enabled him to purchase a new etching press and to travel to Europe. In summer 1975 he was in Albuquerque, at work on two color lithographs at the Tamarind Institute.[6]

Majors was visiting artist at the University of Iowa in 1976, and he taught at the University of Connecticut from 1979 to 1981. Majors died in Portsmouth, New Hampshire on August 29, 1982.

Perhaps Majors's best-known print, *Genesis II* was printed in just one or two proofs during his lifetime; the present impression is from a small edition printed in 1985 by Robert Beauvais. Majors derived the composition of *Genesis II* from his sketches of tree branches against the sky, studies that concentrated on the interplay of positive and negative space.[7] The imagery evokes the Garden of Eden as described in chapter two of the book of Genesis: "out of the ground the Lord God made to grow every tree that is pleasant to the sight, and good for food; the tree of life also in the midst of the garden, and the tree of knowledge of good and evil" (Genesis 2:9). The white lines also have a liquid quality that creates a sense of flow and movement, knitted together in a cellular fabric or a circulatory system, coursing with vital fluids. This flowing imagery also evokes the river running through the garden, described in Genesis (2:10).

In the early 1960s John Ross introduced Majors to the technique of collagraphy, which involved building up a relief printing surface but inking and wiping it like an intaglio plate.[8] The artist began by plotting his design with liquid etching ground, drizzling it onto the copper plate. He worked without a preconceived plan, responding to the materials and his organically growing composition. He superimposed layers of imagery, using progressively thicker media, each with its own unctuous character. At one stage, when the glue was still wet, Majors dusted fine grit on top — probably Carborundum, or silicon carbide — which dried into an abrasive surface. When inked and printed, these textured areas created passages very much like aquatint in an intaglio plate. Majors continued to build up the printing surface further with Duco cement, superimposing complex networks of angled lines. He varied their width by squeezing the dispensing tube quickly and lifting it to elongate and thin the strand of glue, and by trimming the nozzle on the end of the tube to increase the flow of cement and the width of the lines in his print. Little air bubbles, formed when the liquid glue was forced from its tube, dried into tiny pockmarks, which later held ink and created wonderful organic details to the lines. Majors carefully inked this complex surface, assuring that the pigment worked well into the textured areas, and wiping the surface of the glue lines so that they would print chiefly as white, outlined by the ink that gathered around their edges.

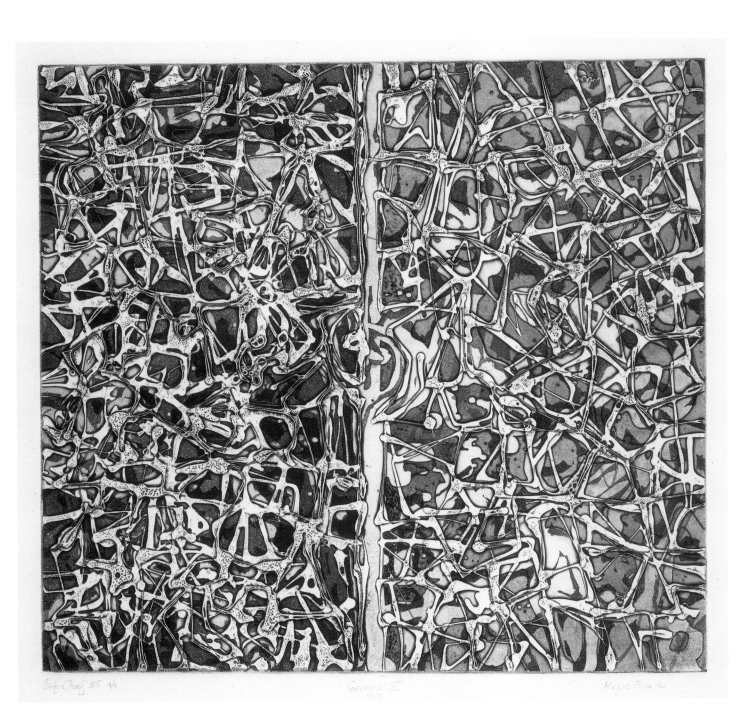

JACK TWORKOV

1900–1982

89. Barrier L#1, 1965

Lithograph on cream wove paper, 13/50
34.6 x 32.6 cm (image)
56.5 x 46.0 cm (sheet)
Inscribed: in graphite, below image: *13/50 Barrier
 L#1 Tworkov '65*; in graphite, on verso, l.l.: *118*
Watermark: *Arches*
Embossed: l.r.: *IH* in a rectangle (Irwin Hollander)
Worcester Art Museum, 1998.225

In his youth, the gentle Jack Tworkov aspired to be a poet. His character combined this sensibility with a fierce, questioning intellectuality. Both are embodied in his work, and together they made him an articulate writer and an outstanding teacher.

Jacob Tworkovsky was born on August 15, 1900, at Biala in eastern Poland.[1] When he was thirteen years old he emigrated with his family to New York. His mechanical drawing teacher at Stuyvesant High School recognized his talent as a draftsman, and persuaded him to join an after-school sketch class. In 1920 Tworkov enrolled at Columbia College as an English major, but soon switched to art. Three years later he attended the National Academy of Design, where he studied with Ivan Olinsky and Charles W. Hawthorne. Tworkov followed Hawthorne to Provincetown, Massachusetts in the summer, where he met Ross Moffett, and became his student in 1924–25. When was a pupil of Guy Pène du Bois and Boardman Robinson at the Art Students League from 1925 to 1928, he became devoted to the work of Paul Cézanne.

In 1929 Tworkov moved to Provincetown, where he painted figural images, landscapes, and still lifes. He exhibited his work in group shows at the Pennsylvania Academy of the Fine Arts, the Dudensing Gallery, and with the Société Anonyme in New York. From 1931 to 1934 Tworkov taught at the Fieldston School of Ethical Culture in the Bronx. He joined the Public Works of Art Project in 1934, where he met Willem de Kooning and began a life-long friendship. He was also a member of the easel painting division of the FAP/WPA from 1937 to 1941. Tworkov's first solo exhibition, at the ACA Gallery in New York in 1940, featured still-life and landscape paintings. However, he turned away from painting during World War II, and worked as a tool designer at Eastern Engineering in Manhattan. When Tworkov returned to his art in 1945 he found little interest in his work from dealers, prompting him to reassess his style. Still lifes and figural

paintings comprised his solo exhibition at the Egan Gallery in 1947, but Charles Egan had seen the artist's automatist drawings, and encouraged him to expand on those experiments.

Tworkov taught part-time at Queens College, and in the summer he also taught at the American University in Washington, D.C., from 1948 to 1951. As he explored gestural abstraction in the late 1940s and early 1950s, he actively exchanged ideas with other artists. He was a founding member of The Club in 1949, and his studio was next to de Kooning's, so the artists conversed daily. Tworkov developed a vocabulary of fragmented organic forms, disposed evenly across the picture plane, which evolved into a gestural grid in his *House of the Sun* paintings, begun in 1952. In that year a solo exhibition of the artist's paintings appeared at the Baltimore Museum of Art, which purchased *Green Landscape*. He taught at the Black Mountain College Summer Institute in 1952, the first of many temporary positions, including residencies at Indiana University, the Pratt Institute, and the University of Illinois at Urbana. At that time he showed at the Stable Gallery in New York.

In 1958 Tworkov established a permanent studio in Provincetown, and began working there annually from May to November. At that time he preferred a somber palette, and began to deemphasize gesture, searching for contemplative effects instead of drama. "The essence of our new art is that instead of being a representation of an experience the painting is an experience itself," the artist wrote in his journal in early 1959. ". . . Only if there are no objects to be seen, more of the painting is seen."[2] In the early 1960s Tworkov exhibited his work at the Leo Castelli Gallery. He was a visiting artist at Yale University in spring 1961; two years later he joined the faculty as William C. Leffingwell Professor of Painting and was awarded a master of fine arts degree. A major traveling retrospective exhibition of the artist's work was organized by the Whitney Museum of American Art in 1964.[3]

In about 1966 Tworkov consciously abandoned gestural painting in favor of a more intellectual framework, and he became a pioneer of Minimalism. Studying elementary geometry, he did drawings based on repeatable formulae, plotting measured grids that he filled in with small spontaneous brushstrokes. Tworkov retired from teaching at Yale in 1969, and he was named professor emeritus. The works he produced with the support of a Guggenheim Fellowship in 1970 were exhibited in

solo shows the following year at the Whitney Museum of American Art and at French & Company in New York. In 1971 and 1972 Tworkov was awarded honorary doctoral degrees from the Maryland Institute of Art and Columbia University. He was artist-in-residence at the American Academy in Rome in 1972. He continued to teach, exhibit, and paint vigorously until his death in Provincetown on September 4, 1982. A memorial retrospective exhibition was mounted at the Guggenheim Museum in New York.[4]

The present print is one of a pair of lithographs made at the Hollander Graphic Arts Workshop in New York in 1965. Its imagery derives from a similarly titled, contemporaneous series of paintings and drawings. The prints are closely similar to Tworkov's charcoal drawings, in which the artist used simple means to provoke the contemplation of space, motion, and time. In this design a horizontal linear element opposes a series of verticals, placed at slight diagonals to create a sense of imbalanced motion. Layered systems of parallel hatching impart an illusion of depth to the image. Across the upper half a thicket of active diagonal hatching seems to push the verticals against the barrier, which seems quite solid in its strict horizontality.

Tworkov delighted in the rich black strokes of the lithographic crayon on the stone's grainy surface. To create dark, thick lines he scribbled repeatedly over a passage. He also rubbed and scraped the stone in areas where the wax built up on the printing surface, creating a visual sense of its gummy substance. As in all of Tworkov's work, the object itself and its creation are the primary subjects. The viewer is prompted to consider the physical quality of the materials, the movement of the artist's hand, the time it took to delineate the image, and even the artist's mood. This record of his activity also expresses energy, and that linear energy becomes mass. This image anticipates Tworkov's development of Minimalist imagery. He also likened line to a voice, or sound. In the works following his *Barrier* series, he established more rigid, more apparent geometric frameworks, and then spontaneously overlayered parallel systems of lines or brushstrokes. By combining a logical overall structure, and the rhythmic, energized pulse, he aimed for images analogous to music. During the 1970s he translated these ideas to the lithographs he made at the Tamarind Institute.[5]

13/50 Barrier L #1 Tworkov '65

PAUL JENKINS

1923–

90. Untitled, 1965

Lithograph on cream wove paper, 63/95
66.0 x 47.1 cm (image)
75.6 x 53.8 cm (sheet)
Inscribed: in graphite, below image:
 63/95 Paul Jenkins 1965
Watermark: *BFK RIVES*
Worcester Art Museum, 1996.123

The distinctive images of Paul Jenkins evoke a natural world of color and motion, subject to chance and the laws of physics and somehow, it seems, beyond human volition. The painter has long made prints, bringing his intuition and his concerns for the behavior of materials to lithography.

Jenkins was born on July 12, 1923, in Kansas City, Missouri, where his father was a real-estate executive and his mother a newspaper publisher.[1] As a teenager he attended summer classes at the Kansas City Art Institute and was an apprentice in James Weldon's ceramic studio. However, his interests in drama and literature rivaled his art activities. In 1943 he began working at the Youngstown Playhouse, and after high school he acted at the Cleveland Playhouse. During World War II Jenkins served in the Naval Air Corps as a pharmacist's mate. After his discharge in 1945, he studied playwriting and painted on his own.

In 1948 Jenkins moved to New York to enroll at the Art Students League, where he studied painting with Yasuo Kuniyoshi and Morris Kantor. He made his first lithographs in printmaking classes taught by Will Barnet. Jenkins went to Europe in 1953 and settled in Paris. There he befriended other American artists such as Claire Falkenstein and Mark Tobey. The gallery owner Paul Facchetti introduced him to the critic Michel Tapié, whose writings and notion of *Art Informel* were already familiar to the artist.[2] By that time Jenkins was pouring paint onto canvas in jewel-like colors inspired by the hues of stained-glass windows. He combined powdered pigments and Chryschrome enamel to achieve liquid effects, perhaps suggested by his early work with ceramic glazes. Jenkins developed his own method of flooding primed canvas with thin oil or acrylic paint. He pulled the fabric back on itself to move pigment on its surface, creating tapering and flaring channels of color. Wishing to avoid evidence of handwork, he used ivory knives to direct the flow of paint, often drawing out elegant tapering lines. These paintings rely on controlled chance to create expressive images that evoke change and growth.[3] They were featured in the artist's first solo exhibition, mounted in 1954 at the Studio Paul Facchetti in Paris.

The Whitney Museum of American Art purchased a painting from Jenkins's first solo exhibition in New York, at the Martha Jackson Gallery in 1956. At that time he swapped studios with his friend Joan Mitchell and worked in New York while she lived in Paris. After returning to Paris in 1960, Jenkins worked also in watercolor, and on canvas, suspending powdered pigments in thin acrylic medium. He returned to lithography in 1962, making a color print with Fernand Mourlot. Martha Jackson produced the film *The Ivory Knife: Paul Jenkins at Work* in 1964,[4] the year that his first retrospective exhibition was mounted at the Kestner-Gesellschaft in Hanover. Jenkins's play *Strike the Puma* was produced Off-Broadway in 1967. At that time he visited the Pratt Graphic Arts Workshop, which occupied the floor below his studio in New York, to print a suite of lithographs. In the late 1960s and 1970s Jenkins also created sculpture, in colored glass, stone, and bronze. He made several lithographs at that time, working at different printshops in the United States and France.

Jenkins was decorated *Officier* by the French government in 1980 and named Commander of Arts and Letters of the Republic of France in 1983. During the 1980s he worked in acrylic on canvas, watercolor, and collage.[5] His choreographed drama *Shaman to the Prism Seen* was presented at the Paris Opera in 1987, with music by Henri Dutilleux and staging by Simone Benmussa. The artist designed costumes and the set for the production, painting two enormous backdrops and a series of paintings on canvas and silk. The following year he traveled to China to create monumental paintings on silk for a performance at the Great Hall of the People in Beijing, as well as a series of long silk banners to hang on the Great Wall. In the late 1980s Jenkins began working with the lithographer Franck Bordas, the grandson of Fernand Mourlot. At his studio in Paris the artist created two suites of lithographs: *Euphories de la couleur*, of 1988, includes text and drawings by André Verdet; *Seven Aspects of Amadeus and the Others*, of 1991–92, is accompanied by the text of Jenkins's own one-act play. The artist experimented with monotype during the 1990s, working with Smith-Andersen Editions in Palo Alto, California. As prolific and versatile as ever, today Jenkins divides his time between Paris, Saint-Paul-de-Vence, and New York.

The present print is one of Jenkins's earliest, printed by Fernand Mourlot at his press near the Gare du Nord in Paris. In this, and the artist's other lithographs, the viewer is elated by the freedom of moving form and delighted by the pure color. He was drawn to color lithography for its bright, jewel-like hues, which behave differently from watercolor or oil or acrylic paint. Indeed, it is often noted that these luminescent hues are similar to those of stained-glass, which inspired Jenkins's early paintings. The artist prefers to print from stone, as opposed to zinc, because of the crystalline colors it produces, and also perhaps because of its mysterious associations. He adapted his painting techniques to lithography, pouring thin washes on the stone and encouraging them to drift and pool as he tipped up and rotated the printing surface. It is quite a different experience from painting, however, since the highly polished surface of the stone is less resistant than canvas or toothy watercolor paper. To divert the flow of the tusche and pull it across the stone in tendril-like lines, the artist also uses the ivory blades that he employs in his canvases and watercolors.

Lithography provides Jenkins with a new tonal vocabulary, in the distinctive behavior and chemistry of its materials. He mixes the liquid tusche himself, in various dilutions and viscosities. He manipulates the behavior of the ink on the stone while drawing and affects different outcomes when printing. The apparent randomness of Jenkins's designs is intentional and is supported by the organic, mottled *peau de crapaud* effect, achieved by chemical manipulation of the tusche on the stone, visible in this print in the magenta and green passages along the right side of the image.

For a color lithograph like this one, the artist created several different stones, working in black tusche. For each he tipped the stone to a different angle, allowing the flaring shapes to interlace. All the decisions concerning color were actively in stages as the work was printed. At that time only were artist and printer able to appreciate the way in which the superimposed translucent colors created new hues, the sense of space and movement. Jenkins's prints speak from imagination and they provoke metaphysical contemplation. However, they are expressive images, executed by a versatile, creative, and able craftsman who makes the difficult appear effortless.

63/95 Paul Jenkins
 1965

LOUISE NEVELSON

1899–1988

91. Untitled, about 1965

Soft-ground etching, aquatint and engraving
60.4 x 44.8 cm (plate)
75.8 x 56.4 cm (sheet)
Inscribed: in graphite, on verso, l.r.: *70027.*
ILN/370
Watermark: *BFK RIVES*
Stamped: in blue ink, on verso, l.r.:
THE/ ESTATE/ OF/ LOUISE/ NEVELSON
Worcester Art Museum, Eliza S. Paine Fund,
1996.83

Notions of assemblage and association that
impelled Louise Nevelson's sculpture in the 1950s
developed in conjunction with her innovative
prints. At that time, her works of graphic art also
reflected the influence of Abstract Expressionism
in ways unapparent in her works in other media.

Leah Berliawsky was born at Pereyaslav, near
Kiev, Russia, in 1899.[1] When she was six years old,
she moved with her family to Rockland, Maine,
where her father became a successful junk dealer.
She married the shipping broker and steamship
owner Charles Nevelson in 1920 and moved to New
York. Two years later they had a son, who became
the artist Mike Nevelson. In 1929 Nevelson
enrolled at the Art Students League, where she
was a pupil of Kenneth Hayes Miller. She sepa-
rated from her husband two years later and trav-
eled to Europe. In Munich she studied with Hans
Hofmann, whose ideas had a lasting effect on her.

Nevelson briefly studied sculpture with Chaim
Gross at the Educational Alliance in New York, and
began to create expressive statuettes of figures
and animals. From 1935 to 1939 she was a teacher
on the FAP/WPA. Her first solo exhibition, at the
Nierendorf Gallery in 1941, included painted plas-
ter sculptures and drawings. The following winter,
Nevelson used junk shop materials to make
painted wooden figures of acrobats and circus per-
formers. Scraps of turned and carved wood and
bits of lace and fringe were the materials free and
available during the war. These works were shown
in her second exhibition, *The Clown Is the Center
of His World*, at the Norlyst Gallery in 1943.[2]

Nevelson made her first prints at Atelier 17 in
1947, but was discouraged by Stanley William
Hayter's strict rules for tools and procedures.
Instead she worked at the Clay Club, an informal
workshop with a basement kiln, where she made
terracotta statuettes. Nevelson traveled to Mexico
to explore Mayan ruins deep in the Yucatán jungle
in 1950, and the next year she visited Guatemala.
She felt an affinity with the power and balance of

Mayan sculptural form, which inspired her series
of semiabstract statuettes in black terracotta. After
Hayter returned to Paris, his successor, Peter
Grippe, invited Nevelson back to Atelier 17 in 1953.
She came to appreciate the workshop camaraderie
and made lifelong friends, including Dorothy
Dehner. Her prints grew from memories of Central
America, and their titles hint at an obscure per-
sonal mythology.[3] The artist experimented with
soft-ground etching, pressing gauze and lace into
the ground to transfer detailed ornamental tex-
tures to the plates. Then she overlaid the patterns
with random imagery in etching and drypoint,
carved with a can opener. She worked at Atelier 17
until the shop closed, completing thirty editions of
intaglio prints.

Around 1955 Nevelson combined wood scraps
in a wooden liquor case and painted the piece flat
black. This reinterpretation of handiwork in a new
context was parallel to the lace patterns of her
prints. She constructed many more boxes, stacking
them against the studio wall when she finished,
and saw that together they made a richer, more
affecting piece. Her solo exhibitions in 1955 and
1958 included prints and sculptural walls. In 1963,
the year that Nevelson's work was shown in the
United States pavilion at the Venice Biennale, she
visited the Tamarind Lithography Workshop in Los
Angeles. She used the same formula for her litho-
graphs that she had for her intaglios, combining
patterns from the weave of fabrics with hand-drawn
gesture.[4] To plan the prints she made impromptu
collages of torn scraps and paper doilies, touched
with charcoal, oil paint, and spray enamel. Nevel-
son made many more collaborative prints in the
late 1960s and 1970s. At the Hollander Graphic
Workshop in New York she made both lithographs
and etchings. The artist created twelve screenprints
to illustrate the poems of Edith Sitwell, published
in the folio *Facade* in 1966. Nevelson returned to
Tamarind in November 1967 to execute a series of
sixteen prints entitled *Double Imagery,* designed to
be framed and presented in polyptych form.[5]

In the late 1960s Nevelson began employing
professional fabricators to execute her major
sculptures; their collaborations were like the team-
work in print workshops. She executed many com-
missions for monumental outdoor sculptures,
including *Transparent Horizon* for the Massachu-
setts Institute of Technology, and *Sky Tree* for the
Embarcadero Center in San Francisco. A show of
her prints was presented in Naples in 1976.[6]
On the artist's eightieth birthday, a retrospective
exhibition of her environmental sculpture was
mounted at the Whitney Museum, and the City of

New York named a plaza after her. Nevelson died
in New York in May 1988.

The present print, uncatalogued by Johnson
and Baro, is one of a group of plates produced in
New York at the Hollander Graphic Workshop in
late 1965. Nevelson developed a good rapport with
Irwin Hollander, the Tamarind-trained Master
Printer whom she had met in Los Angeles. When
the artist first came to his studio, he helped her to
print two lithographs. On her next visit she etched
eight large intaglio plates in a single day.[7]
Nevelson proofed *bon à tirer* impressions of these
plates, working with Hollander and the Master
intaglio Printer Emiliano Sorini, who printed the
editions in the early months of 1966.[8] This impres-
sion is one of those early proofs, printed by the
artist herself, which is darker and richer than the
editioned impressions. For some reason Nevelson
never signed the edition, which was discovered
intact in a special drawer in her studio after
her death.

Nevelson made large intaglio prints at
Hollander's shop, comparable in scale to her
Tamarind lithographs, and as big as easel paint-
ings. Although some of them have figural and
narrative references, the present print is wholly
abstract. The two girdled lozenges surround and
contain a nucleus, in a static, architectural compo-
sition. However, the artist's explicit, dramatic
gestures enliven the stability of the image. She cre-
ated an image in which a monumental form seems
to buzz with potential energy, like a cosmic power
plant, causing lights to fire and flicker behind.
Gesture dominates this print, in the brushstrokes
of acid or in the brutal slashes of drypoint. As was
her custom, she composed the image in layers,
balancing passages of superimposition with those
of transparency to create a sense of space.

Observers commented on how Nevelson aban-
doned herself to work in the printshop. The artist
worked industriously through long hours, exhaust-
ing the printers. She drew impetuously with her
whole arm, working intuitively and physically.
Nevelson got dirty, covering herself with black ink.[9]
Rather than being inhibited by technical complexi-
ties and long printmaking procedures, Nevelson
was exhilarated. She repeatedly commented on
the way in which the process led her to sponta-
neous creativity. "I sort of felt my way," the artist
once recalled. "Like when you turn a page you
know either through the weight or somehow that
you have turned two pages, . . . when you wipe the
plate you know what to expect from your print."[10]

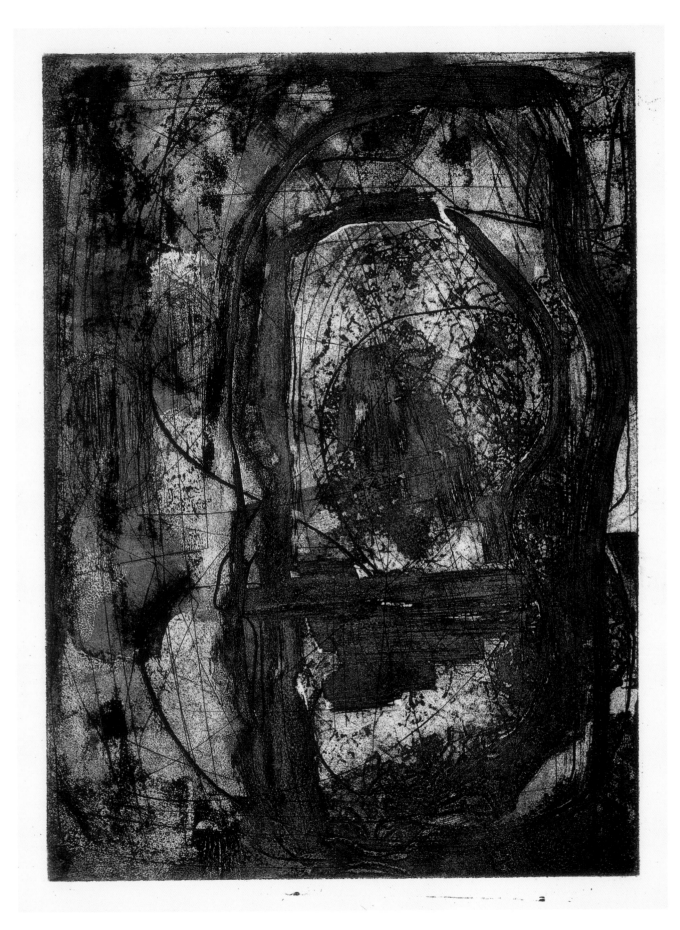

ROBERT MOTHERWELL

1915–1991

92. Automatism A, 1965–66

Lithograph on cream wove paper, 70/100
66.1 x 54.0 cm (image)
71.0 x 54.0 cm (sheet)
Inscribed: in graphite, below image, l.r.:
 70/100 Robert Motherwell
Watermark: *BFK* (Rives)
Embossed: below image, l.l.: *IH* in a box (Irwin
 Hollander)
References: Terenzio/Belknap 1991, no.6; Graham
 1987, pp.25, 78; Gilmour 1988, p.350.
Private collection

The youngest and most intellectual of the pioneers of Abstract Expressionism, Robert Motherwell was the most prolific printmaker among them. He produced over two hundred editions, always approaching the lithography stone and etching plate with the same thoughtfulness and sensitivity that he took to the canvas.

Motherwell was born in Aberdeen, Washington, on January 24, 1915, and he grew up in San Francisco.[1] At age eleven he won a fellowship to study at the Otis Art Institute in Los Angeles, where he studied for three years. After brief studies at the California School of Fine Arts in San Francisco in 1932, Motherwell attended Stanford University, where he majored in philosophy, and wrote a thesis on psychoanalytic theory. He enrolled in the graduate program in philosophy at Harvard University in 1937. He visited Europe, studying briefly at the universities of Grenoble and Oxford, and then took a studio in Paris, where he painted from July 1938 to October 1939. At that time, his first solo exhibition was mounted at the Raymond Duncan Gallery in Paris.

In 1940 Motherwell moved to New York and enrolled in the graduate program in art history at Columbia University. His studies of nineteenth and twentieth century art convinced him that only abstraction could provide a life-enhancing response to modern life. In 1941, he studied printmaking with Kurt Seligmann, who introduced him to the Surrealist artists who found refuge from the war in New York, including Max Ernst, Marcel Duchamp, Roberto Matta, and others. Motherwell's interest in psychology and the subconscious mind attracted him to Surrealism, and especially to its concept of Automatism. His work was included in the group exhibition *First Papers of Surrealism* at the Whitelaw Reid Mansion in New York in 1942. Motherwell visited Atelier 17 in 1943, but made only a few experimental intaglio prints for he was

uncomfortable working beside the older, European artists whom he so admired. One of his collages was included in the group exhibition at Peggy Guggenheim's Art of this Century Gallery, where his first solo exhibition in New York appeared in 1944. Throughout his career the artist maintained an active interest in collage.[2]

At that time Motherwell began editing *The Documents of Modern Art*, a series of writings by twentieth-century artists.[3] In 1945, he taught at the Black Mountain Summer Institute in North Carolina. The artist's emotional reaction to the Spanish Civil War inspired him to begin *Elegy to the Spanish Republic*, a series of over one hundred fifty works, including paintings, drawings, and prints. Motherwell joined Mark Rothko, William Baziotes, Barnett Newman, and David Hare in founding the Subjects of the Artist school in New York in 1949. From 1951 to 1959 he taught at Hunter College in New York. He exhibited his work at the Kootz Gallery, associated with the artists' community of Greenwich Village, and participated in the symposia that evolved into The Club. In summer 1954 he taught at the Colorado Springs Fine Arts Center, where he became friends with Emerson Woelffer. He was married to Helen Frankenthaler from 1958 to 1971, and they often traveled to Europe together in the late 1950s. The artist's first retrospective exhibition was shown at Bennington College in Vermont in 1959.

When Frankenthaler did lithographs at United Limited Art Editions (ULAE) in 1961, she encouraged Motherwell to answer Tatyana Grosman's longstanding invitation, and he produced his first two collaborative prints.[4] His fascinated observation of the ocean waves breaking near his summer home in Provincetown, Massachusetts, inspired him to create the series of automatist drawings *Beside the Sea*. In 1965, a retrospective exhibition of Motherwell's work was mounted by the Museum of Modern Art in New York. During the 1960s Motherwell continued his printmaking activities, working with several different printshops in the United States and Europe. At ULAE from 1968 to 1972 he produced *A la pintura*, a *livre d'artiste*, wedding poems by Raphael Alberti with etchings related to Motherwell's contemporaneous paintings of the *Open* series. In 1973 the artist installed an etching press in his studios in Greenwich, Connecticut, and Catherine Mousley began to work there as his intaglio printer. Three years later he acquired a lithography press, and engaged Robert Bigelow as studio assistant and Master Lithographer. Nevertheless, his belief in the benefits of col-

laboration prompted him to continue his activities at other workshops, particularly Gemini G.E.L. and Tyler Graphics. The artist continued to paint and make prints until his death, in Provincetown, on July 16, 1991.

The present print was the first of Motherwell's collaboration with Irwin Hollander, at the printer's workshop on East Tenth Street in New York. After his retrospective exhibition at the Museum of Modern Art in 1965, the artist became depressed, and found it difficult to work. At that time he was attracted to the printshop as a change from painting, and for the camaraderie of collaboration.[5] Paradoxically, Motherwell used collaboration to pursue a deeply personal creative endeavor, for he had long wished to express the nature of spontaneous inspiration in lithography, with its rich black ink and gleaming, elegant paper.[6] The present print, and the two lithographs that followed it, grew out of Motherwell's automatist exercise, *Lyric Suite*, created the previous spring. In that project, the artist set himself the challenge of working without conscious preconceptions, confining himself to the immediate impulse, and allowing no revisions. Using an English watercolor brush and common inks, he made over five hundred automatist drawings on identical sheets of Japan paper. Many of the images combine an impulsive splash or calligraphic flourish with a double horizontal baseline, and find their beauty in the accidental spattering of ink, or the way it bled into the paper fibers.[7]

In transferring these creative experiences to lithography, Motherwell relied on technical adjustments he then only basically understood; he communicated these concerns to Hollander, who selected the zinc printing plate, and mixed liquid tusche to the perfect consistency. With the media variables in balance, the artist could resign himself to the subconscious act of creation. "When the viscosity is right," Motherwell observed, "it is close to mindlessness — as the Orientals are always trying to express — or to pure essences, with nothing between your beingness and the external world. As though your beingness were being transmitted without intervention."[8] The artist had studied Japanese art and Zen Buddhist calligraphy, and understood how the aesthetic and emotional experiences of a lifetime could be expressed in a spontaneous creative moment. Hollander was impressed by the combination of intellectuality and instinct in Motherwell's images; "they come right from the elbow," he recalled, "right from his *own inner balance*."[9]

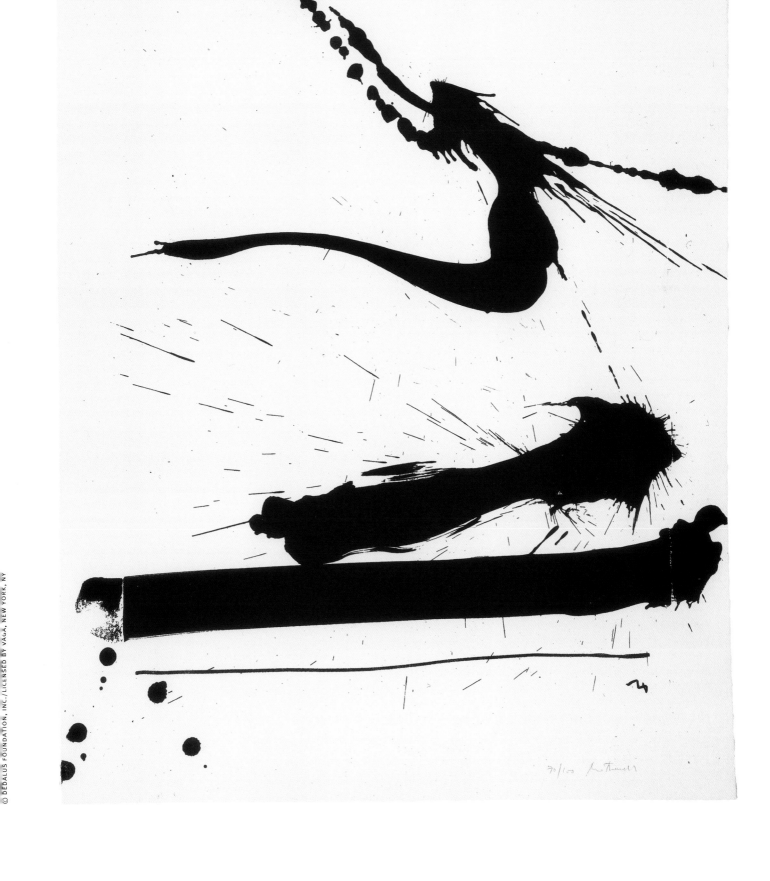

70/100 Motherwell

PHILIP GUSTON

1913–1980

93. Untitled, 1966

Lithograph on cream wove paper, 3/35
45.6 x 65.2 cm (image)
56.8 x 72.9 cm (sheet)
Inscribed: in graphite, below image:
 3/35 Philip Guston '66
Watermark: *Arches*
Blindstamp: l.l.: *IH* (Irwin Hollander)
Worcester Art Museum, 1993.97

When Philip Guston began experimenting with lithography in the 1960s, he produced a sequence of prints that embody the ideas and imagery of drawings produced a decade before. Created in discharges of improvisational energy, these works express a personal vision and creative personality.

Philip Goldstein was born in Montreal, Canada, on June 23, 1913, the son of Russian emigrés.[1] In 1919 he moved with his family to Los Angeles, where he became interested in art as a boy. A drawing correspondence course from the Cleveland School helped to mold his skills as a draftsman and strengthened his commitment to art. He attended the Los Angeles Manual Arts High School, where he became friends with Jackson Pollock. Together, these rebellious teenagers created a satirical pamphlet that resulted in their expulsion. Goldstein attended the Otis Art Institute, where he won a scholarship in 1930. He met fellow student Reuben Kadish, and they began a lifelong friendship. Goldstein became interested in the work of David Alfaro Siqueiros, whom he met in Los Angeles. In 1935 he and Kadish toured Mexico, where they met Diego Rivera, and executed a mural at the University of Michoacan in Morelia.[2]

In 1936 Goldstein went with Kadish to New York, where he made a fresh start, changing his surname to Guston. While working on the mural painting division of the FAP/WPA, he executed a fresco for the WPA building at the New York World's Fair in 1939, wall paintings for the Queensbridge Housing Project in 1940, and murals for the Social Security Building in Washington, D.C., in 1942. Guston taught at the University of Iowa from 1941 to 1944, and at the University of Washington from 1945 to 1947. At that time he worked in a figurative style influenced by Magic Realism, and his images became progressively more abstract and geometric. The artist settled in Woodstock, New York, in 1947. That year his first solo exhibition was

mounted at the Midtown Gallery in New York, and was followed shortly by a show at the Boston Museum School. In 1948 he won the Prix de Rome and traveled to Italy.

Guston returned to New York in 1950, and the following year he began teaching at New York University (NYU). Figures disappeared from his work as he experimented with urban landscapes, influenced by Constructivism and De Stijl. As the artist renewed old friendships with Pollock, Bradley Walter Tomlin, Adolph Gottlieb, and Willem de Kooning; he frequented The Club and considered the concepts of Abstract Expressionism. Guston began to paint loosely in soft pastel colors, in centralized passages of intense color floating on nebulous, painterly backgrounds. In addition to holding a faculty position at NYU, the artist taught at the Pratt Institute from 1953 to 1957. Retrospective exhibitions of his work were mounted at the Saõ Paolo biennial in 1959, the Venice Biennale in 1960, and the Guggenheim Museum in 1962.[3] In the 1960s the artist returned to Woodstock, where he built a studio. He experimented with personal calligraphy in drawings and paintings, and his canvases became muted and nearly monochromatic.

Guston's final style, practiced during the 1970s, was a cartoonlike manner influenced by Pop Art, presenting images of black humor, anxiety, and irony. Symbolic elements representing the perils of life in the post-modern city verged on social commentary. He used this style in "poem-pictures," featuring the verse of Stanley Kunitz, Bill Berkson, Clark Coolidge, and William Corbett.[4] Shortly before his death, the artist worked at Gemini G.E.L. in Los Angeles, where he collaborated with the Master Printer Serge Lozingot on twenty-five editions of lithographs. Quite different from the gestural prints, these were rendered in Guston's late comic-strip style and depict abstruse, often sinister subjects.[5] In 1975 he made a series of red paintings, utilizing the rich impasto of his earlier style. In 1980 the artist suffered a severe heart attack, and several months later he died in Woodstock, New York, on June 7.

Guston made his first prints in 1963 when he briefly visited the Tamarind Lithography Workshop during a trip to Los Angeles.[6] The artist drew on a stone with brush and tusche for one print and sketched in crayon on a zinc plate for another. The images derived from his spontaneous calligraphic drawings of the period. At Tamarind he met the

Master Printer Irwin Hollander, who five years later invited the artist to his own printshop in New York, where Guston produced a suite of nine editions of lithographs, including the present print. The artist drew spontaneously on the stones with a brush and liquid tusche, creating images that relate closely to his work at Tamarind.

Generally, Guston's prints made at Hollander's shop reflect the imagery of his drawings of the early 1960s, works that blur the distinction between a nonobjective image and the associations it may conjure. At that time he was obsessively concerned with the fundamental intellectual and physical aspects of drawing, and he attempted to analyze the process of seeing and replicating form. Guston focused on the essential challenge of how to locate and describe form on a two-dimensional surface.[7] He drew still-life subjects, like piles of fabric or rows of jars sitting on a shelf, abbreviating their contours, and giving equal attention to form and void. Then he copied his own drawings, through several versions, refining line and form to a distinctive vocabulary. Years later the artist compared his approach to Chinese painting: "Song period training involves doing something thousands and thousands of times — bamboo shoots and birds," Guston commented, "until someone else does it, not you, and the rhythm moves through you. I have had it happen to me. It is a double activity, when you know and you don't know, and it shouldn't really be talked about."[8]

When he began to draw each of his gestural lithographs, Guston sought only to reengage the formal vocabularies that he had developed in drawings. Once he found access to his source of inspiration, the speed of his gesture was fluent and true. Although this seems highly intellectualized, it all took place in an instant. Observing this creative process was a moving experience for the printers. Describing a similar project, his chief collaborator, Irwin Hollander, described Guston's working manner: "getting that image out from inside him, it was an act of such a spiritual nature. It was also fast — the gesture that came out, and the line could really describe that. . . . With Guston that was magnificent because the squiggle and the shape and the richness was immediate. Then he would be spent, it would be like being with a boxer, and he had to leave, just to get out."[9]

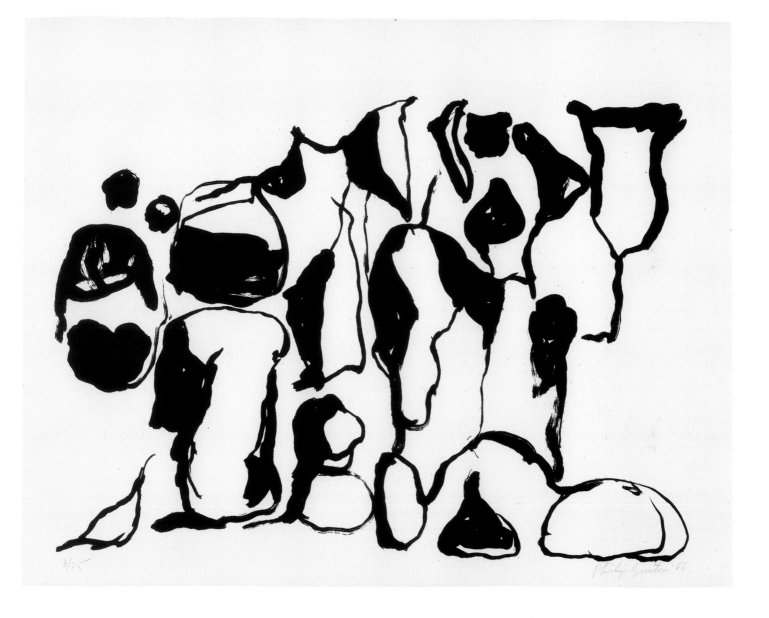

3/15 Philip Guston '66

CY TWOMBLY

1928–

94. Untitled II, 1967

Aquatint and open bite on cream wove paper,
11/23
59.9 x 71.7 cm (plate)
70.0 x 102.5 cm (sheet)
Inscribed: in graphite, l.r.: *11/23 CT 67*
Watermark: *G*
Embossed: l.r.: *ULAE*
References: Bastian 1985, no.11; Sparks 1989,
p.520, no.3.
Worcester Art Museum, Richard A. Heald Fund,
1995.13

Cy Twombly stands out among the painters of his generation for the consistent use of automatism. He employed calligraphic handwriting and stream-of-consciousness doodling to explore and express his personality and his changing psychological state.

Edwin Parker Twombly, Jr., was born in 1928 in Lexington, Virginia, the son of an athletic coach and administrator at Washington and Lee University.[1] He inherited his father's nickname, which came from the baseball great Cy Young. At age twelve he began painting lessons with Pierre Daura, an artist recently arrived from Spain, who introduced him to European Modernism. He attended the School of the Museum of Fine Arts in Boston in 1947, and was exposed to Dada and Surrealism. In 1950 Twombly won a fellowship to study at the Art Students League in New York, where he studied painting with Morris Kantor and printmaking with Will Barnet. He frequented museums and galleries in the city, and vestiges of figuration in his work were replaced by painterly gesture.

Together with his friend and fellow student Robert Rauschenberg, Twombly attended the Black Mountain College Summer Institute in 1951. Both Franz Kline and Robert Motherwell taught during that remarkable term. Twombly painted black and white oils that combine Kline's calligraphy with Jackson Pollock's allover patterning. Twombly also worked with Nichola Cernovich and Joel Oppenheimer in the Black Mountain graphic arts workshop. His linocuts for the broadside cover for the poem *Song of the Border Guard* (fig. 1) combine Kline's bold calligraphy with the simulated look of a gouge in a splintery woodblock.[2] Twombly and Rauschenberg stayed at the college through the following winter term, then traveled to Europe in 1952 with fellowships from the Virginia Museum of Fine Arts. In Tangier, Twombly made a group of wall hangings using geometrically patterned local fabrics. He also created spare, pale canvases evoking sun-bleached Mediterranean walls, which were included in the young artists' exhibition at the Stable Gallery in New York.

Drafted into the Army in 1953, Twombly was sent for basic training and cryptography courses to Camp Gordon in Georgia. He continued to draw, a practice that has remained central to his creative activity.[3] At that time he experimented with automatist drawings. Working in the dark, he made childlike scribblings that gradually became more fluid. When he was posted to Washington, D.C., in 1954, the artist transferred this imagery to paintings that were shown at the Stable Gallery the following winter.[4] After his discharge, he tried teaching at Southern Seminary and Junior College, in Buena Vista, Georgia, but realized he was unsuited to an academic life. In 1957 he returned to Rome, where he met Tatiana and Giorgio Franchetti, siblings from an old aristocratic family, who introduced him to Italian contemporary art circles. He found a studio overlooking the Colosseum and painted canvases grounded with plasterlike *cementito*, touched with earthy red and yellow scumbles. Cursory inscriptions evoke the centuries of graffiti he saw on Roman walls. These paintings remind Italian viewers of their own visual and cultural environment, and they sold well throughout the country.

Twombly married Tatiana Franchetti in April 1959. In the hours spanning 1959 and 1960, while awaiting the arrival of his son, he painted *The Age of Alexander* on a bolt of canvas that covered two walls of his studio. Its use of automatist gesture and free association to express grand cultural issues defined the artist's style of the 1960s and 1970s. In 1977–78 Twombly created *Fifty Days at Ilium*, a suite of ten monumental canvases inspired by epics of the Trojan War. A retrospective exhibition of his work at the Whitney Museum of American Art was criticized as foreign and unfashionably *retardataire*, but in Europe the artist earned esteem.[5] During the 1980s he continued to create paintings in ensemble to be exhibited in one room, concerning human relationships to nature. Among them are the monumental series *The Four Seasons* and a fifty-foot triptych initially called *The Anatomy of Melancholy*. In 1994 a comprehensive retrospective show of Twombly's work was mounted at the Museum of Modern Art.[6] Today the artist divides his time between Italy and Lexington, Virginia.

In 1967 Twombly visited a printmaking studio for the first time in his professional career. He accompanied Rauschenberg to Long Island, where his friend was at work on lithographs at Universal Limited Art Editions (ULAE), and the publisher Tatyana Grosman persuaded him to try his hand. In collaboration with the Master Printer Donn Steward, Twombly made three sets of intaglio prints, derived from his contemporaneous drawings, all relating to notions of handwriting.[7] He clustered words and numbers together haphazardly in the

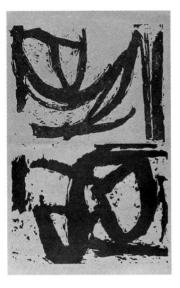

Figure 1. *Song of the Border Guard*, 1951.

small etchings of the *Sketches* suite, which have been compared to Arshile Gorky's automatic drawings of 1944–1945. Twombly used more formal compositions in the four prints of the *Notes* series, with lines of parallel hatching or scribbled loops to evoke different languages and alphabets. Then the artist created two large, untitled plates, including the present print, that enlarge and elucidate the imagery of the *Notes* etchings.[8]

Steward prepared the even aquatint grounds, and mixed mordant in a syrupy solution, which Twombly used with a brush to draw registers of continuous loopy script. Like that of most right-handed writers, his script slants to the right; however, the intaglio process reversed the image in the print. To emphasize the depth of this image and differentiate it from the paper color, Steward underprinted a layer of cream-colored ink. This helps to emphasize the wet lines, evoking the scratch of the nib or ballpoint against paper.

The word *style* derives from the Latin name of a tool for writing on wax tablets, reflecting the fact that we each have our own handwriting, which is effortlessly distinctive. Our writing style changes according to purpose and mood, evolving as we go through life. This common experience perfectly embodies concepts of automatic personal expression that are fundamental to Abstract Expressionism. Everyone can relate to the feeling of creating an image like Twombly's and to the unconscious nature of the process. His energized lines and loops reflect activity, speed, and control. In essence, their expression of movement is parallel to that in the visual experiments of the Futurist painters, like Umberto Boccioni or Marcel Duchamp. The rows of running loops in Twombly's paintings, drawings, and prints of the late 1960s have been compared to the old "Palmer Method" exercises for handwriting students. It reminds us that, although it becomes second nature for most, we must learn to write, as we must learn to talk. Communication involves an agreed-upon language, whether it be visual or spoken, syntactic or intuitive.

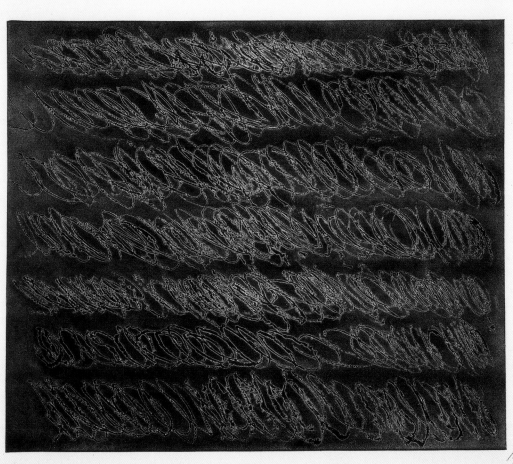

11/23 (.J 67

JULES OLITSKI

1922–

95. Magenta/Orange with Tan,

from the Graphics Suite #1, 1970

Screenprint on cream wove paper, 80/150
88.9 x 66.0 cm (image)
88.9 x 66.0 cm (sheet)
Inscribed: in graphite, l.l.: *80/150*;
 lr.: *Jules Olitski — 70*
References: Wilkin/Long 1989, no.45.
Worcester Art Museum, 1996.124

Echoes of Abstract Expressionism resound in the Color Field paintings of Jules Olitski, in their spontaneous execution, their focus on the nature and behavior of materials, and their use of gesture. These qualities also characterize Olitski's prints.

Jules Demikovsky was born on March 27, 1922, in Snovsk, Russia, the son of a commissar, who was executed before he was born.[1] When he was an infant, his family came to the United States and settled in New York, where his mother married Hyman Olitsky. He began his art education in 1939, when he won a three-month scholarship to study drawing at the Pratt Institute. The following year he studied privately with the Impressionist painter Samuel Rothbort who introduced him to oil painting. From 1940 to 1942 he studied at the National Academy of Design, where he was a student of Sidney Dickinson, and at the Beaux-Arts Institute. Olitski took an altered version of his stepfather's name when he became an American citizen in 1942. He served in the Army over the next three years, continuing to paint portraits and Fauvelike landscapes. In 1947 the artist studied sculpture at the Educational Alliance with Chaim Gross.

With support from the GI Bill, Olitski went to Paris in 1949. He registered at the Académie de la Grande Chaumière and also studied with Ossip Zadkine. Soon he was drawn to the work of Jean Dubuffet, which led him to react against his academic education. To overcome his facility, Olitski began his paintings blindfolded. Filled with fantasy, dream, and sexuality, his work reflected the influence of synthetic Cubism and Surrealist automatism. The artist's first solo exhibition appeared at the Galerie Huit in Paris in 1951. Afterward Olitski returned to Brooklyn and resumed his studies at New York University. He completed his bachelor's degree in 1952, and received his master's degree in 1954. He taught at the State University of New York, New Paltz in 1954–55, and at C.W. Post College of Long Island University from 1956 to 1963.

In his painting of the 1950s Olitski reacted against the heavily layered turbulence of Abstract Expressionism, aiming for quiet, sensual color. He experimented with mixing his own water-based acrylic pigments and staining unprimed canvas in paintings composed with radiating concentric bands of color. In 1962 solo exhibitions of his work appeared at the Poindexter Gallery in New York and at Bennington College in Vermont, where the artist taught from 1963 to 1967. Around that time, in a famous conversation with the artists Kenneth Noland and Anthony Caro, Olitski remarked that for him it would be ideal to spray color into the air and have it remain there. Soon he began using a spray gun to apply paint.

Three of Olitski's paintings were featured in the exhibition *Post Painterly Abstraction*, at the Los Angeles County Museum of Art in spring 1964. In the following months solo exhibitions of his work were mounted at Galerie Lawrence in Paris and at the David Mirvish Gallery in Toronto. In the mid-1960s Olitski perfected his painting technique and imagery. He began by submersing unprimed canvas in thinned acrylic paint to stain and dye it. Then the artist spread the wet canvas on the floor, and atomized water-based acrylic paint onto its surface through the air, using various spray guns powered by an electric air compressor. He defined the edges of the canvas with lines and small forms in pastel, crayon, or brushed-on paint. Sometimes Olitski further emphasized the edges by masking them between coats of spray paint, reserving strips of complementary colors.

In addition to Olitski's ongoing solo exhibitions at the Poindexter Gallery in New York, the Kasmin Gallery in London, and the David Mirvish Gallery in Toronto, his paintings were featured in the XII Venice Biennale in 1966.[2] The following year he won first prize in the Corcoran Gallery biennial exhibition, and his first museum exhibition was mounted there in the spring.[3] In 1968 Olitski's paintings were purchased for the permanent collections of the Whitney Museum of American Art and the Museum of Modern Art. At that time the artist also made his first sculptures of colored, anodized aluminum, which were spray painted.[4] In spring 1969 a solo exhibition of Olitski's work was mounted at the Metropolitan Museum of Art in New York — the museum's first show for a living American artist — and his work was included in the museum's group exhibition *New York Painting and Sculpture: 1940–1970* the following year. In the following

decades Olitski continued to experiment with his painting process. Having reduced painting to diaphanous essays in pure color, he began to reconstruct tactile surfaces. He supplemented clouds of vaporized color with painterly gesture, applied with rollers or mops. The artist added acrylic gel to make his sprayed paint more viscous and also mixed in varnish, and metallic and pearlescent powder. Solo exhibitions of his paintings were mounted in 1973 at the Museum of Fine Arts, Boston, and in 1979 at the Edmonton Art Gallery.[5]

Olitski made his first woodcuts and linocuts in the mid-1950s.[6] He initiated a printmaking program at C.W. Post College in 1956, and in its first term taught himself the rudiments of intaglio before passing them on to the students. Some of his early etchings are portraits and figure studies, but Olitski soon began to experiment with abstract intaglios, often printing a single proof before reworking the plate. He allowed the developing image to prompt his next move and then drastically altered his plates, using the process as a creative tool, as Rembrandt did. In 1967 the artist began making collaborative prints, working in lithography, screenprint, and intaglio; in occasional projects over the next twenty years he worked with Collector's Press, Brandywine Workshop, and Catherine Moseley.

The present print is one from Olitski's most extensive print series, the *Graphics Suites #1* and *#2*, each including five color screenprints, printed by Michael Knigin at the Chiron Press in New York, and published in 1970 by Waddington Graphics Ltd., in London. These works approximate Olitski's canvases in their impact of intense, allover color. To make these prints the artist began by atomizing ink onto sheets of clear Mylar, which could be stacked together to provide some sense of how the merged image would read. These designs were then photomechanically transferred to the silkscreens. In the printshop, Olitski was scrupulous about selecting and balancing ink colors. The artist also worked directly on the screens, using crayon and liquid tusche to prepare the drawing at the edges. These modest gestures remind us of the artist's presence. The scale of Olitksi's prints, and the relatively intimate viewing they demand, also bring us close to the artist's role in their creation. For no matter how detached the images appear, or what role played in their making, the innumerable aesthetic choices that remained reflect an expressive creative personality.

JAMES BROOKS

1906–1992

96. Banter, 1970

Lithograph on cream wove paper, 47/50
35.5 x 42.5 cm (image)
56.6 x 76.2 cm (sheet)
Inscribed: in graphite, below image:
 47/50 J. Brooks '70
Blindstamp: below image, right:
 Martha Jackson Gallery
Watermark: *Arches*
References: Washburn 1995, cat. no. 12.
Worcester Art Museum, 1996.12.2

One of the most consistent and prolific painters of the New York School, James Brooks worked with equal commitment on canvas and paper. He combined the rapid and unconscious with thoughtful nuance and lyrical color. He worked as a printmaker in two periods near each end of his career.

Brooks was born in St. Louis, Missouri, on October 18, 1906.[1] He grew up in Oklahoma, Colorado, and Texas, for his father was a traveling salesman who moved the family often. In 1923 Brooks began studies at Southern Methodist University and the Dallas Art Institute where he was a pupil of Martha Simkins. He moved to New York in 1926, and worked as a commercial letterer, while studying evenings at the Art Students League with Boardman Robinson and Kimon Nicoläides. There he made Regionalist style lithographs from 1931 to 1936, one of which won first prize for prints at the Dallas Museum of Fine Arts in 1935.[2] Brooks worked in the mural painting division of the FAP/WPA from 1936 to 1942, and won acclaim for paintings in Queens, New Jersey, Long Island, and particularly for his mural *Flight* in the Marine Air Terminal Building at La Guardia Airport.[3] On the project he began lifelong friendships with Jackson Pollock, Philip Guston, and many other artists.

Brooks enlisted in the Army in 1942, and during World War II he served as an artist-correspondent in Egypt and the Middle East. After his discharge in 1945, he returned to New York to find that many of his friends had turned to abstraction; soon he followed suit. Impelled by Pollock, he briefly tried pouring and dripping techniques, taking an experimental attitude. He studied briefly with Wallace Harrison, and taught drawing at Columbia University from 1946 to 1948. When he was in Maine in summer 1948, the artist collaged painted papers onto canvas with black paste. Some of the adhesive bled through the fabric to reveal the gesture of its application. He began to apply the paste to the back of unprimed canvas with gestural arm and body movements, making use of these rhythmic marks, superimposing imagery inspired by their pattern.

From 1948 to 1955 Brooks taught lettering at the Pratt Institute. His first solo exhibition appeared at the Peridot Gallery in New York in 1950,[4] the year his paintings were first included in the Whitney Museum annual exhibition. Brooks's work was included in *Abstract Painting and Sculpture in America* at the Museum of Modern Art in 1951, and in the Ninth Street show, among many others. At that time his paintings gradually developed to dense allover designs of dripped, poured, and brushed paint, varying from heavy impasto to translucent, fluid washes. He used a similar range of effects in paintings on paper in oil, gouache, and watercolor. His distinctive style featured poured, rounded shapes, suggesting movement and growth. In 1955 the artist was visiting critic of Advanced Painting at Yale. The following year his work was included in the *Twelve Americans* exhibition at the Museum of Modern Art, and in 1957 his paintings were shown at the fourth biennial in São Paulo, Brazil.

In 1961, Brooks did an offset lithograph for Collector's Graphics, a spare, elegant image derived from his drawings of the period.[5] His work of the 1960s combined heavily brushed passages of color with willowy calligraphic lines in refined counterpoint. In 1963 he was artist-in-residence at the American Academy in Rome, and a retrospective exhibition of his work was mounted at the Whitney Museum of American Art.[6] From 1966 to 1969 Brooks taught at Queens College in New York, and in the coming years he had several temporary residencies, including positions at New College in Sarasota, Florida, the University of Pennsylvania, and Cooper Union. In 1969 the artist had a Guggenheim Fellowship, and he continued to exhibit his work extensively through the decade. In 1973 he became a member of the American Academy of Arts and Letters. A retrospective exhibition of Brooks's work was mounted at the Portland Museum of Art in Maine in 1983.[7] In the mid-1980s, when the artist began to suffer the effects Alzheimer's disease, he ceased painting large canvases, and confined himself to works on paper. The artist died on March 9, 1992, at Brookhaven, Long Island.

Brooks returned to concentrated printmaking in 1970 after a thirty-five-year respite, and over the next decade he made about a dozen Abstract Expressionist lithographs and screenprints. A handful of these were produced on commission, from the Skowhegan School of Painting and Sculpture, the Mobil Oil Corporation, the Spanish Refugee Aid Society, and the Southampton Hospital.[8] Most were produced near the artist's home on Long Island. The present print is one from a project for the Martha Jackson Gallery in 1970, when Brooks created four color lithographs in collaboration with Michael Knigin at Chiron Press in New York. The prints were not conceived as a set, and they vary in size, imagery, and palette, reflecting the artist's tendency to work simultaneously in different modes. These lithographs evolved from his medium-size drawings, and their imagery generally combines poured pigment, gesture, and carefully placed calligraphic lines.

Banter exemplifies the style that Brooks used in the 1970s, in which very large brushstrokes comprise a simple composition. Compared to his earlier work, with its urgent gesture and dripped pigment, these images are simpler, darker, and more placid. Like his painting method of that time, Brooks's technique for preparing the stones combined Automatism, felicitous accident, and judicious editing. He painted with his canvases spread on the floor, using opaque acrylic paint, and drew on horizontal printing surfaces on a low tabletop. He poured out liquid tusche, and spread it across the smooth surface — perhaps using a piece of cardboard as he did for painting — in a rapid, free, purposely unconscious manner he called "irresponsible."[9] As with his painting, Brooks seems to have blotted some of the ink from the stone with crumpled paper, mottling some of the black passages. At that point the artist imposed his will and personality on the automatist design, beginning with a brush to add linear details and extend the edges of forms. He used color passages to balance the composition, exploiting the same combination of accident and intentional adjustment. By overprinting just a few colors, the artist expanded his palette while retaining simplicity. He was mindful of effects of space, and the illusions of projection and recession. As was his habit, Brooks named the work after its completion, with a title meant only to identify.

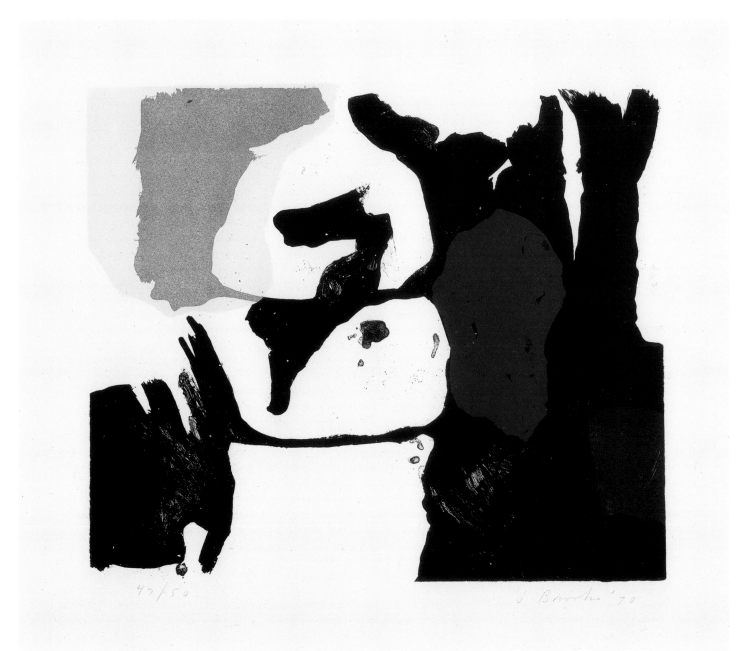

47/50 J. Brooks '70

SAM GLANKOFF

1894–1982

97. Untitled, about 1971

Collagraph and woodcut with casein on white
 wove paper
59.7 x 48.9 cm (image)
61.4 x 49.4 cm (sheet)
Inscribed: in graphite, below image, l.r.: *Glankoff
 '60*; in graphite, on verso, l.l.: *2*; l.ctr.: *SAM
 GLANKOFF © 1981 ALL RIGHTS RESERVED
 PP1066 - 1960*
References: Kushner 1984, cat. no. PP1013, fig. 32;
 Kushner/Wechsler 1985, p.44.
Worcester Art Museum, 1997.173

In the work of Sam Glankoff, printmaking truly became a means of introspection and personal expression. For decades this retiring artist made woodcuts and monotypes that he kept to himself, and the most originative of these prints reflect the energy and emotion of Abstract Expressionism.

Glankoff was born on October 30, 1894, in New York, where his father was a milliner.[1] He taught himself to paint when he was a teenager, and attended evening classes at the Art Students League from 1915 to 1917. When the United States entered World War I, Glankoff had no wish to fight. Without telling his family, he registered as a conscientious objector and fled to Cuba. There he struggled to support himself with his art, painting café murals and trading paintings for food. In 1918 Glankoff was falsely accused of involvement in bombings of Florida railroads and a Miami radio station. He was arrested, tried before a military tribunal, and confined in a Cuban prison for eight months, until the armistice ended the war. Glankoff returned to New York, where he worked as a designer for magazines and industrial pamphlets. The artist made his first woodcuts in 1920, attracted to the straightforward process that enabled him to work entirely on his own. When a business associate gave him a book on woodcut history, he began to exploit the splintery character of the wood grain like German Expressionist printmakers. He used woodcut in his professional work as well, to create illustrations for novels and book jackets.[2] From 1922 to 1928 Glankoff exhibited his work in the annual exhibitions of the Whitney Studio Club, where his traditional landscapes were praised for their expressive style and vivid coloration. During the Depression Glankoff and Frances Kornblum lived in Woodstock, New York,

and though they never married, they remained together for the next forty years. In the mid-1930s the artist designed covers for *Cue* magazine, founded by his brother Mort in 1932.[3] He also worked for *True Comics* from 1942 to 1946, illustrating didactic adventure stories and American and European history for children.

In 1955 Glankoff became the principal designer for "Impulse Items," Kornblum's company, which manufactured children's soft toys, including stuffed animals and characters from popular children's books. He fabricated the original three-dimensional models of hundreds of toys, including the Cat-in-the-Hat and Babar the Elephant. During that period his occasional prints became more experimental. He affixed cords and other dimensional objects to his carved woodblocks, used glue and gesso to build collagraphic textures, and shifted to water-based pigments for softer, transparent colors. When Kornblum died in 1970, Glankoff left the toy business and became reclusive, spending most of his time in his small two-room apartment on East Thirty-third Street. He amassed an extensive library and became interested in Asian philosophy and art, and occupied himself with reading, contemplation, and his art. In his small pastels and prints he resumed the imagery he had used in the 1950s. Glankoff began a personal search for a universal formal vocabulary, progressively reducing his imagery to elementary forms like chevrons, crescents, and vectors. He sought primal motifs that defy identification as symbols, and eventually selected the circle as the quintessential element of his formal vocabulary.

In the mid-1970s Glankoff wanted to work on a larger scale. After seeing a Japanese woodcut polyptych in an exhibition, he began to paste separately printed panels together into larger, compound prints. He developed his own, rather laborious planographic monotype process, printing from thin sheets of plywood or Masonite.[4] He printed by hand, dampening sheets of mulberry-fiber paper and superimposing several layers of pigment to infuse his prints with rich color. Then he glued the component sheets together into a compounded image. In 1979 the artist's brother, Mort, married Wendy Snyder, a fashion stylist and magazine editor. Her interest in his work slowly increased his confidence. She took the first steps in arranging the artist's first solo exhibition at the Graham Gallery in New York in 1981, when he was

eighty-seven years old.[5] Glankoff died a few months later. In 1984 a retrospective exhibition of his paintings, drawings, and prints was mounted at the Jane Voorhees Zimmerli Museum at Rutgers.[6]

Despite its inscription, this transitional print was made after Glankoff's retirement, and reflects the increasing scale and basic shapes of his later compound monotypes. With its simple forms and painterly textures, the image captures a sense of spontaneous energy and creates a sensation of movement. Since the forms are generally rougher along their right edges, they seem to be moving toward the left. The effect is enhanced by the arrowlike angle that points down and to the left.

The imagery calls up the painting of Franz Kline, and the centuries-old Japanese painting style of *zenga*. Indeed, the simple ideographic forms and tawny-colored background evoke an Asian scroll painting on silk, and convey a sense of refinement and age. Though their ragged edges have the appearance of immediate brushstrokes, or a gouged woodblock, Glankoff created this image with a collagraphic relief block. He began this print by preparing the background, scrubbing the thick, white paper with thin casein washes in tones of brown and blue, perhaps applied with brushes and rags. Over this, Glankoff printed the black forms from a relief matrix that combined subtractive imagery carved into a plywood block and additive imagery built up on the printing surface. He outlined his design on the block, carving into its surface along the right side of the forms, and building up the opposite side with cords glued to the woodblock. These pieces of quarter-inch rope stood above the surface and embossed the paper when printed. Glankoff built up the areas between these boundaries to create relief surfaces. He used modern acrylic gesso (polymer latex), slathering it onto the block like wall plaster and creating liquid effects in some areas. As this plasterlike material set up and began to dry, the artist scraped it away from the edges of his forms to achieve the distinctive carved pattern. The rich, saturated, matte black was printed in a combination of gouache, and its opacity contrasts with the translucency of the background. Chalky and particulate, this ink may have begun to dry as soon as it was applied to the printing surface, requiring the artist to work quickly and perhaps encouraging him to overprint.

MILTON RESNICK

1917–

98. Untitled, 1971

Lithograph on cream wove paper, artist's proof
76.3 x 55.8 cm (image)
76.3 x 55.8 cm (sheet)
Inscribed: in graphite, l.l.: *color trial proof Milton
 Resnick*; in graphite on verso, l.l.: 71–167
Watermark: *ARCHES*
Embossed: Tamarind chop l.r.
References: Tamarind 71–167; Schnelker/Booth
 1980, p.57; Devon 2000, p.29.
Worcester Art Museum, 1993.100.2

The eloquent touch of the brush that gives such
power to the paintings of Milton Resnick is present
in his experimental prints. These works also reflect
the inquiring character of this reflective, intellec-
tual artist, whose skirmishes with his medium are
very personal ones, and whose victories in this
arena are triumphant.

Rachmiel "Milya" Resnick was born on January
8, 1917, at Bratslav, Podolia, Ukraine, the son of a
successful builder and businessman.[1] When he
was six years old, his family emigrated to the
United States and settled in Brooklyn. As a child he
dreamed of becoming an artist, despite the disap-
proval of his pragmatic father, and he studied
drawings and painting at the Hebrew Technical
Institute in New York. In 1932 Resnick began
evening courses in the commercial art program at
the Pratt Institute, and the following year he trans-
ferred to the American Artists School in New York.
At that time his representational paintings were
influenced by the work of Paul Cézanne. In 1938
Resnick worked on the FAP/WPA mural painting
division, and returned to the fine arts program at
Pratt. Living in a studio on West Twenty-first Street,
he socialized with such artists as John Graham,
Elaine Fried, and Willem de Kooning.

Resnick was drafted into the Army in 1940.
Trained as a surveyor, he did reconnaissance work
in Europe during World War II. After his discharge
in 1945, he returned briefly to New York, and then
moved to Paris with the support of his GI benefits.
As he painted, Resnick frequented museums and
galleries and studied the works of Cézanne. He
met Alberto Giacometti and Constantin Brancusi.
Returning to New York in 1948, he enrolled at the
Hans Hofmann School to receive his government
benefits, but he seldom attended class, devoting
himself to his solitary painting experiments.

Resnick joined his old colleagues who often
socialized at the Cedar Tavern and the Waldorf
Cafeteria, and he was a founding member of The

Club. He helped to organize the Ninth Street Show
in 1951, and his paintings were included in other
group shows, such as the inaugural exhibition at
the Poindexter Gallery in 1955. At that time, how-
ever, he was more concerned with building a new
language of painting than in showing his grammar
exercises. Resnick taught at the Pratt Institute in
1954–55, and over the course of his career he held
many temporary positions, including residencies
at New York University, Yale University Summer
School, the University of Iowa, and Barnard
College. In summer 1955 he taught at the Univer-
sity of California at Berkeley, and despite surgery
for intestinal cancer, he prepared for solo exhibi-
tions at the M.H. de Young Memorial Museum in
San Francisco and at the Poindexter Gallery in New
York.[2] His postponed recognition was confirmed in
feature articles in *Art News*.[3] Nevertheless, the
artist continued his solitary efforts to forge a new
style of painting. First he abandoned the figure,
then the horizon, and then line. He concentrated
on the physicality of the paint, piling brushstrokes
in even conglomerations across the entire canvas.
There was no point of focus in his paintings, and
no one part of the image was more important than
another. When he rented a large studio on
Broadway, the artist increased the scale of his
paintings. These dramatic works were exhibited at
the Poindexter Gallery in 1959, and the Museum of
Modern Art acquired the painting *Burning Bush*.
The following year the Whitney Museum of
American Art purchased two canvases, and in 1961
the National Gallery of Art acquired a painting.

Resnick married the painter Pat Passlof in
1961, and they spent six months in Europe, where
he concentrated on writing poetry. During the
1960s he applied paint in heavy impasto to larger,
darker canvases. In 1966 he taught at the Univer-
sity of Wisconsin in Madison, and the following
year a retrospective exhibition of his work was
organized by the Madison Art Center. A traveling
exhibition of Resnick's paintings was organized by
the Fort Worth Art Center Museum in Texas in
1971.[4] The artist bought a house in Rifton, New
York, and over the next five years he often lived
there alone with his dog, working in isolation. In
1975 Resnick purchased a disused synagogue in
New York, where he still lives and works. A major
retrospective exhibition of his work was mounted
by the Contemporary Art Museum in Houston in
1985.[5] Five years later Resnick won the Jimmy
Ernst Award from the American Academy of Arts
and Letters. In the early 1990s the arthritis in his
knees made it difficult for the artist to paint on his

accustomed scale. He turned his attention to draw-
ing and worked from the model for the first time in
over fifty years. He transferred images of the figure
to heavily impastoed canvases and began explor-
ing a vital new direction.[6] Today Resnick lives in
New York, where he continues to paint and exhibit
actively.

This lithograph suggests something of the
vigor and complexity that make Resnick's paint-
ings so remarkable. In May 1971 he was artist-in-
residence at the Roswell Art Center in New Mexico,
where he executed a series of twenty canvases, all
titled *Roswell*. Afterward he visited the University
of New Mexico in Albuquerque, and presented a
lecture on the early days of the New York School.
Then Resnick went to the Tamarind Institute to
make three lithographs in collaboration with the
Master Printer Wayne Kimball.[7] Two of Resnick's
prints are quite large — parallel in size to his mon-
umental canvases of the period — and feature
allover compositions. For this print the artist pre-
pared the zinc printing plate as he would a canvas,
propping it up on an easel. He worked sponta-
neously, with no preconceptions, discovering the
image in the process of its creation. He dispersed
short, rapid brushstrokes over much of the
composition, in a cloud that just dissipates along
its edges. Using a brush and liquid tusche, he
scumbled and scrubbed as the brush became dry,
in rapid, lean strokes. This plate was then printed
in the customary Tamarind edition of twenty
impressions.

When the workshop staff encouraged Resnick
to try color prints, he experimented with proofs of
both his large plates. For this lithograph he created
two supplementary plates of the same size. Now
he painted more richly, allowing the tusche to
splash and drip and recharging his brush often.
This approximated his painting practice, for he
often began with thinned pigment and then super-
imposed thick layers of paint right from the tube.
The first supplementary plate was printed in pale
green, then the original plate superimposed its
image in pink, and the third plate was overprinted
in saturated black.[8] The resultant lithograph
approximates the impact of Resnick's palimpsest
canvases. Passages heavy with layers of ink have
a surface richness that shimmers in raking light,
while flashes of color peek through from sub-
merged layers. Like the constant, atomic-level
activity in material objects that appear quite static
to our senses, this image seems to store the
energy that created it.

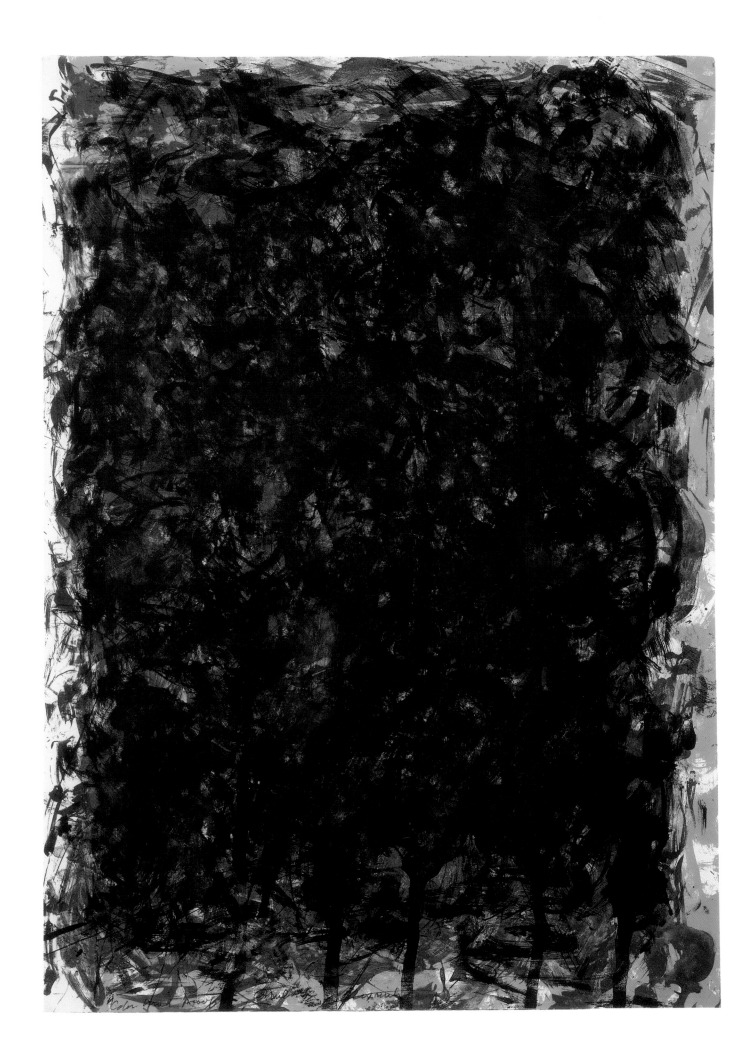

NORMAN BLUHM

1920–1999

99. Untitled, 1974

Screenprint on white wove paper, 45/100
44.9 x 67.3 cm (image)
44.9 x 67.3 cm (sheet)
Inscribed: in graphite, l.r.: *45/100*; l.r.: *Bluhm*
Watermark: *CM FABRIANO 100/100 COTONE*
Worcester Art Museum, Sarah C. Garver Fund,
　1995.19

The physical act of creation, and the behavior of the artist's materials were central to Norman Bluhm's painting style. A love of poetry, sensual color, and gestural muscularity are all combined in the artist's work, including his occasional prints.

Bluhm was born on March 28, 1920, in Chicago, where his father was an engineer and a pilot who insisted that his two sons learn to fly.[1] His mother was Italian, and from 1926 to 1934 the family lived in Florence. In 1936 he enrolled at the Armour Institute of Technology in Chicago (now the Illinois Institute of Technology) where he studied architecture with Mies van der Rohe. After the bombing of Pearl Harbor, Bluhm enlisted in the military, and served as an Air Force pilot in Europe and the invasion of North Africa. After his discharge in 1945 he returned to his studies in Chicago, but soon concluded that he would never excel as an architect. With support from the GI Bill he went to Italy and attended the Accademia de Belle Arte in Florence. He moved to Paris the following year, and studied at l'École des Beaux-Arts and the Académie de la Grande Chaumière. He met Henri Matisse and became friendly with his daughter Margueritte and her husband, the scholar and critic Georges Duthuit. Bluhm also associated with aesthetes like Paul Éluard and Pierre Schneider, and he even appeared in Jean Cocteau's film *Orphée*. He developed a style of lyrical abstraction employing opalescent hues for patterned compositions. It was in Paris, in 1951, that Bluhm first saw the paintings of Jackson Pollock, and soon he began his own experiments with poured and dripped enamel. When he shared a studio in Boulevard Argot with Sam Francis, he was staining canvases and allowing thin pigment to drip and run.

On a visit to New York in 1955, Bluhm met Pollock, Willem de Kooning, and Franz Kline, and was impressed by the sustaining vigor of the New York School and the contributions of his contemporaries. He moved to Manhattan the following year, and began lasting friendships with the critic Thomas B. Hess, the poet and curator Frank O'Hara, and the painter Michael Goldberg. His first solo exhibition, presented by the Leo Castelli Gallery in fall 1957, featured large canvases painted in allover patterns of strokes in a dominant hue.[2] When he moved into a studio atop the Tiffany Glass Building, the artist increased the scale of his paintings, and replaced his continuous fields with a splashy calligraphy. In 1959 Bluhm's paintings were featured in an exhibition organized by the Museum of Modern Art shown at Documenta II in Kassel, Germany. One October Saturday in 1960, O'Hara was visiting Bluhm's studio when they began an impromptu dialogue. The artist extemporized an image on paper tacked to the wall, and the poet responded with free verse inscribed on the same sheet.[3] In the spontaneity of the moment, depths of each creative personality revealed themselves.

Bluhm's paintings were included in the exhibition *Abstract Expressionists and Imagists* at the Guggenheim Museum in 1961. He continued to produce colorful improvised splash paintings of monumental scale in the mid-1960s, even as the styles of Pop Art and Minimalism eclipsed Abstract Expressionism in popularity. Bluhm returned to Paris in 1964–65, to reconfirm his audience; his work appeared in solo exhibitions in Zurich, Brussels, and Paris, and he visited Europe annually for many years. He painted even more physically at that time, flinging acrylic and oil onto canvases in thick layers. In 1967, inspired by the paintings of Henri Matisse, Bluhm began to paint the nude — from which he had drawn continuously throughout the 1960s — using spontaneous gesture and vivid colors. He combined sharp, open gestures with curving, pillowy forms, spontaneously outlined in paint that was allowed to drip and run. Often bunched like luscious fruits, these bulging forms carry erotic energy. In 1969 a solo exhibition of Bluhm's paintings was mounted at the Corcoran Gallery of Art in Washington, D.C., and through the 1970s he exhibited at the David Anderson Gallery in New York, and in 1973 an exhibition of his paintings was mounted at the Everson Museum of Art in Syracuse.[4]

In 1977 the artist contributed a lithograph, printed at the Atelier Arte in Paris, to a volume in honor of Georges Duthuit that combines the writing and images of many writers and artists. He collaborated with John Yau in 1986 on a series of screenprints that combine original poetry with the artist's illuminations, works printed by Jon Cone in Portchester, New York.[5] Bluhm also worked with the printer on a suite of screenprints with pochoir representing nudes. In 1987 a retrospective exhibition of the artist's works on paper was mounted at Hamilton College in Clinton, New York.[6] He multiplied the globous forms in his paintings of the 1990s, containing them in compartments that are often symmetrical and kaleidoscopic in appearance.[7] Bluhm died on February 6, 1999, at his home in East Wallingford, Vermont.

When collaborative projects brought Bluhm to printmaking in the 1970s, the graphic arts failed to fire his imagination, and his printmaking activities were isolated. Though he experimented with lithography, most of his prints are silkscreens, perhaps because of its capabilities for rich, saturated color. The present piece is one of three color screenprints made in Venice in 1974, in association with three exhibitions in Italy that year, the first of which was at the Palazzo delle Prigioni Vecchie in Venice.[8] The prints were made after finished drawings in gouache and crayon on paper. Another, related, image was transformed into a screenprint poster. Their scale and imagery are those of a whole series of drawings done at that time.

The artist brushed, splashed, and dripped paint, building up his composition in layers, from the center out, completing the image with heavy brushstrokes around the perimeter. Overlapping forms and strokes, emphasized by translucent washes, create a sense of physical depth that is emphasized by illusion. The direction of Bluhm's gesture, and the velocity of spattered paint, gives the image a whirling cyclonic feeling, leading the eye of the viewer into narrowing spirals. A few vertical rivulets of dripping paint, which imply the effect of gravity and orient the image, cannot diminish this effect. Bluhm's rapid undulous brushstrokes, and the teardrop shapes they isolate, anticipate the billowy forms of his erotic paintings of the 1980s. So does the remarkable pastel palette, which is somehow pearly yet intense with its pale yellow, steely gray, and accents of lavender and red. It is perhaps no accident that this print was made in Venice, a favorite destination for the artist. For despite his childhood and studies in Florence, Bluhm felt an affinity to Venetian artists through history, with their interest in light, intuitive space, and transitory form.[9] His repeated, serpentine gestures, with their fine details of drips and bristlemarks have a Rococo elegance and energy. The soft, unusual colors of the present print, and the dominance of white, are reminiscent of the paintings of Giovanni Battista Tiepolo, whose work often inspired the artist.

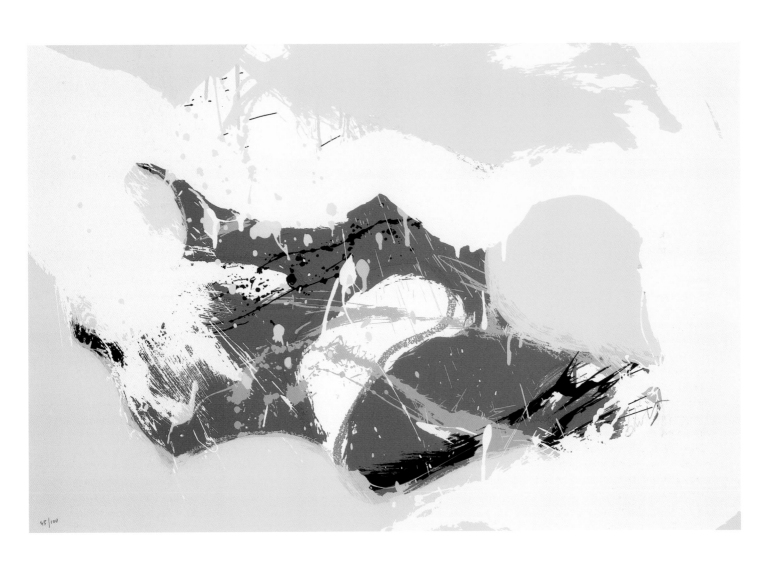

95/100

RICHARD POUSETTE-DART

1916–1992

100. The Densest Skies, 1979–80

Etching touched with India ink and white acrylic
 paint, on cream wove paper
45.5 x 60.7 cm (plate)
57.0 x 76.3 cm (sheet)
Inscribed: in graphite on verso, beneath
 platemark: *3rd State black charbonnel on
 Arches etching buff West Nyack New York
 October 1979*; in blue ballpoint pen on verso,
 l.l.: *"The Densest Skies"/113*; in black felt-tip
 on verso: *inks acrylic Rpousette Dart 80*
Watermark: *ARCHES/FRANCE*
Worcester Art Museum, Richard A. Heald Fund,
 1997.147

In his remarkable paintings Richard Pousette-Dart represented the behavior of light, color, and energy as a metaphor for spiritual experience. Late in his career, the artist experimented with printmaking, and used etching to accomplish his own, unconventional goals.

Pousette-Dart was born in Saint Paul, Minnesota, on June 8, 1916, the son of the painter Nathaniel Pousette, and the poet Flora Louis Dart.[1] He grew up at Valhalla, in Westchester County, New York, where the family moved when he was two years old. As a boy he learned the fundamentals of painting from his father. Pousette-Dart attended the private Scarborough School, and in 1935 he enrolled at Bard College. He left college during his first academic year and moved to New York to pursue his art independently. He studied Modernism and assimilated stylistic lessons from Picasso and the Surrealists. Pousette-Dart supported himself at that time with a series of clerical jobs, while working on drawings, paintings, and sculpture in the evenings. With the fervent belief that abstraction was the most potent mode of artistic expression, the artist developed a distinctive totemic imagery comprised of geometric and biomorphic forms, and often representing themes of growth and change. The first solo exhibition of his work was mounted at the Artists' Gallery in fall 1941. The following year, Pousette-Dart completed *Symphony Number 1: The Transcendental*, one of the first mural-scaled Abstract Expressionist paintings. During the 1940s the artist exhibited his work at the Willard Gallery, the Art of This Century Gallery, and Howard Putzel's 67 Gallery. Pousette-Dart married the poet Evelyn Gracey in 1946, and they began a family.

At that time the artist concentrated more attention on photography and nature studies, finding abstract patterns and compositions in closeups of flowers, seed pods, or ice crystals. Many of these images utilize the radiating mandala image that soon became a frequent motif in his paintings. In 1948 Pousette-Dart began to exhibit his work at the Betty Parsons Gallery. He attended the Subjects of the Artist symposia, and continued his association with the group as it evolved into Studio 35, and eventually into The Club. He appeared among "The Irascibles" in the famous photograph in *Life* magazine in January 1951.

By that time, however, Pousette-Dart had left the city with his family and moved to Rockland County, hoping to isolate himself from the commercial pressures of the art world.[2] He continued to exhibit his work in New York galleries, and his paintings were regularly included in Whitney Museum annual exhibitions during the 1950s. However, his style developed in a solitude that he came to cherish. Fiercely independent, Pousette-Dart was a vegetarian and an impassioned pacifist. He read widely, studying philosophy and world religions, as well as poetry. He also wrote his own verse and prose, filling notebooks with his poems and notes.

From 1959 to 1961 Pousette-Dart taught painting at the New School for Social Research, the first of many temporary positions that included teaching at Columbia University (1967), Sarah Lawrence College (1970–74), the Art Students League in New York (1980–83), and Bard College (1983–92). In 1963 a retrospective exhibition of Pousette-Dart's work was mounted by the Whitney Museum of American Art.[3] During the 1960s, the connections between artistic creativity and mystical spirituality became the guiding principle of the artist's work. He began to paint in daubs of discrete color, delineating complex overall compositions of spiraling grids interweaving many smaller helixes, ellipses, and orbs. The artist also concentrated on centralized circular images made up of thousands of tiny patches of intensely hued impasto forming meticulous images of exploding light. These canvases seem to pulse and radiate energy, changing as the light falling upon them shifts. They are metaphors for natural order, and the arrangement of atoms, solar systems, and galaxies. They also evoke human endeavor, from the stained-glass rose windows of European cathedrals to Hindu mandalas. Pousette-Dart was well aware that such centric images possess a strong psychological power to soothe and integrate, and that they provide the focus for meditation in many cultures. A major exhibition of Pousette-Dart's work was presented by the Whitney Museum in 1974.[4] His paintings were shown at the Venice Biennale in 1982, and

throughout the decade he received numerous commissions, grants, and awards. A retrospective exhibition of the artist's work was organized by the Indianapolis Museum of Art in 1990.[5] Pousette-Dart continued to work until his death on October 25, 1992.

Pousette-Dart came to printmaking only late in his career, when in 1979 he made a series of large, experimental etchings. Transferring the imagery and techniques of his contemporaneous drawings, he explored the intaglio medium and the processes of etching, proofing, and printing. It seems that the artist was most intrigued by the way that an image could be transformed by changing the state of the printing plate. After pulling proofs of his etchings, he continued this process of reworking the images by painting his prints. Pousette-Dart used etching to produce multiple templates that he then modified into unique works.

The artist began the present print by working with an etching needle on the grounded plate, in a manner parallel to his drawings.[6] Working spontaneously, with no preconceived design, he created a grid interlaced with curves and spirals of bundled lines. Repeatedly tracing over the main contours of the composition, he created a thick, impenetrable network made of twisted and interwoven skeins of thin lines. The proliferation and density of this linear hatching, which is parallel to the thousands of brushmarks in Pousette-Dart's paintings, also provides an analogy to nature. From time to time the artist pulled trial proofs from the plate. Then he regrounded the plate and reworked the image, modifying and transforming it. An inscription on the present impression shows that it is a proof of the third state of plate.

Later Pousette-Dart returned to his etchings to continue reworking their imagery, one impression at a time, touching the printed image by hand with paint, ink, and charcoal, and methodically recording these media in inscriptions on each. When he completed each object, the artist assigned a new title, thereby distinguishing it as an independent work. In the present print, the artist used India ink and white acrylic paint, spontaneously applying the pigment in small daubs from the brush. He worked with both media at once, sometimes mixing wet ink and paint on the paper. Occasionally daubs of color follow the contours of the etched line, and in a few places the artist covered the gridwork interstices with white, reasserting the etched structure. More often the brushmarks cluster in swarms that appear to drift before and through the matrix, causing the skies of his title to shimmer and pulse.

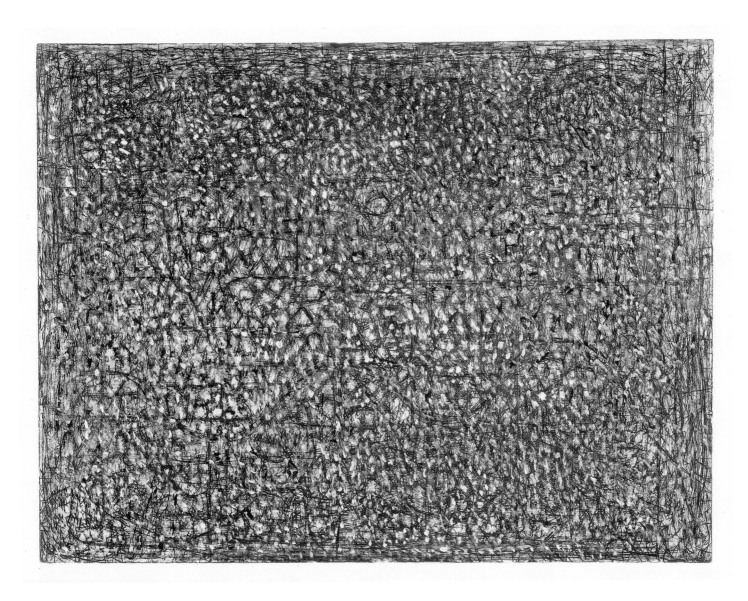

NOTES

INTRODUCTION

1. Basic bibliography on Abstract Expressionism includes: Sandler 1970; Tuchman 1970; Ashton 1972; Seitz 1983.
2. On the FAP/WPA graphic arts division, see Jacob Kainen, "The Graphic Arts Division of the Federal Arts Project," in O'Connor 1972, pp.155–75.
3. On S.W. Hayter, see Hacker 1988; Black/ Moorhead 1992.
4. Barr 1936.
5. Several artists—including Pollock, Kadish, Kamrowski, Stillman, and Mullican—printed just a few proof impressions of their intaglios, which were often lost, but they retained their plates, later to be reprinted.
6. See Landauer 1996.
7. As the program drew to a close the following spring, Robert Goodnough proposed a final session, restricted to artists, to review the proceedings of Studio 35. He was given the task of recording the weekend conference that began on April 21, 1950, and later he assisted Motherwell and Reinhardt in compiling, editing, and publishing the discourse.
8. Variously known as the Artists' Club, the Eighth Street Club, and other names, its contentious members, who could never agree on anything, argued over what to call the organization. Many simply settled on "The Club," which we have used throughout this book.
9. Information on Tiber Press from the author's interview with Floriano Vecchi, New York, June 21, 2000.
10. Among them Davis's *Study for a Drawing*, Sheeler's *Architectural Cadences*, and Shahn's *Luther Hanging His Credo*.
11. See Graham 1987, pp.20–21; Castleman 1994, p.206. One of the proof portfolios and some preparatory materials for the project are now at the Humanities Research Center at the University of Texas, Austin. The collection includes thirty-seven typed letters, twenty-two manuscript letters, and fifteen postcards by project artists, poets, and others who were unable to participate. There are thirty-nine contract forms, each signed by the artist and by Morris Weisenthal as publisher. There are also six author's manuscript copies of five of the poems in this archive, including "Praise of the End!" by Theodore Roethke, "Revenge" by Harold Rosenberg, "Nostalgia" by Peter Viereck, two versions of "Tenement" by Herbert Read, and "Poem" by Frank O'Hara.
12. See Todd 1948, pp.25–37; Hayter 1949, p.75

for the artist's conclusions on this technique. During the 1960s, he developed this method further for his own color intaglios in an Abstract Expressionist manner, see Black 1991, pp.415–18.
13. As noted by Garvey 1961, p.101.
14. Ashton 1958; Rudikoff 1958.
15. See Sparks 1989, pp.16–24.
16. See Gedeon 1984; Wayne 1990, pp.16–33.
17. Also among the artists who made Abstract Expressionist prints at Tamarind in its first years were Louis Bunce, Lee Chesney, John Dowell, Carl and Hilda Morris, Willam Pettet, and Dick Wray.

POETRY AND THE ABSTRACT REVOLUTION

1. Stevens 1951, p.160.
2. Stevens 1951, p.167.
3. The phrase appears in both Stevens's poem "The Man and the Blue Guitar," itself an homage of sorts to Picasso's blue period (part XV), and in *The Necessary Angel* (1951, p.161) though curiously in the prose book "hoard" is spelled "horde."
4. Harry Mathews in conversation with the author.
5. "As American as Franz Kline," reprinted Schuyler 1998, p.12.
6. Seiberling 1949, pp.42–45.
7. "Jack the Dripper" in *Time*, 1956, quoted in Lehman 1995, p.56.
8. "Jackson Pollock II," reprinted in Schuyler 1998, p.126.
9. Kenneth Koch in conversation with the author, June 30, 1994.
10. Irving Sandler's standard history of Abstract Expressionism is titled *The Triumph of American Painting: A History of Abstract Expressionism*. Mark Tansey's *Triumph of the New York School* is a brilliant pastiche of Velazquez's *Surrender at Breda*, with Andre Breton and the School of Paris surrendering to Clement Greenberg and the New York painters. Tom Wolfe advanced the *"berg"* theory in *The Painted Word* (1975). Serge Guilbaut propounded the Cold War theory in his *How New York Stole the Idea of Modern Art* (1983).
11. "Poet and Painter Overture," reprinted in Schuyler 1998, p.2.
12. "My Heart," reprinted in O'Hara 1971, p.231.
13. "Farm Implements and Rudabagas in a Landscape," reprinted in Ashbery, *The Mooring Starting Out: The First Five Books of Poetry*, 1997, pp.260–61.

14. See below, p.60.
15. On the Tiber Press folios, see below, p.142.
16. Author's interview with Nell Blaine, March 30, 1994.
17. Berkson 1999, p.15.
18. See below, p.158.
19. Ashbery 1989.
20. "An Aspect of Fairfield Porter's Paintings," reprinted in Schuyler 1998, p.16.
21. Ashbery 1989, p.243.
22. Ashbery 1982, pp.130–35; reprinted in Ashbery 1989, pp.303, 308.
23. "The Brushstroke's Integrity," in Lehman 1980, pp.225–26.
24. Koch 1994, pp.62–69, 321.
25. Ferguson 1999; see also Lehman 2000, pp.117–21, 143.
26. "Personism" was written in 1959, a year marked by the emergence of independent post-colonial African nations, such as Ghana, which O'Hara mentions in "The Day the Lady Died," his elegy for Billy Holiday, written earlier that summer.
27. Quoted in Ferguson 1999, p.18.
28. Stevens 1951, p.171.

1 JOHN OPPER

1. For biographical information on Opper, see Montclair 1978; additional information from an interview with Jane Opper, the artist's daughter, New York, March 28, 2000.
2. Quoted by Delatiner 1989, p.19.
3. The 1932 *International Print Guild Portfolio* included prints by Louis Lozowick, Karl Hofer, Lucien Simon, David Young Cameron, Leon Underwood, Frank Brangwyn, John Edward Costigan, Wanda Gag, and Adolf Dehn.
4. Lowe 1937, p.17.
5. Opper organized colloquia and residencies for such Abstract Expressionist painters as Franz Kline, Philip Guston, Grace Hartigan, and Cy Twombly; see Click 1953, pp.1–4.
6. These paintings were shown at the Stable Gallery in 1962; see Petersen 1962, p.15; Raynor 1962, p.100.
7. Kramer 1979, p.C-22.
8. Delatiner 1989, p.19.
9. On Carman's use of offset lithography, see Adams 1983, p.148; Morse 1976, pp.432–34.
10. John Opper, *Quarry*, 1942, lithograph, 28.2 x 43.3 cm (image), Worcester Art Museum, Charlotte E.W. Buffington Fund, 1997.131.

2 JACKSON POLLOCK

1. For biographical information on Pollock, see Solomon 1987; Naifeh/Smith 1989.
2. See O'Connor/ Thaw 1978, cat. nos. P.1–12; Williams 1988, pp.347–51.
3. See Wysuph 1970; Varnedoe/Karmel 1998, p.80, n.44; Solomon 1987, pp.93, 95.
4. See Williams 1988, pp.361–66; Harrison 1995; Isselbacher 1998.
5. See Seiberling 1949; Goodnough 1951.
6. Williams 1988, pp.366–71.
7. Some scholars have identified Pollock's intaglio experiments as the point when he shifted to a linear design orientation (see Friedman 1972, pp.73–74; Rose 1979, p.15; Fichner-Rathus 1982). This idea may be valid, but Hayter's influence should not be overestimated, despite the claims of later years (see Halasz 1984); Pollock's association was with Kadish, not with Atelier 17 (see Naifeh/Smith 1989, p.870).
8. Kadish kept the practice plate until his death; see Naifeh/Smith 1989, p.490; Williams 1988, n.18; Harrison 1993, no.25.
9. Jackson Pollock, *There Were Seven in Eight*, about 1945, oil on canvas, 109.2 x 259.1 cm, New York, Museum of Modern Art, Mr. and Mrs. Walter Bareiss Fund and purchase. Other paintings contemporary with the etchings, which have similar imagery, are *The Night Dancer*, *Night Ceremony*, *Night Mist*.
10. See Naifeh/Smith 1989, p.493.
11. A decade after Pollock's death, Lee Krasner found the plates from Atelier 17 in his studio. Seven of them were eventually refurbished, reprinted, and copublished by the estate and the Museum of Modern Art (see Williams 1988, pp.356–59). However, these inferior reprints give an incorrect sense of the nature and quality of Pollock's intaglios.

3 REUBEN KADISH

1. For biographical information on Kadish, see Tully 1986, p.23; Weld 1990, pp.17–18, passim.
2. See Herman Cherry in Weld 1990, p.14.
3. During the Depression Kadish had a small business painting safes with faux-bois graining. In 1932 Jackson's brother, Sande Pollock (later Sanford McCoy), worked as his assistant, and they valued a lifelong friendship (see Naifeh/Smith 1989, p.202).
4. See *Time* 1935, pp.46–48; a photograph of the artists standing before their mural is reproduced in Weld 1990, p.2.

5. *Los Angeles Evening News* 1937. This show was organized by the artist Herman Cherry, who met Kadish and Goldstein through Feitelson five years before (see Cherry in Weld 1990, p.514).
6. See above, p.44.
7. See Campbell 1961, p.18; Smith 1961, pp.51–52.
8. See Tamarind 1989, pp.114–15; Langsner 1962, p.35; Cohn/Rogan 1998, pp.18–19, 34, n.13.
9. Reuben Kadish, *Untitled*, 1961, lithograph on cream wove paper, 76.3 x 56.7 cm (sheet), Albuquerque, The University of New Mexico Art Museum, the Tamarind Archive Collection (Tamarind number 314).
10. Edgar 1963, p.12.
11. Weld 1990; Pekarsky 1992.

4 ADOLPH GOTTLIEB

1. For biographical information on Gottlieb, see Hirsch/MacNaughton 1981, pp.11–28.
2. Reprinted and transcribed in Hirsch/ MacNaughton 1981, pp.169–71.
3. On Gottlieb's prints, see Harvey 1994.
4. See Friedman 1978, pp.96–102.
5. On the Pictographs, see Hirsch 1994.
6. See Linda Konheim Kramer, "The Graphic Sources of Gottlieb's Pictographs," in Hirsch 1994, pp.47–57.
7. Gottlieb 1947, p.52.

5 MARK ROTHKO

1. For biographical information on Rothko, see Waldman 1978, pp.265–79; Breslin 1993.
2. Published June 13, 1942; see Hirsch/ MacNaughton 1981, pp.169–71.
3. On Rothko in San Francisco, see Landauer 1996, pp.91–93.
4. See Carmean/ Rathbone/Hess 1978.
5. See Selz 1961.
6. See Cohn 1988; Nodelman 1997.

6 CLYFFORD STILL

1. For biographical information on Still, see Patricia Still in Kellein 1992, pp.145–68.
2. Sawyer 1960, p.80.
3. See Kuh/Moore 1966; San Francisco Museum of Modern Art 1976; O'Neill 1979; also Kellein 1992.
4. Kellein 1992, pp.147–48.
5. I am indebted to David Anfam, who saw photographs of Still's lithographs in the artist's

archive in 1989, and kindly shared his recollections and thoughts with me.
6. See Decker 1995, pp.112–15. While this impression is inscribed to Robert Neuhaus of the San Francisco Museum of Art, Still's other known lithograph (*Figure*, 1945, 33.3 x 21.9 cm [image], 50.8 x 33.0 cm [sheet], acc.no. 870–78) was given to the Museum of Modern Art by Dorothy C. Miller.
7. Anfam 1993, pp.260–69.
8. As suggested by Anfam 1993, p.267.

7 GEROME KAMROWSKI

1. For biographical information on Kamrowski, see Sawin 1988, pp.181–86; Maurer/Bayles 1983, pp.5–8.
2. See Simon 1967, pp.17–23.
3. See Thompson 1917. Several of Kamrowski's friends found this book useful and were influenced by its illustrations, including the sculptor Tony Smith.
4. See Wechsler 1977, pp.45–46; Sawin 1988, p.181; Barron 1990, pp.56–57.
5. Reed 1946A, p.15.
6. Breton (1972, pp.226–29) repeated his comments on Kamrowski in his *Le surréalisme et la peintre*, in 1965.
7. Breuning 1950, p.20; Seckler 1950, p.50.
8. Porter 1959, p.16.
9. Maurer/Bayles 1983.
10. The only vintage impression of Kamrowski's 1946 intaglios is now in Whitney Museum of American Art.

8 PETER BUSA

1. For biographical information on Busa, see Kraskin 1992, pp.56–62.
2. Indeed, one of these prints, *Mother & Child* of 1935, now in the artist's estate, reflects Barnet's materials and the manner that he used at this time to envision and plan changes to his intaglio plates. See Acton 1996, pp.83–85.
3. See Simon 1967, pp.17–23; Wechsler 1977, pp.45–46.
4. See Wolf 1946, p.18.
5. On the Indian Space Painters, see Brown 1951, pp.103–10; Gibson 1983, pp.98–104; Kraskin 1991.
6. Busa seems to have made some color screenprints in Buffalo in 1955 that generally reflect his contemporaneous painting style, which still retained the influence of Picasso. Lithographs in the artist's estate dating from

1956 to 1959 are disparate in style, ranging from representation to pure abstraction. Their inscriptions suggest that the lithographs were printed in editions of seven to ten impressions.

7. Peter Busa, *Tidal*, about 1960, lithograph, 14/22, 35.3 x 24.7 cm (image), Worcester Art Museum, Richard A. Heald Fund, 1999.23.

8. Anderson 1962.

9. See Flanagan 1973; Greenberg 1977. Busa did two more factory wall paintings for the Valspar Paint Company, in 1980 and 1983.

10. Peter Busa, *Transfigured Night*, 1946, watercolor, 27.3 x 34.2 cm, now in a private collection; see Kraskin 1992, p.26.

9 JULIETTE STEELE

1. For biographical information on Steele, see Falk 1985, p.592.

2. According to Steele's obituary (San Rafael *Independent Journal*, December 14, 1981), he had served in the First Lifeguards of His Majesty's Household Cavalry.

3. On Spohn, see McChesney 1973, pp.20–21; Landauer 1996, pp.41–44, 191.

4. See *Print Collector's Quarterly*, vol.30, June 1949, p.63; Steele's work also won a prize at the Montclair Art Museum the previous year.

5. Steele was a juror for the San Francisco Art Association annual exhibition in 1952, when two of her Abstract Surrealist lithographs were included in the show; see San Francisco Art Association 1952, cat. nos. 84, 85.

6. San Francisco Art Association 1958, p.36.

7. First published in Holmes 1858.

8. Quoted by Landauer, 1996, p.44, from Spohn's notes, now in the Archives of American Art.

10 NELL BLAINE

1. For biographical information on Blaine, see Sawin 1998, pp.138–44, passim.

2. Day made Abstract Expressionist prints herself during the 1950s, see Acton 1990, pp.190–91, 259.

3. See Blaine 1972.

4. Munro 1953, p.50.

5. Nell Blaine, *Abstraction*, 1947, from *nell blaine prints/kenneth koch poems*, linocut, 31.0 x 24.0 cm (sheet), Worcester Art Museum, Eliza S. Paine Fund, 1996.29. The book was published in an edition of 300, in New York, by the artists in conjunction with the Tibor de Nagy Gallery in 1953. Four of the linocuts were printed on separate sheets and tipped in,

while another five are full-page illustrations. Blaine designed the cover and typographical layout. The letterpress printing was done at Lowy Press in New York.

6. See Seiberling 1957, pp.9–10; Campbell 1959A, pp.38–42.

7. Her art-world friends organized the group exhibition *To Nell Blaine* at the Poindexter Gallery, which included the work of seventy-nine artists. Its proceeds helped pay her bills after she left the hospital.

8. On the verso there is a sticker bearing the artist's address and the price of $5.00. However, since the print was unhinged, it is unlikely that it was ever mounted, framed, or exhibited. Perhaps the artist placed it among the stock at the Jane Street Gallery.

11 NORMAN LEWIS

1. For biographical information on Lewis, see Gibson/Euell 1989, pp.58–62; Bearden/Henderson 1993, pp.315–27.

2. See King-Hammond 1989; Williams et al. 1993, p.53. Blackburn became one of the nation's leading lithographic printers, see Jones 1982–83; Parris 1985.

3. For example, the lithograph *Jazz*; see Williams et al. 1993, p.17.

4. For discussions of music and African-American visual arts, see Albert Murray in Melberg/Bloch, 1980, pp.17–28.

5. Quoted by Ann Gibson in Conwill et al. 1998, p.15. For a discussion of Lewis's position in the New York School, see Gibson 1992, pp.66–73.

6. On Spiral, see Gaither 1980.

7. The best-known of these prints is *Red Umbrella*, which grew out of Lewis's rhythmic and lyrical improvised line drawings; see Holland et al. 1998, cat. no. 81.

8. Lawson 1976.

12 HANS BURKHARDT

1. For biographical information on Burkhardt, see Story 1961; Karlstrom/Ehrlich 1990, pp.50–52.

2. He also painted *The Studio of Gorky* in two versions, one of which was featured in the Whitney Museum annual exhibition; see Krasne 1951, pp.6–7.

3. Story 1961.

4. See; Rutberg 1984; Gardner 1985, p.3.

5. *Rattle Snake August*, by William Everson, and *The Many Faces of Jake Zeitlin*, by Amando Blanco. The artist made linocuts for *The Last Good Kiss*, by Ray Bradbury.

6. Hans Burkhardt, *Graffiti, Basel*, 1983, linocut, 40.0 x 40.0 cm (image), Worcester Art Museum, Gift of the Hans G. and Thordis W. Burkhardt Foundation, 1996.72.14.

7. See Shedletsky 1994, pp.34–35, 108.

8. On Kistler, see Adams 1977, pp.100–09; Adams 1983, pp.161–62, 173.

9. Hans Burkhardt, *One Way Road*, 1945, oil on canvas, 88.4 x 101.6 cm, Los Angeles County Museum of Art, 45.17.1. This painting came into the museum collection in 1945, when it won a purchase prize in the Sixth Annual Exhibition of Artists of Los Angeles and Vicinity; see *Artnews* 1945, p.8.

13 FRANK LOBDELL

1. For biographical information on Lobdell, see Hopps 1966; Jones 1993; Landauer 1996, p.186.

2. See Jones 1993, p.7; Landauer 1996, p.143.

3. Other members of the group were Walter Kuhlman, James Budd Dixon, Richard Diebenkorn, George Stillman, and John Hultberg.

4. See below, p.70.

5. Sawyer/Lobdell 1949.

6. Hopps 1966.

7. See Tamarind 1989, pp.138–42; Devon 2000, pp.18–20.

8. The painting is reproduced by Albright/Boswell 1983, p.17.

9. Nordland 1969.

10. Albright/Boswell 1983.

11. Jones 1993; Nixon 1993, pp.4–5.

12. Frank Lobdell, telephone conversation with the author, August 25, 2000.

13. See Landauer 1996, p.103.

14 JOSEPH MEERT

1. For biographical information on Meert, see Harrison 1994, pp.3–10.

2. For reproductions of paintings from this period, see Berardi 1998, pp.17–19.

3. On Creative Printmakers, Inc., see Acton 1990, pp.44–46, 288–89. It is likely that Steffen, who had also been a student of Benton, helped Meert to get his job in the shop. In turn, Meert helped to find work there for Pollock; see Naifeh/Smith 1989, pp.434, 732.

4. *Artnews* 1949, p.46; Reed 1949, p.18.

5. See Cherry 1956, pp.14–17.

6. Joseph Meert, *Untitled,* about 1950, stained and leaded glass, 62.3 x 31.8 cm (sheet), estate of the artist, courtesy of Aaron Galleries.

7. Bradbury 1957, p.31.
8. See Potter 1985, p.34
9. A selection of his late watercolors was presented in a memorial exhibition in March 1991, at the Century Club in New York; the works were shown again in 1994, in a show at the Pollock-Krasner House in East Hampton, Long Island; see Harrison 1994.

15 JOHN HULTBERG

1. For biographical information on Hultberg, see Jacks 1985; Landauer 1996, pp.184.
2. Hultberg's journals are now in the Archives of American Art, reel N70/5.
3. See McChesney 1973, p.10.
4. See Kuh 1956, pp.22–23.
5. Tamarind 1989, pp.96–98.
6. Jacks 1985.
7. Henry 1994, p.140.
8. See Landauer 1996, pp.102–16.
9. Recounted in a letter from Frank Lobdell to the author, dated February 25, 1992.
10. Stone 1949, p.M-8.

16 GEORGE STILLMAN

1. For biographical information on Stillman, see Landauer 1996, pp.102–06, 191–92.
2. The others were Diebenkorn, Dixon, Kuhlman, Lobdell, and Hultberg; see Landauer 1996, pp.102–16.
3. See above, p.70.
4. George Stillman, *Untitled*, 1948, oil on canvas, Oakland Museum, see Landauer 1996, fig.420.
5. See Landauer 1996, p.102
6. George Stillman, *Untitled #5*, 1949, monotype touched with ink and gouache on cream wove paper, 26.0 x 13.1 cm (plate), Worcester Art Museum, Helen Sagoff Slosberg Fund, 1996.82. See Landauer 1993, pp.24, pl.VII; Moser 1997, p.113–14. Apparently Stillman attempted to market his monotypes through the artists' book market, for in 1950 he produced small folios, each containing five unique monotypes, which were published by Bern Porter in Sausalito; an example may be found at the UCLA Library (NC 1075.S85f).
7. Spurgeon Gallery 1991.
8. The pendant print is *Untitled*, 1948, 37.9 x 22.5 (plate), 48.2 x 32.1 cm (sheet), etching and aquatint on WARREN'S OLDE STYLE wove paper, inscribed in graphite, l.l.: *2nd proof*, GS.; Worcester Art Museum, Richard A. Heald Fund, 1999.74.

17 ANNE RYAN

1. For biographical information on Ryan, see Faunce 1974; Myers 1975, pp.8–11.
2. Ryan's surviving literary papers are now in the Special Collections section of the Newark Public Library, donated by her daughter Elizabeth McFadden in 1973. This material includes manuscripts of two novelettes, three poems, fifteen essays, and seventeen short stories. Among them is the typescript of *The Queen's Gift*, a fairy tale illustrated with five original color woodcuts.
3. See *Artnews* 1941, pp.46–52.
4. At the Newark Public Library there are examples of three of Ryan's early etchings, *In the Meadow*, *Dancers Resting*, and *Fugue* of 1943 (R9882.2.51–3). The twenty-five plates of her etched suite of *Constellations* of 1945 may be found at the Brooklyn Museum (45.35.1–25, each about 44.3 x 32.7 cm [plate]). The notes that Ryan took in her etching class at Atelier 17, along with a photograph of the artist and Stanley William Hayter, are now in the Archives of American Art (reel 88).
5. See Johnson 1952B, pp.4–5.
6. On Ryan's collages, see Faunce 1974; Cotter 1991.
7. Ryan adapted a technique developed at the artist's colony in Provincetown, Massachusetts, before 1920; see Flint 1983; Acton 1990, pp.15–16, passim.

18 LOUISE BOURGEOIS

1. For biographical information on Bourgeois, see Gardner 1994; Laure de Buzon-Vallet in Bernadac 1995, pp.163–86.
2. On Bourgeois's *Personnages* sculptures, see Strick 1974.
3. See Reed 1945, p.31.
4. See Wye/Smith 1994, pp.72–73.
5. See Lippard 1975.
6. Wye 1982.
7. See Wye/Smith 1994; the following year, this show was presented in Paris at the Bibliothèque Nationale de France, while an exhibition of the artist's drawings was shown simultaneously at the Musée National d'Art Moderne. On the artist's drawings, see also Bourgeois/Rinder 1995.
8. Many of the proofs of the fourteen states of *Ascension lente* are now in the Museum of Modern Art, and are reproduced in Wye/Smith 1994, pp.120–22. Among them is the only other known impression of the twelfth state printed in color (acc.no.90.94).
9. These are features that appear in Hayter's own pioneering prints of the day, such as *Cinq Personnages*. Hayter explained the process of creation and the development of these techniques in his book *New Ways of Gravure* (1949, pp.155–61).
10. This effect, and a geotropic compositional balance, are lost when the image is inverted, which the artist tried unsuccessfully, according to the erased inscription at the top of the plate.
11. Quoted in Wye/Smith 1994, p.120.

19 EDWARD DUGMORE

1. Ashton 1991, p.7.
2. For biographical information on Dugmore, see Ashton 1991, pp.30–31; Landauer 1996, p.182.
3. On the Metart Gallery, see Landauer 1996, pp.84–85.
4. Ashton 1991, pp.9–10.
5. Shedletsky 1994, pp.42–43; 104, 190.
6. Shedletsky 1994, p.42.

20 JACOB KAINEN

1. For biographical information on Kainen, see Avis Berman in Hopps/Agee/Berman 1993, pp.9–41.
2. The artist finally received his diploma from the Pratt Institute (dated 1930) in 1942.
3. See Kainen 1976; Kainen 1986. Gorky's portrait of the artist is reproduced in Hopps/Agee/Berman 1993, p.15.
4. See Kainen, "The Graphic Arts Division of the WPA Federal Art Project," in O'Connor 1972, pp.155–75.
5. Kainen 1962.
6. Together with his second wife, the writer and publisher Ruth Cole, the artist has assembled a distinguished collection of German Expressionist prints; see Robison/Kainen 1985.
7. Flint 1980.
8. See Hopps/Agee/Berman 1993; Gilkey/Hanson 1994.
9. The circumstances and technique of *Marine Apparition* were described in a letter from the artist to the author, June 12, 1997.
10. *Shoreline* is now in the collection of the Addison Gallery of American Art, Phillips Academy, Andover, Massachusetts; see Hopps/Agee/Berman 1993, pl.23.

21 WALTER KUHLMAN

1. For biographical information on Kuhlman see Carlson 1989; Landauer 1996, pp.106–10, 195–96; additional information from the author's interview with the artist, Sausalito, February 25, 1999.
2. Landauer 1996, pp.102–06.
3. See above, p.70; One of Kuhlman's prints in reproduced by Landauer (1993, p.24).
4. See Goldberg 1988.
5. See Krevsky 1996.

22 RICHARD DIEBENKORN

1. For biographical information on Diebenkorn, see Livingston 1997, pp.17–91.
2. Richard Diebenkorn, *Untitled,* from *Drawings,* 1948, offset lithograph on cream wove paper, 27.5 x 21.7 cm (image), Worcester Art Museum, Heald Foundation Fund, 1990.128.3. On the *Drawings* portfolio of offset lithographs, see above, p.70; for Diebenkorn's first drypoint, see Stevens/Guillemin 1981, pp.12, 128.
3. Tamarind 1989, pp.61–62.
4. Brown 1996, pp.20–24.
5. See Stevens/Guillemin 1981, pp.115–21.
6. See Buck 1978, pp.29–34; Ashton 1985.
7. Buck, et al. 1976.
8. See Stevens/Guillemin 1981; also Nordland 1989.
9. Elderfield 1988.
10. Elderfield 1991.
11. Information from the author's telephone conversation with Phyllis Diebenkorn, the artist's widow, August 30, 2000.

23 LAWRENCE KUPFERMAN

1. For biographical information on Kupferman, see Dunn 1974; further information from the author's interview with Ruth Cobb, the artist's widow, and David Kupferman, the artist's son, Newton, Massachusetts, April 27, 2000.
2. See Carey/Griffiths 1980, pp.35–46; see also Associated American Artists 1992.
3. *Artnews* 1946, p.55; Reed 1946B, p.15.
4. See *Artnews* 1948A, p.50; "Wet & Dry." *Time,* April 19,1948, pp.70–71; Reed 1948, p.13.
5. Dunn 1974.
6. Quoted by Dunn 1974, p.4.
7. Lawrence Kupferman, *Oceanic Forms,* 1950, oil on panel, 60.5 x 58.0 cm, Worcester Art Museum, Gift of the Aarons Family, 1991.241.

8. In his workbook, the artist described this drawing (EK413A) as "very delicate and ingratiating."

24 LEE MULLICAN

1. For biographical information on Mullican, see Cummings 1988, p.461 ; Karlstrom/Ehrlich 1990, pp.143–46.
2. Illustrated with offset lithograph reproductions of Mullican's drawings, *The Gain of Aft* was published by Bern Porter in Sausalito; see Swetzoff 1950, pp.19–22.
3. Onslow-Ford 1969, n.p.
4. See Reed 1950A, p.20; Robinson 1950A, p.48.
5. In his Surrealist journal *Dyn,* published in Mexico from 1942 to 1945, Paalen had promoted a broadly inclusive aesthetic vision; see Stiftung Ludwig 1993.
6. See Paalen's introduction, "Theory of the Dynaton," in *Dynaton 1951.* The name of the group was the same translated from the Greek as *Possibilities,* the title of the 1947 publication of Harold Rosenberg and Robert Motherwell, which articulated key concepts of the New York School. See also Mullican 1977; Halpern 1992.
7. Langsner 1953, pp.34–37, 66–67.
8. See Tamarind 1989, pp.168–71. In 1969 Mullican returned to Tamarind to produce two color prints (T.2824–25; Tamarind 1989, p.171).
9. See Mullican 1977; Phillips 1980; Larsen 1986; Karlstrom/Ehrlich 1990, pp.143–46; Halpern 1992.
10. This may have been the portfolio of prints mentioned by Hyman Swetzoff (Swetzoff 1950, p.22) due to be released that fall but never published.
11. Quoted by Langsner 1953, p.36.

25 EMERSON WOELFFER

1. For biographical information on Woelffer, see Gruenebaum 1978, pp.21–22. Further information was obtained from an interview by the author with the artist, Los Angeles, June 15, 2000.
2. Gruenebaum 1978, p.4.
3. See Ashton 1959.
4. See Tamarind 1989, pp.272–74.
5. See Nordland 1962.
6. See Schnelker/Booth 1980, pp.75–76.
7. Ayres/Dowell 1992.
8. See Drohojowska-Philip 1998, p.CAL-61.
9. See Adams 1983, pp.170–71.

26 ROBERT McCHESNEY

1. For biographical information on McChesney, see Landauer 1996, pp.133–35, 187; Fuller 1996.
2. On the *Mexico* series of paintings, a selection of which was shown in a solo exhibition at Gumps Gallery in San Francisco in 1954, see Frankenstein 1954, p.53.
3. On the *Slipsheets,* see Landauer 1993, pp.21–22.
4. Fuller 1977, p.2.
5. Paintings from McChesney's *Arena* series are in the collections of the Oakland, Laguna, Fresno, and San Francisco Museums; on this series see Barnitz 1966, p.58; Landauer 1996, p.135; Fuller 1990.
6. See Rourkes 1968; Stribling 1970.
7. There are eleven screenprints in the *Yermo Noche* series, which McChesney executed in his Sonoma Mountain studio in 1972. Ten are printed in black ink, while *Yermo Noche #11* is printed in colors similar to the acrylic paintings to which they relate.
8. Pilar 1996.
9. Compare with the oil painting *Composition A #1,* 1950, reproduced in Fuller 1996, p.12.

27 ALFONSO OSSORIO

1. For biographical information on Ossorio, see Friedman 1997, pp.17–18; O'Connor 1998, pp.43–44, passim.
2. See O'Connor 1998.
3. On the *Congregations,* see Friedman 1970; Kertess/Landau/Close 1997.
4. Wolfe 1980.
5. Dubuffet 1951.
6. Fodor 1949; see also O'Connor 1998, pp.11–14, n.22.

28 HASSEL SMITH

1. For biographical information on Smith, see Landauer 1996, pp.37–41, 136–41, 190.
2. See Albright 1985, p.16, fig.15; Landauer 1996, p.40.
3. McChesney 1973, p.26.
4. See MacAgy 1961; Hopps 1961.
5. Temko 1975.
6. Shere 1993; see also Nixon 1989.
7. Letter from the artist to the author of May 31, 1993.

29 HANS HOFMANN

1. For biographical information on Hofmann, see Goodman 1986, pp.117–22; Friedel/Dickey 1993, pp.101–07.
2. *Artnews* 1944.
3. Coates 1946.
4. Hofmann 1968; see also Goodman 1986, pp.163–77; Friedel/Dickey 1993, pp.92–99.
5. Wight 1957.
6. Seitz 1963.
7. See Long 1986, nos.28–31, for Hofmann's only other prints, three transfer lithographs. Trimmed away from the bottom margin of the present impression was the following letterpress inscription: *HANS HOFMANN COMPOSITION IN BLUE Courtesy of 67 Gallery, New York Publishers Tera-Gentle, New York*. A number of impressions of the print also bear a black stamp reading © *Esther Gentle, 1952*.

30 LEON GOLDIN

1. For biographical information on Goldin, see *Who's Who in American Art*, 1999–2000, p.453.
2. Letter to the author from the artist, January 15, 1992.
3. See Ashton 1952C, pp.8–9; Groschwitz 1954, pp.1, 3.
4. Letter to the author from the artist, January 15, 1992.

31 THEODORE BRENSON

1. For biographical information on Brenson, see Luigi Servolini, in Vollmer 1953, vol.1, p.309.
2. Brenson's publications include the series of etchings *Suite San Pietro* (1924–25); *Ancient Rome* (1925–27); *Portofino* (1934); and *Castellammare di Stabia* (1935).
3. See Focillon 1942, pp.8–25.
4. *Art Digest* 1942B, p.15.
5. See *Art Digest* 1942A, p.11; Fogg 1942.
6. See Munson 1949, p.58.
7. Wechsler 1989, pp.144–45.
8. On art education, see Brenson 1944, p.69.
9. On Brenson's late work, see Douglass College Art Gallery 1959.
10. See La Farge 1952, p.41.
11. Brenson 1954, pp.76–78.

32 HERMAN CHERRY

1. For biographical information on Cherry, see Joyaux/Tully 1989, pp.15–17, passim; Campbell 1990, pp.158–61.
2. Weeren-Griek 1948, p.34.
3. *See* Reed 1947, p.18.
4. Note the artist's reminiscences of Willem de Kooning and The Club; Cherry 1989, p.230.
5. Herman Cherry, *poems of pain—and other matters*, translated into drawing by Lewis Alcopley, UNA Editions, New York, 1976.
6. See Leites 1984, p.171; Harrison 1984A, p.7.
7. Joyaux/Tully 1989.

33 SONIA GECHTOFF

1. For biographical information on Gechtoff, see Loughery 1995; Landauer 1996, pp.156–59, 183.
2. Landauer 1996, pp.152–54, nn.95–96.
3. Among these was *From San Francisco: A New Language of Painting* at the Kaufmann Art Gallery of the YM-YWCA in New York (see Newbill 1954A, p.18). James Johnson Sweeney noticed her work there and included it in his exhibition *Younger American Painters* at the Guggenheim Museum (Sweeney 1954, cat. no. 16). Gechtoff's paintings also appeared in *Action I*, Walter Hopps's exhibition of Bay Area Abstract Expressionist paintings shown at the Merry-Go-Round building on Santa Monica pier in 1955.
4. Sonia Gechtoff, *The Mystery of the Hunt*, 1956, oil on canvas, 114.8 x 269.2 cm, San Francisco Museum of Art, gift of Irving Blum; reproduced in Landauer 1996, p.159.
5. See Langsner 1957, pp.64, 81.
6. A commemorative exhibition *Tribute to Mrs. Leonid Gechtoff* was mounted at the Ferus Gallery in Los Angeles in summer 1958, featuring the work of several artists represented by East and West Gallery in San Francisco, among them Jay DeFeo, Philip Roeber, Hassel Smith, Julius Wasserstein, Kelly, and Gechtoff.
7. See Tamarind 1989, pp.76–77. In addition to the *6 Icons* suite, Gechtoff created eight untitled lithographs, printed by Irwin Hollander.
8. Named after the jazz trumpeter Miles Davis and the printmaking workshop, Miles Tamarind Kelly became a professional musician in New York. When they received the news of his birth on October 3, 1963, the printers and artists at the Tamarind Lithography Workshop collaborated on a commemorative lithograph.
9. Tamarind 75–127; see Schnelker/ Booth 1980, p.29.
10. *2 x 3 > 7*, 1974, portfolio of lithographs, edition of 30, printed and published by Nancy Steen, a student of Gechtoff's at UNM, includes prints by Gechtoff, Kelly, and Steen.
11. Loughery 1995; see also Landauer 1993, pp.11–12, 44.
12. Compare, for example, the canvas exhibited in *Younger American Painters* at the Guggenheim in 1954 (Sweeney 1954, cat. no. 16).

34 JAMES KELLY

1. For biographical information on Kelly, see Moss 1990; Landauer 1996, pp.185, 252. Further information from the author's interview with the artist, New York, June 23, 2000.
2. Natsoulas/Novelozo et al. 1989, p.71.
3. See Tamarind 1989, pp.124–26.
4. *2 x 3 > 7*, 1974, lithograph portfolio, edition of 30, printed and published by Nancy Steen for Western Graphics Workshop, Albuquerque, New Mexico
5. Moss 1990.

35 DAVID SMITH

1. For biographical information on Smith, see Wilkin 1984; see also Smith/Gray 1968.
2. See Marter 1984.
3. See Marks/Stevens 1996.
4. Hunter 1957.
5. In 1960 a special issue of *Arts* magazine (vol.34, February) was devoted to Smith.
6. On Smith's prints, see Schwartz 1987.
7. Ponce de León, quoted by Adams 1983, p.185.
8. See Cummings 1979.
9. Although Schwartz recorded *Don Quixote* as an edition of about twenty-seven, the artist's inscription on the present impression, "*E37*," raises the question of whether he signed more prints. Smith's dedication on this print refers to his second wife, Jean Freas, and their first child, Rebecca, born in 1954. Since their daughter Candida arrived in 1955, it seems likely that the artist penned this inscription in 1954.

36 SYLVIA WALD

1. For biographical information on Wald, see Acton 1993.
2. See *Artnews*, vol.37, May 20, 1939, p.14.
3. On Gottlieb and the New York FAP screenprint unit, see Acton 1990, pp.142–43, 265.
4. See Bier 1949, p.5:5; Bier 1953, p.5:7.
5. At that time the Hite Art Institute purchased about thirty of Wald's silkscreens, which

remains the largest selection of her prints in a museum collection; see Meng 1993.

6. See Cole 1951A, p.25; Haas 1951, p.47; Johnson 1952A, cat. no. 78. Wald's screenprint *Sun Caught in a Rock* won a purchase prize at the Brooklyn Museum print national exhibition in 1954.

7. Sylvia Wald, *Black Moonlight*, 1961, woodcut on cream wove paper, ed.10, 60.5 x 45.0 cm (image).

8. Browne 1967, p.16.

9. Acton 1993; Acton/Jessup 1996.

37 JAMES BUDD DIXON

1. For biographical information on Dixon, see Landauer 1996, pp.110–16, 182.

2. From school records, Landauer (1996, p.235, nn.99, 107) determined that Dixon attended the CSFA from 1923 to 1926 and in 1929–30. After a year enrolled as a GI Bill student, he joined the faculty in 1949.

3. On the *Drawings* portfolio of offset lithographs, see above, p.70.

4. Dixon must have been well acquainted with Bertrand (see Hughes 1990, vol.2, p.47) since their student days together the CSFA. On the FAP/WPA, Bertrand painted murals in Coit Tower, and also printed in the project lithography shop with Joseph Danysh. To enable distant project artists to draw their designs on paper and send them to San Francisco to be printed, Bertrand and Danysh perfected a new kind of transfer paper (see Adams 1983, p.128).

5. See Tapié 1960; on Tapié see below, p.130.

6. The most important posthumous exhibition of Dixon's work was mounted at the College of Notre Dame Art Gallery in Belmont, California, in 1977; see Strong 1977; Moss 1977, p.6.

7. According to Susan M. Anderson (1990, p.9).

38 ALBERT URBAN

1. For biographical information on the artist, see Acton 1990, p.288.

2. Reed 1944, p.30.

3. Breuning 1946, p.7.

4. Sawin 1955B, pp.26–27.

5. Porter 1958, p.46; Ventura 1958, pp.56–57.

6. Miller 1959, pp.80–84; Arnason 1961, pp.79, 95, 130.

39 DOROTHY DEHNER

1. For biographical information on Dehner, see Marter 1993, pp.61–63, passim.

2. There seem to have been about twenty-five works in this series, eighteen of which are now in the collection of the Storm King Art Center in Mountainville, New York (acc. nos. 1978.5–17, 1979.10, 1982.5–6, 1984.1, 1985.1); see Tully 1983, pp.58–61.

3. Skidmore 1948. For a consideration of Dehner's relationship with Smith, see Marter 1984.

4. See Ashton 1952B, p.19; Campbell 1952B, p.82.

5. See Weeren-Griek 1965; Grossberg 1965, p.54.

6. Schnelker/Booth 1980, p.24; on Dehner's prints, see also Teller 1987; Glaubinger 1995.

7. Marter 1993.

8. Haeckel 1904.

40 JOSEPH FIORE

1. For biographical information on Fiore, see Thompson 1995; *Who's Who in American Art* 1999, p.379.

2. Harris 1987, pp.151–60.

3. See Campbell 1960A, p.17; Judd 1960, pp.51–52.

4. See Frackman 1969, p.65; Downes 1969, p.14.

5. Thompson 1995.

6. Oppenheimer 1956; Fiore's print is included in the volume in a special author's edition of thirty impressions.

41 DOROTHY MCCRAY

1. For biographical information on the artist, see McCray Gallery 1993; additional information from the author's interview with McCray, Silver City, New Mexico, February 19, 1999.

2. On Francis McCray, see Battenburg/Dawson 1963, pp.23–25. He also produced illustrations and book jackets for children's books, such as Madeleine Durrow Hodson's *The Log Cabin Family* (New York, 1940).

3. See Adams 1991, p.55.

4. See Groschwitz 1956, cat. no. 57.

42 CLAIRE FALKENSTEIN

1. For biographical information on Falkenstein, see Henderson 1991. Additional information from an interview with the artist in Venice, California, March 25, 1993.

2. In 1947 a selection of her plastic sculptures was exhibited at the Architectural League in New York; see *Artnews*, vol.45, January 1947, p.52; see also Falkenstein 1947, p.29.

3. Henderson 1991, pp.122–23.

4. On Tapié, see Bandini 1997.

5. Tapié 1946.

6. Tapié 1952.

7. See Tapié 1960.

8. Claire Falkenstein, *Struttura grafica*, 1963, eleven collagraphs in colors and blind embossing on cream Fabriano wove paper, 70.3 x 50.2 cm (sheets), edition of 70, 30 artist's proofs; the prints are accompanied by a biography, foreword by Tapié, and an essay by the Milanese critic Berto Morucchio; see Anderson Gallery 1993, pp.11–12.

9. Claire Falkenstein, *Fiori*, 1968, lithograph on white Japan paper, 8/60, 64.1 x 47.4 cm (folded), private collection.

10. Plake 1980.

11. Shedletsky 1994, pp.44–49, 167–69.

43 ROLAND GINZEL

1. For biographical information on Ginzel, see Weller 1955, pp.44–45; Bradley 1986, pp.7–13; further information from the author's interview with the artist, Stockbridge, Massachusetts, July 13, 1999.

2. On Ellen Lanyon, see Balken 1999.

3. Each year the works for *Exhibition Momentum* were selected by a panel of artists, dealers, and critics, with jurors from outside the Chicago area, many of whom were associated with Abstract Expressionism, including Jackson Pollock (1951), Robert Motherwell, Betty Parsons, and James Johnson Sweeney (1954), Charles Egan and Jack Tworkov (1956), Philip Guston and Franz Kline (1957).

4. Ginzel was impressed by a show of the Iowa Print Group at the Art Institute of Chicago, similar to a traveling exhibition of works by Lasansky and his students by the Walker Art Center in 1949; see Friedman 1949. On Lasansky, see Thien/Lasansky 1975.

5. See Mark Pascale, in Yood 1996, pp.21–24.

6. Evans 1975.

7. See Bonesteel 1986, p.71; Westerbeck 1986, pp.144–45.

8. Una Johnson (1956, p.29) credited Ginzel with the invention of intaglio printing from nonmetallic materials on an additive surface. The artist's process was developed further by Glen Alps in Washington State, who named the technique *collagraph*, to describe the workable gluey surface that can be printed either in relief or as intaglio after it dries (see Baro 1979). Alps also used Duco cement for his collagraphs in the 1950s, and later switched to

polymer acrylic, sometimes burning imagery into its dried surface.

9. One of these lacquer paintings, *March 15, 1955*, is reproduced in Bradley 1986, p.2.

44 MARK TOBEY

1. For biographical information on Tobey, see Kosme de Barañano in Barañano/Bärmann 1997, pp.443–97.
2. Riley 1944, p.19.
3. A selection of these was shown at the Galerie Stadler in Paris, see Schneider 1958, pp.46, 54.
4. Mark Tobey, *Untitled*, 1970, lithograph on white wove paper, 16/60, 45.5 x 56.2 cm (sheet) private collection.
5. O'Hara 1958.
6. Note Roberts/Gilkey 1984, a survey exhibition of Tobey's prints from the collecton of Hans and Thordis Burkhardt.
7. Whitney 1971; Spangenburg 1972; see also Heidenheim 1976.
8. In a letter from Tobey to Feininger, Seattle, August 10, 1955; see Hauser 1991, p.157.

45 DEBORAH REMINGTON

1. For biographical information on Remington, see Schimmel/Ashton 1983; *Who's Who in American Art 1999–2000*, p.1015.
2. Quoted in McChesney 1973, p.11.
3. On the history of the Six Gallery, see Bruce Nixon in Natsoulas/Novelozo et al. 1989, pp.33–44. The name of the co-op gallery came from its six original members, which also included Wally Hedrick, John Allen Ryan, Hayward King, David Simpson, and Jack Spicer.
4. See also Michael McClure, "The Poetry of the 6," in Natsoulas/Novelozo et al. 1989, pp.19–26.
5. See Kenedy 1974; Robins, 1977; Kuspit 1979.
6. Schnelker/Booth 1980, p.57.
7. See Schimmel/Ashton 1983.
8. Thompson 1987, pp.126–27.
9. Quoted in McChesney 1973, p.11.

46 BERNARD CHILDS

1. For biographical information on Childs, see Johnson 1969, pp.118–21; Acton 1990, p.256.
2. See Restany 1959, pp.25–27.
3. Stedelijk 1959.
4. Storm King 1969; see also Flint 1988.
5. Childs explained his techniques in a letter to

Joan Hansrath, dated November 17, 1965, which is now in the Archives of American Art; Reel 81.
6. Quoted in Johnson 1969, p.118.

47 FRANZ KLINE

1. For biographical information on Kline, see Gaugh 1985, pp.174–80.
2. Among Kline's early etchings is a view of MacDougal Street in Greenwich Village (see Gaugh 1972, no.248; De Kooning 1962, no.1; Gordon 1968, no.1, illus. p.8, fig.1). One *Studio Interior* was used as a holiday greeting card (see Gaugh 1972, no.419, p.108; De Kooning 1962, no.5); another *Studio Interior* in etching with drypoint was made in 1940 (see Gaugh 1972, no.408). Sometime between 1939 and 1941 Kline also made an etched *Portrait of Sam Kramer* (see Gaugh 1972, no.354).
3. Naifeh/Smith 1989, pp.749–50.
4. See Brach 1951, p.19; Porter 1951, p.49.
5. See Goodnough 1952 with its photographs of Kline at work by John Gordon Ross; and Seiberling 1959, accompanied by Bert Stern's photographs.
6. On *21 Etchings and Poems*, see above, p.14.
7. Franz Kline, *Untitled (Study for Elizabeth)*, 1957, ink and paper collage on white wove paper, 29.2 x 30.5 cm (sheet), private collection.
8. In 1958 O'Hara published an interview with Kline in the *Evergreen Review*, and he wrote the catalogue introduction for the artist's retrospective exhibition at the Museum of Modern Art in 1960. Both are reprinted in O'Hara 1975, pp.40–52.
9. A handwritten note from O'Hara, now at the University of Texas at Austin, implies that Kline had the manuscripts of different verses before they were sent to Weisenthal.
10. Franz Kline, *Elizabeth*, 1958, oil on canvas; see Anfam 1994, cat. no. 51.

48 ALFRED LESLIE

1. For biographical information on Leslie, see Schimmel et al. 1984, pp.148–49; Flynn 1992.
2. Porter 1952, p.39.
3. See Schimmel, et al. 1984, pp.102–13.
4. See above, p.22.
5. See Flynn 1992.
6. Now in the Saint Louis Art Museum; see Stein/Shapiro 1991; Lehman 1998, pp.167–68.
7. Arthur 1976.
8. Leslie painted a double portrait *Floriano*

Vecchi and Richard Miller, 1970–71, oil on canvas, 273.6 x 182.4 cm; see Arthur 1976, cat. no. 5; Frumkin 1975, cat. no. 8.

9. At Tiber Press Leslie also created two seminal Pop Art multiples. *Lady with Tomatoes* of 1962–63, has a color screenprint glued to one face of a ten-inch cardboard cube. In *Lady on a Can* he glued a label-like silkscreen to one side of a metal gas can filled with plaster or cement. The sizable editions of both works were all but destroyed in the fire of 1966. They were the models for the cans and boxes of Andy Warhol, who was a frequent visitor to Tiber Press in the early 1960s.

49 ROMAS VIESULAS

1. For biographical information on Viesulas, see Falk 1999, vol.3, p.3408.
2. See O'Hara 1954, p.58; Newbill 1954B, p.24.
3. See Tamarind 1989, pp.260–62; see also Garvey 1961, pp.209–11; Devon 2000, pp.9–10.
4. Baskett 1967, n.p.
5. In 1962 and 1968; see Baro 1976, cat. nos. 302–03.
6. These prints were included in the artist's solo exhibition at the Weyhe Gallery in New York in 1968. See Baskett 1968, p.23; for notes on the technique of embossing, see Viesulas 1979, pp.101–05.
7. On the artist's subsequent technical experiments in printmaking, see Viesulas 1974, pp.249–52; Baro 1976, pp.120–21, 148.

50 WARRINGTON COLESCOTT

1. For biographical information on Colescott, see Richard Cox, "Warrington Colescott: Forty Years of Printmaking," in Cox/Overland 1988, pp.3–20; see also Colescott/Hove 1999, pp.51–67.
2. See Cox 1991.
3. Madison 1979.
4. Cox/Overland 1988.
5. Andera/Gilmour 1996.
6. Occasionally in the 1950s Colescott printed variant editions with minor changes in one screen or in the colors. He indicated this variation by adding a Roman numeral to the title.

51 ELAINE DE KOONING

1. For biographical information on Elaine de Kooning, see Marjorie Luyckx in Bledsoe 1992, pp.105–09; Hall 1993.
2. See Campbell 1960, pp.40–44, 61–63. Over a

decade later, de Kooning's first lithographs, made at the Tamarind Institute, derived from her bullfight series; see Schnelker/Booth 1980, pp.24–25.

3. On de Kooning as a portraitist, see Campbell 1963, pp.38–39, 63–64; see also *Art in America* 1975, pp.35–36.

4. See de Kooning 1964, pp.37, 64–65; Hall 1993, pp.226–27.

5. See Arts Club of Chicago 1983; Hall 1993, pp.298–300; the prints were made at the Tamarind Institute in 1976, see Schnelker/Booth 1980, p.25.

6. See Brown 1996, pp.120–21, 128–29.

7. See Schuyler 1957, p.12; Sawin 1957, pp.55–56.

52 DENNIS BEALL

1. Biographical information on Beall from the author's interviews with the artist, Cazadero, California, August 18, 1996.

2. See Beall/Heyman1966; this exhibition was circulated in Europe for the Art in the Embassies Program by the American State Department from 1966 to 1968.

3. See Monte 1965, pp.2–44; Gray 1966, p.60; French 1967, p.60.

4. Achenbach 1968.

5. E-mail from the artist to the author, March 8, 2000.

6. Beall described the process himself, in the catalogue for an exhibition of prints by George Miyasaki at the Achenbach Foundation, which he helped to organize; see Troche/Beall 1963, pp.3–4.

53 NATHAN OLIVEIRA

1. For biographical information on Oliveira, see Garver/Neubert 1984; Jones 1990, pp.98–119.

2. See Ball 1980.

3. See Jones 1990.

4. Tamarind 1989, pp.180–82; see also Schnelker/Booth 1980, p.52.

5. Jones 1973.

6. Garver/Neubert 1984; see also Adams 1982, pp.4–9.

7. On Oliveira's monotypes, see Baxter Art Gallery 1979; Johnson et al. 1997.

8. In an interview with the author, New York, November 5, 1998.

54 EDMOND CASARELLA

1. For biographical information on Casarella, see Cummings 1988, pp.171–72; Acton 1990, p.242–43, 254.

2. See Acton 1990, pp.42–43.

3. Ashton 1953, p.20.

4. See Holliday 1953, pp.61–62.

5. See Chaet 1958, pp.66–67; Johnson 1980, pp.134–37.

55 ROBERT CONOVER

1. For biographical information on Conover, see *Who's Who in American Art* 1997–98, pp.240–41. Additional information from the author's interview with Christine Conover, the artist's daughter, New York, March 30, 2000.

2. See Krasne 1950, pp.16–17; Robinson 1950, pp.46–47. In 1950 Conover was cited as a promising painter in an overall review of the fine and lively arts in *Mademoiselle* magazine (see Lernan 1950, p.167).

3. See Thaw/Landau 1992, cat. no. 9; Ashton 1951, p.51.

4. See Johnson 1952, p.26; Johnson 1956, pp.44–45.

5. See Fitzsimmons 1952, p.19; Campbell 1952, p.48.

6. See Browne 1968, p.13; Conover had solo exhibitions at the New School for Social Research in 1974, 1977, 1986 and a memorial exhibition following his death in 1998.

7. Conover developed his own version of an old woodcut technique used by Edvard Munch; see Baro 1976, p.30.

8. See Sloat 1999, p.19.

56 LARRY RIVERS

1. For biographical information on Rivers, see Rivers/Weinstein 1992; see also Harrison 1984; Hunter 1989.

2. See Porter 1954, pp.56–58, 81–82.

3. Sparks 1989, pp.238–55.

4. Hunter 1965.

5. Rivers/Weinstein 1992, pp.463–67; Rivers/Brightman 1979, pp.171–76.

6. Haenlein 1980.

7. See Sparks 1989, pp.16–24.

8. Rivers 1982, pp.101–02.

9. Rivers hand-colored two impressions on Howell handmade paper, and then printed the edition including this impression, indicated by the inscribed Roman numeral II; another edition of four impressions on Arches followed.

57 GEORGE MIYASAKI

1. For biographical information on Miyasaki, see Wirtz Gallery 1981; Acton 1990, p.275; Acton 1992, pp.1–16.

2. Quoted by Goodman 1992, p.10.

3. For the same reason Miyasaki later admired Jasper Johns's lithograph *Hanger*, in which a wire coat hanger emerges from a web of crayon scribbles.

4. This exhibition opened simultaneously at eight distant museums; see Print Council 1959, no.38; see also Mayer 1962, nos.32–33.

5. Tamarind 1989, pp.129–30, 163, 271; see also Devon 2000, p.24.

6. Troche/Beall 1963.

7. Wirtz Gallery 1981; Morris 1988, p.205.

8. Quoted by Goodman 1992, p.9.

9. Quoted by Goodman 1992, p.9.

58 JULIUS WASSERSTEIN

1. For biographical information on Wasserstein, see Albright 1985, p.321; Landauer 1996, p.193.

2. See Landauer 1996, p.152–54.

3. Chipp 1959, p.24.

4. Natsoulas/Novelozo et al. 1989, p.52.

5. Ventura 1964, p.25.

59 ULFERT WILKE

1. For biographical information on Wilke, see Nordland 1983.

2. On Rudolf Wilke, see Rosenthal 1973. Mally Brandes Wilke, the artist's mother, was a granddaughter of the painter Willy Brandes.

3. Ulfert Wilke, *Music To Be Seen*, Louisville, Kentucky, Erewhon Press, 1957, comprising photomechanical reproductions of twenty-four of his drawings, printed in an edition of 400 copies numbered and signed by the artist, and accompanied by a foreword by Mark Tobey; see Nordland 1983, pp.26–35.

4. See Burrey 1958, p.57.

5. See Wilke 1958, p.55.

6. Ulfert Wilke, *Fragments from Nowhere*, 1958, a portfolio of nineteen photomechanical reproductions on white wove paper, 37.9 x 35.5 cm (sheets), edition of 200, with title page, introduction, and typeset list of plates, printed by Kuroyama Collotype Printing Company, Kyoto.

7. Ulfert Wilke, *One, Two and More*, 1960, a portfolio of twenty-three photomechanical reproductions on white wove paper, 50.0 x 37.1 cm (sheets), edition of 400, with title page, and

typeset introduction, printed by Kuroyama Collotype Printing Company, Kyoto.

8. See Tamarind 1989, p.271.
9. See Campbell 1965, p.50.
10. These seem to have been made at the same time as another drypoint in which Wilke used a spinning electric drill to rapidly scrawl a cluster of calligraphic lines into the copper plate. *Untitled*, 1959, power drypoint on cream laid paper, 1/10, 37.6 x 30.2 cm (plate), 47.8 x 40.6 cm (sheet); inscribed in graphite below image: *1/10 UW* (intertwined) *'59*; Worcester Art Museum, Alexander and Caroline DeWitt Fund, 1998.114.
11. Tobey's foreword is reprinted in its entirety in *College Art Journal*, vol.16, summer 1957, p.4.
12. See Nordland 1983, p.33.

60 PERLE FINE

1. The Social Security Death Index provides this birth date, over which there is discrepancy in the literature. For biographical information on Fine, see Deitcher 1978; Rubenstein 1982, pp.299–301.
2. Alice Trumbull Mason, Gerome Kamrowski, and Nell Blaine were also among the Guggenheim fellows at that time; see Lukach 1983, pp.151–52.
3. Perle Fine, *Weathervane*, 1944, etching and aquatint with engraving on cream laid paper, 4/25, 13.5 x 12.6 cm (plate), private collection; this print was one of two of Fine's intaglios included in the exhibition *Hayter and Studio 17* at the Museum of Modern Art in 1944; see Sweeney 1944, cat. no. 8.
4. Quoted by Franklin 1947, p.25.
5. Burrey 1955, p.27.
6. Campbell 1963, pp.52–53.
7. Rousseau 1982, p.6.
8. Organized in association with the Brooklyn Museum, this exhibition was afterward circulated by the American Federation of Arts; see Gordon/Johnson 1957, cat. nos. 10–12.

61 JOAN MITCHELL

1. For biographical information on Mitchell, see Marshall/Tilkin 1997, pp.97–109.
2. Brach 1953, p.16.
3. See Carnegie Museum 1972.
4. Tucker 1974; Paris 1982.
5. See Sheehan 1993, cat. nos. 12–17; see also E.C. Goossen, "Spontaneity and the Print," in Armstrong et al. 1987, pp.62–87.
6. See Sheehan 1993, cat. nos. 1–4. This is one of

three extant impressions of this screenprint, which Floriano Vecchi kept in his archive of works from Tiber Press for over forty years.

62 ROBERT GOODNOUGH

1. For biographical information on Goodnough, see Bush 1982.
2. Goodnough went on to study ten New York School painters who most interested him, and wrote a thesis to complete his master's degree in spring 1950; see Goodnough 1950.
3. Notable among his critical writings are articles on Pollock and Kline; Goodnough 1951; Goodnough 1952; see also Goodnough 1965.
4. See Boswell 1952, pp.18–19; Porter 1952, p.42.
5. Bush 1982, pp.80–81.
6. On Goodnough's ULAE prints, see Sparks 1989, pp.108–11, 334–35.
7. Robert Goodnough, *Dinosaur*, 1965, lithograph on cream wove paper, 75.0 x 105.0 cm (sheet), Worcester Art Museum, gift of the artist, 1997.17. Only proofs of this lithograph were pulled, and although the present impression was embossed with the ULAE chop, it was never published.
8. See Myers 1969.
9. See Grand/Adams 1994.

63 WILLEM DE KOONING

1. For biographical information on de Kooning, see Hall 1993.
2. See Greenberg 1948.
3. On *21 Etchings and Poems*, see above, p.140; on de Kooning as a printmaker, see Graham 1991.
4. Ashton/de Kooning 1965.
5. Hess 1968.
6. Ashbery 1971, pp.117–28.
7. Bompuis/Stoullig 1984.
8. See Adams 1982, pp.4–9; Graham 1991, pp.16, 17.
9. Miyasaki later helped James Suzuki, John Grillo, Sam Tchakalian, and Harold Paris to make large prints on the press at Berkeley.

64 ARTHUR DESHAIES

1. For biographical information on Deshaies, see Cummings 1988, p.214.
2. See Swan 1948, p.2.
3. See Haas 1955, p.13.
4. See Ashton 1952, p.11; Johnson 1952, p.27.
5. Sheets of clear methyl methacrylate were marketed as a safe alternative to window glass in

the United States, under the two trade names, Plexiglas and Lucite. In Europe the material is known as Perspex.

6. See Burrey 1956, p.25.
7. See Gray 1966, p.61.
8. For further discussion of this technique, see Ross/Romano 1972, pp.55–56.
9. Deshaies 1961, p.22.

65 SAM FRANCIS

1. For biographical information on Francis, see Selz 1982, pp.284–87.
2. Sweeney 1967.
3. On Francis as a printmaker, see Lembark 1992.
4. Buck et al. 1972.
5. See Feinblatt/Butterfield 1980.
6. Sparks 1989, pp.71–72.

66 HAROLD PERSICO PARIS

1. For biographical information on Paris, see Gilkey 1986, pp.14–16.
2. One of Paris's sketchbooks from his time as a *Stars and Stripes* correspondent is in the Archives of American Art, reel 4013.
3. See Cole 1951, pp.19–20; also Johnson 1952X, pp.4, 31; McNulty 1952, pp.10–11.
4. Krasne 1954, p.22.
5. The definitive portfolio of twenty-one prints was purchased by the Philadelphia Museum of Art (Katherine Levin Farrell Fund, acc. no. 58-62.1–28). It includes one lithograph and twenty intaglio prints from metal and Lucite plates, among them color variants of *In the Garden* (58-62.16, 16A) and *The Innocents* (58-62.17, 17A, 17B); see McNulty 1961. The *Hosannah* suite was exhibited at the Portland Art Museum in Oregon in 1986–87, see Gilkey 1986.
6. On Paris's *Walls*, see Lawrence Dinnean, in Selz 1972, pp.13–19.
7. In 1967 Paris's work was featured in two prominent group sculpture exhibitions on the West Coast: *American Sculpture of the Sixties*, at the Los Angeles County Museum of Art, and *Funk*, at the University of California at Berkeley; see also Paris 1967, pp.94–98.
8. A second version of *Room I* was exhibited at Mills College in Oakland in 1967.
9. *An Unforgiven Vision — 25 Years of Graphics*, Berkeley Art Center, 1970; seven years after the artist's death, another retrospective exhibition of his prints was mounted at the Portland Art Museum in Oregon, see Gilkey 1986.

10. Selz 1972.
11. Harold Paris, *Thoughts about a Sculpture*, 1961, three embossings on white DeWint laid paper, twelve etchings with lift ground and drypoint on tan Crisbrook handmade paper, edition of 30. Begun at the Pratt Graphic Art Center in New York in 1960 (see McNulty 1963, p.14), the portfolio was completed in Berkeley in August 1961.
12 . See Barton 1906, pp.653–54.

67 ADJA YUNKERS

1. For biographical information on Yunkers, see Robinson 1988; Rachel Evans in Bartelik 2000, pp. 121–25. When Latvia became an independent nation in 1919, all citizens were required by law to add an "s" to their surname. In 1926, when the artist lived in Cuba, he changed the spelling of his name again, to assure its correct pronunciation in Spanish.
2. On the identification of Yunkers's school, see Robinson 1988, pp.3–4; Bartelik 2000, p.15.
3. For the remarkable story of this tragic love affair, see Bartelik 2000, pp.20–26.
4. Bartelik (2000, pp.27–28) questions the location and extent of this fresco cycle, a feature of Yunkers's biography, which was supposedly destroyed by a bomb during World War II.
5. Over the next two decades, the artist supported himself chiefly by teaching: at the New School from 1947 to 1956; at the Cooper Union from 1956 to 1967; and in temporary residencies at the Honolulu Academy of Arts, the University of Colorado, the University of California at Berkeley, Columbia University, and Barnard College.
6. See Yunkers 1949, p.52; Moser 1997, p.141.
7. See Fitzsimmons 1953, p.14; Breeskin 1953, pp.4–7; Bartelik 2000 pp.49–55.
8. Johnson/Miller 1969.
9. Tamarind 1989, pp.277–79; see also Johnson/Miller 1969, pp.21–22, 34; Adams 1983, p.203; Graham 1987, pp.19, 80.
10. The *Salt* suite may have been related to Ashton's plans for a projected magazine of that name; see Bartelik 2000, p.117, n.26; Devon 2000, p.34, n.17.

68 GRACE HARTIGAN

1. For biographical information on Hartigan, see Mattison 1989, pp.148–49.
2. See Campbell 1951, p.46; Fitzsimmons 1951, p.18; see also Baur 1954.
3. See Lehman 1998, pp.21–27.

4. See Mattison 1989, pp.26–30; most of the *Oranges* series were shown again at Tibor de Nagy in 1959, along with *Stones*, O'Hara's and Rivers's collaborative lithographs; see Campbell 1959, p.18; Tillim 1959, p.62.
5. On the Tiber Press portfolios, see above, p.142.
6. Ketner 1981.
7. See Mattison 1989; also Edelman 1991, p.117.
8. DeSalvo/Schimmel 1992; see also Goldberg 1993, pp.30–31.
9. See Sparks 1989, pp.341–42.
10. Hartigan's next ULAE project, *The Archaics*, was based on Guest's verse drawn from Virgil's *Aeneid*. The artist conceived of this as an extensive suite of prints, to be published in conjunction with Guest's text. She completed four lithographs in 1961, but the project foundered, and it was not until 1996 that those prints were released, without the text.

69 MICHAEL GOLDBERG

1. For biographical information on Goldberg, see Shapiro/Gilbert-Rolfe/Longari 1997, p.130, passim.
2. Campbell 1953, p.47; Rosenberg 1953, p.20.
3. See Schimmel et al. 1984, pp.66–77; also Berkson 1964, pp.42–45, 65–67.
4. On Tiber Press portfolios see above, p.142.
5. See Ratcliff 1971, p.20; Stewart 1975, p.104.
6. Johnston 1979, pp.42–45.
7. Katz 1996, pp.117–28.

70 HELEN FRANKENTHALER

1. For biographical information on Frankenthaler, see Elderfield 1989, pp.408–18.
2. See Cross/Brown 1998.
3. On Frankenthaler as a printmaker, see Harrison 1996.
4. Goossen 1969.
5. Krens 1980.
6. Carmean 1989; Fine 1993.
7. See Sparks 1989, pp.76, 78–79.
8. See Fine 1993, pp.34–35.
9. Frankenthaler 1977, p.66.

71 MATSUMI KANEMITSU

1. For biographical information on Kanemitsu, see Donovan/Kanemitsu 1990, pp.72–78; the artist's papers, 1970–1990, are in the Archives of American Art.
2. Donovan/Kanemitsu 1990, p.4.
3. See Tamarind 1989, pp.115–17.

4. See Uyemura 1988, pp.1, 10.
5. The *Mikey Mouse Series* (1970, Tamarind 2881–89, 2923–31, 2940) of abstract prints combines painterly gesture with cartoon shapes; it was published in a leather-covered box in a shape with mouse ears. See Donovan/Kanemitsu 1990, pp.30–33.
6. In 1978 *Four Stones for Kanemitsu* was nominated for an Academy Award for Best Documentary and was a finalist in the fine arts category at the American Film Festival.
7. Donovan/Kanemitsu 1990. See also the memorial exhibitions of the artist's work, Nordland 1993; Doizaki Gallery 1993.

72 KARL KASTEN

1. For biographical information on Kasten, see Eiselin 1997, pp.18–19; Landauer 1999, pp.49–56.
2. See above, p.172.
3. For a discussion of collagraphy, see above, pp.00–00.
4. See Meilach/Ten Hoor 1973, pp.178–81. Kasten knowingly adapted the principle of an old color woodcut technique, used in Renaissance block books and later by Edvard Munch and many other artists.
5. See Tamarind 1989, pp.122–23.
6. Landauer 1999.

73 VINCENT LONGO

1. For biographical information on Longo, see Acton/Goldman 1995.
2. On Schanker see Johnson 1943; Acton 1990, pp.128–29, 283–84.
3. Una E. Johnson, the influential curator at the Brooklyn Museum, recognized the talents of these printmakers and collected their work. Longo's prints were included in her prestigious print national exhibitions in 1955, 1956, and 1968.
4. In teaching reductive relief printmaking, for example, Longo used wood veneers, cut to shapes and glued to a cardboard support, as a simple alternative to a fully carved plank in a multiple-block color woodcut; see Peterdi 1959, pp.230–31.
5. Baro 1970.
6. On Longo's paintings of that period, see Westfall 1989, p.174.
7. Acton/Goldman 1995.

74 WILLIAM LUMPKINS

1. For biographical information on Lumpkins, see Wiggins 1990; see also Strickler 1991, p.124.
2. Lumpkins 1981; Lumpkins 1986; see also Traugott 1998.
3. As quoted in Wiggins 1990, pp.14–15; see Monte/Glusker 1982.
4. Wilson 1987.
5. Adams 1991, pp.55–57.
6. William Lumpkins, *Untitled*, 1958–61, screen-print on cream wove paper, 230.0 x 271.8 cm, The Albuquerque Museum, gift of Norma Lumpkins, 82.219; see Adams 1991, fig.43.

75 SEONG MOY

1. For biographical information on Moy, see Acton 1990, pp.275–76; Vevers 1991.
2. *Artnews* 1946, pp.58, 60.
3. Reed 1950, p.18.
4. See Johnson 1956, p.45; Acton 1990, pp.194–95.
5. See Gordon/Johnson 1955, no.55, pp.49–54.
6. See Saff/Sacilotto 1970, pp.77–78, 85–86.
7. Vevers 1991.
8. Moy quoted in *Artist's Proof* 1961, vol.1, p.9.

76 BARNETT NEWMAN

1. For biographical information on Newman, see Rosenberg 1978, pp.229–38.
2. See also Newman 1947; Newman 1948.
3. Greenberg/Goossen 1958.
4. Alloway 1966.
5. On Newman as a printmaker, see Huber 1969; Davies 1983; Sparks 1989, pp.194–211, 418–29; Schor 1996.
6. See Riva Castleman, "Making the Prints," in Davies 1983, p.24.
7. Hess 1971, p.129.

77 ED COLKER

1. For biographical information on Colker, see Bermingham/Anania 1998, pp.40–41, passim; further information from an interview by the author with the artist, Chappaqua, New York, July 13, 2000.
2. See Feinstein 1954, p.22; Sawin 1955, p.28; Kuh 1956, p.20.
3. See Levin 1995, pp.544–45.
4. Garvey 1961.
5. Bermingham/Anania 1998; see also Lombardi 1999, p.18.
6. Graves 1948, p.172.

78 GUY WILLIAMS

1. For biographical information on Williams, see Blaisdell 1982.
2. Williams 1977.
3. Blaisdell 1982; see also Brown 1982.
4. Shamash 1985; see also Schipper 1986, p.139.

79 LEE KRASNER

1. For biographical information on Krasner, see Jeffrey D. Grove in Landau 1995, pp.300–20; see also Hobbs 1999.
2. Porter 1955, p.66.
3. Raynor 1961, p.54; Sandler 1961, p.15.
4. Robertson 1965.
5. Rose 1983.
6. See Chiem 1993.

80 ESTEBAN VICENTE

1. For biographical information on Vicente, see Frank 1995.
2. De Kooning 1953, pp.38–41, 51–52.
3. See above, p.140; Frankfurter 1958, pp.26–27.
4. Ashbery 1972, p.33.
5. See Devon 2000, pp.12–13.
6. On Vicente's drawings, see Frank 2000.

81 JOHN GRILLO

1. For biographical information on Grillo, see Landauer 1996, pp.44–47, 184; further information from the author's interview with the artist, July 31, 1992, Wellfleet, Massachusetts.
2. See Landauer 1990, pp.7–13; Landauer 1993, p.18.
3. Quoted in McChesney 1973, p.10.
4. MacAgy 1947; *Artnews*, vol.47, November 1948, p.56.
5. John Grillo, *Untitled*, 1955, woodcut on cream Japan paper, 42.1 x 52.0 cm (sheet), private collection.
6. See Guest 1953, pp.57, 67; Campbell 1953, p.59; Sawin 1953, p.21.
7. Sandler 1961, p.16.
8. Tamarind 1989, pp.85–86; see also Devon 2000, pp.17–18.
9. See Herter Gallery 1988.
10. Kingsley 1988.

82 SAM TCHAKALIAN

1. For biographical information on Tchakalian, see Susan Boettger in Neubert/Saint John 1978, pp.17–28.

2. See Mendel 1961, p.32; Leider 1962, p.40.
3. Nordland 1967.
4. See French-Frazier 1977, p.262.
5. Neubert/Saint John 1978.
6. Baker 1989.
7. Pilar 1997.

83 JOHN VON WICHT

1. For biographical information on von Wicht, see Herrmann 1995.
2. See Seckler 1957, p.32.
3. Herrmann 1995, p.22.
4. Mellow 1956, p.57; Campbell 1956, p.53.
5. Herrmann 1995, pp.77–79, pls.74–77.

84 CLEVE GRAY

1. For biographical information on Gray, see George Lechner in Weber 1998, pp.155–61.
2. See the artist's dialogue with Rowley on the differences between Asian and Western painting, Gray/Rowley 1955.
3. See Kramer 1986, pp.4, 5.
4. See Smith/Gray 1968; Gray also edited the writings of the artists John Marin (1970) and Hans Richter (1971).
5. Hess/Buck 1976.
6. See Robbins 1971.

85 RICHARD STANKIEWICZ

1. For biographical information on Stankiewicz, see Cummings 1988, pp.606–07; Donadio 1994, pp.9–10.
2. Porter 1955, p.63.
3. Boswell 1953, p.17; see also Guest 1953, pp.50, 64.
4. See Sawin 1997; Spring 1998, pp.102–03.
5. See *Time* 1956; *Newsweek* 1956.
6. See Stankiewicz 1956, pp.16–17.
7. Sandler 1979.
8. See Zabriskie 1983.

86 WALASSE TING

1. For biographical information on Ting, see *Who's Who in American Art* 1991, p.1121; Bénézit 1999, pp.655–56.
2. See Alvard/Weng 1957; Mellow 1957, p.61; Hale 1957, p.58.
3. Ting 1966, p.67.
4. *1¢ LIFE*. Berne, E. W. Kornfeld, 1964, 176 pp., with 68 lithographs by 28 artists, published in a regular edition of 2,000, special edition of 100 printed on handmade paper, all numbered

and signed by the artists. See Ting 1966, pp.38–39, 67–68; also Hogben/Watson 1985, pp.312–13; Castleman 1994, pp.208–09.

5. Kroll 1963, pp.14–15.
6. Notable among these are his translations of poems under the title *Chinese Moonlight*, 1967, illustrated with lithographs printed by Permild & Rosengreen, Copenhagen, distributed in the United States by Wittenborn, New York; and *Hot and Sour Soup*, 1970, a book of fifty original poems and twenty-two lithographs, printed by Rosengreen in Copenhagen, published by the Sam Francis Foundation in 1969; see Frank 1970, p.12.
7. Letter from Ting in Paris to June Wayne in Los Angeles, dated April 29, 1964, Tamarind Archives, University of New Mexico, Albuquerque.
8. This winnowing process continued outside the printshop; in 1971 the artist informed Tamarind that he had destroyed the impressions of *Fortune Kookie* that he possessed; see Tamarind 1989, p.246.

87 HUGO WEBER

1. For biographical information on Weber, see Bruderer-Oswald 1999, pp.15–56; see also Varian 1975; Baumann, et al. 1984.
2. See Weber 1952, p.32; Bruderer-Oswald 1999, pp.91–94.
3. Feinstein 1954, p.16; Porter 1954, p.72.
4. Bruderer-Oswald 1999, pp.168–79.
5. Tamarind 1989, pp.267–68; see also Bruderer-Oswald 1999, p.50, Devon 2000, pp.27–28.

88 WILLIAM MAJORS

1. For biographical information on Majors, see William E. Taylor in Taylor/Warkel 1996, pp.178–81.
2. Panzera/Stedman-Majors 1993, p.5.
3. On the Spiral Group, see Siegel 1966; Gaither 1980; Floyd Coleman in Taylor/Warkel 1996, pp.148–58.
4. William Majors, *Etchings from Ecclesiastes*, 1965, eighteen etchings with aquatint, published by the Museum of Modern Art, edition of 90; with an introduction by Fritz Eichenberg. See Temin 1987, p.1; Taylor/Warkel 1996, pp.105, 107–09. In 1966 the portfolio won the grand prize in graphic arts at the First World Festival of Negro Arts in Dakar, Senegal.
5. See Mandle 1968, pp.4, 16.
6. Produced in collaboration with the printer Stephen Britko from August 7 to 20, 1975, these two lithographs appear as untitled in Tamarind documentation (see nos. 75–631–32; Schnelker/Booth 1980, p.45), but Majors later titled them *Steps to Freedom*. The lithographs were commissioned by Robinson Galleries of Houston.
7. Taylor/Warkel 1996, p.105.
8. See Romano/Ross 1980.

89 JACK TWORKOV

1. For biographical information on Tworkov, see Jocelyn A. Mott in Armstrong/Baker 1987, pp.146–50.
2. Reprinted in Armstrong/Baker 1987, p.133.
3. Bryant 1964.
4. Guggenheim 1982.
5. See Schnelker/Booth 1980, p.73; see also Devon 2000, pp.80–81.

90 PAUL JENKINS

1. For biographical information on the artist, see Elsen 1973, pp.273–75; Arnaud/Trapp 1994, pp.75–80.
2. See Jenkins/Tapié 1956.
3. These works were shown at the Martha Jackson Gallery in 1958; see Sandler 1958, p.16; Tillim 1958, pp.57–58.
4. Directed by Jules Engel, *The Ivory Knife* was shown at the Museum of Modern Art in New York in 1966 and at the Venice Film Festival, where it won the Golden Eagle Award.
5. On Jenkins's collages, see Hagani 1993.

91 LOUISE NEVELSON

1. For biographical information on Nevelson, see Nevelson/MacKown 1976; Lisle 1990. On the confusion over the artist's birth date, see Lisle 1990, p.18.
2. See Riley 1943, p.18.
3. See Johnson 1967, pp.17–19, pls.1–30; Baro 1974, pp.17–35.
4. See Tamarind 1989, pp.172–75; Devon 2000, pp.14–15.
5. See Tamarind 1989, pp.175–77.
6. Causa/Baro 1976.
7. A complete set of artist's proofs of all Nevelson's Hollander Workshop editions is in the collection of the Brooklyn Museum and was a gift of the artist in memory of Theodore Haseltine (Johnson 1967, p.17).
8. Sorini also printed small editions from some of Nevelson's earlier plates, prepared at Atelier 17 from 1953 to 1955. (Johnson 1967, p.13). The *bon à tirer* impressions are on sheets of heavy, white Rives BFK wove paper. Sorini printed the editions of the Hollander Workshop intaglios on dark cream-colored Arches wove paper. He marked them with his chop, and the artist later signed and numbered the prints.
9. So commented Alan Gussow on Nevelson's activities at Atelier 17 in the 1950s; see Lisle 1990, p.172.
10. Lisle 1990, p.172.

92 ROBERT MOTHERWELL

1. For biographical information on Motherwell, see Arnason 1982; Terenzio/Belknap 1991, pp.235–43.
2. See Carmean 1972.
3. For Motherwell's own writings, see Terenzio 1992.
4. Sparks 1989, pp.164–93; see also Terenzio/Belknap 1991, pp.51–57; Rosand et al. 1997.
5. Terenzio/Belknap 1991, p.16.
6. Motherwell's automatist drawings, *Beside the Sea* of 1962, led to the suite of lithographs *Throw of the Dice* at ULAE in 1962–63 (Terenzio/Belknap 1991 Appendix 2–8), which were proofed but never editioned.
7. See Arnason 1982, p.69, 154; this activity also continued in the smaller *Spontaneity* series of ink paintings on paper in 1966.
8. Quoted by Ashton/Flam 1983, p.23
9. Quoted in Terenzio/Belknap 1991, p.26.

93 PHILIP GUSTON

1. For biographical information on Guston, see Arnason 1986; Mayer 1988.
2. See *Time* 1935, pp.46–48; *Los Angeles Times*, February 10, 1935.
3. Arnason 1962.
4. See Balken 1994.
5. See Fine 1985, pp.102–03.
6. See Tamarind 1989, p.89, no. 835–36; Devon 2000, pp.13–14.
7. See Ashton 1976, pp.132–33; Dabrowski 1988, p.27.
8. Quoted in Ashton 1985, p.212.
9. Hollander quoted by Ruth E. Fine, "Bigger, Brighter, Bolder," in Gilmour 1988, London, pp.269–70.

94 CY TWOMBLY

1. For biographical information on Twombly, see Bastian 1995, vol.4, pp.196–99.
2. Cy Twombly, *Song of the Border Guard,* about 1959, linocut on red-brown wove paper, 50.9 x 33.4 cm (sheet), private collection.
3. On Twombly as a draftsman, see Basel 1973; Bastian 1973.
4. See O'Hara 1955, p.46.
5. Whitney 1979.
6. Varnedoe 1994.
7. On Twombly's ULAE editions, see Sparks 1989, pp.276–79, 520–25; see also Watson 1982.
8. Though Twombly completed the plates for his ULAE intaglios in 1967, they were not printed before the artist returned to Italy. Four years elapsed before the prints were editioned and, despite their inscriptions, this print and its pendant were not published until 1974.

95 JULES OLITSKI

1. For biographical information on Olitski, see Moffett 1981.
2. Geldzahler 1966.
3. Fried 1967.
4. On Olitski's sculpture, see Moffett 1977.
5. For the artist's later painting, see Geldzahler/Hilton/Fourcade 1990.
6. Wilkin/Long 1989, p.7.

96 JAMES BROOKS

1. For biographical information on Brooks, see Hunter 1963; Prebel 1983, pp.39–43.
2. Washburn 1995, cat. nos. 1–9.
3. *Artnews* 1942, p.7.
4. See Campbell 1950; Sawin 1950.
5. Washburn 1995, cat. no. 10; on the Collectors Graphics offset lithographs, see above, p.170.

6. Hunter 1963; also Sandler 1963, pp.30–31, 88–89.
7. Prebel 1983; see also Messinger 1988.
8. See Washburn 1995, cat. nos. 11–21.
9. Kingsley 1975, p.57.

97 SAM GLANKOFF

1. For biographical information on Glankoff, see Kushner 1984.
2. Among these books were Gide 1928; Morley 1929; Tietjens 1929.
3. *Cue: The Magazine of New York Living* was published by the North American Publishing Company in New York from 1932 to 1978, and then became *Cue New York,* as published by News Group Publications, until its demise in 1980.
4. On Glankoff's monotype technique, see Kushner/Wechsler 1985. Some commentators have felt that this process merits a new designation, and the artist's estate has catalogued them as "print-paintings." However, they are typical monotypes, overprinted in layers.
5. Wallach 1981; see also Russell 1981, p.C-28; Fort 1981, p.13; Phillips 1981, pp.175–76; Goldman 1982, pp.70–71.
6. Kushner 1984. Posthumous solo exhibitions of Glankoff's work were presented by the Victoria Munroe Gallery in New York in 1991 (see Edelman 1991, pp.125–26), and at Associated American Artists in New York (see Conway 1984).

98 MILTON RESNICK

1. For biographical information on Resnick, see Nina Nathan Schroeder in Cathcart 1985, pp.75–88.
2. Hess 1954, p.51.
3. Hess 1956, p.79; Campbell 1957 pp.38–41, 65–66.

4. Hopkins 1971.
5. Cathcart 1985.
6. Santlofer 1993, pp.87–88.
7. See Schnelker/Booth 1980, p.57; also Devon 2000, p.29.
8. Although the color version of this lithograph was not editioned, Resnick kept the proofs, including the present impression, and proofs from the three component plates are in the Worcester Art Museum collection (1993.100.1, .3).

99 NORMAN BLUHM

1. For biographical information on Bluhm, see Rubenstein et al. 2000.
2. See Sawin 1957, p.59; Schuyler 1957, p.17.
3. See Lehman 1998, p.78; Lehman 2000, p.143.
4. Harithas/Hess 1973.
5. See Cone 1987.
6. Salzillo 1987; see also Harithas/Sansone 2000.
7. See Johnson 1995, pp.91–92.
8. Schjeldahl 1974.
9. See John Yau, "Norman Bluhm and the Venetian Tradition," in Salzillo 1987, pp.13–18.

100 RICHARD POUSETTE-DART

1. For biographical information on Pousette-Dart, see Harriet G. Warkel in Hobbs/Kuebler 1990, pp.178–81.
2. See Perrault 1967, pp.55, 74–75.
3. Goodrich 1963.
4. Monte 1974.
5. Hobbs/Kuebler 1990; see also Sims/Polcari 1997.
6. On Pousette-Dart's drawings, see Arts Club of Chicago 1978.

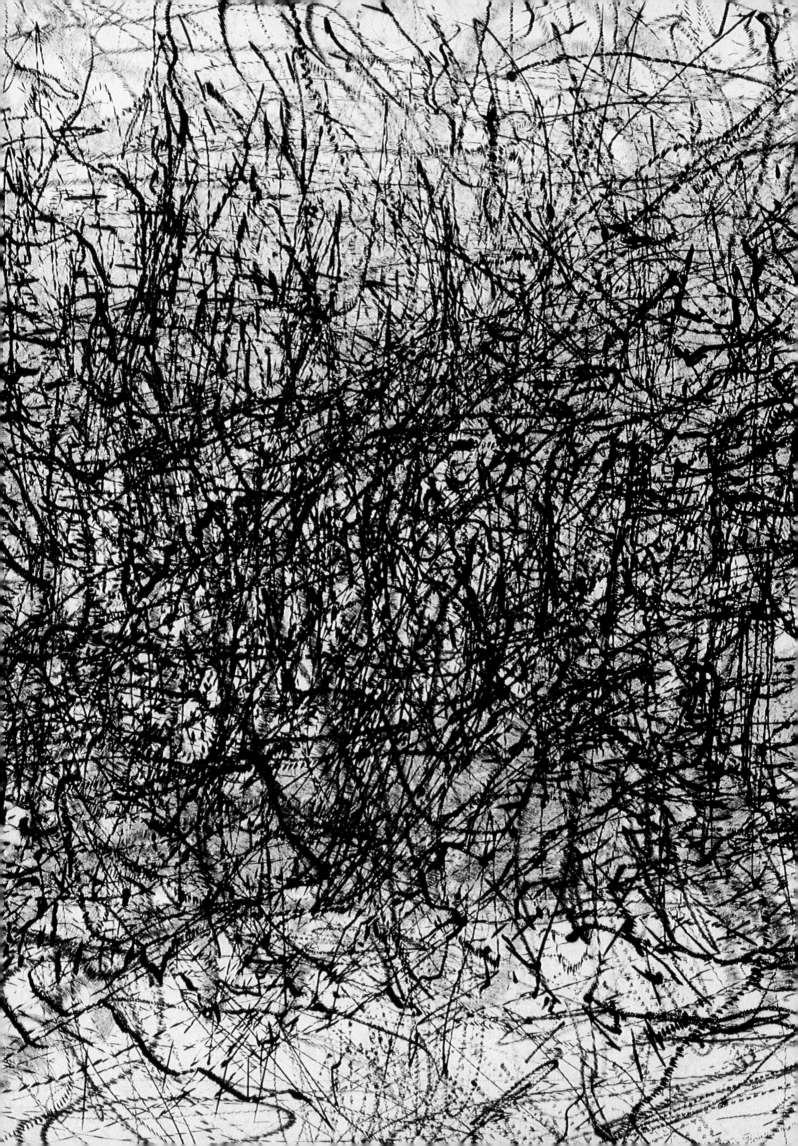

BIBLIOGRAPHY

Achenbach 1968
Achenbach Foundation for Graphic Arts. *Dennis Beall*. Exh. cat. San Francisco, California Palace of the Legion of Honor, 1968.

Acton 1990
Acton, David. *A Spectrum of Innovation: Color in American Printmaking, 1890–1960*. Exh. cat. Worcester Art Museum, 1990.

Acton 1992
Acton, David. *George Miyasaki: The Early Prints*. Exh. cat. San Francisco, Stephen Wirtz Gallery, 1992.

Acton 1993
Acton, David. *Sylvia Wald: Abstract Expressionist Works on Paper*. Exh. cat. New York, Hirschl & Adler Galleries, 1993.

Acton/Goldman 1995
Acton, David, and Judith Goldman. *Vincent Longo: Prints 1954–1995, A Selection*. Exh. cat. New York, Bertha and Karl Leubsdorf Art Gallery, Hunter College of the City University of New York, 1995

Acton/Jessup 1996
Acton, David, and Sally Jessup. *Sylvia Wald*. Exh. cat. South Seoul, Korea, Dong-Ah Gallery, 1996.

Adams 1977
Adams, Clinton. "Lynton R. Kistler and the Development of Lithography in Los Angeles." *Tamarind Technical Papers*. vol.1, 1977–78, pp.100–109.

Adams 1982
Adams, Clinton. "The Personality of Lithography: A Conversation with Nathan Oliveira." *The Tamarind Papers*. vol.6, 1982/3, pp.4–9.

Adams 1983
Adams, Clinton. *American Lithographers 1900–1960: The Artists and Their Printers*. Albuquerque: University of New Mexico Press, 1983.

Adams 1991
Adams, Clinton. *Printmaking in New Mexico 1880–1990*. Albuquerque: University of New Mexico Press, 1991.

Albright 1985
Albright, Thomas. *Art in the San Francisco Bay Area, 1945–1980: An Illustrated History*. Berkeley/Los Angeles: University of California Press, 1985.

Albright/Boswell 1983
Albright, Thomas, and Peter Boswell. *Frank Lobdell, Paintings and Monotypes*. Exh. cat. San Francisco Museum of Modern Art, 1983.

Alloway 1966
Alloway, Lawrence. *Barnett Newman: The Stations of the Cross, lema sabachthani*. Exh. cat. New York, Solomon R. Guggenheim Museum, 1966.

Alvard/Weng 1957
Alvard, Julien, and Wango Weng. *Walasse Ting: Paintings*. Exh. cat. New York, Galerie Chalette, 1957.

Anania 1986
Anania, Michael. *Exhibition of Prints for Poetry: Ed Colker*. Exh. cat., Chicago, Montgomery Ward Gallery, University of Illinois, 1986.

Andera/Gilmour 1996
Andera, Margaret, and Pat Gilmour. *Warrington Colescott*. Exh. cat. Milwaukee Art Museum, 1996.

Anderson 1962
Anderson, Wayne V. *Peter Busa Paintings*. Exh. cat. Minneapolis, Walker Art Gallery, 1962.

Anderson 1990
Anderson, Susan M. *Pursuit of the Marvelous: Stanley William Hayter, Charles Howard, Gordon Onslow Ford*. Exh. cat. Laguna Beach, California, Laguna Beach Museum, 1990.

Anderson Gallery 1993
Anderson Gallery. *Continuous Departures: Eight Printmakers in the Modernist Tradition*. Exh. cat. Buffalo, New York, 1993.

Anfam 1993
Anfam, David. " 'Of the Earth, the Damned, and the Recreated': Aspects of Clyfford Still's Earlier Work." *Burlington Magazine*. vol.135, 1993, pp.260–69.

Anfam 1994
Anfam, David. *Franz Kline: Black & White, 1950–1961*. Exh. cat. Houston, Menil Collection, 1994.

Armstrong/Baker 1987
Armstrong, Richard, and Kenneth Baker. *Jack Tworkov: Paintings, 1928–1982*. Exh. cat. Philadelphia, Pennsylvania Academy of Fine Arts, 1987.

Armstrong/McGuire 1989
Armstrong, Elizabeth, and Shelia McGuire. *First Impressions: Early Prints by Forty-Six Contemporary Artists*. Exh. cat. Minneapolis, Walker Art Center, 1989.

Armstrong et al. 1987
Armstrong, Elizabeth, et al. *Tyler Graphics: The Extended Image*. Minneapolis: Walker Art Center/ New York: Abbeville Press, 1987.

Arnason 1961
Arnason, H.H. *American Abstract Expressionists and Imagists*. Exh. cat. New York, Solomon R. Guggenheim Museum, 1961.

Arnason 1962
Arnason, H.H. *Philip Guston*. Exh. cat. New York, Solomon R. Guggenheim Museum, 1962.

Arnason 1982
Arnason, H.H. *Robert Motherwell* (2nd ed.). New York: Abrams, 1982.

Arnason 1986
Arnason, H.H. *Philip Guston*. New York: Abrams, 1986.

Arnaud/Trapp 1994
Arnaud, Jean-Pierre, and Frank Anderson Trapp. *Paul Jenkins: L'Eau et la couleur*. Angers: Présence de l'Art Contemporain, 1994.

Art Digest 1941
Art Digest. "Louise Nevelson's Debut." vol.16, October 1, 1941, p.7.

Art Digest 1942A
Art Digest. "Theodore Brenson in the U.S." vol.16, July 1, 1942, p.11.

Art Digest 1942B
Art Digest. "Etched Portraits." vol.17, November 15, 1942, p.15.

Art in America 1975
Art in America. "Ten Portraitists: Interviews/Statements." vol.63, January 1975, pp.35–36.

Arthur 1976
Arthur, John. *Alfred Leslie* (with essay by Robert Rosenblum). Exh. cat. Boston, Museum of Fine Arts, 1976.

Artist's Proof 1961
Artist's Proof. "Pratt Graphic Art Center Faculty." vol.1, no.2, 1961, pp.6–12.

Artnews 1939
Artnews. "Roundabout the Galleries: Three New Exhibitions." vol.317, May 20, 1939, p.14.

Artnews 1941
Artnews. "The Passing Shows." vol.40, March 1941, pp.46–52.

Artnews 1942
Artnews. "Flight Murals." vol.41, October 15, 1942, p.7.

Artnews 1944
Artnews. "Hans Hofmann." vol.43, March 25, 1944, p.20.

Artnews 1945
Artnews. "The Annual Season: Los Angeles." vol.44, June 1945, p.8.

Artnews 1946
 Artnews. "First One Man Shows." vol.45, October 1946, pp.58, 60.
Artnews 1947
 Artnews. "Claire Falkenstein." vol.45, January 1947, p.52.
Artnews 1948A
 Artnews. "Lawrence Kupferman." vol.47, April 1948, p.50.
Artnews 1948B
 Artnews. "John Grillo." vol.47, November 1948, p.56.
Artnews 1949
 Artnews. "Joseph Meert." vol.47, January 1949, p.46.
Arts Club of Chicago 1978
 Arts Club of Chicago. *Richard Pousette-Dart Drawings.* Exh. cat. Chicago, 1978.
Arts Club of Chicago 1983
 Arts Club of Chicago. *Elaine de Kooning and the Bacchus Motif.* Exh. cat. Chicago, 1983.
Ashbery 1971
 Ashbery, John. "Willem de Kooning: A Suite of Lithographs Translates His Famous Brushstroke into Black and White." *Artnews Annual.* vol.37, 1971, pp.117–28.
Ashbery 1972
 Ashbery, John. "Absence and Illusion." *Artnews.* vol.71, May 1972, pp.32–33, 60.
Ashbery 1982
 Ashbery, John. "R.B. Kitaj." *Art in America.* vol.70, January 1982, pp.130–35.
Ashbery 1989
 Ashbery, John. *Reported Sightings.* New York: Knopf, 1989.
Ashbery 1997
 Ashbery, John. *The Mooring of Starting Out: The First Five Books of Poetry.* Hopewell, New Jersey: Echo Press, 1997.
Ashton 1951
 Ashton, Dore. "Spiral Group Exhibition at New School." *Art Digest.* vol.26, November 1, 1951.
Ashton 1952A
 Ashton, Dore. "The Print Collector: New Medium." *Art Digest.* vol.26, May 15, 1952, p.11.
Ashton 1952B
 Ashton, Dore. "Dorothy Dehner." *Art Digest.* vol.26, May 15, 1952, p.19.
Ashton 1952C
 Ashton, Dore. "Brooklyn Reviews Today's American Print Techniques." *Art Digest.* vol.26, September 15, 1952, pp.7–9.
Ashton 1953
 Ashton, Dore. "Prints: Brooklyn Changes." *Art Digest.* vol.27, May 1, 1953, p.20.

Ashton 1958
 Ashton, Dore. "Art: Poems with Etchings." *New York Times.* November 7, 1958, p.20.
Ashton 1959
 Ashton, Dore. "Art: Italy in a Symbolic Language." *New York Times*, October 15, 1959, p.45.
Ashton 1972
 Ashton, Dore. *The New York School: A Cultural Reckoning.* New York: Viking Press, 1972.
Ashton 1976
 Ashton, Dore. A Critical Study of Philip Guston. Berkeley/Los Angeles: University of California Press, 1976.
Ashton 1983
 Ashton, Dore, and Jack D. Flam. *Robert Motherwell.* New York: Abbeville, 1983.
Ashton 1985
 Ashton, Dore. *Richard Diebenkorn: Small Paintings from Ocean Park.* Exh. cat. Lincoln, Nebraska, Sheldon Memorial Art Gallery, University of Nebraska, 1985.
Ashton 1991
 Ashton, Dore. *Edward Dugmore, Burning Bright: Paintings 1950–1959.* Exh. cat. Los Angeles, Manny Silverman Gallery, 1991.
Ashton/de Kooning 1965
 Ashton, Dore, and Willem de Kooning. *Willem de Kooning.* Exh. cat. Northampton, Massachusetts, Smith College Museum of Art, 1965.
Ashton/Flam 1983
 Ashton, Dore, and Jack D. Flam. *Robert Motherwell.* New York: Abbeville Press, 1983.
Associated American Artists 1992
 Associated American Artists. *Lawrence Kupferman: Realist/Surrealist Prints and Drawings.* Exh. cat. New York, 1992.
Ayres/Dowell 1992
 Ayres, Anne, and Roy Dowell. *Emerson Woelffer, A Modernist Odyssey: Fifty Years of Works on Paper.* Exh. cat. Los Angeles, Otis Gallery, Otis School of Art and Design, 1992.
Baker 1989
 Baker, Kenneth. *Sam Tchakalian.* Exh. cat. Seoul, South Korea, National Museum of Contemporary Art, 1989.
Balken 1994
 Balken, Debra Bricker. *Philip Guston's Poem-Pictures.* Exh. cat. Andover, Massachusetts, Addison Gallery of American Art, 1994.
Balken 1999
 Balken, Debra Bricker. *Ellen Lanyon: Transformation, Selected Works from 1971–1999.* Exh. cat. Washington, D.C., National Museum of Women in the Arts, 1999.

Ball 1980
 Ball, Maudette. *Nathan Oliveira, Print Retrospective: 1949–1980.* Exh. cat. Long Beach, The Art Museum and Galleries, California State University, 1980.
Bandini 1997
 Bandini, Mirella. *Tapié: un art autre: Torino, Parigi, New York, Osaka.* Turin: Fratelli Press, 1997.
Barañano/Bärmann 1997
 Barañano, Kosme de, and Matthias Bärmann. *Mark Tobey.* Exh. cat. Madrid, Museo Nactional Centro de Arte Reina Sofia, 1997.
Barnitz 1966
 Barnitz, Jacqueline. "Robert McChesney." *Arts.* vol.40, January 1966, p.58.
Baro 1970
 Baro, Gene. *Vincent Longo: Print Retrospective, 1954–1970.* Exh. cat. Washington, D.C., Corcoran Gallery of Art, 1970.
Baro 1974
 Baro, Gene. *Nevelson: The Prints.* New York: Pace Editions, 1974.
Baro 1976
 Baro, Gene. *Thirty Years of American Printmaking.* Exh. cat. Brooklyn Museum, 1976.
Baro 1979
 Baro, Gene. *Glen Alps, Retrospective: The Collagraphic Idea, 1956–1980.* Exh. cat. Bellevue, Washington, Bellevue Art Museum, 1979.
Barr 1936
 Barr, Alfred H., Jr. *Fantastic Art, Dada, Surrealism.* Exh. cat. New York, Museum of Modern Art, 1936.
Barron 1990
 Barron, John. "The Lion in Winter." *Detroit Monthly.* February 1990, pp.56–57.
Bartelik 2000
 Bartelik, Marek. *To Invent a Garden: The Life and Art of Adja Yunkers.* New York: Hudson Hills Press, 2000.
Barton 1906
 Barton, George A. "Moloch." *The Jewish Encyclopedia.* vol.18, New York/ London, 1906, pp.653–54.
Basel 1973
 Kunstmuseum Basel. *Cy Twombly: Zeichnungen 1954–1973.* Exh. cat. 1973.
Baskett 1967
 Baskett, Mary W. *Three Portfolios by Romas Viesulas.* Exh. cat. Cincinnati Art Museum, 1967.

Baskett 1968
 Baskett, Mary W. "American Prints of the
 Sixties." *Cincinnati Museum of Art Bulletin.*
 vol.8, October 1968, p.23.
Bastian 1973
 Bastian, Heiner. *Cy Twombly, Die Zeichnungen
 1953–1973.* Berlin: Propyläen Verlag, 1973.
Bastian 1985
 Bastian, Heiner. *Cy Twombly, Das graphische
 Werk, 1953–1984.* New York: New York
 University Press, 1985.
Bastian 1995
 Bastian, Heiner. *Cy Twombly: Catalogue
 Raisonné of the Paintings.* Munich: Schirmer-
 Mosel, 1995.
Battenburg/Dawson 1963
 Battenburg, John, and E.W. Dawson (eds.).
 Cibolá. vol.1, Silver City, New Mexico, 1963.
Baumann et al. 1984
 Bauman, Felix, et al. *Hugo Weber, 1918–1971.*
 Exh. cat. Zurich, Kunsthaus, 1984.
Baur 1954
 Baur, John I.H. "George Hartigan." *Art in
 America.* vol.42, Winter 1954, pp.18–19.
Baur 1957
 Baur, John I.H. "New Talent in the U.S." *Art in
 America.* vol.45, March 1957, p.15.
Baxter Art Gallery 1979
 Baxter Art Gallery. *Nathan Oliveira: A Survey
 of Monotypes, 1973–78.* Exh. cat. Pasadena,
 California Institute of Technology, 1979.
Beall/Heyman 1966
 Beall, Dennis, and Therese Heyman.
 Contemporary Prints from Northern California.
 Exh. cat. Oakland Museum, 1966.
Bearden/Henderson 1993
 Bearden, Romare, and Harry Henderson. *A
 History of African-American Artists: From 1792
 to the Present.* New York: Pantheon Books,
 1993.
Bénézit 1999
 Bénézit, Emmanuel. *Dictionnaire critique et
 documentaire des peintres, sculpteurs, dessi-
 nateurs, et graveurs.* 10 vols. New edition.
 Paris, 1999.
Berardi 1998
 Berardi, Marianne. *The Work of Our Friends:
 The Collection of Thomas Hart Benton and
 Rita Piacenza Benton.* Exh. cat. Chicago,
 Aaron Galleries, 1998.
Berkson 1964
 Berkson, William. "Michael Goldberg Paints a
 Picture." *Artnews.* vol.62, January 1964,
 pp.42–45, 65–67.

Berkson 1999
 Berkson, Bill. "A Beginner." *ZYZZYVA.* Vol.15,
 Winter 1999, p.15.
Berkson/O'Hara 1974
 Berkson, Bill, and Frank O'Hara. *Hymns of St.
 Bridget.* New York: Adventures in Poetry,
 1974.
Bermingham 1976
 Bermingham, Peter. *The Art of Poetry.* Exh.
 cat. Washington, D.C., National Collection of
 Fine Arts, Smithsonian Institution, 1976.
Bermingham 1990
 Bermingham, Peter (ed.). A Handbook of the
 Prints in the Permanent Collection. University
 of Arizona Museum of Art, Tucson, 1990.
Bermingham/Anania 1998
 Bermingham, Peter, and Michael Anania. *Five
 Decades in Print: Ed Colker.* Exh. cat. Tucson,
 Arizona, 1998.
Bernadac 1995
 Bernadac, Maurie-Laure. *Louise Bourgeois.*
 Paris: Flammarion, 1995.
Bier 1949
 Bier, Justus. "Paintings that Say Something."
 Louisville Courier-Journal. May 1, 1949, p.5:5.
Bier 1953
 Bier, Justus. "Recent Serigraphs (Silk Screen
 Color Prints) by Sylvia Wald are on exhibit at
 Arts Club." *Louisville Courier-Journal.* April 5,
 1953, p.5:7.
Black 1991
 Black, Peter. "Relief Printing and the
 Development of Hayter's Colour Method."
 Print Collectors Quarterly. vol.8, December
 1991, pp.403–17.
Black/Moorhead 1992
 Black, Peter, and Désirée Moorhead. *The
 Prints of Stanley William Hayter: A Complete
 Catalogue.* Mount Kisco, New York: Moyer
 Bell, 1992.
Blaine 1972
 Blaine, Nell. *Getting with Lester and Mondrian
 in the Forties: Jazz and Painting.* Exh. cat.
 Keene, New Hampshire, Thorne Memorial Art
 Gallery, Keene State College, 1972.
Blaisdell 1982
 Blaisdell, Gus. *Guy Williams: Selected Works,
 1976–1982.* Exh. cat. Los Angeles Municipal
 Art Gallery at Barnsdall Park, 1982.
Bledsoe 1992
 Bledsoe, Jane K. *Elaine De Kooning.* Exh. cat.
 Athens, Georgia, Museum of Art, University of
 Georgia, 1992.

Bompuis/Stoullig 1984
 Bompuis, Claire, and Claire Stoullig. *Willem
 de Kooning.* Exh. cat. Whitney Museum of
 American Art, 1984.
Bonesteel 1986
 Bonesteel, Michael. "Roland Ginzel at Gallery
 400 and Dart." *Art in America.* vol.74, October
 1986, p.171.
Boswell 1952
 Boswell, Peyton. "Robert Goodnough." *Art
 Digest.* vol.26, February 1, 1952, pp.18–19.
Boswell 1953
 Boswell, Peyton. "Richard Stankiewicz". *Art
 Digest.* vol.27, January 15, 1953, p.17.
Bourgeois/Rinder 1995
 Bourgeois, Louise, and Lawrence Rinder.
 Drawings & Observations. Exh. cat. Berkeley,
 University Art Museum, University of
 California, Berkeley, 1995.
Brach 1951
 Brach, Paul. "Franz Kline." *Art Digest.* vol.26,
 December 1, 1951, p.19.
Brach 1953
 Brach, Paul. "Joan Mitchell." *Art Digest.*
 vol.27, April 15, 1953, p.16.
Bradbury 1957
 Bradbury, Robert. "The Patron Church." *Craft
 Horizons.* vol.17, November-December 1957,
 pp.30–34.
Bradley 1986
 Bradley, Laurel. "Roland Ginzel: A Sustained
 Vision." in *Roland Ginzel: A Retrospective.*
 Exh. cat. Chicago, Gallery 400, University of
 Illinois, 1986.
Breeskin 1953
 Breeskin, Adelyn. "Adja Yunkers — Pioneer of
 the Contemporary Color Woodcut." *Baltimore
 Museum of Art News.* vol.16, June 1953,
 pp.4–7.
Brenson 1944
 Brenson, Theodore. "About Art and
 Education." *Liturgical Arts.* vol.12, May 1944,
 p.69.
Brenson 1954
 Brenson, Theodore. "Abstract Art and
 Christianity." *Liturgical Arts.* vol.22, May 1954,
 pp.76–78.
Breslin 1993
 Breslin, James E.B. *Mark Rothko: A Biography.*
 Chicago: University of Chicago Press, 1993.
Breton 1972
 Breton, André. *Surrealism and Painting* (trans-
 lated by S.W. Taylor). New York: Harper &
 Row, 1972.

Breuning 1946
Breuning, Margaret. "In Musical Terms." *Art Digest*. vol.20, January 1, 1946, p.7.

Breuning 1950
Breuning, Margaret. "Kamrowski's New Surreal Formula." *Art Digest*. vol.24, May 15, 1950, p.20.

Brown 1951
Brown, Gordon. "New Tendencies in American Art." *College Art Journal*. vol.11, Winter 1951–52, pp.103–110.

Brown 1982
Brown, Betty Ann. "Guy Williams." *Arts*. vol.57, December 1982, p.47.

Brown 1996
Brown, Kathan. *Ink, paper, metal, wood: Painters and Sculptors at Crown Point Press*. San Francisco: Chronicle Books, 1996.

Browne 1967
Browne, Rosalind. "Sylvia Wald." *Artnews*. vol.66, April 1967, p.16.

Browne 1968
Browne, Rosalind. "Robert Conover." *Artnews*. vol.67, November 1968, p.13.

Bruderer-Oswald 1999
Bruderer-Oswald, Iris. *Hugo Weber, Ein Pionier des Abstrakten Expressionismus: Vision in Flux*. Bern: Benteli Verlag, 1999.

Bryant 1964
Bryant, Edward. *Jack Tworkov*. Exh. cat. New York, Whitney Museum of American Art, 1964.

Buck 1978
Buck, Robert T. "Ocean Park Paintings." *Art International*, vol.22, Summer 1978, pp.29–34.

Buck et al. 1972
Buck, Robert T., et al. *Sam Francis*. Exh. cat. Buffalo, Albright-Knox Art Gallery, 1972.

Buck et al. 1976
Buck, Robert T., et al. *Richard Diebenkorn Paintings and Drawings, 1943–1980*. Exh. cat. Buffalo, Albright-Knox Art Gallery, 1976 (rev.ed. 1980).

Burrey 1955
Burrey, Suzanne. "Perle Fine." *Art Digest*. vol.29, June 1955, p.27.

Burrey 1956
Burrey, Suzanne. "A Decade of American Printmaking." *Arts*. vol.30, May 1956, pp.25–26.

Burrey 1958
Burrey, Suzanne. "Ulfert Wilke." *Arts*. vol.32, January 1958, p.57.

Bush 1982
Bush, Martin. *Goodnough*. New York: Abbeville Press, 1982.

Campbell 1950
Campbell, Lawrence. "James Brooks." *Artnews*. vol.49, April 1950, p.56.

Campbell 1951
Campbell, Lawrence. "George Hartigan." *Artnews*. vol.50, March 1951, p.46.

Campbell 1952A
Campbell, Lawrence. "Robert Conover." *Artnews*. vol.51, March 1952, p.48.

Campbell 1952B
Campbell, Lawrence. "Dorothy Dehner." *Artnews*. vol.51, June 1952, p.82.

Campbell 1953A
Campbell, Lawrence. "Michael Goldberg." *Artnews*. vol.52, October 1953, p.47.

Campbell 1953B
Campbell, Lawrence. "John Grillo." *Artnews*. vol.52, November 1953, p.59.

Campbell 1956
Campbell, Lawrence. "John von Wicht." vol.54, *Artnews*. February 1956, p.53.

Campbell 1957
Campbell, Lawrence. "Resnick Paints a Picture." *Artnews*. vol.56, December 1957, pp.38–41, 65–66.

Campbell 1959A
Campbell, Lawrence. "Blaine Paints a Picture." *Artnews*. vol.58, May 1959, pp.38–42, 61–62.

Campbell 1959B
Campbell, Lawrence. "Grace Hartigan, Larry Rivers, Frank O'Hara." *Artnews*. vol.58, December 1959, p.18.

Campbell 1960A
Campbell, Lawrence. "Joseph Fiore." *Artnews*. vol.59, October 1960, p.17.

Campbell 1960B
Campbell, Lawrence. "Elaine de Kooning Paints a Picture." *Artnews*. vol.59, December 1960, pp.40–44, 61–63.

Campbell 1961
Campbell, Lawrence. "Reuben Kadish." *Art News*. vol.58, January 1961, p.18.

Campbell 1963A
Campbell, Lawrence. "Elaine de Kooning: Portraits in a New York Scene." *Artnews*. vol.62, April 1963, pp.38–39, 63–64.

Campbell 1963B
Campbell, Lawrence. "Perle Fine." *Artnews*, vol.62, April 1963, pp.52–53.

Campbell 1965
Campbell, Lawrence. "Hayter, Sedgley, and Wilke." *Artnews*. vol.64, March 1965, pp.17, 65.

Campbell 1990
Campbell, Lawrence. "The Blurred Edge." *Art in America*. vol.78, December 1990, pp.158–61.

Carey/Griffiths 1980
Carey, Frances, and Griffiths, Anthony. *American Prints, 1879–1979*. Exh. cat. London, British Museum, 1980.

Carlson 1989
Carlson, David J. *Walter Kuhlman*. Exh. cat. San Francisco, Carlson Gallery, 1989.

Carmean 1972
Carmean, E.A., Jr. *The Collages of Robert Motherwell: A Retrospective Exhibition*. Exh. cat. Houston, Museum of Fine Arts, 1972.

Carmean 1989
Carmean, E.A. *Helen Frankenthaler: A Paintings Retrospective*. Exh. cat. New York, Museum of Modern Art, 1989.

Carmean/Rathbone/Hess 1978
Carmean, E.A., Jr., Eliza E. Rathbone, and Thomas B. Hess. *American Art at Mid-Century: The Subjects of the Artist*. Exh. cat. Washington, D.C., National Gallery of Art, 1978.

Carnegie Museum 1972
Carnegie Institute Museum of Art. *Fresh Air School: Sam Francis, Joan Mitchell, Walasse Ting, Exhibition of Paintings 1972/73*. Exh. cat., Pittsburgh, 1972.

Castleman 1994
Castleman, Riva. *A Century of Artists Books*. Exh. cat. Museum of Modern Art, 1994.

Castleman 1976
Castleman, Riva. *Prints of the Twentieth Century: A History*. New York: Museum of Modern Art, 1976.

Cathcart 1985
Cathcart, Linda L. *Milton Resnick: Paintings, 1945–1985*. Exh. cat. Houston, Texas, Contemporary Arts Museum, 1985.

Causa/Baro 1976
Causa, Raffaello, and Gene Baro. *Louise Nevelson: grafica*. Exh. cat. Naples, Villa Pignatelli, 1976.

Chaet 1958
Chaet, Bernard. "Interview with Edmond Casarella: Paper Relief Cuts in the Renaissance of Printmaking." *Arts*. vol.33, November 1958, pp.66–67.

Cherry 1956
Cherry, Herman. "Joseph Meert: Experiments in Stained Glass." *Craft Horizons*. vol.16, March–April 1956, pp.14–17.

Cherry 1989
Cherry, Herman. "Willem de Kooning." *Art Journal*. vol.48, Fall 1989, p.230.

Chiem 1993
Chiem, John. *Lee Krasner: Umber Paintings, 1959–1962 (with an interview of the artist by Richard Howard)*. Exh. cat. New York, Robert Miller Gallery, 1993.

Chipp 1959
Chipp, Hershel. "Art News from San Francisco." *Artnews*. vol.58, Summer 1959, p.24.

Click 1953
Click, Margaret. "General Impressions; Bird's-Eye View of Art Critics at Women's College." *The Carolinian* (Women's College of the University of North Carolina). vol.34, March 27, 1953, pp.1, 4.

Coates 1946
Coates, Robert. "The Art Galleries: Abroad and at Home." *The New Yorker*. March 30, 1946, p.83.

Cohn 1988
Cohn, Marjorie B. (ed.). *Mark Rothko's Harvard Murals*. Cambridge, Massachusetts: Harvard University Art Museums, 1988.

Cohn/Rogan 1998
Cohn, Marjorie B., and Rogan, Clare I. *Touchstone: 200 Years of Artists' Lithographs*. Exh. cat. Cambridge, Massachusetts, Harvard University Art Museums, 1998.

Cole 1951A
Cole, Mary. "Henry Mark, Sylvia Wald." *Art Digest*. vol.25, February 15, 1951, p.25.

Cole 1951B
Cole, Mary. "Harold Paris Debut." *Art Digest*. vol.25, April 15, 1951, pp.19–20.

Colescott/Hove 1999
Colescott, Warrington, and Arthur Hove. *Progressive Printmakers: Wisconsin Artists and the Print Renaissance*. Madison: University of Wisconsin Press, 1999.

Cone 1987
Cone, Jon. *Poem Prints: Norman Bluhm and John Yau*. Exh. cat. New York, Cone Editions, 1987.

Conway 1984
Conway, Robert. *Sam Glankoff: Woodcuts and Monoprints*. Exh. cat. New York, Associated American Artists, 1984.

Conwill et al. 1998
Conwill, Kinshasha Holman, et al. *Norman Lewis: Black Paintings, 1946–1977*. Exh. cat. New York, Studio Museum of Harlem, 1998.

Cotter 1991
Cotter, Holland. *Anne Ryan: Collages from Three Museums*. Exh. cat. New York, Washburn Gallery, 1991.

Cox 1991
Cox, Richard. "Warrington Colescott: The London Years 1956–1966." *The Tamarind Papers*. vol.14, 1991–92, pp.70–74.

Cox/Overland 1988
Cox, Richard, and Carlton Overland. *Warrington Colescott, Forty Years of Printmaking: A Retrospective, 1948–1988*. Exh. cat. Madison, Elvehjem Museum of Art, University of Wisconsin, 1988.

Cross/Brown 1998
Cross, Susan, and Julia Brown. *After Mountains and Sea: Frankenthaler, 1956–1959*. Exh. cat. New York, Solomon R. Guggenheim Museum, 1998.

Cummings 1979
Cummings, Paul. *David Smith: The Drawings*. Exh. cat. New York, Whitney Museum of American Art, 1979.

Cummings 1988
Cummings, Paul. *Dictionary of Contemporary American Artists*. fifth edition, New York: St. Martin's Press, 1988.

Dabrowski 1988
Dabrowski, Magdalena. *The Drawings of Philip Guston*. Exh. cat. New York, Museum of Modern Art, 1988.

Dash 1958
Dash, R. Warren. "Robert Conover." *Arts*. vol.32, April 1958, p.61.

Davies 1983
Davies, Hugh M. *The Prints of Barnett Newman*. Exh. cat., Amherst, University Gallery, University of Massachusetts, 1983.

De Kooning 1953
De Kooning, Elaine. "Vicente Paints a Collage." *Artnews*. vol.52, September 1953, pp.38–41, 51–52.

De Kooning 1962
De Kooning, Elaine. "Franz Kline." *Franz Kline Memorial Exhibition*. Exh. cat. Washington, D.C., Washington Gallery of Modern Art, 1962.

De Kooning 1964
De Kooning, Elaine. "Painting a Portrait of the President," *Artnews*. vol.63, Summer 1964, pp.37, 64–65.

De Salvo/Schimmel 1992
De Salvo, Donna, and Paul Schimmel. *Hand Painted Pop: American Art in Transition, 1955–62*. Exh. cat. Los Angeles, Museum of Contemporary Art, 1992.

Decker 1995
Decker, Andrew. "Still waiting and waiting and waiting." *Artnews*. vol.95, February 1995, pp.112–15.

Deitcher 1978
Deitcher, David. *Perle Fine: Major Works, 1954–1978*. Exh. cat. East Hampton, New York, Guild Hall of East Hampton, 1978.

Delatiner 1989
Delatiner, Barbara. "An Abstract Pioneer Gains Recognition." *New York Times* (Long Island Sunday Supplement). September 17, 1989, p.19.

Deshaies 1961
Deshaies, Arthur. "Experiments in Lucite Engraving." *Artist's Proof*. vol.1, 1961, pp.21–23.

Devon 2000
Devon, Marjorie (ed.). *Tamarind: Forty Years*. Albuquerque: University of New Mexico Press, 2000.

Doizaki 1993
Doizaki Gallery. *Matsumi Kanemitsu: Works in Black and White, 1958–1988*. Exh. cat. Los Angeles, Japanese American Cultural and Community Center, 1993.

Donadio 1994
Donadio, Emmie. *Richard Stankiewicz: Sculpture in Steel*. Exh. cat. Middlebury, Vermont, Middlebury College Museum of Art, 1994.

Donovan/Kanemitsu 1990
Donovan, Carrie, and Harumi Zoe Kanemitsu. *Matsumi Kanemitsu Lithographs, 1961–1990*. Exh. cat. Osaka, Yamaki Art Gallery, 1990.

Douglass College Art Gallery 1959
Douglass College Art Gallery. *Light into Color, Light into Space: Paintings by Theodore Brenson*. Exh. cat. New Brunswick, New Jersey, Rutgers, The State University of New Jersey, 1959.

Downes 1969
Downes, Rackstraw. "Joseph Fiore." *Artnews*. vol.67, February 1969, p.14.

Drohojowska-Philip 1998
Drohojowska-Philip, Hunter. "The Master of L.A. Modernism: Emerson Woelffer." *Los Angeles Times,* May 31, 1998, p.CAL-61.

Dubuffet 1951
Dubuffet, Jean. *Peintures initiatiques d'Alfonso Ossorio*. Paris: La Pierre Volante, 1951.

Dunn 1974
Dunn, Roger T. *Lawrence Kupferman: Retrospective*. Exh. cat. Brockton, Massachusetts, Fuller Museum of Art. 1974

Dynaton 1951
San Francisco Museum of Art. *Dynaton 1951: Jacqueline Johnson, Lee Mullican, Gordon Onsow Ford, Wolfgang Paalen*. Exh. cat. San Francisco Museum of Art, 1951.

Edelman 1991
Edelman, Robert G. "Sam Glankoff at Victoria Munroe." *Art in America*. vol.79, July 1991, pp.125–26.

Edgar 1963
Edgar, Natalie. "Reuben Kadish." *Artnews*. vol.62, May 1963, p.12.

Eiselin 1997
Eiselin, Rolf. "Karl Kasten: 1997 Distinguished Award Recipient." *The California Printmaker*, May 1997, pp.18–19.

Elderfield 1988
Elderfield, John. *Drawings of Richard Diebenkorn*. New York: Museum of Modern Art, 1988.

Elderfield 1989
Elderfield, John. *Helen Frankenthaler*. New York: Abrams, 1989.

Elderfield 1991
Elderfield, John. *Richard Diebenkorn*. Exh. cat. London, Whitechapel Art Gallery, 1991.

Elsen 1973
Elsen, Albert E. *Paul Jenkins*. New York: Abrams, 1973.

Evans 1975
Evans, R.J. *Roland Ginzel*. Exh. cat. Springfield, Illinois State Museum, 1975.

Falk 1985
Falk, Peter. *Who Was Who in American Art*. Madison, Connecticut: Sound View Press, 1985.

Falk 1999
Falk, Peter Hastings (ed.). *Who Was Who in American Art, 1564–1975: 400 Years of American Art*. 3 vols., Madison, Connecticut: Sound View Press, 1999.

Falkenstein 1947
Falkenstein, Claire. "Falkenstein." *Arts & Architecture*. vol.64, December 1947, p.29.

Faunce 1974
Faunce, Sarah. Anne Ryan Collages. Exh. cat. Washington, D.C., National Collection of Fine Arts, Brooklyn Museum, 1974.

Feinblatt/Butterfield 1980
Feinblatt, Ebria and Jan Butterfield. *Sam Francis Monotypes*. Exh. cat. Los Angeles County Museum of Art, 1980.

Feinstein 1954A
Feinstein, Sam. "Edward Colker." *Art Digest*. vol.28, April 1, 1954, p.22.

Feinstein 1954B
Feinstein, Sam. "Supersonics and Personalities." *Art Digest*. vol.28, June 1954, p.16.

Ferguson 1999
Ferguson, Russell. *In Memory of My Feelings: Frank O'Hara and American Art*. Exh. cat. Los Angeles, Museum of Contemporary Art, 1999.

Fichner-Rathus 1982
Fichner-Rathus, Lois. "Pollock at Atelier 17." *Print Collectors' Newsletter*. vol.8, November–December 1982, pp.162–165

Fine 1985
Fine, Ruth E. *Gemini G.E.L., Art and Collaboration*. Exh. cat. Washington, D.C., National Gallery of Art, 1985.

Fine 1993
Fine, Ruth E. *Helen Frankenthaler Prints*. Exh. cat. Washington, D.C., National Gallery of Art, 1993.

Fitzsimmons 1951
Fitzsimmons, James. "George Hartigan." *Art Digest*. vol.25, February 1, 1951, p.18.

Fitzsimmons 1952A
Fitzsimmons, James. "Robert Conover." *Art Digest*. vol.26, March 15, 1952, p.19.

Fitzsimmons 1952B
Fitzsimmons, James. "Print Project Launched." *Art Digest*. vol.17, October 1, 1952, p.10.

Fitzsimmons 1953
Fitzsimmons, James. "Print Polyptych." *Art Digest*. vol.27, May 15, 1953, p.14.

Flanagan 1973
Flanagan, Barbara. "Busa Work is Big, Beautiful." *Minneapolis Star*. September 27, 1973.

Flint 1980
Flint, Janet Altic. *Jacob Kainen: Prints, a Retrospective*. Exh. cat. Washington, D.C., National Museum of American Art, Smithsonian Institution. 1980.

Flint 1983
Flint, Janet Altic. *Provincetown Printers: A Woodcut Tradition*. Exh. cat. Washington, D.C., National Collection of Fine Arts, Smithsonian Institution, 1983

Flint 1988
Flint, Janet Altic. *The Prints of Bernard Childs*. Exh. cat. New York, Hirschl & Adler Galleries, 1988.

Flynn 1992
Flynn, Barbara. *Alfred Leslie: The Grisaille Paintings 1962–67*. New York: B. Flynn/R. Bellamy, 1992.

Focillon 1942
Focillon, Henri. "Theodore Brenson." *Print Collector's Quarterly*. vol.29, February 1942, pp.8–25.

Fodor 1949
Fodor, Nandor. *Search for the Beloved: A Clinical Investigation of the Trauma of Birth and Pre-Natal Conditioning*. New York: Hermitage Press, 1949.

Fogg 1942
Fogg Museum of Art. *Etchings of Landscapes and Men of Letters by Theodore Brenson*. Exh. cat. Cambridge, Massachusetts, Harvard University, 1942.

Fort 1981
Fort, Susan Ilene. "Sam Glankoff." *Arts*. vol.56, December 1981, p.13.

Frackman 1969
Frackman, Noel. "Joseph Fiore." *Arts*. vol.43, February 1969, p.65.

Frank 1970
Frank, Suzanne. "Hot and Sour Soup." *Arts*. vol.44, May 1970, p.12.

Frank 1995
Frank, Elizabeth. *Esteban Vicente* (chronology and appendices by Ellen Russoto). New York: Hudson Hills Press, 1995.

Frank 2000
Frank, Elizabeth. *Vintage Vicente: Works on Paper from the 1950s and the 1960s*. Exh. cat. New York, Berry-Hill Galleries, 2000.

Frankenstein 1957
Frankenstein, Alfred. "McChesney's Paintings Reflect a Full Life." *San Francisco Chronicle*. April 19, 1957.

Frankenthaler 1977
Frankenthaler, Helen. "The Romance of Learning a New Medium for an Artist." *Print Collector's Newsletter*. vol.8, July–August 1977, p.66.

Frankfurter 1958
Frankfurter, Alfred. "Poets and Painters 6." *Art News*. vol.57, November 1958, pp.26–27.

Franklin 1947
Franklin, Jean. "Perle Fine and the Latter-Day Mystics." *The New Iconograph*. Fall 1947, pp.21–25.

French 1967
French, Palmer D. "San Francisco." *Artforum*. vol.6, October 1967, pp.58–61.

French-Frazier 1977
French-Frazier, Nina. "Tchakalian at Susan Caldwall Gallery." *Artnews*. vol.76, November 1977, p.262.

Fried 1967
Fried, Michael. *Jules Olitski: Paintings, 1963–1967*. Exh. cat. Washington, D.C., Corcoran Gallery of Art, 1967.

Friedel/Dickey 1997
Friedel, Helmut, and Tina Dickey. *Hans Hofmann*. New York, 1997.

Friedman 1949
Friedman, William M. *A New Direction in Intaglio: The Work of Mauricio Lasansky and His Students*. Exh. cat. Minneapolis, Walker Art Center, 1949.

Friedman 1970
Friedman, B.H. *Alfonso Ossorio*. New York: Abrams, 1970.

Friedman 1972
Friedman, B.H. *Jackson Pollock: Energy Made Visible*. New York: Da Capo Press, 1972.

Friedman 1978
Friedman, B.H. "'The Irascibles': A Split Second in Art History." *Arts*. vol.53, September 1978, pp.96–102.

Friedman 1997
Friedman, B.H. *Alfonso Ossorio: The Shingle Figures, 1962–1963*. Exh. cat. New York, Michael Rosenfeld Gallery, 1997.

Friedman/Slivka/Lewis 1995
Friedman, B.H., Rose Slivka, and Thomas Lewis. *Recovery: The Hospital Drawings of Alfonso Ossorio*. Exh. cat. New York, Michael Rosenfeld Gallery, 1995.

Frumkin 1975
Alan Frumkin Gallery. *Alfred Leslie*. Exh. cat. New York, 1975.

Fuller 1977
Fuller, Mary [McChesney]. *Robert McChesney: From Arena to Barranca, 19 Years*. Exh. cat. Hayward, California, University Gallery, California State University, 1977.

Fuller 1990
Fuller, Mary [McChesney]. *Robert McChesney: The Arena Series of Paintings, 1958–1962*. Exh. cat. San Francisco, The Carlson Gallery, 1990.

Fuller 1996
Fuller, Mary [McChesney]. *Robert McChesney, An American Painter*. Petaluma, California: Sonoma Mountain Publishing Co., 1996.

Gaither 1980
Gaither, Edmund Barry. *Spiral: Afro-American Art of the 70s*. Exh. cat. Roxbury, Massachusetts, The Museum of the National Center of Afro-American Artists, 1980.

Gardner 1985
Gardner, Colin. "War Leaves its Traces." *Artweek*. vol.16, March 2, 1985, p.3.

Gardner 1994
Gardner, Paul. *Louise Bourgeois*. New York: Universe, 1994.

Garver/Neubert 1984
Garver, Thomas W., and George H. Neubert. *Nathan Oliveria: A Survey Exhibition, 1957–1983*. Exh. cat. San Francisco Museum of Modern Art, 1984.

Garvey 1961
Garvey, Eleanor. *The Artist and the Book 1860–1960 in Western Europe and the United States*. Exh. cat., Boston, Museum of Fine Arts, 1961 (rev. ed., 1972; reprint 1982).

Gaugh 1972
Gaugh, Harry F. "The Art of Franz Kline, 1930–1950: Figurative to Mature Abstraction." PhD. dissertation, Indiana University, 1972.

Gaugh 1985
Gaugh, Harry F. *The Vital Gesture: Franz Kline*. New York: Abbeville Press, 1985.

Gedeon 1984
Gedeon, Lucinda H. "Tamarind: Los Angeles to Albuquerque." *Grunwald Center Studies* (Grunwald Center for Graphic Arts, University of California, Los Angeles). vol.5, 1984, pp.13–21.

Geldzahler 1966
Geldzahler, Henry. "Frankenthaler, Kelly, Lichtenstein, Olitski: A Preview of the American Section at the 1966 Venice Biennial." *Artforum*. vol.5, June 1966, pp.32–38.

Geldzahler/Hilton/Fourcade 1990
Geldzahler, Henry, Tim Hilton, and Dominique Fourcade. *Jules Olitski*. Exh. cat. New York, Salander-O'Reilly Galleries, 1990.

Gibson 1983
Gibson, Ann. "Painting Outside the Paradigm: Indian Space." *Arts*. vol.57, February 1983, pp.98–104.

Gibson 1992
Gibson, Ann. "Recasting the Canon: Norman Lewis and Jackson Pollock." *Artforum*. vol.30, March 1992, pp.66–73.

Gibson/Euell 1989
Gibson, Ann, and Julian Euell. *Norman Lewis: From the Harlem Renaissance to Abstraction*. Exh. cat. New York, Kenkeleba Gallery, 1989.

Gide 1928
Gide, André. *The Immoralist* (translated by Dorothy Bussy). New York: Knopf, 1928.

Gilkey 1986
Gilkey, Gordon W. (ed.). *The Hosannah Suite: Prints and Drawings by Harold Paris (1925–1979)*. Exh. cat. Portland Art Museum, Oregon Art Institute, 1986.

Gilkey/Hanson 1994
Gilkey, Gordon W., and Hanson, Virginia W. *Jacob Kainen, A Print Retrospective*. Exh. cat. Portland, Oregon, Vivian and Gordon Gilkey Center for Graphic Arts, Portland Art Museum, 1994.

Gilmour 1988
Gilmour, Pat. *Lasting Impressions: Lithography As Art*. London: Alexandria Press, 1988.

Glaubinger 1995
Glaubinger, Jane. *Dorothy Dehner: Drawings, Prints, Sculpture*. Exh. cat., The Cleveland Museum of Art, 1995.

Goldberg 1988
Goldberg, Beth. *Walter Kuhlman: A Forty-Year Retrospective*. Exh. cat. Rohnert Park, California, University Art Gallery, Sonoma State University, 1988.

Goldberg 1993
Goldberg, Vicki. "Grace Hartigan Still Hates Pop." *New York Times*. August 15, 1993, pp.30–31.

Goldman 1982
Goldman, Judith. "Sam Glankoff: Maybe I'm Not Bad." *Artnews*. vol.81, September 1982, pp.70–71.

Goodman 1986
Goodman, Cynthia. *Hans Hofmann*. New York: Abbeville Press, 1986.

Goodman 1992
Goodman, Linda. "A Conversation with George Miyasaki." *The California Printmaker*. no.2, Spring 1992, pp.8–12.

Goodnough 1950
Goodnough, Robert (ed.). "Artists' Sessions at Studio 35 (1950)" in Motherwell, Robert and Ad Reinhardt. *Modern Artists in America*. New York: Wittenborn, 1950, pp.9–23.

Goodnough 1951
Goodnough, Robert. "Pollock Paints a Picture." *Artnews*. vol.3, May 1951, pp.38–41, 60–61.

Goodnough 1952
Goodnough, Robert. "Kline Paints a Picture." *Artnews*. vol.51, December 1952, pp.36–39, 63–64.

Goodnough 1965
Goodnough, Robert. "About Painting." *Art and Literature: An International Review*. vol.4, Autumn 1965, pp.119–27.

Goodrich 1963
Goodrich, Lloyd. *Richard Pousette-Dart*. Exh. cat. New York, Whitney Museum of American Art, 1963.

Goossen 1969
 Goossen, E.C. *Helen Frankenthaler*. Exh. cat.
 New York, Whitney Museum of American Art,
 1969.
Gordon 1968
 Gordon, John. *Franz Kline 1910–1962*. Exh. cat.
 New York, Whitney Museum of American Art,
 1968.
Gordon/Johnson 1955
 Gordon, John, and Una E. Johnson. *14 Painter-
 Printmakers*. Exh. cat. Brooklyn Museum,
 1955.
Gordon/Johnson 1957
 Gordon, John, and Una E. Johnson. *14 Painter-
 Printmakers*. Exh. cat. New York, Kraushaar
 Galleries, 1957.
Gottlieb 1947
 Gottlieb, Adolph. "The Ides of Art." *Tiger's
 Eye*, vol.1, December 1947, p.52.
Graham 1987
 Graham, Lanier. *The Spontaneous Gesture:
 Prints and Books of the Abstract Expressionist
 Era*. Exh. cat. Canberra, Australian National
 Gallery, 1987.
Graham 1990
 Graham, Lanier. "The Rise of the *Livre
 d'Artiste* in America: Reflections on *21
 Etchings and Poems*." *Tamarind Technical
 Papers*. vol.13, 1990, pp.35–40, 53.
Graham 1991A
 Graham, Lanier. *Willem de Kooning, The
 Printer's Proofs*. Exh. cat. New York, Salander-
 O'Reilly Gallery, 1991.
Graham 1991B
 Graham, Lanier. *The Prints of Willem de
 Kooning: A Catalogue Raisonné. I: 1957–1971*.
 Paris: Baudoin Lebon, 1991.
Graham/Walker/Budnik 1991
 Graham, Lanier, Barry Walker, and Dan
 Budnik. *Willem de Kooning: Printer's Proofs
 from the Collection of Irwin Hollander, Master
 Printer*. Exh. cat. New York, Salander-O'Reilly
 Galleries, 1991.
Grand/Adams 1994
 Grand, Stanley I, and Clinton Adams. *The
 Drum Lithographs: 1960–1963*. Exh. cat.
 Wilkes-Barre, Pennsylvania, Sordoni Art
 Gallery, Wilkes University, 1994.
Graves 1948
 Graves, Robert. *The White Goddess: A
 Historical Grammar of Poetic Myth*. London:
 Faber and Faber, 1948.
Gray 1964
 Gray, Cleve. "Print Review: New York
 Panorama." Art in America. vol.52, April 1964,
 pp.106–12.

Gray 1966
 Gray, Cleve. "Experiment Grows in Brooklyn."
 Art in America. vol.54, September–October
 1966, pp.58–63.
Gray/Rowley 1955
 Gray, Cleve, and George Rowley. "Chinese and
 Western Composition." *College Art Journal*.
 vol.15, Fall 1955, pp.6–17.
Greenberg 1948
 Greenberg, Clement. "Art." *The Nation*. April
 24, 1948, p.448.
Greenberg 1977
 Greenberg, David (ed.). *Big Art: Megamurals
 & Supergraphics*. Philadelphia: Running
 Press, 1977.
Greenberg/Goossen 1958
 Greenberg, Clement, and E.C. Goossen.
 *Barnett Newman: First Retrospective
 Exhibition*. Exh. cat. Bennington Vermont,
 Bennington College, 1958.
Groschwitz 1954
 Groschwitz, Gustave von. "American Colour
 Lithography, 1952 to 1954." *The Studio*.
 vol.148, July 1954, pp.1–9.
Groschwitz 1956
 Groschwitz, Gustave von. *Fourth International
 Biennial Exhibition of Color Lithography*. Exh.
 cat. Cincinnati Art Museum, 1956.
Grossberg 1965
 Grossberg, Jacob. "Dorothy Dehner." *Arts*.
 vol.39, May–June 1965, p.54.
Gruenebaum 1978
 Gruenebaum Gallery, *Emerson Woelffer:
 Paintings and Collages* (with Introduction by
 Robert Motherwell). Exh. cat. New York, 1978.
Guest 1953A
 Guest, Barbara. "Richard Stankiewicz."
 Artnews. vol.51, January 1953, pp.50, 64.
Guest 1953B
 Guest, Barbara. "John Grillo." *Artnews*. vol.51,
 February 1953, pp.57, 67.
Guggenheim 1982.
 Solomon R. Guggenheim Museum. *Jack
 Tworkov: Fifteen Years of Painting*. Exh. cat.
 New York, 1982.
Guilbaut 1983
 Guilbaut, Serge. *How New York Stole the Idea
 of Modern Art: Abstract Expressionism,
 Freedom, and the Cold War*. Chicago:
 University of Chicago Press, 1983.
Haas 1951
 Haas, Irvin. "Henry Mark & Sylvia Wald."
 Artnews. vol.30, February 1951, p.47.

Haas 1955
 Haas, Irvin. "The Print Collector: Graphics
 160." *Artnews*. vol.54, September 1955,
 pp.13, 66.
Hacker 1988
 Hacker, P.M.S. (ed.). *The Renaissance of
 Gravure: The Art of S.W. Hayter*. Exh. cat.
 Oxford, Ashmolean Museum, 1988.
Haeckel 1904
 Haeckel, Ernst. *Kunstformen de Natur*.
 Leipzig/Vienna: Verlag des bibliographischen
 Instituts, 1904.
Haenlein 1980
 Haenlein, Carl. *Larry Rivers, Retrospektive:
 Zeichnungen*. Exh. cat. Hannover, Kestner-
 Gesellschaft, 1980.
Hagani 1993
 Hagani, Lisa. *Paul Jenkins: Collage-Paintings*.
 Exh. cat. New York, Associated American
 Artists, 1993.
Halasz 1984
 Halasz, Piri. "Stanley William Hayter: Pollock's
 Other Master." *Arts*. vol.59, November 1984,
 pp.73–75.
Hale 1957
 Hale, Herbert D. "Walasse Ting." *Artnews*.
 vol.56, March 1957, p.58.
Hall 1993
 Hall, Lee. *Elaine and Bill, Portrait of a
 Marriage: The Lives of Willem and Elaine de
 Kooning*. New York: Harper Collins, 1993.
Halpern 1992
 Halpern, Nora. *Dynaton, Before & Beyond:
 Works by Lee Mullican, Gordon Onslow-Ford
 and Wolfgang Paalen*. Exh. cat. Malibu,
 California, Frederick R. Weisman Museum of
 Art, Pepperdine Univeristy, 1992.
Harithas/Hess 1973
 Harithas, James, and Thomas B. Hess.
 Norman Bluhm. Exh. cat. Syracuse, New York,
 Everson Museum of Art, 1973.
Harithas/Sansone 2000
 Harithas, James, and Luigi Sansone. *Norman
 Bluhm: Opere su carta, 1948–1999*. Exh. cat.
 Milan, Padiglione d'Arte Contemporanea di
 Milano, 2000.
Harris 1987
 Harris, Mary E. *The Arts at Black Mountain
 College*. Cambridge, Massachusetts: MIT
 Press, 1987.
Harrison 1984A
 Harrison, Helen A. "Herman Cherry." *Arts*.
 vol.59, November 1984, p.7.
Harrison 1984B
 Harrison, Helen A. *Larry Rivers*. New York:
 Harper and Row, 1984.

Harrison 1993
Harrison, Helen A. *Atelier 17 and the New York Avant-garde*. Exh. cat. East Hampton, New York, Pollock-Krasner House and Study Center, 1993.

Harrison 1994
Harrison, Helen A. *Color Rhythm: The Late Watercolors of Joseph Meert*. Exh. cat. East Hampton, New York, Pollock-Krasner House and Study Center, 1994.

Harrison 1995
Harrison, Helen A. *Jackson Pollock: The 'New Found' Screen Prints*. Exh. cat. East Hampton, New York, Pollock-Krasner House and Study Center, 1995.

Harrison 1996
Harrison, Pegram. *Frankenthaler Prints: Catalogue Raisonné 1961–1992*. New York: Abrams, 1996.

Harrison 1997
Harrison, Helen A. *Jackson Pollock (1912–1956): Prints*. Exh. cat. Dallas, The Gallery, Southern Methodist University, 1997.

Harvey 1994
Harvey, Ian. *Adolph Gottlieb: The Complete Prints*. Exh. cat. New York, Associated American Artists, 1994.

Hauser 1991
Hauser, Stephen E. (ed.). *Feininger and Tobey, Years of Friendship 1944–1956: The Complete Correspondence*. New York: Achim Moeller Fine Art, 1991.

Hayter 1949
Hayter, Stanley William. *New Ways of Gravure*. New York: Pantheon, 1949 (rev. ed., New York: Watson Guptill, 1981).

Heidenheim 1976
Heidenheim, Hanns W. *Mark Tobey, Das Graphische Werke, I: Radierungen und Serigraphien 1970–1975*. Dusseldorf: Ursus Presse, 1976.

Henderson 1991
Henderson, Maren Henry. "Claire Falkenstein: Problems in Sculpture and Its Redefinition in the Mid-Twentieth Century." Ph.D. dissertation. University of California, Los Angeles, 1991.

Henry 1994
Henry, Gerrit. "Jack Hultberg." *Art in America*. vol.82, October 1994, p.140.

Herrmann 1995
Herrmann, Michael. *John von Wicht (1888–1970) The Way to Abstraction*. Frankfurt-am-Main: P. Lang, 1995.

Herter Gallery 1988
Herter Gallery. *Drawings and Black and White 1973–1986: John Grillo*. Exh. cat. University of Massachusetts, Amherst, 1988.

Hess 1954
Hess, Thomas B. "Milton Resnick." *Artnews*. vol.54, December 1954, p.51.

Hess 1956
Hess, Thomas B. "U.S. Painting: Some Recent Directions." *Artnews Annual XXV*. 1956, pp.73–98, 174–180.

Hess 1968
Hess, Thomas B. *Willem de Kooning*. New York: Museum of Modern Art, 1968.

Hess 1971
Hess, Thomas B. *Barnett Newman*. Exh. cat. New York, Museum of Modern Art, 1971.

Hess/Buck 1976
Hess, Thomas B., and Robert T. Buck, Jr. *Cleve Gray: Paintings 1966–1977*. Exh. cat. Buffalo, New York, Albright-Knox Gallery, 1976.

Heyman 1987
Heyman, Therese. *Cream of California Prints*. Exh. cat. Oakland, California, The Oakland Museum, 1987.

Hirsch 1994
Hirsch, Sanford (ed.). *The Pictographs of Adolph Gottlieb*. New York: Arts Publisher, 1994.

Hirsch/MacNaughton 1981
Hirsch, Sanford, and Mary Davis MacNaughton. *Adolph Gottlieb: A Retrospective*. New York: Arts Publisher, 1981.

Hobbs 1999
Hobbs, Robert. *Lee Krasner*. Exh. cat. New York: Independent Curators International, 1999.

Hobbs/Kuebler 1990
Hobbs, Robert and Joanne Kuebler. *Richard Pousette-Dart*. Indianapolis Museum of Art, 1990.

Hofmann 1968
Hofmann, Hans (eds. Bartlett H. Hayes, Jr., and Sarah T. Weeks). *The Search for the Real and Other Essays*. Andover, Massachusetts, Addison Gallery of American Art, 1948 (reprint, 1968).

Hogben/Watson 1985
Hogben, Carol, and Rowan Watson (eds.). *From Manet to Hockney, Modern Artists' Illustrated Books*. Exh. cat. London, Victoria and Albert Museum, 1985.

Holland et al. 1998
Holland, Juanita Marie, et al. *Narratives of African American Identity: The David C. Driskell Collection*. Exh. cat. College Park, Maryland, The Art Gallery, University of Maryland, 1998.

Holliday 1953
Holliday, Betty. "Casarella and Longo." *Artnews*. vol.52, June 1953, pp.61–62.

Hopkins 1971
Hopkins, Henry. *Milton Resnick: Selected Large Paintings*. Exh. cat. Fort Worth Art Center Museum, Texas, 1971.

Hopps 1961
Hopps, Walter. *Hassel Smith: A Selection of Paintings*. Exh. cat. Pasadena Art Museum, 1961.

Hopps 1966
Hopps, Walter. *Frank Lobdell: Paintings and Graphics from 1948 to 1965*. Exh. cat. Pasadena Art Museum, 1966.

Hopps/Agee/Berman 1993
Hopps, Walter, William C. Agee, and Avis Berman. *Jacob Kainen*. Exh. cat. Washington, D.C., National Museum of American Art, Smithsonian Institution, 1993.

Huber 1969
Huber, Carlo, *Barnett Newman: 22 Lithographien*. Exh. cat. Basel, Kunstmuseum, 1969.

Hughes 1986
Hughes, Edan Milton. *Artists in California, 1786–1940*. 2 vols. San Francisco: Hughes Publishing Company, vol.I, 1986; vol.2, 1990.

Hunter 1957
Hunter, Sam. *David Smith*. Exh. cat. New York, Museum of Modern Art, 1957

Hunter 1963
Hunter, Sam. *James Brooks*. Exh. cat. New York, Whitney Museum of American Art, 1963.

Hunter 1965
Hunter, Sam. *Larry Rivers* (with a memoir by Frank O'Hara and a statement by the artist). Exh. cat. Waltham, Massachusetts, Rose Art Museum, Brandeis University, 1965.

Hunter 1989
Hunter, Sam. *Larry Rivers*. New York: Abrams, 1989.

Isselbacher 1998
Isselbacher, Audrey. *Jackson Pollock Screenprints: A New Discovery*. Exhibition brochure. New York, Museum of Modern Art, 1998.

Jacks 1985
Jacks, Shirley. *John Hultberg, Painter of the In-Between: Selected Paintings, 1953–1984.* Exh. cat. Clinton, New York, Fred L. Emerson Gallery, 1985.

Jeffett 1998
Jeffett, William. *Surrealism in America during the 1930s and 1940s: Selections from the Penny and Elton Yasuna Collection.* Exh. cat. St. Petersburg, Florida, Salvador Dalí Museum, 1998.

Jenkins/Tapié 1956
Jenkins, Paul, and Esther Jenkins (eds.). *Observations of Michel Tapié* (translated by Julia Randall). New York: Wittenborn, 1956.

Johnson 1943
Johnson, Una E. *Abstraction, The Woodblock Color Prints of Louis Schanker.* Exh. cat. Brooklyn Museum, 1943.

Johnson 1952A
Johnson, Una E. "The Brooklyn Museum Sixth National Print Annual." *Brooklyn Museum Bulletin.* vol.13, Spring 1952, pp.24–27.

Johnson 1952B
Johnson, Una E. "New Expressions in Fine Printmaking: Methods—Material—Ideas." *Brooklyn Museum Bulletin,* vol.14, Fall 1952, pp.1–28.

Johnson 1956
Johnson, Una E. *Ten Years of American Prints, 1947–1956.* Exh. cat. Brooklyn Museum. 1956.

Johnson 1964
Johnson, Una E. *Arthur Deshaies, Engravings: Wood—Plastic—Plaster.* Exh. cat. Tallahassee, Florida, The Little Gallery, Lewis State Bank, 1964.

Johnson 1967
Johnson, Una E. *Louise Nevelson, Prints and Drawings 1953–1966.* Exh. cat. Brooklyn Museum, 1967.

Johnson 1969
Johnson, Una E. "The Intaglio Prints of Bernard Childs." *Art in America.* vol.57, November–December 1969, pp.118–21.

Johnson 1980
Johnson, Una E. *American Prints and Printmakers.* Garden City, N.J.: Doubleday, 1980.

Johnson 1995
Johnson, Ken. "Norman Bluhm at Ace." *Art in America.* vol.83. February 1995, pp. 89–90.

Johnson et al. 1997
Johnson, Robert Flynn, et al. *Variations in Time: Nathan Oliveira, Monotypes and Monoprints.* Exh. cat. Fine Arts Museums of San Francisco, 1997.

Johnson/Miller 1969
Johnson, Una E., and Jo Miller. *Adja Yunkers: Prints 1927–1967.* Exh. cat. Brooklyn Museum, 1969.

Johnston 1979
Johnston, John. "Michael Goldberg's New Paintings." *Artforum.* vol.17, Summer 1979, pp.42–45.

Jones 1973
Jones, Harvey L. *Nathan Oliveira: Paintings, 1959–1973.* Exh. cat. The Oakland Museum, 1973.

Jones 1982
Jones, Elizabeth. "Robert Blackburn: An Investment in an Idea." *Tamarind Technical Papers.* vol.6, Winter 1982–83, pp.10–14.

Jones 1990
Jones, Caroline A. *Bay Area Figurative Art, 1950–65.* Exh. cat. San Francisco Museum of Modern Art, 1990.

Jones 1993
Jones, Caroline A. *Frank Lobdell: Works, 1947–1992.* Exh. cat. Stanford University Museum of Art, 1993.

Joyaux/Tully 1989
Joyaux, Alain, and Judd Tully. *Herman Cherry: A Retrospective.* Exh. cat. Muncie, Indiana, Ball State University Art Gallery, 1989.

Judd 1960
Judd, Donald. "Joseph Fiore." *Arts.* vol.35, December 1960, pp.51–52.

Kainen 1962
Kainen, Jacob. *John Baptist Jackson: Eighteenth Century Master of the Color Woodcut.* Washington, D.C., United States National Museum, 1962.

Kainen 1976
Kainen, Jacob. "Memories of Arshile Gorky." *Arts.* May 1976, pp.96–98.

Kainen 1986
Kainen, Jacob. "Remembering John Graham." *Arts.* November 1986, pp.25–31.

Karlstrom/Ehrlich 1990
Karlstrom, Paul J., and Susan Ehrlich. *Turning the Tide: Early Los Angeles Modernists 1920–1956.* Exh. cat. Santa Barbara Museum of Art, 1990.

Katz 1996
Katz, Vincent. "Michael Goldberg at Lennon, Weinberg." *Art in America.* vol.84, November 1996, pp.117–28.

Kellein 1992
Kellein, Thomas (ed.). *Clyfford Still, 1904–1980: The Buffalo and San Francisco Collections.* Exh. cat. Buffalo, Albright-Knox Gallery, 1992.

Kenedy 1974
Kenedy, R.C. "Deborah Remington." *Art International.* vol.18, Summer 1974, pp.21, 59.

Kenkeleba Gallery 1991
Kenkeleba Gallery. *The Search for Freedom: African American Abstract Painting.* Exh. cat. New York, Kenkeleba Gallery, 1991.

Kertess/Landau/Close 1997
Kertess, Klaus, Ellen Landau, and Leslie Close. *Alfonso Ossorio: Congregations.* Exh. cat. Southampton, New York, Parrish Art Museum, 1997.

Ketner 1981
Ketner, Joseph D., II. *Hartigan: Thirty Years of Painting.* Exh. cat. Fort Wayne Museum of Art, 1981.

Kind 1967
Kind, Joshua. "Ginzel, Hoff, Ferrari." *Artnews.* vol.66, Summer 1967, p.61.

King-Hammond 1989
King-Hammond, Leslie. *Black Printmakers and the W.P.A.* Exh. cat. Bronx, The Lehman College Art Gallery, the City University of New York, 1989

Kingsley 1975
Kinglsey, April. "James Brooks: Critique and Conversation." *Arts.* vol.49, April 1975, pp.54–57.

Kingsley 1988
Kingsley, April. *John Grillo: A Selection of Works from the 1950s to the 1980s.* Exh. cat. Provincetown, Massachusetts, Provincetown Art Association and Museum, 1988.

Koch 1994
Koch, Kenneth. *On the Great Atlantic Railway: Selected Poems 1950–1988.* New York: Knopf, 1994.

Kramer 1979
Kramer, Hilton. "John Opper." *New York Times.* November 2, 1979, p.C-22.

Kramer 1986
Kramer, Linda Konheim. *Cleve Gray: Works on Paper 1940–1986.* Exh. cat. Brooklyn Museum, 1986.

Kraskin 1991
Kraskin, Sandra (ed.). *The Indian Space Painters: Native American Sources for American Abstract Art.* Exh. cat. New York, Baruch College Gallery, 1991.

Kraskin 1992
Kraskin, Sandra. *Life Colors Art: Fifty Years of Painting by Peter Busa.* Exh. cat. Provincetown, Massachusetts, Provincetown Art Association, 1992.

Krasne 1950
Krasne, Belle. "Talent: Real and New." *Art Digest*. vol.24, March 1, 1950, pp.16–17.

Krasne 1951
Krasne, Belle. "Whitney Annual, 1951 Edition: What's New in American Painting?" *Art Digest*. vol.26, November 15, 1951, pp.6–7.

Krasne 1954
Krasne, Belle. "Ten Artists in the Margin." *Design Quarterly*. vol.30, Spring 1954, pp.10–23.

Krens 1980
Krens, Thomas. *Helen Frankenthaler Prints: 1961–1979*. Exh. cat. Williamstown, Massachusetts, Sterling and Francine Clark Art Institute, 1980.

Krevsky 1996
George Krevsky Gallery. *Walter Kuhlman: Monotypes*. Exh. cat. San Francisco, 1996.

Kroll 1963
Kroll, Jack. "Walasse Ting." *Artnews*. vol.61, January 1963, pp.14–15.

Kuh 1956
Kuh, Katherine. "New Talent in the U.S.A." *Art in America*. vol.44, February 1956, pp.12–55.

Kuh/Moore 1966
Kuh, Katherine, and Ethel Moore. *Clyfford Still: Thirty-three Paintings in the Albright-Knox Art Gallery*. Exh. cat. Buffalo, New York, Buffalo Fine Arts Academy, 1966.

Kushner 1984
Kushner, Marilyn. *Sam Glankoff (1894–1982): A Retrospective Exhibition*. Exh. cat. New Brunswick, New Jersey, Jane Voorhees Zimmerli Art Museum, Rutgers, The State University of New Jersey, 1984.

Kushner/Wechsler 1985
Kushner, Marilyn, and Jeffrey Wechsler. "Sam Glankoff and Print-Painting." *Print Review*. vol.20, August 1985, pp.45–53.

Kuspit 1979
Kuspit, Donald B. "Deborah Remington: Autonomy and Absence in the Visual Koan." *Art International*. vol.23, Summer 1979, pp.17–23.

La Farge 1952
La Farge, Henry A. "Theodore Brenson—Wittenborn." *Artnews*. vol.50, February 1952, p.41.

Landau 1995
Landau, Ellen. *Lee Krasner: A Catalogue Raisonné*. New York: Abrams, 1995.

Landauer 1990
Landauer, Susan. "John Grillo, the San Francisco Years." *Art of California*. May 1990, pp.56–60.

Landauer 1993
Landauer, Susan. *Paper Trails: San Francisco Abstract Expressionist Prints, Drawings and Watercolors*. Exh. cat. The Art Museum of Santa Cruz County, 1993.

Landauer 1996
Landauer, Susan. *The San Francisco School of Abstract Expressionism*. Exh. cat. Laguna Beach, Laguna Art Museum, 1996.

Landauer 1999
Landauer, Susan. *Breaking Type: The Art of Karl Kasten*. Exh. cat., San Francisco Center for the Book, 1999.

Langsner 1953
Langsner, Jules. "Mullican Paints a Picture." *Artnews*. vol.52, October 1953, pp.34–37, 66–67.

Langsner 1957
Langsner, Jules. "Art News from Los Angeles." *Art News*. vol.56, summer 1957, pp.64, 81.

Langsner 1962
Langsner, Jules. "Is There an American Print Revival? Tamarind Workshop." *Art News*. vol.60, January 1962, p.35.

Larsen 1986
Larsen, Susan C. *Moderns in Mind, Gerome Kamrowski, Lee Mullican, Gordon Onslow-Ford*. Exh. cat. New York, The Mark Rothko Foundation, Artists Space, 1986.

Lawson 1976
Lawson, Thomas. *Norman Lewis: A Retrospective*. Exh. cat. New York, The Mall, The Graduate School and University Center of the City University of New York, 1976.

Lehman 1980
Lehman, David (ed.). *Beyond Amazement: New Essays on John Ashbery*. Ithaca, New York: Cornell University Press, 1980.

Lehman 1995
Lehman, David. "The Artistic Triumph of New York." *American Heritage*. vol.46, September 1995, pp.48–65.

Lehman 1998
Lehman, David. *The Last Avant-garde: The Making of the New York School of Poets*. New York: Doubleday, 1998.

Lehman 2000
Lehman, David. "O'Hara's Artful Life." *Art in America*. February 2000, pp.117–43.

Leider 1962
Leider, Philip. "The Construction as an Object of Illusion." *Artforum*. vol. October 1962, p.40.

Leites 1984
Leites, Edmund. "Herman Cherry at Il Punto Blu." *Art in America*. vol.72, November 1984, p.171.

Lembark 1992
Lembark, Connie W. *The Prints of Sam Francis: A Catalogue Raisonné 1960–1990*. 2 vols., New York: Hudson Hills Press, 1992.

Lernan 1950
Lernan, Leo. "Most Likely to Succeed." *Mademoiselle*. September 1950, pp.166–67.

Levin 1995
Levin, Gail. *Edward Hopper: An Intimate Biography*. New York: Knopf, 1995.

Lippard 1975
Lippard, Lucy. "Louise Bourgeois: From the Inside Out." *Artforum*. vol.13, March 1975, pp.26–33.

Lisle 1990
Lisle, Laurie. *Louise Nevelson: A Passionate Life*. New York: Summit Books, 1990.

Livingston 1997
Livingston, Jane. *The Art of Richard Diebenkorn*. Exh. cat. New York, Whitney Museum of American Art, 1997.

Lombardi 1999
Lombardi, D. Dominick. "Works of Prose and Images Mark Overview of a Career." *New York Times* (Westchester edition). April 11, 1999, p.18.

Long 1986
Long, Stephen. *Abstract Expressionist Prints*. Exh. cat. New York, Associated American Artists, 1986.

Los Angeles Times 1935
Los Angeles Times. "A Fresco in Mexico." February 10, 1935.

Loughery 1995
Loughery, John. *Sonia Gechtoff: Four Decades, 1956–1995, Works on Paper*. Exh. cat. Saratoga Springs, New York, Schick Art Gallery, Skidmore College, 1995.

Lowe 1937
Lowe, Jeanette. "John Opper Interprets the Familiar Aspects of American Life." *Artnews*. vol.36, October 9, 1937, p.17.

Lubell 1976
Lubell, Ellen. "Roland Ginzel/Caspar Henselmann." *Arts*. vol.50, February 1976, pp.23–24.

Lukach 1983
Lukach, Joan M. *Hilla Rebay: In Search of the Spirit of Art*. New York, 1983.

Lumpkins 1981
Lumpkins, William. *Casa de Sol: Your Guide to Passive Solar House Designs*. Santa Fe, New Mexico: Santa Fe Publishing Company, 1981.

Lumpkins 1986
Lumpkins, William. *La Casa Adobe*. Santa Fe, rev. ed. New Mexico: Ancient City Press, 1986.

MacAgy 1947
MacAgy, Douglas. *John Grillo: Oils and Watercolors*. Exh. cat. Berkeley, California, Daliel's Gallery, 1947.

MacAgy 1961
MacAgy, Douglas. *First New York Exhibition: Hassel Smith*. Exh. cat. New York, André Emmerich Gallery, 1961.

Madison 1979
Warrington Colescott: A History of Printmaking. Exh. cat. Madison, Wisconsin, Madison Art Center, 1979.

Mandle 1968
Mandle, E. Roger. *30 Contemporary Black Artists*. Exh. cat. Minneapolis Institute of Arts, 1968.

Marks/Stevens 1996
Marks, Matthew, and Peter Stevens (eds.). *David Smith: Medals for Dishonor*. Exh. cat. New York, Independent Curators, Inc., 1996.

Marshall/ Tilkin 199
Marshall, Richard, and Daniele Tilkin. *Joan Mitchell*. Exh. cat. Valencia, Spain, IVAM Centre Julio Gonzalez, 1997.

Marter 1984
Marter, Joan M. *Dorothy Dehner and David Smith: Their Decades of Search and Fulfillment*. Exh. cat. New Brunswick, Jane Voorhees Zimmerli Art Museum, Rutgers, The State University of New Jersey, 1984.

Marter 1993
Marter, Joan M. *Dorothy Dehner: Sixty Years of Art*. Exh. cat. Katonah, New York, Katonah Museum of Art, 1993.

Mattison 1989
Mattison, Robert Saltonstall. *Grace Hartigan: Four Decades of Painting*. Exh. cat. New York, Kouros Gallery, 1989.

Maurer/Bayles 1983
Maurer, Evan M., and Jennifer L. Bayles. *Gerome Kamrowski: A Retrospective Exhibition*. Exh. cat. Ann Arbor, University of Michigan Museum of Art, 1983.

Mayer 1962
Mayer, Grace M. *American Prints Today*. (introduction by Lessing J. Rosenwald). Exh. cat. New York, Print Council of America, 1962.

Mayer 1988
Mayer, Musa. *Night Studio: A Memoir of Philip Guston, by his daughter*. New York: Knopf, 1988.

McChesney 1973
McChesney, Mary Fuller. *A Period of Exploration: San Francisco 1945–1950*. Exh. cat. Oakland, California, Oakland Museum, 1973.

McCray Gallery 1993
Dorothy McCray: A Retrospective. Exh. cat. Silver City, Western New Mexico University, Department of Expressive Arts, Francis McCray Gallery, 1993.

McNulty 1952
McNulty, Kneeland. "A Decade of American Printmaking." *The Philadelphia Museum Bulletin*. vol.48, Autumn 1952, pp.3–11.

McNulty 1961
McNulty, Kneeland. "Hosannah: The Work of Harold Paris." *Artist's Proof*. vol.1, 1961, pp.12–17.

McNulty 1963
McNulty, Kneeland. "The New Dimension in Printmaking." *Artist's Proof*. vol.3, 1963, pp.8–17.

Meilach/Ten Hoor 1973
Meilach, Dona Z. and Elvie Ten Hoor. *Assemblage and Collage: Trends and Techniques*. New York: Crown, 1973.

Melberg/Bloch 1980
Melberg, Jerald L., and Milton J. Bloch (eds.). *Romare Bearden, 1970–1980*. Exh. cat. Charlotte, North Carolina, Mint Museum, 1980.

Mellow 1956
Mellow, James R. "John von Wicht." *Arts*. vol.30, February 1956, p.57.

Mellow 1957
Mellow, James R. "Walasse Ting." *Arts*. vol.31, April 1957, p.61.

Mendel 1961
Mendel, Claude. "Sam Tchakalian." *Aujourd'hui*. vol.6, July 1961, p.32.

Meng 1993
Meng, Sara. *Sylvia Wald: Explorations in Serigraphy*. Exh. cat. Louisville, Kentucky, Dario A. Covi Gallery, Allen R. Hite Art Institute, University of Louisville, 1993.

Messinger 1988
Messinger, Lisa Mintz. *James Brooks: A Quarter-Century of Work*. Exh. cat. Huntington, New York, 1988.

Miller 1959
Miller, Dorothy C. (ed.). *Sixteen Americans*. Exh. cat. New York, Museum of Modern Art, 1959.

Moffett 1977
Moffett, Kenworth, *Olitski: New Sculpture*. Exh. cat. Boston, Museum of Fine Arts, 1977.

Moffett 1981
Moffett, Kenworth, *Jules Olitski*. New York: Abrams, 1981.

Montclair 1978
Montclair Art Museum. *James Brooks/John Opper: Paintings of the Seventies*. Exh. cat., Montclair, New Jersey, 1978.

Monte 1965
Monte, James. "San Francisco." *Artforum*. vol.3, April 1965, pp.41–44.

Monte 1974
Monte, James K. *Richard Pousette-Dart*. Exh. cat. New York, Whitney Museum of American Art, 1974.

Monte/Glusker 1982
Monte, James, and Anne Glusker. *The Transcendental Painting Group: New Mexico 1938–1941*. Exh. cat. Albuquerque, New Mexico, The Albuquerque Museum, 1982.

Morley 1929
Morley, Frank Vigor. *East South East*. New York: Harcourt Brace, 1929.

Morris 1988
Morris, Gay. "George Miyasaki at Stephen Wirtz." *Art in America*. vol.76, October 1988, p.205.

Morrison 1977
Morrison, C.L. "Roland Ginzel." *Artforum*. vol.16, October 1977, pp.71–72.

Morse 1976
Morse, Peter. *Jean Charlot's Prints: A Catalogue Raisonné*. Honolulu: University Press of Hawaii, 1976.

Moser 1997
Moser, Joann. *Singular Impressions: The Monotype in America*. Exh. cat. Washington, D.C., National Museum of American Art, Smithsonian Institution, 1997.

Moss 1977
Moss, Stacey. "James Budd Dixon and the Painting Process." *Artweek*. vol.8, April 2, 1977, p.6.

Moss 1990
Moss, Stacey. *Mediating Abstraction and Figuration: The Paintings of James Kelly, 1952–1990*. Exh. cat. Belmont California, Wiegand Gallery, College of Notre Dame, 1990.

Mullican 1977
Mullican, Lee. "Thoughts on the Dynaton," in *DYNATON Re-Viewed*. Exh. cat. San Francisco, Gallery Paule Anglim, 1977.

Munro 1953
Munro, Eleanor C. "Nell Blaine." *Artnews*. vol.52, September 1953, p.50.

Munson 1949
Munson, Gretchen T. "Theodore Brenson, Newcomb-Macklin," *Artnews*. vol.48, December 1949, p.58.

Munson 1950
 Muson, Gretchen T. "Lawrence Kupferman." *Artnews*. vol.48, January 1950, p.44.
Myers 1969
 Myers, John Bernard. *One Two Three: (An Homage to Pablo Casals)*. San Juan, Galeries Colibri, 1969.
Myers 1975
 Myers, John Bernard. "Anne Ryan's Interior Castle." *Archives of American Art Journal*. vol.15, no.3, 1975, pp.8–11.
Naifeh/Smith 1989
 Naifeh, Steven, and Gregory White Smith. *Jackson Pollock: An American Saga*. New York: C.N. Potter, 1989.
Natsoulas/Novelozo et al. 1989
 Natsoulas, John, Tony Novelozo, et al. *Lyrical Vision: The Six Gallery 1954–1957*. Exh. cat. Davis, California, Natsoulas/Novelozo Gallery, 1989.
Neubert/Saint John 1978
 Neubert, George, and Terry Saint John. *Sam Tchakalian: Paintings 1958–1978*. Exh. cat. Oakland Museum, 1978.
Nevelson/MacKown 1976
 Nevelson, Louise, with Diana MacKown. *Dawns + Dusks: Taped Conversations*. New York: Scribner, 1976.
Newbill 1954A
 Newbill, Al. "The San Francisco Group." *Art Digest*, vol.28, March 1, 1954, p.18.
Newbill 1954B
 Newbill, Al. "Romas Viesulas." *Art Digest*. vol.29, November 1, 1954, p.24.
Newman 1947A
 Newman, Barnett. "The First Man Was an Artist." *Tiger's Eye*. vol.1, October 1947, pp.57–60.
Newman 1947B
 Newman, Barnett. *The Ideographic Picture*. Exh. cat. New York, Betty Parsons Gallery, 1947.
Newman 1948
 Newman, Barnett. "The Sublime is Now." *Tiger's Eye*. vol.1, December 1948, pp.50–53.
Newsweek 1956
 Newsweek. "Sculpture by Torch." January 16, 1956, p.52.
Nixon 1989
 Nixon, Bruce. *Hassel Smith*. Exh. cat. Davis, California, Natsoulas/Novelozo Gallery, 1989.
Nixon 1993
 Nixon, Bruce. "Lobdell's Burden: Frank Lobdell at Stanford University Art Gallery." *Artweek*. vol.24, April 8, 1993, pp.4–5.

Nodelman 1997
 Nodelman, Sheldon. *The Rothko Chapel Paintings: Origins, Structure, Meaning*. Austin, Texas: University of Texas Press, 1997.
Nordland 1961
 Nordland, Gerald. "Variety and Expansion." *Arts*. vol.36, November 1961, pp.48–49.
Nordland 1962
 Nordland, Gerald. *Emerson Woelffer: Work from 1946 to 1962*. Exh. cat. Pasadena Art Museum, 1962.
Nordland 1967
 Nordland, Gerald. *Sam Tchakalian, Wally Hedrick*. Exh. cat. Balboa, California, Balboa Pavilion Gallery, 1967.
Nordland 1969
 Nordland, Gerald. *Frank Lobdell: 27 Lithographs and Large Paintings*. Exh. cat. San Francisco Museum of Art, 1969.
Nordland 1983
 Nordland, Gerald. *Ulfert Wilke, A Retrospective*. Exh. cat. Salt Lake City, Utah Museum of Fine Arts, University of Utah, 1983.
Nordland 1989
 Nordland, Gerald. *Richard Diebenkorn: Graphics 1981–1988*. Exh. cat. Billings, Montana, Yellowstone Art Center, 1989.
Nordland 1993
 Nordland, Gerald. *Matsumi Kanemitsu (1922–1992), A Retrospective*. Exh. cat. Beverly Hills, Louis Newman Galleries, 1993.
O'Connor 1972
 O'Connor, Francis V. (ed.). *The New Deal Art Projects: An Anthology of Memoirs*. Washington, D.C.: Smithsonian Institution, 1972.
O'Connor 1998
 O'Connor, Francis V. *Alfonso Ossorio: The Child Returns, 1950—Philippines, Expressionist Paintings on Paper*. Exh. cat. New York, Michael Rosenfeld Gallery, 1998.
O'Connor/Thaw 1978
 O'Connor, Francis V., and Eugene Victor Thaw. *Jackson Pollock: A Catalogue Raisonné of Paintings, Drawings, and Other Works*. New Haven: Yale University Press, 1978.
O'Hara 1954
 O'Hara, Frank. "Romas Viesulas." *Artnews*. vol.53, October 1954, p.58.
O'Hara 1955
 O'Hara, Frank. "Cy Twombly." *Artnews*. vol.53, January 1955, p.46.
O'Hara 1958
 O'Hara, Frank. *Lipton, Rothko, Smith, Tobey: Stati Uniti d'America, XXIX Biennale Venezia*. Exh. cat. New York, Museum of Modern Art, 1958.

O'Hara 1971
 O'Hara, Frank. *Collected Poems* (ed. Donald Allen). New York: Knopf, 1971.
O'Hara 1975
 O'Hara, Frank. *Art Chronicles 1954–1966*. New York: Braziller, 1975.
O'Neill 1979
 O'Neill, John P. (ed.). *Clyfford Still*. Exh. cat. New York, Metropolitan Museum of Art, 1979.
Onslow-Ford 1969
 Onslow-Ford, Gordon. *Lee Mullican, Paintings 1965–1969*. Exh. cat. Los Angeles, UCLA Art Galleries, 1969.
Oppenheimer 1956
 Oppenheimer, Joel. *The Dutiful Son: Poems*. (Jargon 16), Highlands, North Carolina: J. Williams, 1956.
Panzera/Stedman-Majors 1993
 Panzera, Anthony, and Susan Stedman-Majors. *William Majors: Distinctions, Approaches to Drawing*. Exh. cat. New York, Bertha and Karl Leubsdorf Gallery, Hunter College of the City University of New York, 1993.
Paris 1967
 Paris, Harold. "Sweet Land of Funk." *Art in America*. vol.55, March/April 1967, pp.94–98.
Paris 1982
 Musée d'art moderne de la ville de Paris. *Joan Mitchell: choix de peintures, 1970–1982*. Exh. cat. Paris, 1982.
Parris 1985
 Parris, Nina. *Through a Master Printer: Robert Blackburn and the Printmaking Workshop*. Exh. cat. Columbia, South Carolina, Columbia Museum, 1985.
Pekarsky 1992
 Pekarsky, Mel. *Reuben Kadish* (with essays by Dore Ashton and Herman Cherry). Exh. cat. Stony Brook, University Art Gallery, Staller Center for the Arts. State University of New York, 1992.
Perreault 1967
 Perreault, John. "Yankee Vedanta." *Art News*. vol.66, September 1967, pp. 55, 74–75.
Peterdi 1959
 Peterdi, Gabor. *Printmaking: Methods Old and New*. New York, 1959.
Petersen 1962
 Petersen, Valerie. "John Opper." *Artnews*. vol.61, March 1962, p.15.
Phillips 1980
 Phillips, Joann. *Lee Mullican, Selected Works, 1948–1990*. Exh. cat. New York/Basel, Galerie Schreiner, 1980.

Phillips 1981
 Phillips, Deborah C. "Sam Glankoff." *Artnews*. vol.80, December 1981, pp.175–76.
Pilar 1996
 Pilar, Jacquelin. *Robert McChesney: From Arena to Canyon Country*. Exh. cat. Fresno Art Museum, 1996.
Pilar 1997
 Pilar, Jacqueline. *Sam Tchakalian: Paintings*. Exh. cat. Fresno Art, Museum, 1997.
Plake 1980
 Plake, Katherine. *Claire Falkenstein in San Francisco, Paris, Los Angeles, and Now*. Exh. cat. Palm Springs Desert Museum, 1980.
Porter 1951
 Porter, Fairfield. "Franz Kline." *Artnews*. vol.50, December 1951, p.49.
Porter 1952
 Porter, Fairfield. "Alfred Leslie." *Artnews*. vol.51, February 1952, p.39.
Porter 1954A
 Porter, Fairfield. "Rivers Paints a Picture." *Artnews*. vol.53, January 1954, pp.56–58, 81–82.
Porter 1954B
 Porter, Fairfield. "Hugo Weber." *Artnews*. vol.53, June 1954, p.72.
Porter 1955A
 Porter, Fairfield. "Stankiewicz Makes a Sculpture." *Artnews*. vol.54, September 1955, pp.36–39, 62–63.
Porter 1955B
 Porter, Fairfield. "Lee Krasner." *Artnews*. vol.54, November 1955, p.66.
Porter 1957
 Porter, Fairfield. "Reviews and Previews." *Artnews*. vol.56, December 1957, p.11.
Porter 1958
 Porter, Fairfield. "Albert Urban." *Artnews*. vol.57, October 1958, p.46.
Porter 1959
 Porter, Fairfield. "Gerome Kamrowski." *Artnews*. vol.58, Summer 1959, p.16.
Potter 1985
 Potter, Jeffrey. *To a Violent Grave: An Oral Biography of Jackson Pollock*. New York, 1985.
Powell 1989
 Powell, Richard J. *The Blues Aesthetic: Black Culture and Modernism*. Washington, D.C.: Washington Project for the Arts, 1989.
Prebel 1983
 Prebel, Michael. *James Brooks: Paintings and Works on Paper*. Exh. cat. Portland, Maine, Portland Museum of Art, 1983.

Print Council 1959
 Print Council of America. *American Prints Today/1959* (introduction by Lessing J. Rosenwald). Exh. cat. New York, 1959.
Ratcliff 1971
 Ratcliff, Carter. "Mike Goldberg." *Artnews*. vol.70, March 1971, p.20.
Raynor 1961
 Raynor, Vivien. "Lee Krasner." *Arts*. vol.35, January 1961, p.54.
Raynor 1962
 Raynor, Vivien. "John Opper." *Arts*. vol.36, May–June 1962, p.100.
Reed 1944
 Reed, Judith Kaye. "Urban Impresses." *Art Digest*. vol.19, December 1, 1944, p.30.
Reed 1945
 Reed, Judith Kaye. "Louise Bourgeois." *Art Digest*. vol.19, June 1, 1945, p.31.
Reed 1946A
 Reed, Judith Kaye. "Kamrowski, Surrealist." *Art Digest*. vol.20, January 1946, p.15.
Reed 1946B
 Reed, Judith Kaye. "Kupferman & Leopold." *Art Digest*. vol.20, March 1, 1946, p.15.
Reed 1947
 Reed, Judith Kaye. "April Brings Spring and Pictograph Mobiles." *Art Digest*. vol.21, April 15, 1947, p.18.
Reed 1948
 Reed, Judith Kaye. "Kupferman Abstracts." *Art Digest*. vol.22, April 15, 1948, p.13.
Reed 1949
 Reed, Judith Kaye. "Adventures in Color." *Art Digest*. vol.23, January 15, 1949, p.18.
Reed 1950A
 Reed, Judith Kaye. "Mullican's War Paint." vol.24, February 15, 1950, p.20.
Reed 1950B
 Reed, Judith Kaye. "Sound Abstractions by Seong Moy." *Art Digest*, vol.24, June 1, 1950, pp.17–18.
Restany 1959
 Restany, Pierre. "Bernard Childs: un language de notre temps." *Art International*. vol.III/9, 1959, pp.25–27.
Riley 1943
 Riley, Maude. "Irrepressible Nevelson." *Art Digest*. vol.17, April 15, 1943, p.17.
Riley 1944
 Riley, Maude. "Tobey's white writing." *Art Digest*. vol.18, April 1, 1944, p.19.
Rivers 1982
 Rivers, Larry. "Tatyana Grosman." *Artnews*. vol.81, October 1982, pp.101–02.

Rivers/Brightman 1979
 Rivers, Larry, with Carol Brightman. *Drawings and Digressions, 1949–1969*. Chicago: C.N. Potter, 1979.
Rivers/Weinstein 1992
 Rivers, Larry, with Arnold Weinstein. *What did I do?: The Unauthorized Biography*. New York: Harper Collins, 1992.
Robbins 1971
 Robbins, Daniel. *Cleve Gray: 29 Bronzes*. Exhibition catalogue. New York, Betty Parsons Gallery, 1971.
Roberts/Gilkey 1984
 Roberts, Miriam, and Gordon W. Gilkey. *Mark Tobey: Prints*. Exh. cat. Portland, Oregon, Portland Art Museum, 1984.
Robertson 1965
 Robertson, Bryan. *Lee Krasner: Paintings, Drawings, and Collages*. Exh. cat. London, Whitechapel Art Gallery, 1965.
Robins 1977
 Robins, Corrine. "Deborah Remington: Paintings Without Answers." *Arts*. vol.51, April 1977, p.141.
Robinson 1950A
 Robinson, Amy. "Lee Mullican." *Artnews*. vol.48, February 1950, p.48.
Robinson 1950B
 Robinson, Amy. "Robert Conover." *Artnews*. vol.44, March 1950, pp.46–47.
Robinson 1988
 Robinson, William H. "A Cloud in Pants: Adja Yunkers, Icons to Abstract Expressionism." PhD. dissertation, Cleveland, Case Western Reserve University, 1988.
Robison/Kainen 1985
 Robison, Andrew, and Jacob Kainen. *German Expressionist Prints from the Collection of Ruth and Jacob Kainen*. Exh. cat. Washington, D.C., National Gallery of Art, 1985.
Romano/Ross 1980
 Romano, Clare, and Ross, John. *The Complete Collagaph*. New York: Free Press, 1980.
Rosand et al. 1997
 Rosand, David, et al. *Robert Motherwell on Paper: Prints, Drawings, and Collages*. New York: Abrams, 1997.
Rose 1979
 Rose, Barbara. *Jackson Pollock: Drawing Into Painting*. New York: Museum of Modern Art, 1979.
Rose 1983
 Rose, Barbara. *Lee Krasner: A Retrospective*. Exh. cat. Houston, Texas, Museum of Fine Arts/ New York, Museum of Modern Art, 1983.

Rosenberg 1953
Rosenberg, James. "Michael Goldberg." *Art Digest*. vol.28, October 1, 1953, p.20.

Rosenberg 1978
Rosenberg, Harold. *Barnett Newman*. New York: Abrams, 1978.

Rosenthal 1973
Rosenthal, Mark. *Rudolf Wilke (1873–1908): Centennial Anniversary of His Birth*. Exh. cat. Iowa City, University of Iowa Museum of Art, 1973.

Ross/Romano 1972
Ross, John, and Clare Romano. *The Complete Printmaker*. New York: Free Press, 1972.

Ross/Romano/Ross 1990
Ross, John, Clare Romano, and Tim Ross. *The Complete Printmaker: Techniques, Traditions, Innovations*. New York: Free Press, 1990.

Rourkes 1968
Rourkes, Nicholas. *Sculpture in Plastics*. New York: Watson-Guptill, 1968.

Rousseau 1982
Rosseau, Irene. "Perle Fine." *Arts*. vol.56, June 1982, p.6.

Rubenstein 1982
Rubenstein, Charlotte Streifer. *American Women Artists*. New York: Avon, 1982.

Rubenstein et al. 2000
Rubenstein, Raphael, et. al. *Norman Bluhm*. Milan: Mazzotta, 2000.

Rudikoff 1958
Rudikoff, Sonia. "Words and Pictures." *Arts*. vol.33, November 1958, pp.32–35.

Russell 1984
Russell, John. "Woodcuts and Monotypes by Sam Glankoff." *New York Times*. October 26, 1984, p.C-28.

Rutberg/Gardner 1984
Rutberg, Jack, and Colin Gardner. *Hans Burkhardt, The War Paintings, A Catalogue Raisonné*. Exh. cat. Northridge, California State University, 1984.

Saff/Sacilotto 1970
Saff, Donald, and Sacilotto, Deli. *Printmaking—History and Process*. New York: Holt, Rinehart and Winston, 1970.

Salzillo 1987
Salzillo, William. *Norman Bluhm, Works on Paper 1947–1987*. Exh. cat. Clinton, New York, Hamilton College, 1987.

San Francisco Art Association 1952
San Francisco Art Association. *Painting and Sculpture, The San Francisco Art Association* (with essays by Erle Loran, Weldon Kees, and Ernest Mundt). San Francisco, 1952.

San Francisco Art Association 1958
San Francisco Art Association. *Painting and Sculpture, The San Francisco Art Association: A Catalogue of the Art Bank of the San Francisco Art Association*. San Francisco, 1958.

San Francisco Museum of Modern Art 1976
San Francisco Museum of Modern Art. *Clyfford Still*. Exh. cat. San Francisco, 1976.

Sandler 1958
Sandler, Irving H. "Paul Jenkins." *Artnews*. vol.57, November 1958, p.16.

Sandler 1961A
Sandler, Irving H. "John Grillo." *Arts*. vol.59, February 1961, p.14.

Sandler 1961B
Sandler, Irving H. "Lee Krasner." *Artnews*. vol.59, January 1961, p.15.

Sandler 1963
Sandler, Irving H. "James Brooks and the Abstract Inscape." *Artnews*. vol.61, February 1963, pp.30–31, 88–89.

Sandler 1970
Sandler, Irving H. *The Triumph of American Painting: A History of Abstract Expressionism*. New York: Praeger, 1970.

Sandler 1979
Sandler, Irving H. *The Sculpture of Richard Stankiewicz: A Selection of Works from the Years 1953–1979*. Exh. cat. Albany, New York, University Art Gallery, State University of New York, 1979.

Santlofer 1993
Santlofer, Jonathan. "Lions in Winter: American Artists in their 70s and 80s." *Artnews*. vol.92, March 1993, pp.86–91.

Sawin 1950
Sawin, Martica. "Brooks's Musical Abstractions" *Art Digest*. vol.24, April 15, 1950, p.20.

Sawin 1953
Sawin, Martica. "John Grillo." *Art Digest*. vol.28, November 1, 1953, p.21.

Sawin 1955A
Sawin, Martica. "Edward Colker." *Art Digest*. vol.29, April 15, 1955, p.28.

Sawin 1955B
Sawin, Martica. "Preview at Ganymede." *Art Digest*. September 15, 1955, pp.26–27.

Sawin 1957
Sawin, Martica. "Norman Bluhm." *Arts*. vol.32, October 1957, p.59.

Sawin 1988
Sawin, Martica. "The Third Man, or Automatism American Style." *Art Journal*. vol.47, Fall 1988, pp.181–86.

Sawin 1997
Sawin, Martica. *The Hansa Gallery (1952–1959) Revisited*. Exh. cat. New York, Zabriskie Gallery, 1997.

Sawin 1998
Sawin, Martica. *Nell Blaine: Her Art and Life*. New York: Hudson Hills Press, 1998.

Sawyer 1960
Sawyer, Kenneth. "U.S. Painters Today, No.1: Clyfford Still." *Artnews Annual*. vol.2, 1960, pp.76–86.

Sawyer/Lobdell 1949
Sawyer Kenneth, and Frank Lobdell. *Poems and Drawings*. Sausalito: Bern Porter, 1949.

Schimmel/Ashton 1983
Schimmel, Paul, and Dore Ashton. *Deborah Remington: A Twenty-Year Survey*. Exh. cat. Newport Beach, California, Newport Harbor Museum, 1983.

Schimmel et al. 1984
Schimmel, Paul, et al. *Action/Precision: The New Direction in New York, 1955–60*. Exh. cat. Newport Beach, California, Newport Harbor Art Museum, 1984.

Schipper 1986
Schipper, Merle. "Guy Williams: Santa Barbara Museum of Art." *Artnews*. vol.85, April 1986, p.139.

Schjeldahl 1974
Schjeldahl, Peter. *Norman Bluhm*. Exh. cat. Venice, Palazzo delle Prigioni Vecchie, 1974.

Schmeckebier 1962
Schmeckebier, Lawrence. *American Printmakers 1962*. Exh. cat. Syracuse, New York, Joe and Emily Lowe Art Center, Syracuse University, 1962.

Schneider 1958
Schneider, Pierre. "Paris: Limits of Style, Luce, Tobey." *Artnews*. vol.57, March 1958, pp.46, 54.

Schnelker/Booth 1980
Schnelker, Rebecca, and Judith Booth. *Tamarind Lithographs: A Complete Catalogue of the Lithographs Printed at Tamarind Institute, 1970–1979*. Albuquerque, 1980.

Schor 1996
Schor, Gabriele. *The Prints of Barnett Newman 1961–1969*. Exh. cat. Stuttgart, Staatsgalerie, 1996.

Schuyler 1957
Schuyler, James. "Elaine de Kooning, de Nagy." *Artnews*. vol.56, November 1957, p.12.

Schuyler 1998
Schuyler, James. *Selected Art Writings* (ed. Simon Pettet). Santa Rosa, California: Black Sparrow Press, 1998.

Schwartz 1987
 Schwartz, Alexandra. *David Smith: The Prints* (with introductory essay by Paul Cummings). New York, Pace Prints, 1987.

Seckler 1950
 Seckler, Dorothy. "Gerome Kamrowski." *Artnews*. vol.49, May 1950, p.50.

Seckler 1957
 Seckler, Dorothy Gees. "John von Wicht. His Paintings on View at the Passedoit Gallery Cap a Half-Century of Accomplishment." *Arts*. vol.32, Nov. 1957, pp.32–37.

Seiberling 1949
 Seiberling, Dorothy. "Jackson Pollock: Is he the greatest living painter in the United States?" *Life*. August 8, 1949, pp.42–45.

Seiberling 1957
 Seiberling, Dorothy. "Women Painters in Ascendance." *Life*. May 13, 1957.

Seiberling 1959
 Seiberling, Dorothy. "The Varied Art of Four Painters." *Life*. November 16, 1959, pp.74–86.

Seitz 1963
 Seitz, William. *Hans Hofmann*. Exh. cat. New York, Museum of Modern Art, 1963.

Seitz 1983
 Seitz, William. *Abstract Expressionist Painting in America*. Cambridge, Massachusetts: Harvard University Press, 1983.

Selz 1961
 Selz, Peter. *Mark Rothko*. Garden City, New York: Doubleday, 1961.

Selz 1972
 Selz, Peter (ed.). *Harold Paris: The California Years*. Exh. cat. Berkeley, University Art Museum, University of California, 1972.

Selz 1982
 Selz, Peter. *Sam Francis*. rev. ed., New York: Abrams, 1982.

Shamash 1985
 Shamash, Diane. *Guy Williams*. Exhibition catalogue. Santa Barbara, California, Santa Barbara Museum of Art, 1985.

Shapiro/Gilbert-Rolfe/Longari 1997
 Shapiro, David, Jeremy Gilbert-Rolfe, and Elisabetta Longari. *Michael Goldberg*. Viterbo: Edizioni Primaprint, 1997.

Shedletsky 1994
 Shedletsky, Stuart (ed.). *Still Working: Underknown Artists of Age in America*. Exh. cat. New York, Parsons School of Design, 1994.

Sheehan 1993
 Susan Sheehan Gallery. *Joan Mitchell, Prints and Illustrated Books: A Retrospective*. Exh. cat. New York, 1993.

Shere 1993
 Shere, Charles. *Hassel Smith: Recent Paintings, 1986–1987; Selected Works, 1948–1963*. Exh. cat. Belmont, California, Wiegand Gallery, College of Notre Dame, 1988.

Siegel 1966
 Siegel, Jeanne. "Why Spiral?" *Artnews*, vol.65, September 1966, p.48.

Simon 1967
 Simon, Sidney. "Concerning the Beginnings of the New York School: 1939–1943, An Interview with Peter Busa and Matta." *Art International*. vol.11, Summer 1967, pp.17–20.

Simon 1968
 Simon, Rita. "John Opper." *Arts*. vol.43, September–October 1968, p.66.

Sims/Polcari 1997
 Sims, Lowery Stokes and Stephen Polcari. *Richard Pousette-Dart (1916–1992)*. New York: Metropolitan Museum of Art, 1997.

Skidmore 1948
 Skidmore College. *Dorothy Dehner: Drawings and Paintings* (with introduction by David Smith). Exh. cat., Saratoga Springs, New York, 1948.

Sloat 1999
 Sloat, Richard. "Robert Conover, 1920–1998, A Poet of Prints." *Journal of the Print World*. Winter 1999, p.19.

Smith 1961
 Smith, Lawrence. "Reuben Kadish." *Arts*. vol.35, February 1961, pp.51–52.

Smith/Gray 1968
 Smith, David. *Sculpture and Writings*; edited by Cleve Gray. New York: Holt, Rinehart and Winston, 1968.

Solomon 1987
 Solomon, Deborah. *Jackson Pollock: A Biography*. New York: Simon and Schuster, 1987.

Spangenburg 1972
 Spangenburg, Kristin L. *Mark Tobey: A Decade of Printmaking*. Exh. cat. Cincinnati Art Museum, 1972.

Sparks 1989
 Sparks, Esther. *Universal Limited Art Editions, A History and Catalogue: The First Twenty-Five Years*. Exh. cat. Art Institute of Chicago, 1989.

Spring 1998
 Spring, Justin. "The Hansa Gallery Revisited." *Artforum*. vol.36, March 1998, pp.102–03.

Spurgeon Gallery 1991
 George Stillman, Up 'til Now: A Selection of Work Since 1947, Paintings, Drawings, and Prints. Exh. cat. Central Washington University, Ellensburg, Washington, 1991.

Stankiewicz 1956
 Stankiewicz, Richard. "The Prospects for American Art." *Arts*. vol.30, September 1956, pp.16–17.

Stedelijk 1959
 Stedelijk Museum. *Childs*. Exh. cat. Amsterdam, 1959.

Stein/Shapiro 1991
 Stein, Judith, and David Shapiro. *Alfred Leslie: The Killing Cycle*. Exh. cat. The Saint Louis Art Museum, 1991.

Stevens 1951
 Stevens, Wallace. *The Necessary Angel: Essays on Reality and the Imagination*. New York: Knopf, 1951.

Stevens/Guillemin 1981
 Stevens, Mark, and Chantal Guillemin. *Richard Diebenkorn: Etchings and Drypoints, 1949–1980*. Exh. cat., Minneapolis Institute of Arts, 1981.

Stewart 1975
 Stewart, Patricia. "Michael Goldberg at Cunningham-Ward." *Art in America*. vol.63, November 1975, p.104.

Stiftung Ludwig 1993
 Wolfgang Paalen: Zwischen Surrealismus un Abstraktion. Exh. cat. Vienna, Museum Moderner Kunst Stiftung Ludwig, 1993.

Stone 1949
 Stone, Judy. "New Art Explained by Sausalitans." *San Rafael Daily Independent* and *Marin Journal*. January 22, 1949, p.M-8.

Storm King 1969
 Johnson, Una E. *Bernard Childs: Paintings/Prints/Images in Light*. Exh. cat. Mountainville, New York, Storm King Art Center, 1969.

Story 1961
 Story, Alan. *Hans Burkhardt: Retrospective Exhibition, 1931–1961*. Exh. cat. Santa Barbara Museum of Art, 1961.

Stribling 1970
 Stribling, Mary Lou. *Art from Found Materials: Discarded and Natural*. New York: Crown, 1970.

Strick 1974
 Strick, Jeremy. *Louise Bourgeois: The Personnages*. Exh. cat. The Saint Louis Art Museum, 1974.

Strickler 1991
 Strickler, Susan and Elaine D. Gustafson. *The Second Wave: American Abstraction of the 1930s and 1940s*. Exh. cat. Worcester Art Museum, 1991.

Strong 1977
Strong, Charles. "James Budd Dixon, Non-Objective Paintings, 1948–1960." unpublished manuscript, 1977, Archives of California Art, The Oakland Museum.

Swan 1948
Swan, Bradford F. "Toward A Common Denominator." *Bulletin of the Rhode Island School of Design.* vol.6, March 1948, pp.1–2.

Sweeney 1944
Sweeney, James Johnson. "Hayter and Studio 17." *Museum of Modern Art Bulletin.* vol.12, August 1944, pp.3–16.

Sweeney 1954
Sweeney, James Johnson. *Younger Painters.* Exh. cat., New York, Solomon R. Guggenheim Museum, 1954.

Sweeney 1967
Sweeney, James Johnson. *Sam Francis.* Exh. cat. Houston, Museum of Fine Arts, 1967.

Swetzoff 1950
Swetzoff, Hyman. "Lee Mullican." *Print Collectors' Quarterly.* vol.30, 1950, pp.19–22.

Tamarind 1989
Tamarind Lithography Workshop, Inc., *Catalogue Raisonné, 1960–1970.* Albuquerque: University of New Mexico Press, 1989.

Tapié 1946
Tapié, Michel. *Mirolobus Macadam et Cie—Hautes Pates de Jean Dubuffet.* Exh. cat., Paris, Galerie Rene Drouin, 1946.

Tapié 1952
Tapié, Michel. *Un Art Autre, où il sagit de nouveaux dévigdages du réel.* Exh. cat. Paris, 1952.

Tapié 1960
Tapié, Michel. "The Formal Universe of Claire Falkenstein." Reprinted in Francese Vicens (ed.). *Prolégomènes à une Esthétique Autre de Michel Tapie.* Barcelona: Centre international de recherches esthétiques, 1960, p.131–32.

Taylor/ Warkel 1996
Taylor, William E., and Harriet G. Warkel. *A Shared Heritage: Art by Four African Americans.* Exh. cat., Indianapolis Museum of Art, 1996.

Teller 1987
Teller, Susan. *Dorothy Dehner: A Retrospective of Prints.* Exh. cat. New York, Associated American Artists, 1987.

Temin 1987
Temin, Christine. "Majors' Posthumous Show Is an Affirmation of Life." *Boston Globe.* January 22, 1987, Calendar section, p.1.

Temko 1975
Temko, Allan. *Hassel Smith: Paintings, 1954–1975.* Exh. cat. San Francisco Museum of Modern Art, 1975.

Terenzio 1992
Terenzio, Stephanie (ed.). *The Collected Writings of Robert Motherwell.* New York: Oxford University Press, 1992.

Terenzio/Belknap 1991
Terenzio, Stephanie, and Dorothy C. Belknap. *The Prints of Robert Motherwell.* New York: Hudson Hills Press, 1991.

Thaw/Landau 1951
Thaw, Eugene, and Jack Landau. *Young Painters USA.* Exh. cat. Ithaca, New York, 1951.

Thien/Lasansky 1975
Thien, John, and Lasansky, Philip. *Lasansky: Printmaker.* Iowa City: University of Iowa Press, 1975.

Thompson 1917
Thompson, D'Arcy Wentworth. *On Growth and Form.* Cambridge: Cambridge University Press, 1917.

Thompson 1987
Thompson, Walter. "Deborah Remington at Jack Shainman." *Art in America.* vol.75, July 1987, pp.126–27.

Thompson 1995
Thompson, James. *Joseph Fiore.* Exh. cat. (Black Mountain College Dossiers I) Asheville, North Carolina, Black Mountain College Museum and Art Center, 1995.

Tietjens 1929
Tietjens, Eunice. *The Romance of Antar.* New York: Coward-McCann, 1929.

Tillim 1958
Tillim, Sidney. "Paul Jenkins." *Arts.* vol.33, November 1958, pp.57–58.

Tillim 1959
Tillim, Sidney. "Poem Paintings." *Arts.* vol.34, December 1959, p.62.

Time 1935
Time. "On a Mexican Wall. Philip Goldstein and Reuben Kadish." April 1, 1935.

Time 1948
Time. "Wet and Dry." April 19, 1948.

Time 1956
Time. "Beauty of Junk." December 31, 1956.

Ting 1966
Ting, Walasse. "Near 1cent Life." *Artnews.* vol.65, May 1966, pp.37–38, 67–68.

Todd 1948
Todd, Ruthven. "The Techniques of William Blake's Illuminated Painting." *Print Collector's Quarterly.* vol.29, November 1948, pp.25–37.

Traugott 1998
Traugott, Joseph. *Pueblo Architecture and Modern Adobes: The Residential Designs of William Lumpkins.* Santa Fe: Museum of New Mexico Press, 1998.

Troche/Beall 1963
Troche, E. Gunter, and Dennis Beall. "Prints by George Miyasaki: Achenbach Foundation for Graphic Arts." *California Palace of the Legion of Arts Bulletin.* vol.21, August 1963.

Tuchman 1970
Tuchman, Maurice. *New York School: The First Generation.* 2nd ed. Greenwich, Connecticut: Abbeville Press, 1970.

Tucker 1974
Tucker, Marcia. *Joan Mitchell.* Exh. cat. New York, Whitney Museum of American Art, 1974.

Tully 1983
Tully, Judd. "Dorothy Dehner and Her Life on the Farm with David Smith." *American Artist.* vol.47, October 1983, pp.58–61.

Tully 1986
Tully, Judd. *Reuben Kadish, Survey: 1935–1985.* Exh. cat. New York, Artists' Choice Museum, 1986.

Tyler 1987
Tyler, Kenneth E. *Tyler Graphics: Catalogue Raisonné, 1975–1985.* Minneapolis, Walker Art Center; New York: Abbeville Press, 1987.

Uyemura 1988
Uyemura, Nancy. "Portrait of an Artist." *Tozai Times.* vol.5, December 1988, pp.1, 10.

Varian 1975
Varian, Elayne H. *Hugo Weber: A Retrospective Exhibition.* Exh. cat. New York, Finch College Museum of Art, 1975.

Varnedoe 1994
Varnedoe, Kirk. *Cy Twombly: A Retrospective.* Exh. cat. New York, Museum of Modern Art, 1994.

Varnedoe/Karmel 1998
Varnedoe, Kirk, with Pepe Karmel. *Jackson Pollock.* Exh. cat. New York, Museum of Modern Art, 1998.

Ventura 1958
Ventura, Anita. "Albert Urban." *Arts.* vol.33, October 1958, pp.56–57.

Ventura 1964
Ventura, Anita. "San Francisco." *Arts.* vol.39, October 1964, pp.22–25.

Vevers 1991
Vevers, Tony. *Seong Moy: Color Prints.* Exh. cat. Provincetown, Massachusetts, Provincetown Art Association and Museum, 1991.

Vicens 1960
Vicens, Francisco. *Prolégomènes à une esthé-tique autre de Michael Tapié*. Barcelona: Centre de recherches esthétiques, 1960.

Viesulas 1974
Viesulas, Romas. "Workshop Problems in the Printing of Oversize Prints." *Leonardo*. vol.7, 1974, pp.249–52.

Viesulas 1979
Viesulas, Romas. "On Making and Displaying Inkless Embossed Prints on Dyed Paper." *Leonardo*. vol.2, 1979, pp.101–05.

Vollmer 1953
Vollmer, Hans. *Allgemeines Lexikon der bildenden Künstler des XX. Jahrhunderts*. 6 vols. Leipzing: E.A. Seeman, 1953–62.

Waldman 1978
Waldman, Diane. *Mark Rothko, 1903–1970: A Retrospective*. Exh. cat. New York, The Solomon R. Guggenheim Museum, 1978.

Wallach 1981
Wallach, Amei. *Sam Glankoff: Print-Paintings*. Exh. cat. New York, Graham Gallery, 1981.

Washburn 1995
Joan T. Washburn Gallery. *James Brooks: The Graphic Work*. Exh. cat. New York, 1995.

Watson 1982
Watson, Scott. *Cy Twombly: Prints*. Exh. cat. The Vancouver Art Gallery, 1982.

Wayne 1990
Wayne, June. "Broken Stones and Whooping Cranes: Thoughts of a Wilful Artist." *The Tamarind Papers*. vol.13, 1990, pp.16–33.

Weber 1952
Weber, Hugo. "Vision in Flux: Paintings about Space in Space." *Arts & Architecture*. vol.69, March 1952, p.32.

Weber 1998
Weber, Nicholas Fox. *Cleve Gray*. New York: Abrams, 1998.

Wechsler 1977
Wechsler, Jeffrey. "Surrealism's Automatic Painting Lesson." *Artnews*. vol.76, April 1977, pp.45–46.

Wechsler 1989
Wechsler, Jeffrey. *Abstract Expressionism, Other Dimensions: An Introduction to Small Scale Painterly Abstraction in America, 1940–1965*. Exh. cat. New Brunswick, New Jersey, Jane Voorhees Zimmerli Art Museum, Rutgers, The State University of New Jersey, 1989.

Weeren-Griek 1948
Weeren-Griek, Hans van. "Woodstock Conference." *Art Digest*. vol.22, September 15, 1948, p.34.

Weeren-Griek 1965
Weeren-Griek, Hans van. *Dorothy Dehner: Ten Years of Sculpture*. Exh. cat. The Jewish Museum, 1965.

Weld 1990
Weld, Alison. *Reuben Kadish: Works from 1930 to the Present*. Exh. cat. Trenton, New Jersey State Museum, 1990.

Weller 1955
Weller, Allen S. "Six Artists from the Great Lakes." *Art in America*. vol.43, February 1955, pp.36–46.

Westerbeck 1986
Westerbeck, Colin. "Chicago: Roland Ginzel, Gallery 400, University of Illinois at Chicago; Dart Gallery." *Artforum*. vol.24, May 1986, pp.144–45.

Westfall 1989
Westfall, Stephen. "Vincent Longo at Condeso/Lawler." *Arts*. vol.77, December 1989, p.174.

Whitney 1971
Whitney Museum of American Art. *Mark Tobey: Prints*. Exh. cat. New York, 1971.

Whitney 1979
Whitney Museum of American Art. *Cy Twombly: Paintings and Drawings, 1954–1977*. Exh. cat. New York, 1979.

Who's Who in American Art
Who's Who in American Art. Various editions, 1937–1997, New York; 1997–2000, New Providence, New Jersey: Reed-Elsevier.

Wiggins 1990
Wiggins, Walt. *William Lumpkins: Pioneer Abstract Expressionist*. Ruidoso Downs, New Mexico: Pintores Press, 1990.

Wight 1957
Wight, Frederick S. *Hans Hofmann*. Exh. cat. New York, Whitney Museum of American Art, 1957.

Wilke 1958
Wilke, Ulfert. "Letter from Japan." *College Art Journal*. vol.18, Fall 1958, pp.55–57.

Wilkin 1984
Wilkin, Karen. *David Smith*. New York: Abbeville Press, 1984.

Wilkin/Long 1989
Wilkin, Karen, and Stephen Long. *The Prints of Jules Olitski: A Catalogue Raisonné 1954–1989*. New York: Associated American Artists, 1989.

Williams 1977
Williams, Guy. *(the) PAPER WORKS: Paintings, Photographs, Texts*. Exh. cat. Santa Barbara, California, University Art Galleries, 1977.

Williams 1987
Williams, Reba and Dave. *American Screenprints*. Exh.cat. New York, National Academy of Design, 1987.

Williams 1988
Williams, Reba and Dave. "The Prints of Jackson Pollock." *Print Quarterly*. vol.5, December 1988, pp.346–373.

Williams et al. 1993
Williams, Dave and Reba, et al. *Alone in a Crowd: Prints of the 1930s–1940s by African-American Artists, from the Collection of Reba and Dave Williams*. Exh. cat., New York, American Federation of Arts, 1993.

Wilson 1987
Wilson, MaLin. *William Lumpkins: Works on Paper 1930–1986*. Exh. cat. Jonson Gallery, University of New Mexico, Albuquerque, 1987.

Wirtz Gallery 1981
Stephen Wirtz Gallery. *George Miyasaki*. Exh. cat., San Francisco, 1981.

Wolf 1946
Wolf, Ben. "Sophisticate or Primitive." *Art Digest*. vol.20, March 15, 1946, p.18.

Wolfe 1975
Wolfe, Tom. *The Painted Word*. New York: Farrar, Straus and Giroux, 1975.

Wolfe 1980
Wolfe, Judith. *Alfonso Ossorio, 1940–1980*. Exh. cat. East Hampton, New York, Guild Hall Museum, 1980.

Wye 1982
Wye, Deborah. *Louise Bourgeois*. Exh. cat. New York, Museum of Modern Art, 1982.

Wye/Smith 1994
Wye, Deborah, and Carol Smith. *The Prints of Louise Bourgeois*. Exh. cat. New York, Museum of Modern Art, 1994.

Wysuph 1970
Wysuph, C.L. *Jackson Pollock: Psychoanalytic Drawings*. New York: Horizon Press, 1970.

Yood 1996
Yood, James. *Second Sight: Printmaking in Chicago 1935–1995*. Exh. cat. Evanston, Illinois, Mary and Leigh Block Gallery, Northwestern University, 1996.

Yunkers 1949
Yunkers, Adja. "[Monotype]." *Tiger's Eye*. vol.1, June 15, 1949, pp.52–53.

Zabriskie 1983
Zabriskie, Virginia M. *Richard Stankiewicz: Thirty Years of Sculpture, 1952–1982*. Exh. cat. New York, Zabriskie Gallery, 1983.

INDEX

Abstract Expressionism: as Action Painting, 30; as American avant-garde, 11; Federal Arts Project, Works Progress Administration (FAP/WPA) and, 9; music and, 19–25; origins of, 9; poetry and, 27–38; postwar, 11, 13; subject matter, 28, 36, 152; use of term, 24; during World War II, 9–11

Abstract Painting and Sculpture in America exhibition, 156, 242

Abstract Surrealism, 11. *See also* Surrealism; Burkhardt, 64; Busa, 56–57; Cherry, 108; Dehner, 124; Gottlieb, 48; Grillo, 210; Kupferman, 88; Moy, 198; Rothko, 50; Ryan, 74; Steele, 58; Wald, 116

Achenbach, Moore, 150

Achenbach Foundation, 148

Action I exhibition, 162

Action Painting, 28, 30, 36, 38

Adams, Bernard, 140

Adams, Clinton, 16

Adventures of the Inner Eye exhibition, 54

Aeneid (Virgil), 262 n.68.10

African American artists, 62

African art, 48, 62, 66

Afro-Cuban ethnic art, 180

Albers, Josef, 126

Alberti, Raphael, 234

Aldan, Daisy, 14, 15, 142, 168

Alechinsky, Pierre, 14, 222

Allen, Frank Leonard, 82

Alps, Glen, 258 n.43.8

Alvin, Danny, 94

American Abstract Artists, 42, 54, 60, 166

American Abstract Expressionists and Imagists exhibition, 122

American Art Today exhibition, 194

American Indian art. *See* Native American art

American Painting at Mid-Century exhibition, 104

American Prints Today exhibition, 160

Amero, Emilio, 42

Amram, David, 18, 19–25, 42

Anania, Michael, 202

Anarcho-Syndicalist Party, 180

Anderson-Lamb Company, 16

Anfam, David, 52

Anisfeld, Boris, 94

antiwar art, 64, 218

Antreasian, Garo Z., 16, 144, 188, 226

Antunez, Nemencio, 78

Apollinaire, Guillaume, 27

Appel, Karel, 222

aquatints: Cherry, 108; Kainen, 82; Mullican, 92; Smith, Hassel, 100; Twombly, 238

Archipenko, Alexander, 130

archetypes, 48

architecture, 194

Arel, Bülent, 144

Arp, Jean, 60

Ars, 180

Ars-portfolios, 180

Art Autre, 120, 130

Art in America magazine, 218

Art Informel, 130, 138, 176, 222, 230

"Artist, The" (Koch), 36

Artist and the Book exhibition, 202

Artists' Club, 252 n.intro.8. *See also* Club, The

Artists for Victory exhibition, 114, 134

Artists of the New York School: Second Generation exhibition, 186

Artnews, 60, 148, 170

Art of This Century Gallery, 10, 11, 44, 52, 54, 56, 166, 206, 234

Art Students League, 108, 114, 124, 138, 184, 186, 188, 206, 244

Ashbery, John, 14, 15, 28, 30, 31–32, 32, 33, 34–35, 35, 38, 142, 168, 186

Ashton, Dore, 180

Asian art, 198, 244. *See also* Chinese art; Japanese art

Asian philosophy, 218, 234, 244

Astoria Stained Glass Studio, 68

Atelier 17, 10, 14, 17, 44, 46, 60, 74, 78, 92, 104, 106, 108, 120, 124, 140, 178, 198, 232, 253 n.2.11, 255 n.17.4, 264 n.91.8, 264 n.91.9

Atelier Arte, 248

Atelier Desjobert, 70, 144

Atelier Mourlot, 218

Australian aboriginal art, 48

Automatism, 56, 92, 94. *See also* Surrealist Automatism; Brenson, 106; Brooks, 242; Colker, 202; Grillo, 210; Hofmann, 102; Hultberg, 70; Kamrowski, 54; Kanemitsu, 188; Kelly, 112; Motherwell, 234; Still, 52; Twombly, 238; Tworkov, 228

Avery, Milton, 42

Babbit, Milton, 144

Babolcsay, Steve, 68

Baker, Chet, 136

Baldessari, John, 204

Barber, Samuel, 25

Barnet, Will, 50, 56, 78, 156, 198, 216, 230, 238, 253 n.8.2

Barr, Alfred, 27, 34, 172

Barrett, Lawrence, 94

Bass, Robert, 60

Baudelaire, Charles, 27, 202

Baumeister, Willi, 122

Bay Area Abstract Expressionism, 72, 100

Bay Area Figurative movement, 152

Baziotes, William, 13, 50, 52, 54, 56, 142, 156, 158, 234

Beall, Dennis, 150, 260 n.52; *¡Socarro!,* 150–51

Bearden, Romare, 62

Beat culture, 136

Beauclair, Gotthard de, 134

Beaudoin, Kenneth, 56

Beauvais, Robert, 226

bebop, 24

Becker, Fred, 10

Beckmann, Max, 122, 152, 156, 192

Bell, Edith, 128

Bell, Leland, 60

Bellamy, Richard, 22

Bellerophon Books, 182

Bell-Opticon machine, 140

Benmussa, Simone, 230

Benson, John Howard, 98

Benton, Thomas Hart, 44, 56, 68, 80, 108, 254 n.14.3

Berezov, Maurice, 166

Berglin, Scott, 190

Berkson, Bill, 236

Berliawsky, Leah, 232

Berman, Eugene, 80

Bernstein, Leonard, 25

Bertrand, Ray, 12, 58, 66, 72, 80, 152, 210, 258 n.37.4

Beyeler, Ernst, 134

Bier, Justus, 116

Bigelow, Robert, 234

biomorphism, 88, 220

birth trauma, 98

Bischoff, Elmer, 11, 86, 100, 136, 152, 162

Bistram, Emil, 194

Blackburn, Lewis, 62; *Red Umbrella,* 254 n.11.7

Blackburn, Robert, 16, 60, 62, 158, 166, 178, 182, 186, 216

Blaine, Nell, 29, 32, 33, 60, 158, 170, 254 n.10, 261 n.60.2; *Abstraction,* 60, 254 n.10.5; *Great White Creature,* 60; *Tropical Formation,* 60–61

Blake, William, 14, 32–33

Blanco, Amando, 254 n.12.5

Blondheim, Adolph, 68

Bluhm, Norman, 168, 176, 248, 265 n.99; *A Haiku,* 35; *Untitled,* 248–49

Boccioni, Umberto, 238

Boganove, A.J., 82

Bolotowsky, Ilya, 126

bon á tirer, 264 n.91.8

Booth, Cameron, 54, 66, 84

Bordas, Franck, 230

Bourgeois, Louise, 10, 78, 255 n.18; *Ascension lente (Slow Ascent),* 78–79, 255 n.18.8; *Cinq Personnages,* 255 n.18.9; *He Disappeared into Complete Silence,* 78; *Sleeping Figure,* 78

Brackman, Robert, 184

Bradbury, Ray, 64, 254 n.12.5

Brancusi, Constantin, 84, 224, 246

Brandes, Willy, 260–61 n.59.2

Braque, Georges, 102

Brenson, Theodore, 106, 257 n.31; *Untitled*, 106–7

Breton, André, 54, 114, 124, 252 n.poetry.10

Briggs, Ernest, 80, 110

Britko, Stephen, 264 n.88.6; *Steps to Freedom*, 264 n.88.6

Brodney, Richard, 112

Brooks, James, 170, 242, 265 n.96; *Banter*, 242–43

Brown, Bolton, 148, 150

Brown, Earle, 144

Brown, Kathan, 86

Brown, Theophilis, 152

Browne, Byron, 70, 188

Brubeck, Dave, 136, 202

brushstrokes: Brooks, 242; Casarella, 154; Ginzel, 132; Goodnough, 170; Kanemitsu, 188; Pousette-Dart, 250; Resnick, 246; Wasserstein, 162

Bucholz Gallery, 10

Buckland, John, 132

Budd, James H., 120

Bufano, Benjamino, 120

Bunce, Louis, 252 n.intro.17

Burckhardt, Rudy, 33, 36

Burkhardt, Hans, 64, 134, 254 n.12; *After the Bomb*, 64–65; *The Burial of Gorky*, 64; *Graffiti*, 64, 254 n.12.6; *One Way Road*, 64, 254 n.12.9; *The Studio of Gorky*, 254 n.12.1

"burning parties," Miyasaki, 160

Burri, Alberto, 70

Busa, Christopher, 56

Busa, Peter, 54, 56, 253–54 n.8; *Constellation*, 56–57; *Transfigured Night*, 56

Bussotti, Sylvano, 144

Calder, Alexander, 24

California College of Arts and Crafts (CCAC), 104, 128, 150, 160, 212

California School of Fine Arts (CSFA), 11–12, 13, 50, 52, 58, 66, 70, 72, 80, 84, 86, 100, 110, 112, 120, 126, 130, 136, 148, 150, 160, 162, 210

Callahan, Harry, 224

calligraphy: Bluhm, 248; Brenson, 106; Brooks, 242; Casarella, 154; Childs, 138; Dixon, 120; Falkenstein, 130; Francis, 176; Frankenthaler, 186; Goldberg, 184; Goodnough, 170; Guston, 236; Kanemitsu, 188; Kelly, 112; Lewis, 62; Majors, 226; Mullican, 92; Stillman, 72; Tchakalian, 212; Tobey, 134; Urban, 122; Wald, 116; Wasserstein, 162; Weber, 224; Wilke, 162, 164, 261 n.59.10

Carman, Albert, 42

Caro, Anthony, 240

Carrière, Eugène, 152

cartoon style, 236

Casa del Sol (Lumpkins), 194

Casarella, Edmond, 154, 156, 192, 260 n.54; *Black and Blue*, 154–55; *Civitavecchia*, 154

CCAC. *See* California College of Arts and Crafts (CCAC)

Cedar Tavern (bar), 13, 19–25, 28, 140, 142, 168, 182, 184, 186, 246

Central American culture, 232

Cerda, Frank, 96

Cernovich, Nichola, 238

Cézanne, Paul, 86, 102, 106, 190, 228, 246

Chamberlain, John, 126

Chan, Chaen, 212

Chapin, Francis, 94, 104, 168

Charles, Dennis, 25

Chenoweth, Mary, 94

Cherry, Herman, 68, 108, 253 n.3.5, 257 n.32; *Deep Sea II*, 108–9

Chesney, Lee, 252 n.intro.17

Chicago Graphic Workshop, 132

Childs, Bernard, 138, 259 n.46; *Images in Light*, 138; *Untitled*, 138–39, 266

Chinese art, 72, 134, 198, 222, 230, 236

Chinese philosophy, 218

Christian religion, 106, 226

cinema. *See* film

Cinque Gallery, 62

Cissarz, Vincent, 122

Clay Club, 232

Club, The, 13, 28, 32, 102, 108, 142, 148, 166, 168, 172, 184, 186, 200, 208, 228, 234, 236, 246, 250, 252 n.intro.8

Cobb, Ruth, 88

CoBRA group, 222

Cocteau, Jean, 248

Cole, Ruth, 255 n.20.6

Cole, Timothy, 84

Colescott, Warrington, 146, 259 n.50; *Birmingham Jail*, 146; *Chilly in Chiswick, II*, 146–47; *A History of Printmaking* series, 146

Colker, Ed, 202, 263 n.77; *Poetic Myth I*, 202–3; *The Song of Amergin* suite, 202

collaborative printmaking: Bluhm, 248; Rivers, 158

collage: Brooks, 242; Goodnough, 170; Kline, 140; Moy, 198; Ryan, 74; Yunkers, 180

collagraphy, 258 n.43.8; Childs, 138; Falkenstein, 130; Ginzel, 132; Glankoff, 244; Kasten, 190; Majors, 226; McCray, 128

Collector's Graphics, Inc., 170

Color Field painting, 100; Conover, 156; Frankenthaler, 186; Newman, 200; Olitski, 240

color lithography. *See also* lithography: Gechtoff,

110; Goldin, 104; Hartigan, 182; Jenkins, 230; Kelly, 112; McCray, 128

"color shapes," Goodnough, 170

color use: Colescott, 146; Goldin, 104; Goodnough, 170; Hofmann, 102; Miyasaki, 160; Olitski, 240; Resnick, 246; Ryan, 74

color woodcuts. *See also* woodcuts: Fine, 166; Kasten, 262 n.72.4; Moy, 198; Ryan, 255 n.17.2; Wald, 116; Yunkers, 180

computer art, 204

Conner, Bruce, 110

Conover, Christine, 260 n.55.1

Conover, Robert, 156, 192, 260 n.55; *Collision*, 156–57

Contemporary Prints from Northern California exhibition, 148

Coolidge, Clark, 236

Coomaraswamy, Ananda, 98

Corbett, Edward, 86, 236

Corso, Gregory, 22

cosmography, 52

Création, 180

Creative Graphics Workshop, 166, 178

Creative Printmakers, 44, 68

Crichlow, Ernest, 62

Crossman, John H., 140

Crown Point Press, 148

Cruikshank, George, 146

Cry of the Dreadful Night (Thompson), 54

CSFA. *See* California School of Fine Arts (CSFA)

Cubism, 27; Busa, 56; Cherry, 108; Colescott, 146; Conover, 156; Dehner, 124; de Kooning, Willem, 172; Frankenthaler, 186; Ginzel, 132; Gray, 218; Hultberg, 70; Olitski, 240; von Wicht, 216; Yunkers, 180

Cue magazine, 244, 265 n.97.3

Cunningham, Merce, 148

Curran, Charles, 206

Dada, 238

Dalí, Salvador, 38, 98, 226

Danysh, Joseph, 258 n.37.4

Dart, Flora Louis, 250

Daura, Pierre, 238

Davis, James C., 218

Davis, Miles, 158, 257 n.33.8

Davis, Stuart, 9, 14, 82

Day, Worden, 60

"Deacon's Masterpiece, or The Wonderful One-Hoss Shay" (Holmes), 58

deCarava, Roy, 24

Decroux, Etienne, 226

De Feo, Jay, 110, 112, 212, 257 n.33.6

De Forest, Roy, 110, 112, 120, 162

Degenerate Art exhibition, 122

Dehn, Adolf, 42

Dehner, Dorothy, 114, 124, 232, 258 n.39; *In the Beginning,* 124–25; *Life on the Farm,* 124; *Lunar Series,* 124

de Kooning, Elaine, 94, 148, 172, 259–60 n.51; *Black Mountain Abstractions* series, 148; *Elaine de Kooning, Tibor de Nagy,* 148–49

de Kooning, Willem, 9, 13, 14, 17, 24, 28, 30, 33, 36, 38, 94, 126, 140, 142, 148, 152, 158, 160, 166, 168, 172, 182, 184, 186, 190, 208, 212, 224, 228, 236, 246, 248, 261 n.63; *Excavation,* 172; *Litho #2 (Waves #2),* 172–73; *Woman I,* 172

Delaunay, Robert, 102

Delaunay, Sonia, 102

Delevante, Sidney, 192

della Francesca, Piero, 138

Denby, Edwin, 33

Deshaies, Arthur, 174, 261 n.64; *Death that Came for Albert Camus, The,* 174–75; *Landscape Sign,* 174

Desjobert, Edmond, 98, 202

Desjobert, Jacques, 98, 202

Desmond, Paul, 202

Diamond, Madeleine, 110, 162

Dickinson, Sidney, 240

Diebenkorn, Gretchen, 86

Diebenkorn, Richard, 17, 70, 86, 100, 152, 160, 256 n.22; *Drawings,* 86; *41 Etchings Drypoints,* 86; *Ocean Park,* 86; *Untitled* (1948), 86, 256 n.22; *Untitled* (1950), 86–87

Diebenkorn Brew, 86

Diller, Burgoyne, 172

Ding Xiong Quan, 222. *See also* Ting, Walasse

Dixon, James Budd, 11, 12, 66, 70, 72, 80, 84, 110, 120, 136, 162, 258 n.37; *Drawings,* 120; *Untitled,* 120–21

Dixon, Maynard, 100

Dixon, Peggy Nelson, 120

Documents of Modern Art, The, 234

Donkey and the Darling, The, 158

Dos Santos, Bartolomeu, 146

Dowden, Raymond, 154

Dowell, John, 252 n.intro.17

Dragon, Ted, 98

Drawings, 66, 70, 72, 84, 86, 120

dripped paint technique: Bluhm, 248; Brooks, 242; Hofmann, 102; Pollock, 29, 44

Drum Lithographers, 170

drypoint: Childs, 138; Stankiewicz, 220

Dubuffet, Jean, 98, 100, 240

Duchamp, Marcel, 58, 234, 238

Duco cement, 132, 258 n.43.8

Dugmore, Edward, 11, 66, 255 n.19; *Untitled,* 80–81

Duino Elegies (Rilke), 192

Duke, The (Brubeck), 202

Duthuit, Georges, 248

Dutiful Son, The (Oppenheimer), 126

Dutilleux, Henri, 230

Dyn, 256 n.24.5

Dynaton, 92

Éditions du Grenier, 202

Edlich, Theodore J., Jr., 140

Egan, Charles, 228, 258 n.43.3

Eighth Street Club, 252 n.intro.8. *See also* Club, The

Eighth Street school, 29

Eliot, T.S., 30, 31

Ellington, Duke, 108, 202

Éluard, Paul, 114, 248

embedded objects, 98

Emmanuel, Herzl, 172

Engel, Jules, 264 n.90.4

engraving, 10, 44–45; Pollack, 44

Ernst, Max, 10, 36, 234

Esquire magazine, 24

etching: Brenson, 106; Cherry, 108; Falkenstein, 130; Gottlieb, 48; Kadish, 46; McCray, 128; Mullican, 92; Paris, 178; Pousette-Dart, 250; Rothko, 50; Stillman, 72; Wilke, 164

ethnographic art, 48, 50, 52, 66, 92, 94, 96, 120, 180; African art, 48, 62, 66; Afro-Cuban ethnic art, 180; Asian art, 198, 244; Australian aboriginal art, 48; Chinese art, 72, 134, 198, 222, 230, 236; Japanese art, 188, 234, 244; Mexican art, 44, 46, 148; Native American art, 46, 48, 56, 92, 96, 126, 144, 200, 224; Oceanic art, 96; Precolumbian art, 144; Roman art, 164; Zen Buddhist art, 194, 234

European Modernism, 14, 62, 64, 102, 120, 126, 146, 238

European Surrealism, 54

Evans, Doc, 94

Evans, Rachel, 262 n.67.1

Everson, William, 254 n.12.5

Ewing, Edger, 132

Exhibition Momentum, 132, 224, 258 n.43.3

Experimental Printmaking Workshop, 142

Facchetti, Paul, 230

Falkenstein, Claire, 84, 130, 230, 258 n.42; *Sign of Leda,* 130; *Struttura grafica,* 39, 130–31, 258 n.42.8

FAP/WPA. *See* Federal Arts Project, Works Progress Administration

Farnsworth, Donald, 100, 212

Federal Arts Project, Works Progress Administration (FAP/WPA), 9, 42, 44, 46, 50, 54, 56, 58, 62, 82, 88, 94, 96, 108, 114, 116,

120, 134, 154, 172, 194, 198, 206, 216, 228, 232, 236, 242, 246, 258 n.37.4

Feeley, Paul, 186

Feininger, Lyonel, 134, 164

Feitelson, Lorser, 64, 108

Ferguson, Russell, 36

Ferlinghetti, Lawrence, 24

Fifteen Americans exhibit, 52

figurative representation: de Kooning, Willem, 172; Oliveira, 152

film, 22–23; Leslie, 142; Ting, 222

Fine, Perle, 166, 261 n.60; *Printed Collage #1,* 166–67; *Weathervane,* 261 n.60.3; *Wide to the Wind,* 166

Fiore, Joseph, 126, 258 n.40; *Dark Stone Map,* 126; *Untitled II,* 126–27

Fischer, Juergen, 17

Five Spot, 23, 24, 26, 29

Florence Crane School, 42

Focillon, Henry, 106

Fodor, Nandor, 98

Folder, 14

Forbes, Edward Waldo, 98

Forst, Miles, 24

Fortune, 32

Fournier, Alain, 192

Four Stones for Kanemitsu, 188, 262 n.71.6

Fourteen Americans exhibition, 134, 210

Fourth International Biennial of Contemporary Color Lithography, 160

Franchetti, Giorgio, 238

Franchetti, Tatiana, 238

Francis, Sam, 16, 17, 24, 84, 168, 176, 222, 248, 261 n.65; *First Stone,* 176–77

Frank, Leslie, 142

Frank, Mary, 22, 24

Frank, Robert, 22, 23, 142

Frankenthaler, Helen, 13, 14, 16, 26, 186, 234, 262 n.70; *First Stone,* 186–87; *Jacob's Ladder,* 186; *Mountains and Sea,* 186

Freas, Jean, 114, 257 n.35.9

"free creations," Hofmann, 102

Freed, Ernest, 128

Freilicher, Jane, 29, 32, 33, 34–35, 158; *The Painter's Table,* 35

French Surrealism, 9, 10

Fricano, Tom, 64

Fried, Elaine, 148, 172, 246. *See also* de Kooning, Elaine

Frost, Robert, 106

Fuller, Buckminster, 54, 148

Fuller, Mary (McChesney), 96

Funk Art, 178

Futurists, 238

Gage, John, 148

Gaisseau, Pierre, 158

Ganymede Gallery, 122

Gaudí, Antonio, 178

Gechtoff, Ethel, 110, 162

Gechtoff, Leonid, 110

Gechtoff, Sonia, 110, 112, 120, 162, 257 n.33; *Four Decades, Works on Paper*, 110; *The Mystery of the Hunt*, 257 n.33.4; *From San Francisco: A New Language of Painting*, 257 n.33.3; *6 Icons*, 110; *Untitled*, 110–11

Gentile, Esther, 102

gestural abstraction: Busa, 56; Casarella, 154; Cherry, 108; Childs, 138; Colescott, 146; de Kooning, Willem, 172; Francis, 176; Gechtoff, 110; Ginzel, 132; Goldberg, 184; Guston, 236; Kainen, 82; Kelly, 112; Longo, 192; Mitchell, 168; Nevelson, 232; Opper, 42; Tworkov, 228; Wald, 116; Wasserstein, 162; Weber, 224; Yunkers, 180

gestural calligraphy: Brenson, 106; Longo, 192; Moy, 198

gestural improvisation, 11

Giacometti, Alberto, 224, 246

Gide, André, 106

Gill, Eric, 98

Gillespie, Dizzy, 25

Gilray, James, 146

Gimond, Marcel, 224

Ginsberg, Allen, 22, 24, 136

Ginzel, Roland, 132, 258 n.43; *Birdscape* series, 132; *November 32nd*, 132–33

Glankoff, Mort, 244

Glankoff, Sam, 244, 265 n.97; *Untitled*, 244–45

Glinn, Burt, 24

Gloeckler, Raymond, 146

Goldberg, Michael, 14, 15, 32, 38, 142, 184, 248, 262 n.69; *Codex* series, 184; *House Paintings*, 184; *Ode on Necrophilia*, 14, 15; *Untitled*, 184–85

Goldin, Leon, 104, 128, 150, 152, 160, 257 n.30; *In Limbo*, 104–5

Goldstein, Philip, 46, 236, 253 n.3.5. *See also* Guston, Philip

Goldwater, Robert, 78

González, Julio, 114

Goodnough, Robert, 13, 142, 158, 170, 252 n.intro.7, 261 n.62; *Dinosaur*, 170, 261 n.62.7; *Homage to Pablo Casals*, 170; *Horsemen*, 170–71

Gorky, Arshile, 9, 13, 64, 82, 114, 172, 202, 238

Gottlieb, Adolph, 28, 48, 50, 62, 88, 92, 114, 124, 200, 236, 253 n.4; *Apparition*, 48–49; Imaginary Landscapes, 48; Pictographs, 48

Gottlieb, Esther, 124

Gottlieb, Harry, 116

Goya, Francisco, 178

graffiti, 238

Graham, John, 9, 82, 114, 124, 172, 206, 246

Graves, Robert, 202

Gray, Cleve, 200, 218, 263 n.84; *Holocaust* series, 218; *Resurrection* series, 218; *Roman Wall* series, 218; *Threnody* series, 218; *Untitled*, 218–19; *Zen Gardens* series, 218

Greek mythology, 48, 182, 216

Greenberg, Clement, 13, 21, 29–30, 142, 148, 158, 182, 186, 208, 252 n.poetry.10

Grillo, John, 11, 160, 210, 212, 261 n.63.9, 263 n.81; *Illuminations of Time and Space* suite, 210; *Untitled, 1955*, 210, 263 n.81.5; *Untitled, 1963*, 210–11

Grippe, Peter, 14, 140, 232

Groschwitz, Gustave von, 144

Grosman, Maurice, 16, 158

Grosman, Tatyana, 16, 158, 182, 186, 234, 238

Gross, Chaim, 232, 240

Grosz, George, 156

Grove Press, 112, 168

Guest, Barbara, 14, 182, 186, 262 n.68.10

Guggenheim, Peggy, 10, 29, 44, 50

Guilbaut, Serge, 252 n.poetry.10

Gussow, Alan, 264 n.91.9

Guston, Philip, 16, 17, 36, 38, 44, 46, 108, 152, 180, 188, 236, 242, 252 n.1.5, 258 n.43.3, 264–65 n.93; *Untitled*, 236–37

haboku, 176

Haeckel, Ernst, 124

Haley, John, 146, 190

Halpert, Edith, 14

Hand Painted Pop exhibition, 182

handwriting, 238

Hansa Gallery, 220

Hans Hofmann and His Students exhibition, 210

Hansrath, Joan, 259 n.46.5

Hard Edge Painting, 42

Hare, David, 13, 50, 52, 234

Harlem Artists Guild, 62

Harlem Community Art, 62

Harrison, Wallace, 186, 242

Hartigan, George, 182. *See also* Hartigan, Grace

Hartigan, Grace, 13, 14, 15, 24, 26, 32, 34, 142, 182, 184, 186, 252 n.1.5, 262 n.68; *American Places* series, 182; *The Archaics*, 262 n.68.10; *The Hero Leaves His Ship*, 182; *Oranges*, 182, 262 n.68.4; *Pallas Athene*, 182–83; *Persian Jacket*, 182

Hartmann, Brüder, 142

Hasty Papers, The (Leslie), 142

Hatchett, Duayne, 148, 150

hatching: Blaine, 60; Dixon, 120; Stankiewicz, 220; Steele, 58; Twombly, 238

Hawthorne, Charles W., 228

Haybarn Press, 202

Hayes, Bartlett, 218

Hayter, Stanley William, 10, 12, 46, 58, 92, 114, 120, 124, 130, 190, 202, 232, 253 n.2.7, 255 n.17.4, 255 n.18.9; *Femme Instable*, 10

Hebald, Milton, 148

Hedrick, Wally, 112, 136, 259 n.45.3

Heidel, Fred, 146

Helfond, Riva, 62

Hélion, Jean, 29, 60

Hess, Thomas B., 248

Heymann, Moritz, 102

Hidai, Nankoku, 164

Hill, Clinton, 156, 192

Hine, Charles, 168

Hite, Allen R., 116

Hite Art Institute, 257–58 n.36.5

Hitofsy, Jerry, 84

Hockney, David, 146

Hodges, Mary Jane, 88

Hofmann, Hans, 29, 33, 42, 54, 60, 86, 102, 158, 166, 168, 170, 184, 186, 190, 200, 206, 210, 220, 232, 257 n.29; *Composition in Blue*, 102–3

Hofmann, Hans, School of Fine Arts, 102, 198

Hogarth, William, 146

Hogner, Nils, 194

Hohe, Ernst Ludwig, 216

Holiday, Billy, 252 n.poetry.26

Hollander, Irwin (Jr.), 17, 222, 232, 234, 236, 257 n.33.7

Hollander Graphic Workshop, 228, 232

Holmes, Oliver Wendell, 58

Homely Girl: A Life (Miller), 78

Homer, 182

Hoppe, Walter, 257 n.33.3

Hopper, Edward, 202

Hopps, Walter, 110, 162

Howell, Douglass, 74

Howl (Ginsberg), 136

Hultberg, John, 70, 210, 255 n.15; *Drawings*, 70; *Untitled*, 70–71

humor in art: Colescott, 146; Guston, 236; von Wicht, 216

Hurd, Peter, 194

Hurtado, Luchita, 92

The Ideographic Picture exhibition, 200

Ihle, John, 148, 150

impasto, 212

Impulse Items, 244

Indian Space Painting, 56–57. *See also* Native American art

"inner light," Rothko, 50

Instant Theater, 92

intaglio printmaking, 252 n.intro.5, 253 n.2.7; Blaine, 60; Bourgeois, 78; Brenson, 106; Cherry, 108; Childs, 138; Colescott, 146; Dehner, 124; Dixon, 120; Francis, 176; Ginzel, 132; Goldberg, 184; invention of, 258 n.43.8; Kainen, 82; Kamrowski, 54; Kasten, 190; Kuhlman, 84; Kupferman, 88; Lewis, 62; Lobdell, 66; Majors, 226; McCray, 128; Motherwell, 234; Nevelson, 232; Olitski, 240; Smith, Hassel, 100; Stankiewicz, 220; Steele, 58; Stillman, 72; techniques, 14; Twombly, 238; Woelffer, 94

International Print Guild, 42

"Irascibles, The," 50, 250

Ivory Knife: Paul Jenkins at Work, 230, 264 n.90.4

Jachens, Robert, 182

Jackson, John Baptist, 82

Jackson, Martha, 70, 230

Jaeckel, Wally, 164

Japanese art, 188, 234, 244

jazz, 21, 62, 184, 224

Jazz Limited, 94

JB, 24

Jenkins, Paul, 230, 264 n.90; *Euphories de la couleur,* 230; *Seven Aspects of Amadeus and the Others,* 230; *Untitled,* 230–31

Johnson, Jacqueline, 92

Johnson, Lyndon, 114

Johnson, Una, 258 n.43.8, 262 n.73.3

Jones, John Paul, 92

Jon-Ives Noblet, 142

Jonson, Raymond, 194

Jorn, Asger, 222

Judaism, 106

Jugend, 164

Jump for Joy, 108

Jung, Carl, 48

Kadish, Reuben, 10, 44, 46, 108, 120, 236, 252 n.intro.5, 253 n.2.7, 253 n.2.8, 253 n.3; *A Dissertation on Alchemy,* 46; *Lilith,* 46–47; *Untitled,* 46

Kahn, Max, 104, 132

Kainen, Jacob, 82, 255 n.20; *Marine Apparition,* 82–83, 255 n.20.9; *Shoreline,* 255 n.20.10

Kamrowski, Gerome, 54, 56, 252 n.intro.5, 253 n.7, 261 n.60.2; *Untitled,* 54–55; *Wind Menagerie,* 54

Kandinsky, Wassily, 216

Kanemitsu, Matsumi ("Mike"), 94, 188, 262 n.71; *Illustrations of Southern California,* 188; *Lovers,* 188–89; *Mikey Mouse Series,* 188, 262 n.71.5; *Spectre,* 188

Kanowitz, Howie, 24

Kansas City Art Institute (KCAI), 68

Kantor, Morris, 70, 230, 238

Kaprow, Allen, 122

Kasten, Karl, 160, 172, 190, 210, 262 n.72; *Aix,* 190–91

Katz, Leo, 192

Kaufmann, Edward, 42

Kazan, Elia, 24

Kelly, James, 110, 112, 162, 257 n.33.6, 257 n.34; *August,* 112–13; *The Last Days of Dylan Thomas,* 112; *Zen Litho,* 112

Kelly, Miles Tamarind, 110

Kelso, David, 66

Kennedy, John F., 148

Kernan, Nathan, 168

Kerouac, Jack, 22, 24, 142, 224

Kim, Po, 116

Kimball, Wayne, 246

King, Hayward, 259 n.45.3

Kingman, Eugene, 98

King Ubu Gallery, 136, 162

Kirstein, Lincoln, 98

Kistler, Lynton, 64, 148, 150

Kitaj, R.B., 35

Kline, Elizabeth, 140

Kline, Franz, 13, 14, 19–24, 28, 36, 94, 126, 140, 172, 182, 224, 238, 248, 252 n.1.5, 258 n.43.3, 259 n.47, 261 n.62.3; *Elizabeth,* 259 n.47.10; *Poem,* 140–41; *Portrait of Sam Kramer,* 259 n.47.2; *Studio Interior,* 259 n.47.2; *Untitled (Study for Elizabeth),* 140, 259 n.47.7

Knigin, Michael, 240, 242

koans, 194

Koch, Kenneth, 14, 15, 28, 29, 30, 31, 32, 33–34, 36, 60, 142, 158; *Bee,* 36; *Campaign,* 36; *The Magician of Cincinnati,* 36

Koehler, Wilhelm, 98

Kohn, Misch, 104

Kokoschka, Oskar, 152

Kootz Gallery, 13

Kornblum, Frances, 244

Kornfeld, Eberhard, 176

Kornfeld, Eli, 222

Koslin, Alan, 184

Kostellow, Alexander, 56

Koutroulis, Aris, 224

Krasner, Lee, 44, 98, 182, 186, 206, 253 n.2.11, 263 n.79; *The Civet,* 206–7; Color Field painting, 206; *Little Image* series, 206; *The Seasons,* 206

Krause, Glen, 132

Kroll, Leon, 206

Kuhlman, Walter, 66, 70, 80, 84, 120, 256 n.21; *Drawings,* 84; *Untitled,* 84–85

Kunitz, Stanley, 180, 236

Kuniyoshi, Yasuo, 188, 230

Kunstformen der Natur (Haeckel), 124

Kupferman, Lawrence, 88, 108, 256 n.23; *Landscapes of the Mind* series, 88; *Microscopic Creatures from the Ocean Deep,* 88–91; *Oceanic Forms,* 88, 256 n.23.7; *Le Penseur,* 88

Kutnewsky, Hildegard, 180

Laboratory of Modern Techniques in Art, 44

Lacourière, Roger, 202

Lamantia, Philip, 136

Landfall Press, 82, 142

Lanyon, Ellen, 132

L'Art Brut, 98

Lasansky, Mauricio, 10, 132, 190

Last Avant-Garde: The Making of the New York School of Poets (Lehman), 33

Laurel Gallery, 156

Lawrence, Jacob, 126

Leach, Bernard, 134

Le Blanc, Georges, 202

Le Corbusier, 78

Ledin, Eric, 66, 70

Lee, Francis, 54, 56

Léger, Fernand, 29, 56, 60, 176, 188, 220

Lehman, David, 27–38

Lemon, Jack, 82

L'ennemi (Baudelaire), 202

Leonardo, 144

Leslie, Alfred, 13, 14, 22, 24–25, 32, 33, 142, 148, 158, 170, 184, 186, 259 n.48; *Floriano Vecchi and Richard Miller,* 259 n.48.8; *Lady on a Can,* 259 n.48.9; *Lady with Tomatoes,* 259 n.48.9; *Self Portrait,* 142; *Untitled,* 142–43

Levy, Edgar, 124

Levy, Lucille Corcos, 124

Lewis, Allen, 114

Lewis, Norman, 62, 226, 254 n.11; *Untitled,* 62–63

Lhote, André, 218

Liberman, Alexander, 218

Lichtdrucke, 102

Life magazine, 28, 29, 44, 48, 50, 60

linocuts, 86

lithography, 16–17. *See also* color lithography; Beall, 150; Brooks, 242; Burkhardt, 64; Colker, 202; de Kooning, Willem, 172; Dugmore, 80; Fiore, 126; Francis, 176; Frankenthaler, 186; Gechtoff, 110; Goldberg, 184; Goldin, 104; Goodnough, 170; Gray, 218; Grillo, 210; Guston, 236; Hartigan, 182;

Hultberg, 70; Jenkins, 230; Kanemitsu, 188; Kelly, 112; Krasner, 206; Lewis, 62; Lobdell, 66; McCray, 128; Miyasaki, 160; Motherwell, 234; Newman, 200; Oliveira, 152; Opper, 42; Ossorio, 98; Remington, 136; Resnick, 246; Rivers, 158; Smith, David, 114; Steele, 58; Still, 52; Tchakalian, 212; Ting, 222; Tobey, 134; Tworkov, 228; Vicente, 208; Viesulas, 144; Wasserstein, 162; Weber, 224; Williams, 204; Woelffer, 94; Yunkers, 180

Litho Shop, 176, 222

Ljubliana International Biennial, 146

Lobdell, Frank, 11, 16, 66, 70, 80, 84, 254 n.13; *Drawings,* 66; *Summer 1967: In Memory of James Budd Dixon,* 66; *Untitled,* 66–67

Longo, Vincent, 154, 156, 192, 262 n.73; *To Admiral Meaulnes,* 192–93

Loran, Erle, 86, 146, 190

Lost Hills (Ryan), 74

Louis, Morris, 186

Lowengrund, Margaret, 114, 216

Lozingot, Serge, 188, 236

Lozowick, Louis, 42

Lucien Labaudt Gallery, 110

Lucite, 261 n.64.5

Lumpkins, William, 194, 204, 263 n.74; *Untitled,* 194–95, 263 n.74.6

Lynch, John, 112

MacAgy, Douglas, 11, 58

Macdonald-Wright, Stanton, 68, 108

MacIntosh, Greg, 84

Macky, Spencer, 100

Macleish, Archibald, 106

Maillol, Aristide, 224

Majors, William, 62, 226, 264 n.88; *Etchings from Ecclesiastes,* 226, 264 n.88.4; *Genesis II,* 226–27

Man Dead? The God Is Slain (Bradbury), 64

Manet, Edouard, 182

Mangroviti, Pepino, 154

Marca-Relli, Conrad, 148

Marin, John, 194

Marini, Marino, 224

Martelley, John De, 80

Martin, Fletcher, 46

Martinelli, Ezio, 202

Masereel, Frans, 180

Mason, Alice Trumbull, 261 n.60.2

Masson, André, 10, 200, 202

Mastro-Valerio, Alexander "Joe," 54

Mathews, Harry, 27

Matisse, Henri, 86, 102, 248

Matisse, Margueritte, 248

Matta, Roberto, 10, 54, 56, 202, 234

Matthieu, Emil, 176

Matthieu, Georges, 70

Matulka, Jan, 124

Maurois, André, 106

Mayhew, Richard, 226

Mcartney, Catherine, 128

McCarthy, Richard, 130

McChesney, Robert, 12, 96, 100, 256 n.26; *Arena* series, 96, 256 n.26.5; *Barranca* series, 96; *Canyon Country* series, 96; *Estadillo* series, 96; *Hair Suite,* 96; *Lahontan* series, 96; *La Noche,* 96; *Mexico* series, 256 n.26.2; *Mountain* series, 96; *Point of View* series, 96; *Rojo* series, 96; *S3,* 96–97; *Yermo Noche* series, 256 n.26.7; *Yermo* series, 96

McClintock, Byron, 110

McClure, Michael, 110, 112, 136

McCray, Dorothy, 128, 258 n.41; *Denizen,* 128–29

McCray, Francis, 128, 258 n.41

McCray, Peter Michael, 128

McDarrah, Fred, 24

McFadden, Elizabeth, 255 n.17.2

McFadden, William J., 74

McGaw, Bruce, 160

McGrath, Julia, 132

McLeish, Archibald, 24

McMillen, Inc., 206

Meeker, Dean, 146

Meert, Joseph, 44, 68, 108, 254–55 n.14; *Dancing Demons,* 68–69; *Evening in Autumn,* 68; *The Four Seasons,* 68; *Untitled,* 68

Melby, Jennifer, 54

Meltzer, Doris, 146

Meltzer, Karl, 188

Meryon, Charles, 156

Messing, Joe, 226

Metart Gallery, 52, 80

methyl methacrylate, 261 n.64.5

Mexican art, 44, 46, 148

Mies van der Rohe, Ludwig, 84, 224, 248

Miljarek, Louis, 128

Miller, Arthur, 78

Miller, Henry, 24

Miller, Kenneth Hayes, 134, 232

Miller, Richard, 14, 15, 142, 168

Minatour Grüppen of Surrealists, 180

Ming, Rem, 212

Mingus, Charles, 21

Minimalism: Blum, 248; Fine, 166; Frankenthaler, 186; Longo, 192; Newman, 200; Tworkov, 228; Williams, 204

Miró, Joan, 10, 14, 46, 54, 78, 166

Mitchell, J.J., 168

Mitchell, Joan, 14, 21, 22, 24, 32, 142, 168, 176, 184, 230, 261 n.61; *Poems,* 168; *Smoke,* 168; *Untitled,* 168–69

Miyasaki, George, 160, 172, 210, 212, 260 n.52.6, 260 n.57; *Light in March,* 40, 160–61

Moffett, Ross, 228

Moholy-Nagy, László, 54, 94, 224

Mondrian, Piet, 29, 60, 156

Monet, Claude, 126

Monk, Thelonious, 25

monoprints: McCray, 128

monotypes: Oliveira, 152; Stillman, 72, 255 n.16.6

Moore, Marianne, 84

Morris, Carl, 252 n.intro.17

Morris, Hilda, 252 n.intro.17

Morris, James, 194

Morris, Richard Allen, 204

Morris Gallery, 14, 16

Motherwell, Robert, 10, 13, 16, 17, 44, 50, 52, 54, 56, 94, 170, 186, 200, 234, 238, 252 n.intro.7, 256 n.24.6, 258 n.43.3, 264 n.92; *Automatism A,* 234–35; *Beside the Sea,* 234, 264 n.92.6; *Elegy to the Spanish Republic,* 234; *A la pintura,* 234; *Lyric Suite,* 234; *Spontaneity* series, 264 n.92.6; *Throw of the Dice at ULAE,* 264 n.92.6

Mourlot, Fernand, 230

Mourlot Workshop, 218

Mousley, Catherine, 234

Mowrey, Helen, 226

Moy, Seong, 84, 198, 263 n.75; *Classical Horse and Rider,* 198; *Nassau County #1,* 198–99

Mueller, Dody, 22, 24

Mullican, Lee, 92, 252 n.intro.5, 256 n.24; *Fables,* 92; *The Gain of Aft,* 92, 256 n.24.2; *Hungry Ghosts,* 92; *Untitled (Five),* 92–93

Mullican, Matt, 92

Mullin, Margaret, 68

Munch, Edvard, 260 n.55.7, 262 n.72.4

Murakishi, Steve, 54

mural painting, 148

Muse, Isaac Lane, 182

Museum of Modern Art (MOMA), 27

Museum of Non-Objective Art, 54, 166, 194

music, 19–25; Automatism and, 202; bebop, 24; jazz, 21, 62, 184, 224; representation of, 62, 68, 204

music-art collaboration: Colker, 202; Tobey, 134; Viesulas, 144; Woelffer, 94

Myers, John Bernard, 13, 14, 32, 60, 142, 148, 182

Mylar techniques, 168, 240

Mystery of the Hunt, The (McClure), 110

mythology, 52, 232

Native American art, 46, 48, 56, 92, 96, 126, 144, 200, 224. *See also* Indian Space Painting

nature themes: Cherry, 108; Colker, 202; Dehner, 124; Ginzel, 132; Goldin, 104; Goodnough,

170; Kainen, 82; Krasner, 206; Kupferman, 88; Pousette-Dart, 250; von Wicht, 216
Necessary Angel, The (Stevens), 27, 252 n.poetry.3
Neel, Alice, 22
Nell, Antonia, 218
Neorealism, 156
Neri, Manuel, 160
Neruda, Pablo, 202
Neuhaus, Robert, 253 n.6.6
Nevelson, Charles, 232
Nevelson, Louise, 10, 16, 232, 264 n.91; *Facade,* 232; *Sky Tree,* 232; *Transparent Horizon,* 232; *Untitled,* 232–33
Nevelson, Mike, 232
New American Painting, The exhibition, 200
New American Painting and Sculpture, The: The First Generation exhibition, 206
New Criticism, 31
New Images of Man exhibition, 150
Newman, Barnett, 16, 28, 56, 200, 234, 263 n.76; *Onement I,* 200; *The Stations of the Cross: lema sabachthani,* 200; *Untitled,* 200–201
New School for Social Research, 156, 180
New Spirit, 27
New Talent 1950 exhibition, 13, 134, 142, 158, 170, 208
New York School, 9, 28, 29–30, 35, 46, 206
New York School of poetry, 30–34, 35
New York Studio School, 208
New York Times, 48, 50, 200
Nicoläides, Kimon, 82, 124, 138, 166, 242
Nielsen, Raymond, 206
Night Thoughts (Young), 54
Ninth Street Show, 13, 186, 246
Noland, Kenneth, 186, 240
Norris, Kathleen, 202
Northwest Coast Indian Painting exhibition, 200
Now's the Time, 25
nudes, 248

Oceanic art, 96
Odyssey (Homer), 182
O'Hagan, Margaret, 146
O'Hara, Frank, 14, 15, 16, 26, 28, 30, 32, 34, 35, 36, 37, 140, 142, 158, 182, 186, 248, 252 n.intro.11, 252 n.poetry.26, 259 n.47.9; *A Haiku,* 35; *Ode on Necrophilia,* 14, 15
Oklahoma City University, 148
Oldfield, Otis, 152
Olinsky, Ivan, 228
Olitski, Jules, 240, 265 n.95; *Graphics Suites #1 and #2,* 240; *Magenta/Orange with Tan,* 240–41
Olitsky, Hyman, 240
Oliveira, Nathan, 12, 136, 152, 160, 172, 260 n.53;

Death of an Ant, 152–53, 160; *To Edgar Allen Poe* series, 152
omphalos, 52
On Growth and Form (Thompson), 54
1¢ LIFE, 168, 176, 222, 263–64 n.86.4
Onslow-Ford, Gordon, 92
On the Road (Kerouac), 23
open-bite etching: Smith, Hassel, 100; Stankiewicz, 220; Twombly, 238
Oppenheimer, Joel, 126, 238
Opper, John, 42, 252 n.1; *Stone #1,* 42–43
Orphée, 248
Orr, I. David, 140
Ossorio, Alfonso, 98, 256 n.27; *Congregations,* 98; *Could I Ask You Something?,* 98; *Palimpsest,* 98–99
Ostrowsky, Abbo, 82
Ozenfant, Amédée, 138

Paalen, Wolfgang, 92, 256 n.24.5
Pace Editions, 142
painted-paper cutouts, 204
"Painter, The" (Ashbery), 35–36, 38
Painting and Sculpture by Living Americans exhibition, 134
paper cutouts, 204
paper relief, 154
Papp, Joseph, 24
Paris, Harold Persico, 160, 178, 190, 212, 261–62 n.66, 261 n.63.9; *Buchenwald,* 178; *In the Garden,* 261 n.66.5; *Hosannah* suite, 178, 261 n.66.5; *The Innocents,* 261 n.66.5; *Mem,* 178; *Pantomina Enfanta,* 178; *Room I,* 178, 261 n.66.8; *Souls,* 178; *Study for a Sculpture,* 178–79; *Thoughts about a Sculpture,* 178, 262 n.66.11
Park, David, 11, 86, 100, 136, 152, 162, 176
Parker, Charlie, 25, 62
Parsons, Betty, 98, 200
Parsons, Betty, Gallery, 200, 218
Parsons, Elizabeth, 140
Parsons, Irwin, 194
Pasilis, Felix, 122
Passlof, Pat, 246
Paz, Octavio, 180
peau de crapaud, 56, 218, 230
Pène du Bois, Guy, 228
Pennell, Joseph, 156
pentre-graveur, 106
Peridot Gallery, 170
Perimeter Gallery, 146
Pernasse, Frances, 142
Personism, 38, 252 n.poetry.26
Perspex, 261 n.64.5
Peterdi, Gabor, 10, 192

Petersburg Press, 134
petroglyphs, 126
Pettiford, Oscar, 24
Phases exhibitions, 138
Philadephia Young Communist League, 110
Philbrick, Alan, 132
Photorealism, 148
Picasso, Pablo, 27, 56, 102, 114, 220, 252 n.poetry.3
pictographs: Cherry, 108; Fiore, 126
Piranesi, Giovanni Battista, 106, 156
plein-air studies: Casarella, 154; Frankenthaler, 186; Opper, 42; Smith, Hassel, 100
Plessix, Francine du, 218
Plexiglas techniques: Deshaies, 174; materials, 261 n.64.5; Williams, 204
pochoir technique: Bluhm, 248; von Wicht, 216
poem-paintings, 14
"poem pictures," Guston, 236
Poems and Wood Engravings (Ossorio), 98
poetry: Abstract Expressionism and, 27–38; by artists, 74, 108; as inspiration for art, 54, 58, 110; New York school, 30–34; sales of, 136
poetry-art collaboration, 14, 16; Bluhm, 248; Colker, 202; Falkenstein, 130; Fiore, 126; Gechtoff, 110; Kline, 140; Kupferman, 88; Leslie, 142; Mitchell, 168; Pousette-Dart, 250; Remington, 136; Rivers, 158; Ting, 222; Yunkers, 180
Poindexter, Eleanor, 94
Poindexter Gallery, 254 n.10.7
Poirier, Richard, 38
Pollock, Charles, 44, 68
Pollock, Jackson, 10–11, 13, 24, 28, 29, 30, 36, 38, 44, 46, 54, 56, 62, 68, 98, 102, 120, 140, 142, 158, 170, 172, 176, 182, 186, 206, 224, 236, 242, 248, 252 n.intro.5, 253 n.2, 254 n.14.3, 258 n.43.3, 261 n.62.3; Black Paintings, 44; *The Deep,* 36; as "Jack the Dripper," 29; *The She-Wolf,* 44; *There Were Seven in Eight,* 44; *Untitled,* 44–45
Pollock, Lee Krasner, 29. *See also* Krasner, Lee
Pollock, Louis, 170
Pollock, Sande, 44, 253 n.3.3
polymer acrylic, 259 n.43.8
Ponce de León, Michael, 114
Pop Art: Blum, 248; de Kooning, Elaine, 148; Deshaies, 174; Guston, 236; Hartigan, 182; Kanemitsu, 188; Miyasaki, 160; Ting, 222
Porter, Bern, 255 n.16.6
Porter, Fairfield, 33, 34, 38, 158
portraiture: Bresson, 106; de Kooning, Elaine, 148; Weber, 224
Posada, José Guadelupe, 180
Post Painterly Abstraction exhibition, 240
Potter, Jeffrey, 68

Pound, Ezra, 31, 168

Pousette, Nathaniel, 250

Pousette-Dart, Richard, 250, 265 n.100; *The Densest Skies,* 250–51; *Symphony Number 1: The Transcendental,* 250

Powell, Bud, 62

Pratt Graphic Art Center, 200, 218, 226, 230

Precolumbian art, 144

"press drawings," Ginzel, 132

Price, Winston, 182

Priede, Zigmunds, 184

Print Collector's Quarterly, 58

Print Council of America, 160

Printmakers, The, 198

printmaking: Abstract Expressionism and, 9, 17; college programs, 13; as creative media, 10; at CSFA, 12, 13; development of, 9; lithography, 16–17; poem-paintings, 14; poet-painter collaboration and, 14–16; workshops, 16; during World War II, 10

print-paintings, 265 n.97.4

Prints for Poetry and Prose exhibition, 202

The Progressive magazine, 146

psychic automatism, 94

Public Works of Art Project, 228

Pull My Daisy, 22–23, 25, 142

Queen's Gift, The (Ryan), 255 n.17.2

Randolph, Lee, 100

Rattner, Abraham, 102

Rauschenberg, Robert, 126, 238

Read, Herbert, 252 n.intro.11

Rebay, Hilla, 54, 166

Redon, Odilon, 178

Refregier, Anton, 96

Regionalism: Brooks, 242; McCray, 128; Meert, 68; Pollock, 44; printmaking and, 10; Still, 52

Reinhardt, Ad, 12, 170, 252 n.intro.7

Reinhart, Ruth, 94

relief printmaking, 154

religion. *See also* spiritual expression: abstract art and, 106; biblical subjects, 144, 178, 226; inspiration from, 226

Remington, Deborah, 112, 120, 136, 152, 162, 259 n.45; *2300 Skadoo,* 136–37; *Statement,* 136

Reported Sightings (Ashbery), 35

Resnick, Milton, 184, 246, 265 n.98; *Burning Bush,* 246; *Roswell* series, 246; *Untitled,* 246–47

Revenge (Rosenberg), 172

Rexroth, Kenneth, 136

Rickey, George, 164

Rilke, Rainer Maria, 192

Riopelle, Jean-Paul, 168, 176

Rivera, Diego, 44, 180, 236

Rivers, Larry, 16, 22, 24, 26, 29, 32, 33, 34, 36, 37, 60, 142, 158, 170, 184, 186, 260 n.56; *Dark Plant,* 158–59; *Washington Crossing the Delaware,* 158

Robinson, Boardman, 228, 242

Rockburne, Dorothea, 126

Roeber, Philip, 257 n.33.6

Roethke, Theodore, 252 n.intro.11

Rollins, Sonny, 24

Roman art, 164

Romein, Bernard, 172

Rosenberg, Harold, 30, 172, 252 n.intro.11, 256 n.24.6

Rosenthal, Rachel, 92

Rosenwald, Lessing J., 14

Ross, John, 226

Rosset, Barney, 168

Rossi, Walter, 218

Roth, Sylvia, 98

Rothbort, Samuel, 240

Rothenstein, Michael, 146

Rothko, Mark, 12, 13, 19, 28, 29, 34, 50, 52, 70, 86, 88, 92, 114, 124, 180, 184, 200, 234, 253 n.5; *Untitled,* 50–52

Rouault, Georges, 122

Rowlandson, Thomas, 146

Rowley, George, 218

Ruse of Medusa, 148

Ryan, Anne, 74, 255 n.17; *Constellations,* 255 n.17.4; *Dancers Resting,* 255 n.17.4; *Fugue,* 255 n.17.4; *In the Meadow,* 255 n.17.4; *XXXIV,* 74–77

Ryan, John Allen, 259 n.45.3

Ryder, Albert Pinkham, 84

Ryder, Worth, 190

SAIC. *See* School of the Art Institute of Chicago (SAIC)

Salt (Kunitz), 180

Sandler, Irving, 252 n.poetry.10

San Francisco Abstract Expressionism, 11, 212

San Francisco Art Institute (formerly CSFA), 120, 162, 212

San Francisco Society of Women Artists, 58

San Francisco State College (SFSC), 148

Satie, Eric, 148

satirical art, 146

Sausalito Six, 66, 70, 72, 86, 120

Savage, Augusta, 62

Sawyer, Kenneth, 52, 66

Schanker, Louis, 74, 192

Schapiro, Meyer, 13, 142, 148, 158, 182, 208

Schlesinger, Charlotte, 126

Schneider, Pierre, 248

School of the Art Institute of Chicago (SAIC), 94, 104

Schuyler, James, 14, 15, 28, 29, 30, 32, 33, 34, 38, 142, 168, 182

Schwartz, Delmore, 84, 257 n.35.9

Schwarz, Willi, 102

Schwitters, Kurt, 74

scrap metal sculpture: Falkenstein, 130; Stankiewicz, 220

screenprinting: Bluhm, 248; Busa, 56; Colescott, 146; de Kooning, Elaine, 148; Hofmann, 102; Kupferman, 88; Leslie, 142; Lumpkins, 194; McChesney, 96; Mitchell, 168; Olitski, 240; Urban, 122; Wald, 116

sculpture: Bourgeois, 78; Casarella, 154; Dehner, 124; de Kooning, Willem, 172; Falkenstein, 130; Nevelson, 232; Paris, 178; Rivers, 158; Smith, David, 114; Stankiewicz, 220; Wald, 116; Weber, 224

Search for the Real and Other Essays, The (Hofmann), 102

Seligmann, Kurt, 10, 234

Semi-Colon, 13–14

Semiology, or *8 and a Totem Pole* exhibition, 56

Serig, Delphyne, 22

Serigraph Gallery, 146

Sessler, Alfred, 146

Seurat, Georges, 182

Seventeen American Painters exhibition, 110

Shahn, Ben, 14, 110, 192

Shaman to the Prism Seen, 230

Sheeler, Charles, 14

signatures: initials, 114; placement of, 98

Silk Screen Group, 68

silkscreening: Bluhm, 248; Hofmann, 102; Leslie, 142; Mitchell, 168; Urban, 122; Wald, 116; Williams, 204

Simboli, Raymond, 56

Simkins, Martha, 242

Simplicissimus, 164

Simpson, David, 112, 120, 136, 259 n.45.3

Singer, Arnold, 184, 200, 218

Siqueiros, David Alfaro, 44, 46, 236

Siskind, Aaron, 224

Sitwell, Edith, 232

Six Gallery, 136, 259 n.45.3

Sixième Salon des Réalitiés Nouvelles, 66, 84

Sixteen Americans exhibition, 122, 142

Sixteen Lithographs exhibition, 120

Skiöld, Birgit, 146

sky painting, 176

Slade School of Art, 146

Sloan, John, 114, 200

Smed, Per, 138

Smith, Candida, 257 n.35.9

Smith, David, 14, 24, 26, 29, 36, 62, 86, 114, 124,

136, 218, 220, 257 n.35; *Don Quixote,* 114–15, 257 n.35.9; *Medals for Dishonor,* 114

Smith, Hassel, 11, 86, 96, 100, 162, 256 n.28, 257 n.33.6; *Untitled,* 100–101

Smith, Rebecca, 257 n.35.9

Smith, Tony, 13, 56, 142, 158, 200

Snyder, Gary, 136

Snyder, Wendy, 244

Social Realism: Cherry, 108; de Kooning, Elaine, 148; Gechtoff, 110; Kadish, 46; Kainen, 82; Kamrowski, 54; Lewis, 62; printmaking and, 10; Smith, Hassel, 100; Wald, 116

soft-ground etching: Blaine, 60; Bourgeois, 78; Cherry, 108; Dehner, 124; Dixon, 120; Kasten, 190; Kline, 140; Kuhlman, 84; Nevelson, 232

Solo Press, 98

Some American Prints exhibition, 202

Some Trees (Ashbery), 35

Sonnets et eaux-fortes, 14

Sorini, Emiliano, 232

Soto, Ernest de, 17

Southern, Terry, 24, 158

Southgate, Patsy, 38

Soutine, Chaim, 88, 158

Spicer, Jack, 259 n.45.3

Spiral Group, 156, 226

spiritual expression. *See also* religion: Majors, 226; Pousette-Dart, 250

Spivak, Max, 206

Spohn, Clay, 11, 58, 70, 120; *Museum of Unknown and Little-Known Objects,* 58

spray gun, 240

Spruance, Benton, 202

Spurrier, Steven, 140

stained glass, 68

Stankiewicz, Richard, 220, 263 n.85; *Untitled,* 220–21

Stanley Rose Bookstore, 108

Staufacher, Jack, 92

Stedman, Susan, 226

Steele, Edward, 58

Steele, Juliette, 58, 254 n.9; *Bridal Veil,* 58; *Deacon's Shay, The,* 58–59

Steen, Nancy, 257 n.33.10

Steffen, Bernard, 68, 254 n.14.3

stencil techniques, 216

Sternberg, Harry, 56, 188

Sterne, Maurice, 100

Stevens, Wallace, 27, 38, 168, 252 n.poetry.3

Steward, Donn, 238

Stewart, Paul, 54

Stiles, Knute, 112

Still, Clyfford, 11, 13, 50, 52, 66, 70, 80, 84, 86, 100, 110, 130, 136, 162, 252 n.intro.5, 253 n.6; *Figure,* 12; *Untitled,* or *Figure,* 52–53

still life, 236

Stillman, George, 70, 72, 80, 120, 255 n.16; *Drawings,* 72; *Golden Gate,* 72; *Untitled #5,* 72, 255 n.16.6; *Untitled,* 1948, 72–73, 255 n.16.4, 255 n.16.8

Stones, 16, 34, 37, 158, 182

Strike the Puma, 230

Strobel, Marion, 168

Stroud, James, 60

Studio 13 Jazz Band, 11, 136

Studio 35, 48, 250, 252 n.intro.7

style, 238

subject matter, 28, 36, 152

Subjects of the Artist school, 13, 50, 52, 234, 250

sumi painting, 134, 188

Surrealist Automatism. *See also* Automatism: Mullican, 92; Olitski, 240

Surrealism, 9, 10, 13, 29, 38. *See also* Abstract Surrealism; Brenson, 106; Busa, 56; Hultberg, 70; Kamrowski, 54; Krasner, 206; Motherwell, 234; printmaking, 14; Stankiewicz, 220; Twombly, 238

Surrealist biomorphism, 166

Surrealist linear calligraphy, 108

Suter, Ernst, 224

Suzuki, D.T., 134

Suzuki, James, 261 n.63.9

Sweeney, James Johnson, 257 n.33.3, 258 n.43.3

Swetzoff, Hyman, 256 n.24.10

symbolic images, 78

tachisme, 70, 144, 168, 222

Taine, Hippolyte, 106

Takizaki, 134

Tam, Reuben, 156

Tamarind Institute, 94, 124, 136, 148, 150, 164, 226, 246

Tamarind Lithography Workshop, 16–17, 46, 66, 70, 86, 92, 110, 112, 144, 150, 160, 164, 188, 190, 208, 210, 222, 224, 232, 236, 252 n.intro.17, 256 n.24.8, 257 n.33.8, 264 n.86.8

Tamayo, Rufino, 186

Tamstone Group, 94

Tanager Gallery, 166

Tanguy, Yves, 10, 78, 92

Tansey, Mark, 252 n.poetry.10

Tapié, Michel, 25, 84, 120, 130, 230

Tapiés, Antoni, 70

Taylor, Cecil, 21

Tchachbasov, Nauhum, 148

Tchakalian, Sam, 160, 212, 261 n.63.9, 263 n.82; *Rubicon,* 212; *Strike Hard,* 212–15

Tchelichew, Pavel, 98

Ten, The: Whitney Dissenters, 50

Teng Kisei K'uei, 134

Terminal Iron Works, 114

Thomas, Dylan, 88, 168

Thomas, Lewis, 98

Thompson, Darcy, 54

Thompson, Francis, 54

Thomson, Virgil, 36

Thoreau, Henry David, 200

3EP Ltd., 66, 152

306 Group, 62

Tiber Press, 14, 32, 142, 148, 168, 184, 259 n.48.9, 261 n.61.6

Tiber Press Portfolios, 14, 15, 142

Tibor de Nagy Gallery, 13, 32, 142, 148, 170, 182, 184, 186, 254 n.10.5

Tiepolo, Giovanni Battista, 248

Time magazine, 29, 46

Ting, Walasse, 168, 176, 222, 263–64 n.86; *Black Orpheus,* 222–23; *Chinese Moonlight,* 264 n.86.6; *Fortune Kookie* series, 222, 264 n.86.8; *Hollywood Honeymoon* series, 222; *Hot and Sour Soup,* 264 n.86.6

Tinguely, Jean, 158

titles, significance of, 28, 146

Tobey, Mark, 64, 134, 164, 230, 259 n.44, 260–61 n.59.3; *Broadway,* 134; *Composition,* 134–35; *The Promenaders (Written in the Air),* 134; *Untitled,* 134, 259 n.44.4

Todd, Ruthven, 14

Tomlin, Bradley Walter, 236

Toro Desconocido, 16

Transcendental Painters Group, 194

Très Riches Heures du Duc de Berry, Les, 124

Turner, Leroy, 54

Twelve Americans exhibition, 176, 242

21 Etchings and Poems, 14, 16, 140, 172, 208, 222

Twombly, Cy, 16, 126, 238, 252 n.1.5, 265 n.94; *The Age of Alexander,* 238; *The Anatomy of Melancholy,* 238; *The Four Seasons,* 238; *Sketches* suite, 238; *Song of the Border Guard,* 238, 265 n.94.2; *Untitled II,* 238–39

Tworkov, Jack, 13, 17, 228, 258 n.43.3, 264 n.89; *Barrier L#1,* 228–29; *Green Landscape,* 228; *House of the Sun,* 228

Tyler, Kenneth, 17

Un Art Autre exhibition, 130

Universal Limited Art Editions (ULAE), 16, 158, 170, 182, 186, 200, 234, 238

University of California at Santa Barbara (UCSB), 204

Uno, Grafico, 190

Upiglio, Giorgio, 130, 190

Urban, Albert, 122, 258 n.38; *Untitled,* 122–23

Urban, Reva, 122

urban landscapes: Colescott, 146–47; Conover, 156; Guston, 236

Ussachevsky, Vladimir, 144

Valentine, Curt, 10
Valéry, Paul, 106
van der Wiele, Jerry, 126
van Doren, Mark, 106
van Pappelendam, Laura, 132
Varèse, Edgard, 24, 25
Vecchi, Floriano, 14, 15, 142, 148, 168, 261 n.61.6
Velonis, Anthony, 154
Verdet, André, 230
Viaggo in Italia (Taine), 106
Vicente, Esteban, 16, 17, 208, 263 n.80; *Untitled,*
 208–9
Viereck, Peter, 252 n.intro.11
Viesulas, Romas, 16, 144, 259 n.49; *Dainos,* 144;
 The Fall, 144–45; *Toro Desconocido,* 144
View, 182
Villon, Jacques, 218
Volz, Herman, 96
von Wicht, John, 263 n.83; *The Four Seasons,* 216;
 Icarus, 216–17
Voulkos, Peter, 178
Vytlacil, Vaclav, 62, 78, 186, 198

Wald, Sylvia, 116, 257–58 n.36; *Black Moonlight,*
 116, 258 n.36.7; *Chrysalis,* 116;
 Metamorphosis, 116; nature, 116; *One;*
 Another, 116–19; *Sun Caught in a Rock,* 258
 n.36.6
Wanderer, The (Fournier), 192
Ward, Charles, 156
Warhol, Andy, 259 n.48.9
Wasserstein, Julius, 110, 112, 120, 162, 257 n.33.6,
 260 n.58; *Untitled,* 162–63
Waste Land, The (Eliot), 30
Wayne, June, 16, 94, 144, 160, 188, 222
Weber, Hugo, 94, 224, 264 n.87; *Black Punch,* 224;
 Untitled, 224–25
Weber, Max, 50, 94, 110
Weeks, James, 152
Weinstein, Arnold, 36
Weisenthal, Morris, 14, 252 n.intro.11
Weiss, Alter, 116
welding, 130
Wells, Cady, 194
West Coast Modernism, 92
Wheeler, Steve, 56
White Goddess, The (Graves), 202

"white writing," Tobey, 134
Whitney Museum of American Art, 28
Whitney Studio Club, 244
Wickert, Paul, 84
Wickey, Harry, 200
Wilke, Mally Brandes, 260–61 n.59.2
Wilke, Ulfert, 160, 164, 260–61 n.59; *Fragments*
 from Nowhere, 164, 260 n.59.6; *Music To Be*
 Seen, 164–65, 260–61 n.59.3; *One, Two and*
 More, 260–61 n.59.7; *Untitled,* 261 n.59.10;
 UW, 261 n.59.10
Williams, Guy, 204, 263 n.78; *Painter's Notebook,*
 204; *Untitled,* 204–5
Williams, Valdo, 25
Wilm, Juliette Eleanor, 58. *See also* Steele, Juliette
"wire delineations," Falkenstein, 130
Woelffer, Emerson, 94, 224, 234, 256 n.25; *Bird*
 series, 94; *Numbers* series, 94; *Untitled,*
 94–95
Wolf, Leslie, 36
Wolfe, Tom, 252 n.poetry.10
Wood, Grant, 128
woodcuts. *See also* color woodcuts: Brenson, 106;
 Casarella, 154; Conover, 156, 260 n.55.7; Fine,
 166; Glankoff, 244; Kasten, 262 n.72.4;
 Longo, 192; Meert, 68; Moy, 198; Ryan, 74;
 Wald, 116; Yunkers, 180
wood engraving: Guy Williams, 204
Woodruff, Hale, 142
wood scrap figures, 232
World War II, 9–11
writing style, 238

Yau, John, 248
Young, Edward, 54
Young American Printmakers exhibition, 104
Yunkers, Adja, 14, 86, 180, 262 n.67; *Blanco,* 180;
 Ostia Antica, 180; *Poems for Marie José,* 180;
 Polyptych, 180; *Prints in the Desert,* 180; *Salt*
 suite, 180, 262 n.67.10; *Skies of Venice,* 180;
 Untitled (Skies of Venice VIII), 180–81

Zadkine, Ossip, 188, 220, 240
Zen Buddhist art, 194, 234
zenga painting, 188, 244
Ziemann, Richard, 192
"Zip," Newman, 200
Zirker, Joseph, 17, 66, 208
Zogbaum, Wilfred, 172

PHOTO CREDITS

Page 8 and back cover, *The Prepared Lithography Stone for Willem de Kooning's* Waves #1, *1960* © Karl Kasten

Page 10, soft-ground etching and engraving, 7/50, 37.8 x 50.0 cm (plate), private collection

Page 11, lithograph with black crayon additions, Museum of Modern Art, gift of Dorothy C. Miller

Page 12, photo courtesy of Nikki Casarella

Page 14, gelatin silver print, 27.9 x 35.4 cm, Worcester Art Museum, Richard A. Heald Fund, 1997.3 © Burt Glinn, Magnum Photos

Page 15, photo courtesy of Floriano Vecchi

Page 15, screenprint, 106/200, 44.5 x 35.8 cm (sheet), private collection

Page 15, photo courtesy of Floriano Vecchi

Page 16, Center for Southwest Research, General Library, University of New Mexico

Page 17, photo courtesy of Irwin Hollander

Page 18, © Burt Glinn, Magnum Photos

Page 20, © John Cohen

Page 21, © Bob Parent

Page 22, © John Cohen, photo courtesy of Deborah Bell

Page 23, © John Cohen, photo courtesy of Deborah Bell

Page 25, © Burt Glinn, Magnum Photos

Page 26, gelatin silver print, 35.5 x 27.9 cm, Worcester Art Museum, Richard A. Heald Fund, 1997.2 © Burt Glinn, Magnum Photos

Page 28, photo courtesy of Floriano Vecchi

Page 29, gelatin silver print, 28.0 x 35.3 cm, Worcester Art Museum, Heald Foundation Fund, 1996.51

Page 30, gelatin silver print, 22.3 x 18.9 cm, Worcester Art Museum, Heald Foundation Fund, 1996.51

Page 31, © Willem de Kooning Revocable Trust/Artists Rights Society (ARS), New York

Page 32, gelatin silver print, 27.9 x 35.5 cm, Worcester Art Museum, Richard A. Heald Fund, 1995.67.63

Page 33, photo courtesy of Floriano Vecchi

Page 35, The Bluhm Family Collection

Page 37, © Hans Namuth

Page 44, © 2001 Pollock-Krasner Foundation/Artists Rights Society (ARS), New York

Page 45, © 2001 Pollock-Krasner Foundation/Artists Rights Society (ARS), New York

Page 49, © Adolph and Esther Gottlieb Foundation/Licensed by VAGA, New York, NY

Page 51, © 1998 Kate Rothko Prizel and Christopher Rothko/Artists Rights Society (ARS), New York

Page 79, © Louise Bourgeois, Licensed by VAGA, New York, NY

Page 115, © Estate of David Smith/Licensed by VAGA, New York, NY

Page 135, © 2001 Artists Rights Society (ARS), New York/Pro Litteris, Zürich

Page 140, photo courtesy of Barbara Mathes Gallery © 2001 Artists Rights Society (ARS)

Page 141, © 2001 Artists Rights Society (ARS)

Page 173, © 2001 Willem de Kooning Revocable Trust/Artists Rights Society (ARS), New York

Page 177, © 2001 The Estate of Sam Francis/Artists Rights Society (ARS), New York

Page 201, © 2001 Barnett Newman Foundation/Artists Rights Society (ARS), New York

Page 207, © 2001 Pollock-Krasner Foundation/Artists Rights Society (ARS), New York

Page 233, © 2001 Estate of Louise Nevelson/Artists Rights Society (ARS), New York

Page 235, © Dedalus Foundation, Inc./Licensed by VAGA, New York, NY

Page 241, © Jules Olitski/Licensed by VAGA, New York, NY

Page 243, © Estate of James Brooks/Licensed by VAGA, New York, NY

Page 296, Edmond Casarella at the press, photo courtesy of Nikki Casarella

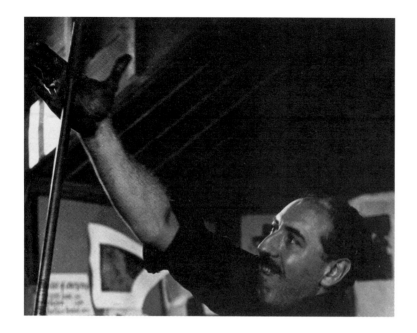

DESIGNED BY SUSAN MARSH

COPYEDITED BY DENISE BERGMAN

TYPE COMPOSED IN META BY SUSAN MARSH

PRINTED BY SNOECK-DUCAJU & ZOON, GHENT, BELGIUM